b-89 $55.00

b-89 $55.00

OWLS
OF THE NORTHERN HEMISPHERE

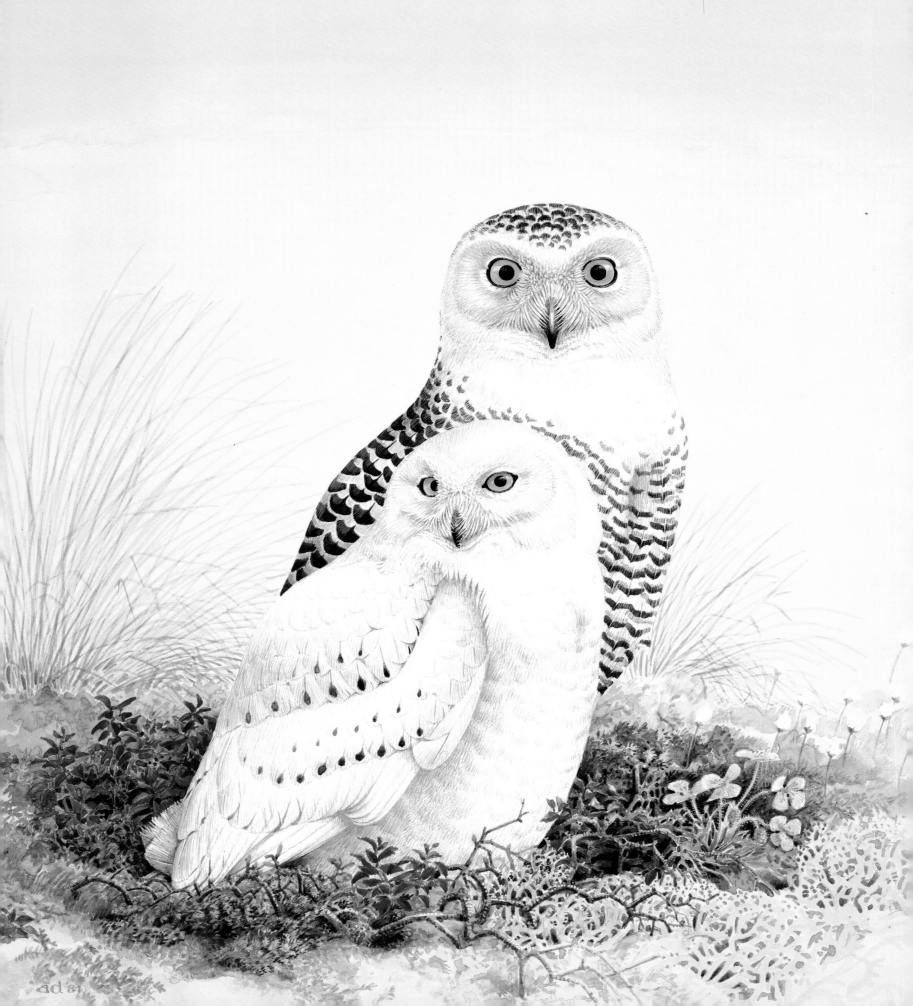

OWLS
OF THE NORTHERN HEMISPHERE

Karel H. Voous
Illustrated by Ad Cameron

The MIT Press
Cambridge, Massachusetts

For HENNY
who has shared my love of owls since the days of
our engagement in 1945 and who has put up with
having a house full of books, papers and notes on
owls, and owl figurines

Frontispiece
A pair of Snowy Owls *Nyctea scandiaca*,
male in front and female behind

First published in 1988
by William Collins Sons and Co. Ltd., London, UK

Designer: Caroline Hill

First MIT Press edition, 1989

Text © 1988 Karel H. Voous
Illustrations © 1988 Ad Cameron

All rights reserved. No part of this book may be reproduced in any
form or by any electronic or mechanical means (including
photocopying, recording, or information storage and retrieval)
without permission in writing from the publisher.

Library of Congress Cataloging-in-Publication Data

Voous, K. H. (Karel Hendrik)
 Owls of the Northern Hemisphere.
 Bibliography: p.
 Includes index.
 1. Owls. I. Title.
 QL696.S8V66 1988 598'.97 88-13367
 ISBN 0-262-22035-0

Filmset by Ace Filmsetting Ltd, Frome, Somerset
Origination by Gilchrist Brothers Ltd, Leeds
Printed and bound by C S Graphics PTE Ltd, Singapore

Contents

PREFACE	7	CUCKOO OWLET	165
		Glaucidium castanopterum	
BARN OWL	9	ELF OWL	170
Tyto alba		*Micrathene whitneyi*	
GRASS OWL	23	BROWN HAWK OWL	177
Tyto capensis		*Ninox scutulata*	
MOUNTAIN SCOPS OWL	29	LITTLE OWL	181
Otus spilocephalus		*Athene noctua*	
ORIENTAL SCOPS OWL	33	SPOTTED OWLET	189
Otus sunia		*Athene brama*	
STRIATED SCOPS OWL	37	BURROWING OWL	193
Otus brucei		*Athene cunicularia*	
EUROPEAN SCOPS OWL	41	MOTTLED OWL	200
Otus scops		*Strix virgata*	
COLLARED SCOPS OWL	48	BROWN WOOD OWL	205
Otus bakkamoena		*Strix leptogrammica*	
FLAMMULATED OWL	53	TAWNY OWL	209
Otus flammeolus		*Strix aluco*	
WESTERN SCREECH OWL	59	HUME'S OWL	220
Otus kennicottii		*Strix butleri*	
EASTERN SCREECH OWL	64	BARRED OWL	225
Otus asio		*Strix varia*	
WHISKERED OWL	69	SPOTTED OWL	231
Otus trichopsis		*Strix occidentalis*	
VERMICULATED SCREECH OWL	74	URAL OWL	237
Otus guatemalae		*Strix uralensis*	
GREAT HORNED OWL	79	GREAT GREY OWL	244
Bubo virginianus		*Strix nebulosa*	
EURASIAN EAGLE OWL	87	LONG-EARED OWL	252
Bubo bubo		*Asio otus*	
SPOTTED EAGLE OWL	100	STYGIAN OWL	262
Bubo africanus		*Asio stygius*	
FOREST EAGLE OWL	105	STRIPED OWL	267
Bubo nipalensis		*Asio clamator*	
BLAKISTON'S FISH OWL	109	SHORT-EARED OWL	271
Ketupa blakistoni		*Asio flammeus*	
BROWN FISH OWL	114	AFRICAN MARSH OWL	279
Ketupa zeylonensis		*Asio capensis*	
TAWNY FISH OWL	119	TENGMALM'S OWL	284
Ketupa flavipes		*Aegolius funereus*	
SNOWY OWL	123	NORTHERN SAW-WHET OWL	293
Nyctea scandiaca		*Aegolius acadicus*	
NORTHERN HAWK OWL	132		
Surnia ulula		DISTRIBUTION MAPS	299
EURASIAN PYGMY OWL	138		
Glaucidium passerinum		APPENDIX I	307
NORTHERN PYGMY OWL	146	*Owl Species Mentioned in the Text*	
Glaucidium gnoma			
LEAST PYGMY OWL	153	BIBLIOGRAPHY	308
Glaucidium minutissimum			
FERRUGINOUS PYGMY OWL	157	INDEX	317
Glaucidium brasilianum			
COLLARED OWLET	161		
Glaucidium brodiei			

Author's Acknowledgements

I wish to repeat here that without the help of numerous other owl enthusiasts throughout the world this book could not have been written. My principal debt is to the authors of well over a thousand books and publications I have consulted; the titles of most of those of which appeared before 1978 have been listed in the useful *Working Bibliography of Owls of the World* (1978) compiled by Richard J. Clark, Dwight G. Smith and Leon H. Kelso. I also gratefully acknowledge the continuous help I have received from the librarians of the Institute of Taxonomic Zoology (Zoological Museum) of the University of Amsterdam (including the library of the Netherlands Ornithological Union) and of the State Museum of Natural History in Leiden and the curators of those institutions. During my absence Dr Tjalling van Dijk and later Dr E. Nieboer supervised experimental research on owls in the Biological Laboratory of the Free University at Amsterdam (VU), for which I am grateful. Their names and those of the students working under their direction are mentioned below.

Special mention must also be made of my former secretary at the Free University at Amsterdam, Mrs Tineke G. Prins, Dr Ruth Sharman of Collins Publishers, who efficiently revised the English grammar of my texts and gave other editorial assistance, and Mr J. J. Suren, who kindly translated Russian texts which would otherwise have been unavailable to me.

The full list of those who have helped me with publications, first-hand information, and otherwise, is as follows:

H. Abdulali (India), R. Altmüller (FRG), R. Arlettaz (Switzerland), H. Alvarez-López (Colombia), P. Ballmann (FRG), J. Bastin (UK), H. Baudvin (France), W. Baumgart (DDR), G. Beven (UK), B. Biswas (India), H. Blokpoel (Canada), E. Boerma (NL), R. Boscaini (Italy), P. C. Boxall (Canada), M. A. Brazil (Japan), D. F. Brunton (Canada), L. Brussard (VU, NL), A. Bruijn (NL), J. B. Buker (NL), K. O. Butts (USA), R. Wayne Campbell (Canada), Stephen R. and Jean Cannings (Canada), Richard J. Cannings (Canada), Syd Cannings (Canada), C. E. Corchran (USA), Tso-Hsin Cheng (Zuoxin Zheng) (China), R. J. Clark (USA), C. K. Coldwell (Canada), C. T. Collins (USA), L. Contoli (Italy), F. Cooke (Canada), A. Demeter (Hungary), G. E. Duke (USA), T. van Dijk (VU, NL), S. Eck (DDR), K. R. Eckert (USA), C. Edelstam (Sweden), M. H. Edwards (Canada), E. Erkinario (Finland), S. Erlinge (Sweden), D. G. Follen, Sr (USA), E. Forsman (USA), M. D. Gallagher (Oman), O. H. Garrido (Cuba), H. Gasow (FRG), E. E. Godfrey (Canada), Lenie G. Groen (NL), the late William M. Gunn (Canada), Frances and Frederick Hamerstrom (USA), A. Hartog (NL), G. P. Hekstra (NL), C. J. Henny (USA), J. Hinshaw (USA), F. Hiraldo (Spain), S. Houston (Canada), K. Hudec (Czechoslovakia), C. Imboden (UK), F. M. Jaksić (USA), J. R. Jehl (USA), A. Jensen (Sweden), L. Kelso (USA), Gerda van Keulen (VU, NL), S. Kohl (Roumania), Claus König (FRG), N. Kuroda (Japan), E. Kurotchkin (USSR), Mary LeCroy (USA), G. M. Lenton (UK), Y. Leshem (Israel), V. Lilleleht (USSR), J. Lindblad (Sweden), S. Lovandri (Italy), S. Lovari (Italy), A. Lundgren (Sweden), Joe T. Marshall (USA), H. D. Martens (FRG), C. D. Marti (USA), D. J. Martin (USA), G. R. Martin (UK), T. M. Matthiae (USA), Th. Mebs (FRG), G. F. Mees (NL), H. Mikkola (Finland), J. H. Mooij (NL), Cécile Mourer-Chauviré (France), J. F. Murphy (USA), A. A. Nazarenko (USSR), R. W. Nero (Canada), E. Nieboer (VU, NL), D. M. Niles (USA), J. Noorduyn (NL), R. Årne Norberg (Sweden), D. F. Parmelee (USA), J. Paul (NL), M. R. Perrin (South Africa), J. D. Pettigrew (USA), A. R. Phillips (Mexico), H. Pieper (FRG), H. Pietiäinen (Finland), R. Plomp (NL), Tineke G. Prins (NL), Y. B. Pukinsky (USSR), K. Radler (FRG), S. Dillon Ripley (USA), D. H. S. Risdon (UK), F. Ritter (DDR), A. Robertson (South Africa), C. S. Roselaar (NL), A. Ross (USA), H. Sandee (NL), W. Schelper (FRG), W. Scherzinger (FRG), E. Schmidt (Hungary), J. Schönn (DDR), J. Schwartzkopff (FRG), L. Schwarzenberg (FRG), O. Schwerdtfeger (FRG), Ruth Sharman (UK), C. Smeenk (NL), D. G. Smith (USA), R. Solheim (Norway), L. J. Soucy, Jr (USA), L. Stepanyan (USSR), R. W. Storer (USA), J. J. Suren (NL), E. Sutter (Switzerland), E. Tchernov (Israel), J. Valentijn (NL), H. J. Veltkamp (VU, NL), B. Vos (NL), J. Wahlstedt (Sweden), P. M. Walters (USA), J. Wattel (NL), P. D. M. Weesie (NL), R. D. Weir (Canada), D. R. Wells (Malaya), W. J. van der Weyden (NL), H. J. Wight (NL), Jon Winter (USA), H. Wijnandts (NL), H. Zang (FRG).

I have probably unintentionally omitted the names of some who have helped me, but to all I express my sincerest thanks and I hope that their valuable data and views will be recognizable in this book.

Artist's Acknowledgements

Indispensable to any painter of birds is access to a wide selection of skins. Most of the following paintings were done from owls in the collection of the State Museum of Natural History in Leiden (Holland). Dr G. F. Mees, of the Department of Birds, has given much time and attention to choosing the best examples. For this reason I owe him a particular debt of gratitude. I also want to thank my friend Bas Valk for providing me with some important details on Hume's Owl (*Strix butleri*). Last but not least I owe a very special debt of gratitude to Prof. Dr Karel Voous – being the expert in the field of owls – for writing the text to my plates.

PREFACE

*"To watch a gyrfalcon and a snowy owl pass each other
in the same sky is to wonder how the life of the one
affects the other"*
　　　　　　　　Barry Lopez, *Arctic Dreams*, 1987:159

Whether we observe a Gyrfalcon and a Snowy Owl flying in the same sky or a Peregrine Falcon and an Eagle Owl nesting on the same rock face, the curiosity we feel and the questions we ask ourselves will be the same. It is questions such as these which form the principal subject matter of this book: how owls relate to other owls, whether of the same or of different species, and how they relate to their geographic origin and range, their environment, their prey, their predators, and man. The present book is not a handbook on owls; it is not even a work of science in the strict sense of the word; I prefer to call it a work of love.

　When, in 1981, I was asked by Collins Publishers to write a text to accompany the illustrations done by my fellow countryman Ad Cameron, the event was in fact a sad one, for I was to take over the task assigned to the late Leslie H. Brown who had died unexpectedly in early August 1981. Leslie Brown, author of a number of well-known monographs on birds of prey, had undoubtedly already elaborated an approach to this book. I was full of admiration for Mr Cameron's magnificent and skilful drawings, but it now remained for me to decide what form the book should take. The appearance of several other splendid, mostly semi-popular, books on owls in every corner of the world didn't make the task any easier. The most noteworthy of these are the works by Theodor Mebs (1966, 1980), Jan Lindblad (1967), John Sparks & Tony Soper (1970), Cameron & Parnall (1971, 1972), Siegfried Eck & Horst Busse (1973), John A. Burton (ed., 1973), Yü. B. Pukinsky (1977), G. Steinbach (1980), Richard Schodde & Jan J. Mason (1980), Heimo Mikkola (1983), Wardhauch (1983), Heintzelman (1984), Peter Steyn (1984) and Calburn & Kemp (1987). In the meantime Professor Urs N. Glutz von Blotzheim and Dr Kurt M. Bauer's *Handbuch der Vögel Mitteleuropas*, volume 9 (1980), and the fourth volume of the *Handbook of the Birds of Europe, the Middle East and North Africa* (1985), edited by Stanley Cramp, have appeared, each containing detailed monographs of a total of 17 species occurring within the geographic limits of their works. Important additions to our knowledge of western North American owls have been published in the Proceedings of the National Audubon Society's Symposium on Owls of the West (ed. Philip P. Schaeffer & Sharyn Marie Ehler, 1979), whereas a very readable overall review of owls was provided by R. Å. Norberg at the Symposium on the Biology and Conservation of Northern Forest Owls held in Winnipeg, Manitoba, Canada, in February 1987 (Nero *et al.*, 1987:9–43).

　Leslie Brown appeared to have completed writing one or more introductory chapters, which the four instructive plates (reproduced on pp. 14, 44, 140, 256) showing hunting flights, nest sites, cryptic postures and juvenile plumage were probably intended to illustrate.

　My own approach in this book has been as follows. The text of each species is divided into the following sections: (1) introductory remarks, (2) general, (3) geography, (4) structure, hearing and vision, (5) behavioural characteristics, (6) ecological hierarchy, (7) breeding habitat and breeding, (8) food and feeding habits, (9) movements and population dynamics, (10) geographic limits, (11) life in man's world, (12) concluding remarks. I have not provided introductory chapters of a general nature, but for topics of more than specific interest, such as hearing, vision, vocalizations, population fluctuations, geographical variation, morphs or colour phases, fossil species, etc., more general information can be found in the subject index. My reason for this is that I have always preferred to deal with species rather than with models, schemes or generalities, for if a theory in biology contains a truth, then this truth must have been deduced from nature, and it is to nature that we must look first of all. I am therefore less interested in, for example, the hearing capacities of owls in general than in those of, say, the Great Horned Owl in relation to that species' life style and its ecological position. Unfortunately, though it is well known that each species has its own structural, ecological and ethological characteristics, our knowledge of owls is mostly very incomplete, if not anecdotal. In numerous instances, therefore, I have had to stress not only our ignorance in many areas, but the uncertainty of many of the facts we *think* we know.

　I have not personally selected the species dealt with in this book; they had already been agreed upon by Leslie Brown and Collins Publishers jointly. They include all the species mentioned in my *List of Recent Holarctic Bird Species* (1977), with the addition of some geographically marginal ones, so that virtually all owl species occurring north of the tropics are described here. At my request, one more tropical American species, the Striped Owl *Asio clamator*, has been added, with the result that the present work deals with a total of 47 species, of which 7 have at least a Holarctic distribution (non-tropical Eurasia and North America combined), 24 are restricted to the Old World and 16 are restricted to the Americas.

　I have endeavoured to use a minimum of technical jargon and have made ample reference to sources in the literature. Numerous ornithologists and naturalists, both living and dead, have had a much more intimate and profound knowledge

PREFACE

of owls in their natural habitat than I have; what they have entrusted to print has been an invaluable help to me. Their names appear in the Bibliography, though they deserve a place in the Acknowledgements. The list of all those who have responded to my queries and helped me in most generous ways is very long and will be found in the Acknowledgements. Here I would simply like to say that Ad Cameron's paintings have provided me with a constant source of inspiration while I was engaged in writing my texts. His motivation must have been the same as mine: love of owls.

<div style="text-align: right;">

K. H. Voous
Huizen, The Netherlands
September, 1987

</div>

BARN OWL

Tyto alba

The Barn Owl is one of the two monkey-faced owls *Tytonidae* (8–10 species in total) which occur within the geographic limits covered by this book. The main themes which will be treated in the following species account are the Barn Owl's relationship with the *Strigidae* owls; the probably parallel evolution of its outer ear structure and highly developed sense of hearing and sound location; its geographic origin and the possibility of a distributional centre of origin in the Australian and Wallacean regions; the age and history of its semi-cosmopolitan range, and the tendency of recent systematists to split the one species – usually divided into 35–40 geographical races – into several (Olson, 1978; Bond, 1982).

The presence of two species of parasitic feather lice *Strigiphilus* (*Mallophaga*), one living on Barn Owls in Africa, Europe and the Middle East, the other on Barn Owls in southern Asia, Australia and the Americas, may suggest the former existence of two subspecies groups of Barn Owl (Clay, 1966). The significance of this discovery is unclear and it is not known how and where Old World and New World Barn Owls have ever been in geographical contact with one another.

Cave deposits in the Caribbean islands and mediterranean Europe have shown extinct species of *Tyto*, including giants as large as or larger than present-day eagle owls *Bubo*. The former structural and, without doubt, also ecological diversity of *Tyto* has led to the question of whether the present Barn Owl and its relatives are no more than remnants of a group which passed its heyday long ago. The probably close relationship between *Tyto* and the Bay Owls *Phodilus* from the dark depths of Asian and African rain forests (Wells, 1986) and the occurrence of an eccentric barn owl species in Madagascar (*Tyto soumagnei*), Sulawesi (Celebes) (*Tyto inexpectata*) and New Guinea (*Tyto tenebricosa*) may confirm the great antiquity of the Barn Owl group. Specific characteristics such as the pigment epithelium contained in the retina of the Barn Owl's eye (Dieterich, 1975) and the chemical composition of the wax secreted by its uropygial gland (Jacob & Poltz, 1974) also indicate the Barn Owl's unique position among owls. The immunity of Barn Owls, and also of wood owls of the genus *Strix*, to the lethal epidemic viral disease *Hepatosplenitis infectiosa strigum* (Mikulica et al., 1981) suggests a more complicated genetico-chemical relationship among owls than a simple division into *Tytonidae* and *Strigidae*. Most remarkably, a male Barn Owl and a female Striped Owl *Asio clamator* produced partly fertile eggs in a North American zoo on more than one occasion (Flieg, 1971).

The occurrence of Barn Owls in temperate regions of North America and Europe and its absence in China and virtually all temperate Asia give rise to the supposition that the Barn Owl is originally a tropical and subtropical species. It is certainly seriously affected by long, cold winters during which substantial proportions of the population die. Like the Long-eared and Short-eared Owls *Asio otus* and *Asio flammeus*, the Barn Owl is a "restricted feeder", specializing in a diet of colonially living terrestrial rodents. During the cyclic periods of food shortage it resorts to other methods for ecological survival than those employed by the Long-eared and Short-eared Owls or the resident wood owls *Strix*.

GENERAL

Faunal type Cosmopolitan.

Distribution Almost cosmopolitan, but absent in virtually the whole of Canada, Fennoscandia, central and northern Russia, Turkestan, Siberia, central Asia, China and Japan. Widely distributed in temperate and tropical America, north to the southwestern corner of British Columbia (southern Vancouver Island; nesting in 1909 at Ladner at the mouth of the Fraser River, slightly over 49° north (Bent, 1938); northern United States, Massachusetts (Stewart, 1980) and, probably irregularly and sparsely, southeastern Ontario (Speirs, 1985). In South America south to Isla Grande, Tierra del Fuego, at 52° south (Humphrey et al., 1970). Temperate and mediterranean Europe north to Skåne, southernmost Sweden, though very few Barn Owls, if any, are left there; east to western Russia. The whole of Africa except the most arid and desolate parts of the Sahara and the lowland tropical rain forest areas; Madagascar. In Asia, possibly most of the Middle East and southwestern Iran, all Pakistan, India, Sri Lanka, part of Burma and most of the Indo-Chinese countries, but sparingly in moist tropical lowlands and probably only recently in the Malay Peninsula and Sumatra, though long established on Java and the Lesser Sunda Islands east to Timor; absent in Borneo, the Philippines, Moluccas and most of New Guinea except the southeast. Australia and Tasmania and possibly Flinders Island in the Bass Strait, but not New Zealand, though sub-recent bones and recent stragglers have been recorded.

In addition, numerous small islands, often far removed from

the continents, indicating the Barn Owl's amazing colonizing ability. They include: San Juan Island, Juan de Fuca Strait, Washington, United States (Bruce & Long, 1962); Socorro, Revillagigedo Islands (Jehl & Parkes, 1982), Tres Marias Islands, and Todos Santos Islands, Baja California (Bent, 1938); Bermuda and the larger Bahama Islands; Cuba (Garrido, 1978), Isle of Pines, Jamaica, Hispaniola, possibly Puerto Rico (Bond, 1984:7), southernmost Lesser Antilles, including Dominica, St Vincent, Grenada and the Grenadines; Gran Caiman and Caimon Brac (J. Bond), also Bonaca and Roatan, Bay Islands, Belize (Parkes & Phillips, 1978), in the central and west Caribbean; Curaçao, Trinidad and Tobago in the south Caribbean; Pearl Islands, Gulf of Panama; six or seven of the Galápagos Islands (Steadman, 1986); Falkland Islands (stragglers only?) (Woods, 1975); most islands in the Mediterranean; Madeira, Porto Santo and Desertas Islands; Canary and Cape Verde Islands; Fernando Po and São Tomé in the Gulf of Guinea; Zanzibar and Pemba; islands in the western Indian Ocean: Comoro Islands, Seychelles (introduced), Aldabar (now extinct); islands in the eastern Indian Ocean: south Andaman Islands, Thousand Islands and Kangean in the Java Sea; most of the Lesser Sunda Islands east of Java (White & Bruce, 1986). Numerous Melanesian and some Polynesian islands in the tropical west Pacific north and east of New Guinea: Karkar (Dampier I.), Manam (Vulcan I.), Solomon Islands, Santa Cruz Islands (Vanikoro), Banks Islands, New Hebrides, Loyalty Islands, New Caledonia, Fiji, Tonga, Samoa, Union Islands, east to Society Islands, Lord Howe Island (introduced from Australia and California), Hawaiian Islands (introduced Hawaii 1958, Kauai 1959, from California, now widespread over the archipelago; Berger, 1972; but an extinct long-legged owl may have been of this genus: see Olson & James, 1984:771). Map 1.

Climatic zones Widely distributed and absent from tundra and boreal climatic zones only. The northern limit reaches the mean annual isotherm of 8°C in North America and 6°C in Europe, corresponding approximately with the isotherm of 0–5°C of the coldest month in North America and Europe (January) as well as the tip of South America (July).

Habitat An almost endless variety of open, mosaic vegetation types, at present most often in relation to human activity and more often in arid than in moist conditions: wide river valleys with bush, grassland, rows of trees bordering footpaths, roads and canals; agricultural fields, including fields of potato, beet, cereals, corn, rice, and also plantations of coffee, cacao, tobacco and oil palms (Lenton, 1984); forest clearings and the edges of natural and planted forests, marshes and moors; cattle pastures, cleared bush, arid grasslands in the tropics, evergreen xerophytic, mediterranean bush, maquis and chaparral; in South America, selvas and savannahs; in Africa, strips of riparian woods, *miombo* (*Brachystegia*) and *mopane* (*Colophospermum*) woodland and acacia savannah; semi-deserts and deserts, including the beds of ephemeral rivers in the Kalahari Desert; in Australia, *mallee*, saltbush and spinifex, rarely eucalypt forest and exceptionally rain forest; among sea bird colonies on rocks and keys on arid seacoasts of subtropical and tropical Central and South America (see Bonnot, 1928). Day-roosting sites include rock fissures, narrow holes – natural or self-made – and spacious caves, cliffsides and river banks, large, isolated trees or dense tree stands where the owls can hide in holes or thick foliage, including the stately baobab trees in the African savannah and the sacred fig trees in tropical Asia, where they find spacious natural holes. Above all, Barn Owls seem to prefer to live in spaces under rooves, in the lofts and attics of any house or public building, in church towers, ruined castles, farmhouses, derelict sheds, mills, wells, cisterns, mine shafts, even abandoned agricultural gear left in the field. Frequently also at the base of palm fronds high above the ground, often in rows of palm trees bordering streets and roads in tropical towns. Whenever possible the Barn Owl lives in suburbs and towns, in temperate regions as well as in the tropics.

In accordance with its habitat preferences, the Barn Owl does not penetrate high in the mountains. In the Alps it rarely ascends as high as 600–800m (Scherzinger, 1981), but it was once found nesting in the central Berner Alps at 1,020m (Glutz & Bauer, 9, 1980:245). On the southern Himalayan slopes and in the Nepal Valley it reaches 1,280m or somewhat higher (Fleming *et al.*, 1976), and in the Moroccan Atlas it is thought to ascend to 1,500m. In the Cameroon Highlands it lives in the montane savannah among boulders of lava at 2,500m (Eisentraut, 1963:186), and on the East African plateau it is known to ascend as high as 3,000m (Britton *et al.*, 1980). In the Ecuadorean Andes it occurs from sea level to over 3,000m in the paramo zone of Mt Pichincha above Quito (Chapman, 1926:253); also to 3,000m in the Venezuelan Andes, and up to about 4,000m in central Peru (J. Dorst) and at 4,080m around Lake Junin, Peru (Fjeldså, 1983). On the Mexican Plateau, as in many mountain regions, it occurs mainly in towns and villages, though it has reached almost 1,900m in Guatemala under natural conditions (Griscom, 1932).

GEOGRAPHY

Geographical variation Geographical variation in the Barn Owl is conspicuous and complicate, relating to body size, relative and absolute strength of bill, legs and talons, colour of the plumage and degree of spotting and other marks on the underparts. However, over large areas variation is non-existent or clinal and there are numerous island populations which differ from one another in degree rather than in absolute character. Thus, the number of geographical races recognized by name is probably larger than in any other bird species and varies between 34 (Peters, 4, 1940) or 35 (Cramp, 4, 1985) and 40 (Eck & Busse, 1973). The number of island forms is astonishingly large and amounts to 23–25.

The Barn Owls from continental North and South America are largest. Compared with birds from continental Europe (*Tyto alba guttata*, average wing length of male 286mm, of female 287mm), North American birds (*T. a. pratincola*) are larger in wing length by about 20%, tropical South American ones (*T. a. hellmayri*) by about 12%, Afrotropical ones (*T. a. affinis*) by about 2%, but Australian ones (*T. a. delicatula*) are smaller by about 3%. Insular populations are small as a rule but have large talons and claws, though the Barn Owls from Cuba (*T. a. furcata*) are the

Barn Owl *Tyto alba*
Central European race *T. a. guttata* (above)
British and South European race *T. a. alba* (below)

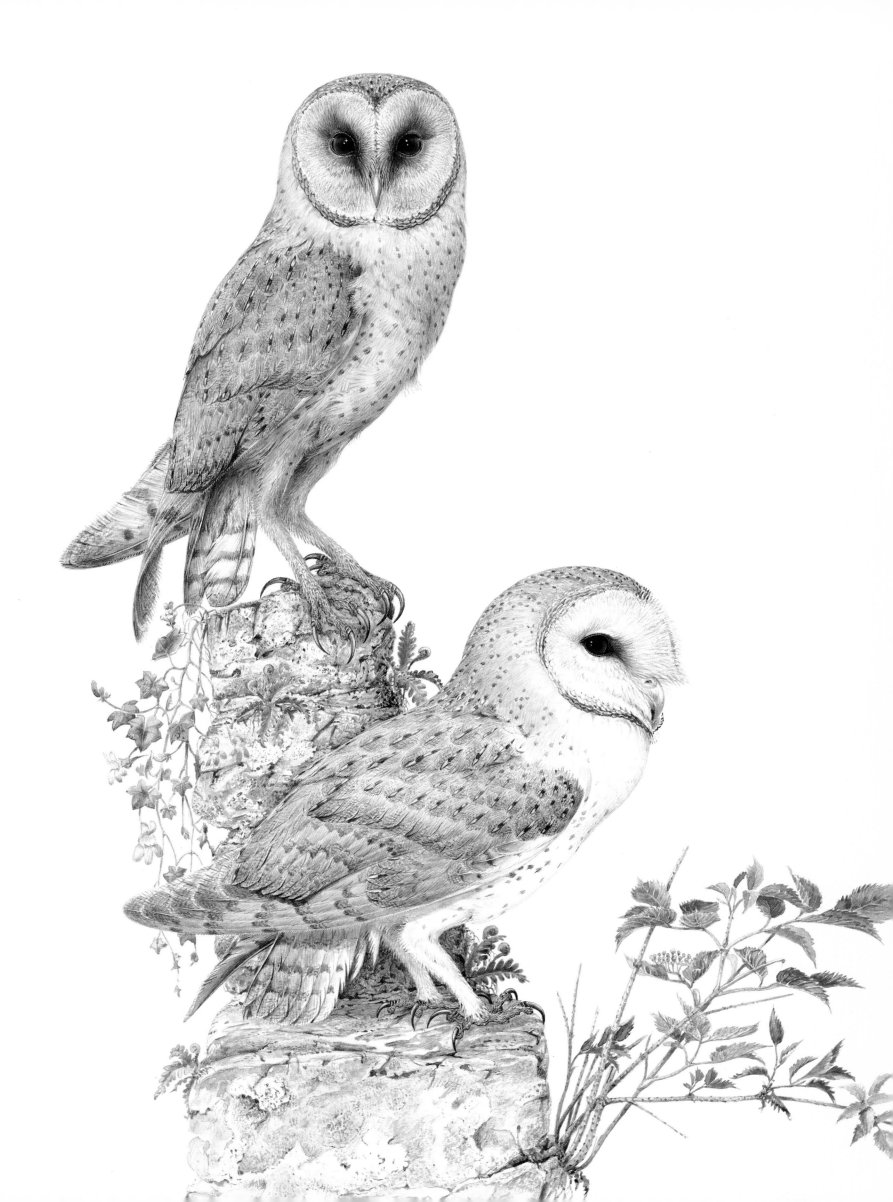

real giants of the species (20–23% larger than in Europe) (Parkes & Phillips, 1978). The smallest birds are those from the eastern Canary Islands (*T. a. gracilirostris*) and the Andaman Islands (*T. a. deroepstorffi*), with wing lengths 10% smaller than in Europe; other small forms are from São Tomé (*T. a. thomensis*) (11%), Hispaniola (*T. a. glaucops*) (11%) and Grenada (*T. a. insularis*) (15%).

Coloration varies between golden buff on the upperparts, unspotted silvery white on the underparts and face, and a practical absence of dark markings on flight and tail feathers, on the one hand, and, on the other, a dark blue-grey or blackish colour on the upperparts, variegated, marmorated or finely spotted with buff or white, and buffish or reddish brown on the underparts and face, usually with numerous spots and other dark markings below. The Barn Owls from Britain and the Mediterranean countries (*T. a. alba*) offer examples of splendidly white "ghost owls", the extremes of this type being the relatively small form from Corsica and Sardinia (*T. a. ernesti*) and the somewhat larger form from the Middle East (*T. a. erlangeri*). Dark extremes are found in east-central Europe (*T. a. guttata*), on the Cape Verde Islands (*T. a. detorta*) and Grenada and other small islands of the southern Lesser Antilles (*T. a. insularis*). A whole variety of intermediate types exists between these extremes and individual variation is often large. Females are usually darker and more heavily spotted than males.

When one compares specimens from opposite ends of the range it is sometimes difficult to believe that they are members of a single species, but this is exactly what one would expect of an almost cosmopolitan species living under a multitude of different selection forces. Even the large and heavily bristle-toed Barn Owl of Sulawesi (Celebes, *Tyto rosenbergii*), for all its distinguishing features, might eventually be included in the present species. The situation is quite different when two forms of Barn Owl settle in one place, e.g. on Hispaniola, where the large, white North American or Bahaman form (*T. a. pratincola*) has appeared alongside the indigenous, small and relatively dark form (*T. a. glaucops*), probably as a result of man-induced changes of the environment, while interbreeding has not yet been observed. At this point I do not consider it compulsory to treat this and other small, dark east Caribbean Barn Owls as a separate species *Tyto glaucops* distinct from *Tyto alba* (but see Olson, 1978). A similar situation occurs at present on Lord Howe Island, halfway between Australia and New Zealand, where Barn Owls of different origin have been introduced (*T. a. pratincola* from California, *T. a. delicatula* from Australia), probably without interbreeding (but is anyone investigating this?).

Related species Apart from the Grass Owl *Tyto capensis*, which lives alongside the Barn Owl in Australia, south Asia and Africa, the occurrence of more than one member of the genus in the same place is restricted to Australia, New Guinea, Wallacea and Madagascar. In New Guinea and Australia the dark, large-eyed, forest-inhabiting Sooty Owl *Tyto tenebricosa* is quite different from the Barn Owl, but the Masked Owl *Tyto novaehollandiae* from the woodlands of Australia, Tasmania and possibly some Indonesian islands is simply a large, sexually dimorphic (female much larger than male), strongly built Barn Owl, being 8–19% heavier than the Australian Barn Owl (see Mees, 1964). Even more interesting is the situation in Sulawesi (Celebes), where three species of *Tyto* occur: *T. rosenbergii*, *T. capensis*, *T. inexpectata*. The small and rare Minahasa Barn Owl (*T. inexpectata*) seems to be a deep-forest bird and more widespread than originally supposed, whereas the large Sulawesi Barn Owl (*T. rosenbergii*) is a true member of the Barn Owl species in appearance as well as in habits; the Grass Owl (*T. capensis*) is a grassland bird mainly of south Sulawesi. On New Britain *Tyto aurantia* occurs and in Madagascar the almost orange *Tyto soumagnei*, the latter together with a large member of the Barn Owl group, *T. a. hypermetra*. This may mean that the genus *Tyto* originated in the Australian region or, again, that it represents an element of the old southern Gondwana continent.

FOSSIL SPECIES

Sub-recent and Pleistocene Barn Owl bones have been found in North America, Nuevo Leon and Yucatan in Mexico, Brazil, Galápagos Islands, New Zealand, Ireland, southern Europe and Israel (Brodkorb, 1971; Mourer-Chauviré, 1975). The cosmopolitan character of the species' range is therefore not of recent date. Other species of extinct sub-recent and Pleistocene (Wisconsin age) Barn Owls have been described from cave deposits in Malta in the Mediterranean (*T. melitensis*) and Mauritius in the western Indian Ocean (*T. sauzieri*), and particularly from the West Indies, some of the latter being considerably larger than present-day *Tyto alba*. They have been described by Alexander Wetmore as *Tyto cavatica* (Puerto Rico), *T. ostologo* (Haiti) and *T. pollens* (Great Exuma and New Providence, Bahama Islands) and by Oscar Arredondo as *Tyto noeli* and *T. riveroi* (Cuba) (Arredondo, 1976; Olson, 1978). Remains of a large Barn Owl, almost 1.5 times the size of the present *Tyto alba* have been found in caves in Mallorca and Menorca, Balearic Islands, Mediterranean Sea, dating from the end of the Tertiary or the beginning of the Pleistocene period (*T. balearica*) (Mourer-Chauviré et al., 1980). Another large Barn Owl *Tyto robusta*, comparable in size to the large West Indian fossil owls, lived from Upper Miocene times in the Gargano Peninsula (then an island), Italy (Ballmann, 1973, 1976, 1978), but remains of a really gigantic Barn Owl, *Tyto gigantea*, larger even than the present-day European Eagle Owl *Bubo bubo* and with probably noteworthy terrestrial habits, have been found there too. There is strong evidence to suggest that Barn Owls of three different size classes must have lived simultaneously in Upper Miocene southern Europe, indicating a large variety of vertebrate prey, including large mammals, which have indeed been found. A similar situation must have occurred in the Caribbean area, but there the analogous giant owl, larger even than present-day Eagle Owls, was probably a member of the *Strix* group: *Ornimegalonyx oteroi*, described from Upper Pleistocene cave deposits on Cuba (Arredondo, 1975). Second largest was the Pleistocene *Tyto riveroi*, also from Cuba, with a tarsus (125mm) 34% longer (and relatively heavier) than that of the other extinct Caribbean species and almost 60% longer than that of present-day Cuban Barn Owls.

The history of the Barn Owl is apparently an old one and it is not known whether it originated in the eastern or the western hemisphere. The representatives of six genera of the *Tytonidae* have been described from the Paleocene–Oligocene phosphorites of Quercy, France, which illustrates the differentiation and wide radiation of tytonid owls before the present era of mainly strigid owls (Mourer-Chauviré, 1987).

STRUCTURE, VISION AND HEARING

The Barn Owl has a distinctive, heart-shaped facial disc with relatively small, dark eyes set in the central part of the disc. The skull is narrower than in other owls, the rostrum long and flat and the bill elongated, with long nasal grooves. Other characteristics by which the genus *Tyto* distinguishes itself from strigid owls are a pneumatic, rather thick and complete interorbital septum, very large lacrymal and very small supraorbital process, inflated ectethmoid, palatines and vomer, an open tympanic cavity not roofed by temporal or squamosal bones, a differently shaped quadratum and the fusion of cartilaginous parts of the syrinx (Miller, 1934). There are also differences in the coracoid, the coalesced, rather than articulated, junction of the furculum and the keel of the breastbone, the posterior edge of the breastbone and the tarsometatarsus (Ford, 1967). The legs are very long, thin and sparsely covered with short feathers or bristles, those on the posterior side of the tarsus reversed and pointing upwards. Outer ear openings are relatively small, quadrangular rather than ovate, about 7mm in height and asymmetrical in position, the left one usually higher on the skull than the right one (Norberg, 1977). Pre-aural dermal flaps are large, conspicuous by their square shape and movable, and, when not raised, they reach beyond the posterior edge of the ear opening.

Combined with a difference in planal position of left and right ear flap by about 15%, the asymmetrical outer ear structure suggests a high degree of directional hearing. The complete facial disc works as a parabolic sound-reflector; its loose, silky feathers are sound-transmitting, and it focuses in particular the higher sound frequencies to the ear openings. As the skull is relatively narrow, the two elements of this sound-reflector system are a mere 6cm apart and therefore offer physical restrictions for localizing long-wave sounds with frequencies below 5.6kHz (Bühler, 1972; Clark *et al.*, 1980).

Prey location by hearing has been proved in behavioural experiments by Roger S. Payne (1962, 1971) and by physical experiments involving the insertion of an electrode in the midbrain auditory area (Knudsen, 1980). In complete darkness an American Barn Owl could accurately locate and strike a sound-producing prey but failed when frequencies above 5kHz were filtered out. Otherwise it can determine the direction of sound sources to within 2° in both azimuth and elevation (Knudsen, 1980). Left and right ears proved to be different in sensitivity to high and low sounds (Knudsen, 1981) and the receptive fields covered separately by the left and right ear are not symmetrical (Knudsen & Konishi, 1980). The acuteness of the Barn Owl's hearing is demonstrated by the fact that the most accurate sound location is possible at frequencies of over 11kHz, which is above the normal range of hearing in man (8kHz), and that frequency differences as small as 0.5–0.7% could be detected and even memorized (Quine & Konishi, 1974; Konishi & Kenuk, 1975). This performance is made possible by the existence of the largest number of auditory neurons found in owls to process acoustic information to the brain stem – a larger number even than that found in Long-eared and Tawny Owls (though no Tengmalm's Owls were examined) (Schwartzkopff, 1963:1,063). In addition, the structure of the auditory area in the brain (mid-brain auditory nucleus), comparable to the visual cortex in mammals, contains neurons which are involved with deciphering orientation and binaural hearing (Pettigrew & Konishi, 1976).

The outer ear openings differ in size and structure from those of Tawny, Long-eared and Tengmalm's Owls and are considered to have evolved along different lines. This fits in with certain skeletal characteristics not found in other owls: the distinctively shaped, swollen base of one of the earbones, the stapes, which bulges into the perilymphal canal of the interior ear; a differently shaped and less flexible syrinx than that found in other owls; an absence of sexual dimorphism (Miller, 1965); and the unique chemical composition of the wax produced by the tail gland which is absent in other owls (Jacob & Ziswiller, 1982). The theory of the Barn Owl's taxonomic uniqueness is further confirmed by the different number, shape and structure of its chromosomes (diploid 92, instead of 40–50 as in other owls; Belterman & de Boer, 1984) and by details of the molecular structure of its DNA (Sibley; Ahlquist; Monroe, Jr).

Whereas acoustical information seems to be of prime importance for orientation and hunting, the Barn Owl's vision is less acute and its ability to see rather than recognize objects in the dark seems very poor (Bunn, 1976). The pigment epithelium in the retina nevertheless shows fine structural specializations in the cells not found elsewhere (Dieterich, 1975). Though the eyes may be relatively small, maximum activity was still possible in the poor light of 0.2–0.4 lux, which is a greater achievement than that of the Long-eared Owl (0.4 lux) and much greater than that of the Little Owl (4.6–15.5 lux) (Erkert, 1969).

All the structural characteristics described above confirm the existence of important differences between *Tyto* and other owls and hence the recognition of a family *Tytonidae* versus *Strigidae*.

BEHAVIOURAL CHARACTERISTICS

Songs and calls Like other owls Barn Owls produce a great variation of sounds under different conditions. As a result of a differently structured syrinx (Miller, 1934), Barn Owls do not have a resonant hooting. Instead, their vocalizations are the most strange combination of hissing, purring, screeching and yelling, none of which is remotely melodious to human ears (Bühler & Epple, 1980; Bunn *et al.*, 1982). The territorial song and advertising call is a loud hissing scream or screech, sometimes with a tremulous effect and often rendered as *shrrreeee*. A type of screech is also heard during the sexual pursuits characteristic of Barn Owls and is probably answered by the female with a loud, un-tremulous wailing. Screams, explosive yells, piercing whistles and other loud noises are heard in situations of alarm, fear, anger or distress. A loud and prolonged hissing accompanied by bill-snapping, or rather tongue-clicking, is produced in aggressive encounters and must intimidate and frighten off potential enemies. Numerous purring and chirruping sounds accompany courtship and copulation. The male's contact call is a high, chattering *kwee-kwee-kwee* or *quick-quick-quick*, presumably also uttered in order to attract the female prior to food exchange. The food-begging call of the young is a hissing, snoring sound. Chirruping and hissing by small young – a kind of defensive hissing not uttered by any other owl outside the *Tyto* group – prevents them from being left unattended by the female and consequently exposed to predators.

Circadian rhythm The Barn Owl is nocturnal, but data are conflicting and opinions differ as to the strictness of this habit. It

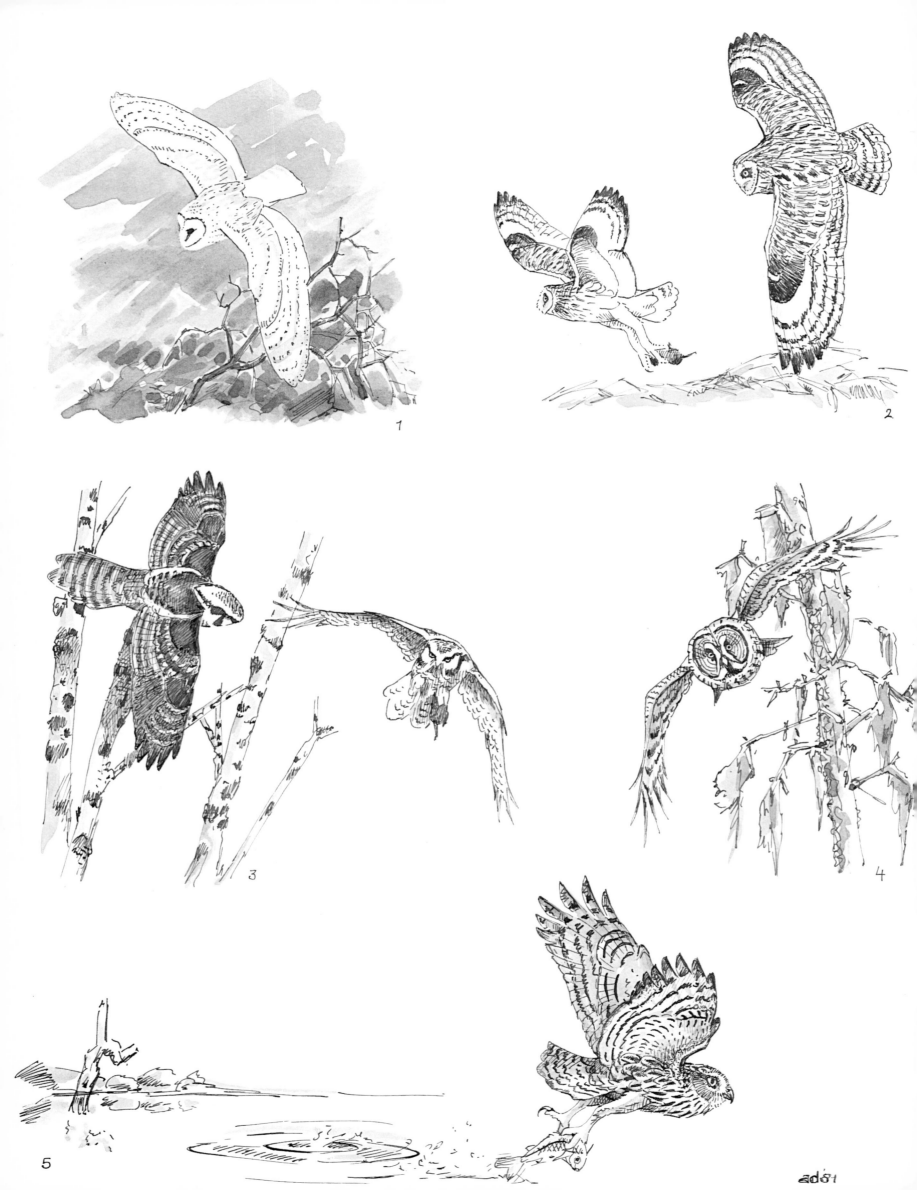

is equally unclear whether in Europe Barn Owls start their nocturnal activity earlier or later than the Tawny Owl or the Long-eared Owl. Nevertheless, the Barn Owl hides by day and becomes active and starts hunting well after sunset almost everywhere. In Colorado, United States, it was the last to start, leaving its roost in total darkness on average 90 minutes after sunset in summer (Marti, 1974). In Britain Barn Owls have been found hunting in late afternoon in winter and an hour or more before sunset in summer (Bunn et al., 1982), but this may have been due to a previous night of poor hunting in unfavourable, rainy or windy weather. Hunting in daylight has also been observed in Surinam, though this may have been exceptional (Haverschmidt, 1970). Whereas some authors in Europe claim to have observed two activity peaks during the summer night separated by a rather quiet period of three hours around midnight, other authors elsewhere have noted other nocturnal rhythms, e.g. in the Netherlands. Whether the rhythm is induced by cycles of light and darkness (Erkert, 1969) is not clear. Other factors, e.g. the presence of other owls, seem to play a role.

Antagonistic behaviour The contracted facial disc, narrow eye slits and wings pressed against the body shown by a Barn Owl roosting by day offer as dramatic a contrast with the rounded cat-face of a relaxed and active Barn Owl as any seen among owls. Even more impressive and exceptional are its antagonistic postures and threatening behaviour whereby it inflates itself into a huge, hissing creature with dangerously outstretched wings and formidable aspect. With its grotesque bowing and shaking of the head, rocking movements of the body and elongated neck, the "forward-threat posture", combined with a loud hissing and tongue-clicking, the owl reminds one of an angry snake or spitting civet or cat. Body-swaying and sudden forward lunges are accompanied by deep bows and trampling of the feet. Even half-grown young can indulge in this display, which is characteristic of all *Tyto* owls. Barn Owls have been known to attack dogs, cats and large cobras, but, despite such displays of aggression, they are usually timid. Attacks on man, even near their nest sites, are extremely rare, but when they occur, the owls strike from the front, rather than from behind, and scratch the human face (West Germany, Schneider, 1953; England, Madge, 1985).

ECOLOGICAL HIERARCHY

In spite of its long and slender wings, the European Barn Owl (average 312g in males, 362g in females) is about 35% lighter than the Tawny Owl and only about 10% heavier than the Long-eared Owl. In North America it is about 75% larger (average 442g in males, 490g in females) than the Long-eared Owl and about 35% smaller than the Barred Owl. In its North and South American habitat it most frequently encounters Great Horned Owls and Burrowing Owls and, in Europe, Eagle Owls and Little Owls. Body weight in these owls relative to that of the Barn Owl is 300–350% and approximately 30–35% in North America and 700–800% and approximately 50% in Europe. The surface of talon spread at striking impact on prey is recorded in North America to be about three times as wide as in the Burrowing Owl, somewhat more than twice as wide as in the Long-eared Owl and about half as wide as in the Great Horned Owl (calculated after data from Marti, 1974).

In a comparison of sympatric owls in Colorado, United States, the average prey weight of Barn Owls was calculated at 46g, that of Great Horned Owls at 177g, Long-eared Owls 30g, Burrowing Owls 3g (Marti, 1974). Elsewhere quite different average prey weights have been recorded: in xerophytic California, 41g in Barn Owls, 63g in Great Horned Owls; and for the same owls in central Chile, 123g and 266g, respectively (Knight & Jackman, 1984). Expressed in percentage of the owl's body weight, the mean mammal prey weight in central Chile was 35% of the Barn Owl's weight (310g), 17% of the Great Horned Owl's weight (1,500g) and 26% of the Burrowing Owl's weight (250g) (Jaksić et al., 1981). The Barn Owl is nevertheless a very versatile hunter and a ubiquitous bird, and, though generally a rodent-hunter, its prey is extremely varied, though it is synanthropic almost everywhere. Hence, in villages and towns it usually feeds on mice and rats more regularly than does the stronger Tawny Owl and when resorting to birds it takes small species (e.g. House Sparrows 93% of total prey in Hungary) rather than larger ones, unlike the Tawny Owl (only 35% House Sparrows) (Schmidt, 1972). Similarly, on the Galápagos Islands it takes many more small mammals (85% of prey biomass) than birds (3%), as against 51% and 47%, respectively, taken by the larger and less exclusively nocturnal Short-eared Owl (de Groot, 1983).

The great *Bubo* owls are the Barn Owl's principal enemy in almost all areas of its range and they must frequently encounter one another on arid, rocky nest sites. Of 1,363 owl prey reported for the European Eagle Owl, 46 (3%) were Barn Owls. The only other owl recorded as having preyed on Barn Owls is the Tawny Owl (1×) (Mikkola, 1983), and it also looks as if Tawny Owls expel Barn Owls from their nests in tree holes and possibly also from those nests in town and city buildings which are accessible to the Tawny Owl (see Bunn et al., 1982). Nevertheless, the Barn Owl is a strong and, when necessary, fierce fighter, though the only other owl it is reported to have killed and fed upon is the Little Owl (Mikkola, 1983). In North America the Great Horned Owl seems to be the Barn Owl's main natural enemy (Bent, 1938; Rudolph, 1978), whereas its predators in Africa are the Cape Eagle Owl and the Giant Eagle Owl (Gargett & Grobler, 1976; Steyn, 1984; Avery et al., 1985). Nothing is known of the interrelations between Barn Owls and other owls in Australia and South America.

Of the few diurnal birds of prey reported to have killed Barn Owls in Europe, the Goshawk is the most frequent (13×), followed by Buzzard (3×), Peregrine Falcon (2×), Lanner Falcon (1×) and Red Kite (1×) (Mikkola, 1983); in North America only the Prairie Falcon is known to prey on the Barn Owl (Bent, 1938); in Africa its predators are the Tawny Owl, African Hawk Eagle and Wahlberg's Eagle (Steyn, 1984:8), though numerous other species are undoubtedly involved over the Barn Owl's large range. Such cases of predation do not necessarily signify incidences of ecological hierarchy; the owls may have been killed accidentally when active by day or at dusk. In its turn, the Barn Owl is known to have preyed incidentally on Kestrels in

Hunting flight. (1) South European Barn Owl *Tyto alba alba*. (2) Short-eared Owl *Asio flammeus*. (3) Northern Hawk Owl *Surnia ulula*. (4) Great Grey Owl *Strix nebulosa*. (5) Tawny Fish Owl *Ketupa flavipes*.

North America (Smith *et al.*, 1972) and in Europe (Mikkola, 1983).

Sexual dimorphism in size is relatively small and may be locally non-existent or even reversed. In Europe females are on average 16% heavier than males; in North America, about 11%. Virtually nothing is known of average differences in diet between male and female Barn Owl, but in Tuscany, Italy, the food taken by the female was found to be more varied in species and size than that caught by the male (Lovari, 1978).

Cannibalism, that is Barn Owls feeding on adult Barn Owls, has been reported at least once (Amsterdam, Netherlands, Voous, 1951; see also Hoekstra, 1975), but in most reported instances it was in times of food shortage that parent birds or larger young had eaten a younger nestling when this had been behaving abnormally or was already dead.

BREEDING HABITAT AND BREEDING

Throughout its wide range the Barn Owl nests in natural or man-made holes, usually in pitch darkness. Day-roost sites and nest sites are generally the same and the female at least tends to stay in her chosen nest site the whole year round. Whenever possible, male and female remain together for life and they sit close together by day. Favourite and traditional places are occupied for many years in succession, though probably not always by the same pair (Murray, 1952).

Natural nest sites occur in clefts, holes and caves in rocks, in the earthen and clay walls of river banks and cliffs; also in holes in tree trunks, whether huge baobabs *Adansonia* in the African savannah, sacred fig trees in tropical Asia, tall eucalypts in Australia, palms anywhere in the tropics, cottonwoods in North America, age-old oaks in Britain, gnarled fruit trees, oaks and beech in continental Europe. It is possible that holes in either trees or rocks are the Barn Owl's original nest sites. In industrialized continents tree nests are increasingly rare. In Britain 32% of the nests are still in trees, but before 1932 the ratio was higher (43%) (Bunn *et al.*, 1982); in the Netherlands it has decreased from 4% before 1960 to 1.5% or even less at present (Braaksma & de Bruijn, 1976). In rural Africa most or all nests have been found inside the enormous, roofed stick nests of the Hamerkop Stork, built in trees (Brown, 1970; Wilson *et al.*, 1986). However, the Barn Owl's preferred nest sites are in man-made structures. Favourite places are holes, dark recesses, lofts and attics and other roof spaces in church towers, temples, castles, pyramids, stone ruins, derelict houses, mine shafts, deep wells, windmills, dovecotes, haystacks outside or in open barns, farmhouses and houses on plantations; recently also any dark, sheltered place in large industrial plants and in discarded agricultural machinery, and large wooden nest boxes, preferably when placed inside barns, cabins and lofts with free access from the outside and often in total darkness; also the deserted burrows of badgers in the North American arid prairie lands (Bent, 1938). There is no evidence that Barn Owls nest in the abandoned stick nests of diurnal birds of prey like so many other owls, but they do seem to have accepted deserted crows' nests in California (Bent, 1938) and Germany (Alexander Koenig, Bonn).

The male chooses the nest site and begins hissing and screeching at the entrance or inside the intended hole in order to lure the female there (Löhrl, 1965). Thereafter the male performs an impressive courtship flight with long-drawn-out hissing screams *shrrreeee*, followed by sexual pursuit flights, which are often accompanied by a wailing screech reminiscent of the noise made by fighting cats (Bunn *et al.*, 1982). The nest itself is most often a thick layer of dried pellets, heaps of broken bones and fragments of the skulls of mice and rats, the owl's main prey. In church towers the Barn Owl has been found nesting successfully as close as 2–5m from an equally successful Kestrel (Fellowes, 1967; Baudvin, 1975). On cliffsides the nest may be close to those of Kestrel and Raven, elsewhere to those of Eagle Owls, Great Horned Owls or Burrowing Owls. One nest hole in a thick tree trunk on a rubber estate on east Java, Indonesia, contained six young of varying ages, while in a hole one metre above it, a large Malaysian Fish Owl *Ketupa ketupu* nestling was waiting to fledge; some days later it had left and a fresh egg belonging to a Spotted Wood Owl *Strix seloputu* was found in its place: thus began a new adventure in cohabitation, which ended with the safe fledging of six Barn Owls and three Spotted Wood Owls (J. G. Kooiman).

It is often said that in former times each European village had its own pair of Barn Owls and that the territory defended by the male was 0.8–1.5km in diameter. In Britain a territory size of 250ha is a good average (Bunn *et al.*, 1982); in central Europe it is not uncommon to find one double the size (Glutz & Bauer, 9, 1980). In Oklahoma, United States, Barn Owls provided with radio transmitters remained within an approximate range of 1km from the nest site (Ault, 1982). In Mali, central Africa, the territory was on average 6.1ha (Wilson *et al.*, 1986) and in Malaysia at least 20ha (Lenton, 1984). Successful Barn Owl nests have nevertheless been found as close together as between 4.5 and 300m, sometimes inside the same building. In a village in French Burgundy one church contained two nests, a church close by another three nests (Baudvin, 1976). In this and other cases of "colony building", the male, and sometimes also the female, may have indulged in polygamous relations. In an abandoned gold mine in Zimbabwe five occupied Barn Owl nests were found over a distance of 100m and two other nests on the opposite side of a mine trench (Steyn, 1984). The most impressive colony has been reported from an abandoned steel mill comprising 60 major iron structures in Utah, United States, which harboured a total of 11 Barn Owl nests with eggs, 4.5–100m (average 50m) apart, built amid supporting framework and in the hollows of overhead cranes, pipes and blast furnaces, together with the nests of 2,000 Feral Rock Doves *Columba livia* and hundreds of Starlings and House Sparrows (Smith *et al.*, 1974; Smith & Marti, 1976).

The breeding season is dependent on weather and climate and above all on the availability and quantity of prey. In Europe it usually starts later than in the Tawny Owl, in North America later than in the Barred Owl, but unlike in these owls a second clutch is the rule rather than the exception, and third and fourth consecutive broods, some of them overlapping with previous ones (Altmüller, 1976), have been reported from temperate regions and the tropics. Egg-laying starts on average between 9 March and 16 April in North America (Smith & Marti, 1976), mid-April in France and West Germany, early May in Britain, early or mid-May in Denmark and Sweden. But breeding may be continuous throughout the year in North America and from February to October in Europe; in the Netherlands small young have been reported even in February (F. Haverschmidt). In

most of Africa, Assam and Sri Lanka Barn Owls nest in the dry season, but in Zimbabwe eggs have been found in all months of the year (Irwin, 1981), as in most of India (Baker, 3, 1934), the Malay Peninsula (Lenton, 1984) and Surinam, South America (Haverschmidt, 1962), though even here there are peaks in the dry season. Not only are Barn Owls very prolific breeders, when food is abundant they start breeding at a very early age, which contributes to an even greater population increase. In Australia one female laid her first egg at the age of 10 months (Fleay, 1968); in Germany one female was only 8.5 months old when she produced the 14th egg of her first clutch (Schönfeld & Girbig, 1955). Totally non-breeding years, not uncommon in the equally resident Tawny Owl and other owl species, seem to be rare in the Barn Owl (see Bühler, 1964).

Eggs are elliptical rather than round as in other owls and are therefore well suited to being deposited on the flat bottom of a cave niche where there would otherwise be a constant danger of their rolling off. This may mean that nesting in tree holes is secondary to nesting among rocks and in walls. Large geographical races produce large eggs. Egg size in North America is on average 43.1 × 33.0mm (Bent, 1938), in South America 41.3 × 33.6mm (Haverschmidt, 1962), on Java 42.9 × 33.6mm (Hoogerwerf, 1949). Central European eggs are smaller (41.3 × 31.8mm) by about 11% than North American ones, British eggs by about 15% and African ones by about 20%. Clutch size depends on food supply and is usually large. Average data are of little value but have been reported as follows: North America 5.7, France 6.2, Britain 4.7, the Netherlands 4.0, Switzerland 5.3, West Germany 5.8, East Germany 5.5, Denmark 5.6, Sweden 4.6; Europe in general 5.0 (Mikkola, 1983), Mali, central Africa, 6.05, the Malay Peninsula 6.6. In extreme cases clutches of 10–20 eggs are known for most parts of the species' range.

Not only clutch size but also the number of consecutive clutches depends on the food situation. This is most impressively demonstrated in the tropics. During an explosive increase of the prolific multimammate mouse *Praomys natalensis* and the gerbil *Tatera leucogaster* in Zimbabwe, one pair of Barn Owls produced four clutches within 8.5 months, resulting in the fledging of 32 young in total in 11 months, between January and December 1967 (Wilson, 1970; Steyn, 1984). Similar situations have occurred in Mali, central Africa, again in response to peak numbers of multimammate mice (Wilson *et al.*, 1986). Likewise, in the Malay Peninsula, Barn Owls uninterruptedly produced two or three clutches annually, with an average clutch size of 6.6 (but nests with 20 eggs have been found) and an average ultimate brood size of 4–6 (Lenton, 1984). The occurrence of two or more clutches in temperate North America and Europe may therefore be considered a remnant of the Barn Owl's tropical life. Most significantly, the size and breeding success of the second clutch are usually higher than those of the first clutch, bred in the colder season of the year. In Burgundy, France, the average first clutch size was 5.4 (producing 4 young on average), against 6.7 (5 young) in the second clutch (in summer), produced when common voles had multiplied to their annual early-summer peak (Baudvin, 1976). Greater differences have been reported from Germany, with averages of first and second clutches of 5.4 (in 158 nests) and 7.2 (in 69 nests), respectively. High egg productivity in German Barn Owls has been reached experimentally in captivity by abundant feeding (Bühler, 1965).

Eggs are laid at intervals of 1–2 or more days (average in Mali, central Africa, 2–3 days) (Wilson *et al.*, 1986). The female starts brooding from the first egg onwards, leading to differences in size among siblings as large as or larger than those found in any other owls. The difference in body weight between the oldest and youngest nestlings in a brood of seven in October in Kansas, United States, was as large as 475% (Downhower, 1963), that in a brood of four in Zimbabwe 800% (16g and 129g, respectively) (Steyn 1984:153), which is fairly standard among these owls. Only the female incubates and she alone has a well-developed brood patch. When incubating, the female leaves the nest for no more than 10–12 minutes at a time; she is fed by the male, who often stands guard close to her by day, and, in good years, he accumulates a large stock of prey at the nest site. When the eldest young is 3–4 weeks old, or even earlier, the female stops brooding and warming the young and resumes hunting with the male, leaving the younger nestlings to warm themselves against their fluffy, older nest mates (see p. 256). This is earlier than in, for example, the Long-eared Owl, where the female gradually starts hunting when the smallest young is 2 weeks old. It is probably because of the dark, well-concealed nature of the nest site that the female Barn Owl is able to leave her young unprotected for periods of time, while their food supply is increased by her hunting. Young Barn Owls seem rarely to quarrel or fight over prey and larger young have been observed to feed younger ones begging for food (e.g. Bühler, 1981). When, for some reason, such as undernourishment, a chick behaves abnormally or remains motionless, it is considered prey and eaten by other nestlings or the parent birds.

Young develop relatively slowly; the loss of the egg tooth is late, at about the 14th day, as against the 9th day in the Long-eared Owl (Bunn *et al.*, 1982). In the Netherlands young reached their full weight at 6 weeks on average, as against 3–4 weeks in the Long-eared Owl (de Jong, 1983). In North America, Europe, Africa and Malaysia young Barn Owls leave the nest at about 8–10 weeks, which is late when compared with the Long-eared Owl. However, young Barn Owls start to explore the surroundings of the nest site at about 4 weeks and wander freely in the dark over eves and in attics.

Survival rate is directly related to food supply. Naturally, the number of eggs laid and of young fledged is larger in vole peak years than in years of food shortage, e.g. in Burgundy, France, in 1974, 5.2 young fledged on average, as against 1.8 in the previous year (Baudvin, 1975, 1976); comparable data for second clutches in Germany were 8.2 in favourable years and 2.7 in poor years (Schönfeld & Girbig, 1975).

The Barn Owl seems to have few nest predators; but in church towers in Burgundy, France, 7 out of 1,031 nests with eggs or young were destroyed by stone martens, and one adult was also taken (Baudvin *et al.*, 1985:96).

FOOD AND FEEDING HABITS

Like the Long-eared and Short-eared Owls and unlike the Tawny Owl, the Barn Owl hunts by searching flights over open fields broken by stands of trees, bushes, depressions, river valleys and marshes. Its flight is more unsteady even than that of the Short-eared Owl and it banks, hovers and drops to the ground in a most erratic manner (see p. 14). In Europe the wing-loading is less (0.29g/cm^2 wing area) than that of the Long-eared

Owl (0.31), Short-eared Owl (0.34) and Tawny Owl (0.34) (Mikkola, 1983), but in North America, where the Barn Owl is larger, it is somewhat greater ($0.28=3.62cm^2/g$) than in the Long-eared Owl ($0.22=4.61cm^2/g$) (Marti, 1974). Barn Owls pursue their prey on foot more frequently and more efficiently than all owls of similar size except the Grass Owl *Tyto capensis*. They have been observed hunting from poles by the roadside, though the frequency of this habit is not known.

The Barn Owl is classified as a "restricted" as opposed to a "generalist" feeder, preying on small terrestrial rodents of field and marsh, mainly common voles and other colonially living voles in Europe, meadow voles in North America and multimammate mice in tropical Africa. Elsewhere it takes other voles and mice. In Australia too Barn Owls "are predominantly rodent eaters (introduced house mouse and brown rat) unable to make a ready switch to an alternative diet" (Fleay, 1968:105). Where an alternative diet is available, shrews and not birds are the main prey, the Barn Owl differing in this respect from the Long-eared and Short-eared Owls and most other rodent-hunting species in which birds rank second. The literature on the Barn Owl's diet, mainly based on the examination of regurgitated pellets, is very extensive (see also Schmidt, 1973) and is summarized here. Of roughly 77,600 prey items from central Europe analysed by Otto Uttendörfer (1952), 96% consisted of mammals, no more than 3% of birds and the balance (1%) of frogs and toads. Small voles *Microtus, Pitymys, Clethrionomys* predominated with 50%, real mice *Mus, Apodemus, Micromys* were represented by 17%, shrews *Sorex, Crocidura, Neomys, Suncus* by as much as 26%, bats (at least 11 species) by 0.15%. Birds amounted to 3% (11 species), as against 15% (100 species) in the Tawny Owl and 8% (52 species) in the Long-eared Owl. Of another sample of 145,368 prey items from six countries in Europe (Britain, France, Germany, Denmark, Spain, Italy) summarized by Heimo Mikkola (1983), an average of 95% consisted of mammals, 3% of birds, 1% of reptiles and amphibians, 1% of arthropods and others. Voles were represented by 39%, mice by 11%, shrews by 29% and bats by 0.15%. Expressed in terms of biomass, other analyses of 180,691 (Glutz & Bauer, 9, 1980) and 243,099 (Cramp, 4, 1985) prey items from 11 countries in Europe led to the following results: mammals 95% and 94%, small voles 45% and 45%, mice 25% and 34%, shrews 15% and 14%, bats 0.2% and 0.1%, birds 6% and 4%, lizards, frogs and toads 1% and 1%, respectively. In vole years almost 100% of the food consists of common and short-tailed voles (Bohnsack, 1966).

The variety of mammals taken is extraordinary, particularly in non-agricultural countries with small arable fields, and ranges from the Etruscan shrew (2g) and the harvest mouse to water vole, sizeable brown rats, hamster, edible dormouse, stoat, mole, musk rat and red squirrel. With regard to birds, House and Field Sparrows are taken most frequently in Europe, but the Barn Owl can be a versatile hunter when necessary and I have found as many as 73 bird species mentioned as forming part of its diet, including such unexpected species as Moorhen, Lapwing, Woodcock, Green Woodpecker, Jackdaw, Corncrake and Collared Turtle Dove (see Glue, 1972; de Bruijn, 1979). In the arid Mediterranean countries small shrews *Suncus*, as well as geckos, lizards, skinks, slow worms, chameleons and relatively large numbers of large insects (grasshoppers, mole crickets, beetles, earwigs) play an important part in its diet (Lovari et al., 1976), as do grass snakes, frogs and toads in marshy areas of the owl's range. Mean prey size in Europe is 16–21g, average 19g (Glutz & Bauer, 9, 1980).

Of 4,366 prey items identified in north-central Colorado, United States, mammals (16 species) made up almost 99%, birds (6 species) somewhat more than 1%. Expressed in terms of biomass, the figures were 98.6% and 1.3%, respectively. The majority of mammals were meadow and prairie voles (44%, biomass 37%); white-footed mice were represented by 25% (biomass 10%), shrews (least shrew *Cryptotis parva*) by 0.2% (biomass 0.02%) (Marti, 1973, 1974). Elsewhere in North America mammals amounted to 100% down to 70% or less of total prey numbers; birds and large insects made up the balance. Thus, around Ann Arbor, Michigan, of 1,888 prey items, 99% were mammals, of which 91% were meadow voles, 2% deer mice and 4% shrews, and 0.5% were birds (Wilson, 1938). In Oklahoma mammals were represented by 100%, 46% being small voles, 54% rats and gophers and less than 0.1% shrews (Ault, 1982). In California 61% were small voles, 37% white-footed mice, 0.2% shrews and 0.5% birds, but another analysis showed 95% mammals, 3% birds, 2% insects and less than 0.1% reptiles and amphibians (Jaksić et al., 1982). Mammals included not only a large variety of small terrestrial rodents, but also pocket gophers *Thomomys*, ground squirrels, moles, musk rats, blacktail jackrabbits and spotted skunk (Bent, 1938).

Birds taken in North America were as varied as those reported in Europe; most of them were small and medium-sized songbirds, sparrows, Starlings, blackbirds, but also Blue Jays, Flickers and a fair proportion of marsh birds, indicating that Barn Owls had been hunting over wet grasslands and marsh: Sora, Clapper Rail, Lesser Yellowlegs, Green Heron, Coot (Bent, 1938; Smith et al., 1972). On a rocky islet off the Californian coast a pair of Barn Owls had occupied an abandoned cabin and had raised a family of four on the locally breeding Leach's Storm Petrel *Oceanodroma leucorhoa beali*, the feathers, wings and bodies of which formed a carpet three inches deep on the cabin floor (Bonnot, 1928).

Nocturnal lizards, marsh-inhabiting box turtles *Terrapene carolina*, frogs, toads and fish have been reported on various occasions. Once as many as 30 Barn Owls were observed at night on a beach in southern California, feasting together on grunion *Leuresthes tenius*, a fish whose delectable flavour attracts the attention of both man and beast during the short period of its famous spawning run (Bent, 1938). Large insects, mainly grasshoppers, Jerusalem crickets and other katydids, played an important part in numerous analyses of the Barn Owl's diet reported from Texas and arid parts of the western United States.

Mean prey size was 27g in the state of Washington, 30g in northern California and 50g in central California (Knight & Jackman, 1984), 24g in Spain and as much as 109g in central Chile (Jaksić, 1983). In South America the Barn Owl's diet is also reported to consist mainly of mammals, including rodents, marsupials (opossums) and bats (7% in Surinam) (Haverschmidt, 1962), but also of birds (*Furnariidae, Passeridae, Icteridae*) (Uruguay, Mones et al., 1973), large toads, frogs and insects of various kinds. Mean weight of mammal prey in Chile varied between 71 and 123g (Jaksić et al., 1982; Knight & Jackman, 1984; see also Jaksić & Yáñez, 1980).

Barn Owl *Tyto alba*. Light and dark races

In Africa rodents, shrews *Crocidura* and *Suncus* and elephant shrews *Elephantulus* form the owl's main diet. Most frequently taken are the multimammate mouse and the gerbil *Tatera leucogaster* with their cycles of overwhelming abundance (88% and 12%, respectively, in Zimbabwe) (see Hanney, 1963; Wilson, 1970). In the north Nigerian savannah woodland mammals were represented in collected pellets by 74% (biomass 91%), shrews by 27% (biomass 12%), birds by 2% (biomass 1%), reptiles and amphibians by 6% (biomass 4%), insects by 19% (biomass 4%) (Demeter, 1981). In West African diets birds were numerous, including plovers, sandpipers, godwits, turnstones, pratincoles and weaver birds (de Naurois, 1982). Barn Owls also plunder the nests of songbirds and of swallows (e.g. Striped Swallow) under the roofs of bungalows in Zambia (Mitchell, 1964).

In Asia mice, rats, shrews *Suncus murinus*, bats, small and medium-sized birds (Glossy Starling *Aplonis panayensis*), snakes (cobra) and frogs have been reported, but detailed data have only been published from the oil palm plantations of Malaysia (98% rats, mainly *Rattus tiomanicus*) (Lenton, 1984).

I have found few data from Australia, where the main prey consists at present of house mice and European rats.

The food and feeding habits of Barn Owls living on small islands are of especial interest. Though concentrating on small terrestrial mammals, Barn Owls have turned to colonially living sea birds in several places, notably on the Selvagens Islands, West Africa (exclusively Frigate or White-faced Storm Petrels) (de Naurois, 1982), and on Raso and Branco, Cape Verde Islands (numerous Madeiran Storm Petrels and White-faced Storm Petrels, elsewhere in the islands Bulwer's Petrels) (de Naurois, 1982; Bannerman & Bannerman, 1968). On Santa Cruz (Indefatigable) in the Galápagos Islands house mouse and brown rat formed 88% of the Barn Owl's prey, while 10% was made up of land birds of all kinds, including Darwin's finches *Geospiza*, but no sea birds (Abs *et al.*, 1965). Expressed in terms of biomass, birds formed 3% (sea birds 1%) of the general diet of the Galápagos Islands Barn Owl, with mammals predominating (85%, as against 51% in the Short-eared Owl) (de Groot, 1983).

MOVEMENTS AND POPULATION DYNAMICS

The Barn Owl is basically a sedentary bird, but in temperate climates a considerable dispersal of young takes place following seasons of prolific reproduction. Dispersal is virtually random, but the most frequent direction is a southern one, particularly in northern, suboptimal regions in North America and north-central Europe, and the impression is more that of a retreat from the cold than of a random dispersal (Stewart, 1952). European stragglers have nevertheless appeared in Norway and North American ones in Alaska and Cuba. A high juvenile mortality coincides with the post-juvenile dispersal. Together, these factors help to reduce the population increase to average values and to spread it out over large areas, including those outside the region of maximal reproduction. In continental Europe the suggestive term *Wanderjahre* (years of wandering and dispersal) has been used for the periodic years of large-scale movements sometimes involving hundreds of Barn Owls, which turn up in such odd places as on ice floats in the former Zuiderzee, Netherlands (in the cold winter of 1928–29) (M. F. Mörzer Bruyns). During *Wanderjahre* other owls with fluctuating populations, such as Long-eared and Short-eared Owls, often join the Barn Owls and suffer comparable loss of juveniles. The life expectancy of young Barn Owls is considerably lower than in the sedentary Tawny Owl; calculations have in fact reached almost unbelievably low values. Although individual birds may attain an impressive age, the average life span of adults is much shorter than in the Tawny Owl. Thus, the turnover of a Barn Owl population is very rapid, particularly in north-temperate regions, though probably less so in the tropics. Notable population fluctuations attracting the attention of newspapers and other publicity media are also known from Australia (J. H. Calaby). The following specific data are intended to support and illustrate the hypotheses and generalizations given above (Braaksma & de Bruijn, 1976; Glutz & Bauer, 9, 1980; Bunn *et al.*, 1982).

Dispersal over less than 50km in Barn Owls ringed as nestlings in Britain was established in 92% of cases, in the Netherlands in 68%, in Switzerland and West Germany in 55%, in Denmark in 65%, in Sweden in 83%, in France in 82%. Dispersal over more than 200km occurred in 0.6%, 7%, 21%, 2%, 2%, 22% and about 12% of cases, respectively. The largest distance covered by young Barn Owls from the Netherlands was by one ringed on 29 June 1976 and recovered in France on 30 November 1976, 890km southwest of its original location. Another interesting case is that of two siblings from a nest in Erfurt, West Germany, ringed in June 1952 and recovered, one in January 1953 at Zaragoza, Spain (1,380km SW), the other in August 1953 at Winniza, Russia (1,260km E) (Sauter, 1956). The largest distances covered by older Barn Owls from Switzerland have been reported from Poland (1,060km NE), Roumania (1,080km ESE) and Spain (1,100km and 1,625km SW) (Glutz & Schwarzenbach, 1979). In North America long-distance dispersal has occurred over even longer distances, as shown by the following examples: from Wisconsin to Florida (1,920km SSE), from Ohio to Florida (1,720km S), from Wisconsin to the Atlantic Ocean off Georgia (1,504km SE) (Stewart, 1952). Movements in other continents are practically unknown, but those reported show the same tendency as described above, e.g. in Australia, where the distances covered were 0–840km (Purchase, 1972).

Mortality in North America is high in the first year (65%), much lower in the second (possibly 43%), and higher in the north than in the south. The average life expectancy in the southern United States has been calculated as 2.24 years, in the north as 1.10 years (Stewart, 1952). First-year mortality in Britain has been calculated at 39% (Glue, 1973), in Switzerland at 64%. Life expectancy in Switzerland after the first year was 1.3 years and after the third year 2.1 years. Comparative figures for Swiss Tawny Owls were condsiderably better: 47% first-year mortality; 2.2 years and 3.7 years life expectancy. Compensating for the high mortality rate in the Barn Owl, the mean annual production of young in Switzerland was calculated at 4.4 young fledged, as against 2.1 young in the Tawny Owl (Schifferli, 1957). Recent data are based on greater statistical precision but show the same tendency: after completion of the first year, life expectancy was calculated at 0.93 years (Denmark and Sweden), 1.06 years (West Germany), 1.3 years (East Germany), 1.2 years (Switzerland); after the third year, 1.2 years (West Germany) and 1.8 years (Switzerland) (Glutz & Bauer, 9, 1980:258). In spite of a rapid population turnover, the greatest known age reached by Barn Owls in Europe is high, viz. 21 years and 4 months; several other records exist of Barn Owls aged between 12 and 17 years (Glutz & Bauer, 9, 1980).

GEOGRAPHIC LIMITS

The Barn Owl does not extend as far north as other medium-sized owls in North America and Europe, nor does it ascend as high into the mountains. Winter mortality in central Europe starts to pose a serious threat at a snow cover of more than 7cm and when this snow cover lasts for more than two weeks and rodents are scarce as a result (Güttinger, 1965).

After 5–8 days of fasting, the owl is already close to death (de Jong, 1983). Its fat reserve is smaller than in other owls of the temperate climatic zone, being on average 5.3% (male) and 6.6% (female) of the net body weight, as against 12.3% and 9.1% in the Long-eared Owl, 11% and 9% in the Short-eared Owl and 9.2% and 9.3% in the Tawny Owl (Glutz & Bauer, 9, 1980:240). Under laboratory conditions the Barn Owl proved the most inefficient at utilizing food. Nutrition efficiency was found to be 75% in the Barn Owl, 76.5% in the Long-eared Owl and 80% in the Tawny Owl (Ceska, 1980). Consequently, lethal body weight (starvation weight) is reached earlier in the Barn Owl than in the other species. Hunger resistance, expressed in percent of the difference between net weight and starvation weight, is relatively small, being on average 22% (male) and 25% (female), as against 28% and 29% in the Long-eared Owl, 34% and 32% in the Short-eared Owl and 34% and 36% in the Tawny Owl (Glutz & Bauer, 9, 1980:240). Winter mortality in the Barn Owl in Europe is therefore higher than in other owls of similar size. Data from North America and other continents are non-existent, but the owls' low cold and snow tolerance is indicated by their desertion of nests during brief periods of cold February weather in Utah (Smith & Marti, 1976) and after an unusual snowstorm in April in Colorado (Martin, 1969). The Barn Owl appears to be basically a subtropical and tropical species; its extension outside warm and tropical regions only becomes possible when cycles of prolific breeding and random dispersal equal the losses caused by food limitations and adverse winter conditions. The Barn Owl's existence in south Sweden, at present almost a thing of the past (none known in 1985), is only slightly more tenuous than in Denmark and the Netherlands. Its absence in Siberia and China and the whole of temperate Asia can therefore be attributed mainly to climatological conditions. Other owl species do not seem to have influenced the Barn Owl's present distribution limits.

LIFE IN MAN'S WORLD

Not only does the Barn Owl live close to man on farmsteads and in villages and towns in the temperate regions of Europe and North America, in the tropics it hunts on cultivated fields as well and nests in the roof spaces of huts and houses. It penetrates tropical rain forests only in the wake of man and his gardens, plantations, villages and towns. Occurring at 4,080m altitude in the Peruvian Andes, one Barn Owl had chosen the church of Ondores at the Titicaca Lake for its roost and nesting site (Fjeldså, 1983). As far south as the inhospitable Useless Bay in Tierra del Fuego at 53° 30′ south, it nests only in chimneys (Crawshay, 1907; see Humphrey et al., 1970). The same applies to villages and towns in Central America, Africa, Madagascar and Asia, less so in Australia. The association with man is probably an old one, for Lower Pleistocene bones, indistinguishable from the present species, have been found in Early Man deposits in the famous Olduvai Gorge in Tanzania (Brodkorb & Mourer-Chauviré, 1984). Barn Owls have without doubt profited from the cutting of woods and the extension of agricultural lands in Europe and North America, and from the voles, mice and rats which have followed everywhere in the wake of man. They would probably not have been so numerous in Australia were it not for the mice and rats introduced by man. Gradually, however, the balance is shifting. Although out of 599 breeding sites in the Netherlands, 98% were in man-made structures, 61% of 760 known mortality cases were also directly or indirectly caused by man. These included collisions with motor traffic, trains and overhead wires, and instances of shooting and trapping, while the balance (39%) involved owls that had starved to death in unfavourable winters (Braaksma & de Bruijn, 1976). Even when all nest sites were in special next boxes and other artificial locations, numbers did not increase due to winter mortality. In Utah, United States, the erection of 30 artificial nest constructions in abandoned silos resulted in 154 young being fledged in two years (Marti et al., 1979; Tate, 1981). In addition to supplying safe nest sites, European bird protection societies are trying increasingly to help Barn Owls in winter by providing free food (laboratory mice) for them in heated tubs and open boxes, which has proved successful in otherwise critical winter periods (Schmidt 1965; de Jong, 1981), but in the long run such efforts may prove to be fruitless. Traffic accidents are at present among the most serious mortality causes, not only in Europe (Glue, 1973) and North America, but in Africa (Wilson, 1970) and Asia as well. On the interstate highway between Pocatello and Jerome, Idaho, 35 dead Barn Owls were picked up in one day (Smith & Marsh, 1976). On a 2.5-km stretch of highway in East Germany as many as 151 dead Barn Owls were found during three controls in the course of three weeks (de Jong, 1983).

Cases of poisoning by mercury, thallium and organic biocides and thinning of eggshells have been recorded, but the relation of these to overall mortality in the Barn Owl is not known (Conrad, 1977).

Barn Owls have flourished on the Hawaiian Islands, Lord Howe Island and particularly the Seychelles Islands after their introduction there by man. In the Seychelles the Barn Owl has failed to kill off the rats in the sugar cane plantations (the purpose for which it was introduced) since, like the mongoose elsewhere, it has resorted instead to feeding on birds (including sea birds) and attempts are now being made to eradicate it.

Probably on account of its almost worldwide distribution, Leslie H. Brown (1970:150) described the Barn Owl as "the world's most successful bird". There is some truth in this description, though it is now clear that the Barn Owl has basically remained a mainly subtropical and tropical species which has probably succeeded in spreading outside warm climates only by direct association with man. Authors have praised the adaptable reproductive behaviour of the Barn Owl, to the extent that it is still unclear whether its original nest sites were in caves and rock fissures or in tree holes. Its marmorated yellowish and grey plumage suggests colours more adapted to roosting in sandstone cliffs and caves than in

the secluded darkness of tree holes. To cite Leslie Brown (1970:152) once more, the Barn Owl in Africa is probably "a bird that is spreading and increasing because of the increased human population of Africa, and especially because of the development of permanent structures". The same description could be applied to former European conditions as well. An interesting problem is the Barn Owl's absence in China, where one might have expected houses and temples to offer it suitable nesting sites. It may be that the Chinese people did not appreciate the commensal presence of a bird of ghost-like appearance and which at times yelled and screeched in the dark. Or there may be some other explanation.

The basic facts of the Barn Owl's life can be summarized as follows: (1) a predilection for terrestrial voles and mice and, in their absence or scarcity, for shrews of various species; (2) prolific breeding and (3) wide, virtually random dispersal of the multiple offspring; (4) breeding twice yearly or more in temperate regions; (5) high winter mortality in cold climates. Some of these characteristics can be considered as the Barn Owl's inherited tropical traits. The Barn Owl's extension outside tropical regions has been possible only when breeding results and dispersal of young equalled the losses caused by periodic poor food conditions and adverse winter weather. It may be that the Barn Owl has not been able to adapt as well to these conditions in interior Asia and China.

GRASS OWL

Tyto capensis

As a terrestrial owl, the Grass Owl is even more highly developed and can run better than the Barn Owl *Tyto alba*. It has become an open-country bird, even more specialized and having longer legs than the Marsh Owl *Asio capensis*, which often shares its habitat in its African range.

Since it has disjunct ranges in Africa, south and east Asia and Australia, the first question that arises is whether all Grass Owls form one species or whether two separate species, an African one *Tyto capensis* and an Asian–Australian one *Tyto longimembris*, should be recognized. Any taxonomic conclusion here also relates to the origin of the species: whether it developed from a Barn Owl stem as an Indo-African arid-grassland form, or whether it represents two independent lines of development with similar results. As the second possibility is the less likely and the morphological difference between the various populations is slight and mainly refers to the colour of the tail feathers, I have followed the majority of recent authors (Amadon & Jewett, 1976; Snow, 1978; Clark *et al.*, 1978; White & Bruce, 1986) in treating all Grass Owls as one species. The question will frequently arise in the following species account, however, and cannot be considered as settled.

The Grass Owl's habitat coincides with that of the Marsh Owl in Africa and that of the Florican Bustard *Eupodotis bengalensis*, Lesser Coucal *Centropus bengalensis* and barasingha or swamp deer *Cervus duvauceli* in southern Asia. It is one of the species which are supposed to have followed the "grassland route" from continental Asia east of the humid tropical range, through the Philippines, Sulawesi (Celebes) and the Lesser Sunda Islands (Flores) to Australia, where it is considered a rather recent, late glacial or post-glacial colonist (Stresemann, 1939). This thesis will be discussed below.

With an average body weight of approximately 420g in Africa (Biggs *et al.*, 1979) and 370g in Australia, the Grass Owl is heavier than the local Barn Owls by about 25% and 23%, respectively. In wing length the difference is on average about 20% (334mm) in Africa, 14% (327mm) in India and 17% (328mm) in Australia. The wingspan appears to be somewhat wider, the tail absolutely shorter and the bill longer and heavier than the Barn Owl's (see Structure), but on the whole the Grass Owl resembles the Barn Owl more closely than any other member of the genus. Ecologically the Grass Owl is not unlike the Short-eared and Marsh Owls in its food and feeding habits and its tendency towards gregariousness and nomadism. Like these other owls it resembles a nocturnal harrier *Circus*, although it is definitely short- rather than long-tailed like the harriers. Comparisons will thus be made in the following text with Barn Owls, Marsh Owls and harriers.

GENERAL

Faunal type Indo-African.

Distribution Discontinuous. In Africa, most of east and south Africa south of the equatorial forest zone. North to central Angola, central Zaire, Rwanda and Burundi, southernmost Uganda, central Kenya up to 3,200m on Mt Kenya, north to Lake Edward (Schouteden, 1954); possibly southern Ethiopia, from whence one field record dated 9 May 1973 south of Addis Ababa is known (Turner, 1974). Local and rare and apparently absent in many places. An isolated population, separated by about 1,500km from any other, also occurs in the Cameroon Highlands at 1,500–2,000m (Serle, 1949, 1950). In Asia, the Indian peninsula south of the submontane tracts of the Himalayas, from Dehra Dun, Uttar Pradesh, to eastern Assam and parts of Burma, and south to the Nilgiris and other southern hills, but not Sri Lanka. The distribution in south and southeast China is very sporadic and the range is probably separated by a gap from the Burmese–Indian ranges, but the owl has been recorded from Yunnan (Hartert, 1929). It occurs north to Hunan and Chekiang, south of the Yangtze River; also in Taiwan. Knowledge of its distribution in the Indo-Chinese countries is very incomplete; it occurs in south Vietnam, but is unknown in Thailand and the Malay Peninsula. Most of the Philippines, at least south and east Sulawesi (Celebes) and nearby Tukangbesi (Kaledupa) (White & Bruce, 1986). Flores (J. A. J. Verheyen), in the Lesser Sunda Islands chain. In Australia, a northeastern coastal range of about 70-km width from Cape York and the coast of Queensland south to Harrington in New South Wales (Blakers *et al.*, 1984) and a central range in the Rolling Downs of the Barkly Tableland and Lake Eyre Basin area (Schodde & Mason, 1980); also the Huon Peninsula and central highlands (Balim Valley and Snow Mountain) of New Guinea at 1,500–2,000m, New Caledonia and Viti Levu, Fiji Islands. Map 2.

Climatic zones Savannah, steppe, desert, tropical winter-dry, temperate and tropical rain forest zones. In China it may reach the January isotherm of as low as 8°C; in South Africa south to the isotherm of 18°C in the coldest month (July).

Habitat Open, often swampy grasslands, vleis, flood-plains, and *dambos* in east Africa; the *terai* and *duars* in the sub-Himalayan plains with grasses and reeds of 0.5–3.0m in height. Elsewhere, grasslands in valleys and on hillsides, swampy moorland in the mountains up to great heights, seasonally moist savannahs, grasslands and swampy patches of rushes and sedge in semi-deserts, marshy heaths and swampy tussock grassland, rice fields and other suitable extensive areas of crops and fallow lands.

GEOGRAPHY

Geographical variation Two clearly separable groups of races, but geographical variation within each group is poorly understood. The African group (*capensis*) is more contrastingly coloured, with upperparts more solidly sooty black and central tail feathers of the same colour and unbarred. Either one or four races are recognized; it is doubtful whether even the most isolated population in the Cameroon Highlands (*Tyto capensis cameroonensis*) can be recognized as a separate race. Similarly, of the Indo-Australian groups, between one and as many as eight geographical races are recognized, though the consensus tends to one, *T. c. longimembris*. Isolated races have been described from Taiwan (*T. c. pithecops*), the Philippines (*T. c. amauronota*), central New Guinea (*T. c. baliem*), southeastern New Guinea (*T. c. papuensis*) and the Fiji Islands (*T. c. oustaleti*). Some of these may prove to be distinct races, but the picture so far may have been obscured by the possible occurrence of long-distance stragglers or nomads.

Related species Of all *Tyto* owls, the Barn Owl *Tyto alba* seems to be the Grass Owl's nearest relative. This conclusion, though unconfirmed, is based on outward appearance, voice and antagonistic habits.

STRUCTURE

Little appears to be known of the Grass Owl's structural characteristics. Of all *Tyto* owls, the Grass Owl has the longest and thinnest tarsus, rendered more noticeable by the virtual absence of feathers. The tarsus is usually more than 80mm long. Compared with the local representatives of *Tyto alba*, the tarsus of the Grass Owl in Africa is about 32% longer, in India 38%, in Australia probably more than 50%. Possibly as an adaptation to its terrestrial, running habits, the basal two phalanges of the fourth toe are fused, a unique occurrence among owls (Ford, 1967:21).

The tail is shorter than in any other member of the genus; it reaches 34.0–39.5% of the wing length, as against 39.6–44.0% in the Barn Owl (Eck, 1971). The combination of a short tail and long wings is thought to favour a whirling flight and sudden stoops on prey detected in the grass cover. A similar method of hunting has been adopted, however, by the long-tailed harriers.

Grass Owl *Tyto capensis*
Southern African race *T. c. capensis*

BEHAVIOURAL CHARACTERISTICS

Songs and calls The Grass Owl is considered to be one of the few silent owls and anyone who has heard a Grass Owl calling can count himself lucky. The calls that have been described closely resemble the Barn Owl's territorial and contact calls: a muted screech (Peter Steyn) and a harsh rasping or snoring, though shorter, deeper in tone and much softer than the Barn Owl's call (Schodde & Mason, 1980); also, in Zambia, a frog-like *kwark* (Tucker, 1974), "a heavily sibilant, high-pitched tremolo note lasting one or two seconds" (D. R. Aspinwall). A soft, high-pitched twitter and chirrup may accompany courtship activity. The hunger call of young is likewise subdued. The Grass Owl seems to make every effort to render itself as inconspicuous as possible in its vulnerable terrestrial habitat.

Circadian rhythm The Grass Owl is considered much more strictly nocturnal than the Marsh Owl (Masterson, 1973) although it has occasionally been observed quartering the fields at dusk. Hunting starts earlier in the evening and ends later in the morning than in the Barn Owl (Earlé, 1978). In tropical western Arnhem Land, Australia, in times of food scarcity the Grass Owl has been seen to continue hunting well into the middle of the morning (Schodde & Mason, 1980).

By day the owl hides in rank grass and reeds, standing on its long legs, sometimes in pairs side by side, on a pad of trodden grass in a dome-like structure 40–60cm in diameter at the end of a grassy tunnel. Unlike the Marsh Owl, the Grass Owl makes constant use of its roost, as indicated by the pellets assembled in one such spot. Communal roosts, perhaps formed by family groups, are known to occur in Africa and Australia; in such cases a labyrinth of well-covered tunnels connects the individual sleeping sites.

Antagonistic behaviour When cornered in its daytime retreat or otherwise threatened, the Grass Owl displays similar swaying movements, with wings spread and head protruding, to the Barn Owl's. The effectiveness of this snake-like behaviour in the dark recesses of the owl's grass tunnels may be enhanced by a loud hissing produced by the female (and perhaps also the male) and resembling one or more disturbed and angry puffadders (Peter Steyn), and also by an occasional bill-snapping.

ECOLOGICAL HIERARCHY

There are numerous parts of the African savannah regions where Grass Owls and Marsh Owls nest and hunt in the same spot, though in general the Grass Owl selects wetter sites and is therefore the more marsh-inhabiting species of the two (see Masterson, 1973). It is also the rarer, except in a few places like the Nyika Plateau at 2,200m and at Lake Chilwa, Malawi, where the Grass Owl outnumbers the Marsh Owl (R. J. Dowsett). On the other hand, it tolerates longer grass and drier situations than the Marsh Owl for purposes of lying up during the day.

The Grass Owl is the larger of the two. Its body weight is about 38% greater and its wing 15% longer than that of the Marsh Owl. Since its feet are larger and stronger too, its average prey, where the two owls hunt together, is thought to be larger than the Marsh Owl's and it takes, in particular, a greater number of grass-inhabiting rats and mice (Steyn, 1984).

Competition with other owls is unlikely though the Grass Owl may meet several other owls when out hunting at night and it must have been under such conditions that one was caught and eaten in Zambia by a Giant or Verreaux's Eagle Owl (Benson, 1962). Competition with diurnal harriers *Circus* hunting in the same habitats is hardly to be expected, but in the semi-arid centre of Australia competition for food and problems of co-existence are thought to occur with Letter-winged Kites when the food supply, mainly long-haired rats, rapidly diminishes after a season of plenty (Schodde & Mason, 1980).

Female Grass Owls are 23% heavier on average than males; in Australia the wing is 4% longer and the wingspan 6% greater than that of males (data after Schodde & Mason, 1980). Since little has been reported on the life of the Grass Owl, it is not surprising that nothing at all is known of the differences in average prey size taken by the sexes.

BREEDING HABITAT AND BREEDING

Like the Marsh Owl, the Grass Owl nests on the ground, hidden below rank grass, sedges, reeds, bracken or bush. It deposits its eggs on a pad of grass, beaten down and matted together, usually a few centimetres above the ground. No material appears to be added to the nest site. Nest and roost sites are often interconnected by a system of roofed tunnels running through the vegetation over distances of up to ten metres. Unlike the Marsh Owl, but as in the case of the majority of Barn Owls, the Grass Owl defends only a small nesting territory. Probably stimulated by a temporary or seasonal abundance of food, Grass Owls often nest in loose communities, and nests have been found in Australia as close as 50m apart (Schodde & Mason, 1980). Thus, at Ingham, Queensland, Australia, 40–50 pairs have been found nesting in 0.4km^2 of fallow rice field, in comparison with, on average, somewhat fewer than one pair per 0.01km^2 (Schodde & Mason, 1980).

Breeding is usually connected with the seasonality of the rains, but also with the effects of grass-burning and jungle fires. For hiding and hunting purposes, the Grass Owl needs the fresh, rank grass and reeds which appear with the rains after the dry season and the grass fires, while the young, on the other hand, are raised in the early dry season. However, eggs and young have been found virtually at any time of the year, food conditions permitting. In the Indian plains the Grass Owl breeds in the cold-weather period October–March, mainly October–November; in the Cachar Hills, Burma, in May–June, when the vegetation is renewed after the spring jungle fires (Baker, 3, 1934); in Australia, at the end of the wet summer season and the beginning of the dry winter season. Clutch size in Africa is 4–6; in southern Africa 3–9; in Australia 3–8. It is materially smaller than in the Barn Owl but, in Australia at least, probably depends directly on the food supply. The eggs measure on average 41.8 × 33.6mm in southern Africa and 39.9 × 32.7mm in India (data after Maclean, 1985, and Baker, 3, 1934), which is 24% larger in volume than in the African Barn Owl and 1% smaller than in the Indian Barn Owl.

Probably only the female incubates, but the male is often reported to stand guard close to her in the nest hollow. In Africa incubation does not start before the clutch is nearing completion; hence all eggs hatch within one or two days and there is no dramatic difference in age and size between the nestlings and consequently less competition for food (Davidson & Biggs, 1974; Earlé, 1978; Steyn, 1984). However, in Australia differences between nestlings of up to 16 days have been reported, as in the case of the Barn Owl (Schodde & Mason, 1980). This may signify that African and Australian populations have adapted differently to terrestrial life, or that the Australian Grass Owl is more nomadic; or the differences attributed to the African and Australian populations may in fact be illusory.

The young's first downy plumage is white and may persist until the 12th–14th day. The second down is very long, fine and fluffy, buff-coloured, golden buff or tawny rufous. It does not appear to differ in the various parts of the species' range. Whereas the small white young are well hidden beneath the carpet of grass and reeds and are brooded by the female, the buff coloration of the older birds blends with the vegetation, allowing the female to leave the nest and resume hunting.

Until that time the male alone provides food for the female and young. The hunger or position call of young begging for food is a soft wheezing, snoring or rasping and does not easily reveal their hiding place in the grass. The overall nestling time is long; the young disperse from the nest and hide in separate tunnels shortly after they have assumed their brown coat, but they are still largely covered with down at six weeks of age when Barn Owl young are usually fully feathered, and they make their first flight when probably about seven weeks old (Steyn, 1984). Family parties often stay together for another 30 days at least.

FOOD AND FEEDING HABITS

The Grass Owl hunts in harrier fashion, quartering fields and marshes in unsteady flight a few metres above the vegetation. With its long legs it can grasp deep down into rank grass and plants. It has been seen to perch on a pole in a field or on the side of a road, apparently conserving energy for hunting. Its food is said to be larger on average than that of the Marsh Owl. In Africa it comprises for the greater part rodents of moist grasslands such as vlei rats (up to 120g) and in Australia long-haired rats. The number of mammal species taken is large and is known to include the rodent genera *Dasymys*, *Selomys*, *Rhabdomys*, *Aethomys*, *Praomys*, *Rattus*, *Uromys*, *Mus*, *Colomys*, the tree mice *Steatomys* and the vlei rats *Otomys*; further, shrews *Suncus* and *Crocidura*, elephant shrews *Elephantulus* and bats, as well as the Australian marsupial mice *Antechinus* and the sugar opossum or glider *Petaurus breviceps*. Birds recorded include Button Quail, Black Crake and snipe *Gallinago* and the eggs and young of other birds (southern Asia). In addition, reptiles, sometimes frogs, grasshoppers, locusts, cicadas and other insects, the latter mainly in India. The Australian long-haired rat, in particular, and also the African vlei rats *Otomys* are susceptible to dramatic population fluctuations. These have led to considerable local increase of Grass Owl populations and to subsequent nomadic dispersal and mortality. In general, however, less is known of the Grass Owl's food than of that of the ecologically similar Marsh Owl.

Grass Owl *Tyto capensis*
Southern African race *T. c. capensis* from Zimbabwe highlands with multimammate mouse *Mastomys natalensis* as prey

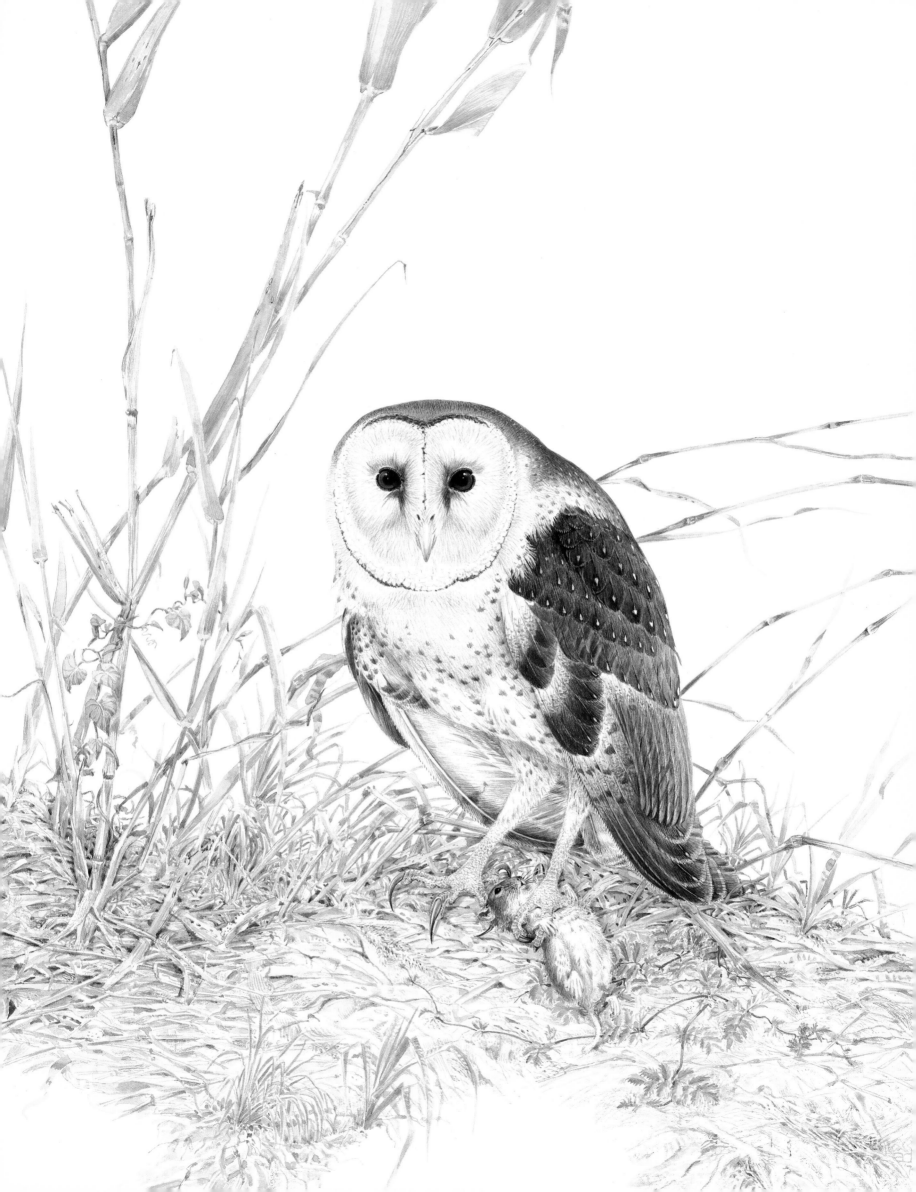

MOVEMENTS

The Grass Owl is virtually resident in many parts of Africa, but where natural or man-caused grass and bush fires occur its presence is unpredictable. Only in Australia is it at times truly nomadic. It is stationary along the coastal strip of northeast Australia, where the swamp rat *Rattus littoralis*, the white-tailed rat *Uromys caudimaculatus* and the ubiquitous house mouse provide a reliable food supply throughout the year. Where it is dependent on the 3–7-year population cycles of the long-haired rat *Rattus villosissimus* and the dusky field rat *R. sordidus*, both notable "plague rats", its population outbursts coincide with those of the rats and of the Letter-winged Kite, another specialized rodent-predator from Australia. Like the kite, the Grass Owl disperses widely in all directions when the food supply collapses. Stragglers have been observed as far north as the Torres Strait between Australia and New Guinea, at Port Darwin at 12° south and at 122° east in the Kimberley Region in the Northern Territory; as far south as Wilson's Promontory, on the Bass Strait, Victoria; and once at Cranbrook, at 117° 32' east, 34° 15' south, in western Australia (June 1944), about 2,100 km west of its nearest interior breeding grounds (Schodde & Mason, 1980). There is no record of nomadic movements in Africa and Asia.

GEOGRAPHIC LIMITS

Deserts and lowland forests devoid of extensive tracts of open grassland and moors apparently determine the limits of the Grass Owl's ranges in Africa and Australia. To these may be added mountain ranges and northern climates with winter frosts in south and east Asia. In its intolerance of low temperatures the Grass Owl concurs with the other species of its genus, including the Barn Owl, which co-occurs virtually throughout the Grass Owl's range.

LIFE IN MAN'S WORLD

The Grass Owl does not come into conflict with man. The owl is declining in Africa, probably even more than the Marsh Owl, as a result of drainage of low-lying swamps and the destruction of its habitat, but it has continued as an elusive breeding bird in fallow grasslands surrounding the outskirts of Salisbury (now Harare) in Zimbabwe (Steyn, 1984). In south and east Asia and in northwestern Australia it has probably profited from the extension of rice fields and low-growing crops for roosting and nesting purposes.

In most aspects of their structure, plumage, behaviour and ecology the African and Indo-Australian Grass Owls are closely similar. The African form appears to be the more advanced, given the unusually dark colour of its tail, the relatively small number of eggs laid and the late start of incubation, which results in all the young being of approximately the same age and size. These last two factors may represent an adaptation to a more reliable food supply: large clutches and the co-existence of young of different age and size, as in the case of the Australian Grass Owl and the Barn Owl *Tyto alba*, are well-known safety measures intended to counteract a sudden food shortage. All Grass Owls have fluffy, golden-buff or brown second downy plumages, which help the young to blend magnificently with their surroundings of dry, yellowish grass stems and reeds. African Grass Owl chicks may maintain their downy coats longer and fledge at a later age than their Australian counterparts, and even later than Barn Owls, to ensure greater safety in their otherwise vulnerable terrestrial position. All these factors could be interpreted as representing a more advanced ecology in the African Grass Owl, but the differences described may be misleading or indeed non-existent, and the evidence for the existence of two species is by no means conclusive. Less is known of the Asian Grass Owl's life habits; they probably differ little from those of the Australian populations, but a comparative study would be worth undertaking.

All the evidence seems to support the theory that the Grass Owls originated in the Indo-African savannah and grasslands of the Pliocene, like so many grazing ungulates of present-day Africa and southern Asia. Their present range is not dissimilar to that of the Black-shouldered Kite *Elanus caeruleus* and the southern range of the Black Kite *Milvus migrans*, the Cattle Egret *Bubulcus ibis* and the Fan-tailed Warbler or Zitting Cisticola *Cisticola juncidis*. All these species are supposed to be relatively recent arrivals in northern Australia. The Grass Owl itself is most probably the latest addition to the *Tyto* owls in Australia, of which, remarkably, there are already three. If this is so, the Grass Owl must have had to establish its own, specific place in opposition to other Australian owls, and its present habits should therefore be interpreted in the context of recent ecological exploration of the species. Evidently, African and Australian Grass Owls have not proceeded at an equal pace along the road towards ecological specificity, or rather, specific independence. The fact that the eggs of African Grass Owls are decidedly larger in volume (24%) than those of sympatric Barn Owls, but of almost similar size or somewhat smaller (1%) in southern Asia indicates that the interrelations between the Grass Owl and the Barn Owl, and possibly between other species of owls as well, have followed different routes in the different continents. A distinction, therefore, between African and Indo-Australian Grass Owls at the specific level is perhaps justified after all.

MOUNTAIN SCOPS OWL
Otus spilocephalus

The main zoogeographic problems relating to the genus *Otus*, which, with the exception of Australia, is represented worldwide, have been summarized in the introductory remarks to the European Scops Owl. The Mountain or Spotted Scops Owl, of 18–20cm length, is one of five species of its genus treated in this book; it is only marginally Palaearctic in distribution and habitat. Since perhaps as many as 21 species of *Otus* inhabit Palaearctic and Oriental or Indo-Malayan Asia, some far beyond the Line of Wallace, the distributional patterns and ecological relationships among them are understandably very complicated, though the nocturnal songs of most are highly distinctive. The Mountain Scops Owl is an inhabitant of southeast Asiatic mountain forests as distinct as the oak, rhododendron and deodar forests of the Himalayas and the gloomy, moss-covered elfin forests of the mountains of Sumatra and Borneo. Neither its habits nor its ecological relations with other members of its genus have been well documented or described.

GENERAL

Faunal type Montane Indo-Malayan.

Distribution Evergreen forests of the Himalayas, from Murree in Pakistan eastwards, including the Kathmandu Valley of Nepal, to south China in the provinces of Kwantung, Kwangsi and central Fukien; southwards through the mountain tracts of Burma, Thailand and Vietnam to Malaya, with isolated populations in the mountains of Taiwan, the Philippines (Luzon and Negros, provided the endemic mountain forms *Otus longicornis* and *Otus nigrorum* are included in this species; Hekstra, in Burton, 1973), Borneo and Sumatra, but nowhere beyond the Line of Wallace. Map 3.

Climatic zones Tropical, subtropical and temperate mountain zones.

Habitat Dense evergreen mountain forests of oak, rhododendron, pine and deodar, in *duars* (alluvial plains) and higher up in the foothills of the Himalayas at 600–2,700m, but generally above 1,500m (Ripley, 1982). Elsewhere cool, evergreen broad-leaved forests, generally over 1,000m and up to 2,300m in Taiwan, 2,700m on Mt Kinabalu in Sabah, Borneo, and 2,500m in Sumatra, but incidentally probably as low as 900m on the lower slopes of Mt Kerinci, Sumatra (920m altitude, type locality of *Otus stresemanni*).

GEOGRAPHY

Geographical variation At least nine subspecies recognized, distinguished by size, variations in the dark, misty or frosty pattern of the dorsal plumage and the density of the feathering of tarsus and toes (see Marshall, 1978). The form inhabiting the western Himalayas in Himachal Pradesh is known as *Otus spilocephalus huttoni*, that from Nepal, the eastern Himalayas and northern Burma as *O. s. spilocephalus*, that from Taiwan as *O. s. hambroecki*, that from Borneo as *O. s. luciae*, that from Sumatra as *O. s. vandewateri* (possibly including *O. stresemanni*, based on a unique type specimen from the lower forested slopes of Mt Kerinci).

Related species Nearest relative seems to be the Collared Scops Owl *Otus bakkamoena*, which may be the lowland species from which the Mountain Scops Owl derived. Another possible relative is the montane, dark-plumaged Javan Spotted Scops Owl *Otus angelinae*.

STRUCTURE

See Common or European Scops Owl. The Mountain Scops Owl is characterized by a row of black-margined, white scapular feathers, but this is a relatively minor distinguishing feature and one whose behavioural significance remains uncertain. The feathers surrounding the base of the bill form long and rather strong filoplumes or bristles; they cover the face and clearly have a significant tactile function. The ear tufts are not very conspicuous. The eyes are golden yellow or greenish yellow as in most other scops owls. The legs are covered with a dense feathering but are bare on the distal parts in tropical forms; the toes are bare throughout the owl's range. The wings are rela-

OVERLEAF: **Mountain Scops Owl** *Otus spilocephalus* from Java, Indonesia, here treated as a separate species *Otus angelinae*

Mountain Scops Owl *Otus spilocephalus* from Java, Indonesia, here treated as a separate species *Otus angelinae*, with convolvulus hawk moth *Herse convolvuli* as prey

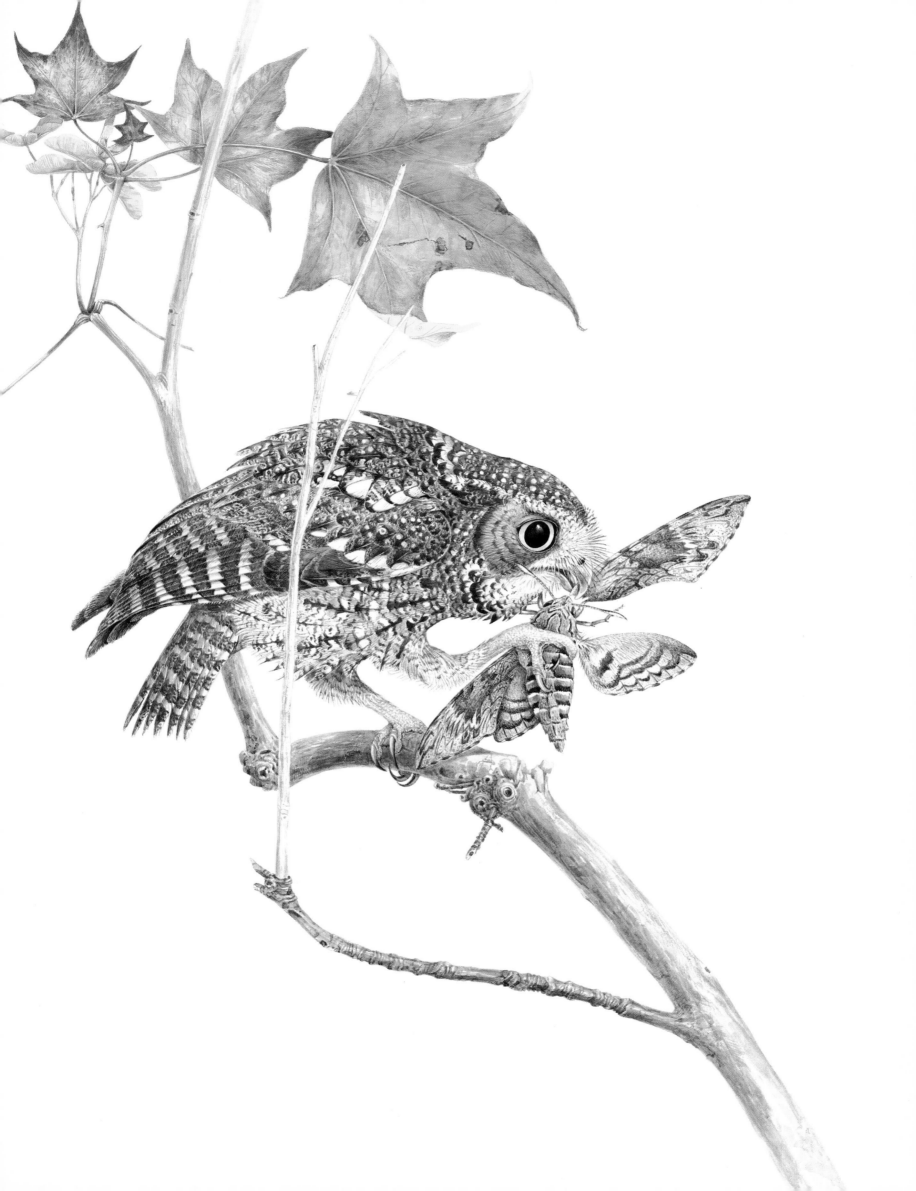

tively short and rounded. An indication of a light-brown neck collar suggests a resemblance with the Collared Scops Owl.

BEHAVIOURAL CHARACTERISTICS

Songs and calls The song in India has been described as a "metallic, cowbell-like double whistle *tunk . . . tunk* or *phew . . . phew*, with ½ to 1 second between the notes" (Ali & Ripley, 3, 1969:257), but the interval is longer in the southern, insular populations (Marshall, 1978). It may have the quality of beating a hammer on an anvil (Smythies, 1953:376) and in some places in the Himalayas the bird is known as the "bell-bird". The double whistle has also been recorded in Taiwan, Borneo and Sumatra, with pitches higher than the Oriental and European Scops Owl, viz. 1,300–1,600Hz, against 740–1,300Hz and 1,200–1,450Hz, respectively (van der Weyden, 1975).

Circadian rhythm The Mountain Scops Owl is nocturnal like most of the scops owls and is hardly ever encountered by day. Whether it hides or sleeps in holes in trees or in shady foliage is not clear.

Antagonistic behaviour No data.

ECOLOGICAL HIERARCHY

Nothing has been reported regarding interactions or contact with other owl species or diurnal birds of prey. The Mountain Scops Owl shares its mountain habitat more particularly with the Collared Owlet. The latter is of almost the same size or slightly smaller, but a mainly diurnal hunter, whereas the Mountain Scops Owl is active only at night. On the continent it may meet the Collared Scops Owl (*c.* 25% larger) in the lower altitudes of its range and on the islands of Sumatra and Borneo Brooke's or Rajah's Scops Owl (*c.* 18% larger), but no information on ecological differences between any of these species is available, presumably due to the inherent problems of gathering such data for a mainly nocturnal species.

BREEDING HABITAT AND BREEDING

In the Himalayas nests have been found in nest holes abandoned by woodpeckers and barbets (Baker, 3, 1934). Eggs are of approximately the same size as those of the Oriental Scops Owl: average of 56 eggs from the Himalayas and Burma 32.3 × 28.0mm, as against 31.9 × 27.0mm in the Oriental Scops Owl (from data by Baker, 3, 1934). As a montane species the Mountain Scops Owl has a later breeding season (April–June) than the lowland Oriental Scops Owl (February–May; Baker, 3, 1934).

FOOD AND FEEDING HABITS

Few records available. Beetles, cicadas, mantids and other large insects have been found in the stomachs of collected specimens, but the Mountain Scops Owl is thought to take small rodents, birds and lizards as well. It hunts more regularly than other scops owls in the darkness of the forest, probably in or just below the lower strata of the canopy.

MOVEMENTS

The Mountain Scops Owl is considered strictly resident.

GEOGRAPHIC LIMITS

The Mountain Scops Owl is a montane species whose range rarely overlaps with that of other lowland scops owls of similar size. The larger Rajah's Scops Owl from lower mountain zones in Sumatra and Borneo (1,200–2,200m) may restrict the Mountain Scops Owl's range in the Sunda Islands to generally 1,500–2,500m altitude.

LIFE IN MAN'S WORLD

The Mountain Scops Owl does not seem to come readily into contact, let alone conflict, with man (although its mountain forests are constantly under threat of destruction). Its plaintive song is well known among mountain-inhabiting tribes in Burma where it has become the subject of legend (Smythies, 1953).

It is no easy matter tracking down the Mountain Scops Owl in its continental mountain habitats, nor in the cool, montane tropical evergreen forests of Luzon, Borneo and Sumatra. The systematic and ecological relationship between the Mountain Scops Owl and the partly sympatric Collared Scops Owl *Otus bakkamoena* and Brooke's or Rajah's Scops Owl *Otus brookii* is nevertheless worthy of study. And in particular the status of Stresemann's Scops Owl *Otus stresemanni* (possibly a colour morph of *Otus spilocephalus vandewateri*) in the mountains of central Sumatra needs elucidating. Likewise, the degree of relationship between the Mountain Scops Owl and the Luzon and Negros Scops Owls *Otus longicornis* and *O. nigrorum* (belonging either to *O. spilocephalus*, *O. sunia* or *O. bakkamoena*) and the Javan Mountain Scops Owl *Otus angelinae*.

ORIENTAL SCOPS OWL
Otus sunia

The yellow-eyed Oriental Scops Owl shares most of its characteristics with the European Scops Owl *Otus scops* except for its song and the less extensive feathering of its tarsus and toes. It is of virtually the same size (18–20cm) and also feeds mainly on large flying insects, but as a result of its shorter migration route it has not developed the European Scops Owl's long, pointed wing tip. It has a wide range in south and east Asia and belongs to the species complex of *Otus scops* with which it is sometimes treated as one zoogeographic or biological species comprising up to 63 subspecies (Stresemann, 1925; Voous, 1960; Eck & Busse, 1973). It is well known due to its persistent calls, heard both in tropical nights and in warm summer nights in the north of its range. Little is known about its life and virtually nothing regarding interactions with other owls. A particularly regrettable gap in our knowledge of this species concerns its ecological confrontation with the approximately 25% larger Collared Scops Owl *Otus bakkamoena*, which occurs throughout the whole of the Oriental Scops Owl's range.

GENERAL

Faunal type Indo-Malayan.

Distribution Indo-Malayan and southeast Palaearctic. The whole of continental southern Asia east of the Indus River and south of the Himalayas. Probably the whole of China, Korea, the Soviet Far East and part of Mongolia, north to about 56° north (Sokolov, 1986). Japan, from Hokkaido to the Ryu Kyu Islands and other small islands south to Taiwan; also at least eight islands in the Philippines and the small Mantanani Island off Sabah, north Borneo. Further, Sri Lanka, the Andaman and Nicobar Islands, but not Indonesia, nor the southernmost tip of Malaya. Its range is separated from that of the European Scops Owl on the Afghan–Pakistan frontier by about 500km (Roberts & King, 1986), and in Mongolia by probably less than 300km (see Piechocki, 1968). Map 4.

Climatic zones Tropical rain forest, tropical winter-dry, savannah, temperate and the southern fringes of the boreal climatic zone. In the north its range may reach the July isotherm of approximately 20°C.

Habitat In southern Asia, tropical evergreen and deciduous forests in lowlands and hills up to oak and pine forests in the Himalayan foothills at about 1,500m and up to 2,300m in the Murree Hills in north Pakistan (Roberts & King, 1986). Hill cultivation and gardens in rural villages, also teak forests in Burma. Elsewhere in open or primeval deciduous and mixed forests, particularly in river valley bottoms (Pukinsky, 1977; Knystautas & Sibnev, 1987); in the north also on the edges of the coniferous taiga, up to 1,400m in the Mongolian Altai and 1,100m in the Kentei Mountains (Piechocki, 1968). Apparently common only in a few places, such as in the Amur–Ussuri region, particularly in the valleys of the Usurko and Bikin Rivers (Knystautas & Sibnev, 1987), and in Honshu, Japan, where it occurs in broad-leaved forests up to 1,500m.

GEOGRAPHY

Geographical variation Not very pronounced, relating to size, wing shape, general colour of the plumage, boldness of the dark feather patterns, which may tend to either bars or streaks, and extent of feathering on the legs; also to songs and calls and possibly eye colour, which is orange-yellow except in the Philippine race *Otus sunia mirus* (Mindanao) where it is brown. Between 12 and 15 races are recognized (Dementiev & Gladkov, 1, 1951; Vaurie, 1960; Eck & Busse, 1973). Geographic differences are of degree and usually gradual. The largest owls occur in the Soviet Far East, the smallest (by c. 15%) in south India and Sri Lanka. The darkest forms are also from southern India and the lightest from the Soviet Far East. Indian birds are known as *Otus sunia sunia* (north) and *O. s. rufipennis* (south), with *O. s. leggei* in Sri Lanka, the principal Japanese forms as *O. s. japonicus* and the continental Palaearctic race as *O. s. stictonotus*.

Related species The Oriental Scops Owl is a member of a species complex to which the European Common Scops Owl *Otus scops*, the central Asian Striated Scops Owl *O. brucei* and the Afrotropical *O. senegalensis* also belong. It has been considered conspecific with either one or all of these species. Specific differences between the Oriental Scops Owl and these other owls, and also the east Indonesian *Otus manadensis* and the West Sumatran Islands' *O. mentawi* and *O. enganensis*, are hard to define and relate to territorial song rather than plumage. In spite of suggestions that the scops owls living in south Arabian oases

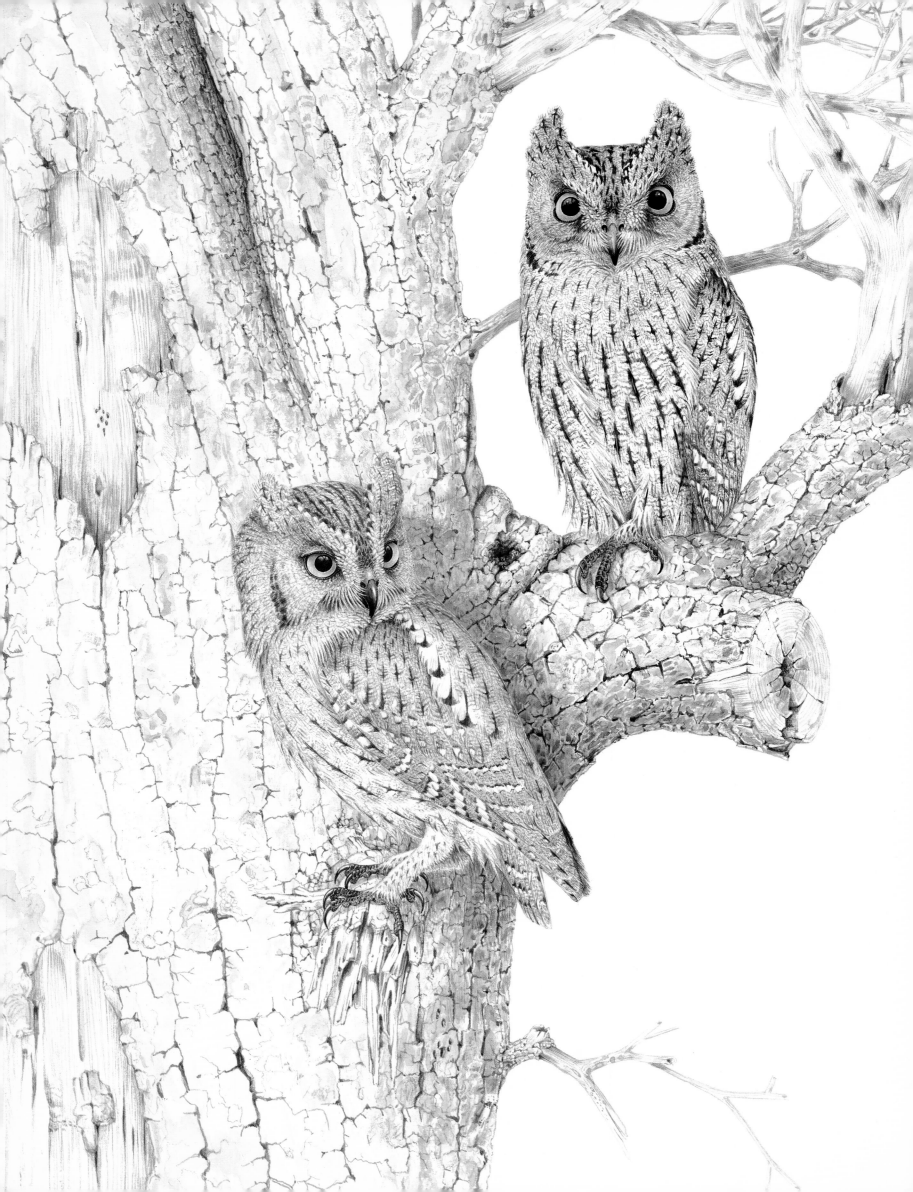

from Oman to South Yemen are westernmost members of the Oriental Scops Owl and should be known as *Otus sunia pamelae* (Gallagher & Rogers, 1980), these owls are again at present considered a race of the Afrotropical Scops Owl *Otus (scops) senegalensis* (Bates, 1937).

STRUCTURE
The Oriental Scops Owl scarcely differs from the European Scops Owl. Its less pointed wing seems to have adaptive value only. The same may be true of the less completely feathered legs, which are bare on the lower parts, and of the bare toes. Unlike in the European Scops Owl, the presence of rufous and grey morphs is conspicuous; the adaptive significance of this fact is worth studying.

BEHAVIOURAL CHARACTERISTICS

Songs and calls The territorial song is basically not unlike that of the European Scops Owl, but the tempo is more rapid and it is 2- to 5-syllabic (Roberts & King, 1986); it frequently resembles the song of a toad. Differences among local dialects are more apparent than in the European Scops Owl. The song is 2- to 3-syllabic in the Soviet Far East (*oot-to-ta* or *oot-ta*; Pukinsky, 1977), 3-syllabic in Japan and 4-syllabic in south Asia, to the tune of "Here comes the bride" (Marshall, 1978:8). A song of 3–5 notes in tropical Asia resembles a barbet's call and like that call is repeated over and over again at short intervals. A frequency of 94–136 hoots per minute has been recorded in Japan and 88–214 in Thailand (van der Weyden, 1975:table 1). The monotonous, toad-like series of rather high notes in Japan has a "bouncing ball" effect. The song is less melodious, lower pitched and with shorter intervals in southeast Asia, where it seems to be frequently mistaken for a nightjar's song (Smythies, 1953), and has been described in various ways, e.g. *tiok clock-clock* in Hong Kong, *wook took-toorroo* and *tuk-tok-torok* in Sri Lanka, and *tonk tonk-ta-tonk* in Burma (Smythies, 1953:376). Other guttural notes have been described, as well as twittering sounds produced by the female.

Circadian rhythm Like the European Scops Owl, the Oriental Scops Owl is nocturnal. It hides by day in dense foliage, often high up in a tree. Feeding activity of a pair tending young in June in the Lower Utunga River district of the Soviet Far East peaked at two hours after sunset and again at one hour before sunrise, the whole period of darkness lasting 7½ hours.

Antagonistic behaviour No data.

ECOLOGICAL HIERARCHY
Numerous other owls of similar or larger size occur alongside the Oriental Scops Owl but no interactions or conflicts with any of these have been recorded; neither has any predation by diurnal birds of prey. The Oriental Scops Owl is as small as the European Scops Owl; in India its body length (18–20cm) is about 80% of that of the Collared Scops Owl. There is a similar difference in body weight, but data on the Oriental Scops Owl are scarce (north India, male, 79g; Ali & Ripley, 3, 1969:263; China, two females, 95g and 98g; Cheng, 1964:432). At about 1,500m in west Nepal it has been heard whistling in the same area as the Mountain Scops Owl of similar size (Fleming & Taylor, 1968), and it overlaps widely with the Collared Scops Owl, which, however, is sedentary, even in the northern woods of the Soviet Far East and Japan, whereas northern Oriental Scops Owls are long-distance migrants.

BREEDING HABITAT AND BREEDING
No appreciable differences between the Oriental Scops Owl and the European Scops Owl have been recorded. Nests have been found in holes in old broad-leaved trees, often high above the ground, and in hollow tree trunks and stone walls. Egg size is similar to that of the European Scops Owl: the average size of 33 eggs from Burma was 31.6×27.0mm (Baker, 3, 1934), and from Ussuria, Soviet Far East, 29.33×26.27mm (Pukinsky, 1977), as against 31.8×27.2mm in the European Scops Owl (Makatsch, 1976).

FOOD AND FEEDING HABITS
Few food records from the main tropical areas are available, but similarities with the European Scops Owl are apparent. Preys include moths, beetles, cicadas, locusts and other large insects; also mice, shrews, even rats and birds, but no species are mentioned. Records from Ussuria, Soviet Far East, include butterflies (*Nymphalidae*), moths (*Noctuidae*, *Geometridae*, *Arctidae*, *Lasiocampidae*, *Sphingidae*), beetles, grasshoppers, mole crickets, caterpillars and spiders, the latter taken, sometimes in great numbers (Nechaev, 1971), from their webs in bushes; rodents, on the other hand, are taken only in the cold early-morning hours and in prolonged cold weather and early spring (Pukinsky, 1976, 1977). The Oriental Scops Owl appears to hunt in glades, at forest edges and in open park-like country. It takes prey from the forest floor as well as from the tree canopy.

MOVEMENTS
Southern Oriental Scops Owls are sedentary. Those living in central and northern China northwards and in northern Japan are usually migratory; they arrive as late as early May from wintering grounds in south China, Thailand and Malaya, doubtless also Indo-China. Oriental Scops Owls wintering in Thailand have been recognized as the east Palaearctic race *Otus sunia stictonotus* (Deignan, 1963); most of those recorded between October and March in Malaya belonged to the migrant Chinese race *O. s. malayanus*. Such migrants have frequently crashed into lighthouses on islands in the Straits of Malacca, e.g. in November on One Fathom Bank (Medway & Wells, 1976:195). There are two records from northern Sumatra, but none from Borneo. On rare occasions Oriental Scops Owls have been found wintering in Honshu, Japan.

Striated Scops Owl *Otus brucei* (above)
Oriental Scops Owl *Otus sunia* (below)

GEOGRAPHIC LIMITS

As in other, probably originally tropical, insectivorous Indo-Malayan bird species extending into the Ussuri valley in the Soviet Far East, such as the Collared Scops Owl, Brown Hawk Owl, Roller and Paradise Flycatcher, the northern limit of the Oriental Scops Owl's breeding range is apparently determined by the presence of old broad-leaved forests and parklands in protected river valleys of tributaries of the Amur and Ussuri Rivers and other pockets of temperate climates. The warm summers even of boreal Hokkaido are to its liking, as are possibly Sakhalin and the southern Kurile Islands (Tuzenko, 1955).

LIFE IN MAN'S WORLD

The Oriental Scops Owl has little contact with man, but it occurs in tropical village gardens and has been observed in "city orchards" at Harbin, Manchuria (Dementiev & Gladkov, 1, 1966:420). Though it is not often seen, it is surrounded by folklore in Japan and Korea. Its call, traditionally, but erroneously, ascribed in Japan to the Roller, is transcribed as *bupposo*, which denotes the three *ratnas* or mystical treasures of Buddhism (Austin & Kuroda, 1953:472). Both the Roller and the Oriental Scops Owl nest in holes in the big sacred trees surrounding temples and shrines.

The main problems relating to the Oriental Scops Owl are of old date. They comprise: (1) its systematic and distributional relationship with the European Scops Owl *Otus scops*, including possible near-contact with that species in Mongolia; (2) degree of differentiation among the numerous island populations south of Japan, in the Philippines and in the Andaman and Nicobar Islands, and relationship with other island forms in Indonesia (*Otus manadensis* and others inhabiting small off-lying islands); (3) proportion of migrants in northern populations and length of migration routes; (4) development and functioning of the owl's dialects; (5) interactions with other owls, particularly with other sympatric members of its genus.

Though the "bouncing ball" quality of the song of tropical Oriental Scops Owl populations somewhat resembles the song of the North American Western Screech Owl *Otus kennicottii*, there is no reason to suppose a particularly close relationship between these species (van der Weyden, 1975).

STRIATED SCOPS OWL
Otus brucei

The main problems surrounding the Striated or Pallid Scops Owl, known in Russian literature as the Yellow or Desert Scops Owl, relate to its taxonomical and ecological position. It belongs to the species group of *Otus scops*, which includes the Oriental, European and African Scops Owls *Otus sunia*, *O. scops* and *O. senegalensis*, all of which have the same size (19–22cm), shape, colour pattern and bright-yellow eyes. Wing shape, territorial song and migration habits have been used as distinctive criteria, but without resulting in any firm conclusions. Though its pale, buffish coloration and relatively long, more extensively feathered legs and toes accord with supposed adaptations to a life in semi-deserts, the Striated Scops Owl does not seem to be a real desert owl at all, apart perhaps from the populations living in the Tarim Basin in the Sinkiang (Xin-Kiang) province, China, and those occurring in winter in Baluchistan, Sind and the Punjab in northern Pakistan and India. The elongated but rather rounded shape of the wing tip is probably connected with the owl's migratory habits and therefore not a particularly useful species characteristic, nor is its relatively large size (length 21–22cm), while the more rapid, lower pitched and less mellow whistle-like hoots distinguish it in the breeding season from the European Scops Owl. The Striated Scops Owl's range overlaps with that of the European Scops Owl in the western Tien Shan (Gavrin *et al.*, 2, 1962), Kazakhstan and possibly in the Zagros Mountains of Iran (Vaurie, 1960). The Scops Owls from Oman and South Yemen in the Arabian Peninsula have been described as *Otus senegalensis pamelae* (Bates, 1937), but have been transferred by various authors to *Otus scops*, *O. sunia* and *O. brucei*, respectively. The situation is complicated by the fact that a northern Thailand race of the Oriental Scops Owl *Otus sunia distans* has been found to resemble *Otus brucei* more than Indo-Malayan races of *O. sunia* (Friedmann & Deignan, 1939). The following species account compares the Striated Scops Owl with Oriental and European Scops Owls and, on the basis of recent information from Russian sources, describes its ecological position.

GENERAL

Faunal type Palaeoxeric.

Distribution South-central Palaearctic. From the valleys of the Euphrates and Tigris rivers in Iraq, east through adjacent areas of Iran and north Pakistan (Baluchistan) (Roberts & King, 1986), north through river valleys in Turkmeniya, Tadzhikistan, the Fergana Valley and the valleys of the Amu Darya in Uzbekistan and the Syr Darya in Kazakhstan; east of the Pamirs and south of the Tien Shan in river valleys in the Tarim Basin in Sinkiang, China. In winter also in south Pakistan and the north Indian plains. Also Jordan, Syria and Israel, but earlier breeding records from these countries have not been substantiated and it is doubtful whether the Striated Scops Owl has nested there recently. It is unclear whether breeding records from north Oman (e.g. Jebal Akhdar) attributed to the Striated Scops Owl (Gallagher, 1977) really do refer to this species. There is a possible overlap of breeding ranges with the European Scops Owl in the western Tien Shan, Kazakhstan, Afghanistan, north Pakistan and the Zagros Mountains, Iran. Map 4.

Climatic zones Mediterranean, steppe and desert climatic zones. The breeding range does not extend into regions with temperatures lower than 15–20°C in July.

Habitat Riverine forests of poplar, willow and tamarisk; orchards, including vineyards, citrus groves and date palm plantations; also parks and gardens in villages and towns, roadside groves, cultivated farmlands and *saxaoul* vegetation in semi-deserts. In winter in cultivated and riverine woodlands and in northern India and Pakistan in stony semi-deserts (Ali & Ripley, 3, 1969; Pukinsky, 1977) and "steep cliffs and rocky gorges where few trees grow larger than bush size" (Roberts & King, 1986:300).

GEOGRAPHY

Geographical variation Apart from Arabian Scops Owls described under Related species, the geographical variation of the Striated Scops Owl is not conspicuous, and most authors do not recognize any subspecies at all (Vaurie, 1960; Stepanyan, 1975; Ripley, 1982). However, on the basis of differences in size and general coloration, four races have recently been recognized (Hekstra & Roselaar, in Cramp, 4, 1985): the northernmost ones are relatively large and rather grey or ochraceous yellow (*Otus brucei brucei* in northern Uzbekistan and southern Kazakhstan, and *O. b. semenowi* in Sinkiang); the southernmost ones are smaller by perhaps 4% and darker grey and sandy buff (*O. b. obsoletus* in northern Iraq to northern Afghanistan, and

O. b. exiguus in south Iraq probably to Baluchistan). Opinions vary on how real these differences are and I am personally inclined to accept the existence of slightly larger northern migrants and smaller southern residents.

Related species The Striated Scops Owl is a member of the *Otus scops* complex, now usually divided into an Oriental, Striated, European and African Scops Owl *Otus sunia*, *O. brucei*, *O. scops* and *O. senegalensis*. Another small, buff, scops owl from Dailami, Wadi Bisha, southwest Arabia, was described as *Otus senegalensis pamelae* (Bates, 1937), thought to be an Afrotropical element in the Arabian fauna. In the meantime similar birds have been found in oases in Dhofar, Muscat and elsewhere in Oman; these have peculiar, somewhat rasping songs, transcribed as *prrok*, *wokk*, *kyar* or *kwar* (Hekstra, in Burton, 1973). While also treated as a member of the Oriental Scops Owl, this owl was later incorporated into the Striated Scops Owl, together with the tiny, pure-grey, insular race *socotranus* from Socotra Island between Arabia and Somalia (Hekstra, in Cramp, 4, 1985). These systematic treatments are confusing and apparently arbitrary, and on zoogeographical grounds an Afrotropical origin of the south Arabian Scops Owls seems to be the most likely probability (see also Lees-Smith, 1986), recently confirmed by an analysis of vocalizations (Roberts & King, 1986).

STRUCTURE

For general characteristics of the genus, see European Scops Owl. The Striated Scops Owl resembles the Oriental Scops Owl and has a similarly rounded, though longish, wing tip, unlike the European Scops Owl's long and pointed one. The tail and the tarsus are longer than in either of these owls, the tarsus being *c.* 20% of the length of the wing, as against 17% in the Oriental Scops Owl and 15% in the European Scops Owl (Vaurie, 1960). The tarsus is more densely feathered than in the European Scops Owl, being fully feathered down to the first one or two phalanges of the toes. A greyish and a more ochraceous colour morph have been reported, but the differences are not as striking as in the Oriental Scops Owl. The face is paler and the juvenile plumage is barred rather than vermiculated or streaked as in the European Scops Owl. All these characteristics, together with the pale, often "desert-coloured" plumage, seem to have a direct ecological significance.

BEHAVIOURAL CHARACTERISTICS

Songs and calls The old controversy regarding the vocalizations of the Striated Scops Owl seems to have been largely resolved. The territorial song resembles that of the European Scops Owl. It consists of a long series of hollow, resonant *whoo* or *whoop* notes at precisely measured intervals like a metronome (Roberts & King, 1986). The rhythm is slow, but still more rapid than in the European Scops Owl, viz. 67 notes per minute, as against 22–26 in the European Scops Owl (Pukinsky, 1977; Mikkola, 1983). The nocturnal song can be as persistent as that of any other scops owl. Other known calls include a hollow and resonant *whoo* of low pitch (Roberts & King, 1986), a barking alarm note and a fierce rattling resembling the noise produced by the Little Owl.

For the loud, more rasping song of the scops owls breeding in Oman and possibly elsewhere in south-central Arabia, see under Related species.

Circadian rhythm Generally considered nocturnal, like the other species of its group, but the Striated Scops Owl has been observed hunting before dusk and in Baluchistan even by day.

Antagonistic behaviour No data.

ECOLOGICAL HIERARCHY

In the riverine forests of the Amu Darya and Syr Darya and surrounding cultivated areas and orchards in Turkmeniya and Tadzhikistan the Striated Scops Owl's habitats are similar to those of the Little Owl, though the latter occurs more frequently in more arid, stony regions. No reports indicate, however, that these two owls behave as rivals. In the Badginsky Steppe on the border between Turkmeniya and Afghanistan 25 Little Owl nests were found as opposed to 2 Striated Scops Owls' (A. N. Suganin, in Pukinsky, 1977). In body weight the Little Owl is 35% heavier on average than the Striated Scops and may be the stronger and the more diurnal of the two. Where it meets the European Scops Owl the Striated Scops is about 30% heavier (100–110g, against 80–85g; Dementiev & Gladkov, 1, 1951) and lives in a different, warmer, habitat. In the arid Middle East Barn Owls inhabit the same villages and palm groves as Striated Scops Owls; the Barn Owl is more than twice as heavy and one wonders what the outcome of any encounters may be.

Measurements of study skins suggest a 5–10% greater body mass in females than males, but whether this involves differences in average prey size still requires investigation.

BREEDING HABITAT AND BREEDING

Nests in central Asia and Baluchistan have been found in holes in trees, usually woodpecker holes, e.g. those of Green Woodpeckers in poplars and willows (Euphrates valley, Iraq), but also in mulberry, almond and other fruit trees and date palms, holes in river banks, crevices and clefts in stone walls, under the roofs of houses and deep inside *saxaoul* bushes in the semi-desert and in roofed Magpie nests (Dementiev & Gladkov, 1, 1951). In the Amu Darya valley 30 out of 40 nests reported were in Magpie nests (Gavrin *et al.*, 2, 1962), but this was considered a suboptimal situation, as most hole-nesters were adults and those using Magpie nests were first-year birds. The presence of mixed clutches containing the fresh eggs of Magpie and owl proved that the Striated Scops Owl had been able to evict Magpies from their nests. Other nests found had been built on top of old Starling nests, often in nest boxes (Gavrin *et al.*, 2, 1962).

Striated Scops Owls start nesting in central Asia in mid-April, continuing into mid-June. They are earlier than European Scops Owls, which are late spring arrivals and nest in hill and mountain forests where the season is later than in the river valley bottoms (Gavrin *et al.*, 2, 1962; Pukinsky, 1977). In Baluchistan and Iraq the breeding season is somewhat earlier. Egg size is similar to that of the Oriental Scops Owl, with an average of 31.1 ×

Striated Scops Owl *Otus brucei* (upper two)
Oriental Scops Owl *Otus sunia* (below, including details)

27.3mm in Baluchistan (Baker, 4, 1927) and 31 × 27mm in Turkmeniya (A. M. Mambetshumajev, in Pukinsky, 1977). Clutch size is not particularly large, usually 4–5. Breeding density is often relatively low; in the Tiger Valley Nature Reserve in Tadzhikistan an average of one pair was found per 3–4km^2 (R. L. Potatov, in Pukinsky, 1977).

FOOD AND FEEDING HABITS
All records indicate a diet similar to that of the European Scops Owl, including grasshoppers, locusts, mole crickets, ground beetles, dor beetles, rose chafers, long-horned beetles and other large beetles, large moths and other insects. Most of these seem to be caught in flight, as are bats. Lizards and small birds have also been reported (House Sparrows in Iraq), as well as small rodents, including house mice and gerbils.

MOVEMENTS
Striated Scops Owls in central Asia are migratory, leaving all breeding areas north of the January isotherm of 0°C in September–October and returning late March–April. In Tadzhikistan some have been reported back as early as the end of February, but around Samarkand most arrive mid-April (Pukinsky, 1977). Winter ranges are in Pakistan and the northwest Indian plains (Ali & Ripley, 3, 1969) and probably throughout the Middle East, where the owls have been observed in winter or on migration on the island of Bahrain in the Persian Gulf and have been caught in mist nets in Eilat on the Gulf of Aqaba, Israel (23 Feb. 1979; Mikkola, 1983). Wintering birds seem to frequent the xerophytic woodlands and other arid regions of Iran and Iraq which are also inhabited by resident populations of the same species, though exactly where the various central Asiatic populations spend the winter remains a mystery. Total migration routes do not seem to exceed 2,500–4,000km, which is half the distance of those travelled by the European Scops Owl.

GEOGRAPHIC LIMITS
The Striated Scops Owl's range does not extend beyond the warm summers of lowland steppes and deserts and it is replaced by the European Scops Owl in boreal and subalpine coniferous forests. To the south the Oriental and African Scops Owls inhabit complementary ranges.

LIFE IN MAN'S WORLD
The Striated Scops Owl does not shun the presence of man. In the Middle East it has been found in village gardens and on cultivated land; in central Asia it sleeps and nests in trees bordering country roads and in villages. In the Amu Darya valley it has frequently nested in nest boxes intended for Starlings and has been observed hunting insects attracted to artificial lights at night. Its rhythmic song is a well-known background sound in gardens, groves and oases during warm summer nights in the Middle East.

It is now clear that the Striated Scops Owl represents a geographically and taxonomically well-defined palaeoxeric unit within the widespread species group of Common Scops Owl *Otus scops sensu lato*. In view of possible overlap of breeding ranges with the European Scops Owl *Otus scops sensu stricto* and the occurrence of an Afrotropical scops owl in south Arabia, it would be worth clarifying the exact breeding range, population density and ecological preference of the Striated Scops Owl, particularly in the Middle East west of Iraq. What induced the development of a semi-arid species of scops owl and when and where the process leading to its formation took place are questions which still have to be answered.

EUROPEAN SCOPS OWL

Otus scops

The European Scops Owl's most conspicuous features are its small size (body length 19–20cm), remarkably cryptic plumage pattern, mainly insectivorous diet and migratory habits, with winter ranges in tropical Africa. In body mass and length the European Scops Owl is 15% larger than the Eurasian Pygmy Owl *Glaucidium passerinum* from the boreal forests and 10% smaller than the Little Owl *Athene noctua*; its wingspan of 51–54cm (Dementiev & Gladkov, 1, 1951) is approximately the same as, or somewhat greater than, the Little Owl's and it does not have the undulating, bounding flight of that open-country species. It does not appear to meet the Pygmy Owl, but it has numerous opportunities to share mediterranean and warm-temperate habitats with the Little Owl and their ecological relations are worth studying. Interesting though these details are, important questions still remain regarding the origin of the whole genus *Otus* and the geographic origin and taxonomic limits of its species.

As for the origin of the genus *Otus*, the problem is whether the small, long-winged, insectivorous *Otus* owls, with their uncomplicated external ears (as in *Bubo* owls) and long, tactile rictal bristles (as in nightjars *Caprimulgus*), are close to the root of all owls, or whether they are miniature *Bubo* owls, derived from once formidable predators. As the whole group of *Otus* owls is in a stage of intense and complicated species differentiation in most parts of the world except Australia (over 40 species recognized) and its antagonistic behaviour resembles that of a diminutive *Bubo* owl, an insectivorous, small-sized origin of these (and other) owls seems unlikely. An analysis of skeletal characteristics has confirmed the close similarity between the *Otus* dwarfs and the *Bubo* giants (Ford, 1967). In their chromosome structure most species of *Otus* are less advanced than the *Bubo* owls, but they share some non-original characteristics with the Snowy Owl *Nyctea*, the Fish Owls *Ketupa* and the Long-eared Owls *Asio* (Belterman & de Boer, 1984). The significance and implications of these characteristics are nevertheless unclear.

The European Scops Owl forms part of a zoogeographic unit, collectively known as the Common Scops Owl, which extends over the whole of the Old World as far as eastern Indonesia, but probably not North and South America. It has been treated by various authors (Stresemann, 1925; Meinertzhagen, 1948; Voous, 1960; White, 1965; Eck & Busse, 1973; Colston, in Snow, 1978; Ripley, 1982) as one widespread species. Others have split this group into at least eight species (Marshall, 1966; Voous, 1973, 1977). For a former, probably erroneous, inclusion of the North American Flammulated Owl *Otus flammeolus* into *Otus scops*, see that species. Opinions also differ regarding the status of the tropical African Scops Owl *Otus senegalensis*, but there is a growing consensus which treats it as specifically distinct. Wing shape (wing formula) and extent of feathering of tarsus and toes have been used to distinguish between the species of scops owl, but these characteristics seem to have direct adaptive values and hardly, if ever, reflect phylogenetic relationships. Territorial songs whereby potential mates and conspecific competitors are recognized are better clues for understanding specific relations among scops owls, though their value should not be overestimated either. It is the European Scops Owl's life style throughout the year which should provide the answers to these various questions.

GENERAL

Faunal type European–Turkestanian.

Distribution Southern Europe and southern west Siberia, from Morocco, Spain (estimated at 35,000 pairs in 1975; Cramp, 4, 1985) and most of the Mediterranean countries to the wooded hills and mountains of western and northern Iran, northern Pakistan and Kashmir, from Chitral to Gilgit (Ripley, 1982), the western Pamirs, Tien Shan and Altai Mountains, Semipalatinsk and the Kentei (Chentej) Mountains in western Mongolia (Piechocki, 1968). In France it is still fairly common south of the River Loire and north to Dijon (estimated at 10,000 pairs; Yeatman, 1976), but has retreated from the Paris Basin and the climatically warm pockets in northeast France (formerly nesting St Dié, Alsace), as well as from most of the warm mountain slopes of the Rhône valley, Switzerland (Arlettaz, 1987). It may still nest 400km north of its continuous range near Volkach on the River Main at 50° north in southwest Germany (Mebs, 1960, 1980), and also in southwest Slovakia (Stollmann, 1958), which are both warm xerotherm climatic cells on calcareous soils. It no longer nests in Poland, but in Russia reaches the warm Moscow area and occasionally north as far as Leningrad (nesting 1915 at least; Malievsky & Pukinsky, 1983) at 60° north. In the arid regions of the Middle East and central Asia it meets the range of the Striated Scops Owl *Otus brucei*, with which it has often been

confused, but the two species live in different habitats. In Afghanistan (probably) and in western Mongolia (more definitely) it approaches the range of the Oriental Scops Owl *Otus sunia*, but evidence of the occurrence of both species nesting in one place is lacking (Vaurie, 1960). Map 4.

Climatic zones Temperate, mediterranean, steppe and marginally boreal climatic zones and mountain ranges.

Habitat Open woodlands of all kinds, from palm groves and willows bordering river courses to montane oak forests and clumps of pines and birches in forested steppes and scrub juniper forest in mountain deserts and at the edges of the taiga and of the subalpine mountain forests. The European Scops Owl is probably most attracted, however, by cultivated land, including a variety of parks and gardens, fruit plantations, roadside trees and forest edges in warm basins and protected river valleys. Though generally a lowland species of warm environments, it ascends as high as 1,200–1,300m in Valais (Arlettaz, 1987) and 1,500–1,600m in Zernez in the Engadin Valley, Graubünden, Switzerland (Glutz & Bauer, 9, 1980), 1,700m in the Caucasus Mountains, 1,000–1,500m in Armenia and the Tien Shan (Dementiev & Gladkov, 1, 1951), occasionally even 2,300m in the Altai and 2,500m in Pakistan and Kashmir (Ripley, 1982).

GEOGRAPHY

Geographical variation Slight, relating to size, general colour of plumage and width of dark shaft streaks and vermiculations on the feathers of upper- and underparts. About seven races recognized (Vaurie, 1960; C. S. Roselaar, in Cramp, 4, 1985). Westernmost birds (Portugal, Spain, probably also northwest Africa) are smallest and relatively dull brownish grey (*Otus scops mallorcae*); Siberian and Kazakhstan birds are largest (by barely 2%) and somewhat lighter grey (*O. s. pulchellus*); those from Iraq, Iran, Uzbekistan, Afghanistan and Baluchistan are palest, somewhat silvery grey (*O. s. turanicus*). Scops Owls from Cyprus (*O. s. cyprius*) are dark with conspicuous crossbars and are apparently exceptional in being sedentary rather than migratory (Flint & Stewart, 1983). The difference in size and colour pattern between Cyprian Scops Owls and the continental European race *Otus scops scops* is more conspicuous than that between the European and the African Scops Owl *Otus senegalensis*. Evidently the species limits applied in the taxonomy of these owls are far from consistent.

Related species The African Scops Owl *Otus senegalensis* from south Arabia and sub-Saharan Africa is smaller (body length 17–18cm) and differs from the European Scops Owl in wing shape and voice and in its finer, more detailed colour pattern in white, grey and black. Similar differences are found in the Striated Scops Owl *Otus brucei* from arid central and southwestern Asia, but this species is also lighter in coloration and has longer, less densely feathered legs and toes. The Oriental Scops Owl *Otus sunia* has a darker plumage with stronger markings, more restricted feathering on tarsus and toes and a different voice. The Flammulated Owl *Otus flammeolus* from western North America, though according to its voice a scops rather than a screech owl (van der Weyden, 1973), resembles most strongly a minute Collared Scops Owl *Otus bakkamoena* from east Asia; its suggested inclusion in *Otus scops* from the Old World (Delacour, 1941) is evidently erroneous. Other scops owls with distributions on off-lying islands in Indonesia and the Philippines (a.o. *Otus manadensis*) have been included in *Otus scops* at one time or another.

STRUCTURE

The external ear openings of the European Scops Owl, like those of the big eagle owls *Bubo*, are uncomplicated, relatively small in size, oval in shape and symmetrical in position, but the auditory cavity extends beneath the skin higher up on the skull than in the *Bubo* owls (Pycraft, 1898). As in the case of other southern owls, the toes are not actually feathered but are scantily covered with bristles, while the tarsus has a rather short, but dense, feathering. The opaque-index of the rim feathers of the facial disc, indicating the degree to which sound waves are reflected, is higher than in the North American Great Horned Owl and comparable to that in the Short-eared Owl (Clark *et al.*, 1978). Nothing is known, unfortunately, regarding hearing and vision in the European Scops Owl. The base of the skull is incompletely desmognathous in structure as in the case of the Elf Owl and the Boobook Owl, signifying either an adaptation to relatively small size and slender proportions or a less advanced stage of development. Dimorphism in plumage is poorly developed. The "red" colour morph is slightly less rufous than the grey coloration, which is the most frequently occurring morph.

BEHAVIOURAL CHARACTERISTICS

Songs and calls The territorial song is a musical, though somewhat monotonous, series of monosyllabic high-pitched hoots, *kyü-kyü* or *djü-djü*, repeated sometimes for hours on end at a frequency of 22–27 hoots a minute and at steady intervals of 1.8–4.0 seconds (van der Weyden, 1975). Each male sings in its own rhythm and its own pitch. Females have a somewhat higher and probably less regular song. The European Scops Owl's song resembles the nocturnal piping of the midwife toad to such an extent that a German recording inadvertently presented the toad's song as the owl's. The error was detected only after a sonographical analysis (König, 1968). The song also resembles that of the Eurasian Pygmy Owl, though it has a mellow and more musical quality. The occurrence of dialects in, e.g., Crete and Asia Minor has been described (Kumerloeve, 1970), as have numerous other vocalizations which, uttered at various stages of alarm and aggression, are less mellow and more rasping than the territorial song. The African Scops Owl's song is similar; single hoots differ from those of the European species in that they are lower pitched and end in a kind of tremolo ("chirrup"), while the intervals are longer (broadly four seconds) (van der Weyden, 1973). The song of South Arabian Scops Owls is halfway between the stuttering song of African Scops Owls and the purr of Oriental Scops Owls from Thailand (Ben King, after Marshall, 1978:8).

European Scops Owl *Otus scops* in gnarled olive tree *Olea europaea*. Female (front) and two males

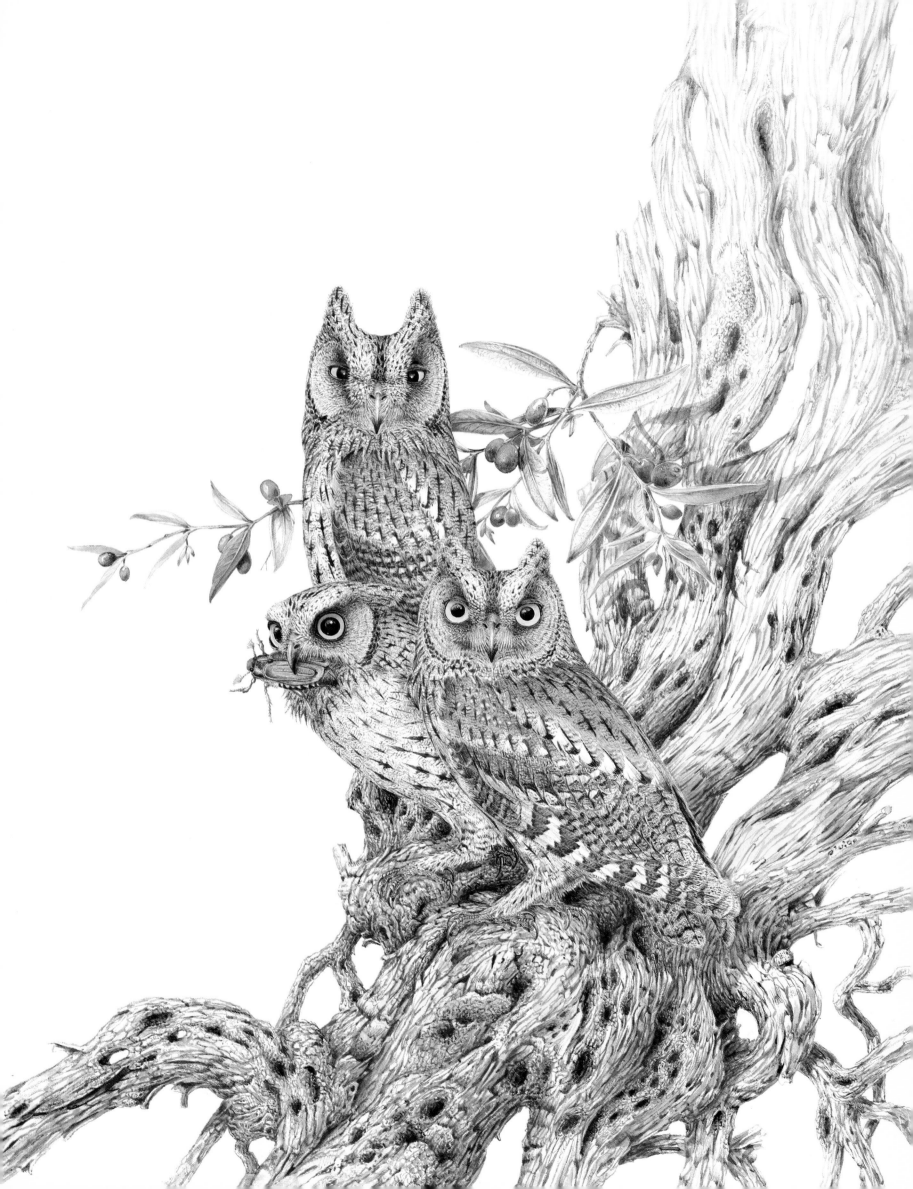

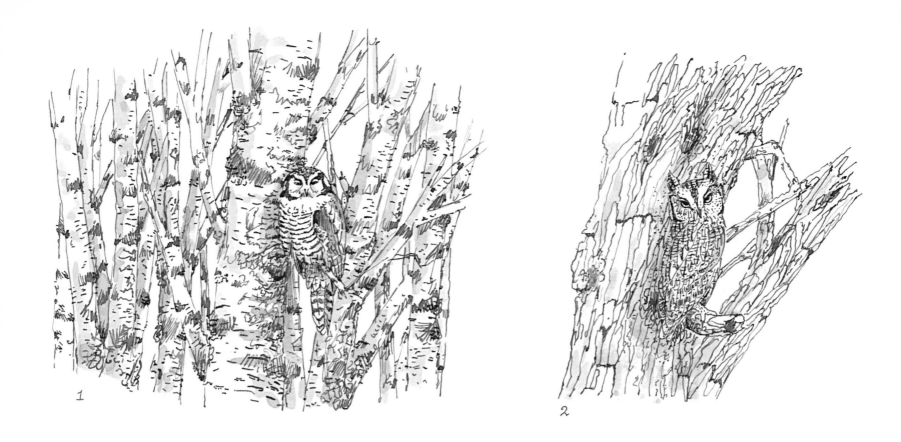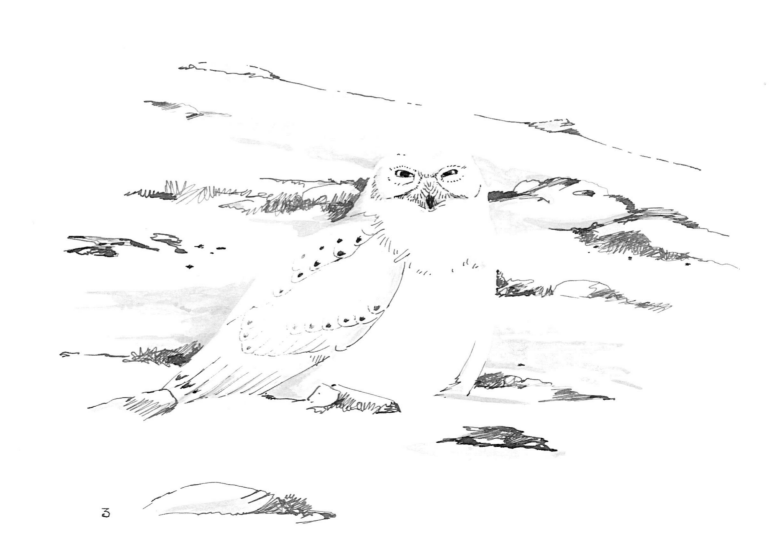

Circadian rhythm The European Scops Owl is nocturnal. Its activity starts after sunset and is bimodal, with a peak before midnight and a resting period at 0.00–2.00h (L. Koenig, 1973). Being a bird of lower latitudes, it does not have to cope with the inconveniences of short northern summer nights.

Antagonistic behaviour In its cryptic posture the European Scops Owl resembles a miniature Long-eared Owl. With ear tufts raised, its body feathers sleeked and eyes reduced to vertical slits, a Scops Owl is hard to distinguish by day from the rough texture of the bark of the tree in which it is hiding. It threatens any persistent intruder by raising its feathers, arching its half-opened wings, swaying to and fro, flicking its upper eyelids over viciously staring eyes and snapping its bill (Scherzinger, 1971; L. Koenig, 1973). Unless it ends up in unaccustomed places while migrating, the Scops Owl seems to be less frequently found and mobbed by small birds than most other owls in Europe.

ECOLOGICAL HIERARCHY

With a body weight (96g in males, 112g in females; Mikkola, 1983) of only about 60% of the Little Owl's, 30% of the Barn Owl's and 20% of the Tawny Owl's, together with a harmless insect diet, the European Scops Owl plays an insignificant role in the hierarchy of predation. Whenever possible, Tawny Owls occupy Scops Owls' nesting holes and prey heavily on these smaller owls. Other owls preying on the Scops Owl in Europe are the Eagle Owl (Mikkola, 1983) and probably the Barn Owl. Its nocturnal life style saves the Scops Owl on the whole from predation by diurnal birds of prey and the only record of such predation refers to two Scops Owls found in an Eleonora Falcon's nest in Crete (Uttendörfer, 1952:118). The owls had probably been captured at dusk on their autumn migration over the Aegean Sea.

Being more arboreal and more completely nocturnal than Little Owls, Scops Owls do not seem to have to compete seriously with Little Owls for food, though they may dispute nesting holes with them. In the Mediterranean countries 94% of prey numbers recorded for the Scops Owl consisted of arthropods, mainly insects, against an almost equal number (96%) in the Little Owl (Mikkola, 1983:table 60), but the balance, still rather high in biomass (total prey weight), may be different in the two species.

The dimorphism index of male and female Scops Owls (+5.13) is somewhat below the average of owls in Europe (+6.50) (Mikkola, 1983:table 54). It exceeds that of the Little Owl (+0.61) and ranks with that of the Long-eared Owl (+4.24) and the Barn Owl (+4.95). This could indicate a minimal amount of interspecific difference in prey size; at the same time it accords with the fact that the smaller male feeds the female and the small young in the nest.

BREEDING HABITAT AND BREEDING

The European Scops Owl occurs in open wooded country and cultivated areas. It finds nesting sites in any natural hollow in trees, rock crevices, stone walls and ruins, usually under cover of trees; also in cavities under tiles or thatched roofs and, to some considerable extent, in old woodpecker holes; sometimes also in the safety of domed Magpie nests, much less frequently in the nests of crows or large birds of prey in treetops. Recently also in nest boxes (Hungary, Switzerland, France). Depending on habitat and place, the nest is in a date palm, a gnarled cork oak, apple tree, ash, poplar, willow, birch or pine, or in the disused hole of a Green, Grey-headed, Great Spotted, Syrian, White-backed or Black Woodpecker. Some nests are at less than a man's height, others much higher up.

Though the European Scops Owl is strictly territorial, when habitat and food conditions are favourable nests can be fairly close together. In warm valleys and on sunny slopes in South Tirol, Italy, as many as five pairs have been found nesting on 1ha of land and nests have been reported as close as 50m apart (H. Psenner, cited by Glutz & Bauer, 9, 1980). Densities of five nests per 0.6ha have been recorded elsewhere in southern Europe.

Egg-laying starts late in the season, after the birds arrive from tropical wintering grounds, usually May–June, which is much later than in the Little Owl. As in other hole-nesting species, the male Scops Owl tries to entice a female to enter a potential nesting site by singing from the entrance or the inside of a hole. During egg-laying, incubation and care of the young, the male supplies the female with food. Clutch size is usually 4–5, but may be as low as 3 or as large as 6 or 7. The variation is less conspicuous and less dependent on variations of food supply than in the small boreal owls which have to rely on rodent population cycles. As an insectivorous species, the European Scops Owl lays relatively small eggs, 31.3×27.0mm on average, as against 34.5×29.3mm in the Little Owl and 29.0×23.1mm in the Pygmy Owl (Makatsch, 1976), with a fresh weight of 11.9g, which is 77% of the egg weight of the Little Owl, but 142% of that of the Pygmy Owl (data by Makatsch, 1976). As many of the nesting holes are semi-open, the chicks are not able to profit completely from the safety of the nest site and leave the nest when not fully fledged (after 21–29 days), which is earlier than in the more advanced, hole-nesting Pygmy and Tengmalm's Owls. However, as in these species, young hatch at intervals of not more than two days. The juvenile plumage is basically the same as the adult plumage.

FOOD AND FEEDING HABITS

The European Scops Owl has a mainly insect diet, catching great green bush crickets, cicadas, cockchafers and other beetles from at least eight families. It catches numerous other insects and arthropods in the tree canopy and in bushes, including large moths and sphingids (e.g. oleander hawk moth) in flight, and cockroaches, grasshoppers, praying mantids, earwigs, caterpillars and mole crickets, scorpions, spiders, harvestmen, myriapods, diplopods, isopods and earthworms on the ground. In Spain 94% of prey numbers in summer were invertebrates (Herrera & Hiraldo, 1976). The principal vertebrate prey were tree frogs; lizards and an unknown proportion of small terrestrial mammals (mice, voles) and birds (adults and young of sparrows, buntings, Chaffinches, Linnets, Goldfinches, titmice, warblers) were less frequently reported. The proportion of flying insects seems to be larger, that of rodents considerably smaller, than in the Little Owl.

Camouflage. (1) Northern Hawk Owl *Surnia ulula*. (2) European Scops Owl *Otus scops*. (3) Snowy Owl *Nyctea scandiaca*.

The European Scops Owl's food in its tropical winter quarters is virtually unknown, but the indigenous Afrotropical *Otus senegalensis* is known to have fed nestlings on crickets, cockroaches, praying mantids and a scorpion (Weaving, 1970).

MOVEMENTS AND POPULATION DYNAMICS
The European Scops Owl is a summer visitor in its European and Asiatic breeding ranges. It arrives late in the season, passing through the bird-ringing stations in the Camargue, southern France, in late March and April, but arriving in western Siberia not before the second half of May (Dementiev & Gladkov, 1, 1951). It winters in tropical Africa where, thanks to its silent nocturnal life, it almost vanishes from the ornithological picture. It may spend the winter in a Saharan oasis, or remain in the arid woodlands at the southern desert fringes, but it is usually found much further south. It seems to be less rare in sub-Saharan west Africa than was for a long time thought (Wells, 1966), but most winter records come from wooded savannahs and riverside forests in Ethiopia, Uganda and Kenya, south to southern Tanzania at about 11° south (Britton, 1980) and northern Zaire at 1° south (Schouteden, 1961:78). Some European Scops Owls winter in Arabia and south Asia (Pakistan, northwestern India south to Bombay) and occasionally wintering Scops Owls have been found in the countries surrounding the Mediterranean, and, exceptionally, in winter as far north as Copenhagen (3 Jan. 1917) and the Orkney Islands (27 Nov. 1970). Migration flights to and from central Asia cover distances of between 7,000 and 8,000km each (Mikkola, 1983). Like other long-distance migrants, some European Scops Owls do not remain on their breeding grounds, but undertake prolonged migrations when warm air masses in spring penetrate far into Europe. Scops Owls have thus been found, mainly in late spring and summer, as far beyond the breeding range as in Denmark, Sweden (north to 65° 43' north), Norway, Britain, including the Orkney Islands, Ireland, the Faroes, Iceland, Madeira, Porto Santo and probably the easternmost Canary Islands (Glutz & Bauer, 9, 1980; Cramp, 4, 1985).

No short-term population fluctuations have been reported, which accords with the owl's insect (rather than rodent) diet. In this century the breeding range of the Scops Owl in central and eastern Europe has contracted considerably, though this can hardly be considered a process of short-term fluctuation.

GEOGRAPHIC LIMITS
To the north the breeding range of this owl seems to be limited by the presence of a sufficiently large supply of large insects, hence by summer temperatures. In the continental climates of eastern Europe and central Asia the northern limit reaches locally 56° north. In cool Atlantic weather conditions the Scops Owl does not penetrate further north in France than 46° north (formerly 49° north). Warm air pockets, such as in the Main river basin in southwest Germany, southwestern Slovakia and the Pannonic basin (Stollmann, 1958), provide regular or occasional breeding opportunities for the Scops Owl, comparable with similar infiltrations of Bee-eaters and Syrian Woodpeckers. Closed boreal forests in the north and deserts in the south form the boundaries of this scops owl's breeding range in Asia.

LIFE IN MAN'S WORLD
In Europe the Scops Owl is a bird of cultivated country. It can therefore be assumed to have profited from man's cutting of closed forests throughout the whole of Europe. Its occurrence in city parks, such as in Sevilla, often close to busy traffic, has been reported on many occasions (Sevilla, Córdoba, Cáceres, Granada, Skopje, Budapest, Vienna and Leningrad, 1915, Pavlov Park). The birds perch on lamp posts in order to catch insects attracted by the light. The European Scops Owl has nested under the eaves of roofs and has readily accepted nest boxes in Switzerland (Arlettaz, 1987), Hungary (Barthos, 1957; Randik, 1959), Russia (Kadochnikov, 1963) and Siberia. In these ways the European Scops Owl has profited from the presence of man, and its future would seem bright, were it not for the spread of biocides, seriously reducing or destroying the populations of large insects on which it feeds. Environmental pollution is probably one of the principal reasons for the sharp decline of the European Scops Owl in parts of the Middle East (including Israel) and the warm lowlands of southeastern Austria, but climatic changes are probably mainly responsible for its decline in the major part of France. The decrease of the Scops Owl in Switzerland has been attributed to unfavourable changes in the environment, particularly the unchecked extension of vineyards on lower mountain slopes in the Rhône valley and the reduction of trees with natural hollows (Arlettaz, 1987).

European Scops Owl *Otus scops*

The European Scops Owl has most likely profited from man's influence on the landscape and vegetation of Europe. Its original range was probably more exclusively mediterranean than it is today. With increasing human intervention in the forests of southern west Siberia, the Scops Owl is becoming less rare in that part of Asia than it was 50 years or more ago.

The total range of the European Scops Owl and its Asian and African relatives *Otus sunia* and *Otus senegalensis* is comparable with the combined ranges of the Shikra and the Levant Sparrow Hawk. This may mean that the most recent affinities of the European Scops Owl should be sought in sub-Saharan Africa. At present at least 2,000km of desert separate the southernmost European Scops Owls in Morocco and Algeria from the northernmost African Scops Owls in Senegal, but this gap must have been much narrower (if it existed at all) during the glacial periods when scrub and arid woodland extended over parts of the present-day Saharan deserts. The African Scops Owl's song does not differ in structure from that of the European Scops Owl, but a tendency to an intermediate song has been reported from Nigeria (van der Weyden, 1973) and has been used to support the theory of an extant conspecificity of the European and the African populations. As no fossil bones belonging to the European Scops Owl have been found in deposits in Hungary and France older than Upper and Middle Pleistocene (Mourer-Chauviré, 1975) and the majority of related species occur in southeast Asia, the European and African Scops Owls probably have the same Asian source.

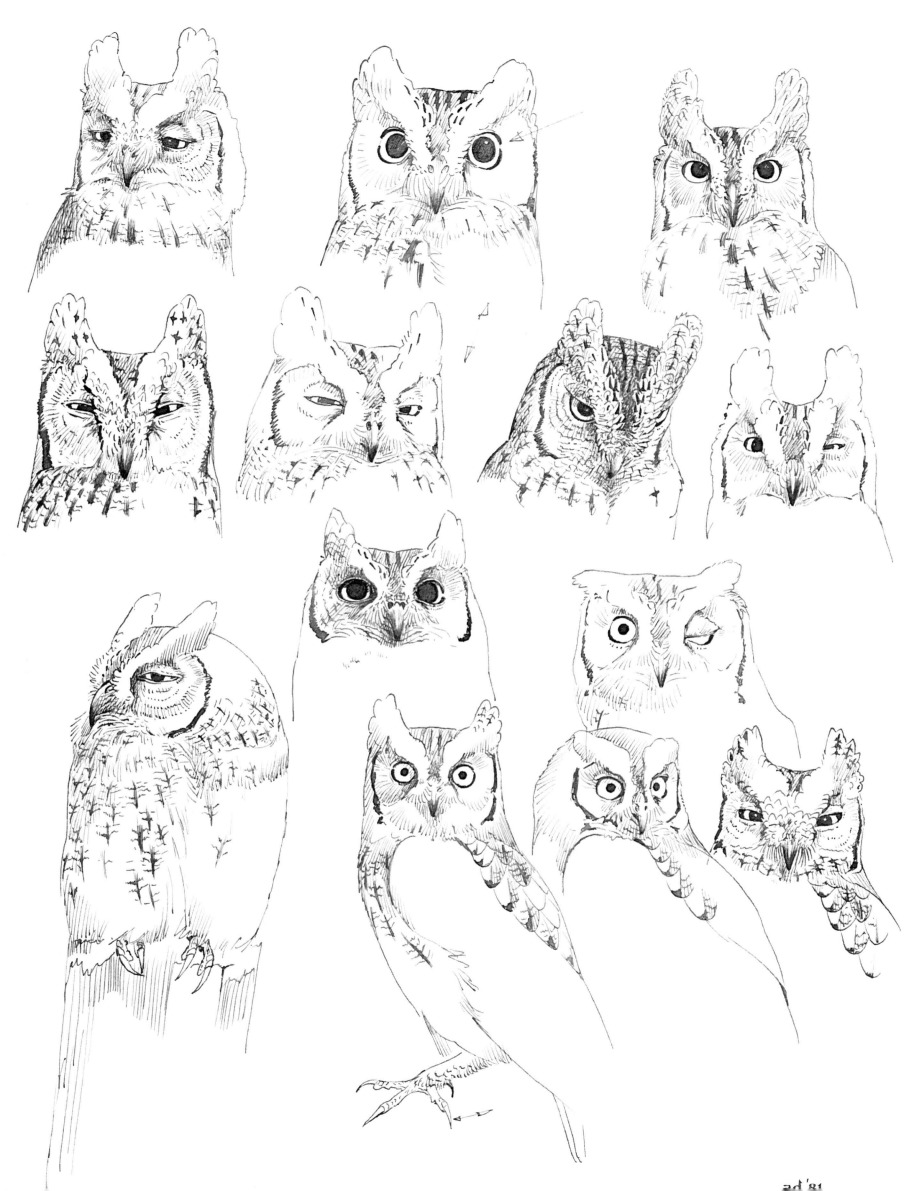

COLLARED SCOPS OWL
Otus bakkamoena

Apart from the Lesser Sunda Islands' Wallace's Scops Owl *Otus silvicola* (wing up to 221mm; White & Bruce, 1986), the Collared Scops Owl (body length 23–25cm, wing up to 194mm) is the largest representative of its genus in Asia. Its wide range in south and east Asia poses various problems, such as its ecological relations with other, smaller, *Otus* species with which it shares its habitat and range. Another problem posed by this mainly tropical species is its potential as a resident bird in climates with cold winters where it cannot depend on an abundance of insect food, but must be able to feed on larger, vertebrate prey as well. A further problem relates to the degree of speciation of numerous insular populations from Japan southwards, some of which have been treated by various authors as nominal subspecies of the Collared Owl, but as members of other species by other authors, or even as separate endemic island species. The species is a good colonizer producing 18 (Deignan, 1950) to 25 (Eck & Busse, 1973) geographical races, 13–17 of which are endemic island forms.

The theory of a close phylogenetic relationship between the Collared Scops Owl and the North American Western and Eastern Screech Owls *Otus kennicottii* and *Otus asio*, first formulated by the realistic Washington museum ornithologist Robert Ridgway in 1874 (cited by Deignan, 1950), revived in 1941 by the inventive Jean Delacour (1941), and adopted in 1966 by owl specialist Joe T. Marshall (1966), who combined all of these owls into one species with a total of 51 geographical races or subspecies, is in keeping with the Collared Scops Owl's colonizing abilities. In spite of surprising resemblances between these owls in terms of structure, appearance, size and life style, conspecificity is, at first sight, contradicted by differences in vocalizations. The following account deals with these aspects, together with the east Palaearctic range.

GENERAL

Faunal type Indo-Malayan.

Distribution Indo-Malayan and marginally east Palaearctic. Asia south of the Himalayas, from Baluchistan and Sind in Pakistan and possibly southern Iran (Bushire?) and even further west to Muscat in south Arabia, east to Indonesia as far as Wallace's zoogeographical dividing line and including Java, Bali and the Philippines, further Indo-China, China, Hainan, Taiwan and virtually all of the Japanese islands from the southern Kuriles (Kunashiri, Shikotan) southward; probably the whole of Korea, Manchuria and part of the Soviet Far East along the Ussuri River and its tributaries, and south Sakhalin (Tuzenko, 1955). Map 5.

Climatic zones Tropical rain forest, tropical winter-dry, savannah, temperate and marginally boreal climatic zones. The northern boundary is around the July 20°C isotherm.

Habitat Evergreen and deciduous tropical and subtropical, humid as well as arid forests and wooded places in cultivated areas, villages and towns; *sal* (dipterocarp), oak, pine and deodar forests in the foothills of the Himalayas up to 2,400m (Ali & Ripley, 3, 1969). In China, subtropical and temperate, mixed deciduous forests. In Primorye, Soviet Far East, primeval broad-leaved forests with elms and ashes, open, grass-covered spaces (Nechaev, 1971; Knystautas & Sibnev, 1987) on hill slopes and in river valleys, and at the edges of coniferous taiga mixed with birch and poplar.

GEOGRAPHY

Geographical variation Considerable and varied (Deignan, 1950; Marshall, 1978); some of the most differentiated island populations are often treated as specifically distinct. The number of subspecies recognized ranges from 18 (Peters, 4, 1940) to 25 or more. Geographic differences relate to body size, intensity of buff, brown and grey tinges of the plumage, extension and intensity of dark markings on the feathers of the upperparts and distinctness of dark blotches, streaks, lines, bars and fine pencilling on the underparts, extension of feathering on tarsus and toes and frequency of ferruginous and grey colour morphs. There is also a geographical variation in the colour of the eyes and a marked variation in territorial song (see Songs and calls). Apart from insular populations all geographical differences are clinal. The largest birds (by 30%) occur in Japan (wing up to 194mm) and the Soviet Far East (weight up to 200g; Pukinsky, 1977; as against 121g in central India; Ali & Ripley, 3, 1969). Other data suggest a minimum body weight of 100g in the south and up to 160g in the north (Marshall, 1978:21). The smallest

Collared Scops Owl *Otus bakkamoena*
Japanese race *O. b. semitorques* in maidenhair tree *Gingkgo biloba*

birds probably live on Java or other, smaller islands in Indonesia (wing 136–150mm) and in south India and Sri Lanka. The races from Sumatra and Java are darkest; those living in arid northwest India west to Baluchistan are palest. The most rufous ones occur in the Soviet Far East, on the Ryu Kyu Islands and in south China. Most populations have unfeathered toes, with the exception of those from the Himalayas, northern Japan and the Soviet Far East, though in some of these the feathering is restricted to small "top band" patches on the upperside of the basal phalanges. In south India, Taiwan, some of the Philippines, Java and Sumatra the eyes are dark brown or hazel. Elsewhere unspecified proportions of yellowish, golden-yellow, reddish and brown eye colour occur. Collared Scops Owls from the western Himalayas (*O. b. plumipes*) can hardly be distinguished from those from the Soviet Far East (*O. b. ussuriensis*) in any of their characteristics. Individuals from northern Japan are known as *O. b. semitorques*, from China as *O. b. erythrocampe*, from Indo-China, Thailand and Burma as *O. b. lettia*, from central India as *O. b. marathae*, from southern India and Sri Lanka as *O. b. bakkamoena* and from Java as *O. b. lempiji*.

Related species Numerous island forms of scops owl in southeast Asia may have originated from continental Collared Scops Owl populations and may or may not have reached specific status. Those most often discussed and included in this species are: (1) *Otus mentawi* (Mentawai Islands, west Sumatra), (2) *Otus enganensis* (Enggano, west Sumatra), (3) *Otus mantananensis* (some Philippine Islands and Mantanani Island, Sabah, north Borneo), (4) *Otus nigrorum* (Negros Island, Philippines; Rand, 1950), (5) *Otus elegans* (Ryu Kyu Islands; Marshall, 1978). Intriguing and instructive though these cases may be, they are not of great scientific interest for our present purposes. The question of the relationship between the Collared Scops Owl and the North American Screech Owls *Otus kennicottii* and *Otus asio* opens up a wider field of enquiry. It is virtually inconceivable that *Otus* owls, so closely resembling each other as those living in similar humid, temperate, forested habitats on opposite sides of the Pacific, should not be closely related (Deignan, 1945; Marshall, 196, 1978).

STRUCTURE

The Collared Scops Owl shows all the structural characteristics of its genus. Its tarsal feathering may be reduced to two thirds the tarsus' length or extend to basal or subterminal phalanges of the toes. The wing tip is rounded, as in all basically non-migratory and forest-inhabiting species of its genus. The eye colour is highly variable. The bird's appearance has been described as "A white bridle, minutely speckled with black, extends along the inner webs of the long eartufts, down over the forehead and around the bill to give the Collared Scops-owl a distinctive, frost-rimmed face" (Marshall, 1978).

BEHAVIOURAL CHARACTERISTICS

Songs and calls The territorial song is a monotonous and seemingly endless series of single hoots, sounding like a rising and interrogative, mellow *what?* or *woot?* in India and Sri Lanka, and an almost two-syllabic *poo-oop* or *kee-oop* in Malaya, but lower pitched and inflected downward in China and Japan, where it is transcribed as *coo-cooroo*; in the Soviet Far East it is transcribed as *koog-koog* or *kgook-kgook* (Pukinsky, 1977; Marshall, 1978; Knystautas & Sibnev, 1987). It is higher pitched (730–1,180Hz) than in the Western Screech Owl (516–635Hz), which has in addition an average of six (2–9) syllables per motive instead of one or two as in the Collared Scops Owl. Intervals between the separate hoots are rather long, viz. 10–17, average 13 seconds, as against an average of 6.3 s in the Western Screech Owl (van der Weyden, 1975). The female's call is higher, a more quavering and whining *wheoo*. Both sexes frequently indulge in long monologues; duetting has not been recorded regularly. Gruff, aggressive notes, bubbling and chattering and friendly twittering greeting calls have been described and the vocabulary seems to be as extensive as in other, better-known, members of the genus. The difference between the interrogative and irregular series of mellow, frog-like notes of Pakistani and Indian Collared Scops Owls and the longer, softer and less staccato calls uttered by Collared Scops Owls in the eastern Himalayas and eastern Asia has recently been adduced as evidence for the recognition of a western Indian Scops Owl *Otus bakkamoena* and an eastern Collared Scops Owl *Otus lempiji* (Roberts & King, 1986). However, this fails to take into account the phenomenon of geographical variation in vocalizations found in other owls and birds in general.

Circadian rhythm Strictly nocturnal everywhere. During the relatively short summer nights in Palaearctic east Asia nocturnal activity extends after sunrise and thereby surpasses the Oriental Scops Owl's activity in the same area. This possibly relates to the Collared Scops Owl's more vertebrate prey, which move around more widely after dawn than at night. In south Ussuria the owl has also been found hunting at midday (Panov, 1973).

Antagonistic behaviour The Collared Scops Owl can look impressively threatening, showing off like a miniature Eagle Owl with half-spread wings and raised feathers. Caught between threat and flight it lowers its head and moves it slowly and deliberately from side to side, thereby resembling a Barn Owl in its ambivalent swaying movements. It is not known whether other members of the genus indulge in the same behaviour.

ECOLOGICAL HIERARCHY

The Collared Scops Owl (body length 23–25cm, weight 120–200g) shares its habitat with numerous other owls, but there are no reports of confrontations with these or other avian predators. It is larger by 20–30% than the widely sympatric Oriental Scops Owl, which is more insectivorous, particularly in non-tropical situations. The Brown Hawk Owl, also occurring in large parts of the Collared Scops Owl's range, is 10–25% larger and differs by hunting insects in flight. Size differences between males and females and resulting differences in average prey size are to be expected in the northern populations which prey more frequently on terrestrial rodents and sometimes remarkably large forest birds, but exact data are lacking. Such differences may be

Collared Scops Owl *Otus bakkamoena*
Japanese race *O. b. semitorques*; upperside of outer toe unfeathered (1), all other toes feathered (2)

more restricted, in the tropical, mainly insectivorous populations, though even here females are as much as 5–10% larger than males (Ali & Ripley, 3, 1969:270). In the Soviet Far East the smaller males are thought to remain in the woodlands in winter, hunting for small forest birds, while the females either remain too or go hunting rats, mice and sparrows around human habitation, in farmyards, sheds and attics (Pukinsky, 1977).

BREEDING HABITAT AND BREEDING
Though it seems that most nests have been found in holes dug by woodpeckers, barbets or parakeets in forest trees of various kinds and sizes, a not insubstantial number have been reported from under the eaves and roofs of houses, in walls, among epiphytic nidulous ferns, in the crotch of palm fronds, in the base of the massive nests of vultures and eagles, in old Magpie nests (frequently in Hong Kong) and frequently in nest boxes with entrance holes as large as 15cm in diameter specifically erected for this purpose, or for Mandarin Ducks (Panov, 1973; Pukinsky, 1977). In tropical Asia sacred fig trees, *asvattha* or peepal (India) and banyan (mainly Indonesia), and impressive mango trees appear to provide favourable sites. In China and the Soviet Far East nesting holes earlier used by colony-nesting Grey Starlings are frequently accepted or taken by force.

Since the Collared Scops Owl is a mainly sedentary and vertebrate-hunting species its breeding season in northern, temperate climates starts a month earlier than that of the migratory and insectivorous Oriental Scops Owl, viz. late March–early April. Near Vladivostok fledged young have been reported as early as 26 May (Pukinsky, 1977). The male provides the breeding female and her young with food; in the Soviet Far East females leave their holes at the invitation of the food-carrying male and the transfer of food (often a decapitated mouse) takes place outside the nesting hole (Knystautas & Sibnev, 1987). Very large clutches of 4–9 (average 6.4) eggs have been reported from the Soviet Far East (Polivanov et al., 1971), suggesting serious winter losses. Eggs are larger in the north (37–39 × 30–31mm; Pukinsky, 1977) than in the south by approx. 35%. In the Soviet Far East they are approx. 60% larger than the eggs of the Oriental Scops Owl from the same region. Nestlings are covered with a conspicuously dense and long white down (Nechaev, 1971; Pukinsky, 1977).

FOOD AND FEEDING HABITS
Though the Collared Scops Owl's diet comprises large insects, mainly beetles, grasshoppers, cockroaches and moths, it also includes often surprisingly large terrestrial rodents and small birds (e.g. munias) in the northern part of its range and in Borneo and Sri Lanka. On illuminated verandahs in the Asian tropics Collared Scops Owls have frequently been observed catching bats and large insects in flight and snatching geckos from the walls. In the Soviet Far East the majority of 27 preys recorded as food for the young in mature riverine forests consisted of voles and mice in addition to some frogs, spiders and large insects. Later in summer the diet also included small passerine birds (Polivanov et al., 1971), whereas in winter Tree Sparrows, mice and rats were recorded (Panov, 1973; Pukinsky, 1977).

MOVEMENTS AND POPULATION DYNAMICS
An unknown but probably large proportion of the northern populations is resident, as are all subtropical and tropical Collared Scops Owls. Migrant or winter stragglers identified by feather characteristics as continental *Otus bakkamoena ussuriensis* have been recorded from the Japanese island of Honshu and more regularly from southern Korea. Northern owls on the continent and in Japan spend the winter on mountain slopes with reduced snow cover, or descend into lowland valleys and enter villages and towns, or remain in attics and barns where they hunt inside for mice and rats and outside for Tree Sparrows (Panov, 1973; Yamamoto, 1967).

GEOGRAPHIC LIMITS
While several other species of scops and pygmy owls occur in altitudinal zones above the mainly lowland range of the Collared Scops Owl in the tropics, e.g. the Mountain and Rajah's Scops Owl and the Collared Pygmy Owl, there is no data on any ecological exclusion. Outside the Sunda Region other scops owls, in Wallacea, and hawk owls of the genus *Ninox*, further east in the Papuan–Australian regions, may have restricted the range expansion of the Collared Scops Owl on low off-shore islands. In the north the occurrence of the exclusively nocturnal Tengmalm's Owl of similar size and the Brown Hawk Owl (125% of the Collared Scops Owl's weight) may have prevented the Collared Scops Owl from entering and spreading in boreal woods.

LIFE IN MAN'S WORLD
Collared Scops Owls are deeply revered or feared on Java and Borneo as birds of ill omen and death. In China and even more so in Korea their dried bodies serve as medicine for various illnesses and, particularly in Korea, large numbers are killed yearly for this purpose (Austin, 1948; Gore & Won, 1971). The owl is not otherwise molested. It has adapted to life in areas of human cultivation and has nested in villages and towns, even as far north as a park in suburban Vladivostok (Panov, 1973). In the Soviet Far East the breeding density has been increased by placing nest boxes in riverine woods. In one season seven out of ten boxes were occupied by these owls and the broods were all raised successfully (Pukinsky, 1977).

The relationship of this large, mainly dark-eyed, scops owl to the Western and Eastern North American Screech Owls *Otus kennicottii* and *Otus asio* remains a mystery, though a close affinity is likely. Its ecological and behavioural relations with those owls, either of its own genus or of other genera, which share its habitats offers a more rewarding area of study than do the processes of speciation of the numerous island populations.

Flammulated Owl
Otus flammeolus

With an average body weight of 54.7g in males and 57.2g in females (Earhart & Johnson, 1970), the Flammulated Owl from the semi-arid mountains of western North America is only 35–40% heavier than the tiny Elf Owl *Micrathene whitneyi*. It is the smallest (body length 15–17cm) of its genus (more than 30 species) and 30–35% of the body mass of the widespread Western Screech Owl *Otus kennicottii* (Earhart & Johnson, 1970). Thanks to its small size and secretive life style, the owl has long eluded ornithological study. Because of its colour pattern, voice and migratory behaviour, it has been suggested (Delacour, 1941) that the Flammulated Owl is a North American representative of the Old World Scops Owl *Otus scops* with its Asiatic, European and African forms. By thus being designated as a subspecies of *Otus scops* or, for that matter, as a scops owl rather than a screech owl (van der Weyden, 1975; Hekstra, 1982), the Flammulated Owl automatically became an Old World element in the fauna of North America. But the question remains as to how, where and when Old and New World scops owls ever had recent enough distributional contact for them to continue to be members of the same species. Only recent studies of the owl's songs and calls have provided an insight into the possible relations between this and other American and non-American species of *Otus*. These will be discussed in the following account.

The Flammulated Owl's remarkably deep voice suggests a much larger and more formidable species. The structure of its song is different from that of any of the nine species of North and Middle American screech owls. More than the Elf Owl, the Flammulated Owl lives its nocturnal life in close proximity to nocturnal predators of the owl genera *Otus*, *Strix* and *Bubo*. One is tempted to suppose that, in order to survive, the Flammulated Owl simulates greater size and strength by its bravado and ventriloquial voice, at the same time behaving elusively and inconspicuously both by night and by day. Its plumage has an, even for an owl, quite astonishing capacity for camouflage. The minute feather design of vermiculations and dark wavy lines on creamy-white, buff and rufous ground colours is not unlike, though not identical to, those of some Old World scops owls and probably originated independently of them. In accordance with its size and fragile structure, the Flammulated Owl lives almost exclusively on insects and other arthropods. Its northern populations nesting in temperate climates must therefore retreat in winter to warmer countries where food is available all the year round. Thus, the Flammulated Owl is a long-distance migrant with a strong flight and a relatively pointed wing, though opinions differ regarding the migratory habits of its various populations. Similarly, authors are far from unanimous on the subject of geographical variation in the Flammulated Owl: as few as no geographical races and as many as six have been recognized.

GENERAL

Faunal type Arid Rocky Mountain or neoxeromontane.

Distribution The arid mountain pine forest zones of the western North American mountain ranges, from Kamloops in southern British Columbia, the Kootenai and Blaine Counties in northern Idaho and the Rocky Mountain National Park in northern Colorado, south through the Rocky Mountains, Cascade Range and Sierra Nevada to southern Baja California, Nevada, Arizona, New Mexico and extreme western Texas (Guadelupe and Chisos Mountains), south through the western Sierra Madre ranges and the Sierra del Carmen, Coahuila, northeastern Mexico, to the southern mountainous edges of the Mexican Plateau. Absent on the humid, coastal mountain slopes of the west, but in recent years it has turned up in many more places than formerly expected. The southernmost known breeding localities are in the State of Mexico (Chimalpa) and Veracruz (Las Vigas; Phillips, 1942). Map 4.

Climatic zones Tropical winter-dry, mediterranean, temperate and marginally boreal climatic and mountain zones, with temperatures averaging 26–33°C in summer and with 600–2,000mm rainfall a year (Winter, 1974).

Habitat Open, arid mountain pine forest, particularly of ponderosa and yellow pine, intermixed with oak (in the south) and aspen (in the north) and always with an understorey of *Ceanothus*, mahogany or other bush, from upper subtropical to temperate zones. Other trees characterizing the habitat are piñon, bristle-cone, lodgepole and sugar pines, incense cedar, white fir and, above all, Douglas fir. Also second growth and logged, open ponderosa pine forests (Johnson & Russell, 1962).

The range covers altitudes of 800–2,700m in southern California, up to 2,300–2,400m in southwest Nevada (Johnson, 1973), 1,500–2,400m in Arizona, up to 3,000m in pine-yucca forest in Nuevo Leon, Mexico (Hubbard & Crossin, 1974), up to 2,700m in the Rocky Mountains and 375–1,250m in the warm southern Rocky Mountain Trench and Okanagan Valley (J.

Burbridge, Steve R. Cannings, Richard J. Cannings) and at the junction of the Thompson River valleys at Kamloops, British Columbia (Howie & Ritcey, 1987:249-54). The Flammulated Owl does not occur optimally in pine-oak forest at lower elevations, nor in the higher spruce and red fir forest above it, but it is often present in the transitional stages of mountain forest zones and in canyon bottoms, including the Grand Canyon, Arizona. In the Madera Canyon in the Santa Rita Mountains, Arizona, it was remarkably abundant in stands of large oak; in the Santa Catalina Mountains it was common where fir and spruce were mixed with aspen (Phillips et al., 1964). Locally it is the most numerous owl in the Sierra Nevada at 2,100-2,400m, with two territorial males per 0.4km^2 (Marshall, 1939; Winter, 1974).

GEOGRAPHY

Geographical variation While the northernmost populations tend to be larger by about 8% in wing length and 7% in body weight than populations from the southern United States and Mexico, they are also paler in general coloration and whiter underneath. There is no agreement, however, on the number of subspecies recognized. The picture is complicated by the presence of individual variations involving more rufous than brown and grey colours and finer rather than coarser feather patterns. No real rufous colour morph is known for the Flammulated Owl, nor a pure grey and white form such as occurs in the Western Screech Owl *Otus kennicottii* and the Whiskered Owl *Otus trichopsis*. In the Pacific Coast Range brown and rufous colours predominate; further inland these colours are darker and duller brown, whereas in the Great Basin and Rocky Mountains the birds are blackish and heavily marked. Rufous extremes occur on the Mexican Plateau (Marshall, 1967). Thus, while some geographical variation in relation to climate, vegetation and distance of migration may be mixed up with individual variation, to claim the existence of six races (Hekstra, 1982) is undoubtedly going too far, whereas to recognize none at all (Ridgway, 1914; Phillips et al., 1964; Marshall, 1967) is equally unrealistic. If it is true that the northernmost populations have wing lengths of 133-149mm and the southern ones wing lengths of 127-137mm (Hekstra, 1982), then at least a northern, long-winged migrant (*O. f. idahoensis*) may be distinguished, with some difficulty, from a shorter-winged resident in Mexico. Unfortunately, the name *flammeolus* given by Dr Johann Jakob Kaup in 1853 seems to refer to an intermediate, rather long-winged migrant from around the Mexican border of the southwestern United States (A. R. Phillips, see Marshall, 1978:9) and thus precludes the objective use of subspecific names. Possible colour clines present in this species are chaotic or mosaic.

Related species All authors who have studied the Flammulated Owl (Phillips et al., 1964; Hubbard, 1965; Marshall, 1967, 1978) have stressed the ecological and ethological differences between this species and its sympatric congeners. An alleged relationship with the Old World Scops Owls *Otus sunia* and *O. scops* (Delacour, 1941, and others) is now generally discarded, on the basis also of voice: "It is inconceivable that a female of *scops* would recognize the singing male *flammeolus* as a potential mate and *vice versa*. They cannot be in the same species" (Marshall, 1966:240).

STRUCTURE

The Flammulated Owl is the smallest and most delicately built species of its genus, its bones resembling those of the Elf Owl in size and fragility (Loye Miller, 1933). The breastbone is relatively broad and flat; its carina is less developed than one might expect of a migratory species (Johnson, 1963). The bill is fine, the feet are small and the toes thin (Marshall, 1967:fig. 1). The tarsus is densely feathered down to the base of the toes, which are naked. The wing is long, relatively pointed, and the tail is short. The facial disc is moderately developed; its upper rim is more conspicuous than in the Oriental Scops Owl. Ear tufts are broad, short, no longer than the adjacent feathers and erected only when the bird is agitated or hiding by day. The eyes are dark brown, giving the bird an exceptionally friendly appearance. There is no red colour morph with reduced dark feather pattern, but the amount of rufous colouring in the face and on the upperparts, particularly on the scapulars, is variable and can be conspicuous. The alleged resemblance to the Old World *Otus scops* complex is superficial, birds of the latter group having yellow eyes and long ear tufts.

BEHAVIOURAL CHARACTERISTICS

Songs and calls The territorial song is a series of low hoots, sometimes preceded by one or two quavering grace-notes somewhat lower in pitch (Marshall, 1939, 1967, 1978). It is slow and monotonous, sounding like *hoop* or *hoo-oop*, uttered at regular intervals of 3-4 seconds. It reaches 450-500Hz (van der Weyden, 1975). The hoots have a rare, ventriloquial effect and sound as if they have been produced by a formidable bird some way away whereas in reality the calling bird is at less than half the distance that one imagines. The song is unlike the bouncing-ball calls of the other "screech" owls; instead, it consists of widely spaced notes similar to those of the Old World "scops" owls (van der Weyden, 1975). It does not, however, resemble the song of the Oriental and European Scops Owls. When disturbed on its own territory, the Flammulated Owl utters gruff, throaty hoots, also short clucks and barks (Phillips et al., 1964). The female does not appear to duet with the male; she has a much higher, quavering note with a whining quality (Marshall, 1967). Other calls, including frog-like notes, have also been described (Jacot, 1931; Marshall, 1939).

Alden H. Miller (1947), the former University of California (Berkeley) professor in zoology, described the anatomical and physical base of the Flammulated Owl's exceptionally low voice. In general, the larger the owl, the wider the air passage through the syrinx and the longer the vibratile membrane, resulting in a slower vibration and a consequently lower pitch. Not so in the Flammulated Owl! Its song is 5-6 half-tones lower than the trills of the much larger Western Screech Owl, which is fully twice the Flammulated's body weight. The inner diameters of the lower part of the windpipe or trachea and of the bronchi are 3.7mm and 2.1mm, as against 2.2-2.3mm and 3.8-3.9mm in the Western Screech Owl. Comparative data for the 15% larger (body weight) North American Pygmy Owl are a tracheal width of 2.5-3.0mm and a bronchial width of 1.8-1.9mm. The

Flammulated Owl *Otus flammeolus* with gipsy moth *Lymantria dispar* (female) as prey

Flammulated Owl's syrinx is enlarged, with an inner vibratile membrane of 4.5mm in width (4.7–5.0mm in the Western Screech Owl). The external and internal tympaniform membranes were thicker in proportion to their length and tension than in any other owl species studied by Alden Miller; their surface was rugose and partially papillose, which reduces the rate of vibration and gives the voice a somewhat hoarse quality. The function of other rigid structures of the cartilaginous half-rings of the syrinx remains unexplained. All data underline the unique position of the Flammulated Owl among its northern hemisphere relatives.

Circadian rhythm The Flammulated Owl is a strictly nocturnal bird, probably mostly active shortly, though not less than 20 minutes, after sunset and hunting at dusk like most of the nightjars, with another, smaller peak at dawn and a period of lesser activity in the middle of the night (Marshall, 1939, 1957). This activity pattern corresponds to that of the nocturnal insects on which the owl preys and which also become less active in the cold hours of early morning.

Antagonistic behaviour Practically nothing known. The Flammulated Owl is well camouflaged and blends in well with tree trunks. It is rarely encountered by day. Its small size and the rufous scapular stripes which suggest sunbeams penetrating the tree crowns make it almost invisible. Even when delivering its territorial song, it remains effectively concealed in the tree crown in the angle between branch and trunk (Marshall, 1939, 1967). One record shows it assuming the thin elongated cryptic posture of other *Otus* owls; this was described as follows: "It elongated itself against the trunk of the [lodgepole] pine in such a way that it resembled a knob of bark rather than a bird. Furthermore, its plumage blended so perfectly with the colour of the bark that the outline of the owl was almost indistinguishable" (Marshall, 1939:78). One record, from Kansas, described a Flammulated Owl striking the head of an observer in a violent defence of its young (Wetmore, 1935:218).

ECOLOGICAL HIERARCHY

The Flammulated Owl shares its habitat with few other owls, but in the marginal areas of vegetation types and altitudinal zones it is known to meet the Western Screech Owl, Whiskered Owl, Elf Owl, Northern Pygmy Owl, Long-eared Owl, Sawwhet Owl (southern Sierra Nevada at 2,100–2,400m; Johnson, 1965; and Okanagan Valley, British Columbia; Steve R. Cannings, Richard J. Cannings), Spotted Owl and, of course, the Great Horned Owl. In comparison with the Flammulated Owl (length 15–17cm, body weight 53.9g in males, 57.2g in females), the sympatric Western Screech Owl is a giant, being about three times heavier and 20% longer. Even the tiny Northern Pygmy Owl in the Sierra del Carmen, Coahuila, Mexico, is at least 15% heavier (Miller, 1955). The Spotted Owl is more than ten times and the Great Horned Owl 25–30 times heavier than the Flammulated Owl. At 1,150m in the Huachuca and Chiricahua Mountains, Arizona, the Flammulated Owl shares its habitat with the Western Screech Owl, Whiskered Owl, Pygmy Owl and Elf Owl (Phillips *et al.*, 1964). Interspecific conflicts are reduced by the different habitat preferences of these species: the Western Screech Owl is a bird from open woods and bottomlands, the Whiskered inhabits closed pine-oak forests on warm temperate mountain slopes, the Pygmy prefers conifer forests and the Elf arid regions, whereas the Flammulated's optimal biotope is the open, mainly ponderosa pine forest with a variable shrub layer of *Ceanothus* and other plants.

Though the Flammulated Owl is undoubtedly susceptible to predation by other owls and crepuscular birds of prey (Winter, 1971), I have found only two pertinent records: a Flammulated Owl recovered from the stomach of a Great Horned Owl in Modoc County, California (Johnson & Russell, 1962), and one found in the stomach of a female Cooper's Hawk in Grand Canyon National Park, Arizona (Borell, 1937). A female breeding in a nest box near Penticton, British Columbia, was reported to have been killed by a flying squirrel (Syd Cannings).

As in other arthropod-eating species, size difference between the sexes is small (+7% in weight, −1% in wing length), smaller even than in the Whiskered Owl (Earhart & Johnson, 1970), and considered nil by Joe Marshall (1967:23), but data are contradictory and a female in Nuevo Leon, Mexico, just prior to egg-laying, weighed 87g, which is 52% more than the accepted average of 57.2g (Earhart & Johnson, 1970). Recent data from Colorado indicate a body weight of 56.7g in males during the incubation period and 78.3g in females, while total season weights are 54.7g and 65.6g, respectively, which means a difference of 20–38% in favour of females (Reynolds *et al.*, 1987:239–248).

BREEDING HABITAT AND BREEDING

Nests have been found in woodpecker holes, mainly those of the Northern (Red-shafted) Flicker in aspen, but also in other holes at various heights in oak and pine stumps, even in a yucca stem (Hubbard & Crossin, 1974). They were often rather well exposed in open, mixed pine woods. The existence of a Flicker egg alongside two Flammulated Owl's eggs in a nesting hole in Colorado indicated a possible struggle between the woodpecker and the owl and the probability that the valiant Flicker had been evicted from its hole by the tiny, but by no means timid, Flammulated Owl. On another occasion one aspen trunk harboured the nest of a Flammulated Owl and a Flicker's nesting hole six feet higher on the same trunk, complete with young (cited by Bent, 1938:292). Flammulated Owls have been reported to nest in nest boxes in various places. They are territorial, but not particularly aggressive towards each other (Marshall, 1939); two males were reported to have called in the same tree without evidence of any clash between them (Winter, 1971). Clutch size is small, not more than 3–4, indicating a relatively low mortality rate and a virtual absence of notable population fluctuations. Egg size is between that of the Elf Owl and that of the Western Screech Owl, being on average 29.1 × 25.5mm (Bent, 1938:292) in size and 10.0g in fresh weight (Hanna, 1941), which is about 30% larger and 37% heavier than that of the Elf Owl and 34% smaller and 58% lighter than that of the Western Screech Owl.

FOOD AND FEEDING HABITS

The Flammulated Owl is primarily a moth-hunting species, darting with great rapidity and dexterity from tree to tree and

Flammulated Owl *Otus flammeolus*

among and over tree crowns, catching insects with its beak "in an accelerated poor-will or flycatcher style" (Marshall, 1939:76), or gleaning them from foliage, large flowers (e.g. madrones *Arbutus arizonica*) or outer branches, sometimes also from the ground. The following is a summary from the literature (Marshall, 1939, 1957; Kenyon, 1947; Ross, 1969). Owlet moths with large wings and an average body length of 14mm formed a characteristic part of the prey in the southwestern United States and adjacent Mexico, but representatives of at least five other families of moths and butterflies have been recorded, among which were the fast-flying hawk moths. Other insects included beetles (7 families), grasshoppers, crickets and katydids (4 families), among which the large Jerusalem crickets, also weevils and numerous other free-flying nocturnal insects. Non-insect prey included millipedes, centipedes, scorpions, sun spiders, harvestmen and wolf spiders. Prey items varied in length between 6mm and 55mm; the most frequent preys were about 15mm long. Prey remains recovered from the stomachs were very fragmented, indicating that the owls tear relatively large prey into small bits. One Flammulated Owl in the Sierra Nevada, California, which had tried to swallow a long-horned grasshopper of 33mm length not including the legs, was found choked to death (Kenyon, 1947). Insect prey caught by Whiskered Owls was of about the same size (6–75mm, average 15mm) as that captured by Flammulated Owls, but Western Screech Owl prey was larger on average (15–75mm, average 35mm) (Ross, 1969). No vertebrates have been recorded as Flammulated Owl's prey; captive Flammulated Owls refused to eat dead lizards and small birds offered as food. A superabundance of food in summer does not necessitate food competition between Flammulated, Whiskered and Western Screech Owls. In winter the smallest and most timid of the three retreats to southern regions and thereby avoids possible competitive stress.

MOVEMENTS AND POPULATION DYNAMICS

For a long time the Flammulated Owl was considered an unchallenged summer resident in the United States and northern Mexico, where it was found to be absent in winter. Wintering grounds were sought in the mountain forests bordering the southern part of the Mexican Plateau and beyond, from Jalisco, Mexico, to Guatemala and El Salvador (Phillips, 1942; Winter, 1974; Marshall, 1978:9). Recently doubt has arisen as to the migratory habits of this species and it has been suggested that the Flammulated Owl, like the Poorwill, may enter into a state of torpor and hibernate on its southern breeding grounds (Johnson, 1963), but there is no evidence to support this (Banks, 1964). As stragglers have appeared out at sea (e.g. 1 July 1974, beached specimen, San Diego County, California; also Gulf of Mexico, about 75 miles southeast of Galveston) and as far beyond the limits of the owl's breeding range as Louisiana (9 January 1949, Baton Rouge; Glasgow *et al.*, 1950), Alabama (Shelby County) and Florida (Reddington Beach), the migratory capacities of the Flammulated Owl seem to be beyond doubt. Winter records in Arizona and possibly elsewhere in the United States do not contradict a general migratory behaviour in this species. As a species, it is usually present in Arizona in the period 26 March–31 October, New Mexico 11 April–19 October, California 19 April–10 October, Oregon 30 April–15 October, Idaho 25 April–28 September (Phillips, 1942; Marshall, 1957).

Although the Flammulated Owl does not follow the population fluctuations of any rodent, fluctuations have been described from a place at 1,750–1,800m in the Huachuca Mountains, south Arizona, where a year with 5 singing males was followed by a season with 14 (Marshall, 1957).

GEOGRAPHIC LIMITS

As a species with an exclusively arthropod diet, the Flammulated Owl has a primarily southern and continental range. It is all the more remarkable therefore that in summer it extends as far north as some warm air pockets in northern Idaho, United States, the Okanagan Valley (Penticton, Vernon) and the Thompson Rivers junction at Kamloops, British Columbia, Canada, at 50°40′ north. It is crucial for the owl's survival that it retreat to the south in winter and arrive rather late on its breeding grounds. An exceptionally late spring freeze, mid-May 1967, in southeast Arizona, resulted in starvation among insectivorous passage migrants, including at least one Flammulated Owl (Ligon, 1968). The unfortunate bird, a female, weighed 39.8g, which is 77% of the minimum body weight of 12 spring and summer birds from California and the Coahuila Mountains, Mexico. Evidently the Flammulated Owl's range is directly and indirectly determined by high temperatures.

LIFE IN MAN'S WORLD

The spread of open, arid ponderosa pine forest, resistant to natural and man-caused forest fires, has benefited this species. Though rather inconspicuous and reclusive, it does not appear to be shy or to avoid the presence of man. It has nested in nest boxes erected for American Kestrels in California, in those intended for Abert squirrels in Utah, and in special owl boxes in Arizona (Hasenyager *et al.*, 1979) and southern British Columbia. In California (Cannings *et al.*, 1978) Douglas squirrels were notable competitors for nest boxes.

In spite of recent important additions to our knowledge of the Flammulated Owl's life style, the species is still an enigmatic one. Its status as an originally Old World species in North America has been challenged, but how and where it originated remains unclear. Records of Flammulated Owls from Pleistocene deposits in California (Loye Miller, 1933) and Nuevo Leon, Mexico (Wetmore, 1956), confirm that the species is probably basically American. Only by recovering ringed birds of known origin will any light be shed on its migratory habits and degree of geographical variation. Up to now the occurrence of stragglers far away from their breeding ranges and of others out at sea, and the virtual absence of winter records north of the United States–Mexican border, have been considered as evidence of more than short-distance annual migration routes. At present probably the only potential threat to the Flammulated Owl's survival as an arthropod-eating specialist of the North American *Otus* stem is the reduction of large flying insect populations by pesticides.

WESTERN SCREECH OWL
Otus kennicottii

The Western Screech Owl from western North America raises several intriguing questions (Marshall, 1967).

First, there is its relation to the Eastern Screech Owl, which, apart from its vocalizations, is often hard to distinguish from the Western Screech Owl. There is no known zone of intergradation or hybridization between these species, which are the western and eastern representatives of a species pair collectively known as the Common Screech Owl. There are several other well-known examples of such western and eastern distributions in the avifauna of North America, and some of these are now frequently treated as one species: e.g. the Red-shafted and Yellow-shafted Flickers *Colaptes cafer* and *C. auratus*, Western and Eastern Wood Pewee *Contopus sordidulus* and *C. virens*, Audubon's and Myrtle Warbler *Dendroica auduboni* and *D. coronata* (Mayr & Short, 1970). The Spotted and Barred Owls *Strix occidentalis* and *S. varia* also belong to this kind of species pair.

Second, there are striking differences between the territorial songs and the duetting of pairs of Western and Eastern Screech Owls. Whether these differences will suffice to maintain a distinction in the breeding behaviour cannot yet be fully estimated, but unless additional ecological differences develop, the Western and Eastern Screech Owls can hardly evolve further beyond the specific level and stabilize their specific differences, which will continue to remain vague.

Third, there is the owl's relation to other Central and South American species of the genus (14 in total). Some of these, like the Tropical Screech Owl *Otus choliba*, show great resemblances to the Common Screech Owl and replace it geographically in all its main characteristics. This may perhaps mean that all North American Screech Owls have an ultimately tropical South American source.

Fourth, there is the question of the Western Screech Owl's relation to east Asian species, notably the Collared Scops Owl *Otus bakkamoena*, which ranges north along the Pacific fringe of Asia to about 54° north. This compares favourably with the Western Screech Owl's Pacific Coast Range north to about 57° north in south Alaska. Consequently, these two owls have been treated as one species by certain authors (Delacour, 1941; Deignan, 1945:175), though more analytical minds (Marshall, 1966, 1967) have unearthed structural differences between them and ascribed the similarity to convergent evolution.

Fifth, there are the owl's ecological relations with sympatric larger owls and other nocturnal and diurnal avian and mammalian predators, regarding which, unfortunately, detailed information is lacking.

These various questions are treated in the following species account.

GENERAL

Faunal type Western North American and a Sierra Madrean woodland element (Davis, 1959:77).

Distribution Western North America west of the Rocky Mountains, from Juneau, Alaska, south along humid coastal slopes and protected river valleys in British Columbia, Canada, to Baja California, the Mexican Plateau, Jalisco and Michoacan, Mexico; east to Boise City in the Oklahoman panhandle, Texas, and Chihuahua and Coahuila, Mexico. Map 5.

Climatic zones Tropical winter-dry, savannah, desert, mediterranean, temperate and marginally boreal climatic zones. In upper tropical, subtropical and temperate mountain zones with summer temperatures close to 30°C or more. The whole range is situated between the January isotherms of 12°C and −7°C (Miller & Miller, 1951).

Habitat A great variety of open woodland and scrub from humid coniferous forests of the Sitkan coastal belt and riparian forest of any type, with sycamores, cottonwoods, willows and oaks, to tropical deciduous woods with giant *cardon* and tall mesquite, but also bushes and scrub of mesquite and greasewood in *palo verde* and saguaro deserts and other wooded pockets in desert environments. Locally in dry ponderosa pine forests, piñon-juniper woods and pine-oak (Chisos Mountains, Texas) and montane oak forests. Up to 1,000m altitude in British Columbia, Oregon and California and 2,500m on the Mexican Plateau.

GEOGRAPHY

Geographical variation Conspicuous, relating to colour pattern, size and voice. Colour varies from plain brown to cold grey and is rich fuscous in the humid northwest, plain brown in

California, pinkish grey and cold grey in the western deserts, vinaceous grey in Sinaloa and blackish on the Mexican Plateau. Colour pattern below varies between coarse streaks and bars and fine dark lines and spots; in the north the birds have a coarse, dark herringbone pattern. Tarsus and toes are more densely feathered in the north and the whole plumage is longer and more fluffy in humid, cold northern areas and higher mountain altitudes. The darkest forms are the Western Screech Owls of coastal British Columbia and the Queen Charlotte Islands where there is high precipitation and high relative humidity (*Otus kennicottii kennicottii*); the birds are palest and ash grey in Baja California and the arid western Great Plains where there is seasonal precipitation (*O. k. cinerascens*) (Owen, 1963). Measured in wing length, the largest geographical race (*O. k. macfarlanei*, mountains of Oregon and interior British Columbia – wing of male 184mm, female 189mm) is 21% greater and 82% heavier in body weight (Marshall, 1967:11) than the smallest race (*O. k. xanthusi*, mid-southern tip of Baja California – wing of male 144mm, female 149mm; Owen, 1963; Hekstra, 1982). The number of subspecies recognized varies between 8 (Marshall, 1967) and 18 (Hekstra, 1982). For geographical variation in song, see Songs and calls.

Related species Eastern Screech Owl and possibly the little-known Lamb's Screech Owl *Otus lambi* from the Pacific slopes of southern Oaxaca, Mexico. Also the tropical savannah-inhabiting species, the Balsas Screech Owl *Otus seductus* from southern Mexico, Cooper's Screech Owl *Otus cooperi* from the Pacific slopes of Central America and the Tropical Screech Owl *Otus choliba* from the whole of southern tropical Central America and South America.

The most intriguing of these relations, however, is that with the Eastern Screech Owl, now considered a separate species on account of different vocalizations. A small zone of contact or geographical overlap between the Western and the Eastern Screech Owl exists at Colorado Springs, Colorado, and a more extensive one in a stretch of 190km of riparian forest along the Rio Grande where this river crosses the desert in its Big Bend course on the Texas–Mexican border (Marshall, 1967). Where the owls coincide, the forest strip of mesquite and willow is narrow and offers a marginal existence for Screech Owls. In the zone of overlap the owls are said to maintain their distinctive, specific songs and no intergradation has been reported. Downstream of Langtry on the Texas side of the Rio Grande is the exclusive territory of the Eastern Screech Owl race *Otus asio mccallii*, which has a black bill and a whinnying song ending in a long trill. Upstream of Boquillas on the Mexican side of the river, opposite the Big Bend National Park, the exclusive range of the Western Screech Owl *Otus kennicottii suttoni* begins; this owl has a green bill and a bouncing-ball song ending in a double trill. In the thin populations of Screech Owls along the Rio Grande's Big Bend the different owls are probably more likely to meet each other and occasionally form mixed pairs. Thus, at Boquillas, a mixed pair with grown-up young was detected in July 1962 (Marshall, 1967); the male performed the bouncing-ball song and produced the double trill of the Western Screech Owl, while the female uttered the long terminal trill characteristic of the Eastern Screech Owl. However, the male had a pale-green rather than a black bill and might therefore already have been of mixed origin. Similar opportunities for contact and possible hybridization have been found on the Arkansas and Cimarron Rivers, beyond the plains at the Colorado–Kansas border and in northwest Oklahoma, and along the Canadian River in Texas and the Rio Pecos in New Mexico, though in all these places there may be border gaps of 65km or more (Marshall, 1967).

A similarly intriguing relationship exists between the Western Screech Owl and the Collared Scops Owl *Otus bakkamoena* from east Asia (discussed under that species). These owls continue to be treated here as two different species.

DIMORPHISM

The Western Screech Owl is generally not dichromatic in plumage, but a subdued cinnamon-buff to red morph and some intermediates have been recorded in British Columbia and Baja California at frequencies of 7% and 5%, respectively (Owen, 1963), and may have occurred elsewhere too.

STRUCTURE

Basically little different from other screech and scops owls. The feet are thick, toes and claws strong. The tarsus is densely feathered; toes are bristled or covered with feathers at the base. Long bristly tips to the facial feathers, otherwise a characteristic of the Whiskered Owl, have been recorded in mountain populations of the northwestern United States. The iris is yellow. The Western Screech Owl differs from the Eastern Screech Owl in having a black rather than greenish or yellowish bill and a plumage pattern of dense, linear shaft streaks with fine crossbars and vermiculations above and below. Its wing is relatively shorter and tail longer than in the Eastern Screech Owl (Owen, 1963:10, fig. 2).

BEHAVIOURAL CHARACTERISTICS

Songs and calls Differences in vocalization are one of the main reasons for distinguishing a Western and Eastern Screech Owl species. The primary or territorial song is of the "bouncing ball" type, first described by Ralph Hoffmann as "a ball bouncing more and more rapidly over a frozen surface" (Hoffmann, 1927:166). It consists of a series of 4–20 (usually 12–15) notes accelerated in the same pitch and ending in a fine roll. The secondary or courtship song, also employed in duets between male and female, is the so-called "double trill", a short trill followed by a long one (Marshall, 1967). These songs have a relatively low pitch (500–650Hz), lowest of all Common Screech Owls and their relatives, and a frequency of 3.5–11.4 notes per second (van der Weyden, 1975). Geographical variation in the song amounts to a longer, less "bouncing" primary song in the north and a shorter, but more clearly bouncing type in the south (Marshall, 1967). Various other notes have been described, but the complete vocabulary is not known. Female notes seem to be higher pitched than those of males and one syrinx examined was 10% smaller than that of males (Miller, 1934:207).

Circadian rhythm Strictly nocturnal, retreating by day to sleep in thick foliage and tree hollows, and once observed by day in California in an old wood rat's nest.

Antagonistic behaviour Few data available. Cryptic postures by day appear to be similar to those assumed by the Eastern Screech Owl. Western Screech Owls can be very aggressive towards human intruders in the proximity of their nest tree (Walker, 1978).

ECOLOGICAL HIERARCHY

Depending on the place, the Western Screech Owl (body mass in the arid western United States 111g in males, 123g in females; Marshall, 1957; in British Columbia, Canada, 153g in males and 187g in females) is two to three times heavier than the Flammulated Owl, only slightly heavier than the Whiskered Owl and more than three times heavier than the Elf Owl. In the San Bernardino Mountains, California, the Western Screech Owl nests together with the Flammulated and Elf Owls. Size differences between these owls are demonstrated by the average weight of fresh eggs, which is 17.5g, 10.0g and 7.3g, respectively (Hanna, 1941). The Western Screech Owl lives happily alongside the Flammulated and Elf Owls, though it usually retreats before the aggressive Whiskered Owl.

Interactions with other owls and diurnal birds of prey related mainly to cases of nest hole competition with American Kestrels and woodpeckers, and once with an Elf Owl over a hole in a saguaro cactus near Tucson, Arizona, when a Screech Owl was found sitting on three Elf Owl eggs (Bent, 1938:283). The only data I have found regarding predation by other, larger owls referred to a Western Screech Owl found in the stomach of a Spotted Owl (Marshall, 1942).

Females are on average between 15% (Marshall, 1957) and 33% (Miller, 1934:207) heavier than males, but differences in average prey size have not been recorded.

BREEDING HABITAT AND BREEDING

Western Screech Owls nest in natural holes in trees and in abandoned woodpecker holes in trees and large saguaro cactus. They are only able to enter the nests of the larger woodpeckers, e.g. those of the Red-shafted Flicker and Lewis' Woodpecker in the north and the Gilded Flicker and Gila or Desert Woodpecker in the south. Competition for suitable nest sites seems to be heavy, as is testified by a Flicker's nest containing a mixed clutch of Flicker and Screech Owl eggs (successfully incubated by the owl) and another mixed clutch of four Kestrel eggs and one Screech Owl egg, all apparently incubated by the Kestrel (Bent, 1938).

The life history of the Western Screech Owl, though incompletely known, does not appear to differ from that of the Eastern species. Eggs are largest in the northwest (average 37.8 × 32.0mm), smallest in the south (34.8 × 29.9mm) and about the same size as those of the Eastern Screech Owl. Clutch size is 2–5, average 3.04–3.57 (Murray, 1976). Territories, particularly those in the southern populations, are relatively small, rarely more than 300m across.

FOOD AND FEEDING HABITS

Food and feeding habits are very varied. The most frequently used hunting technique seems to be that whereby the owl perches on a twig projecting slightly from the foliage or beneath the canopy of a tree to allow for a clear view of the bare or grassy ground below (Marshall, 1957). Though a variety of mice, voles and other terrestrial mammals and many kinds of songbirds have been recorded as its prey, the Western Screech Owl probably feeds more than the Eastern species on insects and other arthropods, on average 35mm in length in Arizona (Marshall, 1957), but sometimes of a remarkably large size, including a centipede *Scolopendra* of 62mm and a giant hairy scorpion *Hadrurus* of 80mm, swallowed whole in Utah (Ross, 1969). Representatives of at least 15 insect families are mentioned (Marshall, 1957; Ross, 1969): short-horned grasshoppers, crickets, Jerusalem crickets, mole crickets, walking sticks (70–78mm), praying mantids, roaches, sowbugs, giant water bugs (*Belostomatidae*, 30–44mm), large noctuids and hawk moths (*Celerio*, 49mm), caterpillars, cutworms, beetles, ants; also scorpions, whip scorpions or vinegarroons, sun spiders, wolf spiders, harvestmen and crayfish. Like the Eastern species, the Western Screech Owl is also known to have taken voles, pocket gophers, mice, including pocket mice, deer mice, harvest mice and grasshopper mice, rats, kangaroo rats and many small and medium-sized birds up to the size of a Robin, Flicker, Steller's Jay, Domestic Pigeon, even Ring-necked and Golden Pheasant and Bantam hen. Also nocturnal lizards, geckos, snakes (17–20cm, including night snake *Hypsiglena*) and fish (white fish *Coregonus*).

MOVEMENTS AND POPULATION DYNAMICS

Strictly sedentary and, probably as a result of its versatile feeding habits, no population fluctuations have been recorded. In the Rocky Mountains some of these owls may descend in winter to lower altitudes or into more protected valleys.

GEOGRAPHIC LIMITS

Of all the small and medium-sized birds examined, northern Western Screech Owls possessed the most highly insulating plumage after the thickly feathered Canadian or Grey Jay. Southern populations living in semi-arid regions are less densely feathered than northern ones from the humid boreal forests, since overheating can rapidly prove fatal; in cold weather these owls remain remarkably inactive (Miller & Miller, 1951). In laboratory experiments the danger of overheating was reduced by the fact that, at neutral ambient temperatures of 19–26°C, the minimal level of metabolism (amount of oxygen used per gram body weight) was lower than in any other species of western North American owl examined (Pygmy, Saw-whet, Whiskered, Elf Owl) (Ligon, 1969). The Western Screech Owl can thus tolerate a wide range of temperatures.

LIFE IN MAN'S WORLD

The Western Screech Owl has not profited from the change of land use by white colonists in western North America on the same scale as has the Eastern Screech Owl in the eastern United States. Like that species, it has entered suburbs to nest in suitable shady trees and visits towns and cities in winter, including many university campuses. It is attracted by insects swarming around electric lights in summer and by house mice and House Sparrows around houses in winter.

The Western Screech Owl probably forms a superspecies with four other parapatric species, viz. Eastern, Balsas, Cooper's and Tropical Screech Owls, the total geographic range of which covers a continuous area from southern Alaska to central Argentina. Though treated as a separate species, it may eventually prove more realistic to consider it as conspecific with the Eastern Screech Owl as formerly. Whether the Western and Eastern Screech Owls are ultimately of a tropical North American, or of an east Asiatic origin, is a question that still has to be answered, but at present the consensus is in favour of an American origin. Fossil fragments of a kind of screech owl of the *Otus kennicottii/asio* type from the Upper Pliocene (Early Blancan) of Kansas (Ford, 1966) seem to confirm this view. The presence of different species of the feather lice genera *Strigiphilus* and *Kurodaia* (*Mallophaga*) on the Western Screech and the Collared Scops Owl (Emerson & Elbel, 1959) has also been advanced in favour of the independent taxonomic status of each of these owls. Somewhere, sometime and somehow, however, American and Old World screech and scops owls must have had a common source.

Eastern Screech Owl *Otus asio*
O. a. asio from Iowa, east-central USA, red morph (upper left), grey morph (lower left), intermediate (upper right)
Western Screech Owl *Otus kennicottii* (lower right)

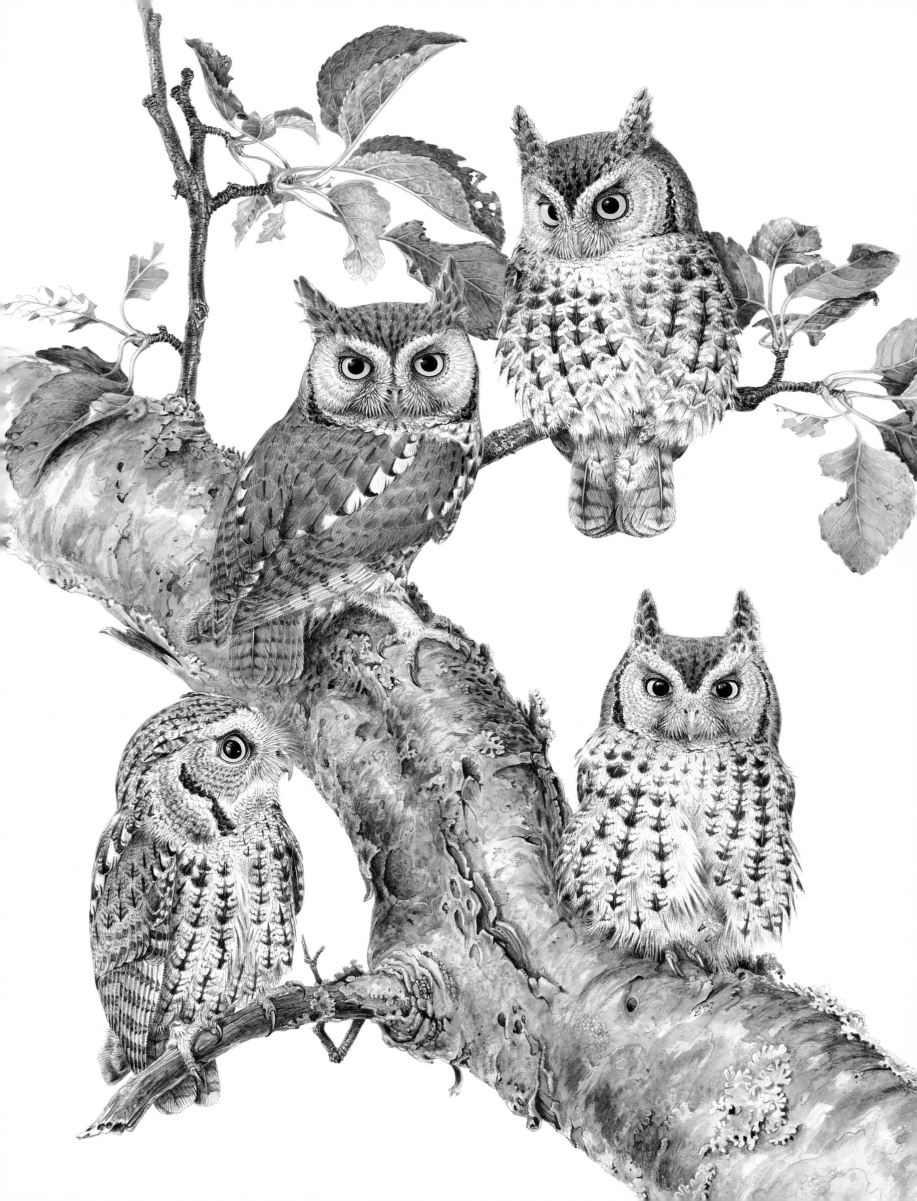

EASTERN SCREECH OWL

Otus asio

The relationship of the Eastern and Western Screech Owls as representatives of a species or species pair of continental distribution in North America has been dealt with in the chapter on the Western Screech Owl. The problems summarized in relation to that species apply also to the Eastern Screech Owl, but relatively more attention will be devoted here to eco-geographical questions concerning the species' geographic limits and its potential predators among other owls. The question will also be tackled of why Europe lacks a species comparable in size and predation potential to the Western and Eastern Screech Owls, collectively known as Common Screech Owl.

Common Screech Owls have been likened to "feathered wildcats", which is an appropriate description, particularly for the northern, less insectivorous populations. In this sense, they are like miniature Long-eared Owls, combining the life style of this species and that of the small European Little Owls. The presence of these owls in Europe may be the reason why there is no place available there for a year-round resident *Otus* species and also why in North America the Long-eared Owl is much less ubiquitous and ecologically widespread than in Europe. The Eastern Screech Owl is capable of preying more heavily on small mammals and birds than the European Scops Owl and more extensively on insects and other arthropods than the Long-eared Owl. The presence of discrete colour morphs in the Eastern Screech Owl has probably attracted more attention than that in any other owl with the exception of the European Tawny Owl. These morphs will be discussed principally in relation to environmental conditions.

GENERAL

Faunal type Eastern North American.

Distribution Southeastern North America, east of the Rocky Mountains, meeting the Western Screech Owl in the Rio Grande Valley on the Texan–Mexican border and possibly in the riparian woods of the Cimarron and Arkansas Rivers on the edge of the southern Great Plains. From extreme southern Quebec and Ontario, and isolated copses in the southern parts of the Canadian prairie provinces as far west as Saskatchewan, through the eastern United States to Florida and northeast Mexico, south to Nuevo Leon, Tamaulipas, San Luis Potosi and possibly northernmost Veracruz (Hekstra, 1982). Map 5.

Climatic zones Mainly temperate, mediterranean and winter-dry tropical and, marginally, savannah, steppe and boreal climatic zones. From upper tropical to temperate mountain zones, with summer temperaures of close to 30°C and more. The whole range is situated between the January isotherms of 12°C and −10°C.

Habitat Deciduous broad-leaved forests and forest edges, open woodlands, orchards, cultivated land, parks and gardens, riparian forests of oak and cottonwood bordering streams flowing through grasslands and deserts; also wooded creek bottoms and large live-oaks in southern canyon bottoms. In the Rocky Mountain foothills up to 1,800m. Also palmetto groves, upper tropical pine forest, semi-deciduous woods, thorn forest and scrub, stunted oak forest at the edge of the desert and pine-oak cloud forest at over 1,500m in the Eastern Sierra Madre.

GEOGRAPHY

Geographical variation Conspicuous in colour and size, also in relative length of the tail and in features of the territorial song. As the complicate variation patterns are confused by variable frequencies of colour morphs and by recent contractions and extensions of local populations caused by the destruction of habitats, the delimitation of geographical races is difficult and sometimes seemingly chaotic. Thus, the number of subspecies recognized varies between five (Marshall, 1967) and nine (Hekstra, 1982), or none at all (Owen, 1963). However, the general pattern follows well-known eco-geographical regularities. The largest birds occur in the north (*O. a. naevius*, southern Ontario) and the northwest (*O. a. maxwelliae*, Colorado, Wyoming) with average wing lengths of 173–174mm (Hekstra, 1982) or 168mm in males and 173mm in females (Owen, 1963); the smallest forms in Florida (*O. a. floridanus*; average wing length of 150mm (Hekstra, 1982), 145mm in males and 149mm in females (Owen, 1963)). Darker brown Screech Owls are found in the humid areas of Florida, the paler and greyer forms in the north and northwest. The plumage is fluffier and the ear tufts are longer in the north and the tarsus and toes are covered with longer, more silky feathers; in the south the toes are bristled. Geographical variation in song relates to length and quality of the end phrase (Marshall, 1967).

Related species The Eastern and Western Screech Owls are parapatric forms of one superspecies. Their specific distinction, based on differences in territorial song (Marshall, 1967; van der Weyden, 1975), is not fully convincing. Possible geographical contacts with the Western Screech Owl have been described under that species. Apart from the Western Screech Owl and its geographical representatives and relatives, Lamb's Screech Owl *Otus lambi* from the coastal mangroves and thorn woods of southern Oaxaca, Mexico, is the Eastern Screech Owl's only other close relative. Together, all these species cover the greater part of the American continent, from southern Alaska, southern Quebec and New Brunswick in the north to northern Argentina in the south.

DIMORPHISM

The occurrence of highly distinct bright reddish-brown and dull-grey colour morphs in the Eastern Screech Owl has intrigued ornithologists since John James Audubon. It appears that mixed pairs and a mixed offspring are of frequent occurrence and that red is dominant over grey through different alleles (Owen, 1963). Intermediate morphs are relatively uncommon. Grey Screech Owls resemble the rough bark of old trees and red Screech Owls blend with the red bark of certain pine trees and with the colourful leaves of deciduous trees in the temperate southeast of the species' range. Out of a total of 1,320 specimens examined (Owen, 1963), 54% had a grey, 38% a rufous and 8% an intermediate plumage. Highest frequencies of red morphs were found in east Tennessee (79%) and southern Illinois (78%); lowest frequencies in the north and northwest (Toronto, Ontario, 13%, Michigan 17%, Minnesota and North Dakota 22%). In Florida and along the Gulf coast red, grey and intermediate colour morphs are roughly equivalent and the species can scarcely be called dichromatic therefore. The colour of the plumage appears to relate to thermal adaptiveness since, under laboratory conditions, at $-5°C$ and $-10°C$ red-morph owls had significantly higher metabolic requirements than grey owls. Mean oxygen consumption of red owls was higher at these low temperatures by 28% and 16%, respectively (Mosher & Henny, 1976). Differential mortality had already been observed in northern Ohio where, after the exceptionally severe winter of 1951–52, with long and heavy snowfall, the percentage of red morphs of 760 Screech Owls had dropped from 23.3% to 14.7% and failed to show any substantial recovery the following years (Van Camp & Henny, 1975). It has been suggested that either differences in physiology are linked with each separate colour morph, or that red and grey body feathers have a different thermal conductance or other qualities of absorption of radiant energy (Mosher & Henny, 1976). This would mean that the frequency of red and grey morphs is subject to direct environmental selection.

During both fair and inclement weather in October–November 1980 in Virginia, United States, a grey-morph Screech Owl was found in 38% of the control observations roosting by day in a cavity, in 33% on an open tree limb and in 28% in a thicket or dense conifer; for two red-morph owls in the same area these figures were 80% and 60%, 4% and 27%, and 15% and 13%, respectively (Merson *et al.*, 1983). The red-morph owls had sought more sheltered places more frequently than had the grey-morph owls. Irrespective of colour morphs, Eastern Screech Owls were found roosting in foliage more frequently in summer and in tree holes and nest boxes more frequently in winter (Van Camp & Henny, 1975).

STRUCTURE, HEARING AND VISION

As in the Western Screech Owl. The bill is greenish, not black. Long, hairy facial feathers, reminiscent of a Whiskered Owl's, occur in the southeastern populations.

No data are available on the Eastern Screech Owl's hearing capacities, or regarding its vision at night. In this connection it is worth noting that 13 out of more than 3,000 of these owls caught and ringed in northern Ohio had a defective eye or were blind in one eye. The authors (Van Camp & Henny, 1975) rightly asked themselves if this could have been the result of non-fatal accidents met by owls trying to capture prey in heavily wooded areas or among shrubs at night.

BEHAVIOURAL CHARACTERISTICS

Songs and calls These differ from the Western Screech Owl's. The male's primary or territorial song is a tremulous and lugubrious wailing, which appears to have given rise to the group name "screech" owl. It consists of a mellow whistle with a falling inflection and ends in a shrill shriek, the well-known "whinny" (Marshall, 1967) or "screech". This latter part of the song is usually considered as weird, if not blood-curdling and ominous, and was described in the previous century in the following terms: "A most solemn, graveyard ditty, the mutual consolation of suicide lovers remembering the pangs and delights of supernal love in the infernal groves, *oh-o-o-o* that I had never been *bor-r-r-n*" (James Hubbard Langille, 1884, cited by Bent, 1938:256–257). The secondary song, the so-called long single trill (Marshall, 1967), employed in courtship and probably also in duetting, consists of a series of 30–70 rapid, monotonous notes uttered at a constant speed, unaccented and with a fine terminal tremolo. In the south the song tends to be split into two phrases, while in the north it is shorter but with a longer terminal tremolo and a greater resemblance to a horse's whinny. The songs are slightly higher pitched (570–690Hz) than in the Western Screech Owl and have a frequency of 10.0–17.6 notes per second (van der Weyden, 1975). Other notes include barks and yips of excitement. Alarm calls around the nest have also been described, as well as a sharp cry *keerr* "like a child's voice", which is the fledgling's hunger or position call (Bent, 1938:257).

Circadian rhythm The Eastern Screech Owl is considered one of the most nocturnal of North American owls. It has been found sleeping by day in hollow trees and in the foliage of particularly leafy trees, close to the main trunk, in rock crevices, a disused Magpie's nest, nest boxes, martin houses and under the eaves of barns. In the very cold winter of 1884–85 it was observed hunting successfully by day in Rocky Mountain valleys in Montana, United States (C. E. Bendire, cited by Bent, 1938).

Antagonistic behaviour Apparently as in the Western Screech and Eurasian Scops Owls and their relatives. Like these, the Eastern Scops Owl is often mobbed by small arboreal birds

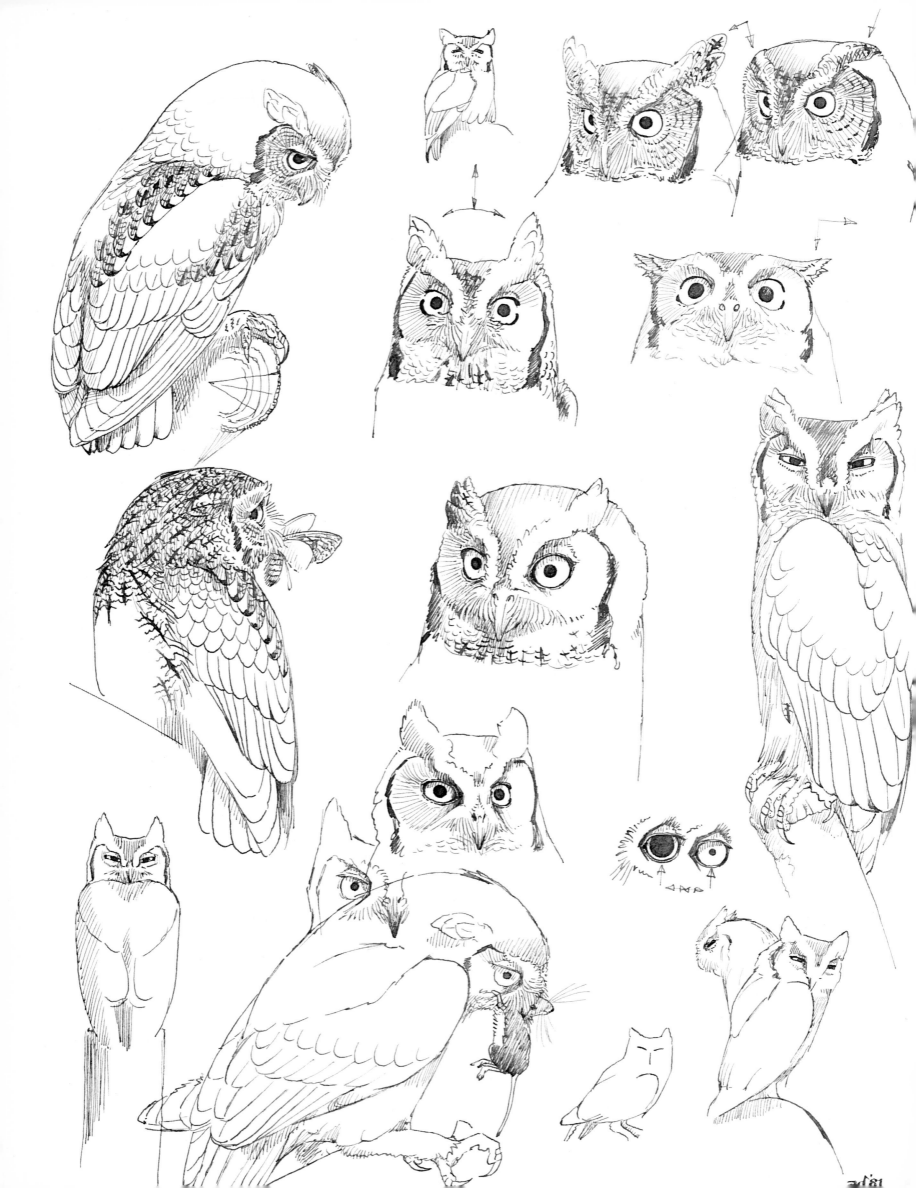

from which it escapes by retreating into a favourite tree hole, sometimes together with its mate, or by assuming a most effective cryptic posture. Various postures have been described as follows: "with open eyes it resembles an ill-humored cat; with eyes shut it resembles the bark. A second roosting shape mimics a broken-off branch. It is elongate, with feathers compressed, head held high, ear tufts straight up, and loral feathers folded laterally to screen the eyes" (Marshall, 1967:2). Like the Western Screech Owl, it is very fierce in defence of its nest and there have been numerous instances of Eastern Screech Owls attacking humans around houses (Bent, 1938:254).

ECOLOGICAL HIERARCHY

The Eastern Screech Owl shares its habitat with a large number of diurnal and nocturnal predators, which it has to avoid if it can. A nestling was reported to have been killed and eaten by a raccoon in Connecticut (Smith & Gilbert, 1981) and fox squirrels compete for nesting holes and rob the owls' eggs (Craighead & Craighead, 1956). In Michigan it hunts in the same habitat as Great Horned Owls and Red-tailed, Red-shouldered and Cooper's Hawks (Craighead & Craighead, 1956), and has consequently been found among the prey items of the Great Horned Owl and Cooper's Hawk. Though the Eastern Screech Owl is very vulnerable to these raptors, which are 8–9 and 2.0–2.5 times its weight, respectively, 13 pairs of Eastern Screech Owls occurred in the Superior Township of Michigan, alongside 6 pairs of Great Horned Owl, 1 pair each of Long-eared Owl and Barn Owl, 22 pairs of Red-shouldered Hawk, 2 of Red-tailed Hawk, 9 of Cooper's Hawk and 2 of Kestrel. Out of 90 owls reported as Great Horned Owls' prey in Wisconsin, 65 were Screech Owls; clearly, the species suffers heavy losses to this predator, particularly in winter and in the fledgling stage (Errington et al., 1940). In Kentucky it was the Barred Owl which posed the greatest threat to the Screech Owl, though both owls preyed upon the same common mammal food as the other owls present: Great Horned, Long-eared and Barn Owls. Likewise, in Ohio, Great Horned, Long-eared and Screech Owls seemed to prey on the same mammal food (Dexter, 1978). Competition with these species is hardly to be expected.

Few owls are likely to fall victim to the Eastern Screech Owl and the only report I have found concerned a Saw-whet Owl caught by a Screech Owl in New Hampshire in January (Clark, 1985:124) and one Screech Owl that had fallen prey to another in the nesting season in Ohio (Van Camp & Henny, 1975).

Females are 15% heavier than males, but there are no data to support the existence of differences in average prey size between the sexes.

BREEDING HABITAT AND BREEDING

Eastern Screech Owls nest in tree holes in woods and orchards of all kinds, often in disused woodpecker holes, provided the entrances are wide enough (7–20cm, e.g. Flicker), but also in the decayed limbs of cypresses and other conifers, in charred pine stumps and palmetto stubs. They readily accept nest boxes, even the large ones put up in Ohio for Wood Duck (Van Camp & Henny, 1975), dovecotes and martin houses, often devouring the rightful owner first. Nest openings may be at any height between 1.5 and 25m from the ground. In Michigan the owls started laying eggs approximately two months later than neighbouring Great Horned Owls, somewhat earlier than Cooper's Hawks and two weeks earlier than Kestrels (Craighead & Craighead, 1956). In New England most eggs were laid between 15 and 27 April (Bent, 1938). The male does not incubate and provides the nesting female with food, though both male and female have frequently been found together in the nesting hole with the eggs. The male can build up a store of food, such as meadow voles, inside the nest, but, when actually feeding the female and her young, he has to work hard at bringing small insect prey to the nest in regular quantities throughout the night.

Eggs are larger in the northeastern United States (average 35.5×30.0mm) and in the Rocky Mountains (36.3×30.2mm) than in Texas (33.9×29.2mm) (Bent, 1938). They are of the same size as, or slightly smaller than, Western Screech Owl eggs. Whiskered Owl eggs are on average 13% smaller and Flammulated Owl eggs 35% smaller than Eastern Screech Owl eggs from Texas. Clutch size in Ohio is 2–6, average 4.43; in Florida 3.00; in the northeastern United States 4.27, and in the north-central United States 4.56 (Van Camp & Henny, 1975; Murray, 1976). Young leave the nest rather late. They do not have a distinctive juvenile plumage, which indicates limited territorial aggressiveness in the adults.

FOOD AND FEEDING HABITS

For its size the Eastern Screech Owl is a fierce and versatile predator. It hunts insects and small birds through the treetops, darts in kingbird-manner after nocturnal insects and bats in flight and takes mice and voles on the ground as frequently as any other rodent-eating owl. It also turns to reptiles, frogs, fish and crayfish on occasion. It also "caches" prey in tree holes and nest boxes, where it will also consume freshly caught prey in winter. Of hundreds of prey remains recovered in Ohio (Van Camp & Henny, 1975), 41% consisted of mammals (23% mice and voles), 18% of birds and 41% of lower vertebrates, insects and other arthropods. Of vertebrates taken in the nesting season, 65% were birds (54 species), 30% mammals, mainly meadow voles (11%), house mice (8%) and deer mice (8%), 1% amphibians, 3% fishes, 0.5% crayfish (*Cambarus*) and 0.5% leeches. Birds amounted to 68% in the nesting season, 30% in winter. Mammals predominated in winter; insects were numerous prey in summer. Winter food in Michigan comprised 40–50% meadow voles (average weight 34.2g), *c.* 45% white-footed mice (average weight 14.9g) and 1–10% birds; during nesting these figures were 30%, 23% and 19%, respectively; 28% crayfish were also taken (Craighead & Craighead, 1956).

Prey variety is considerable (Cahn & Kemp, 1930; Bent, 1938; Stewart, 1969; Van Camp & Henny, 1975). Apart from mice and voles (mentioned above), the mammals preyed upon include brown rats, jumping mice *Zapus*, chipmunks, squirrels, including the arboreal red squirrel, moles and bats (e.g. little brown bat). The variety of birds is even greater and those recorded amount to more than 100 species, as diverse as sparrows, warblers, chickadees, swallows, Blue Jay, Red-winged Blackbird, Common Grackle, Mourning Dove, Domestic Pigeon (in

Eastern Screech Owl *Otus asio* (upper two rows)
Western Screech Owl *Otus kennicottii* (lower row)

dovecotes), Flicker, Downy Woodpecker and Woodcock. Other vertebrates include snakes (*Heterodon*), nocturnal lizards, tree frogs, newts (*Diemictylus*) and salamanders, as well as fish, including horned pouts (Bent, 1938) on sea coasts. The mean weight of vertebrate prey is 26g in Michigan and 28g in Wisconsin (Jaksić, 1983). Insects, on which young are fed almost exclusively, and other arthropods are no less varied and include large moths, beetles, June bugs, spiders, scorpions and millipedes; snails and earthworms have also been recorded.

MOVEMENTS AND POPULATION DYNAMICS

The Eastern Screech Owl is considered as strictly resident as the Great Horned Owl. Breeding pairs in Michigan have lived in the same woodlot and slept in the same hole year after year and winter after winter (Craighead & Craighead, 1956). Ringed birds have been recaptured in the same nest boxes in Ohio for 13 and 8 years in succession (Van Camp & Henny, 1975). The greatest distance covered by birds ringed in Ohio was 235km. Birds of the northeastern race *O. a. naevius* have turned up in Kentucky in the range of *O. a. asio* (Mengel, 1965). Being a "generalist" feeder and a non-obligatory rodent-eater, the Eastern Screech Owl does not seem to be subjected to regular population fluctuations. However, after the exceptionally severe winter of 1977–78, the number of nest boxes occupied by Screech Owls in a study area in Ohio had fallen from 15–18 to 6 (Van Camp & Henny, 1975). Whenever the snow cover is deep in the northern parts of its range, numerous Screech Owls become emaciated and many die.

GEOGRAPHIC LIMITS

Treeless plains and arid plateaus seem to define the geographic limits of the Eastern Screech Owl's range, which extends from the limits of tall, deciduous and mixed forests in the north to humid tropical forests in the south. The species shows a great lability of body temperature, established in laboratory experiments as 37°C at an ambient temperature of 10°C and as 35°C at an outside temperature of 35°C (Ligon, 1969; Mosher, 1976:107). This may be seen as an adaptation in an effort to economize metabolic energy. In addition several authors (Craighead & Craighead, 1956; Van Camp & Henny, 1979) have found the food intake and subsequent increase in body weight in winter to be proportionately much higher than in summer. The daily food intake relative to body weight is surpassed only by the Saw-whet Owl and the American Kestrel (Duke, 1978). Five owls captured, weighed and ringed in northern Ohio in April (*c.* 160g in males, 190g in females), when recaptured next autumn (October–December) had gained on average 28g, in winter (January–February) 13g. These data are exceptionally high for owls of the Eastern Screech Owl's size and adapt it well to cold winter weather. In Michigan at winter temperatures of −2°C Eastern Screech Owls consumed 25–26% (38–40g) of their own body weight per day, as against 10% (14g) in summer. At approximately 3°C a Barred Owl ate no more than 12% of its body weight per day (Craighead & Craighead, 1956). An Eastern Screech Owl collected in Montana while hunting by day during the severe winter of 1884–85 proved to be "excessively fat" (C. E. Bendire, 1892, cited by Bent, 1938:273). Clearly, this owl is well adapted to life at low winter temperatures.

LIFE IN MAN'S WORLD

The Eastern Screech Owl's association with man was well described by Fisher (1893:163): "At night-fall they begin their rounds, inspecting the vicinity of farm-houses, barns, and corncribs, making trips through the orchard and nurseries, gliding silently across the meadows or encircling the stacks of grain in search of mice and insects." The species continues to live on cultivated land and to nest under roofs and barn eaves, in nest boxes, pigeon cotes and martin houses. At the expense of other owls, such as the Barred and Great Horned Owls, it has profited from the almost total deforestation of northern lands, e.g. in Ohio (Trautmann, 1940) and Michigan (Wood, 1951). It enters farmyards, towns and cities in winter to prey on House Sparrows and house mice, even living on very busy highways (Roberts, 1932) and in a recess of an overhead electric light in the lobby of Pillsbury Hall on the University campus while hundreds of students came and went below. At their nest sites the owls have shown great boldness and aggression towards intruders. Unfortunately, the number of fatalities caused by collision with motor traffic and trains, or with windowpanes, or while feeding on road kills (e.g. Bobwhites; Sutton, 1981), is increasing. As a result of biocide poisoning of the environment the species has also suffered from eggshell thinning. The Eastern Screech Owl is now on the North American Blue List of endangered species (Tate, 1981).

Whereas the Eastern Screech Owl has been treated here as a species distinct from the Western Screech Owl, doubt still remains regarding the justification of this systematic distinction and it is not known how frequently, if at all, mixed pairs are formed and hybrids raised. Eastern and Western Screech Owls have identical breeding and feeding habits, but Eastern Screech Owls may turn out to be the more ferocious hunters and to lay greater claim to the name "feathered wildcat". These owls are the real hunters of the eastern North American mixed deciduous woods and, particularly in their reddish plumage, are hard to detect by day. It is noteworthy that a species of owl of the size and kind of the Eastern Screech Owl is lacking in the west Palaearctic fauna. Its approximate equivalent in the forests and woodlands of Europe is the Long-eared Owl, which is about 45% heavier and, though at times a versatile hunter, is less insectivorous and better adapted to rodent-eating. Probably because of the presence of Eastern and Western Screech Owls, Long-eared Owls in North America are much more closely restricted to northern forests than they are in Europe. Eastern Screech Owls have profited from the cutting of lowland virgin forest in North America and have penetrated the open woodland and cultivated strips in the central Great Plains at the expense of other species of owl, notably the Barred Owl and the Great Horned Owl, and have probably only recently met the Western Screech Owl in the lowlands of the Midwest.

WHISKERED OWL
Otus trichopsis

The strong resemblance in coloration and size between the Whiskered or Spotted Screech Owl in the mountains of southern Arizona and adjacent Mexico and the local Western Screech Owl *Otus kennicottii* raises important questions regarding the former's specific ecological position and geographical origin (Marshall, 1967). Rather than having descended as an insectivorous species from the northern Common Screech Owl *Otus kennicottii* and *O. asio*, the Whiskered Owl could equally have originated directly from the same stem as the Vermiculated Screech Owl *Otus guatemalae* in former "Tropical North America". However, there are at least nine species of screech owl of the genus *Otus* resident in Central America south of the United States, three of these being restricted to that area. All these owls are of more or less similar, small size, but they differ in voice, habitat, distribution and degree of geographical variation. Since, in spite of recent detailed research (Marshall, 1967; Hekstra, 1982), even the specific differences and relations between these owls are uncertain, one cannot yet hope to understand their evolutionary history and present life style.

GENERAL

Faunal type Highland Mexican, or Madrean–Cordilleran and Chihuahuan type.

Distribution Mountain areas from Santa Catalina to the Chiricahua Mountains and other mountains in southeast Arizona and the San Luis Mountains in New Mexico, south through Mexico, Guatemala and El Salvador to Honduras. Map 5.

Climatic zones Tropical winter-dry and temperate, in upper tropical, subtropical and lower temperate mountain zones.

Habitat Dense groves on mountain slopes, mostly pine-oak woodland or dense stands of oak within this zone; also oak-juniper woodland. Marginally in pure oak and pine forest. More regularly in mountain canyons and riparian vegetation with dense woods of oak, pine and sycamore (Marshall, 1967). Locally common even in coffee *fincas* (El Salvador). Up to about 1,500m in pine-oak (Arizona white oak) forests in Arizona and 2,500m in Michoacan, Colima and Jalisco in Mexico (Hekstra, 1982). The forest habitat is denser, more closed and located at higher elevations than that inhabited by the Western Screech Owl *Otus kennicottii*, but below the zone of the Flammulated Owl *Otus flammeolus*, which prefers pine forest to oak woodland.

GEOGRAPHY

Geographical variation Conspicuous and complicated; relates somewhat to size, more obviously to colour and colour pattern of the plumage, frequency of grey and red (Blake & Hanson, 1942) colour morphs and feathering of the tarsus and toes (Moore & Peters, 1939). The number of races recognized varies between three (Marshall, 1967) and seven (Hekstra, 1982); a low, intermediate number seems realistic. The largest birds occur in the highlands of Guatemala, El Salvador and Nicaragua (wing 142.0–153.5mm); the smallest (by 3%) on the Pacific slopes of Honduras (wing 138–149mm; Hekstra, 1982). General colour in the north (*Otus trichopsis asperus*) is more grey, with a coarse pattern of black stripes and wavy crossbars on the underparts, an absence of red morphs and densely feathered toes. Southern birds (*O. t. mesamericanus*) are brown, with a fine pattern of stripes on the underparts, a relatively high frequency of dull red-brown colour types (up to 18%) and bristled, not feathered, toes.

Apart from these geographical trends there are interesting cases of parallelism with other *Otus* species, first disclosed by Joe T. Marshall (1967): (1) in Arizona and on the northern Mexican Plateau there is a remarkable resemblance to the cold-grey-and-white Western Screech Owl *Otus kennicottii*, (2) in northwest Mexico there is a resemblance to the dark, blackish-brown extreme of the Vermiculated Screech Owl *Otus guatemalae*. Probably the same environmental pressures (climate and vegetation) have led to similar results in different species of the genus.

Related species The species' closest relatives are probably the Western and Eastern Screech Owls *Otus kennicottii* and *O. asio*, and possibly the Santa Barbara Screech Owl *Otus barbarus* from the high mountain forests of southern Mexico and the Cloud-forest Screech Owl *Otus marshalli* (Weske & Terborgh, 1981) from the mid-elevation cloud forests of south-central Peru (Hekstra, 1982). Possible relations with other mountain-inhabiting screech owls from tropical America, the White-throated Screech Owl *Otus albogularis* and Rufescent Screech Owl *Otus ingens*, are not yet fully understood.

STRUCTURE

The Whiskered Owl shares with the Western and Eastern Screech Owls a herringbone pattern of streaks on its underparts. Its most important distinguishing features are the long, black, hair-like bristles surrounding the bill and the face, which are longer and more numerous than in the northern Common Screech Owls, with six instead of three elongated hair-like extensions of the rachis and the distal barbs of the feathers (Marshall, 1967); also its small feet and short toes (in particular the middle toe). Ear tufts are moderately developed, legs less densely feathered than in the Common Screech Owls, uppersides of toes bristled (Marshall, 1967:39, fig. 1) and eyes yellow (see Moore & Peters, 1939:42). No difference has been found between the Whiskered and Western Screech Owl in the anatomy of the syrinx (Miller, 1935).

BEHAVIOURAL CHARACTERISTICS

Songs and calls The territorial or primary song consists of a series of short whistles, in one pitch and evenly spaced but of irregular duration, like a Morse code (Marshall, 1967; Davis, 1972; Martin, 1974). A series of 4–10 (average 6) soft, mellow hoots, *boot* or *boo*, each series 1.2–1.5 seconds in duration, is followed by a syncopated series of 1–2 short and 2–5 long and more distantly spaced notes. One series consists of 4–16 notes, in a pitch of up to 610–830Hz (van der Weyden, 1975). The Whiskered Owl's song has been contrasted with the Western Screech Owl's and described as a slowed-down and syncopated trill. The more syncopated the song, the more belligerent its intent; when the owl is fully roused, the song sounds as *hoo-hoo hoo hooo hoo-hoo hooo hooo hooo* (Davis, 1972:59). A male can easily be caught if its song is imitated or a recording of the song is played. "The male becomes so incensed at imitated hoots within his territory that he will sometimes strut along the ground toward the observer and allow himself to be picked up" (J. T. Marshall, in *Audubon Western Bird Guide*, 1957:137). The female's song, often heard in duet with the male, is higher pitched and more melodious. Various other sounds, including a worried *meeow* by the female, have been described.

Circadian rhythm Strictly nocturnal.

Antagonistic behaviour No information. This owl is a master at concealing itself by day and cannot easily be provoked into leaving its daytime roost. When roosting, its plumage blends admirably with the bark of the Arizona white oak in daylight as well as at night (Jacot, 1931).

ECOLOGICAL HIERARCHY

In a few places at the lower edge of the pine zone at approximately 1,650m in canyons in the Huachuca and Chiricahua Mountains in Arizona three species of *Otus* occur together in the same or adjacent habitats, where they are joined by the Northern Pygmy Owl and the Elf Owl (Phillips *et al.*, 1964:47). Generally, however, the Whiskered Owl lives at higher elevations than the Western Screech Owl (Marshall, 1957) and below the Flammulated Owl. Though fractionally smaller than the Western Screech Owl, the Whiskered seems to be the more belligerent of the two and other small owls usually leave when the Whiskered enters their woods. Hostile or violent interactions with other owls and birds of prey are likely to be frequent, but only one such has been described, viz. a fight between a Whiskered male and a pair of Saw-whet Owls in October in Arizona (Phillips *et al.*, 1964).

Size differences between males and females are slight. Among North American owls the dimorphism index is possibly only smaller in the Flammulated Owl (Earhart & Johnson, 1970; Snyder & Wiley, 1976). This accords with the owl's mainly arthropod diet, and differences in average prey size taken by males and females are not to be expected.

BREEDING HABITAT AND BREEDING

The Whiskered Owl nests in pine-oak and other semi-deciduous montane woodlands. Males and females are territorial throughout the year and remarkably pugnacious towards any bird near their nesting site. Territories are smaller than those of the Western Screech Owl, but larger than those of the Flammulated Owl (Marshall, 1957). Nests are in natural tree cavities and in disused woodpecker holes in broad-leaved trees or dead juniper stumps. The eggs (33.0 × 27.6mm; Bent, 1938:288) are approximately 12% smaller than eggs of Western Screech Owls from Arizona. Clutch size is given as 3–4.

FOOD AND FEEDING HABITS

The Whiskered Owl hunts in the foliage of the lower canopy of dense groves, often at the top end of the branches, but rarely above 10m from the ground; only occasionally does it descend to the ground to capture non-volant insects, scorpions, mice or other small mammal prey. Flying insects form the major part of the prey; they are caught on the wing. A summary of prey items recorded revealed 1.8% mammals, 0.4% birds, 0.4% reptiles and amphibians and 97.4% invertebrates, probably all arthropods (Snyder & Wiley, 1976). The list of insects recorded is long (Jacot, 1931; Campbell, 1934; Bent, 1938; Marshall, 1957; Ross, 1969). It includes representatives of at least five families of orthopterans (locusts, grasshoppers, crickets, praying mantids, roaches), numerous kinds of beetles, butterflies, moths, large, often hairy, caterpillars, other insects, wolf spiders, centipedes, whip scorpions or vinegarroons. Prey items have a length of 6–75mm, usually around 15mm (Ross, 1969).

MOVEMENTS

None known; the species is considered resident.

GEOGRAPHIC LIMITS

The Whiskered Owl lives in areas south of and, in mountains, below the frost line, with a rainfall of 45–175cm a year (Leopold, 1950). It seems to be better adapted to high temperatures than the more northern Common Screech Owls. In laboratory experiments oxygen consumption decreased less rapidly at decreasing ambient temperatures than in the Common Screech Owls (Ligon, 1969; Mosher, 1976:107, fig. 1). North of the

Whiskered Owl *Otus trichopsis*

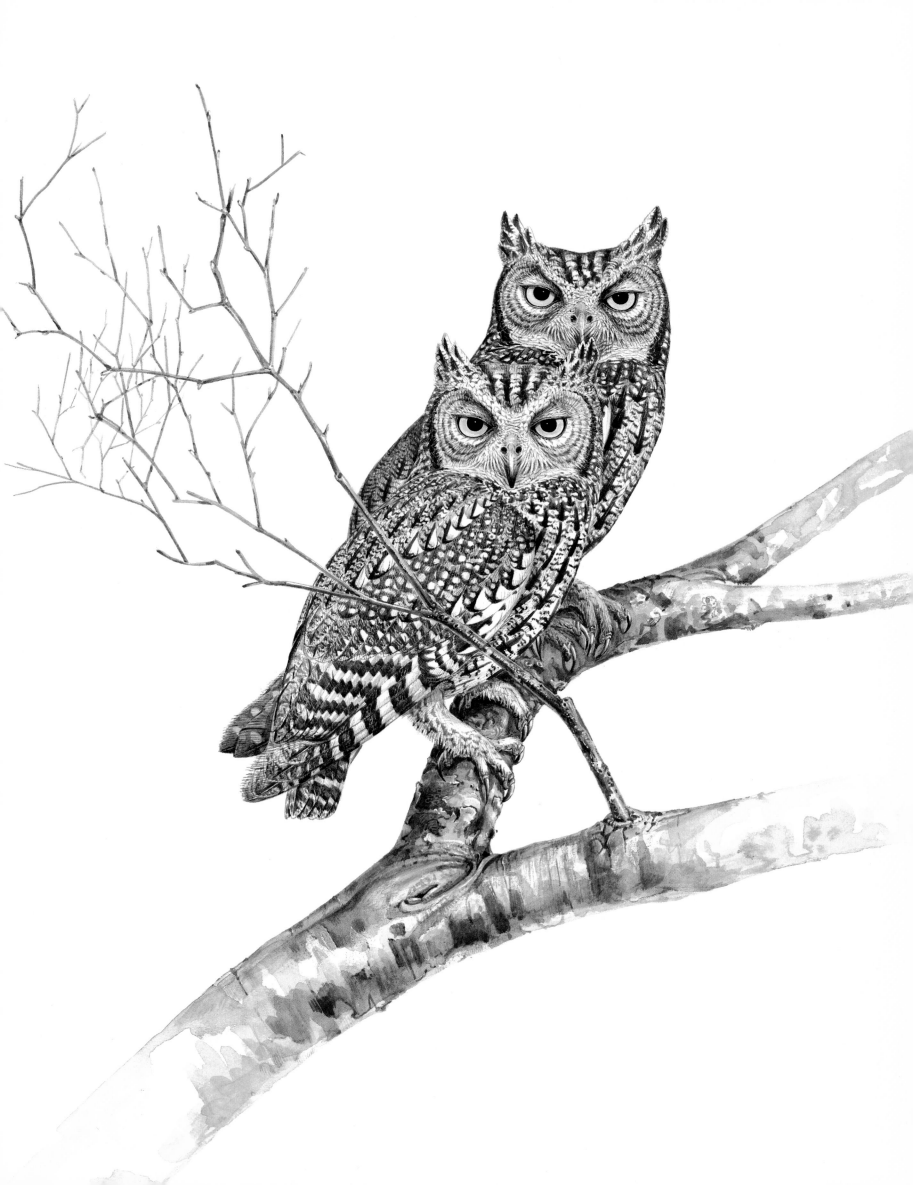

Chihuahua, Catalina and Pinaleno Mountains in Arizona it is replaced by the Western Screech Owl, even where dense oak groves would seem to favour its existence. It does not appear to find enough large, arboreal insects in the pine forests at higher elevations, which are inhabited by the Flammulated Owl. Possibly other owls of its size and feeding habits restrict the Whiskered Owl's range in the south.

LIFE IN MAN'S WORLD

The pine-oak woodland preferred by the Whiskered Owl grows in one of the most healthy, temperate climates in Mexico and is also favoured by man. It is the most important vegetation type in Mexico for game and human economics, covering 25.8% of Mexico's total land surface. This habitat was already exploited by the age-old Mayan system of rotating *milpas* (corn fields). Consequently, pine-oak woodlands have been utilized "intensively by man and in many places they are largely destroyed" (Leopold, 1950). The transformation of large parts of its habitat must have had an adverse effect on the Whiskered Owl's total population numbers. Locally, however, it is still an abundant species.

Whiskered Owl *Otus trichopsis*

The Whiskered Screech Owl appears to be a mainly insectivorous, forest canopy-inhabiting descendant of the group of Common Screech Owls. What it has lost in the predation power of its talons, it has gained in territorial belligerence. The significance of this fact is not clear, but might indicate an increased interspecific competition in hunting large, flying insects. Unfortunately, nothing is known regarding the Whiskered Owl's interrelations with other owls and other avian and mammalian carnivores.

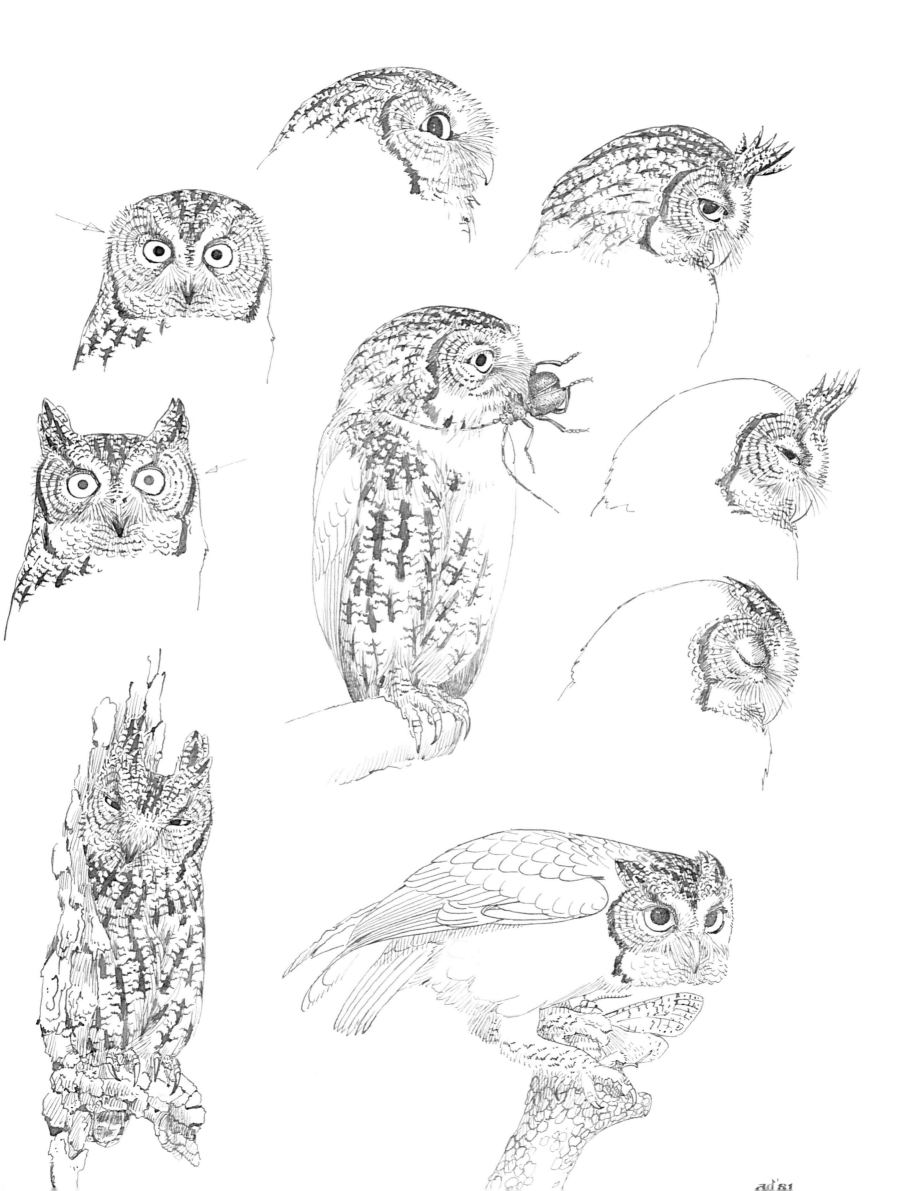

VERMICULATED SCREECH OWL
Otus guatemalae

In contrast to the other North American screech owls, the Vermiculated Screech Owl inhabits mainly tropical and subtropical habitats. Its distribution is Central and South American, from northwest Mexico to Bolivia, covering a stretch of approximately 7,000km. Throughout this range it raises interesting questions with regard to ecological, altitudinal and geographical vicariance, or replacement of some 10 or 11 other species of *Otus* with which it shares its geographic range, though not its habitat. Its occurrence in the Nearctic region is marginal only.

The Vermiculated Screech Owl is somewhat smaller than, or the same size (body length 20–33cm) as, the Tropical or Savannah Screech Owl *Otus choliba*, whose range covers an area of over 10,000km, from Costa Rica to Buenos Aires, Argentina. The Tropical Screech Owl is considered the Vermiculated Screech Owl's nearest relative, but this remains unproven. The vocalizations of these species play a major role in their recognition and supposed relationship. The geographic origin of the Vermiculated Screech Owl has not been established, but it may have developed as a Late Tertiary or Early Pleistocene Tropical North American element. It is possible that two parapatric species are involved, a northern Middle American *Otus guatemalae sensu stricto* and a more southern *Otus vermiculatus* from northern Costa Rica southward (see Peters, 4, 1940:105, footnote 1). This could signify the existence of two separate centres of development under different ecological conditions, or that the species is a long-distance colonizer, hopping over large uninhabited areas.

GENERAL

Faunal type Not clear, but possibly Tropical North American.

Distribution Central America and western South America. From southeast Sonora and Sinaloa in northwest Mexico and Tamaulipas in northeast Mexico, through most of Central America and along mainly the east Andean slopes to Peru and Bolivia (Rio Chapare, Cochabamba; Bond & de Schauensee, 1941); also Venezuelan mountain ranges north of the Orinoco and the isolated sandstone tablelands or *tepuis* on or near the borders of Venezuela, Brazil and Guyana, including Mt Roraima, Mt Duida and the Cerro de la Neblina including Pico Phelps (Mayr & Phelps, 1967). Map 5.

Climatic zones Tropical winter-dry, less frequently tropical rain forest or subtropical and transitional zones in lowlands and on lower mountain slopes, only locally somewhat higher.

Habitat Dense, tall, continuous broad-leaved woods, from tropical deciduous and thorn forest in lowlands and foothills up into oak woodland (Marshall, 1967), also evergreen upper tropical rain forest in southern Campeche, Mexico.

Generally from mangroves at sea level up to 2,100m in subtropical and temperate woodland of oak and giant cacti in the western and southern Sierra Madre. Also tropical cloud forest at 900–1,200m in Honduras (Monroe, 1968) and Venezuela, but not in parkland and savannah. Humid and arid tropical and subtropical slopes of the Andes, up to 2,400m in the Urubamba valley and Junin in Peru.

GEOGRAPHY

Geographical variation Conspicuous, mostly relating to colour and pattern of the plumage, less to size. The number of subspecies recognized varies between 10 (Eck & Busse, 1973) and 19 (Hekstra, 1982) and requires critical re-evaluation. Northern birds are tawny brown above, with conspicuous, sharp, black streaks below (*guatemalae* type); southern birds are lighter, reddish brown and speckled above and indistinctly vermiculated below (*vermiculatus* type). Wing length does not vary more than between 140.5m and 178.5mm; the smallest birds occur in north Mexico (wing 140.5–150.5mm), the largest in Nicaragua (wing 164.0–178.5mm) and northwest South America in the Andes of Bogotá, Colombia, and possibly of Mérida, Venezuela (wing 171–178mm) (Hekstra, 1982). The feathering of the legs varies between fully feathered in the northern, *guatemalae* type populations and a bare lower part of the tarsus in the southernmost *vermiculatus* populations.

Related species There is a proposed specific relation with the long-legged, almost bare-shanked Puerto Rican Screech Owl *Otus nudipes* of the upper tropical and subtropical woods and scrub of Puerto Rico, Vieques Island and the Virgin Islands St Thomas, St John and St Croix (see also Songs and calls) (van der Weyden, 1974; Hekstra, 1982). Another close relative may be the Bare-shanked Screech Owl *Otus clarkii* from southern

Vermiculated Screech Owl *Otus guatemalae*
Mexican race *O. g. hastatus* from Tehuantepec, Puebla, with dark ground beetle as prey

Nicaragua and Panama, inhabiting dense mountain forest at 1,000–1,800m above the more arid mountain woods of the Vermiculated Screech Owl's range (Marshall, 1967), but other Central American screech owls do not seem to be particularly closely related to the Vermiculated. Probably the most realistic proposition is a direct relationship with the North American Western and Eastern Screech Owls *Otus kennicottii* and *Otus asio*. These owls almost exactly complement the Vermiculated Screech Owl geographically. Where their ranges meet in Mexico, the Vermiculated species inhabits denser, almost tropical types of wood, filling in the gaps in the Western Screech Owl's range in the humid strip from Sinaloa to Colima (Marshall, 1967). Its affinity with the Tropical Screech Owl *Otus choliba* requires further careful study; it may prove to be a close one.

STRUCTURE

Structurally the Vermiculated Screech Owl resembles the Tropical Screech Owl and, like that species, has relatively small ear tufts and yellow eyes. The tarsus is feathered but in tropical populations the distal third is either only thinly feathered or bare. The toes are long and bare, longer and stronger than in the Whiskered Owl, but much smaller than in the Western and Eastern Screech Owls, probably due to the owl's usually smaller, non-mammalian prey. The wings are more rounded than in savannah- and open-woodland-inhabiting species, indicating life in denser vegetations. Conspicuously different grey-brown and rufous colour morphs occur in most of the Vermiculated Screech Owl's range, which may be the result of an unstable or ambivalent habitat preference.

BEHAVIOURAL CHARACTERISTICS

Songs and calls The territorial song in Mexico has been described as a long trill in one pitch, like a spadefoot toad's call; it starts softly, gradually swelling until it becomes extremely penetrating, then cuts off abruptly (Marshall, 1967). Except for the crescendo it is not unlike the Eastern Screech Owl's song (see also Davis, 1972). The monotonous trill has 40–140 notes and a total duration of 3–9 seconds (van der Weyden, 1975). The female song is 3–5 tones higher. There is some geographical variation in pitch and duration, but owls in Guatemala (Land, 1970) and Panama (Wetmore, 2, 1968) have the same song as those in Mexico. In Venezuela the song has a higher pitch and a shorter duration than in Mexico. Duetting by male and female occurs, but is not synchronous (Marshall, 1966:240). The Puerto Rican Screech Owl has a similar, very rapid, but shorter trill, often preceded by a few notes. Its duetting is synchronous. These differences do not seem to warrant a specific distinction of the Puerto Rican Screech Owl from the Vermiculated species (van der Weyden, 1974; Hekstra, 1982).

Circadian rhythm Generally considered strictly nocturnal.

Vermiculated Screech Owl *Otus guatemalae*
Mexican race *O. g. hastatus* from Tehuantepec, Puebla

Antagonistic behaviour Practically nothing has been recorded, but the following observation by Alexander Wetmore, made at the foot of the Cerro Azul, Panama, is worth citing in full: "I saw a small vermiculated screech owl watching us from a tree perch only 5 or 6 meters distant. The bird rested with head bent forward, feathers pressed closely on head and body, and the ear tufts displayed so prominently that at first glance, in the dim forest light, I took it for a small mammal" (Wetmore, 2, 1968:150). This observation supports the predator-mimicry theory of the function of ear tufts, rather than the alternative camouflage and species recognition theory (Perrone, 1981).

ECOLOGICAL HIERARCHY

Of a similar size to the southern races of the Western and Eastern Screech Owls, the Vermiculated Screech Owl is about 15% larger than the Whiskered Screech Owl, which it replaces in lower, tropical elevations. There is usually little chance of Western and Eastern Screech Owls meeting a Vermiculated Screech Owl, as they affect more open vegetation types, but they may nevertheless live as close to a neighbouring Vermiculated as approximately 20km in Oaxaca, 15km in Colima and less than 1 km in Sonora, Mexico (Marshall, 1967). The Vermiculated species may also coexist with the Whiskered Owl in upper tropical woodlands in the highlands of Chiapas, Mexico, where the habitats of these species meet (Marshall, 1967).

Since virtually nothing is known about its food, the status of the Vermiculated Screech Owl in the hierarchy of predation remains uncertain. It shares its tropical habitat with at least 11 other species of owl representing 7 genera and with numerous diurnal birds of prey. Interactions with these species must necessarily be numerous. In the northeastern lowlands of Costa Rica a forest falcon, probably a Barred Forest Falcon, killed a Vermiculated Screech Owl and presented it as food to its female and young (Slud, 1964:130).

BREEDING HABITAT AND BREEDING
No data available.

FOOD AND FEEDING HABITS
No data available.

MOVEMENTS
None recorded.

GEOGRAPHIC LIMITS

Though it may be supposed that the geographical range of the Vermiculated Screech Owl is limited in the north by the presence of the Western and Eastern Screech Owls, this northern range does not extend beyond the regular frost line (Leopold, 1950), which may represent a climatological distribution limit. In the Andean mountain zones it does not seem to occur higher than in areas where temperatures do not drop below 18°C in the coldest month (Hekstra, 1982:57). It appears then that the Vermiculated Screech Owl is really a thermophilous species.

LIFE IN MAN'S WORLD

There is no reason to suppose that the Vermiculated Screech Owl is persecuted by man in any part of its range, but this owl does not frequently occur near human habitation or in plantations and gardens as is the case with the Tropical Screech Owl. It has suffered from the destruction of its natural habitat of tropical deciduous forest in Mexico, which has now been almost entirely converted into secondary scrub forest, stripped of trees. Not quite half a century ago tropical deciduous forest covered 9.1% of the total land area of Mexico (Leopold, 1950), but the percentage must be considerably reduced by now. Local, geographically marginal populations in Mexico and South America have already disappeared as a result of habitat destruction and some of these probably extinct populations have recently been described as new subspecies in an attempt to call attention to their former existence (Hekstra, 1982).

In spite of its large range, virtually nothing is known of the Vermiculated Screech Owl's life style. The most detailed studies have been devoted to its song, but results here throw hardly any more light on the species' systematic position.

The facial disc, lacking a conspicuous rim, seems to indicate that the face does not function as a specialized sound-reflecting disc as in the case of owls hunting terrestrial mammals at night. At the same time, the absence of "whiskers" or elongated bristles at the base of the bill may lead one to suppose that this owl is not adapted to catching large insects in thick foliage.

The Vermiculated Screech Owl most probably occupies a position halfway between the North American Common Screech Owls *Otus kennicottii* and *Otus asio* and the Tropical Screech Owl *Otus choliba*. The latter's ascending song of 10–18 notes, terminated by one or more accented strokes, may be a type of song derived from the trill of the Vermiculated species, which may therefore once have been the common ancestor of the Western, Eastern and Tropical Screech Owls (Hekstra, 1982). However, this theory contradicts the supposed close relationship between the North American Western Screech Owl and the Asiatic Collared Scops Owl *Otus bakkamoena*, a theory which has not yet been completely discarded.

GREAT HORNED OWL

Bubo virginianus

The Great Horned Owl belongs to the group of eagle owls genus *Bubo*. They are silent, ferocious and largest of the owls, real "tigers of the air" (Austing & Holt, 1966). Whereas the Great Horned Owl is the only member of its genus in America, there are 11 species in the Old World, with the exception of Australia where there are none. There are reasons for supposing that eagle owls originated in Africa. The Great Horned Owl probably entered America over the Bering land bridge at the beginning of the Pleistocene era. Like the jaguar, the cougar and other spectacular predatory mammals of Asian origin, it spread from the far north to the extreme south as far as the southern tip of South America, in the meantime developing a number of geographical races while still maintaining their specificity. Given sufficient time, Great Horned Owls will undoubtedly evolve a number of species of different size classes, comparable with the seven or eight species in Africa. In the meantime the degree of subspeciation in the Great Horned Owl and its evolutionary developments to date provide interesting subjects for study.

The Great Horned Owl is the geographical and ecological counterpart of the Eurasian Eagle Owl *Bubo bubo*, but the reasons for treating these as distinct species have rarely been made clear. Differences in plumage, such as the more apparent barring of the underparts in the Great Horned Owl, and its somewhat smaller size, have been mentioned as evidence of specific distinction. Nevertheless, at Dudley Zoo in England, a male Great Horned Owl and a female Eurasian Eagle Owl produced a fine intermediate hybrid which, when three months old, was already almost as big as its mother (Risdon, 1951). As regards plumage, the Great Horned Owl and the Eagle Owl differ little more than the New and Old World representatives of the Great Grey Owl *Strix nebulosa* and the Long-eared Owl *Asio otus*. To treat the Great Horned Owl as a distinct American species is merely a matter of subjective definition regarding geographical variation; as long as one bears this in mind, there is no reason not to accept it as a traditionally separate species.

Though lighter in body weight than the Eurasian Eagle Owl by at least 40%, the Great Horned Owl is as ferocious a predator, with a wingspan of 125–150cm. Remarkably opportunistic, it is nevertheless primarily a mammal-hunter. With the decline of mammals in Pleistocene and Holocene times and the man-induced destruction of plains rodents in North America, the Great Horned Owl became a more frequent bird-hunter. In this capacity it must have entered into competition with other owls of a smaller size class and somewhat less predatory force.

We should add a few words here regarding man's relationship with the Great Horned Owl, which, due to its great predatory strength and skill, even nature lovers have sometimes failed to appreciate. The first genuine nature conservationists, when campaigning against the "Extermination Being Waged Against the Hawks and Owls" (Quinn, 1929), continued to advocate the destruction of the Great Horned Owl. Even the great romantics of that time, like William J. Long in his evocative Canadian nature stories, were not always able to resist the temptation to aim a gun at the huge silhouette of this nocturnal hunter as it appeared in the crown of a spruce or pine around a peaceful campsite at dusk.

GENERAL

Faunal type Nearctic.

Distribution Virtually the whole of America, from the northern edge of stunted, subarctic woodland in Alaska and the Yukon Territory at 68° north, Fort Chimo in Ungava and Okak in Labrador, almost continuously south to Tierra del Fuego at 54° south on the southern tip of South America. It is absent on the Queen Charlotte and West Indian Islands and in the lowland tropical rain forests of South America. Map 6.

Climatic zones The Great Horned Owl occurs in all climatic zones, with the exception of the tundra climatic zone (which, however, is reached by some wanderers) and the tropical rain forest zone (where it occurs only very sporadically). Its breeding range in the north almost reaches the isotherm of 10°C in July, while in the south it extends as far as, or beyond, the isotherm of 10°C in the warmest month.

Habitat Extremely varied, from boreal forest and deciduous woodlands, dry forested uplands, foothill ravines and river bottoms, up to at least 2,100m in California and 3,300m in the Rocky Mountains of Colorado, to aspen forests in western North America (Flack, 1976) and isolated groves and wooded coulees in the prairie countries, open grasslands and deserts, provided there are rocky canyons, steep gullies and shade-giving trees.

In the tropics it does not occur in the primeval, closed rain forest but has been found in all kinds of open, evergreen and deciduous woodlands, including open types of mangroves (*Avicennia*) and covering all altitudinal climatic life zones. It has been found widespread on rocky hillsides bordering Lake Junin, Peru, up to almost 4,100m (Fjeldså, 1983) and at over 4,300m in the treeless barrancas zone of the Ecuadorean Andes alongside the Short-eared Owl (Chapman, 1926).

GEOGRAPHY

Geographical variation Conspicuous, relating to colour and size and mostly following continuous, regular clines, or else corresponding with the well-known eco-geographical trends of Bergman (size) and Gloger (pigmentation). The plumage is darkest in warm and temperate humid climates and lightest in cold surroundings. The number of subspecies recognized in the literature still seems excessively large following some outdated revisions (Oberholser, 1904) and in spite of recent valuable studies on subspecies in Canada (Taverner, 1942; Snyder, 1961) and South America (Traylor, 1958). Between 16 (Peters, 4, 1940) and 19 (Kelso & Kelso, 1934; Eck & Busse, 1973) subspecies are currently recognized. The darkest and blackest races are *Bubo virginianus saturatus* from humid coastal forests of western North America and *B. v. heterocnemus* from Newfoundland, Labrador and northern Quebec. The palest and most buff-coloured owls are from Arizona and northwestern Mexico (*B. v. pallescens*), while those from subarctic Canada (*B. v. subarcticus* or *wacaputhu*) are very white and distantly resemble female or young Snowy Owls from further north.

Northern Canadian and Alaskan Great Horned Owls seem to be largest, with average wing lengths of 355.8mm in males and 375.8mm in females (Ridgway, 6, 1914:751), but the eastern North American race *B. v. virginianus* is barely any smaller. The pale desert form *B. v. pallescens* has a wing length of on average 97% (male) and 94% (female) of that of the northern races, while the few data available indicate that the small Yucatan Horned Owl does not exceed 86% (male) and 80% (female) of their wing length (data from Webster & Orr, 1958). Southern South American birds *B. v. magellanicus* reach 93% (male) and 90% (female) of the wing length of the northern races, while some tropical South American birds are much smaller still. Expressed in body weight, well-fed eastern Great Horned Owls *B. v. virginianus* (average of male 1,318g, female 1,769g) are somewhat heavier than northern birds, while Desert Horned Owls *B. v. pallescens* reach 69% (male) and 65% (female) of *B. v. virginianus* (after Earhart & Johnson, 1970) and lowland tropical South American birds *B. v. nacurutu* (?) (mangroves, Surinam) around 80% (male) (after Haverschmidt, 1968) and 75% (female) (personal data). Size differences between northernmost Great Horned Owls and lowland tropical South American birds are as significant as those between northern Eurasian Eagle Owls and Spotted Eagle Owls from the African savannahs. If the distribution were not continuous tropical American Great Horned Owls could hardly be considered conspecifics of their giant northern relatives.

Related species The Eurasian Eagle Owl *Bubo bubo* is the Great Horned Owl's nearest relative and the one most closely resembling it, though the Eagle Owl's wing length is on average 25% and its body weight almost 70% greater. The Great Horned Owl's characteristic transverse barring is as distinctive as the dark barring of the American Great Grey Owl *Strix nebulosa nebulosa* and Long-eared Owl *Asio otus wilsonianus*, which are generally treated as conspecific with their longitudinally striped and mottled Old World representatives. Specific distinction between the Great Horned Owl and the Eurasian Eagle Owl is therefore a matter more of convenience than of scientific conviction. The ease with which a male Great Horned Owl and a female Eagle Owl of unknown origin and age produced an offspring at Dudley Zoo, England, confirms the close relationship of these owls. The hybrid's plumage showed an intermediate mixture of the black-barred and smudged feather design of *Bubo virginianus* and the dark streaks of *Bubo bubo*; its eyes remained straw-coloured as in adult *Bubo virginianus* (Risdon, 1951).

STRUCTURE AND VISION

Virtually the same as that of the Eurasian Eagle Owl. As the Great Horned Owl is a smaller version of the latter, the outer ear openings are also smaller (vertical axis *c.* 23mm), non-operculate, with the right one slightly larger than the left (Norberg, 1977). Bill and claws are very strong. Tarsus and toes are densely feathered.

Only one anatomical study has been published revealing the owl's great visual acuity (Fite, 1973). Data on specific hearing and visual abilities in the Great Horned Owl are otherwise lacking, except for one remark that in captivity a Great Horned Owl walked directly towards a dead mouse placed on the floor under 13×10^{-6} foot-candles of light (Marti, 1974).

BEHAVIOURAL CHARACTERISTICS

Songs and calls The male's advertising or territorial song is a low, deep, more or less strongly accented *whoo-hoo-ho-o-o*. It is less sonorous but as far-reaching as and at times no less terrifying than the comparable call of the Eurasian Eagle Owl. When the female joins in duetting, her song is more high-pitched (because of a relatively smaller syrinx; see Miller, 1934) and two- rather than three-syllabic. Warning and aggressive notes are a loud *wac-wac*, often alternating with a more mildly aggressive *whoooo-hoo-hoo*. Sexual excitement is expressed by cat-calls, groans and demonic laughter, while the young can produce chirping notes and blood-curdling screams. The position or hunger call of the fledged young is a hawk-like scream. Vocal differences in the species' large breeding range are likely.

Circadian rhythm Great Horned Owls are largely nocturnal and become active only after sunset. Those observed hunting in broad daylight and quartering the dazzling surface of a snow-covered field in Iowa in bright sunlight (Sherman, 1912) were probably very hungry. Some Great Horned Owls have acquired the knack of chasing squirrels from their untidy tree nests by day (Packard, 1954) or have learned from experience that certain desert lizards which are active during the hottest parts of the day (e.g. the chuckwalla) can be caught more easily in the cooler hours of the late afternoon (Vaughan, 1954).

Great Horned Owl *Bubo virginianus*

Antagonistic behaviour Resembles that of the Eurasian Eagle Owl. The slender, un-bird-like hiding posture with contracted body plumage is perhaps more often assumed than in the latter owl. Eastern and Western Kingbirds are known to fly in hot pursuit of Great Horned Owls by day.

ECOLOGICAL HIERARCHY

The Great Horned Owl is as powerful a hunter relative to its body size as the Eurasian Eagle Owl, and its food is no less varied. The diversity of its prey therefore overlaps with that of numerous other avian and mammalian predators which share its habitat and range.

More particularly the Red-tailed Hawk (average body weight of male 1.0kg, of female 1.2kg, as against 1.3kg in the male Great Horned Owl and 1.7kg in the female) is considered the Great Horned Owl's vicariant by day, hunting and nesting in the same habitat, but in Michigan the Great Horned Owl surpasses the Red-tailed Hawk by 27% in the male and 39% in the female (data from Craighead & Craighead, 1956). Throughout North America more often than not the Great Horned Owl occupies a nest abandoned by the Red-tailed Hawk or takes one by force after a fight which it usually wins. In spite of the owl's greater body weight and possibly also body strength, the owl and the hawk are ecologically complementary species and their territories are usually as evenly distributed as if they were conspecifics, though sometimes part of their territories do overlap. In the aspen parkland of Saskatchewan nests of Great Horned Owls and Red-tailed Hawks have been found as close as 30m apart, with the owls always enjoying normal breeding success and the hawks only occasionally so (Houston, 1975). In Utah nests in holes and on ledges of cliffsides were competed for by Golden Eagles, Red-tailed and Ferruginous Hawks and Great Horned Owls. These species nested closer to each other the more their daily activity patterns were different. Thus, Golden Eagle and Great Horned Owl, though generally not on friendly terms, nested at average distances of 1.12km, usually on opposite sides of the valley, but the nearest nests were only 8m apart in the same quarry cliff, while the maximum distance was 2.45km (Smith & Murphy, 1982). The nearest distance between nests belonging to a Great Horned Owl and a Red-tailed Hawk reported in Utah was 21m (Smith, 1970), but the final results of these breeding case studies have not been disclosed.

The tremendous impact which the Great Horned Owl exerts on other owls and birds of prey has been demonstrated by John J. and Frank C. Craighead (1956) working in Michigan. They proved that any change in its nest site in late winter or early spring tended to require immediate changes in the nest locations of all diurnal raptors. The Great Horned Owl does not normally tolerate any other owl in its territory (Baumgartner, 1939). While there may be several species of birds of prey nesting in selected corners of the owl's territory, not even a Barred Owl occurs simultaneously in the same woodlot. On the other hand, species which hardly compete with the Great Horned Owl have been found nesting in close proximity to it: thus, Turkey Vultures and Great Horned Owls nested in separate cavities in one large live-oak in Colorado (Bent, 1938:324); and a nest belonging to Harris' Hawks was located at 40ft and a Great Horned Owl's nest at 30ft in the same live-oak in Texas (Freemeyer & Freemeyer, 1970).

As in the Eurasian Eagle Owl, the number of owls and birds of prey which have fallen victim to a hunting Great Horned Owl is large, but no quantitative summary ever seems to have been attempted. Only a list of species known to have been taken and devoured by Great Horned Owls in North America can be given here in estimated sequence of frequency. Of owls: Eastern Screech Owl (Errington et al., 1940) (12% of body weight of Great Horned Owl), Western Screech Owl, Long-eared Owl, Short-eared Owl, Barn Owl, Barred Owl, Burrowing Owl, Saw-whet Owl. Of birds of prey: Cooper's Hawk (29–33% of body weight of Great Horned Owl), Red-tailed Hawk (including nestlings), American Kestrel, Red-shouldered Hawk, Marsh Hawk or Northern Harrier, Sharp-shinned Hawk, Goshawk (Bent, 1938; Errington et al., 1940; McInvaille & Keith, 1974; Marti, 1974; and others). This list should undoubtedly be much longer. These instances of predation do not necessarily indicate the existence of interspecific competition for food; rather, they illustrate the importance of body weight as predatory power. Interspecific competition for nest sites, however, is apparent and includes species as large as the Bald Eagle and the Golden Eagle.

The number of diurnal raptors with which the Great Horned Owl has to cope is larger still in the arid plains and prairies in western North America. More than 90% of the biomass of prey eaten by the Golden Eagle, Ferruginous Hawk, Red-tailed Hawk and Great Horned Owl is reported to consist of blacktail jackrabbits, with an additional 9% desert cottontail for the Great Horned Owl, 6% for the Red-tail and 3% for the Ferruginous Hawk. All these predators follow the population fluctuations of the hare closely and synchronously (Smith & Murphy, 1979). As long as hares and rabbits are abundant there can hardly be any question of interspecific competition for food. The same applies to central Alberta and Saskatchewan where the Great Horned Owl and Red-tailed Hawk follow the population cycles of the snowshoe hare. These species also preyed on meadow voles and Richardson's ground squirrels, though the Red-tailed Hawk did so more than the Great Horned Owl (McInvaille & Keith, 1974). In Saskatchewan Great Horned Owls and Red-tailed Hawks have been found feeding on a similar diet of ground squirrels and pocket gophers *Thomomys*, but the owl took proportionally less of the diurnal ground squirrels and the hawk less of the nocturnal gophers. In a coulee in eastern Washington Great Horned Owls and Barn Owls shared the same general nesting site when mammalian prey was temporarily abundant. Three species of rodents and the mountain cottontail formed 98% of the prey quantities taken by each of the owls, which corresponded with 78% of the biomass eaten by the Great Horned Owl and 98% of that eaten by the Barn Owl. Larger prey was more frequently eaten by Great Horned Owls than by Barn Owls; the average weight of the Great Horned Owl's prey was 55g, that of the Barn Owl 27g. Not unexpectedly, the Great Horned Owl ate a considerable number of its Barn Owl neighbours – up to 10.7% of the total prey weight (Knight & Jackman, 1984).

Great Horned Owl *Bubo virginianus*
Moderately dark male *B. v. virginianus* from eastern North America (left) and pale female *B. v. heterocnemis* from Labrador

To summarize, Great Horned Owls are opportunistic feeders, hunting in places inhabited by numerous other avian and mammalian predators. They take adults and nestlings of any owl they happen to meet. They are themselves not subjected to any serious predation, though nestlings are known to have been robbed by black bears (Gabrielson & Lincoln, 1959:529), Harris' Hawks (Huey, 1913), Crows and Ravens.

Competition is likely with Peregrine and Prairie Falcons for nest sites in sandstone cliffs and earthen walls. No published reports exist, however, apart from a general description of nests on the cliffs of an 11-km stretch of the Columbia River in Washington, involving 6 species of hawk and falcon, 5 species of owl and a Raven (Knight, Smith & Erickson, 1982).

Data are unfortunately lacking for the ecological hierarchy in South America, except for semi-arid habitats in Chile (Jaksić & Yáñez, 1980). Here the introduced European rabbit and black rat formed a substantial part of the diets of both Barn Owls and Great Horned Owls, with smaller rodents in the Barn Owl and more birds in the Great Horned Owl's prey.

Female Great Horned Owls have on average 7% longer wings and are 30% heavier than males. Their predatory power must therefore be somewhat greater, though the difference is smaller than in Eurasian Eagle Owls. No data on average or absolute differences in prey size between the sexes are available, however, for this species.

BREEDING HABITAT AND BREEDING

In the breeding habitat in open woodland Great Horned Owls usually nest in the abandoned stick nests of diurnal birds of prey, most often in those of the Red-tailed Hawk in the top of a deciduous or coniferous tree. Since they begin their breeding activity early in the season, when the trees are still bare of leaves, these nests can be very conspicuous. The owls make no repairs to the nests. Often such nests are alternately occupied by Red-tailed and Red-shouldered Hawks, Goshawks, Great Horned Owls and sometimes Barred Owls. Old squirrels' nests, and nests belonging to Swainson's and Ferruginous Hawk, Magpie, Crow, Bald Eagle, Osprey (Hickey, 1969), Great Blue Heron and Night Heron, even Harris' Hawk in spiny mesquite, and Caracara in saguaro organpipe cacti, have all been occupied by the Great Horned Owl, as well as shallow tree holes and lofty crotches in tall hardwood trees. Large hollows in snags and the decayed tops of old and dead trees have also been used, though none were as deep as those favoured by Barred and Barn Owls. Of 86 nest sites reported in Indiana and Ohio, 44 were in snags, holes in trees and the like, the remaining ones in Red-tailed Hawk's nests (Austing & Holt, 1966:66). Great Horned Owls also nest in clefts and fissures in rocks and on cliff ledges, though less regularly than Eurasian Eagle Owls. Ground nests, at the foot of large tree trunks, in long grass (Florida) and under bushes in the desert do occur but again are much less frequent than in the Eurasian Eagle Owl. Eggs have been found in Newfoundland on frozen ground surrounded by snow and some owls' feathers, and also in an old Canada Goose nest on a tussock of grass (cited by Bent, 1938). Numerous other, mainly incidental, nest sites have been reported. Nest sites in Middle and South America are barely known. It is unclear whether the Great Horned Owl's original nest sites are holes in trees and rocks or large stick nests in trees.

The Great Horned Owl is strictly territorial. In the cultivated parkland of Michigan the defended nesting territory was almost identical with the roosting area and surrounding hunting range in winter (Craighead & Craighead, 1956). It was on average 16km^2. Elsewhere, much smaller territories, of less than 2.6km^2, have been reported (Baumgartner, 1939), e.g. in Wyoming where an average size of 2.1km^2 and an average diameter of 2.6km was recorded, which compares well with the territory size of the Red-tailed Hawk (2.1km^2, average diameter 2.3km). For the Long-eared Owl, data from Wyoming were 0.5km^2 and 1.1km, respectively (Craighead & Craighead, 1956). In an 11-km stretch of the Columbia River in Washington nests were 0.8–10.3km apart, average 3.9km.

Courtship is a very early and noisy affair with much bill-rubbing, mutual head-preening, deep, sonorous calling and a high-pitched giggling, screaming and bill-snapping, combined with ludicrous antics involving drooped wings, cocked tail and frog-like swelling of the white throat.

Egg-laying is accordingly early: in Florida sometimes as early as December and in most of the colder parts of the United States in February, when the eggs and the sitting female can still be exposed to heavy spring storms and late blizzards. In California, too, eggs have been found as early as January; in northern Canada and Alaska not before April. In Michigan the earliest laying date was 12 February, the latest 19 March, which is earlier than those recorded for the Red-tailed Hawk (26 March and 2 April, respectively), while the Long-eared Owl did not begin laying before 28 March (Craighead & Craighead, 1956). Clutch size is 1–2, but may rise to 5 or 6 in years of food abundance, with an average in Michigan of 1.8 and in Wyoming of 2.2. Eggs in the eastern United States average 56.1 × 47.0mm, in Labrador 56.2 × 47.4mm, in California 53.4 × 45.1mm, in Baja California 53.3 × 43.7mm (Bent, 1938) and in Chile 50.5 × 42.1mm (Johnson, 1967); the latter eggs are about 28% smaller than the North American ones. In contrast, North American eggs are smaller by about 15% than the eggs of the Eagle Owl from Europe and Siberia. The male hunts for the incubating and brooding female and for the nestlings. He usually provides his family with an abundance of prey which he deposits in the nest or on the nest's edge. In one famous case from New England the nest with young contained "a mouse, a young muskrat, two eels, four bullheads (catfish *Ictalurus*), a Woodcock, four Ruffed Grouse, one rabbit, and eleven rats" (C. E. Bendire, 1892, cited by Bent, 1938:311). The young (see p. 256) remain in the nest for 5–6 weeks and are able to fly well by 9–10 weeks of age (Austing & Holt, 1966). Most young owls leave the nest during the first half of April when numerous migrant birds pass through on their way to their northern breeding grounds and small mammals become more active or produce their first litters. This enables the parent owls to take good care of their young and themselves, but the young owls remain dependent on their parents throughout the summer, sometimes begging for food up to the latter half of October. The mean number of young produced per breeding pair was 1.1 in Michigan, 2.0 in Wyoming and 2.4 in Saskatchewan (Craighead & Craighead, 1956; Houston, 1971).

FOOD AND FEEDING HABITS

The Great Horned Owl is a generalized and opportunistic feeder, hunting from vantage points on conspicuous rocks, tall

trees, telegraph poles and roadside posts in open country. It flies from perch to perch over a distance of 20–100m (Marti, 1974) and apparently does not hunt on the wing (Rudolph, 1978). Its prey is very varied, including both large and small items.

When summarized, 77.6% of prey numbers in North America consisted of mammals, 6.1% of birds, 1.6% of other vertebrates (including rattlesnakes) and the balance was made up of insects, spiders, scorpions, crabs, etc. Mammals probably formed the basic diet and, among these, hares and cottontail rabbits were the main prey (68.5% in 4,838 pellets examined in the north-central United States) (Errington *et al.*, 1940), followed by microtine rodents such as meadow voles and also white-footed mice. In total, small mammals formed 89.0% of the prey as compared with 92.4% in the Red-tailed Hawk. When rodents are scarce in winter the numbers caught may be less, as in Michigan in 1942, when they dropped to 40.5%, as against 62.1% in 1948, while the number of birds taken decreased from 59.6% (1942) to 29.7% (1948) (Craighed & Craighead, 1956). Similar data are available from central Alberta, where in 1966 only 2% of prey numbers (23% of biomass) consisted of snowshoe hare while the numbers rose in 1971 to 27% (81% of biomass). Simultaneously, mice and voles had dropped from 18% to 4% of biomass and Ruffed Grouse from 23% to less than 0.5% of biomass (McInvaille & Keith, 1974). In the short-grass prairies and bush-grass foothills of Colorado hare and cottontail predominated as food in October–December (42.9% of numbers) and were least represented in April (9.3%), while voles were mostly taken in May (32.2%) and least in October–December (10.2%); birds never amounted to more than 6% and were least represented in June (1.6%). Mean prey weight was 177g (most prey 20–50g), as against 46g in the sympatric Barn Owl and 30g in the Long-eared Owl (Marti, 1974). In semi-arid regions of California 76.6% of prey numbers consisted of mammals, 4.2% of birds and 15.0% of insects, mainly Jerusalem crickets. In central Chile these figures were 74.9%, 9.8% and 12.2% (mainly spiders *Grammostola*). Most mammals weighed over 20g in Chile and the introduced rabbit and brown and black rats were predominant. In California 29 of 37 terrestrial rodent species (78%) present were recorded as prey, in Chile 12 out of 15 (80%) and in Colorado 18 out of 18 species (100%) (Jaksić & Marti, 1984). The total list of mammal species caught has never been drawn up, but the number must be considerable (see Errington *et al.*, 1940) and include voles, pocket gophers, mice, woodrat, brown and black rats, kangaroo rats, prairie dogs, chipmunks, ground squirrels, arboreal squirrels, flying squirrel, woodchuck, muskrat, porcupine (sometimes with unpleasant, if not fatal, results; see Eifrig, 1909), opossum, weasel, mink, skunk (including adults!), striped skunk, fox, domestic cat, shrews and bats (sometimes as a specialized diet; see Baker, 1962). Though extraordinarily varied, the Great Horned Owl's prey is not generally as large as that of the Eurasian Eagle Owl. The average body weight of prey taken by Eurasian Eagle Owls in Spain was six times greater than that taken by Great Horned Owls in a comparable mediterranean vegetation in California (Jaksić & Marti, 1984). Instances of the Great Horned Owl catching large preys and scavenging on carrion and recently trapped fur animals have been reported in Canada, most frequently in winter.

The Great Horned Owl's avian prey is as varied in species as in kind and size (Errington *et al.*, 1940). It includes Ptarmigan, Ruffed Grouse and Bobwhite, several kinds of duck (e.g. Mallard, Pintail, Canvasback), geese, swans, herons, coots, rails, waders, pigeons, several kinds of owl, woodpeckers, Magpies, Crows, Starlings, Red-winged Blackbirds and numerous other medium-sized and small passerines, up to a total of more than 50 species. Great Horned Owls make night raids on the nests of other owls, hawks and Crows and seize Crows on their communal roosts. When tempted they enter farmyards and breeding pens and catch domestic fowl and turkeys.

Data from South America are very scarce but include arboreal marsupials (didelphids), monkeys and herons in Surinam (Haverschmidt, 1968), small terrestrial mammals and rabbits in Chile (see above) and adult and young Southern Black-backed or Kelp Gulls at a breeding colony on small islands in the Beagle Channel in Tierra del Fuego at almost 55° south (Humphrey *et al.*, 1970).

To sum up, the Great Horned Owl has a wider range of prey than that known for any other owl or bird of prey in North and South America. It is nevertheless a less formidable predator than the Eurasian Eagle Owl.

MOVEMENTS AND POPULATION DYNAMICS

The Great Horned Owl is virtually sedentary. Breeding pairs in Wyoming have held the same territory for seven and eight consecutive years (Craighead & Craighead, 1956:222) and in Saskatchewan for a much longer time (Houston, 1978). Movements to lower elevations with less snow cover in winter have been recorded in the Rocky Mountains. In the rare years when Ptarmigan move en masse south in Labrador they are usually followed by corresponding flights of Great Horned and Snowy Owls. Other autumn and winter flights involving hundreds of individuals have been reported irregularly for the whole of Canada and the northern United States and were usually thought to be associated with low prey numbers further north. A famous southward irruption took place in 1915–16, when hundreds of these owls were shot on south Vancouver Island; at the same time white Great Horned Owls appeared everywhere in southwestern Canada and as far south as Portland, Oregon (Bent, 1938:333). Of 2,329 young banded at their nests around Saskatoon, Saskatchewan, 209 were recovered. Of these, more than half were picked up during the first half-year of their lives and within a radius of 10km. Only 36 had come further than 250km; the longest flight was one of 1,415km, to Nebraska. The oldest resident bird recorded was one of 13 years and 6½ months (Houston, 1978). Massive "flights" must result in noteworthy local population declines in the northern countries of origin. Peak populations, on the other hand, involving 2–3 times the number of breeding pairs of other years and correspondingly high breeding successes, are known from central Alberta when snowshoe hares were extraordinarily numerous (McInvaille & Keith, 1974) and also from the eastern Great Basin Desert of Utah following a population high of blacktail jackrabbits (Smith & Murphy, 1979). No movements and no population fluctuations are known for areas outside North America.

GEOGRAPHIC LIMITS

It is difficult to imagine what limits the Great Horned Owl meets in its vast geographic range, which covers 122 latitudinal degrees north to south. The owl's absence from lowland tropical

rain forest does not seem to be the result of intolerable temperatures since it does occur in tropical mangroves on the South American north coast. North of the arctic timber line it is the Snowy Owl and not the Great Horned Owl which occupies a habitat that obviously cannot support two large species of owl. Being resident, the Great Horned Owl must nevertheless be able to tolerate the low temperatures of the continental northern winter. In contrast to a species like the Red-tailed Hawk, which has a mean body temperature of 41.1°C, the Great Horned Owl (mean body temperature 39.5°C) did not show a substantially lower body temperature under extremely cold laboratory conditions (difference 0.8–1.5°C, as against 0.8–3.5°C in the Red-tailed Hawk), but instead responded with longer periods of inactivity when exposed to excessive cold and deprived of food (Chaplin et al., 1984).

LIFE IN MAN'S WORLD

Like the Eurasian Eagle Owl, the Great Horned Owl has been severely persecuted by man, but probably only by western man, not by the native Indian. In western North America (and perhaps elsewhere) the Great Horned Owl was and still is surrounded by superstition, as Margaret Craven has so movingly illustrated in her novel *I Heard the Owl Call my Name* (1967). Of 209 owls ringed as nestlings and subsequently recovered in North America, 56 were shot, 41 trapped, 15 hit by a car, 14 found dead on a highway and 13 electrocuted by overhead power lines (Olendorf et al., 1981). Of all mortality causes, highway casualties and electrocution by overhead wires seem by far the most serious, being hard to avoid. But, above all, shooting and un-sportsman-like trapping at game farms, cutting of woodlots in forests and on farmlands and destruction of the owl's mammalian prey will surely decimate this species over the next few hundred years if nothing is done to curb these activities. Though the Great Horned Owl is still astonishingly widespread in some cultivated areas, its future needs to be considered with care. Ploughing of originally forested land and extensive rodent control have in many places all but annihilated the Great Horned Owl's mammalian food. As a result it now feeds increasingly on birds. In South America, however, the owl has profited from the introduction of the Old World rabbit, which now forms a major part of its diet in semi-arid Chile, leading to a recent increase there in numbers of Great Horned Owl (Jaksić & Marti, 1984). Biocide poisoning has occurred, but has not been widespread or well documented as in the case of falcons, eagles and other diurnal raptors (Hickey, 1969; Peakall & Kemp, 1980; Blus et al., 1983). When left in peace, the Great Horned Owl thus seems to be able to survive well in rural areas close to man. It defends its nestlings against human intrusion more effectively even than the fiercest of the other owl species. Instances of aggression towards humans have been described as involving spectacular no-nonsense attacks (Keys, 1911; Bent 1938:313; Austing & Holt, 1966), even in well-known winter skiing resorts when breeding early.

"Often described as the fiercest and most savage of all predatory birds, it [the Great Horned Owl] has been shot, trapped, and discriminated against for years throughout its wide range, by farmers, sportsmen, gamekeepers, and even some naturalists, but it continues to survive as one of our commonest large owls" (Austing & Holt, 1966:13). The Great Horned Owl is nevertheless a bird more of the past than of the present. Its prey is generally decreasing in size and so probably, in the long run, is its own body. The remains of Great Horned Owls from Upper Pleistocene cave deposits in California, named *Bubo sinclairi*, were larger than the bird's descendants today (Brodkorb & Mourer-Chauviré, 1984; see, however, Miller, 1916). The same is true of other owls from Pleistocene America, such as the very large owl recently found in the Late Pleistocene (Rancholabrean) of Georgia (Olson, 1984) and, more impressive still, the giant *Ornimegalonyx steroi* from Cuba, about twice as large and probably twice as heavy as the present-day central Asian Eagle Owl and Snowy Owl (e.g. femur length 161mm, as against 108mm and 96.4mm, respectively; Arredondo, 1975). One wonders what this owl looked like; it was most probably not related to *Bubo*.

An unknown member of the genus *Bubo* must have arrived in America over the Early or Middle Pleistocene Bering Sea land bridge and immediately have conquered the whole of America, from Alaska to Tierra del Fuego. The resulting small tropical South American Great Horned Owl *Bubo virginianus nacurutu* of today strikingly resembles the Spotted Eagle Owl *Bubo africanus* of the African savannahs, but the latter is the ancestor rather than the descendant of its huge northern relative, in this case the Eurasian Eagle Owl *Bubo bubo*.

EURASIAN EAGLE OWL
Bubo bubo

With a wingspan of 155–175cm, a body length of 48–72cm and a body weight of 2,400–3,000g, the northern Eurasian Eagle Owls are among the largest owls of the northern hemisphere. They are also larger than the owls from the southern continents: the Giant, Milky or Verreaux's Eagle Owl *Bubo lacteus* from the Afrotropics has an average wing length of 94–102%, a body length of 91–112% and a weight of 71–80% of that of the Eurasian Eagle Owl. Data are largely non-existent for the mysterious Banded or Shelley's Eagle Owl *Bubo shelleyi* from the African tropical lowland forests, but the wing length of this owl seems to be about 96% and its body length about 90% of that of the average northern Eurasian Eagle Owls. However, Blakiston's Fish Owl from the Asian Far East has a recorded wingspan of 180–190cm and is larger than Far Eastern Eagle Owls by almost 10%, though the data are far from complete. Eurasian Eagle Owls are by no means the largest owls ever to have lived. Fossil owls of more gigantic proportions have been discussed in the chapter on the Barn Owl *Tyto alba*. During the Middle Pleistocene (Mindel Glaciation) Eagle Owls in southern France were larger than recent birds by probably 6–10% and have accordingly been given a chronological subspecies name *Bubo bubo davidi* (Mourer-Chauviré, 1975), but smaller eagle owls lived during that time on the islands of Corsica and Sardinia (Mourer-Chauviré & Weesie, 1986). Possibly still larger and more robust Eagle Owls, *Bubo binagadensis*, existed even later (Upper Pleistocene) in Azerbaijan, Caucasus (Burtchak-Abramowitch, 1965).

Tropical Africa harbours at present the largest number of *Bubo* owls. These include three forest species with seemingly relict distributions (Shelley's Eagle Owl, Akun Eagle Owl *Bubo leucostictus* and Fraser's Eagle Owl *Bubo poensis*), as well as two savannah species, the Giant Eagle Owl and the Spotted Eagle Owl *Bubo africanus*. Africa has therefore been regarded as the continent of origin of these large owls. A sixth African species is the mountain-inhabiting Cape Eagle Owl *Bubo capensis*, a near relative of the northern Eurasian Eagle Owl, though barely reaching 50% of its weight. It is a powerful predator and may represent a secondary expansion of the northern Eagle Owls into Africa during one of the Pleistocene Ice Ages. Eagle Owls ultimately did spread through northeastern Asia to the Americas (one species: Great Horned Owl *Bubo virginianus*), but failed to reach Australia where their ecological position as large mammal-hunters is occupied at present by a huge representative of the hawk owls, the Powerful Owl *Ninox strenua*. The latter, however, does not reach more than about 96% of the Eurasian Eagle Owl's body length, 82% of its wingspan and 60% of its weight.

The Eurasian Eagle Owl raises significant ecological questions. Being almost ten times heavier than the somewhat similar but miniature Long-eared Owl *Asio otus*, and about six times heavier than the Tawny Owl *Strix aluco*, it kills and devours large numbers of these species, but nevertheless shares with them considerable numbers of relatively small prey, such as voles and mice of open country, grassland and forest edges. On the whole the Eurasian Eagle Owl preys heavily on other species of owls and on diurnal raptors and their nestlings. This does not necessarily mean, however, that all these birds effectively compete for the same food under the same conditions. Competition for nest sites certainly exists between Eurasian Eagle Owls and cliff-nesting eagles, Ravens and other large birds, but seldom is this actually a risk to these birds' lives. Still, when Eurasian Eagle Owl and Peregrine Falcon *Falco peregrinus* attempt to nest on the same cliffs bordering narrow river valleys they rarely manage to cohabit, to the detriment of the Peregrine.

The following species account compares the Eurasian Eagle Owl with other *Bubo* owls and diurnal birds of prey in terms of their geographical history, present geographic range, species diversity and ecological relations.

GENERAL

Faunal type Palaearctic.

Distribution The whole of temperate and boreal Eurasia, from Norway in the west to Sakhalin Island in the east, but not extreme northeast Siberia, nor Kamchatka and Japan (straggling to Hokkaido and possibly nesting on the southern Kurile Islands, Etorofu and Kunashiri), where locally replaced by Blakiston's Fish Owl *Ketupa blakistoni* of similar size and habits. The European Eagle Owl is also absent from the British Isles and Ireland where it is known from Late Pleistocene and prehistoric bones and probably became extinct before the Middle Ages. It does not extend as far north in the Siberian boreal forest belt as the Great Grey and Ural Owls, nor does it seem to reach the southern limit of the Snowy Owl's arctic range, but Russian authors are not explicit in this respect. In the south it penetrates far into the Saharan deserts, nesting in numerous places, includ-

ing the rocky outcrops and oases of Tassili, Ahaggar, in south Algeria, Aïr in Niger (at 18° north) and possibly Tibesti at 21° north in Chad (Simon, 1965), if not right in the desert. Nowhere does it seem to overlap with the Sahelian range of the Afrotropical Spotted Eagle Owl *Bubo africanus*, which reaches the oases of Ennedi in Chad at 17° north, about 400km southeast of the supposed southern limit of the Eurasian Eagle Owl in Tibesti. It does seem to occur, however, in the rocky deserts of central Arabia and the Gulf States and in the deserts and highlands of Iran, but not in the mountain ranges of Yemen and Oman, which are inhabited instead by the Spotted Eagle Owl. The Eurasian Eagle Owl has an additional contiguous Oriental range in the Indian subcontinent and in virtually the whole of China. The southern and eastern limits in Bangladesh, Burma and Indo-China are far from well documented, though it is generally accepted that the species does not occur east of Sikkim and Bangladesh (Ripley, 1982). Map 6.

Climatic zones Almost everywhere, in boreal, temperate, mediterranean, steppe, desert and tropical winter-dry climatic zones, reaching north at least to the July isotherm of 14°C and hot desert temperatures in the south.

Habitat Extremely varied, from boreal coniferous and mixed deciduous forests to mediterranean scrub, wooded and grassy steppes and rocky and sand deserts, provided there are rocks, steep slopes or cliff faces, usually with broad or narrow stretches of open water and always with ample opportunities for hiding in dark places in and under trees and among rocks.

It has nested in the Alps at up to 2,100m altitude and has been recorded hunting beyond the tree line at 2,800m (Glutz & Bauer, 9, 1980). In the Himalayas it occurs at up to 1,800m in the southern foothills and at 4,500m in Ladakh (Baker, 3, 1934:511), but its presence in Nepal is poorly documented (see Ripley, 1982:180). In the east Tibetan highlands it has been found at up to 4,700m, where the wild yak is the characteristic grazing animal, and in the Hsifan mountain range with its wild and deep, narrow canyons (Schäfer, 1938).

In the closed mountain forests, in the Himalayas and the Alps, it is replaced by the Tawny Owl. In hot deserts, where the main animal life is active during the cool hours of darkness only, Eurasian Eagle Owls feel equally at home, but the presence of rocky outcrops (or the Egyptian pyramids, for that matter) is usually a necessity.

GEOGRAPHY

Geographical variations Conspicuous, generally clinal and following well-known climatic and eco-geographical trends. The plumage is considerably darker in humid oceanic regions than in arid continental ones. Size increases from warm to cold northern areas or high-altitude surroundings in the western Himalayas and Tibet.

Desert Eagle Owls of the races *Bubo bubo ascalaphus* and *B. b. desertorum* have pale-cream and cinnamon-brown desert colorations with a mottled rather than streaked design; they are small and relatively long-legged and short-tailed, while in their extreme form only the upperside of the toes is sparsely feathered. The number of nominal subspecies is large, varying among authorities between 17 (Dementiev & Gladkov, 1, 1951) and 24 (Peters, 4, 1940).

The west European race *B. b. bubo* is darkest throughout and almost black above, particularly in southern Norway. Eurasian Eagle Owls of west-central Siberia (*B. b. sibericus* and *B. b. turcomanus*) show a conspicuous amount of white in their plumage, though not as much as Great Horned Owls in Canada, nor do they approach the arctic breeding range of the Snowy Owl that closely. If one takes the gigantic central Siberian Eagle Owl (*B. b. sibericus*), with wing lengths of on average 460mm in males and 490mm in females, as a standard, central European birds (*B. b. bubo*) are about 96–98% of their size, Iberian (*B. b. hispanus*) 92–94%, southwest Asian (*B. b. nikolskii*) 89–92%, south Asian (*B. b. bengalensis*) 78–80% and North African (*B. b. ascalaphus*) 75% (mainly after data from Vaurie, 1960, and C. S. Roselaar). Intermediate populations, either as gradual clines, or evolved after secondary contact with formerly isolated populations, connect the diversity in coloration and size throughout the range.

Intermediates exist in Kashmir even between the large and pale central Asian races from north of the Himalayas and the small, dark race *B. b. bengalensis* from the Indian subcontinent. Also in the Middle East, between the large and dark northern race *B. b. interpositus* and the pale desert race *B. b. desertorum*, with possible hybrid populations, known as *Bubo bubo aharonii*, in the Jordan valley region in Syria, Lebanon and Israel (Hartert, 1912–21:967; Vaurie, 1960:7–9). A similar hybrid population between *B. b. nikolskii* and *B. b. desertorum* is supposed to occur on the Euphrates in southern Iraq (Vaurie, 1960:8). Geographical variation also exists in eye colour, which is orange in most races but yellow in *B. b. desertorum* from the Saharan and Arabian deserts and orange-yellow in *B. b. ascalaphus* from northwest Africa. Because of its small size, alleged difference in territorial song and the probably sympatric presence of Eagle Owls of European colour type and size (*B. b. hispanus*) in the northwest mountain ranges of Morocco, Algeria and Tunisia, the Desert or Pharaoh Eagle Owl has been regarded by some authorities as a distinct species *Bubo ascalaphus* (Savigny, 1809), or at least treated as a borderline case between a species and a subspecies (see Vaurie, 1960). Intermediate birds between the two groups are known from the Middle East (see above), but not so far from northwest Africa.

Related species Though generally treated as conspecific with the Eurasian Eagle Owl, the Pharaoh Owl *Bubo ascalaphus* and the Indian Eagle Owl *Bubo bengalensis* have sometimes been regarded as separate species, clearly forming part (allospecies), however, of the wide-ranging superspecies Eurasian Eagle Owl. The powerful Cape Eagle Owl *B. capensis* of the high mountain ranges of south and east Africa north to the Ethiopian highlands and south Eritrea (Benson & Irwin, 1967) is another member of this superspecies, differing from the northern Eagle Owls mainly in size and range. Its wing length is 86–88% of that of the European and 112–114% of that of the Pharaoh Eagle Owl (*B. b. ascalaphus*). As there is no distributional contact between the Cape Eagle Owl and any of the recognized subspecies of the Eurasian Eagle Owl, the former is generally treated as a distinct species. However, like the African Mountain Buzzard *Buteo*

Eurasian Eagle Owl *Bubo bubo*
Central European race *B. b. bubo*

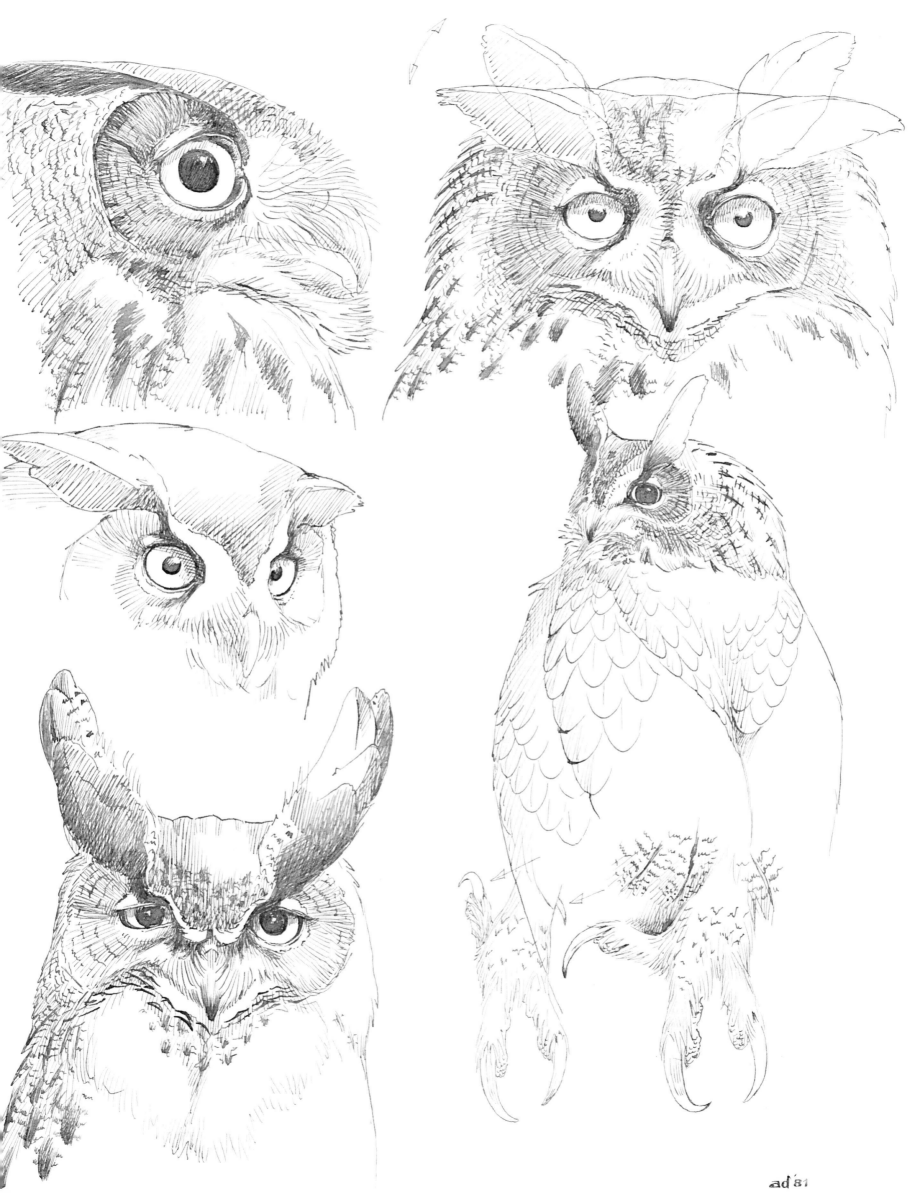

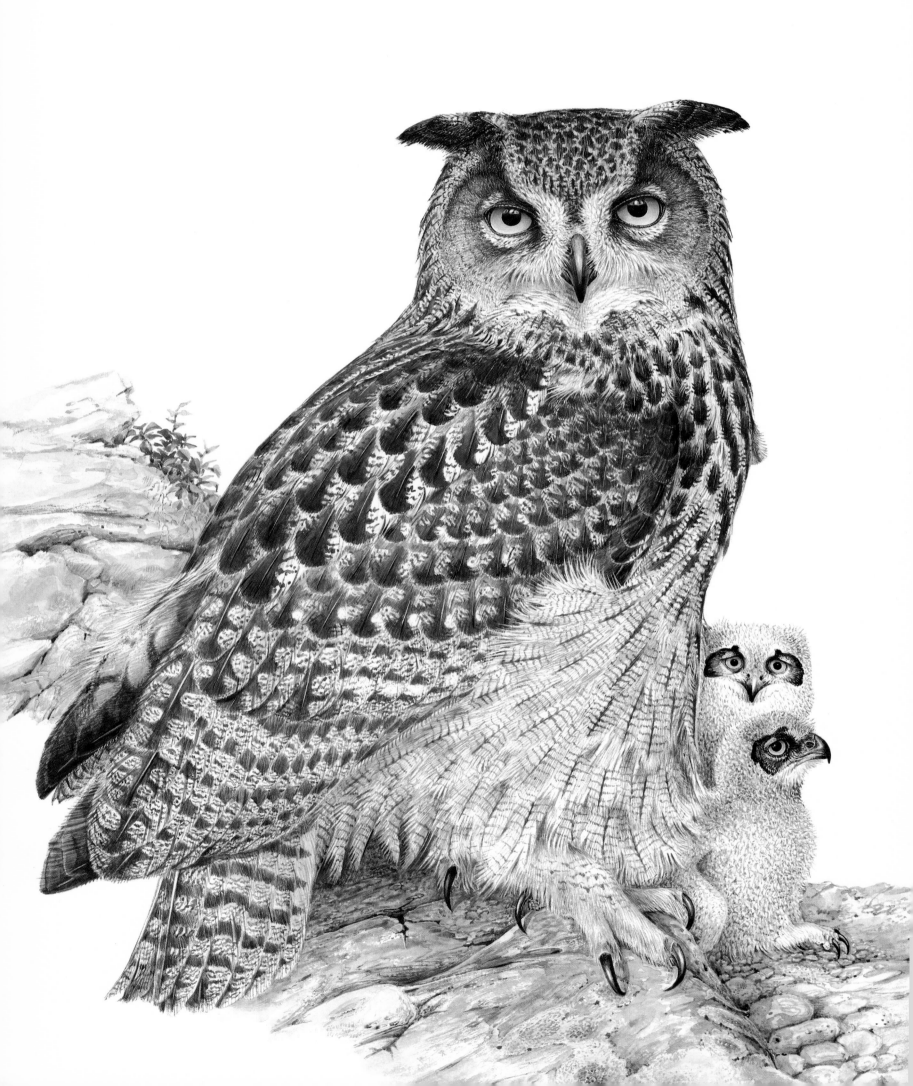

oreophilus, it may have originated from a northern, Eurasian stock during one of the Pleistocene periods of extensive glaciations in western Eurasia simultaneous with increased humidity in Africa. The Spotted Eagle Owl *Bubo africanus* is a still smaller Afrotropical representative of the genus *Bubo*. Its wing length is on average 74% and its weight a mere 26% of that of the European Eagle Owl (*B. b. bubo*). It probably represents the savannah form of the basic African stock from which all northern eagle owls are supposed to have derived. A relatively recent derivation of the Eurasian Eagle Owl is the American Great Horned Owl *Bubo virginianus* which, though as ferocious a hunter as *Bubo bubo*, even in its large Canadian form is only 80% in wing length and barely 60% in body weight of the average of that species. Nevertheless, in an English zoo, a male Great Horned Owl and a female Eurasian Eagle Owl produced remarkably intermediate hybrids (Risdon, 1951).

STRUCTURE

Together with the Snowy Owl the Eurasian Eagle Owls are the largest of the world's owls. Their sumptuous plumage makes them appear larger still, and they have broad skulls, heavy, well-feathered legs and toes and formidable claws. Osteologically they are essentially similar to the screech and scops owls *Otus* and the wood owls *Strix* and *Ciccaba* (Ford, 1967). The outer ear openings of the Eurasian Eagle Owl are oval in shape, uncomplicated and relatively large. In females they measure (vertical axis) on average 31.7mm on the right-hand side and 27.4mm on the left (left 14% smaller than right); in males the measurements are 26.8mm and 24.4mm, respectively (left 9% smaller than right). The asymmetry is noteworthy, as is the fact that the smaller opening is always the left one (Norberg, 1977). The sclerotic ring surrounding the eye forms a long bony tube, the length of which is 0.7 times to nearly equal the diameter of its anterior opening. This suggests a highly developed visual acuity. In its length the sclerotic ring is surpassed only by that of the almost diurnal Snowy Owl (Ford, 1967; Mikkola, 1979).

BEHAVIOURAL CHARACTERISTICS

Songs and calls The male's advertising and contact call with the female is the well-known and far-reaching sonorous *oohoo* or *oohu* with emphasis on the first syllable, from which the species' imaginative German name *Uhu* is derived. It is low, 250–350Hz, deeper and more impressive than the Great Horned Owl's call. The female call, often heard in antiphonal duet, is higher pitched, sometimes more drawn out, and does not travel as far. Intruding males and other potential dangers are often met with a one-syllabic, terrifying *hoo*. Early courtship song can be very persistent, the male starting before sunset and continuing until half an hour later, at intervals of 8–10 seconds or more (Desfayes, 1951; Glutz & Bauer, 9, 1980). In extreme song position the body is held horizontally with the wings slightly drooped and the tail cocked, not unlike the corresponding posture of the Great Horned Owl, though not as bizarre. Numerous other calls have been described. Giggling, laughing, growling

Eurasian Eagle Owl *Bubo bubo*
Central European race *B. b. bubo* with downy chick

and rattling are uttered at various stages of contact between male and female, when soliciting or during sexual excitement, against intruders of either sex or when attending to nestlings. Alarm and warning notes are a series of impressive barks which may also follow a monosyllabic advertising *hoo* directed against all-too-persistent intruders. Raucous barks recall similar vocalizations in Long-eared and Ural Owls but are still more powerful and impressive. The whole vocabulary has been described in detail by various authors (Lindblad, 1967; Glutz & Bauer, 9, 1980; Cramp, 4, 1985; Piechocki & März, 1985).

Vocal differences between the European and the North African Desert Eagle Owls have been suggested (Hartert, 1913; see Vaurie, 1960:5; Cramp, 4, 1985) and have penetrated the literature but have never been verified.

Circadian rhythm Eurasian Eagle Owls are largely nocturnal but have been observed sunbathing on exposed perches on rocks and in trees. When occasionally they soar high in the air or are otherwise active by day, they have usually been disturbed by crows or humans. Hunting may occur in broad daylight during the northern summer, when activity often starts before sunset and continues all through the short summer night. Otherwise, two activity peaks seem to be the rule, one shortly after sunset and another before sunrise (P. Krantz, cited by Mikkola, 1983).

Antagonistic behaviour The Eurasian Eagle Owl rarely assumes the sleek cryptic posture with vertically raised ear tufts so well known in the small "eared" owls, though it has been observed to do so. When cornered it raises its feathers and spreads its wings in a semicircle, making itself large and impressive (see Glutz & Bauer, 9, 1980:345), and produces fierce bill-clicking. Eurasian Eagle Owls are as a rule much less aggressive towards man at their nest sites than Great Horned Owls and, when appropriate, sometimes even indulge in the broken-wing distraction display. They can be powerful nest-defenders nevertheless (Blondel & Badan, 1976). During the day they tend to be tormented by crows and diurnal birds of prey.

ECOLOGICAL HIERARCHY

The Eurasian Eagle Owl is a powerful hunter and no other owl is known to prey so heavily on all owls and diurnal birds of prey which happen to occur within its hunting range. Conversely, no other owl has been reported to kill and eat a Eurasian Eagle Owl. No less than 3–5% of the total food numbers and 23–36% of the total bird prey is stated to be owls and birds of prey (Mikkola, 1983). Heimo Mikkola (1976, 1983) has made up the balance of such cases reported in Europe and arrives at the figure 1,288, with reference to 12 species. Primary victims are the Long-eared Owl (768 ×) and the Tawny Owl (286 ×). Others include Little (48 ×), Barn (46 ×), Short-eared (42 ×), Tengmalm's (36 ×), Northern Hawk (17 ×), European Scops (7 ×), Ural (6 ×), Snowy (4 ×), Pygmy (2 ×) and Great Grey Owl (1 ×).

While this does not mean that the Eurasian Eagle Owl competes with all these species for food, it is nevertheless a fact that this owl is a serious predator of most of the prey taken by these other owls (with the exception of the Little Owl and the Scops Owl) in great quantities and in virtually the same places. With

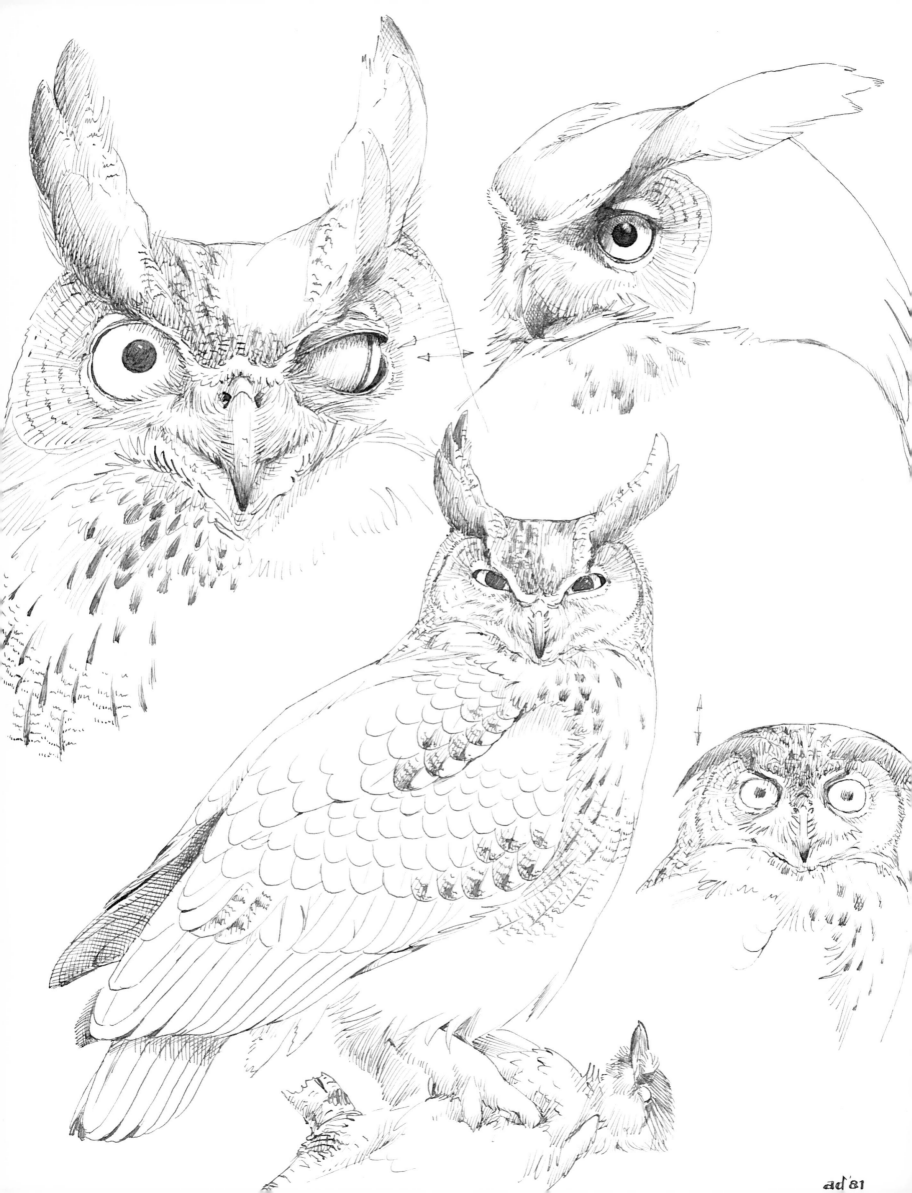

an average body weight of 2.4kg in the male and 3.0kg in the female, the Eurasian Eagle Owl is in no way matched by the Long-eared Owl (10% of the Eagle Owl's body weight), or the Tawny Owl (18%). Even the impressive-looking Great Grey Owl barely reaches more than 38% of the Eagle Owl's body weight. The Eurasian Eagle Owl is also a great nest-robber and some of the data referred to above pertain to nestlings and fledglings rather than to adult owls. If we accept that "larger predators utilize food sizes unavailable to smaller predators" and are therefore at a "competitive advantage", the Eagle Owl has a wider food potential than the smaller owls which share its habitat (Wilson, 1975).

Diurnal birds of prey known to have fallen victim to the Eurasian Eagle Owl are also numerous. The European list mentions 705 instances, referring to at least 18 species (Mikkola, 1983:table 57). Prime victim is the Common Buzzard (327 ×), followed by the Kestrel (194 ×). Others include the Goshawk (55 ×), Sparrow Hawk (35 ×), Peregrine Falcon (22 ×), Rough-legged Buzzard (18 ×), Honey Buzzard (12 ×), Osprey (8 ×), Merlin (5 ×), Montagu's Harrier (3 ×), Saker Falcon (3 ×), Hobby (3 ×), White-tailed Eagle (2 ×, young), Red Kite (2 ×), Black Kite (1 ×), Hen Harrier (1 ×), Booted Eagle (1 ×), Gyrfalcon (1 ×) and Raven. These data do not indicate a list of potential food competitors; rather, they illustrate the wide range of large prey the Eurasian Eagle Owl can handle and the high place it occupies on the predation scale. While no other owl has been known to subdue a healthy Eurasian Eagle Owl, two diurnal raptors, viz. the Golden Eagle and the White-tailed Eagle, have been reported to kill and eat an Eagle Owl (Mikkola, 1983). Indeed, Eagle Owls and Golden Eagles use the same mountain cliffs for nesting purposes and their nests are equally spaced, probably by interspecific territorial pressure. Nest site competition and direct predation prevent any close proximity between Eurasian Eagle Owls and Peregrine Falcons. In south Germany, the Vosges Mountains in France, the Belgian Ardennes and Switzerland reintroductions of the Eurasian Eagle Owl at optimal breeding sites have annihilated the already only lingering Peregrine Falcons, an unexpected and undesirable side effect of sincere nature conservation efforts. When, on the other hand, Eagle Owls disappeared from the rock faces of Burgundy, France, in the early 1960s, the Peregrine Falcon returned there to nest (Blondel, 1967).

The hierarchy of predation can be visualized much more clearly if prey taken by various raptors in the same locality is compared. Generally speaking, the total food scale of the Eurasian Eagle Owl most resembles that of the Golden Eagle, bearing in mind the fact that one species hunts by day, the other by night. Nocturnal habits allow the Eagle Owl to hunt more regularly over cultivated ground than the Golden Eagle can do by day. Nevertheless, the Golden Eagle, whose habitat overlaps almost entirely with that of the Eagle Owl, is more than twice as heavy and has a wingspan 25–30% greater than that of the Eagle Owl, which indicates considerably greater powers of predation. In Spain 49% of the Eagle Owl's food was found to consist of rabbits, as against 40% for the Golden Eagle, 50% for the Imperial Eagle, 61% for Bonelli's Eagle and 79% for the Spanish lynx (Jaksić & Marti, 1984). The local abundance of rabbits probably leads to competition, not directly for food, but for hunting space and nesting territory.

Whether male and female Eagle Owl occupy different positions in the hierarchical scale has never been investigated. Females are larger than males by 7% and heavier by 10%; their claws are 8% longer and considerably stronger: they must therefore be able to master heavier and more formidable prey than males. However, as most prey seems to consist of relatively small animals, interspecific differences in preferred or actual prey size seem to be negligible, at least in Europe. Under primeval or harsh winter conditions the different potential of male and female may be of significance for survival.

BREEDING HABITAT AND BREEDING

In their breeding habitat rocks, boulders, cliff faces and steep slopes bordering river valleys usually provide enough opportunities for Eurasian Eagle Owls to make their nest scrapes in fissures, crevices and holes, and on ledges, often protected by overhanging rocks, bushes or tree trunks. Most of these nest sites are inaccessible, or nearly so, to mammalian predators such as fox or man. Elsewhere, in more densely forested areas, Eagle Owls also generally nest on the ground, among the roots of trees or under tree trunks lying on the forest floor. No real nest is made (see p. 140). In contrast to the American Great Horned Owl, the Eurasian Eagle Owl only infrequently takes possession of the stick nests of birds of prey, either on cliffs or in trees. Those nests found occupied by Eagle Owls belonged to Buzzard, White-tailed and Spotted Eagle and Black Stork. The use of tree holes is even rarer; few pertinent cases have been described (see Mikkola, 1983) and apparently none is known for Russia or Siberia.

The Eurasian Eagle Owl is strictly territorial. Territory size, though varying according to locality, does not seem to differ essentially from that recorded for the Great Horned Owl, or may be somewhat larger, and is of the order of 15–80km^2. Nests, particularly those in river valleys, are often regularly spaced at 2–7km (e.g. Engadin, Switzerland; Haller, 1978); shorter distances have been recorded in Lower Austria (400m; Frey, 1973), the Massif Central, France (400m; Blondel & Badan, 1976) and Auvergne, France (300m; Choussy, 1971).

Breeding activity starts as early as circumstances permit and in the early stages both the eggs and the sitting bird are often surrounded by fresh snow. Only the female incubates while the male provides the food for her and the young until they are four or five weeks of age, when the female gradually resumes hunting for herself and the growing chicks. Clutch size is small, as in the Great Horned Owl, usually 1–2, rarely 3 or 4. Eggs in central Europe average 59.8 × 49.5mm in size (Glutz & Bauer, 9, 1980) and 59.4 × 50.1mm in west-central Siberia (Dementiev & Gladkov, 1, 1951). They are somewhat larger than the eggs of the eastern North American Great Horned Owls *Bubo virginianus virginianus* (average dimensions 56.1 × 47.0mm) (Bent, 1938:302). Eggs from the Indian subcontinent, however, are considerably smaller (53.6 × 43.8mm) (Baker, 4, 1927), as are those from Tunisia (*B. b. ascalaphus*, average 53.2 × 44.6mm) (after Koenig, 1936).

Like all free-nesting owls, Eurasian Eagle Owl chicks have, not a white, but a mottled grey, white and buff second downy plumage which provides effective camouflage on the ground

Eurasian Eagle Owl *Bubo bubo*
One of the West Siberian races, probably *B. b. sibiricus*

among stones, rocks and bushes. From the evolutionary perspective this cryptic coloration may be considered a characteristic acquired once owls had departed from their original nesting habitats in tree holes (W. Scherzinger). Young leave the safety of the nest site when five or six weeks old; they are able to fly by seven or eight weeks of age and are cared for and fed by the parent birds for another month at least. In northern and temperate regions they do not begin to fend for themselves before October. The average number of young reaching the stage of independency is somewhat more than one (Glutz & Bauer, 9, 1980), while the mean number of young per active nest was 1.77 in Bavaria, Germany (Mebs, 1972), 1.1 in Lower Austria (Frey, 1973) and 0.6 in southeast Sweden (Olsson, 1979).

FOOD AND FEEDING HABITS

The Eurasian Eagle Owl does not appear to differ from the Great Horned Owl in feeding habits and diet. Both species are opportunistic predators, adapting their hunting methods and prey to circumstances and seasons. Perching on lookout posts on rocks or poles and in trees is apparently the most frequent method of detecting prey; also recorded are short flights over open meadows and plains, robbing of nests and scavenging in colonies of sea birds on marshy and rocky coasts and among the tree nests of Grey Herons and Great Cormorants (Schnurre, 1941), even hovering over open water when in quest of fish, which is also taken from the shore.

The food is as varied in quality and extent as that of the Great Horned Owl. It is primarily mammalian and may more frequently include larger species such as roe deer fawns, chamois and ibex kids and half-grown wild sheep and their lambs. Small or medium-sized rodents, including common and water voles, vole-rats and other microtine voles, house mice, field mice, brown rats and house rats, hamsters (Schmidt, 1971) and other cricetine rodents, moles, shrews and hedgehogs often compose the main biomass taken. Rabbits and hares do not appear to be as essential in central and northern Europe as they are for Great Horned Owls in North America (Bayle et al., 1987) although they are in southern France and Spain (Blondel & Badan, 1976). In contrast, narrow predator–prey relations between Eurasian Eagle Owls and several kinds of hares exist in Asiatic steppe regions (Dementiev & Gladkov, 1, 1951) where numbers of Eagle Owls and hares fluctuate simultaneously; long-term population studies have still to be made, however. Other mammals not yet mentioned but regularly taken are squirrels, stoats, weasels, mink, marten, fox (mainly young ones), domestic cats and several kinds of bats. The food of any avian raptor is rarely as varied as that of the Eurasian Eagle Owl.

The following attempt to describe its range is based on data supplied by numerous authors (Baumgart et al., 1973; Baumgart, 1975; Cramp, 4, 1985; Frey, 1973; Glutz & Bauer, 9, 1980; Hiraldo et al., 1975; Janossy & Schmidt, 1970; Mauersberger et al., 1982; Mikkola, 1983; Piechocki & März, 1985; Pukinsky, 1977; Uttendörfer, 1952; and others). Over 110 species of mammals (26,500 prey items) and over 140 species of birds (2,300 items) have been described, apart from lizards, geckos, snakes, frogs, newts, salamanders, toads, fishes, shore crabs (Norway) and an occasional large insect or spider (Janossy & Schmidt, 1970). Where rabbits and hares constitute a major part of the diet in warm and arid countries, mammals form up to 90% or more of the total biomass taken. Elsewhere, such as along the coast of the Baltic Sea (Olsson, 1979) and the Caspian Sea (Pukinsky, 1977), large-sized birds, including Mallards, Tufted Ducks, Garganeys, Coots and grebes, form the greater part of the prey biomass. Only under primeval conditions in the European taiga do Capercaillie, Black Grouse, Hazel Grouse and other tetraonid species compose a substantial part of the prey (Janossy & Schmidt, 1970). Ring-necked Pheasants, Common and Red-legged Partridges, Chukars, francolins and quails have likewise been taken in relatively large numbers only where these birds were fairly abundant. Birds of prey and owls may constitute up to 6% of the total prey numbers, while doves and pigeons, gulls, waders, woodpeckers, Carrion and Hooded Crows, Jackdaws, Jays, Magpies, Nutcrackers, even adult Raven, larks, thrushes and Starlings, swifts (including Alpine Swift) and swallows, cormorants, ducks, Grey Herons, Bitterns, Little Bustards and Crane have also been reported.

On Asian steppes and in deserts Eagle Owls take ground squirrels, cricetine or hamster-like rodents, the robust microtine mole lemmings *Ellobius*, gerbils *Gerbillus*, sand mice or jirds *Meriones* and other gerbilline species, long-tailed springmice or desert jerboas *Jaculus* and *Dipus* and the larger jerboas *Allactaga* and *Alactagulus*, the North African fennec foxes *Fennecus*, Turkestan or steppe polecats *Putorius eversmanni*, the evil-smelling zorillas or African striped polecats *Ictonyx*, Houbara Bustards and sandgrouse, including Pallas' Sandgrouse from the windswept central Asian high plateaus. From the European and central Asian mountains, Ptarmigan, snow partridge *Lerwa*, snowcock *Tetraogallus*, Rock and Snow Pigeon, Red-billed and Alpine Chough; also the Casarca or Ruddy Shelduck and other cliff-nesting species have been reported as prey.

To summarize, the Eurasian Eagle Owl's prey range covers that of all sympatric *Buteo* hawks and *Aquila* and *Haliaeetus* eagle species combined. It is not matched by any other owl sharing its geographic range, with the possible exception of the formidable Blakiston's Fish Owl. In the qualitative and quantitative aspects of its trophic relations the Eurasian Eagle Owl is unique among owl species of the world.

MOVEMENTS AND POPULATION DYNAMICS

Like the Great Horned Owl, the Eurasian Eagle Owl is virtually sedentary and strongly territorial. Territorial pairs remain together for life. Young ringed at the nest do not move over more than 100km as a rule, though some have turned up at distances of 200km or more (Mebs, 1972; Glutz & Bauer, 9, 1980). Only in years of food scarcity do individuals from the northernmost populations wander south over considerable distances. Thus, irruptive dispersal flights, comparable to those known for the Canadian Great Horned Owls, have been recorded from Siberia, though in no great detail (Dementiev & Gladkov, 1, 1951). Only central Siberian Eagle Owls move southwestward in substantial numbers, perhaps annually, and appear in the Kazakhstan steppes and Aralo-Caspian deserts in winter. Likewise, Eagle Owls with the characteristics of the west Siberian race (*Bubo bubo ruthenus* or *B. b. sibiricus*) have been found in

Eurasian Eagle Owl *Bubo bubo*
One of the West Siberian races, probably *B. b. sibiricus*, with Siberian Jay *Perisoreus infaustus* as prey

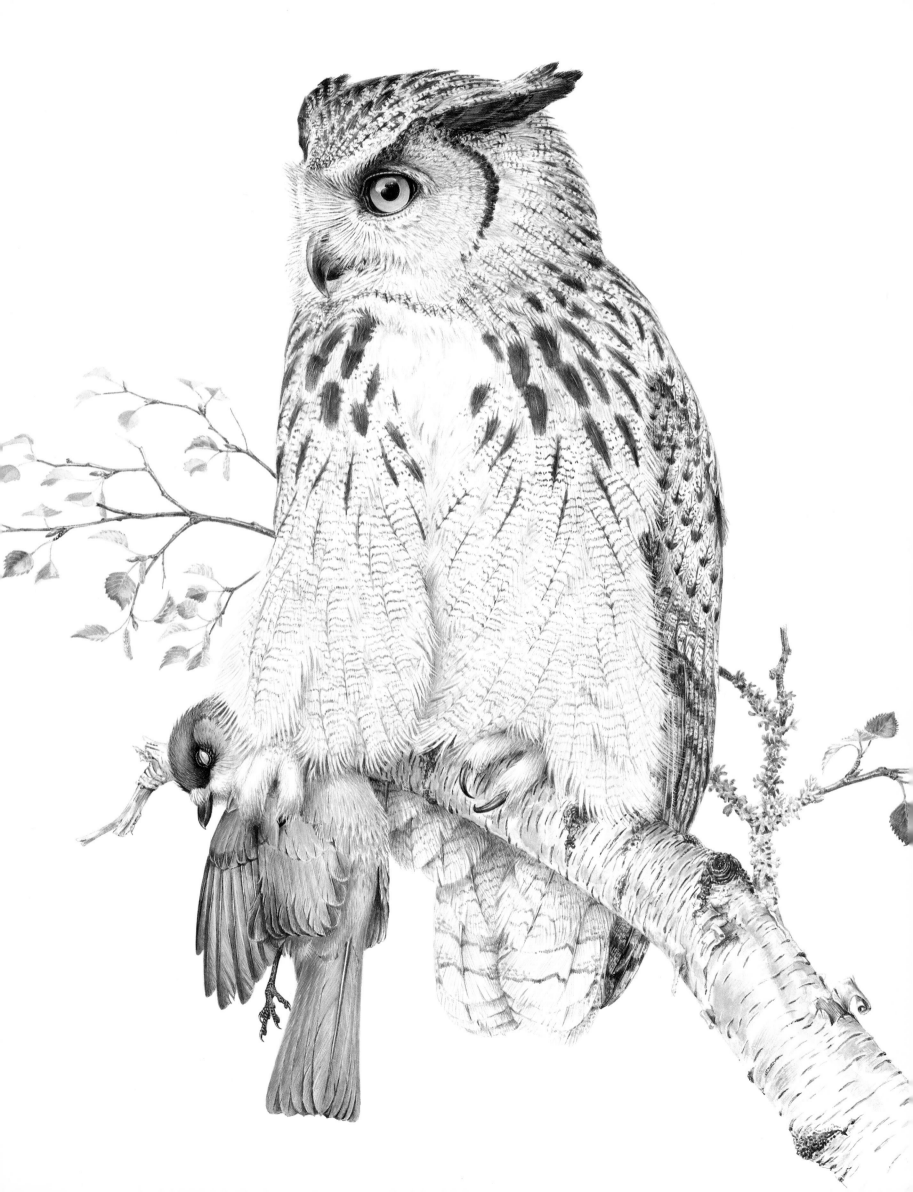

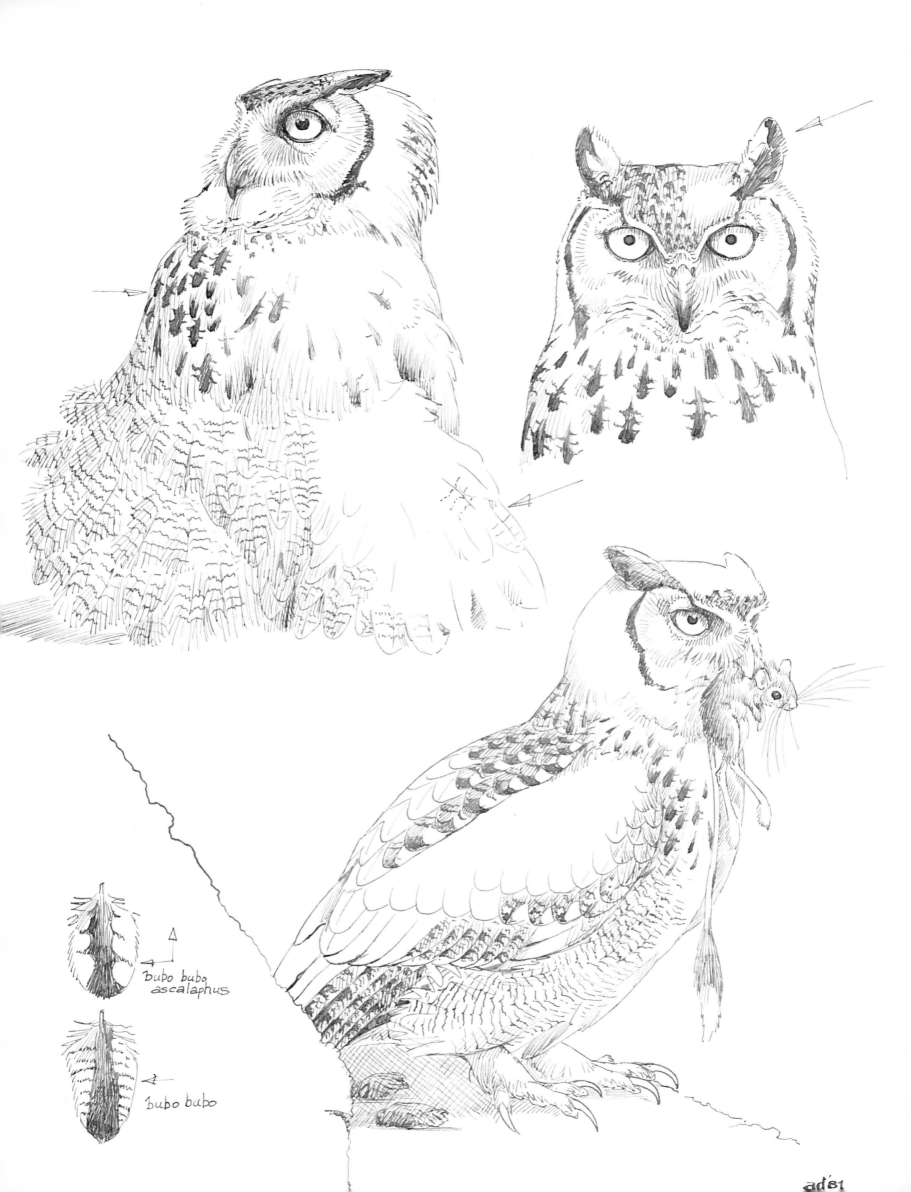

the Dobrudsha, Roumania, in winter (Pascovischi & Manolache, 1970). Because of these, mostly irregular, movements over unknown distances the racial characteristics of Eagle Owls in Siberia are hard to define, as are those of the Great Horned Owl in Canada.

No population fluctuations of any considerable extent have been described, but they are supposed to occur when hare populations in Siberia are at their highest, though they may equally occur elsewhere. Eurasian Eagle Owls are known to live to a considerable age. A Swedish bird ringed as an adult was found dead at the same place 20 years later and had therefore reached a life span of 21 years at the least (A. Lettesjö, cited by Olsson, 1979:8).

GEOGRAPHIC LIMITS

Russian authors are unanimous as to the northern delimitation of the Eurasian Eagle Owl's Asiatic range, but this owl is absent from large areas of northeast Siberia and also from Kamchatka. Winters may be too long and too cold to allow for the year-long presence of so large a raptor, and opportunities for migrations may be unrealistic. Besides, the Great Grey Owl and the Ural Owl, apparently better adapted to forest life in winter, do occur in these regions and their presence may already complete the forests' ecological winter carrying capacity by night, while in Kamchatka the large Golden Eagle and two species of huge river eagles *Haliaeetus* are too great a match for the Eagle Owl by day. Far to the north, in the Low Arctic, the range of the Snowy Owl excludes the presence of the Eagle Owl. At present at least six species of huge *Bubo* owls in sub-Saharan Africa and three species in humid tropical south Asia define the Eurasian Eagle Owl's southern limit.

LIFE IN MAN'S WORLD

The Eurasian Eagle Owl has suffered greatly at the hands of man. In most parts of Europe it is rare or already extinct as a result of superstition and direct persecution (most of West Germany, Denmark, the Netherlands, Belgium, the British Isles, Ireland). On the other hand, the species seems to have profited from the deforestation activities of man, as it now hunts regularly for voles, mice and rats over cultivated fields and grasslands bordering forests and groves. As long as it is not disturbed by day it does not seem to shun man's presence at all and has been found nesting at remarkably short distances from villages and farms for years in succession, and in oases, ruins and village outskirts in the Middle East and the Egyptian deserts. It has even turned up in the city centres of Leningrad and Moscow. Man is nevertheless directly responsible for the Eurasian Eagle Owl's high mortality rate. Enormous numbers of these owls are killed by overhead wires, either by direct collision or electrocution (Mebs, 1972; Olsson, 1979); and it is hard to imagine how in some places where high power lines follow the course of fertile river valleys Eagle Owls are able to survive at all. Mountaineering, alpinism and the extension of lifts and cables into the most remote and inaccessible places in winter-sport areas are seriously disturbing the owl's last refuges, providing almost unavoidable deathtraps (Haller, 1978). Motor traffic and railways take an additional heavy toll throughout the year, particularly on young birds. Biocide poisoning of the natural environment has also seriously affected the Eurasian Eagle Owl. In Sweden and elsewhere organic mercury compounds used as seed dressing have destroyed a substantial part of the owl's breeding population by poisoning its prey and subsequently the owls. After the ban on methyl mercury in Sweden in 1966 and the prohibition of organochlorines in most European countries, the numbers of Eagle Owls have been steadily growing, but the recovery is slow and may not be definitive (Odsjö & Olsson, 1975; see also Conrad, 1977).

Exceptionally, however, in the case of the Eurasian Eagle Owl, man has come to the aid of its endangered populations by starting reintroduction schemes over parts of its lost range, mainly in Germany, but also in the Vosges Mountains in France, in Belgium, Switzerland, Sweden (Bjurholm, 1980) and Norway. Between 1956 and 1972, over 222 owls bred in captivity were released in Germany, but far more than 50% of these had already died within the first four months of their life in nature. Similar losses have been reported from other reintroduction schemes. Nevertheless, in Bavaria alone, more than 200 pairs are presently occupying stable territories – a great success indeed after the entire German population had dropped to less than 50 pairs in the mid-1950s (Herrlinger, 1973; Bezzel & Schöpf, 1986; Mannes, 1987). Such a large and powerful predator as the Eurasian Eagle Owl can hardly be expected, however, ultimately to succeed in adapting itself to a life permanently close to human civilization, let alone find its required variety of prey there. Besides, up to 22% of known mortality causes of these owls in Bavaria still related to direct killing and shooting (Mebs, 1972) and, unbelievably, as late as 1971 in Sweden, the effect of nest-robbing by fanatic egg collectors could still not be ruled out.

Eurasian Eagle Owl *Bubo bubo*
Desert Eagle Owl or Pharaoh Owl *B. b. ascalaphus*

In some senses the Eurasian Eagle Owl is now a bird of the past. It appears to be designed to hunt medium- and large-sized mammals and yet has been forced to turn to voles and other small terrestrial mammals and medium-sized birds. Remains of its known oldest relatives have been found in Upper Eocene or Lower Oligocene deposits at Quercy, France, and have been described by Henry Milne-Edwards as *Bubo incertus* (see Brodkorb, 1971:216), but the real relationship of these fossils to the present *Bubo* owls is quite uncertain. Other large owls have occurred throughout the Tertiary period in many parts of the world. All of these seem to have been mammal-hunters. The decline of the mammal fauna since the Tertiary has certainly led to a decrease in size and predatory power of the Eurasian Eagle Owl's ancestors. The present species may continue on this evolutionary path of decreasing size. It has been suggested that the small Pleistocene Eagle Owl *Bubo insularis* from Corsica and Sardinia, with skeletal material approximately 75% the length of the present continental Eagle

Owl, became extinct simultaneously with the disappearance of its presumed main prey, an endemic species of rabbit or hare *Prolagus* (Mourer-Chauviré & Weesie, 1986). On the continent the Eurasian Eagle Owl may have flourished as an opportunistic feeder, in which respect it is scarcely surpassed by any other living owl except the Great Horned Owl *Bubo virginianus* and the Giant Eagle Owl *Bubo lacteus* from the Afrotropical woodlands, but it is equalled by some of the large *Aquila* eagles which it avoids by day and complements by night. Locally some Eurasian Eagle Owls have specialized in catching freshwater fish, e.g. in southeast Sweden (Olsson, 1979), thereby encroaching upon the ecological specialization of the fish owls *Ketupa*. The chances of the Eurasian Eagle Owl's survival as a widespread species in civilized temperate Eurasia are slight, however.

At least four main ecological questions relating to the Eurasian Eagle Owl remain unanswered. One is the relationship of the African Desert or Pharaoh Owls *Bubo bubo ascalaphus* with the larger northern Eagle Owls (see Related species). The second is the ecological relation between the Indian Eagle Owl *Bubo bubo bengalensis* and the sympatric Dusky Eagle Owl *Bubo coromandus*, the tropical south Asian representative of the African Giant Eagle Owl, of similar size and strength. The third concerns the comparative ecology of the Eurasian Eagle Owl and the tropical Asian *Bubo* species at their mutual geographic boundaries in southeast Asia. The fourth question is how Eagle Owls behave towards the large and impressive Blakiston's Fish Owl *Ketupa blakistoni* in the narrow areas of geographic overlap in Far Eastern Asia, assuming that these species meet at all.

Eurasian Eagle Owl *Bubo bubo*
Desert race, known as Pharaoh Owl *B. b. ascalaphus* from Tunisia, with desert jerboa *Jaculus jaculus* as prey

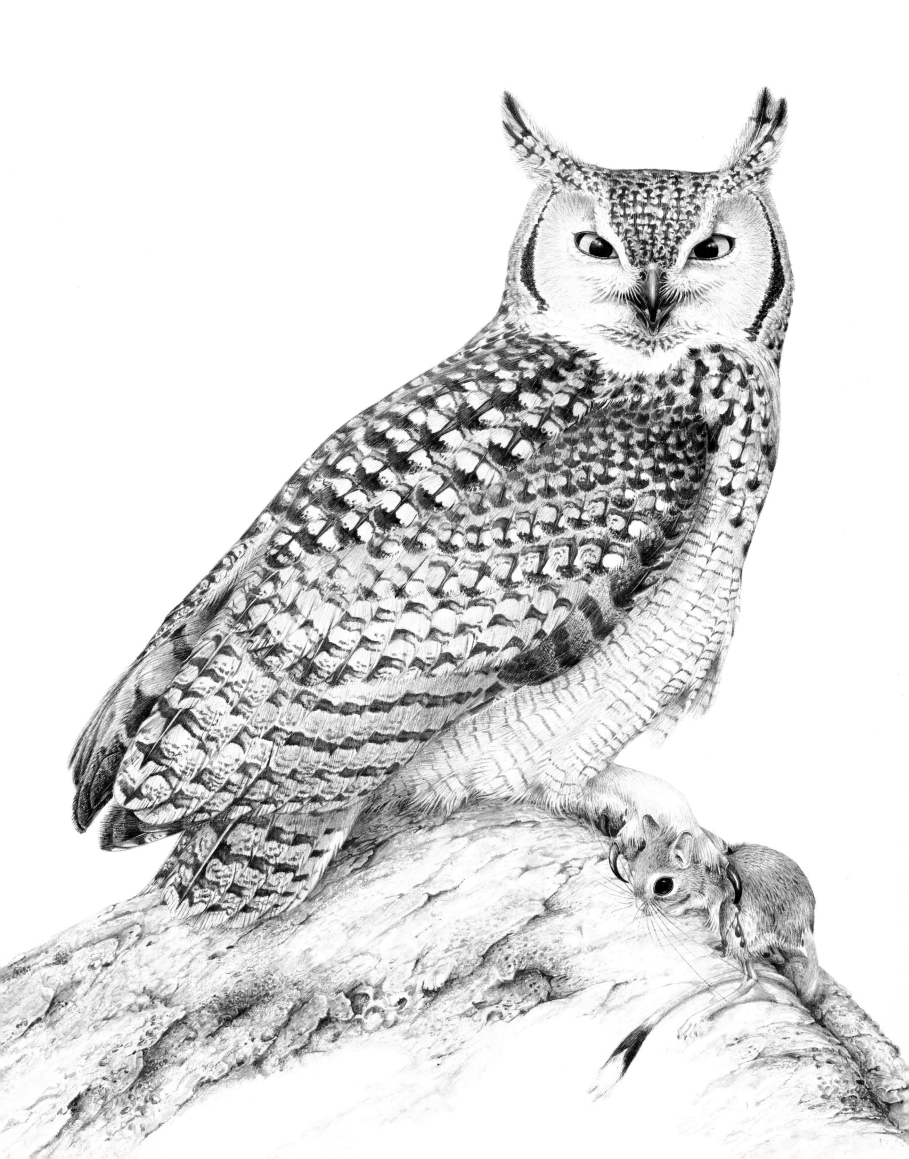

SPOTTED EAGLE OWL

Bubo africanus

With an average length of 43–47cm and a weight of about 690g in southern Africa, the Spotted Eagle Owl has a body mass of only 61% of that of the Cape Eagle Owl *Bubo capensis*, 31% of that of the Giant or Verreaux's Eagle Owl *Bubo lacteus* (data from Biggs *et al.*, 1979), 26% of that of the Eurasian Eagle Owl from Europe *Bubo bubo* and 66% of that of the tropical South American Great Horned Owl *Bubo virginianus*. It is basically a savannah owl and the most inoffensive and most insectivorous of all African eagle owls, with much weaker claws than any other African representative of its genus. Its distributional and ecological relations with the other African *Bubo* species and other owls are worth studying (see already Brooke, 1973), as they seem to involve more than mere ecological vicariance (Voous, 1966). This problem has been discussed in the introductory remarks to the chapter on Eurasian Eagle Owls. Above all, we need to know if the Spotted Eagle Owl and the Desert Eagle Owl *Bubo bubo desertorum* occur together in the 1,800–2,000m-high Aïr mountain massif in the southern Sahara with its deep rocky gullies, as was concluded from specimens collected by A. Buchanan early this century (see Colston, in Snow, 1978:maps 265 and 266), and in the mountainous outcrops of Tibesti, as presumed by K. M. Guichard (Simon, 1965).

In spite of its English name the Spotted Eagle Owl is as strongly barred below as the African forest-inhabiting Fraser's Owl *Bubo poensis* and the Great Horned Owl *Bubo virginianus* from America, but it does have white spots on the upperparts. The presence of distinct northern and southern subspecies groups is a common situation in numerous other African savannah birds. The separation may have occurred in one of the late Pleistocene periods of climatic humidity when evergreen forests extended from coast to coast across equatorial Africa, creating widely separated savannah and steppe habitats to the north and the south.

GENERAL

Faunal type Afrotropical.

Distribution The whole of sub-Saharan Africa, from Richard-Toll in Senegal at over 16° north (Morel, 1972) throughout the whole sahel and savannah belt, including the Aïr and Ennedi oases in the southern Sahara, to the Red Sea coast hills of Sudan at 19° north. Sporadically in most of southern and central Arabia to the Gulf coast of Oman, the Hejaz Mountains and Mecca (Jennings, 1981). South throughout Africa, where it is absent only in the equatorial forests and in the most desolate open grasslands and deserts. Map 7.

Climatic zones All tropical and subtropical zones, including tropical rain forest and desert climatic zones, but not in real desert and rain forest. Mean temperatures reach at least 30°C in the warmest month in the north and drop as low as 20°C in the south.

Habitat Open woodland and savannah, thorn bush and riverine woods, with rocky hills and stony slopes, ravines and *kopjes*, and cultivated parklands, often in the neighbourhood of villages and towns. It is ubiquitous, widespread and common and occurs at up to 1,800m in the Ethiopian Highlands (Urban & Brown, 1971), 2,100m in east Africa (Britton, 1980) and above the closed forest at up to 2,300m in the Cameroon Highlands (Eisentraut, 1963).

GEOGRAPHY

Geographical variation Conspicuous; two groups recognized. A dark-brownish one with fine vermiculations and crossbars and dark-brown eyes north of the equatorial forest belt (*Bubo africanus cinerascens*) and a lighter-coloured one with yellow or orange eyes from most of Uganda and Kenya southwards (*B. a. africanus*). Intergradation is supposed to occur in north-central Kenya, from lowland Garissa on the Tana river to upland Isiolo. A pale specimen has been described as occurring in the Ennedi oasis in Chad (*B. a. kollmannspergeri*) (Niethammer, 1957), another pale race on the lower Tana river in Kenya (*B. a. tanae*) (Keith & Twomey, 1968), and also one in Namibia (*B. a. trothae*); but these seem to be no more than local extremes and can hardly be recognized nominally. Arabian birds form a distinctive race: paler and also more tawny (*milesi*); the iris has been described as bright lemon to orange, and once as dark brown (Meinertzhagen, 1954). Southern birds have wing lengths of 315–370mm, average 340mm (Maclean, 1985), which is greater than those found along the Tana river, Kenya (290–315mm,

Spotted Eagle Owl *Bubo africanus*

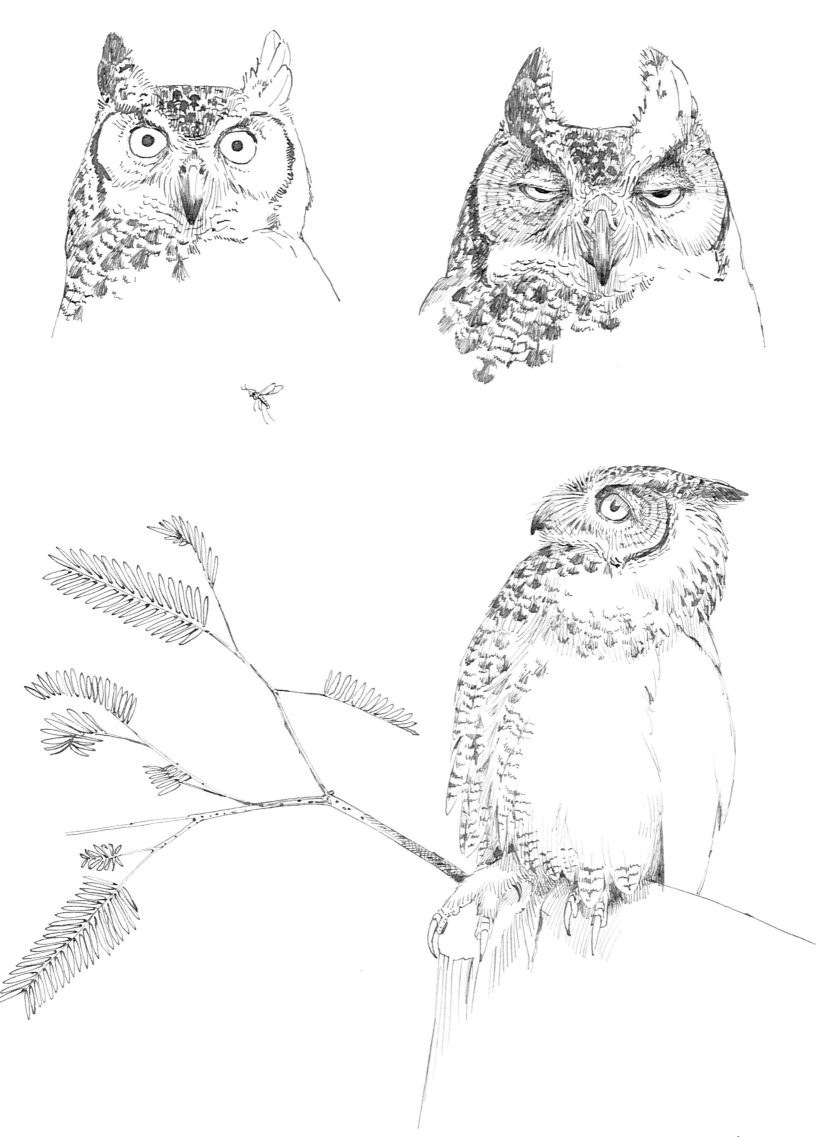

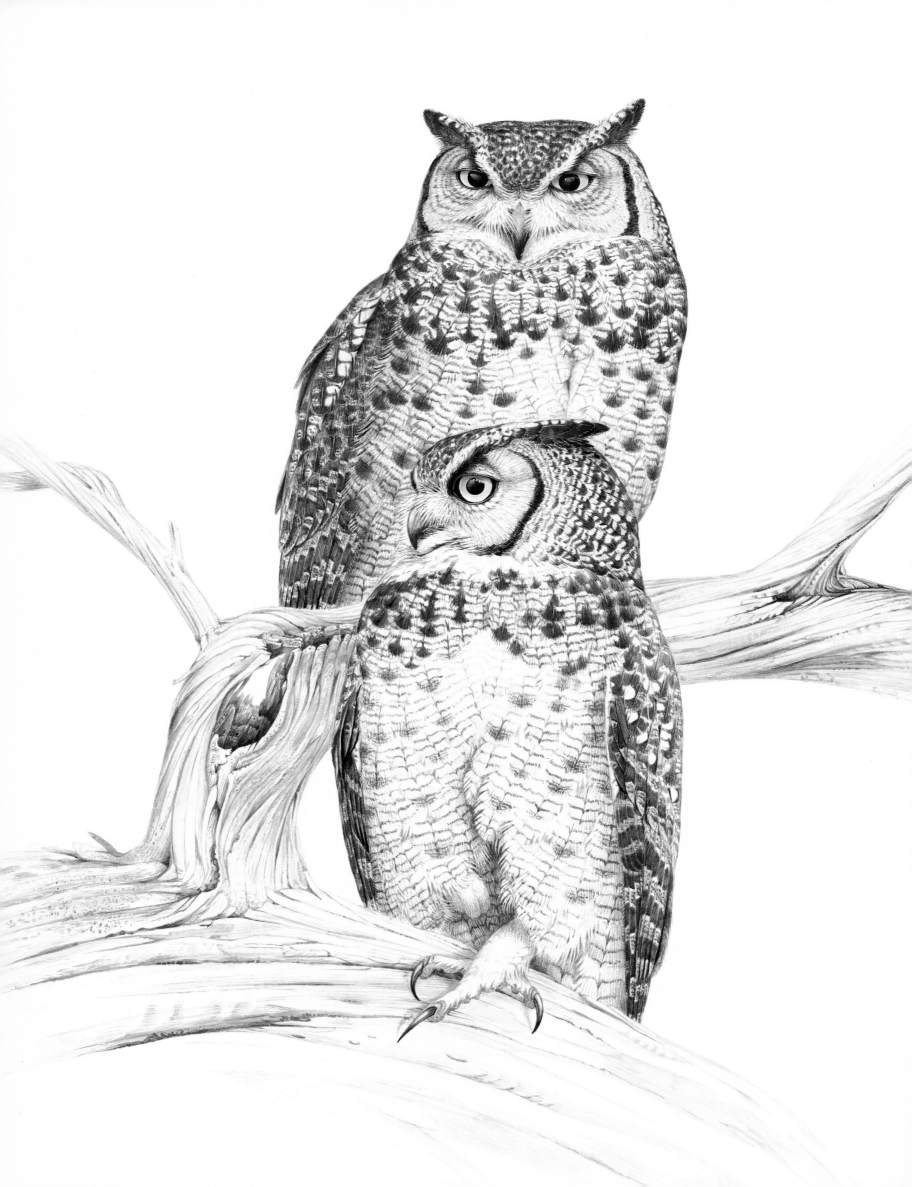

average 306mm, or about 89%) (Keith & Twomey, 1968), in Ethiopia (295–325mm, or 91%) (Moltoni & Ruscone, 1940) and in Arabia (302–330mm, or 93%) (Meinertzhagen, 1954).

Related species It is not clear which of the three Afrotropical forest eagle owls is the Spotted Eagle Owl's nearest relative. It is possible that the Eurasian Eagle Owl *Bubo bubo* shares the same African root (see introductory remarks on *Bubo bubo*). The resemblance of the Spotted Eagle Owl to lowland tropical South American forms of the Great Horned Owl *Bubo virginianus* is striking.

STRUCTURE

The Spotted Eagle Owl is considerably smaller than either the Eurasian Eagle Owl or the Cape Eagle Owl and its claws are less massive. The outer ear opening is non-operculate, oval in shape, and measured about 22×18mm in a specimen from Zimbabwe and 18×11mm in a female from south Arabia. The toes are less densely feathered and more bristled in the northern race *cinerascens*. The eye colour in southern birds is chromate, fiery yellow or orange; brown in *Bubo africanus cinerascens*. The eye is surrounded by a conspicuous, dark-red or purplish-red eyelid, which gives dark-eyed birds a notable *Strix*-like appearance. In some populations distinct brown and grey colour morphs exist.

BEHAVIOURAL CHARACTERISTICS

Songs and calls The territorial call of the Arabian race has been rendered as a soft *hoo-hoo-hoo* and a deep, fluty, nasal *wheeoo*. A similar, mournful hooting is described for the east African race. In South Africa duetting pairs produced a deep *vooo-hoo* (male) and a three-syllabled note *hoo-hoohoo* (female), the middle note pitched a little higher (Steyn, 1982). Vocalizations during courtship are very varied. The alarm call is a wailing *keeyow* (Steyn, 1982).

Circadian rhythm Generally considered nocturnal, the Spotted Eagle Owl has nevertheless been observed following the honey badger on its prowl by day, together with the Pale Chanting Goshawk, which does so habitually (Brown, 1970:161).

Antagonistic behaviour When encountered by day the Spotted Eagle Owl is often mobbed by birds of prey, crows, drongos and rollers. One was observed being attacked and injured by a pair of White-necked Raven in the Serengeti, Tanzania (J. Verschuren). As regards its antagonistic behaviour, only fierce bill-cracking and hissing have been described.

ECOLOGICAL HIERARCHY

Few other owls share the Spotted Eagle Owl's savannah habitat, but the number of diurnal savannah birds of prey is large. Geographically the Spotted Eagle Owl is separated from the Desert Eagle Owls of the *Bubo bubo* complex, but they may meet in Aïr, south-central Sahara. Ecologically it is separated from the Cape

Spotted Eagle Owl *Bubo africanus*
Arabian race *B. a. milesi*. Grey (front) and rufous phases

Eagle Owl which lives at higher elevations and in more rocky surroundings, although they may meet each other in the Kenya Highlands, the Matopos Hills in Zimbabwe, and probably elsewhere. However, it does occur alongside the Giant, Milky or Verreaux's Eagle Owl in most of its range, but the latter is about twice as heavy, generally roosts in higher and more dense riverine woodlots and takes larger prey (e.g. hyrax, hare, Guineafowl). Apart from different trends in feeding ecology, the overlap of prey size ranges in the three species of *Bubo* occurring in the Matopos Hills was considerable (Brooke, 1973). There are no reports of known interspecific confrontations between these owls, but these must certainly occur. Spotted Eagle Owls are known to have killed and eaten a Lanner Falcon in the Kalahari Desert, presumably on its roost at night (Brown, 1970:161), and have also taken a Black-shouldered Kite, another common savannah bird (Steyn, 1984:92).

BREEDING HABITAT AND BREEDING

In its woodland, savannah or steppe habitat the Spotted Eagle Owl selects rocky outcrops, cliff ledges, canyon walls and protected sites on the ground between rocks or tree roots to deposit its eggs. It has also been found nesting in a multitude of other sites, including in and on top of the nests of Hamerkop Storks, on the roof of the huge Sociable Weaver nests (Hoesch & Niethammer, 1940), in old nests belonging to birds of prey and crows in trees, in the crown of *Borassus* and other palms, on haystacks, on the roof and in the gutter of large stone buildings, far less frequently, however, in tree holes. In South Africa Dr Ger J. Broekhuysen listed 359 nest sites, 61% being on the ground or against cliff walls, 26% in trees (including on a drey belonging to the introduced American grey squirrel) and 11% on buildings (cited by Steyn, 1982). It is a dry-season breeding bird, which means that the young are just on the wing when the first heavy rains bring about an abundance of insects. Territory size (3 breeding pairs in 5.8km^2 in Zimbabwe; Steyn, 1982), incubation and care of the sitting female and small young are much the same as in the Eurasian Eagle Owl. Eggs from the Sudan measure on average 48.4×40.3mm (data from Koenig, 1936) and those from southern Africa 49.1×41.1mm, which is approximately 73% and 77%, respectively, of the egg volume of Desert Eagle Owls *Bubo bubo ascalaphus*. Incubation lasts 30–32 days; young leave the nest at about six weeks of age and are fed by the adults for another five weeks or more and disperse from the nest area at 2–4 months of age (Steyn, 1982).

FOOD AND FEEDING HABITS

Though the claws are less formidable than those of other African *Bubo* species, the range of prey is very wide, but insects and other arthropods form a more substantial part of the total prey than in the other species. The Spotted Eagle Owl hunts from a perch, a fence post or a telegraph pole, and pursues small prey on foot; it also catches termites and bats in flight. Pellets collected in steppe grassland overgrazed by livestock in the Awash National Park at 1,000m in the Ethiopian Highlands contained the remains of 1,409 mammals, 45 birds, 47 reptiles and 87 arthropods (Demeter, 1982). The mammals represented 23 species, the main biomass of which was formed by gerbils of the genera *Tatera* and *Gerbillus* (62% and 6%, respectively) and grass

mice *Arvicanthis* (19%); included were also 6 species of bats, 7 species of shrew *Crocidura* and one young hare *Lepus habessinicus* of about 500g. Pellets collected in the Yankari Game Reserve in northern Nigeria contained 86% vertebrates, including 76% mammals (e.g. 2 species of bats) and 14% scorpions and insects, which represented a biomass (prey weight) of 91% mammals, 6% other vertebrates and 3% scorpions and insects (Demeter, 1981). In the Cape Province, South Africa, Dr Ger J. Broekhuysen analysed 1,076 prey remains containing 62 species (cited by Steyn, 1982). Rats, mice, shrews, moles, mole-rats, gerbils, young hare, a bushbaby or galago and other mammals formed the main biomass, followed by birds, which included francolins, pigeons, doves, sandgrouse, a Yellow-billed Hornbill and, most remarkably, Common and Arctic Terns caught on a coastal roost at night. Snakes, lizards, geckos and fish were also present; but locusts, grasshoppers, crickets, beetles (mainly darkling and dung beetles), termites, scorpions, millipedes, spiders and other arthropods were particularly conspicuous by their numbers though forming a minor part of the total biomass taken.

Here, as with its other prey, the Spotted Eagle Owl must expend a considerable amount of energy in order to catch large enough numbers of this small prey. The picture is the same everywhere in Africa: the Spotted Eagle Owl often hunts over roads and on roadsides, attacking whatever small animal it can, feasting on gerbils and other rodents during their population explosions, or preying almost exclusively on grasshoppers and locusts when these swarm over the countryside or are attracted by the lights of motor traffic (Carnegie, 1961; Benson, 1962; Mitchell, 1964; Siegfried, 1965).

To sum up, the Spotted Eagle Owl's food consists mainly of small mammals, medium-sized birds and their nestlings, small reptiles and all kinds of arthropods active at night. It is an opportunistic hunter and has been observed feeding on road kills in South Africa (Day, 1987:40).

MOVEMENTS AND POPULATION DYNAMICS
Very sedentary. No evidence of any population fluctuations.

GEOGRAPHIC LIMITS
The Spotted Eagle Owl's geographic range coincides with the extent of the Afrotropical open woodland, savannah and steppe. As it even occurs in any fertile place or riverine grove in the Kalahari Desert, parts of the Sahara desert are probably also inhabited by this species. The presence of the large Desert Eagle Owl in the central Saharan oases most probably defines the northern limit of the Spotted Eagle Owl's range. The same probably happens in the Arabian peninsula where it is an Afrotropical element (Lees-Smith, 1986). Due to the presence there of three other species of eagle owl, the Spotted Eagle Owl does not inhabit the lowland equatorial evergreen forests, nor the African mountains, the exclusive habitat of the Cape Eagle Owl. The Spotted Eagle Owl's geographic limits seem to be defined, therefore, by the presence of related, stronger species in the surrounding habitats, rather than by vegetational, topographic or climatic factors.

LIFE IN MAN'S WORLD
In one sense the Spotted Eagle Owl has profited from the presence of man, since it is attracted to insects and small rodents on dirt roads and the verges of tarred roads in the countryside. It is thus a well-known phenomenon on African roads at night. As a result many of the owls are killed by motorcars throughout the whole of Africa and in Arabia. As many as 26 were once found dead along a 200km-stretch of road in Namibia (Steyn, 1982).

The Spotted Eagle Owl not only enters cultivated lands and shady gardens, it also occurs in villages and towns, where it has been found nesting on large buildings. One famous pair of Spotted Eagle Owls, studied by Dr Ger J. Broekhuysen, occupied for years the ivy-covered lintel over the entrance to the Botany Department of the University of Cape Town. The birds later moved to another university building where as many students were daily passing at close range as before. Unfortunately, Broekhuysen's early death prevented him from completing his eagle owl saga, "It's an Owl's Life", but interesting data derived from it have been published by Peter Steyn (1984). Other town nest sites recorded include an ornamental window box intended for flowers, a drainpipe and a sloping roof.

Varying, though not alarming, quantities of organochlorine residues have been found in the bodies of Spotted Eagle Owls in South Africa (Peakall & Kemp, 1980).

African people do not appear to persecute the Spotted Eagle Owl, though many of them regard it as an evil omen when it calls from the roof of a house.

Though a remarkably small member of its genus, the Spotted Eagle Owl is nevertheless an impressive bird. The smallness of its prey is noteworthy in relation to the owl's size, appearing to indicate rather inefficient feeding. The reason for this situation, however, may be that the arthropods, small rodents and reptiles on which the bird feeds are mostly extremely abundant. The Spotted Eagle Owl's diet may also represent an attempt to reduce overlap in the size and variety of its prey with surrounding and sympatric owls, and its prey size may for this reason be destined to decrease further. Its prey was apparently larger in the Pleistocene, as indicated by remains discovered at Early Man sites in the Olduvai Gorge, Tanzania, where it lived alongside at least the Giant Eagle Owl and the Barn Owl (Brodkorb & Mourer-Chauviré, 1984).

Though much more is known about the life of this owl than about that of the very similar tropical South American forms of the Great Horned Owl, it is still to be hoped that the data collected by Dr Ger J. Broekhuysen on Spotted Eagle Owls in Cape Town will be published posthumously (see Brown 1970:255; Steyn, 1982, 1984). These could provide a good starting point for further comparative studies on the seven species of eagle owl occurring in Africa. For example, what possible function can the dark eye colour serve in a part of the Spotted Eagle Owl's populations? Dark-brown eyes are an exception in eagle owls and are usually associated with a nocturnal life. The question then arises whether northern African Spotted Eagle Owls are more nocturnal or live in darker surroundings than southern birds, and if so, why.

FOREST EAGLE OWL
Bubo nipalensis

The Forest or Spot-bellied Eagle Owl is one of the few, if not the only, eagle owl inhabiting continental Asian tropical forests. In size and life habits it compares favourably with the eagle owls of the African equatorial forests, the Akun Eagle Owl *Bubo leucostictus* and Fraser's Eagle Owl *Bubo poensis*. With its body length of 50–60cm and a wing length of 45cm, the Forest Eagle Owl is somewhat larger even than Fraser's Eagle Owl (40–45cm; wing length 30cm), but does not reach the dimensions of the gigantic Banded or Shelley's Eagle Owl *Bubo shelleyi* (over 60cm), both of which are considerably stronger and fiercer predators than the small-clawed, presumably mainly insectivorous Akun Eagle Owl. There are at present six known species of eagle owl *Bubo* in the Afrotropics, whereas Asia has four. Close geographical links must formerly have existed between African and Asian forest eagle owls and the present species appear to be closely related. A much-needed comparison of the life habits and structure of the African Fraser's and the Asian Forest Eagle Owl is scarcely practicable at present, however, since little, if anything, is known regarding ecological interrelations between the Forest Eagle Owl and the other owls of its native country.

GENERAL

Faunal type Indian.

Distribution Peninsular India and Sri Lanka, from east Pakistan and Kumaon, the southern slopes of the Himalayas and the Nepal Valley to Burma, Laos, central Vietnam and south in Thailand to 12° north in the northern peninsula. Map 8.

Climatic zones Winter-dry tropical and tropical rain forest.

Habitat Heavy forest, from evergreen and deciduous tropical lowland forests and *duars* in the *terai* at the foot of the Himalayas, and forested hills and patches of montane wet temperate forests (*sholas*) in the south, up to 1,800m in submontane Nepal, over 2,100m in the Nepal Valley and 1,800m in Sri Lanka (Ali and Ripley, 3, 1969).

GEOGRAPHY

Geographical variation Slight. Northern and eastern birds (*Bubo nipalensis nipalensis*) have an ill-defined pectoral band of a honey-brown colour and are larger by *c.* 10% than the owls from southern India and Sri Lanka (*B. n. blighi*) which also lack the darker pectoral band.

Related species Barred or Malay Eagle Owl *Bubo sumatranus* from the Malay Peninsula south of the Isthmus of Kra at 10° north, Sumatra, Borneo, Java and Bali. Not unlike the Malay Fish Owl *Ketupa ketupu* in relation to the Indian *Ketupa zeylonensis*, the Malay Eagle Owl is a considerably smaller, tropical lowland version of the Forest Eagle Owl, with an approximate body length of 77% and approximate wing length of 76% of that of the Indo-Chinese Forest Eagle Owls. Its toes are entirely unfeathered.

STRUCTURE

The structure of the Forest Eagle Owl resembles that of other eagle owls, but the terminal digits of the toes are unfeathered. Legs and toes, and particularly the inner claw, are heavy. The ear tufts are long, thick and composed of feathers of conspicuously different size. They are white-marked and cross-barred, usually rough in appearance, and seem to play a primary role in the expression of behavioural intention (Scherzinger, 1986:39).

The young have a conspicuously pale-buff or white, downy plumage, barred above and below with narrow dark lines. On account of this, the Forest Eagle Owl and its smaller Malaysian representative have often been placed in a separate genus *Huhua*.

BEHAVIOURAL CHARACTERISTICS

Songs and calls The territorial song, which matches the songs of other *Bubo* owls, has appropriately been described as a "soft and resounding boom" (B. E. Smythies) and a "low, deep and far-sounding moaning hoot" (T. C. Jerdon). Numerous other "snoring" and "shrieking" sounds have been described; the vocabulary of a forest owl is inevitably extensive and varied.

OVERLEAF: **Forest Eagle Owl** *Bubo nipalensis*

Forest Eagle Owl *Bubo nipalensis*
Nepal race *B. n. nipalensis*

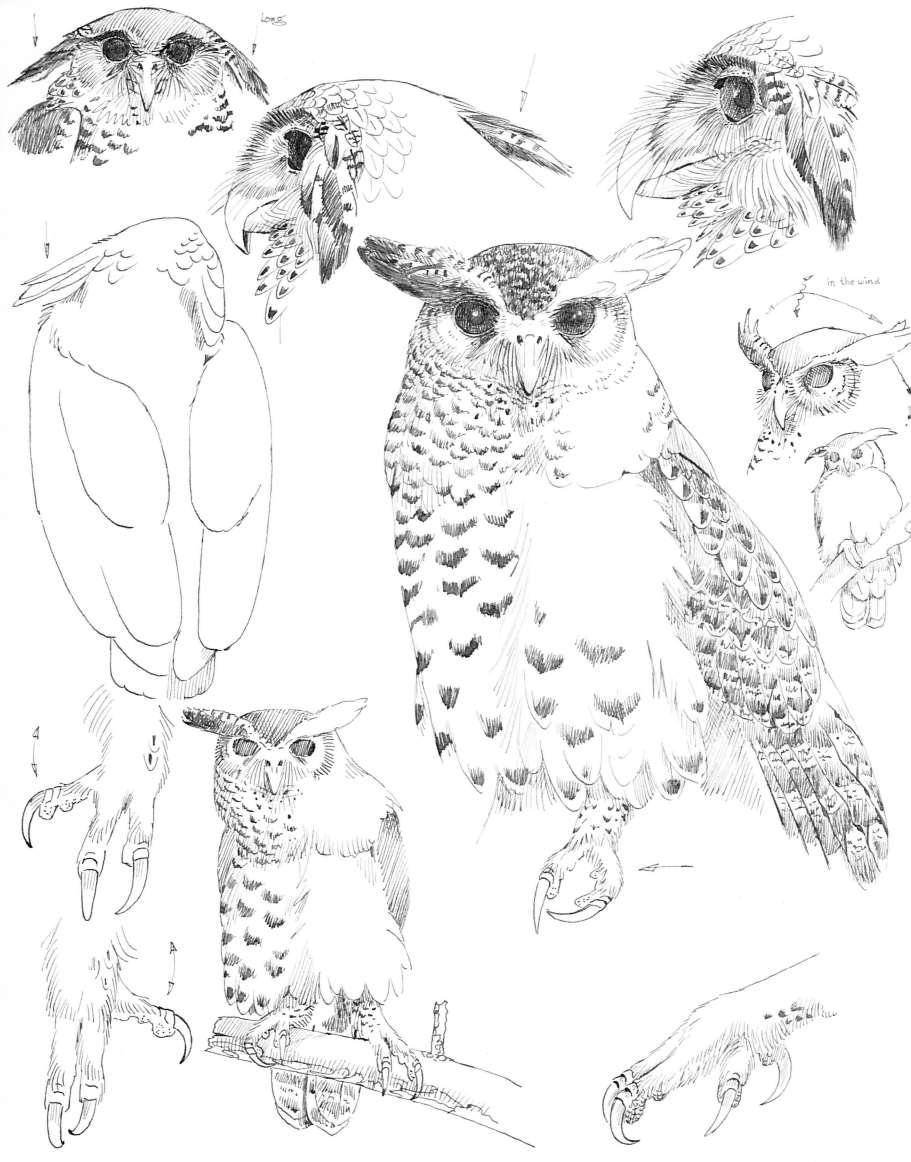

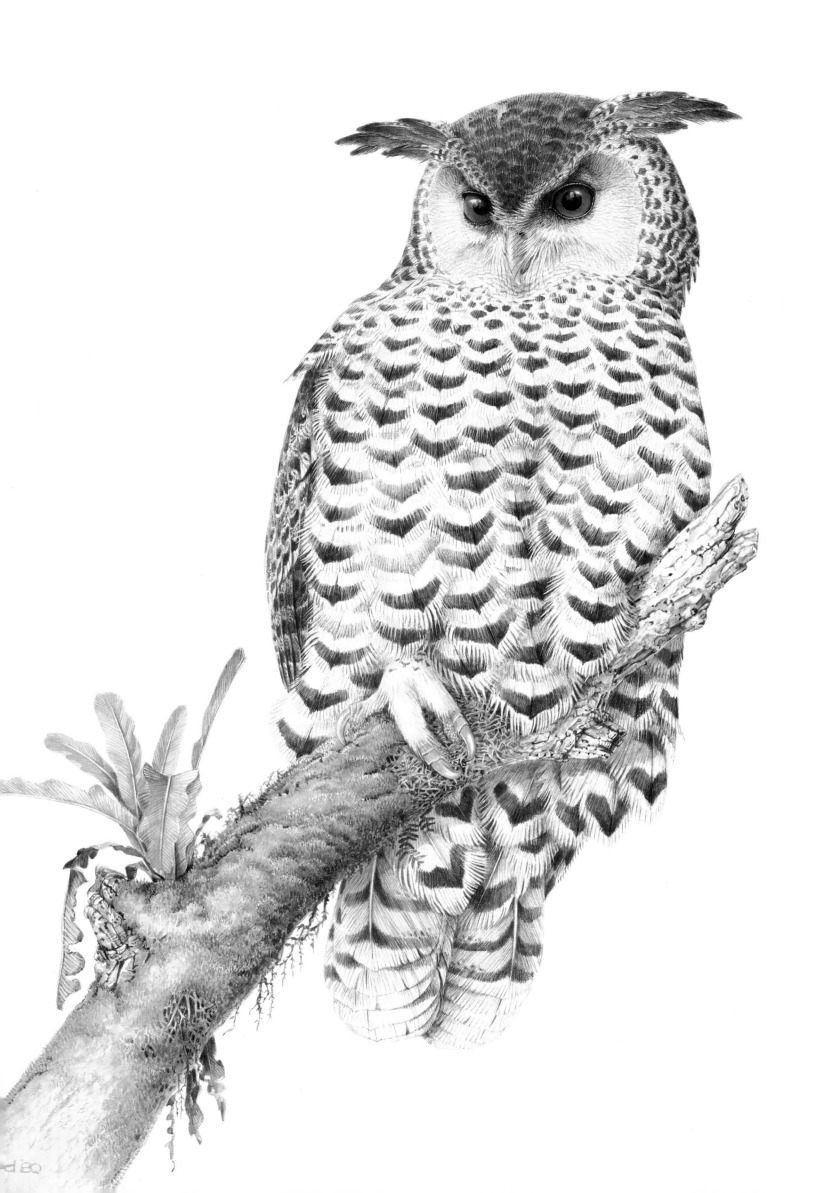

Circadian rhythm The Forest Eagle Owl is generally considered to be largely nocturnal, hiding by day in deep forests and *sholas* (thickly wooded valleys in the south). A few instances of diurnal activity have been reported. In view of its forest habitat, such behaviour is not unexpected.

Antagonistic behaviour There are no data for this species, probably due to its nocturnal life style.

ECOLOGICAL HIERARCHY

The Forest Eagle Owl is about 10% larger than the Indian Eagle Owl and the Dusky Eagle Owl and about 35% larger than the largest of the Indian *Strix* owls, the Brown Wood Owl. Egg volume is approximately 48%, 11% and 57% greater than in the aforementioned owls. These figures are presumed to indicate a kind of ecological hierarchy. Actual ecological encounters, however, have not been recorded. Females are approximately 10% heavier than males, but it is not known whether there are differences between male and female in the average size of prey taken.

BREEDING HABITAT AND BREEDING

Nests have been located in spacious holes in trees, in caves and sheltered fissures in rock walls and the abandoned nests of eagles and vultures. The clutch size recorded is a single egg (Baker, 3, 1934).

FOOD AND FEEDING HABITS

The Forest Eagle Owl is extremely bold and powerful. Recorded prey items are remarkably large; they include mammals such as hare, fawns of barking deer, jackals, civet cats and, recorded on one occasion, a large flying squirrel. Also large birds, such as Kaleej Pheasants, Jungle Fowl and Peafowl, some of which were taken while the owls were raiding the night-time roosts of these birds in forest trees. In addition, lizards, snakes and fish; also carrion, viz. remains of a tiger and a goat (Baker, 4, 1927; Ali & Ripley, 3, 1969), have been recorded.

MOVEMENTS

None recorded. The species is probably very sedentary.

GEOGRAPHIC LIMITS

To the north, in non-tropical regions, the Forest Eagle Owl's range is probably limited by the occurrence of the large northern Eagle Owl. To the south, the smaller Malay Eagle Owl takes its place in what seems to be an identical type of habitat.

LIFE IN MAN'S WORLD

The Forest Eagle Owl has been described as extremely fierce and aggressive in defence of its nest, even towards human intruders. Otherwise, contact with man is minimal, since this owl rarely shares its habitat with man.

The only factor in the life of the Forest Eagle Owl of which we can be certain is the bird's boldness and strength. It is probably a stronger predator than the Indian Eagle Owl *Bubo bubo bengalensis* or the African Fraser's Eagle Owl *Bubo poensis* and must approach in strength of predation the gigantic West African Shelley's Owl *Bubo shelleyi* of which, however, very little is known. The Forest Eagle Owl reaches the borders of the Palaearctic only in the southern central Himalayas at about 2,100m. It has more of an Indian–African than of a Palaearctic affinity. The Malay Eagle Owl *Bubo sumatranus* is its small southern representative. Its life in the darkness of the Indo-Malayan forests must be highly adventurous. Like the elephant and the tiger and other large mammalian forest-inhabiting ungulates and predators, the Forest Eagle Owl depends for its survival on the continued existence of the much endangered tropical south Asian lowland and hill forests.

BLAKISTON'S FISH OWL

Ketupa blakistoni

With a length of 72cm and a wingspan of 180–190cm, Blakiston's Fish Owl is even more formidable than the east Siberian Eagle Owl *Bubo bubo ussuriensis*, which has a length of 90% and a wingspan of 90–93% of that of Blakiston's Fish Owl. Blakiston's Fish Owl consequently falls into the category of such Far Eastern giants as the Korean and Alaskan Steller's Sea Eagle *Haliaeetus pelagicus*, the Japanese Hodgson's Hawk Eagle *Spizaetus nipalensis orientalis* and the Oriental White Stork *Ciconia boyciana* and, like these birds, its range is indicative of a relict species. Blakiston's Fish Owl is only one of a number of east Siberian anomalies found on the north Japanese island of Hokkaido, as was demonstrated by the British businessman and consul Thomas Wright Blakiston (1832–91, living at Hakodate, Hokkaido, 1861–84) after whom not only this owl was named, but also the notable zoogeographical dividing line between boreal Hokkaido and the temperate northern part of the Japanese main island Honshu. Details of the life and habits of Blakiston's Fish Owl have gradually come to light through the efforts of Far Eastern Soviet ornithologists (A. J. V. Knystautas, A. A. Nazarenko, V. T. Pererra, Yu. B. Pukinsky, J. B. Sibnev, B. K. Sibnev) and owl researchers in Japan (Brazil & Yamamoto, 1983).

Blakiston's Fish Owl's systematic position among owls and its nearest relatives are still matters of dispute. In 1933, in the heyday of the wide, geographical species concept, it was considered simply a subspecies of the south Asian Brown Fish Owl *Ketupa zeylonensis* (Dementiev, 1933; Meise, 1933). A few years later, however, Ernst Hartert and Friedrich Steinbacher, in their authoritative *Ergänzungsband* to *Die Vögel der paläarktischen Fauna* (1932–38), listed Blakiston's Fish Owl as *Bubo blakistoni* whilst placing, on the same page, the Brown Fish Owl in a different genus as *Ketupa zeylonensis*. Questions of genetic and geographic origin and present ecological position of this largest Japanese owl form the main themes of the following account. There is an impressive photograph of a four-year-old captive bird from the Kurile Island Kunashiri, taken by Sten Bergman (1935, fig. 26), and a fine colour drawing from life by R. David Digby (Sayers, 1976).

GENERAL

Faunal type Manchurian.

Distribution Palaearctic eastern Asia, from the basins of the Amur and Ussuri Rivers and their tributaries Bolschaja, Ussurka, Bikin and Chor (Knystautas & Sibnev, 1987), also including the famous Lake Khanka, in the Soviet Far East, and a probably restricted area west of the Great Khingan Mountain Range (Jakschi=Yakoshi) in northwest Manchuria or Heilungkiang, China, to the coasts of the Sea of Okhotsk, and possibly adjacent parts of northern Korea; the islands of Sakhalin, Hokkaido and the southernmost Kuriles (Kunashiri, Shikotan, Etorofu), the islands that join the northern tip of Japan to the southern tip of Kamchatka. Map 9.

Climatic zones Boreal, within the range of the January isotherm of −20 to −25°C.

Habitat Dense conifer, mixed and broad-leaved forests in wide river plains with river islands in fast-flowing waters and permanent wells that do not freeze over in winter. Also on the Kurile Islands in dense fir and spruce forests mixed with some deciduous trees, bordering lakes, river mouths and sea coasts (Tuzenko, 1955).

GEOGRAPHY

Geographical variation Slight, if any. Said to be darkest on Sakhalin (*Ketupa blakistoni karafutonis*), palest west of the Great Khingan Mountains (*K. b. piscivorus*), intermediate in the Amur Province (*K. b. doerriesi*, relatively paler) and Japan (*K. b. blakistoni*, relatively darker). Generally only two races are recognized (Dementiev & Gladkov, 1, 1951; Vaurie, 1965).

Related species Three other species of Asian fish owl *Ketupa*, one of which, *K. zeylonensis*, is sometimes considered as conspecific. A close relationship with eagle owls *Bubo* is apparent.

STRUCTURE

Blakiston's Fish Owl is almost identical in structure to the eagle owls *Bubo* and, like them, has a completely feathered tarsus; the toes are naked, however, or covered only with sparse bristly feathers. The facial ruff is little developed, flattened over the eyebrows, and the ear tufts consist of a greater number of feathers, which are longer and more roughly arranged than in *Bubo*. The bill is longer and carried forward rather than downward. The plumage is less soft and the feathers are stiffer than in other owls, while the leading flight feathers appear to lack the sound-reducing fringe of barbs on their outer webs (Thorpe & Griffin,

1962), though flight is silent as in other owls (Brazil, 1985). The sharp cutting edges of the formidable claws and the colour pattern of wavy cross lines on the feathers of the underparts are basically the same as in *Bubo* owls, particularly the North American Great Horned Owl.

There are no convincing reasons, therefore, for distinguishing Blakiston's Fish Owl as a species of *Ketupa*, let alone for treating it as conspecific with the south Asian Brown Fish Owl *K. zeylonensis*. The skull of Blakiston's Fish Owl does not seem to differ from that of the Eagle Owl, nor did other skeletal details differ from species of the genus *Bubo* (Ford, 1967). One could therefore return to the hypothesis that Blakiston's Fish Owl is a member of *Bubo*, in contrast to the south Asian fish owls, which show minor skeletal differences from *Bubo*, thereby justifying the recognition of a genus *Ketupa* for these owls.

BEHAVIOURAL CHARACTERISTICS

Songs and calls The territorial song is described as a short and deep eagle owl's call, rendered either as *boo-boo-uoo* (Japan) or *shoo-boo* and *foo-fooroo* (Ussuriland) (Sibnev, 1963). Elaborate duet songs have also been described (Pukinsky, 1974). The cry of young for food is a long-drawn-out and slurred triller *pee-pee-pee* (J. B. Sibnev).

Circadian rhythm On the Bikin River in Far Eastern Ussuriland Blakiston's Fish Owl was found to be equally active at dusk, during the day and at night (Sibnev, 1963), but this was in the season when young had to be reared, and the northern summer nights are, in any case, short.

Antagonistic behaviour No information.

ECOLOGICAL HIERARCHY

There is no information on encounters by Blakiston's Fish Owl with other species of owl and diurnal predators. It is probable, however, that Blakiston's Fish Owl would meet Eagle Owls (wingspan 80–86% of Blakiston's Fish Owl) and Goshawks in its Manchurian and north Japanese forest haunts, and the White-tailed and Steller's Sea Eagles on the coasts of the rocky Kurile Islands.

BREEDING HABITAT, NEST SITES, BREEDING

In the dense, mainly broad-leaved riparian forests of the Bikin and other tributaries of the Ussuri River in the Soviet Far East nests have been reported (Sibnev, 1963; Pukinsky, 1973) in hollow trees, often poplar and Manchurian ash, up to 12–18m above the ground, as well as on fallen tree trunks and on the forest floor (Galushin & Pererra, 1982). Nesting holes are usually wide and spacious; one hole in a Manchurian ash had previously been used by a black bear as a winter den (Knystautas & Sibnev, 1987). Some 30 nesting pairs were found along a 350-km stretch of the broad Bikin River valley, where the owls behaved as genuine fish or river owls. The owls are early nesters, starting egg-laying as early as mid-March when the ground and trees are still widely covered with snow (Brazil, 1985). Clutch size is 1–3, usually 2. The male provides food for the nesting female and later also for the young. Probably as a result of frequently critical food conditions, Blakiston's Fish Owl does not appear to nest each year (Knystautas & Sibnev, 1987).

FOOD AND FEEDING HABITS

Blakiston's Fish Owl is a true fishing owl. Reports show that it walks and wades in shallow water and tramples conspicuous trails in the rank vegetation of the river banks. All published data indicate that the owl's main food is fish, some of which – Amur pike, catfish, burbot and salmon, for example – is of considerable size. Crayfish (e.g. *Astacus schrenckii*) and grass frogs (sometimes fed in large quantities to young; Meise, 1934; Pukinsky, 1973, 1976) are also taken; in winter also mammals up to the size of hares, martens, cats and small dogs (Brazil, 1985). Footprints have been found in the snow around air holes in the river ice in winter (Sibnev, 1963) and there are reports of winter concentrations of 5–6 owls near rapids and non-freezing springs, not unlike those of White-tailed, Steller's and Bald Sea Eagles in winter (Pukinsky, 1973; Knystautas & Sibnev, 1987). On the Kurile Islands, and perhaps elsewhere, Blakiston's Fish Owl also fishes on rocky sea coasts (Bergman, 1935).

MOVEMENTS AND POPULATION DYNAMICS

Though this owl is generally considered to be sedentary, many Blakiston's Fish Owls are suspected to leave the Bikin River valley, Ussuriland, in winter (Sibnev, 1963), but there is no indication of where they might go. Concentrations, not unlike those of sea eagles, have been reported in single trees in April. As this owl sometimes seems to skip a whole breeding season, notable population fluctuations are likely to occur.

GEOGRAPHIC LIMITS

It is no small feat for a fish-eating species of the size of Blakiston's Fish Owl to have survived in a region where winters are severe and the rivers are frozen over for many months of the year. One may wonder, therefore, what has caused this formidable owl to restrict its range (which it could hardly have extended further northwards). One possible explanation is that Blakiston's Fish Owl may have suffered competition from large diurnal, fish-eating and scavenging raptors, particularly the sea eagles of the genus *Haliaeetus*. It may have been prevented for the same reason from spreading into North America, though Pleistocene fossils belonging to fish owls of Blakiston's type may eventually be uncovered in northwestern and western North America.

South of its present range, in lowland eastern China, ecological possibilities for the existence of a large fish owl appear to have been plentiful. Its current absence there may therefore be due to the presence of a dense human population. Apparently there is a gap of at least 800km between the ranges of Blakiston's Fish Owl in the north and the Tawny Fish Owl in the south. But evidence that Blakiston's Fish Owl originated in tropical Asian surroundings and that it is therefore an Indo-Malayan element in Palaearctic east Asia is not conclusive.

Blakiston's Fish Owl *Ketupa blakistoni* with ide *Leuciscus idae* as prey

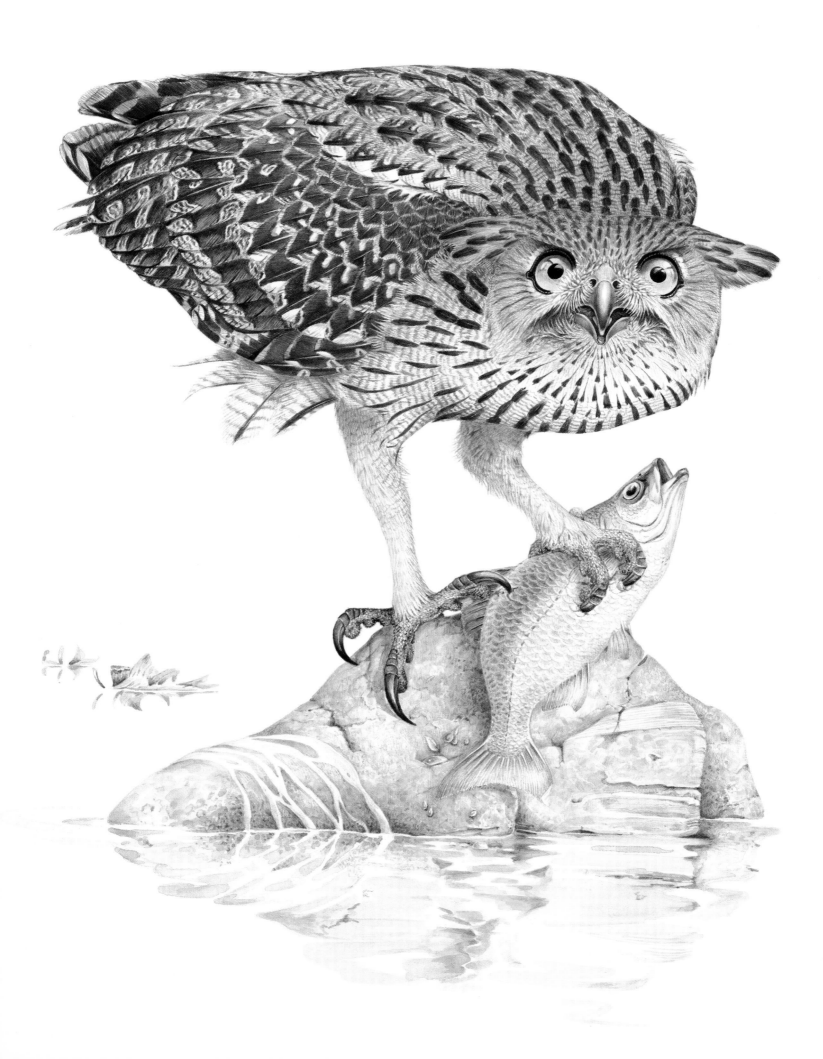

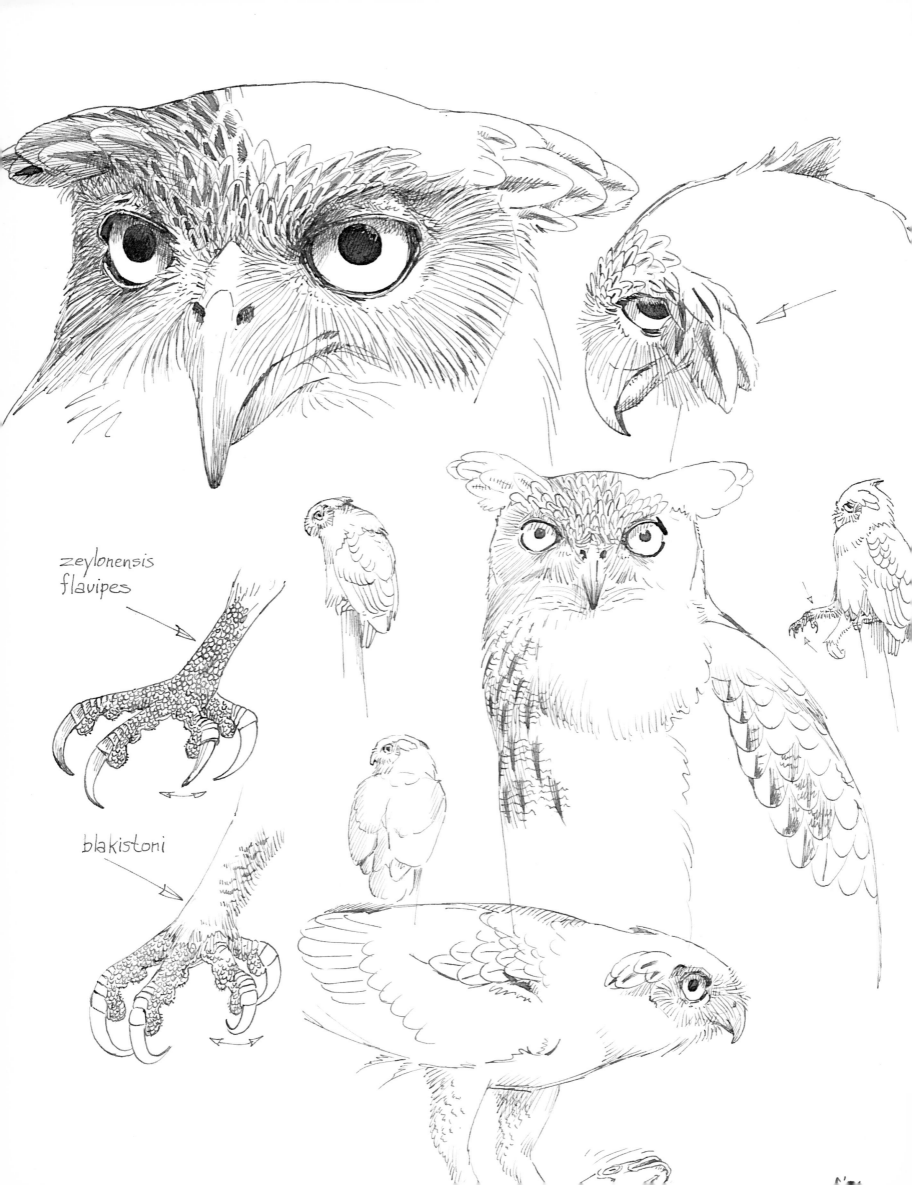

LIFE IN MAN'S WORLD

Blakiston's Fish Owl leads a reclusive life, far removed from the haunts of modern man, though it shared old riverine forests and fishing grounds with the old, now almost extinct Ainu people from Hokkaido, Japan; among them it was revered much like the brown bear and known by a name that signifies "the god who defends the village" (Brazil, 1985). In the Soviet Far East its concentrations around air holes in winter make it vulnerable to hunters and fishermen. Human population pressure on the lower Bikin River has already pushed this species back to less favourable upper river courses where the surrounding forest is of the coniferous taiga type (Knystautas & Sibnev, 1987). Probably no more than a few hundred pairs survive in the Soviet Far East and probably less than 30 individuals in Japan (Brazil & Yamamoto, 1983). As it is confined in Hokkaido to undisturbed taiga forest it is equally endangered in Japan and both the Environment Agency and the Wild Bird Society of Japan have set up projects to provide large, square nest boxes for this large species (Brazil & Yamamoto, 1983).

Blakiston's Fish Owl *Ketupa blakistoni* with details of leg of Brown and Tawny Fish Owls for comparison

Although nothing is yet known of ecological interactions between Blakiston's Fish Owls, the other large fish-eating raptors (sea eagles *Haliaeetus*) with which they are sympatric and other semi-aquatic predators, ecological conditions seem no less favourable to this owl in present-day western North America than they are in northeastern Asia. The absence of fish-eating owls of whatever origin and genus in the American tropics is a further mystery. A correlation has been suggested with the existence of fish-eating bats (Fenton & Fleming, 1976), but in view of the size of fish owls this explanation is barely convincing. The nearest ecotype of fish-eating owl in the American tropics is the Spectacled Owl *Pulsatrix perspicillita*, but it has adapted in quite a different way from the Old World *Ketupa* owls.

The question of whether Blakiston's Fish Owl is of tropical or Palaearctic origin must remain unanswered for the present. There is less doubt surrounding its nearest relatives, presumed to be the group of eagle owls *Bubo*, and Blakiston's Fish Owl could equally have been assigned to that genus. Even the generic distinction *Ketupa* for the other fish owls is debatable. A realistic arrangement would include Blakiston's Fish Owl in the genus *Bubo* and the tropical fish owls in *Ketupa* (in contrast to Voous, 1973, 1977). Comparative studies of structure, anatomy, physiology of vision and hearing, vocalizations, diet and breeding ecology of Blakiston's Fish Owl and the sympatric Eagle Owl *Bubo bubo ussuriensis* are all badly needed, as is a comparison with the tropical members of the genus *Ketupa*.

BROWN FISH OWL

Ketupa zeylonensis

Little is known regarding the origin of the Brown Fish Owl's semi-aquatic habits or of its present range. The existence of this species disrupts any attempts to distinguish – in terms of structure, life style and vocalizations (see e.g. Dementiev 1933; Meise, 1933) – a specialized fish owl genus *Ketupa*, centring on south and east Asia, from the almost universal eagle owl genus *Bubo*. There can hardly be any doubt that fish owls originated from the mighty eagle owls, and in tropical Asia. How, where, and when, is not known, nor whether the Indian Dusky Eagle Owl *Bubo coromandus* and the Philippine Eagle Owl *Bubo (Pseudoptynx) philippensis* represent contemporary intermediate or rudimentary stages of development.

The present range of the Brown Fish Owl extends over 7,000km from eastern China to Palestine, a distribution pattern which is rare among birds. A Pleistocene Brown Fish Owl is thought to have existed on Crete (Weesie, 1987), thus completing a south Palaearctic range. The presence of three species of fishing owls, genus *Scotopelia*, in the Afrotropics has most probably inhibited the expansion of Asian *Ketupa* owls in tropical Africa. African Fish Owls in no way resemble *Bubo* owls and it is difficult to imagine how they could have derived from African eagle owls, of which, incidentally, there are at present no less than seven species. As they nevertheless agree in many skeletal details (Ford, 1967), this development may have occurred at a very early date. Most other south Asian species of wide distribution extend in an Indo-African distribution pattern into tropical Africa or have close relatives there.

The Brown Fish Owl and the east-Palaearctic Blakiston's Fish Owl *Ketupa blakistoni* have sometimes been regarded as conspecific despite considerable differences in size and appearance and a distribution gap in temperate China of approximately 2,000km (Dementiev, 1933). The present work rejects this view (see under Blakiston's Fish Owl), but the relationship between these species and the relationship of fish owls in general with eagle owls, genus *Bubo*, are problems of more than casual interest.

No less interesting is the question of interrelationship between the three tropical Asian species of fish owl. All three appear to overlap in certain areas of Burma, southern Thailand, Cambodia and southern Vietnam, and each seems to have its preferred habitat. North of the Brown Fish Owl's range the somewhat smaller Tawny Fish Owl *Ketupa flavipes* inhabits the forested shores of running waters in cool mountainous and temperate regions; towards the south the small Buffy or Malay Fish Owl *Ketupa ketupu* lives in denser riverine and coastal forests, including mangroves. At present no more than a few basic facts are known about the Brown Fish Owl. These will be summarized here from the existing literature.

GENERAL

Faunal type South Asian.

Distribution Southern Asia, from the Middle East to south Yunnan, Kwangsi and Kwantung in south China, and Hainan (Cheng, 1976), north of the Gangetic Plain to about 1,500m in the Himalayas, south to Sri Lanka and the state of Kedah (6° north) in Malaysia. Some ten or more pairs may survive in riverine woods around Lake Tiberias in northern Galilee (H. Mendelssohn, in Mikkola, 1983:94); in the Hula Valley, Israel, in wadis in the Golan Heights (Frumkin, 1983), and possibly elsewhere in adjacent parts of Lebanon and Syria (Kebir River). This owl was first recorded in the Middle East by Canon H. B. Tristram (1864) in 1863 "in a wild wooded glen", the Wadi el Kurn near Akkā (= Accre), present northwest Israel. It may still occur at the foot of the eastern Taurus Mountains in Turkey where it was last seen at Adana a century or more ago. It possibly occurs also in the hills southwest of the Zagros Mountains, where it was collected by N. Sarudny (1905), and in the lowland border country of Iraq and Iran, where R. E. Cheesman caught a pair of these owls between 1920 and 1923 (Ticehurst et al., 1926), but it has never been reported elsewhere in the wooded mountain ranges of southern Iran and Baluchistan and the springs west of Sinah. Map 9.

Climatic zones Mediterranean, steppe, savannah, winter-dry tropical; possibly temperate in east China.

Habitat Forest and woodland bordering streams, lakes and rice fields; clumps of bamboo and other large, shady trees near water reservoirs (*jheels*) and along canals; also on the outskirts of villages and on sea coasts (Ali & Ripley, 3, 1969). Usually lowlands, up to 1,500m in the foothills and submontane zones of the Him-

Brown Fish Owl *Ketupa zeylonensis*
Sri Lanka race *K. z. zeylonensis* in mangrove *Rhizophora mucronata*

alayas (*bhabar*, *duars* and *duns*), to *c.* 1,400m in the Nilgiri Hills and 1,800m in Sri Lanka. The Brown Fish Owl is the commonest lowland owl of Sri Lanka (Henry, 1971).

GEOGRAPHY

Geographical variation Affects colour and size. The owl is small and dark in Ceylon (*Ketupa zeylonensis zeylonensis*, wingspan 92% of that of northern birds); much larger on the continent; paler and more rufous in the extreme west, and somewhat darker in the east, but the differences are slight and gradual and all continental populations could be grouped together as *K. z. leschenault* (originally from Bengal) rather than being distinguished as three, probably clinal, forms (*K. z. semenowi* in the west, *K. z. hardwickii* in the north, *K. z. orientalis* in the east).

Related species The huge Blakiston's Fish Owl *Ketupa blakistoni* (wingspan 10% greater than in the northern Brown Fish Owl) from boreal Palaearctic east Asia is sometimes regarded as conspecific with the Brown Fish Owl. The Tawny Fish Owl *Ketupa ketupa* is a miniature representative in tropical southeast Asia, from Assam south to Borneo, Java and Bali (wingspan 10% smaller).

STRUCTURE

The Brown Fish Owl is structurally similar to the eagle owls *Bubo* except in so far as it has adapted to catching slippery fish and crabs. Most characteristic in this respect are the long, unfeathered legs, and toes covered with small granular scales. On the soles of the feet the scales are somewhat pointed, resembling, though not identical to, the similarly located spicules in the fish-eating Osprey. The claws are long and powerfully curved but, unlike the Osprey's, have sharp cutting edges and a longitudinal sharp keel situated underneath the middle claw as in the larger *Bubo* owls. The facial ruff is poorly developed. The head is directed further forward, so that, in rest, the bill is on a level with the centre of the eyes, not below them as in *Bubo*, making the face more flat-browed and, together with the solidly brown, bushy "ear tufts", giving the bird a remarkably morose and sinister expression (Scherzinger, 1986:39). The feathers are less soft than in other owls. Some authors have remarked upon the Brown Fish Owl's audible flight, exceptional among owls; others note that its wings make a "singing" noise, while E. C. Stuart Baker (4, 1927:408) claims that the flight is "silent as that of all other owls".

Nothing appears to be known about vision and hearing in the Brown Fish Owl.

BEHAVIOURAL CHARACTERISTICS

Songs and calls The territorial song and the duet performed by a male and female resemble the deep calls of all *Bubo* owls. They have been variously rendered as a muted *hoo-hoo-hoo*, "like old men talking together" (Fleming, Fleming & Singh Bangdel, 1976), and "a succession of mumblings and mutterings in a definite rhythm, with some of the syllables raised to a honking or yowling sound" (J. T. Marshall), but when the owl is excited the call may rise to a "maniacal chuckle" (Boonsong Lekagul).

Circadian rhythm Considered crepuscular and nocturnal.

Antagonistic behaviour No data.

ECOLOGICAL HIERARCHY

The Brown Fish Owl has a length of *c.* 54–57cm. Average wingspan of 16 males from the northern Indian subcontinent was 402mm and of 15 females 395mm (various sources). The bill was found to average 49.0mm in males (9 specimens examined) and 51.5mm in females (10 specimens) (Humayun Abdulali).

Nothing is known regarding the ecological interrelationship between the Brown Fish Owl and other owl species and diurnal raptors of comparable size. One would expect some conflict with lowland Dusky Eagle Owls *Bubo coromandus* and Greyheaded and Pallas' Fish Eagles, genera *Ichthyophaga* and *Haliaeetus*, at least during the breeding season. But none of these birds is as terrestrial as the Brown Fish Owl and none seems to have specialized in feeding on crayfish. Females are said to be larger than males by not more than a few percent, but the bill is noticeably heavier in females.

BREEDING HABITAT AND BREEDING

Nests have been reported in shady places in ancient mango and fig trees (peepal and banyan, the latter with aerial roots) and other large trees in the tall lowland *sal* (*Shorea*) forest, often near villages or in suitable *nullahs* (village quarters) along roadsides or bordering *jheels*, canals and rice fields. They were located either in wide, natural holes, in hollows at the junction of large branches, in the fork of the main trunk and side branches, or in the deserted nests of fish eagles or vultures. Nests have also been found on rock ledges, in caves in shady cliff faces, or among stone ruins (Baker, 4, 1927; Ali.& Ripley, 3, 1969). Breeding usually takes place in the dry monsoon season (November–March in northern India) when water levels are low and fish are readily available. Most other large owls and raptors also nest in the dry season, however. The clutch size is quite small usually only consisting of one or two eggs.

FOOD AND FEEDING HABITS

The Brown Fish Owl fishes either by stationing itself on a rock overlooking water or on an overhanging perch, or, alternatively, by wading in shallow water or skimming the surface with its long legs dangling ready to seize its prey. It may appropriate a particular stretch of water by repeatedly flying up and down it. The owl's diet consists principally of rather large fish and freshwater crabs *Potamon*; also snakes, lizards, frogs, water beetles and other insects, small mammals, including bats, and occasionally water birds (e.g. Lesser Whistling Duck, Indian Pond Heron; see Eates, 1938). Although carrion-eating is rare among owls, there is a record of a pair of Brown Fish Owls feeding on the putrefying carcase of a crocodile at the water's edge (C. M. Inglis, *fide* Baker, 4, 1927).

Brown Fish Owl *Ketupa zeylonensis*

MOVEMENTS
The Brown Fish Owl is considered sedentary.

GEOGRAPHIC LIMITS
No data.

LIFE IN MAN'S WORLD
The Brown Fish Owl does not appear to shun the presence of man. It is often found in village groves and in trees surrounding fish ponds. Whether, in the latter circumstances, it is regarded as a nuisance, and whether it has suffered as a result of persecution or tree-cutting in the lowlands of east-central China, where an old freshwater fish culture still exists, is not known. The questions are tantalizing ones, for at present there is a gap of c. 800km in the distribution of members of the fish owl genus in east China.

In Israel the Brown Fish Owl, like other raptors and owls, has been utterly decimated by the uncontrolled use of thallium sulphate as a rodenticide, which has had the effect of also poisoning surface waters. The drying up of streams and rivers in western Galilee as a result of hydrological planning has been almost as detrimental (H. Mendelssohn).

The present account provides no new data on this enigmatic species. Gaps in current knowledge have proved to be all too numerous. Even relatively simple basic data are lacking, such as occurrence and distribution in the Middle East and in lowland east-central China. More interesting still, ecological relationships with other species of owls and diurnal birds of prey are virtually unknown. The Brown Fish Owl may be a relict in Israel, Lebanon and Syria – comparable in a sense to Hume's Tawny Owl or Lilith of the Desert *Strix butleri* – to judge by a Pleistocene fossil recorded from Crete. Above all, its specific relationship, if any, to the cold-temperate Blakiston's Eagle Owl *Ketupa blakistoni* remains a mystery. The comparative ecology and ethology of the three tropical south Asian species of fish owl would particularly repay study.

Tawny Fish Owl

Ketupa flavipes

Almost nothing is known about this beautiful, brightly coloured fish owl other than that it is a south and east Asian species with a submontane Himalayan and subtropical and warm-temperate Chinese distribution just beyond the southern border of the Palaearctic region. It is larger (133%) than the humid tropical Buffy or Malay Fish Owl *Ketupa ketupu*, somewhat smaller (98%) than the equally tropical Brown Fish Owl *Ketupa zeylonensis* and considerably smaller (85%) than the boreal Blakiston's Fish Owl *Ketupa blakistoni*. Its life habits and genetic and ecological relationship with the Brown Fish Owl are virtually unknown. Because they replace each other geographically, the Tawny Fish Owl has been combined into one species with the Malay Fish Owl (Eck & Busse, 1973), but additional evidence is slight. It may meet the Brown Fish Owl along most of its southern borders, in Laos and Vietnam, but the two birds live in different habitats. Nothing new can be added here, however, to data so far published on this mysterious species.

GENERAL

Faunal type Submontane Chinese–Himalayan.

Distribution Himalayan foothills from Kashmir and Garhwal east to the mountains of northern Laos and Vietnam, south China, north to Chekiang and Anhwei, almost to the Huang Ho or Yellow River (Cheng, 1976), also Taiwan. Map 9.

Climatic zones Mainly winter-dry tropical and subtropical and temperate mountain zones.

Habitat Mountain streams in submontane forest tracts and *duars*, up to 1,500m in Nepal and 2,100m in Darjeeling; forest streams in China. The Tawny Fish Owl is scarce in all these localities.

GEOGRAPHY

Geographical variation None has been recognized, but the Tawny Fish Owl was once regarded as conspecific with the Malay Fish Owl *Ketupa ketupu*.

Related species Possibly Malay Fish Owl; see also Brown Fish Owl *Ketupa zeylonensis*.

STRUCTURE

In structure the Tawny Fish Owl resembles the Brown Fish Owl, but the tarsus, though long, is only feathered along about half its length and the bill is somewhat larger and more powerful than the Brown Fish Owl's.

This species is specifically mentioned as having no comb-like fringes on the outer webs and no hair-like fringes on the emarginations of the inner webs of the leading primaries as in other owls (Graham, 1934), although this also applies to the other fish owls. Consequently, these species are probably not silent in flight (Thorpe & Griffin, 1962). This poses no problem where underwater prey are being pursued.

BEHAVIOURAL CHARACTERISTICS

Songs and calls The territorial song is a deep *whoo-hoo*. A cat-like mewing, as in the Brown Fish Owl, has also been described.

Circadian rhythm The species is said to be crepuscular, even partly diurnal, but detailed data are lacking.

Antagonistic behaviour No data.

ECOLOGICAL HIERARCHY

The Tawny Fish Owl is said to be the most powerful and savage of all *Ketupa* owls and occasionally to take remarkably large prey, including such large animals as Jungle Fowl and pheasants (Baker, 4, 1927).

BREEDING HABITAT AND BREEDING

Breeding and nesting habits are not known to differ from those of the Brown Fish Owl, except that the Tawny Fish Owl seems to be found mainly along running or fast-flowing water and the Brown Fish Owl on slow-moving and stagnant waters. Nests have been located in holes in river banks, caves in cliffs, and in the forks of trees; also in unused fish eagles' nests, which principally are probably nests that have been abandoned by the widespread, lowland Pallas' Fish Eagle (Baker, 4, 1927). The normal size of a Tawny Fish Owl clutch varies from one to two eggs.

FOOD AND FEEDING HABITS
The Tawny Fish Owl is said to swoop down to capture fish near the water's surface, like the fish eagles *Ichthyophaga* and *Haliaeetus*, even in bright daylight (see p. 14). Fish form the owl's staple diet, but crayfish, crabs, rodents (bamboo rats), lizards, large beetles and ground birds up to the size of Jungle Fowl, wood partridges and pheasants have also been recorded.

Tawny Fish Owl *Ketupa flavipes*

OVERLEAF: **Tawny Fish Owl** *Ketupa flavipes*
Nepal, montane habitat, with Grey Wagtail *Motacilla cinerea*

MOVEMENTS
The species is considered sedentary.

Any additional information that comes to light on this species will obviously be of value. Its ecological relationships with other owls and diurnal birds of prey throughout its range are certainly worthy of study. One wonders, for example, whether any area exists in which this owl is not "scarce".

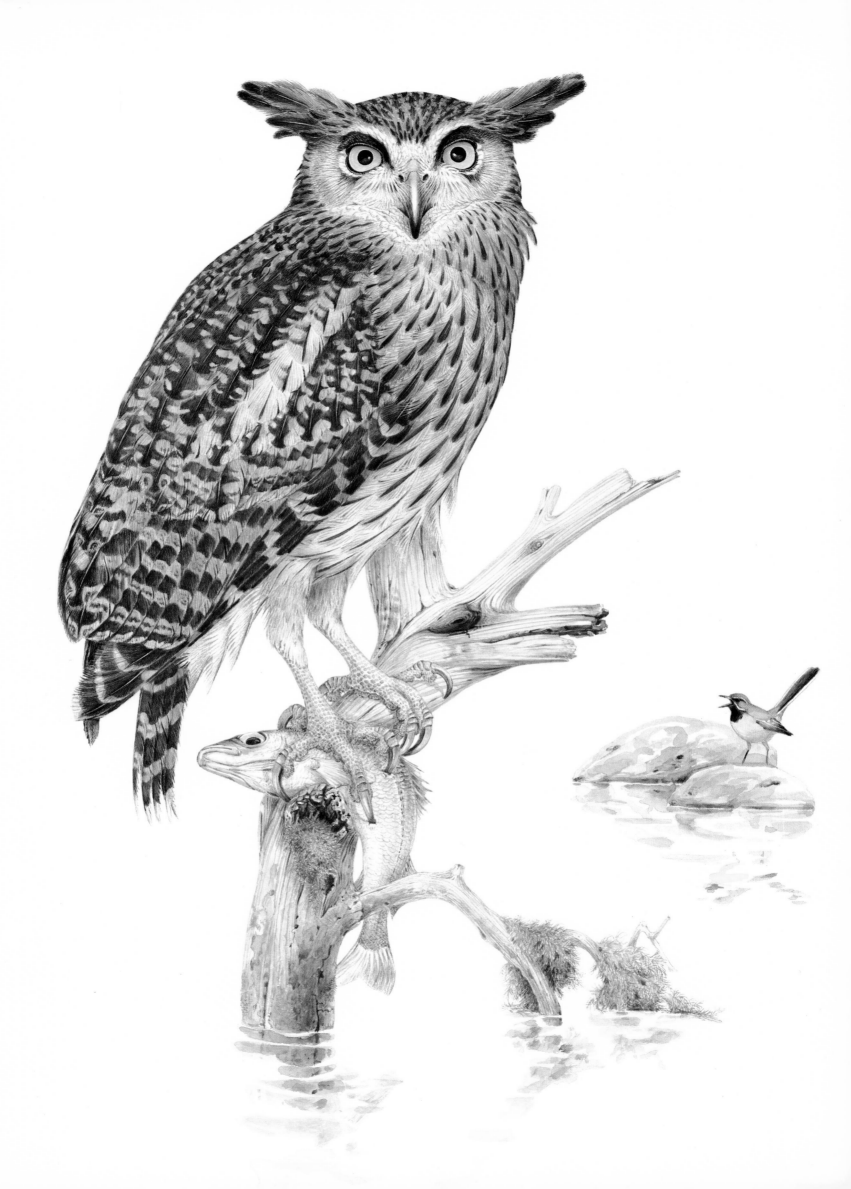

Snowy Owl

Nyctea scandiaca

With an average body weight of 1.75kg in males and 2.1kg in females (Watson, 1957), and a wingspan of on average 1.5m and 1.6m, respectively, the Snowy Owl is 30–33% smaller than the Eurasian Eagle Owl *Bubo bubo* and 20–33% larger than the American Great Horned Owl *Bubo virginianus*. It is the largest avian predator of the Arctic. Only the discovery of its origin will reveal how it got its thick and exceptionally insulating plumage and why it developed a colour dimorphism between the sexes on a scale otherwise unknown among owls. It is as white as the polar bear (see p. 44), the white Gyrfalcon and the Rock and Willow Ptarmigan in their winter plumages, the arctic fox, arctic hare and stoat in their winter pelts, and the Snow Goose and Glaucous Gull. The Snowy Owl may have had a different origin from these species, however, both in place and in time. It is not, like some of them, a montane or high plateau species of central Asiatic origin but exclusively an inhabitant of the Low and High Arctic tundra. It may well have derived from a *Bubo*-like stock and its range starts where the ranges of the Eagle Owl and Great Horned Owl fade away at the arctic tree line.

Geologically the tundra is a young biome and probably did not exist before the Pleistocene Ice Ages. The Snowy Owl's morphological structure and ecological characteristics must therefore be young too. The owl was present in the tundra and arctic steppes of the late Middle Pleistocene of Europe (Mourer-Chauviré, 1975) and Russia south to the Caucasus Mountains, but there is only one prehistoric record from North America (Illinois) (Brodkorb, 1971). How it lived and behaved in those glacial times is not known, though it must have played its part in the sort of ecosystem described here: "Microtine rodents, particularly lemmings *Lemmus* and *Dicrostonyx* play a pivotal role in tundra ecosystems, markedly affecting the vegetation, microtopography and soil. Predatory mammals and birds determine the timing and amplitude of microtine cycles. They are therefore critical components of the ecosystem, rather than decorative ones" (Fitzgerald, 1981:503). The Snowy Owl is one of these crucial predators and its role in the tundra ecosystem may well prove to be rather complex. As an owl, the Snowy Owl is exceptional in its extreme choice of habitat, its terrestrial way of life, multiple-year breeding cycle and apparent nomadism. The Snowy Owl's life style basically resembles less that of *Bubo* owls than that of the Short-eared Owl *Asio flammeus*, which, living predominately at lower latitudes as it does, has explored different methods of ecological adaptation.

GENERAL

Faunal type Arctic.

Distribution All areas of Eurasia and North America north of the tree line, provided these are inhabited by lemmings or other microtine voles. Thus, in North America it extends north as far as the land at 82°40′ north near Cape Sheridan, Ellesmere Island, Canada (breeding at least 1876 and 1909, but not 1951; Parmelee & MacDonald, 1960), and at 82°50′ north in Peary Land, Greenland (Salomonsen, 1951). It does not nest as a rule on the west and south coasts of Greenland, where lemmings are absent, nor on Jan Mayen, Bear Island, Spitzbergen and Franz Josefland, and has only nested by accident in lemming-free Iceland (doubtfully during the last 25 years) and on Fetlar, Shetlands, 1967–75 (R. J. Tullock; Robinson & Becker, 1986). Snowy Owls have also been found nesting at 76° north on Novaya Zemlya, at 81° north on Severnaya Zemlya, on the New Siberian Islands and on Wrangel Island. Regular nesting occurs as far south as the southern boundaries of the tundra, viz. Hooper Bay on the west coast of Alaska, Hall Island, also Attu and Budir in the Aleutian Islands and the Shumagin Islands off the Alaskan Peninsula; also along the shores of southern Hudson Bay, northern Quebec and the north coast of Labrador. Also at 1,200–1,300m in the alpine heights of the Hardangervidda in south Norway (Barth, 1959), on the fjelds of Sweden and in the tundras of north Finland and Russia, and all along the lowland tundras of north and northeast Siberia and the Komandorski Islands, where it has increased after the accidental introduction of the house mouse and the northern red-backed vole.

The occurrence of Snowy Owls as breeding birds is irregular, however, and depends on the dramatic population cycles of lemmings. Provided lemmings or arctic land or sea birds are available as prey during the meagre winter months, Snowy Owls remain in unknown numbers throughout the winter in most parts of their breeding range. There are also regular migratory movements south into the Canadian prairie provinces and the Siberian and Mongolian steppes and there are mass irruptions to more southerly regions every fourth year or so. Map 10.

Climatic zones Low and High Arctic tundra zones. The southern limit approaches the July isotherm of 12°–14°C, coinciding

with the northern limit of the Eagle Owl and the Great Horned Owl. To the north the breeding range extends slightly north of the July isotherm of 2°C.

Habitat In the breeding season, rolling tundra with dry hummocks, ridges, bluffs and other rocky outcrops, frost-raised knolls and all kinds of glacial deposits; both the marshy tundra of the Low Arctic, with dry rocky mounds, and the arid, desert tundra of the High Arctic. Also tidal flats of the Arctic Ocean in the Hooper Bay region, Alaska (Murie, 1929). In winter scrub tundra, steppes, prairies and other grasslands, extensive cultivated fields, preferably stubble fields where mice and voles gather on spilt grain, other farmlands, airports, golf courses, moors, lake shores, sea soasts, including sandy beaches and other wide, often windswept, places. The Snowy Owl rarely perches in trees or shrubs, mostly settling on the ground, on hummocks, fence posts, telegraph poles by the side of roads, radio and electricity towers, haystacks, chimneys and the roofs of houses and large stone buildings.

GEOGRAPHY

Geographical variation None reported, not even variations in specific dimensions, such as wing length.

Related species Most probably the Great Horned Owl *Bubo virginianus* and the Eurasian Eagle Owl *Bubo bubo*, as confirmed by comparative study of the skeleton (Ford, 1967).

STRUCTURE

The Snowy Owl resembles eagle owls *Bubo* in most respects. As an inhabitant of a cold and stormy arctic environment it has an exceptionally dense and luxurious plumage in which the bill and the claws remain almost hidden. The undertail coverts reach the end of the tail feathers and the underside of the toes has a hairlike covering. The feathers covering the toes are the longest among owls in these places (33.3mm), greatly surpassing the length of corresponding feathers in the Great Horned Owl (13.0mm), which are second longest (Barrows, 1981). The head is relatively small, as are the eyes, while the facial disc is even less completely formed above the eyes than in *Bubo* owls. As in the latter, the outer ear opening is uncomplicated, oval or roundish in shape, without an operculum, though the caudal rim is a thin piece of skin which seems to be erectable. The dimensions in a male which I measured were 21 × 14mm (left) and 21.00 × 14.5mm (right). Ear tufts are small (20-25mm in length), consisting of about ten feathers each, and are usually overlooked. Raised ear tufts have been observed on a few occasions, e.g. in an incubating female on Bathurst Island, Canadian Arctic, when they protruded as little pointed horns giving the sitting bird a devilish appearance (Sutton, 1971:70). There appears to be no further need for Snowy Owls to have long ear tufts as in *Bubo* owls, either for mimicking mammalian predators, or for assuming cryptic postures.

Though the owl is virtually terrestrial, the legs are short and the tarsometatarsus is thick, measuring in length about 68% of that of the Eurasian Eagle Owl, while the total length of the claws is about 89% of that species'. Other skeletal differences are few; those mentioned by Norman L. Ford (1967) in his thesis on the anatomy of owl skeletons include a relatively shorter, more decurved rostrum of the skull, a proportionately greater length of the interorbital roof and a much longer sclerotic ring surrounding the eye, the length of which is about 1.2 times the diameter of the anterior opening and relatively the deepest known in owls. It probably protects the eye against extreme cold and serves long-distance vision.

The number and structure of chromosomes and the morphology of the five pairs of macro-autosomes found in the Snowy Owl have also been observed in members of the genera *Bubo*, *Ketupa*, *Asio* and an exceptional *Otus* and probably represent general, ancestral types (Belterman & de Boer, 1984).

BEHAVIOURAL CHARACTERISTICS

Songs and calls Territorial, advertising and courtship songs consist of a short series of loud, hollow hoots, *hoo-hoooo*, sometimes ending in a fierce *aaow* resembling the alarm call of a Great Black-backed Gull. The song is loudest in territorial defence; the male's song is deeper, the female's higher pitched. The booming sound is audible at great distances; in the thin air of the polar regions it has been heard as far as 3–10km distance. Sound quality and performance, including violent bowing movements with a strangely cocked tail, resemble those of the large *Bubo* owls. Loud, grating alarm barks, a hoarse *keeeea* note of attack, a mewing call by the female and various shrill whistles, squeals, cackles and hisses seem to be more directly related to the wide, rough and windswept arctic environment (descriptions by Bent, 1938; Watson, 1957; Portenko, 1972). The hunger or position call of the dispersed young is a high-pitched whistling squeal with a ventriloquial effect. Though the owl is often said to be silent south of its breeding grounds, vocalizations have been described from its winter quarters in the northern United States (Evans, 1980), possibly in relation to early territorial and sexual activity which sometimes occur on these grounds before the move northwards.

Circadian rhythm The Snowy Owl is frequently active in bright daylight, not only perforce in the arctic summer, but also during the short winter days. Greatest activity, however, has been noted in the twilight of dusk and dawn and during the less bright hours of the northern summer, which means between 21.00 and 03.00h in southern Norway (Y. Hagen) and between 22.00 and 23.00h on the Shetland Islands (R. J. Tulloch). The activity seems to reflect the activity pattern of the owl's main prey: lemmings and other microtine voles. When feeding on birds, particularly those of sea coasts and marshes, the owl is a daytime hunter. In winter, when it has to economize on body energy, it has been found in Sweden to be least active between 10.00 and 15.00h, though hunger may alter this pattern in the same way as it does in the otherwise nocturnal *Bubo* owls of subarctic woods and boreal forests.

Antagonistic behaviour Snowy Owls are no less formidable opponents than the large *Bubo* owls. They can be very aggressive

Snowy Owl *Nyctea scandiaca*

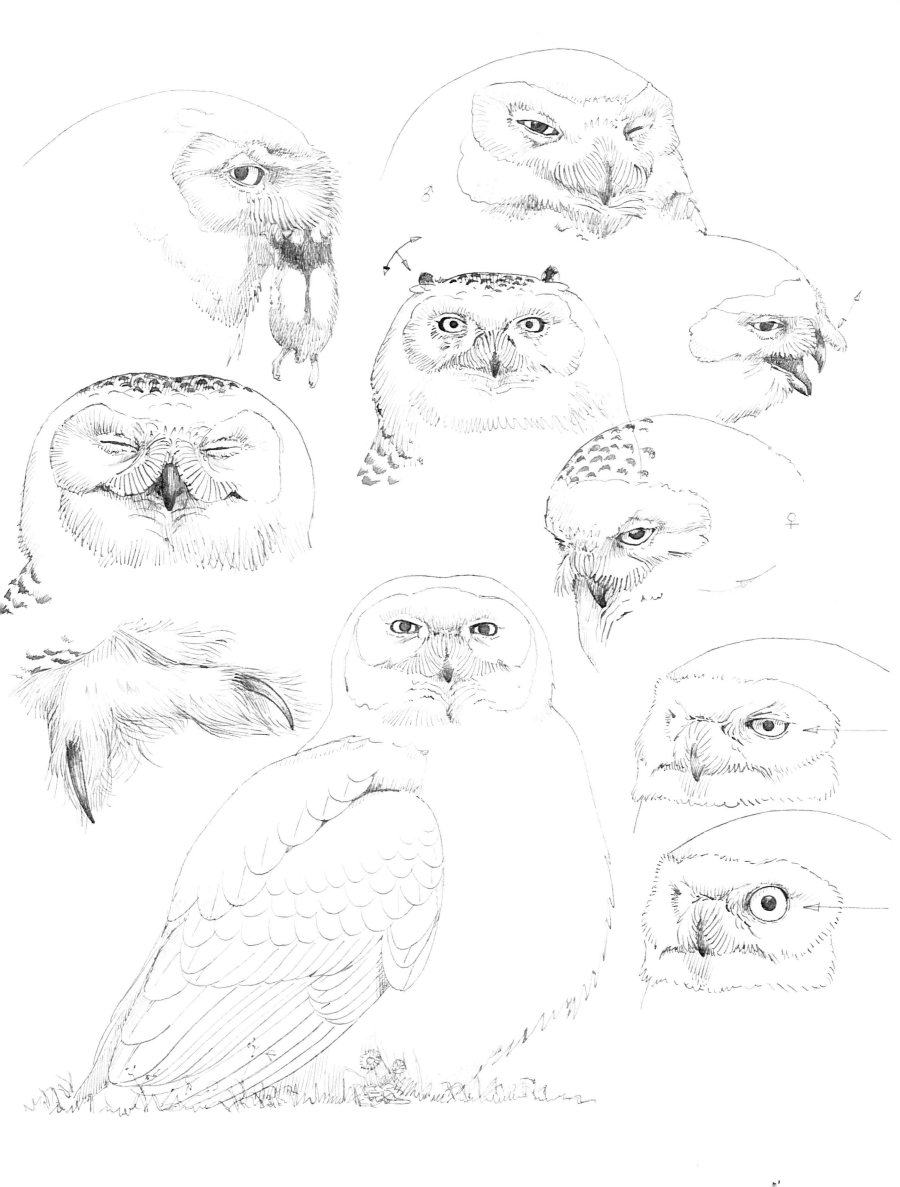

in defence of their nests and young, but individual birds and individual pairs behave differently. Genuinely dangerous encounters with dive-bombing owls at their nest sites have been described by various authors (Bent, 1938; Watson, 1957; Parmelee, 1972). "Forward-threat" postures in males walking towards intruders near their nests have also been described, as well as the impressive feather-raising and fanning-out of half-spread wings in a show of bluff. As an adaptation to terrestrial life some Snowy Owls indulge in distraction display in which the birds literally fall out of the air, then run and struggle in a broken-wing act while uttering high, thin squeals interspersed with weird squeaks. Thus, one observer (Parmelee, 1972) was drawn up to two miles away from a nest on Victoria Island, Canada. Snowy Owls are sometimes seriously mobbed by skuas and terns; also by Lapland and Snow Buntings and Rock Pipits, though on other occasions these little birds have been observed sitting almost alongside a big Snowy Owl, neither paying attention to the other. No special concealment posture has been described, though female Snowy Owls, lying flat on their nests while incubating, are said to be hard to detect in an early-summer tundra with patches of snow and open ground all around.

ECOLOGICAL HIERARCHY

Apart from a few Short-eared Owls during lemming peak years in the southern Low Arctic, no other owls share the Snowy Owl's breeding grounds. With a body weight more than five times greater than the Short-eared Owl's, the Snowy Owl can hardly be a food competitor for the smaller species, nor does it regularly prey on it. The Snowy Owl is nevertheless known to kill an occasional Short-eared Owl in the tundra in summer and in the open grasslands of the boreal south in winter (Levin et al., 1977; Lein & Boxall, 1979).

Few other owls and diurnal birds of prey have fallen victim to the Snowy Owl. In Europe one Rough-legged Buzzard and one Gyrfalcon have been recorded (Mikkola, 1983). Data from North America include, apart from Short-eared Owls, one Saw-whet Owl (Ontario, Canada; Catling, 1973) and one Goshawk. In Alaska a fully fledged Peregrine Falcon was taken by a Snowy Owl, but in retaliation one of the parent falcons struck the owl and killed it in flight (Edward W. Nelson, 1887, cited by Bent, 1938).

As a lemming-eater the Snowy Owl shares its periodic feast with Pomarine and Long-tailed Skuas, Glaucous Gulls and to a lesser extent with Rough-legged Buzzards, Hen Harriers, Gyrfalcons, Peregrine Falcons, Ravens and, of course, polar foxes, stoats and other arctic weasels. During the peak lemming summer of 1953 near the Arctic Sea coast at Point Barrow, Alaska (Pitelka et al., 1955; Fitzgerald, 1981), the average number of Snowy Owls per square kilometre was 1.0, Short-eared Owls 2.0, Pomarine Skuas 15.0 and least weasels 24.7. In percentage of total predator biomass this was equivalent to 11.9%, 4.4%, 73.1% and 10.5%, respectively, while the percentages of total prey consumed per day were calculated at 5.1%, 4.5%, 68.0% and 22.4%, respectively. By dint of cunning and the advantage of numbers, once in a while Pomarine Skuas manage to steal a Snowy Owl's egg or a small chick from the nest mound (Parmelee, 1972). In Alaska two of these ferocious hunters killed a female Snowy Owl on its nest (Charles D. Brower, cited by Bailey, 1948:265), as did a throng of mobbing Arctic Terns in Greenland (Meinertzhagen, 1959). On the whole, though, Snowy Owls are quite capable of chasing any kind of bird, marauding polar fox or tundra wolf away from their nests or young. The relationship between these predators is mostly one of mutual kleptoparasitism in all places and all seasons of the year, though they generally try to avoid one another. The same is true of Snowy Owls, Eurasian Eagle Owls and Great Horned Owls when they occasionally meet in winter. Geese breeding in the Arctic have been found to profit by the Snowy Owl's aggressive defence of its nest and young. On Jenny Lind Island, Canada, a Snowy Owl's nest was surrounded in 1966 by no fewer than 23 Lesser Snow Geese nests, while in 1969 on Bathurst Island scattered pairs of Greater Snow Geese were nesting as close as 13 steps from a Snowy Owl sitting on its nest (Parmelee, 1972).

Sexual dimorphism in Snowy Owls is considerable; females outstrip males by on average 30% in body weight, 12% in body length and 8% in wingspan, and are armed with 16% longer claws. One wonders what advantages this brings the female in the northern breeding grounds, where she is principally cared for by the hunting male. Such dimorphism in favour of the female may explain why on the wintering grounds in Alberta, Canada, and northern Minnesota and Wisconsin, United States, only the females defend winter territories, whereas the males, after an abortive attempt by some to establish a territory earlier in the winter season, are said to wander around as nomads. In this respect it is also significant that in southern Alberta, Canada, in winter only female Snowy Owls are known to have caught the large white-tailed jackrabbits and the fierce long-tailed and least weasels (Boxall & Lein, 1982). Conversely, probably more males than females winter in the far north, males requiring less food than females under the same conditions.

BREEDING HABITAT AND BREEDING

Snowy Owls nest in high spots in the tundra, usually some windswept prominence, commanding a wide view and often established by long tradition (see p. 140). In the Low Arctic these places may have been the former nesting site of Rough-legged Buzzards or other birds of prey, hence known in the Hardanger fjelds of south Norway as *rovfugltue* or raptor hillocks. Such nest mounds are well fertilized by excrements and food remains and are therefore characterized by an especially rich, nitrophilous vegetation in which, on Victoria Island, Canada, at least 36 species of plants have been recognized (Parmelee, 1972). Thanks to the rich food supply provided by this vegetation the nest mounds attract lemmings, which dig their tunnels right under and around the owl's nest. The nest itself is a scrape or shallow hollow, usually with no nest lining at all. Whatever plant roots, grass stems or pieces of moss or lichen may be found in it have been carried there accidentally or have fallen in when the incubating owl was cleaning the nest or adjusting its position. Evidently Snowy Owls have no choice but to lay their eggs on such sites, since they are not cliff-breeders; they therefore do not enter into nest site competition with eagles, falcons and Ravens, nor do they meet *Bubo* owls in their breeding habitats.

Snowy Owls defend nesting territories vigorously against intruders in territorial flights which follow an undulating course and include stiffly raised wings and bouts of exaggerated, delayed wing beats (Taylor, 1973). The birds fly like large,

white moths, exposing the white upper- and underside of the wings which can be seen at great distances, while uttering *Bubo*-like hoots. Competing males fight each other with interlocked claws in mid-air. Territorial and nuptial flights are followed by a ground display on the part of the male, which raises its wings in an "angel" posture serving as a flashing white signal visible for well over a mile. While actually courting the male carries in its bill a lemming, whose dark colour contrasts with the whiteness of the owl's plumage, and begins hooting while assuming a grotesque posture, with cocked tail, on some prominent piece of ground. Great Horned and Eagle Owls display similar courting behaviour. At one spot on Southampton Island at least 20 hooting males were observed in late May in a "lemming-year" (Sutton, 1932). The conspicuous "lemming-display", in which the lemming is only rarely replaced by another prey (e.g. Snow Bunting), seems to be an exaggeration of a familiar food-carrying habit and serves to announce to the female the presence of a proficient hunter and a food supply sufficient for the coming breeding season. It has been assumed that unless the male follows this ritual the female does not respond to courtship and refuses to breed.

As in the Short-eared Owl, nesting territories vary considerably in size, ranging from 1.2–3.9km^2 (average 2.6km^2) on Baffin Island, Canada, in years of food abundance, to 8–10km^2 in years of scarcity (Watson, 1957). Smaller territories have also been recorded on Ellesmere Island, viz. four pairs on 2.6km^2 (Parmelee & MacDonald, 1960). In top lemming years on Southampton Island territories were as large as about 22km^2 and distances between nests were on average 4.5km (Sutton, 1932). Again like Short-eared Owls, Snowy Owls wander around in search of suitable food conditions for breeding, but, unlike these owls, Snowy Owls have to adhere to a strict breeding season during the short arctic summer. Unlike most owls, Snowy Owls do not attempt to breed each year but profit from the four-year lemming cycle to reproduce prolifically once in every 3–5 years, as do the other lemming-eaters, the Pomarine and Long-tailed Skuas. Thus, on the coastal tundra of Point Barrow, Alaska, no Snowy Owls nested in 1951, a few only nested in 1952 and at least seven pairs nested in 1953, with territories of 5–10km^2 and distances between nests of 1.5–6.0km (Pitelka *et al.*, 1955). Similarly, in the south Norwegian highlands, Snowy Owls have been found breeding in years of plenty only, nesting at distances of 1.2–3.7km, average 2.1km (Hagen, 1960).

Breeding activity is determined by arctic climatic conditions. There are some weak indications of Snowy Owls having already completed pair formation in their winter quarters in south Alberta (Boxall & Lein, 1982), but generally the whole breeding process does not start before the end of April or the middle of May. There is no indication that male and female form a pair for more than one season, nor that any individual Snowy Owl is attached to a certain territory or breeding site. Unlike *Bubo* owls, but like Short-eared Owls, Snowy Owls are nomadic.

There is no "normal" or "average" clutch size, for either Snowy Owls produce exceptionally large clutches with a high reproductive expectancy, or they produce small, abortive clutches with a virtual zero success rate, or they do not nest at all. Clutch size in reproductive years amounts to 8–15 (Portenko, 1972), or even 16. The average in the top lemming year 1960 on Victoria Island, Canada, was 9.8 eggs (Parmelee *et al.*, 1967); near Point Barrow, Alaska, in 1953, 6–7 eggs (Pitelka *et al.*, 1955). For an owl of the Snowy Owl's size these clutches are exceptionally large; compare, for example, the 2–4 eggs laid normally by the big northern *Bubo* owls. To cover the eggs, female Snowy Owls have a conspicuous brood patch, described as "an enormous, flabby, highly vascularized featherless area of pink belly skin" (Parmelee, 1972:33). Eggs in northern Europe average 57.4 × 45.15mm (Makatsch, 1976), in Russia 57.1 × 44.9mm (Portenko, 1972), in North America 56.4 × 44.8mm (Bent, 1938), underlining the fact that there are no geographic differences in the size. The eggs are approximately 20% smaller than eggs of northern Eagle Owls and 8% smaller than eggs of northern Great Horned Owls.

At first young have a rather thin white down and need careful brooding. The second down is sooty brown, but the chicks have a peculiar, white face (see p. 256; see Murie, 1929). They are brooded by the female for 7–14 days, after which time they disperse from the nest to find safety in nooks and crannies among vegetation and rocks while the female continues to incubate eggs that have not yet hatched and to brood the chicks' smaller siblings. By 43–50 days the young can fly and when 60 days old they hunt by themselves. As eggs are laid at 2-day intervals, which may increase to 3- or 4-day intervals during inclement weather, the laying of a clutch of 11 eggs takes 20–30 days. Since the female starts incubating when the first egg is laid, there can be a size difference between the oldest and the youngest chicks of as much as between 50 and 350g chick weight (Barth, 1949) or between 20 and 380g (Watson, 1957).

Assuming the food supply lasts, the female does not resume hunting until the youngest chick no longer needs brooding. The male meanwhile has been providing food for the female and the young, which means constant hunting. Surplus prey is often cached around the nest rim or in a secluded spot. Unused prey heaps surrounding a nest at Cape Barrow, Alaska, have been found to contain as many as 83 brown lemmings, with an average weight of 77.8g (male) and 70.3g (female) (Pitelka *et al.*, 1955). Whether the female or young regularly resort to the cached prey is not known, but young, wandering between a few and a hundred metres from the nest and uttering ear-splitting squeals from their various hiding places, tend to be supplied with fresh prey by the male, who drops it near to them. Young are relatively safe from predators, but both parents sometimes indulge in an extraordinary show of the broken-wing act, which, in addition to direct attacks, usually leads arctic foxes and tundra wolves away from the owls' young.

Nesting success in peak lemming years is usually relatively high and has reached 90–100% of even the largest clutches. Such successes more than compensate the virtual lack of reproduction in non-peak years.

Due to the arctic conditions, the whole reproductive cycle takes a considerable length of time. With a clutch of, e.g., 11 eggs at least 54 days elapse between the laying of the first egg and the hatching of the last young (e.g. 20 May–13 July), and another 50 days are required for fledging (Parmelee *et al.*, 1967), the whole cycle lasting 3–3½ months (F. A. Pitelka). Arctic summers rarely allow a longer cycle than this. Like Short-eared Owls vis-à-vis Long-eared Owls, the young Snowy Owls develop more rapidly than the northern *Bubo* owls. They can walk on their 12th day, eight days earlier than young Eagle Owls. The whole nesting cycle is approximately two months shorter than the Great Eagle Owl's (Scherzinger, 1974).

FOOD AND FEEDING HABITS

The Snowy Owl has a hawk-like flight and hunts in the manner of a large *Buteo* hawk, flying low, sometimes hovering, but mostly looking out from an exposed site or, in winter, from a roadside post, telegraph pole, haystack or other prominent lookout. Apart from frequently being active by day and hunting in the open, Snowy Owls basically hunt like *Bubo* owls. Unlike the northern *Bubo* owls, the Snowy Owl is in a sense a "restricted feeder". Although it breeds successfully only in peak lemming years, it is a versatile and powerful predator under any conditions and anywhere where lemmings are scarce or absent. Wandering around as nomads, like Short-eared Owls, Snowy Owls can survive on any mammalian and avian prey and their prey list is as extensive as that of any *Bubo* owl. When nesting in profusion on the Low Arctic tundra plains at Point Barrow, Alaska, in 1953, Snowy Owls fed almost exclusively on brown lemmings, while only one collared lemming, one least weasel, one Old Squaw duck and one Lapland Longspur (Pitelka *et al.*, 1955) were recorded to have been taken. Similarly, on Victoria Island, Canada, in 1960, brown and varying lemmings were the only prey noted, except for one young Snow Bunting and one adult male King Eider found at two different nest sites (Parmelee *et al.*, 1967). On Baffin Island, also in the Canadian Arctic, hundreds of lemmings, mainly brown lemmings, were recorded in 1953 as Snowy Owls' prey, in addition to only one Snow Bunting (Watson, 1957). However, on Prince of Wales Island, where brown lemmings were virtually absent in the meadow habitats and collared lemmings abundant in the higher areas, lemmings made up only 78.3% of the biomass taken by Snowy Owls, in addition to 3.3% stoats, 17.8% ducks, 0.6% waders and 0.3% songbirds (Kennedy, 1981). On Agattu, Aleutian Islands, the summer diet was quite different: 68.4% of prey biomass consisted of Ancient Murrelet and 6.5% of three other alcid species. Green-winged Teal and Harlequin Duck together formed 13.4% of the diet and storm petrels (two species) 6.1%, while five other bird species made up the balance (Williams & Frank, 1979). Similarly, in the absence of lemmings, sea birds, including gulls and terns, were important food items for Snowy Owls nesting on the Murman Coast, north Russia (Krasnov, 1985).

It is not particularly hard to understand why Snowy Owls have specialized on lemmings, for the nutritional value of these large voles is extremely high. In the American Low Arctic at least, there are two types available: brown lemming *Lemmus* of lower, wetter habitats and feeding by preference on grasses, sedges and mosses, and varying or collared lemming *Dicrostonyx* of more arid, often higher habitats and heathlands and a preference for willow leaves and forbs (Batzli, Pitelka *et al.*, 1983; Batzli & Pitelka, 1983). In the Old World Arctic the Norwegian lemming and most of the north Siberian lemmings are the New World brown lemming equivalents. Adults of all of these reach body weights of up to 80–90g; those found as prey around Snowy Owls' nests on Baffin Island weighed 30–95g (Watson, 1957).

The Snowy Owl's summer diet also includes the root vole and other microtine voles when available, house mouse and brown rat where these have been introduced, as well as arctic hare, stoat and other mustelids, and above all the High Arctic Ptarmigan and the more ubiquitous and often nomadic Willow Grouse. Snowy Owls also take duck of all sizes, e.g. Common Eider, King Eider, Old Squaw, and young geese, gulls, waders, guillemots *Uria* and *Cepphus*, Little Auks and Snow and Lapland Buntings; also fish (e.g. char) caught in the manner of Ospreys in open leads of coastal ice. Unlike other owls, except perhaps northernmost *Bubo* owls, Snowy Owls readily eat carrion, such as dead walrus on ice floes out at sea and the remains of dead or slaughtered seals, a dead arctic fox or, on their wintering grounds, any bird or fur-bearing animal caught in a trap and either struggling or dead.

On their wintering grounds Snowy Owls take any prey available, including terrestrial mammals like meadow voles, deer mice, white-tailed jackrabbits (see Boxall & Lein, 1982), ground squirrels, muskrats, brown rats, moles, shrews and, in the Old World, hares; also rabbits, ground voles, bank voles, field voles and all kinds of steppe mammals including pika. Birds recorded as winter prey include grebes, geese, duck (at least 11 species), alcids (10 species), gulls (6 species), coots, pheasants, partridges, waders, an occasional bird of prey, owl or Raven and some sparrows and buntings. The avian prey of Snowy Owls wintering in Victoria, Vancouver Island, Canada, 1973–74, consisted of at least 21 species, 26% by weight being grebes, 46% waterfowl, 23% gulls (Campbell & Maccoll, 1978).

Snowy Owls examined in the Old World Arctic in November exhibited extremely thick subcutaneous fat deposits (19–22mm; Portenko, 1972). When wintering in the Arctic the owls seem to have to rely heavily on this reserve, since food is scarce; they also conserve energy by behaving lethargically and scarcely moving, and are able to fast for 24–40 successive days (Gawrin, cited by Portenko, 1972).

MOVEMENTS AND POPULATION DYNAMICS

The original picture of the Snowy Owl as a resident species which wanders south en masse only when lemming populations have crashed has proved too simple. There are regular movements south each autumn and Snowy Owls winter annually on the plains of Siberia and Mongolia and in the prairies and marshlands of Canada. After top productive summers, each 3–5 years, numbers moving south are more conspicuous than in other years and first-year birds in particular disperse over great distances and often far to the south. Lemming cycles do not run parallel throughout the Arctic; besides, the more southern, lowland brown lemming behaves differently from the more northern varying or collared lemming. The first increases almost limitlessly within its preferred habitat whereas, during population explosions, the second invades suboptimal habitats and does not therefore reach the high densities known for brown lemmings. The effect upon the Snowy Owl's productivity is consequently largest in brown lemming top years, but the separate effects of both lemming cycles may balance each other out, causing great irregularities in the basic four-year cycles. Since the Snowy Owl has a successful breeding season virtually once every four or five years, its population fluctuations are immense. In reproductive years Banks Island (63,700km^2) in the Canadian Arctic harboured between 15,000 and 20,000 Snowy Owls, as against 2,000 in non-breeding years (Manning, Hohn *et al.*, 1956).

In at least 24 separate years thousands of Snowy Owls are known to have invaded southern Canada and the United States. Seventeen irruptions between and inclusive of the years 1882 and 1883 and 1945 and 1946 took place with intervals of 3–5

years, average 3.9 years (Gross, 1947). Similar data, with mass movements every 3–5 years, have been recorded in Europe, Russia and cold and temperate Asia. During invasion years hundreds of Snowy Owls have been observed migrating along arctic coastlines or following leads in coastal ice. They have appeared far out at sea, perching on floating sea ice, and have crossed oceans. Most remarkable is the recovery of three Snowy Owls ringed as siblings in one nest in Cambridge Bay, Victoria Island, Canada, in the breeding year 1960: one was found 19 October 1961 in east Ontario; another 8 May 1962 on the southern Hudson Bay coast; the third 18 February 1962 on Sakhalin Island, eastern USSR (Parmelee et al., 1967, 1972). A nestling ringed in 1963 in Hondaland, Norway, was found July 1964 in Finmark, Norway, 1,380km NNE; an adult ringed December 1960 in Pori, Finland, turned up in February 1962 in Nordland, Norway, 810km NNW (Mikkola, 1983).

Southernmost records in North America include southern California, Nevada, Utah, central Texas and Florida. In Europe Snowy Owls have turned up as far south as France, Yugoslavia and the Crimea, while from Asia records come from the Caspian Sea coast of Iran, northern Pakistan, Kazakhstan, Tien Shan, northern China (south Shensi, Hopeh), Korea and Japan (Honshu). Insular records include those from Bermuda, the Azores and the Faroes. There are numerous records from far out in the Atlantic Ocean, e.g. on 8 November 1945 two owls landed on a ship following the great circle route between Gibraltar and New York, some 1,300 miles from New York and 320 miles from Newfoundland; and on 9 March 1946 another landed on a ship some 300 miles southeast of Newfoundland (Gross, 1947).

The oldest ringed Snowy Owl on record is one of 9 years and 5 months (Glutz & Bauer, 9, 1980), but one in the Basel Zoo, Switzerland, lived for at least 28 years (Schenker, 1978), an age which Snowy Owls may probably also reach in nature. Thus, the Snowy Owl is simultaneously nomadic, migratory and irruptive. Populations constantly intermingle as the owls wander in search of favourable feeding grounds and breeding conditions. It is not known how many birds remain on their arctic breeding grounds through the winter.

GEOGRAPHIC LIMITS

Even in winter the Snowy Owl has been found at the northernmost tip of the earth's landmass. Exactly how the Snowy Owl manages to withstand the scarcity of food and the darkness, cold and wind of the far north is a question worth asking. Though in the laboratory food and oxygen consumption and metabolic rate were found to be lower than in other birds, including other owls (Gessaman, 1972), no Snowy Owl can be supposed to survive the polar winter without food. Thus, at ambient temperatures of -12.9 to $-34.0°C$ at Point Barrow, Alaska, two Snowy Owls required 4–6.7 brown lemmings of 60g each in order to maintain their body weight (Gessaman, 1972). In the breeding season, by contrast, 2–4 lemmings of on average 80g were required (Watson, 1957). The thermoneutral zone extended from an ambient temperature of 2.5 to $18.5°C$. Below this the metabolic rate rose; above it the birds started to pant from overheating. It is known that Snowy Owls can survive ambient temperatures below the lowest recorded in the northern hemisphere, viz. $-62.5°C$. In a laboratory experiment one even withstood without ill effects a five-hour exposure to $-93°C$, but then oxygen consumption was 45% higher than computed.

In contrast to earlier suggestions, body temperatures of Snowy Owls did not vary according to a circadian pattern, nor was there a correlation between air temperature and wind speed. Mean daily body temperatures in four Snowy Owls kept in outdoor aviaries at Point Barrow, Alaska, varied between 39.7 and $41.1°C$, while individual differences ranged over 0.3–$0.8°C$ (Gessaman, 1978).

The principal factor allowing the Snowy Owl to survive low temperatures, including the effects of extreme wind chill, is probably the overall insulation of its plumage. Numerous air cells in the white feathers are responsible for the insulation capacity. Thermal conductance of the plumage is second lowest among birds, viz. 0.05cal/g/h (the lowest record is for the Adelie Penguin: 0.041cal/g/h) and "is equivalent to the highest insulation reported for the pelts of arctic fox and Dall sheep, which had the best insulation among 16 arctic mammals studied by (P. R.) Scholander and coworkers" (Gessaman, 1972:229).

LIFE IN MAN'S WORLD

On their breeding grounds eskimos and other northern peoples hunt Snowy Owls for food. In response the owls are extremely wary and it is hard to get within 200–300m of them. Early winter migrants in southern Canada and south-central Siberia have been described as "lumps of fat", attractive food, therefore. Hunting Snowy Owls for food or other purposes seems to have been an old tradition, since cave deposits at Pessac-sur-Dordogne, France, dating from the Last Glaciation (Late Würm) contained 1,130 Snowy Owl bones, representing 84 individuals or 90% of all bird bones collected. They were almost as numerous as reindeer (caribou) bones. The majority of bones were claws and the adjacent phalanges of the hind toe, which suggests that the Magdalenian reindeer people who lived in the European tundra at that time made ornaments or magical use of Snowy Owl claws (Mourer-Chauviré, 1979). The habit may have continued since that time and the relative rareness of Snowy Owls in northern Europe may be the result of persecution by man as much as of the contraction of arctic habitats in northern Europe during the past few hundred years.

Snowy Owls do not shun human cultivation in winter when hunting for voles, mice and rats in extensive agricultural fields, mainly stubble fields and rank grasslands. They even enter small towns and sometimes spend most of the day perched on roofs, chimneys, TV aerials, radio towers or church spires. Under these conditions inexperienced first-year birds are extremely tame and fall victim to many a gun or trap. In New Strawn, Kansas, a Snowy Owl remained undisturbed for nearly a month, catching mice in the town's lumberyard, before it was accidentally electrocuted (Parmelee, 1972) (death by electrocution is a major threat to these large birds).

The Snowy Owl has recently become a problem for airports in Canada and possibly also in Siberia and Mongolia. The owls are attracted to the wide, relatively undisturbed fields surrounding the airports where the tall grass offers a home for numerous mice and voles, particularly meadow voles (Catling, 1973; Baker & Brooks, 1981). On runways and taxiways, particularly at Toronto and Vancouver International Airports, owls have collided with aircraft causing serious damage to engines though,

so far, no fatal accidents have occurred (Blokpoel, 1976). Professional and amateur bird-ringing groups have been helping to trap and ring Snowy Owls at all the larger airports, subsequently releasing the birds at safe distances. The number of Snowy Owls found at Canadian airports fluctuates annually considerably but is always far smaller than the number of Short-eared Owls trapped in the same place (e.g. Vancouver International Airport, 1964–67, 6 Snowy Owls compared with 426 Short-eared Owls, but at Toronto Airport the figures were considerably higher).

Snowy Owl *Nyctea scandiaca*
Young female (front) and adult male with Norway lemming *Lemmus lemmus* (behind)

Together with the Rock Ptarmigan *Lagopus mutus*, Raven *Corvus corax*, collared lemming *Dicrostonyx groenlandicus* and arctic fox *Alopex lagopus*, the Snowy Owl has been observed in winter at the very northernmost tip of the Arctic. Though much else is now known about the Snowy Owl, its origins and evolution remain a mystery. A somewhat stronger and more robust Snowy Owl, its long bones on average approximately 2% longer and 6% thicker than the present-day species', particularly in the female, has been described from Mindel glacial deposits in a cave in the Bouches-du-Rhône department of southern France as *Nyctea scandiaca gallica* (Mourer-Chauviré, 1975). The owl's remains are smaller by about 22% than Eagle Owl *Bubo bubo* remains from probably the same time and place. Late glacial and present-day Snowy Owls are somewhat slimmer of build and exhibit slighter sexual dimorphism in size (4.8% on average, as against 9.9% in the longer bones of the older *N. s. gallica*; Chauviré, 1965; Mourer-Chauviré, 1975). Late Pleistocene Snowy Owl remains have been found in association with reindeer, saiga antelope, Ptarmigan, Rough-legged Buzzard and, most remarkably, often with Alpine Chough.

Perhaps the Snowy Owl did in fact develop in ice-free pockets surrounded by or situated north of the Pleistocene glaciations, either in Asia or, more probably, in Canada; but this is mere hypothesis.

Its dependence on lemming cycles guarantees the Snowy Owl a favourable nesting season at least once every 3–5 years. This is the species' most characteristic ecological adaptation. Clutch sizes of up to 14 and 15 eggs (average 8.5 in northern Europe) are another outstanding specific distinction and should be compared with the 2–5 eggs (average 2.4 in northern Europe) laid by the large northern *Bubo* owls, which breed yearly however. The Snowy Owl produces eggs equivalent to 25–43% of the female's body weight, which is formidable for a species of its size, a significant physiological achievement and quite exceptional in large owls and large raptors in general. Such a situation stresses the force of ecological necessity which can apparently counteract restrictions of a genetic nature.

Unless it is able to develop other means of surviving the arctic winter and of avoiding life-wasting migrations and irruptions, the Snowy Owl appears to have reached a terminal point in its evolution.

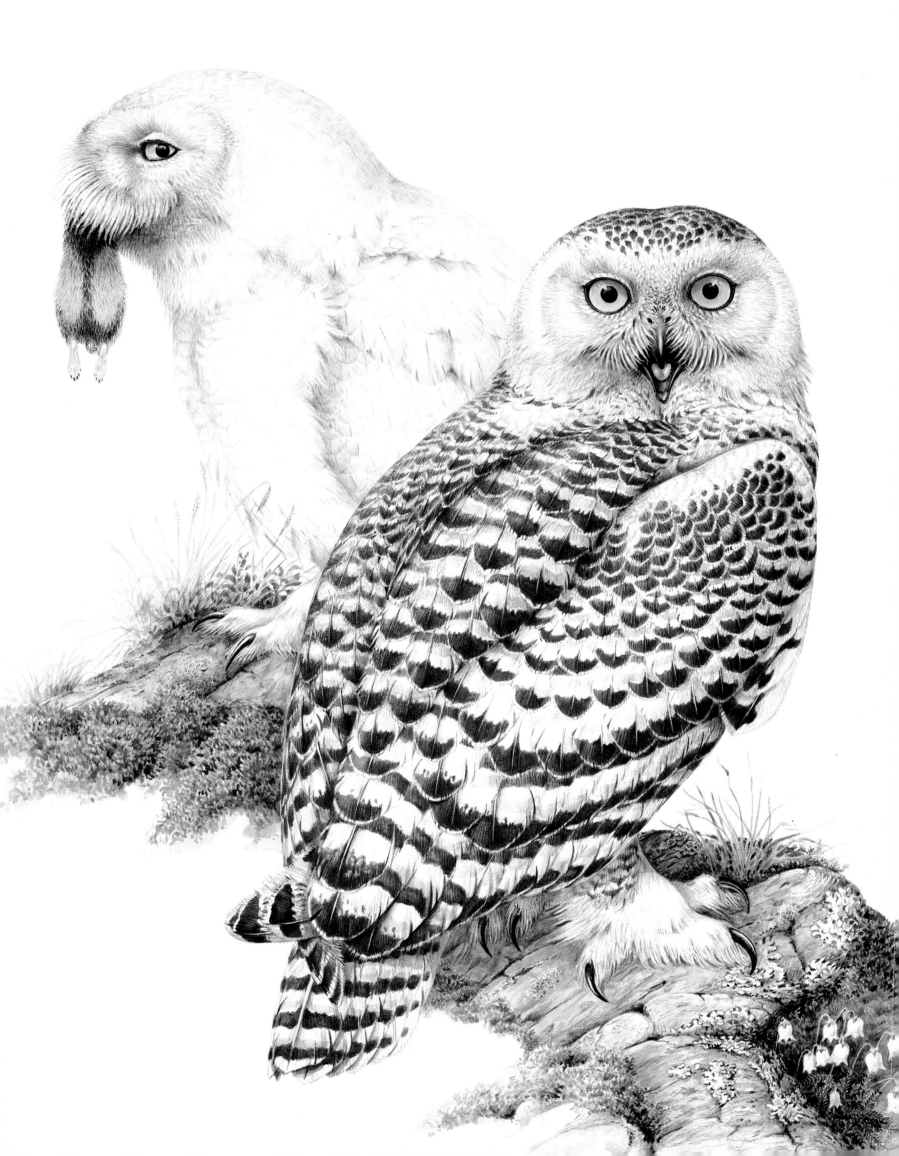

NORTHERN HAWK OWL

Surnia ulula

In appearance, structure and life style the Northern Hawk Owl is the most hawk-like of the boreal owls. It is no less diurnal than the Short-eared Owl *Asio flammeus* and the Eurasian Pygmy Owl *Glaucidium passerinum*, which may share its range and habitat, and the Snowy Owl *Nyctea scandiaca* from the Arctic. It is essentially a high-boreal and even subarctic species and therefore enjoys continuous daylight in summer, while the darkness of its winter habitat may be partially dispersed by the northern lights.

The principal questions surrounding the Northern Hawk Owl concern its origin and age as a taiga and birch zone-inhabiting species and its closest present relative. It is the only species of its genus. Of all northern hemisphere owls only two other species (Snowy Owl *Nyctea*, Elf Owl *Micrathene*) have been assigned a genus of their own.

The Northern Hawk Owl has further attracted attention by its conspicuous appearance in the field, usually perched on a post that commands an excellent view, on the very top of a spruce or the dead snag of some isolated tree, by its bold and seemingly fearless behaviour towards man, and above all by its erratic occurrence, since it may scarcely be observed for years in large areas where it was previously abundant. Less mysterious than other owls whose nocturnal habits make them elusive, the Northern Hawk Owl nevertheless remains an enigma, not least in respect to its ecological relations with diurnal birds of prey rather than with other owls sharing its habitat and range. Its characteristics have been well described by Roland C. Clement from observations made at Indian House Lake County, Quebec, Canada, in 1948: "Few birds are more dashing in the woods than this diurnal owl. Its long wings beat through deep arcs, or they are held stiffly as the bird maneuvers through the trees at breath-taking speed. It is as though a duck hawk [Peregrine Falcon] had taken to the forest and suddenly acquired the skill of a woodcock in dodging through the trees" (cited by Todd, 1963:446).

GENERAL

Faunal type Siberian–Canadian.

Distribution Holarctic, from Scandinavia continuously through Russia and Siberia to Alaska and the full breadth of Canada with southern extensions only in the central Asiatic mountains of the Tarbagatai, Dzungarian Ala Tau and Tien Shan from Altai ranges eastward, but not in the southward-extending mountains of North America, where it has been found nesting not further south than Banff in the Canadian Rocky Mountains and recently (1980) in the Lakes of the Wood County in northern Minnesota (Kehoe, 1982).

As compared with the situation in the nineteenth century, the current European range of the Northern Hawk Owl is retreating northwards. The owl has nested in Livonia (Loewis, 1883) and was a regular autumn visitor in the Baltic countries south to Pomerania, but it no longer occurs regularly there. It was not seen in Poland for 33 years in succession (between 1937 and 1970). In Scandinavia it is likewise diminishing in numbers and, except in years of extraordinary abundance of voles, is currently retreating northwards. The southernmost breeding area at present seems to be near Smolensk in western Russia. Map 11.

Climatic zones Exclusively boreal, reaching north to the July isotherm of 10°C and probably not extending beyond the July isotherm of 18–20°C in the south, except in East Asia where summers can be warmer.

Habitat Open coniferous forests of the northern taiga with forest glades, muskegs, clearings, forest burns, swampy valleys and meadows; often light woodland with larch, birch, poplar and willow; not the dark, impenetrable spruce-fir forest. In the Altai and Tien Shan up to 1,800–2,000m.

GEOGRAPHY

Geographical variation Slight, relating to depth of pigmentation, extent of white spotting and, somewhat, to size. The North American form (*Surnia ulula caparoch*) is darkest; the Tien Shan form (*S. u. tianschanica*) is almost as dark, and larger by about 5%; the contiguous European populations (*S. u. ulula*), though ranging over at least 10,000km, do not differ throughout, though northeast Siberian birds tend to be on average lighter and slightly larger.

Related species The Northern Hawk Owl is monotypic in its genus and no fossil relatives are known. Fossil records show its presence in the Late Pleistocene in Tennessee, United States (Wisconsin cave deposits, together with other boreal birds like Canada Jay *Perisoreus canadensis* and Pine Grosbeak *Pinicola*

enucleator) (Parmelee & Klippel, 1982), in France (end of Würm Glacial, department of Isère) (Mourer-Chauviré, 1975), Switzerland, Austria and Hungary (Riss-Würm Interglacial) (Janossy, 1963). Structurally the Northern Hawk Owl could be described as an aberrant *Glaucidium*; its behaviour too shows characteristics of that genus (W. Scherzinger). Its relationship with *Ninox* also needs clarifying.

STRUCTURE

The Northern Hawk Owl is exceptional among owls of the northern hemisphere in possessing a long, graduated tail; the primaries are straight and taper at the tip and the wings are pointed. Its plumage is compact and does not have the fluffy, downy feathers of other boreal owls. Though the face is conspicuously patterned, the facial disc is poorly developed and there are no real ear tufts. The external ear openings are elliptical, about 13mm high, without enlarged margin or transverse ligament. As in the case of the pygmy owls *Glaucidium*, the openings are symmetrical in position and size (Collett, 1881). Whether the "occipital face" formed by oblique, white-bordered black lines on either side of the neck (Scherzinger, 1986:51) also points to a relationship with *Glaucidium*, in which such a pattern can be quite marked, is a matter of conjecture. The eyes are remarkably small and have the fierce expression of pygmy owls and *Accipiter* hawks. The lower mandible has a distinct terminal notch as in falcons. Tarsus and toes are short, slender and densely feathered. The length of feathers covering the toes is exceeded only by the Snowy Owl; the feathers are somewhat longer, but less densely packed than in Tengmalm's Owl and considerably longer than in all *Strix* species (Barrows, 1981). Though the feathering of legs and toes is less specialized than in most other northern owls, the Northern Hawk Owl apparently often hides its feet among its belly feathers to keep them warm in cold winter weather.

BEHAVIOURAL CHARACTERISTICS

Songs and calls The Northern Hawk Owl is a vociferous bird, particularly when attending to its fledged young, but the season of its pre-breeding and territorial vocalizations and song is short and in winter the owl is usually silent. Its trilling territorial song comprises a high-pitched, monotonous series of whistles, sharper and more rapid than that of Tengmalm's Owl and resembling the sounds *hoo-hoo-hoo-hoo* or *ulululu*. It is the call from which Linnaeus is supposed to have derived the bird's specific name *ulula* (from Latin *ululare*, to cry or scream), though this would have been more appropriate for the better-known Tawny Owl. When defending their nest site and young both male and female indulge in an uninterrupted series of penetrating screams, *kee-kee-kee* or *kree-kree-kree*, resembling the call of a bird of prey rather than the alarm call of an owl. Other throaty and rattling calls have been described. Food-begging calls of fledged young are not unlike those of the Short-eared Owl (Lindblad, 1967).

Circadian rhythm The Northern Hawk Owl is mainly diurnal in habits. Even when tending a brood or feeding nestlings it stops foraging and is less aggressive in defence of its nest during the few hours of midnight twilight. It hunts rather like a diurnal raptor, its rodent prey being active both day and night.

Antagonistic behaviour When surrounded by a mob of birds the Northern Hawk Owl can make itself thin and assume a position of camouflage (p. 44) as other owls do under similar conditions, but reports of the owl's eyes being closed to narrow slits have not been corroborated. Generally the Northern Hawk Owl remains conspicuous throughout the day and behaves in an unrestrained manner. It is fearless to the extent of being aggressive and ferocious and there are numerous, colourful reports of attacks on large mammalian and avian predators and on man nearing the owl's nest site or climbing the tree in which the nest was located. On many occasions the attacking owl has harmed the intruder and drawn blood.

ECOLOGICAL HIERARCHY

Body weight in Finland varies between an average of 270g in males and 320g in females (von Haartmann *et al.*, cited by Mikkola, 1983) and in North America between 294g in males and 345g in females (Earhart & Johnson, 1970), the females being larger by 19% and 17%, respectively. The overall sexual dimorphism index (4.2) in the North American Hawk Owl is slightly larger than in the North American Pygmy Owl, much larger than in all species of screech owl *Otus*, but considerably less than in owls of the genera *Bubo*, *Nyctea* and *Aegolius* (Snyder & Wiley, 1976). In spite of these differences, hunting methods and food intake of Northern Hawk Owls are not known to differ between the sexes.

During the summer at least, the Northern Hawk Owl is an almost exclusive rodent-hunter like other circumboreal owls. There seems to be little competition between these owls, either because food is abundant or else virtually non-existent, or because the forest habitat is too open for a Tengmalm's Owl, too low and stunted for a Ural Owl or too heavily forested for a Short-eared Owl. How the Northern Hawk Owl behaves towards the powerful Ural Owl, which it may meet in its southern ranges, and towards the Great Grey Owl which also inhabits forest glades, is interesting matter for speculation. Only in winter has it been known to prey on other owls (Tengmalm's Owl, 3 × in Finland) (Mikkola, 1983), but one wonders how much more frequently this may occur and how often Pygmy Owls in either continent may be taken. In winter the Northern Hawk Owl captures avian prey as large as that taken by any Goshawk, but the interspecific consequences of this are not known. When no other predators are present the Northern Hawk Owl may share a common food source with the Short-eared Owl, e.g. on a small island in the Bothnian Gulf, Finland, where the two species tolerated each other and during a whole breeding season subsisted 99.4% and 97.8%, respectively, on water voles, a species which is active both day and night (Pulliainen, 1978).

In spite of its aggressive disposition, the Northern Hawk Owl is generally considered tolerant towards other birds of prey and owls intruding into its territory, some of which have been found nesting at less than 500m from a Northern Hawk Owl nest (Mikkola, 1983). Relatively few Northern Hawk Owls have been recorded as prey of other owls and raptors; the instances mentioned from Europe relate to the Eagle Owl (17 ×), Ural Owl (1 ×), Golden Eagle (1 ×), Rough-legged Buzzard (1 ×),

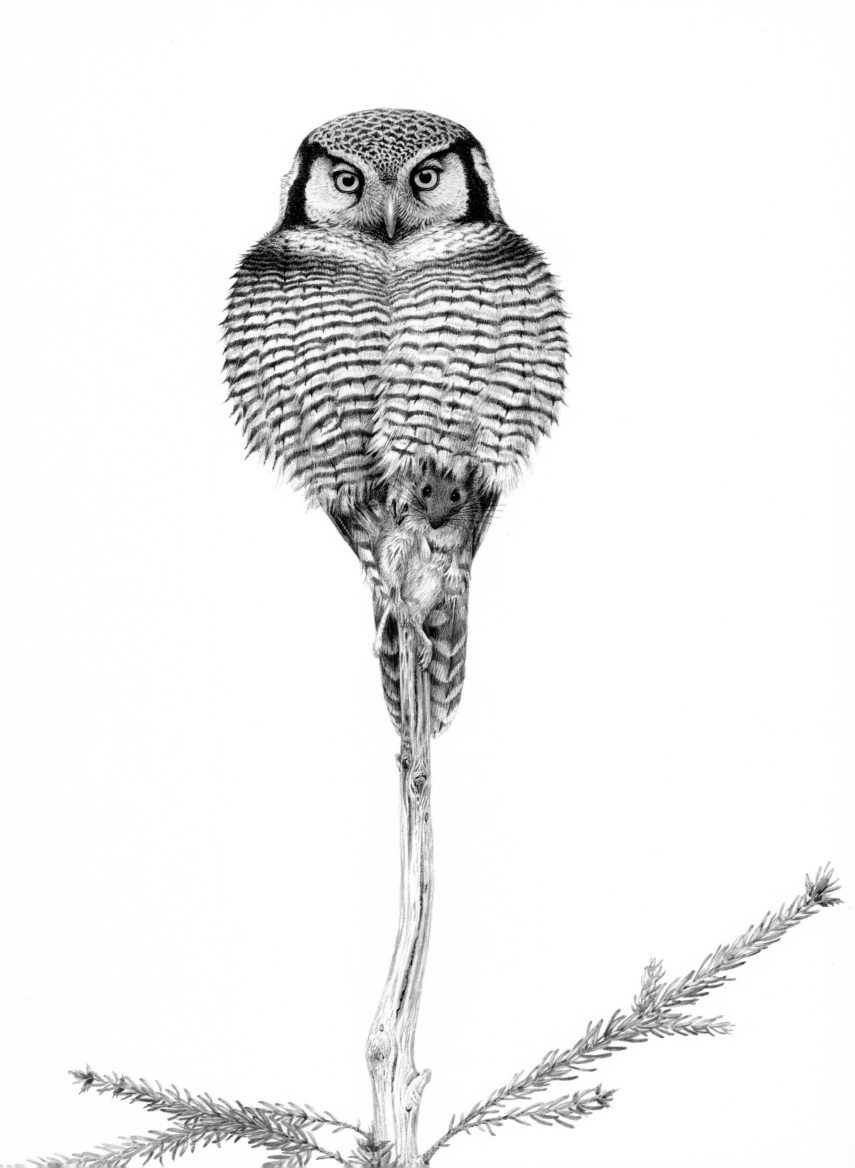

Goshawk (1 ×), Gyrfalcon (1 ×) and Peregrine Falcon (1 ×) (Mikkola, 1983; Semenov-Taishanski & Giljasov, 1985). Data from North America, where Great Horned Owl and Goshawk are serious potential predators, are lacking, though a Hawk Owl has been observed hiding in a dense spruce tree immediately after a Goshawk had entered its range.

BREEDING HABITAT AND BREEDING

Most frequently recorded nesting sites are decayed holes in trees, snags and other open hollows where the tops of trees have been broken off, holes in mouldering stumps and rotten birch stubs, and vacant nests of Black and Pileated Woodpeckers, particularly when these allow an unobstructed view through the open forest. Also the edges of forest glades or the ghostly, black remains of tree trunks left standing after a forest fire. Nests can be very small and sometimes have hardly room enough for the sitting bird's long tail, which may protrude through the nest opening or the decaying bark. In open hollows at the top of a snag or broken tree the incubating bird is fully exposed to the force of wind, rain, snow and sun. Breeding in the old nests of crows, magpies and birds of prey has been reported in Siberia as well as in North America. Nest boxes erected in Sweden for Goldeneyes and Goosanders have also been accepted by Northern Hawk Owls.

Clutch size varies according to the food situation and there may be no breeding at all in years of scarcity. In northern Soviet Lapland Northern Hawk Owls are said to nest only twice every four years in accordance with the fluctuation cycle of on average four years of voles and lemmings (Semenov-Taishanski & Giljasov, 1985). Hence there are no normal or average clutches. The number of eggs reported varies between 3 and 13.

Though males occasionally take to short bursts of incubating, it is predominantly the female which sits on the eggs and provides shelter and warmth for the small chicks, while the male goes in search of food for her and her young.

The plumage of the young when newly fledged resembles the grey and white shades of lichen-covered pines and mouldering birches and protects them effectively from the dangers of predation and human intrusion (see p. 256).

FOOD AND FEEDING HABITS

Hunting mostly by day, the Northern Hawk Owl looks around for prey from an exposed treetop or other commanding post, in the manner of a Great Grey Shrike. On other occasions it dashes with astonishing speed low through the forest and over and round shrubs like a Sparrowhawk, soars like a falcon or hovers like a Kestrel watching for moving prey. In all these respects it behaves more like a diurnal raptor than an owl. It catches prey on the ground as well as on the wing (see p. 14).

Rodents of the forest floor and forest glades, moors and meadows are the owl's main food in summer (Bent, 1938; Mikkola, 1971, 1972, 1983). In northern Europe 93–98% of the food consists of microtine voles, mainly bank voles and field voles. Bog lemmings in North America and wood lemmings in Eurasia are other major food items in the northernmost forests, as are the classic Norway lemmings in the alpine tundras and fjelds of northern Europe (Semenov-Taishanski & Giljasov, 1985). Hence the population fluctuations of the Northern Hawk Owl do not closely follow the dramatic population cycles of these lemmings, but respond rather to the less extensive, though sometimes synchronous, fluctuations of other rodent species (Mikkola, 1983). In the absence of rodents the Northern Hawk Owl is sufficiently versatile to take other species of mammal such as shrews, chipmunks, ground squirrels, flying squirrels, even weasels, and, in its southern ranges, deer mice and long-tailed field mice, as well as an occasional large insect, frog or fish.

When terrestrial rodents are absent or hard to get in winter, the Northern Hawk Owl may become a fierce hunter, catching large Norway rats near human habitation as well as birds of all sizes, including resident boreal species as large as Willow Grouse, Ruffed and Hazel Grouse (Malievsky & Pukinsky, 1983) and Goldeneye, and songbirds like Siberian and Canadian Jays, Crossbills and Siskins; in its southern winter range also thrushes, Chaffinches, Starlings and many other species. Some of the prey items are larger and heavier than the owl itself.

MOVEMENTS AND POPULATION DYNAMICS

Though generally considered resident, but nomadic within its range, the Northern Hawk Owl is in fact erratic in movements and sporadic in occurrence, depending on the cyclic fluctuations of its main prey, voles and lemmings. Northernmost populations seem to retreat south regularly and the birds are reported to appear annually in the forested steppes of Asia and the prairie provinces of Canada south of the boreal forest belt, where they also appear in groves of tall trees in cultivated areas and farmsteads and, fearless of the human residents, take mice from the hay put out for cattle. Irruptive flights are known to have occurred in both the Old and the New World, but these have been more extensive in North America than in Eurasia and more conspicuous in the nineteenth than in the twentieth century. In North America irruptions rarely extend beyond the northern United States, but there is a record of one extending as far south as Nebraska (November 1891). East Siberian stragglers have reached the Kurile Islands and other islands in the Bering Sea area, but not Japan and only exceptionally China, while North American stragglers are said to have been taken in Britain, though the subspecific identification of some of these has been rightly questioned. C. S. Roselaar (in Cramp, 4, 1985) also accepts a bird caught on board a ship on the roads off Las Palmas, Gran Canaria, in the autumn of 1924 (probably October) as belonging to the North American race *Surnia ulula caparoch*. Though no irruptive movements seem to have been recorded in 1924 for eastern North America, this remains the furthest known flight of a Northern Hawk Owl and a most remarkable one at that.

In Europe irruptions usually affect the Scandinavian countries only, though stragglers are known from much further south, e.g. from Alsace, northeastern France (1835), Belgium, the Netherlands, Britain, Switzerland, Austria, Yugoslavia, Hungary and Roumania. In Britain there were eight records in the period 1830–1903, two in the period 1959–72 and none in between (Sharrock & Sharrock, 1976). During and immediately

Northern Hawk Owl *Surnia ulula*
North European race *S. u. ulula* with root vole *Microtus ratticeps* as prey

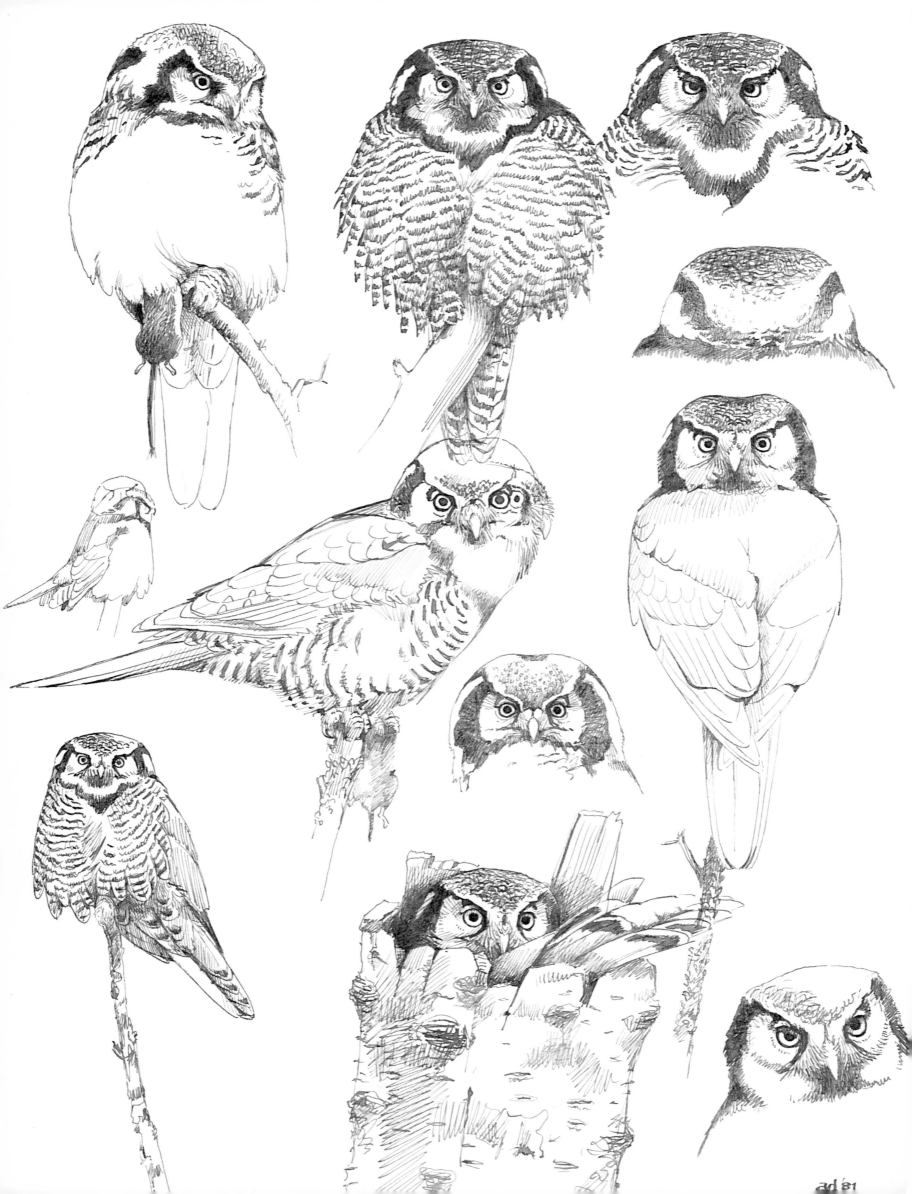

following years of food abundance Northern Hawk Owls have turned up as breeding birds as far south in Scandinavia as the valleys in the south Norwegian fjelds, where they are unknown in other years (Hagen, 1956). Under these conditions Scandinavian populations can reach remarkably high levels, e.g. an estimated 4,000 birds after the breeding season of 1950, even up to 10,000 pairs in other favourable years (Ulfstrand & Högstedt, 1976), as against a few hundred at other times. Timing of population cycles and origin of irruptions are hard to foretell and to trace, but it is improbable that Northern Hawk Owls recorded during years of irruption in western Scandinavia and central Europe have come from east of the Ural Mountains (Edberg, 1955).

GEOGRAPHIC LIMITS

The Northern Hawk Owl does not breed beyond the timber line in the forested tundra in the north or beyond the southernmost fringes of the taiga in the forested steppe in the south. In these areas geographic limits seem to be set by the presence of suitable nesting trees. What additional biotic factors, including competition with other species of owls and diurnal raptors, determine its occurrence and abundance is not known. Its occurrence is not affected by the abundance of voles outside the main boreal zone. Its metabolic rate was found to be the same as that of other non-passerine species of comparative body weight, whereas the metabolic rate of other owls is less than in these species (Johnson & Collins, 1975).

LIFE IN MAN'S WORLD

The Northern Hawk Owl does not shun the presence of man and in Finland has been found to nest within a hundred metres of human habitation (Mikkola, 1983). With regard to man it is both fearless and inquisitive. It uses telegraph poles and utility lines as freely as do other birds of prey and owls and has been found nesting in nest boxes erected for Goldeneyes and Goosanders. Perhaps its use of nest boxes could be increased. As long as the natural communities of the northern taiga and birch zones remain, nothing apparently challenges its survival.

Northern Hawk Owl *Surnia ulula*
North European race *S. u. ulula*

It is clear that the Northern Hawk Owl adjusts itself to the fluctuation cycles of northern rodents inhabiting the forest floor. As a primarily myophagous, taiga-inhabiting species it shows impressive population fluctuations and erratic movements which can assume the character of irruptions. During the middle of this century it was the most abundant owl in northern Finland with an estimated population of 3,600 pairs (Merikallio, 1958), but this hardly represents an average situation. The number of pairs nesting in Finland is 25–50 times less in most years (Mikkola, 1983). This density seems to be a reasonable estimation for most of the species' range. The increased predation on large-sized birds in winter may be especially responsible for the survival of this species in its frequently inhospitable habitat.

With regard to structure, the ecological and ethological significance of the owl's sexual dimorphism in size – which is greater than in any species of pygmy owl *Glaucidium*, probably the Northern Hawk Owl's nearest relatives – remains a mystery. The absence of ear tufts, increasing the impression of a raptor's head rather than an owl's, could indicate that arboreal mammalian predators play no part in the life of this species (Perrone, 1981) and that the ability to mimic a mammal's frightening silhouette with raised ears would serve no purpose during the long daylight of the northern summer.

With regard to geography, one might ask why the Northern Hawk Owl is absent in the main southern mountain chains, whereas the other circumboreal owls (Tengmalm's, Old and New World Pygmy Owls *Aegolius funereus*, *Glaucidium passerinum* and *G. gnoma*) have extensive glacial relict ranges in the subalpine zones of southern mountains. The answer may lie in the Northern Hawk Owl's relatively narrow ecological base, because of which it would have to retreat to lower montane zones in winter where competition and predation by other owls and by *Accipiter* hawks would probably be too severe. With regard to ecology, the fast-flying Northern Hawk Owl is more highly specialized than any of the other boreal owls and can hardly evolve further. Its interspecific relations with other owls and diurnal birds of prey, with the equally conspicuous, birch zone-inhabiting Great Grey Shrike *Lanius excubitor*, and with the woodpeckers, which provide the owl with nest holes, are subjects requiring detailed study, as is its life in winter.

EURASIAN PYGMY OWL

Glaucidium passerinum

The short-winged Eurasian Pygmy Owl (length of male 153–170mm, female 174–190mm) is smaller than its boreal compatriot Tengmalm's Owl *Aegolius funereus* and the southern Scops Owl *Otus scops* by as much as 49% and 33%, respectively. Its weight of on average 58g in males and 73g in females is equivalent to that of 2–3 Chaffinches *Fringilla coelebs*, 6 Crested Tits *Parus cristatus* or 3 fair-sized bank voles *Clethrionomys glareolus* (data from Glutz & Bauer, 9, 1980:233). Like Tengmalm's Owl and unlike the Scops Owl, it is a permanent inhabitant of boreo-alpine coniferous forests where it leads a diurnal rather than a nocturnal life. It lacks the specialized ear structure of Tengmalm's Owl but exploits in its own way the often very variable food supply of boreal forests. It is not clear where, when and why the Eurasian Pygmy Owl, one of 13 species of mostly tropical pygmy owl *Glaucidium*, developed (along with a few other members of its genus) its diurnal habits. Also how it adapted to hunting birds in the tree crowns. And why boreal pygmy owls from North America and Eurasia developed into two species instead of remaining conspecifics as in the case of Tengmalm's Owl. This last question will be dealt with in the chapter on the North American or Boreal Pygmy Owl *Glaucidium gnoma*.

The Eurasian Pygmy Owl is a ferocious dwarf. The postures it adopts are among the most elaborate and expressive of any owls (Scherzinger, 1970, 1986). Their purpose may be to counteract the risk of such a small, diurnal owl being either captured by birds of prey or too severely mobbed by swarms of small birds in the tree crowns or chased by dangerous, larger ones. The two white-edged black patches on the back of its neck simulating "occipital" eyes, though less marked than in some tropical representatives of the genus, may also be a feature intended to mislead both predators and prey and represent a definite adaptation to diurnal life (Schüz, 1957; Scherzinger, 1986).

GENERAL

Faunal type Siberian.

Distribution Northern Europe and Asia, in a belt from Norway to eastern Siberia and Sakhalin, with isolated, probably post-glacial relict populations in the mountains of central Europe, the Alps, Jura, Vosges and Black Forest Mountains, Thuringian and Bohemian Forest, Fichtel and Ore (Erz) Mountains, Krkónose Mountains (Riesengebirge), Carpathian Mountains, Slovenian and Dinarian Alps and Rila Mountains. Its range in the Harz Mountains is doubtful and it has probably disappeared from the lowlands of East Germany and Poland west of Bielowieza. Also the Altai and Sayan Mountains in central Asia. Map 12.

Climatic zones Boreal and corresponding cold mountain zones.

Habitat Coniferous forest of the boreal forest belt (taiga) and corresponding subalpine mountain forests with spruce, fir, larch and arollo pine, in the Alps usually above 900–1,000m, up to the tree line at 1,900–2,150m (Scherzinger, 1970; Bille, 1972), preferably where the forest is interrupted by windfalls, glades, meadows and rivers. It hunts at forest edges and in young open forest more often than in tree crowns in deep forest where, however, it nests, hides and "caches" its food.

GEOGRAPHY

Geographical variation Slight. A somewhat paler and greyer plumage may predominate in Asia east of the Altai Mountains (*Glaucidium passerinum orientale*), but similarly grey birds occur as possible colour morphs in the western part of the owl's range. Pygmy Owls from central Europe tend to be rather brown; those from east Asia are possibly somewhat larger in size (Vaurie, 1965; Roselaar, in Cramp, 4, 1985:513).

Related species Of the 13 species of *Glaucidium*, the Eurasian Pygmy Owl is the only member in the west Palaearctic. Its nearest relative is the Northern Pygmy Owl *Glaucidium gnoma* from the mountain forests of western North and Middle America, with which previous authors (Voous, 1960) combined it into one Holarctic species of Siberian–Canadian faunal type. Other related species, forming with the northern pygmy owls a geographically defined superspecies, are the Pearl-spotted Owlet *Glaucidium perlatum* from the Afrotropical savannahs and woodlands and the Least and Ferruginous Pygmy Owls *Glaucidium minutissimum* and *G. brasilianum* from Central and South America. The core of the genus is probably to be found in the Old World tropics, where some species resemble the hawk owl genus *Ninox* and the little owl genus *Athene*.

Eurasian Pygmy Owl *Glaucidium passerinum*

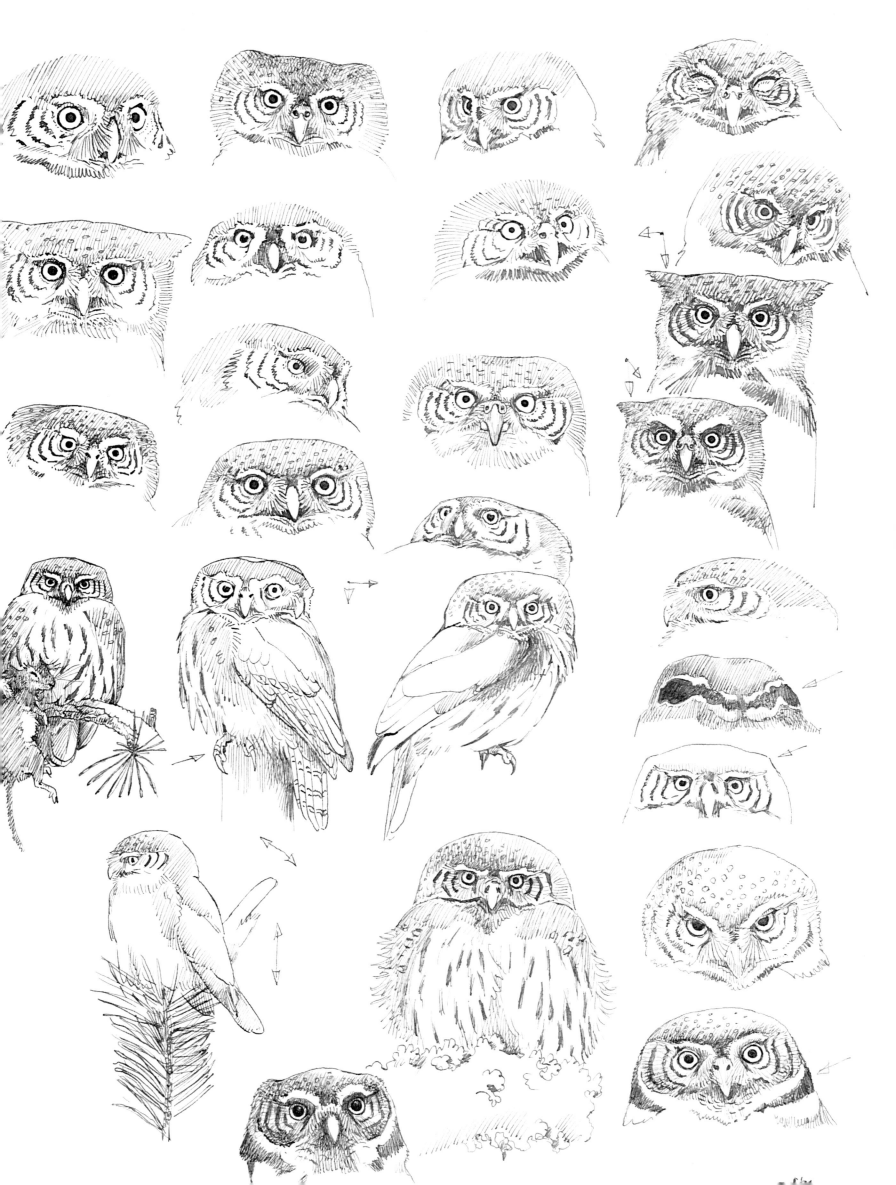

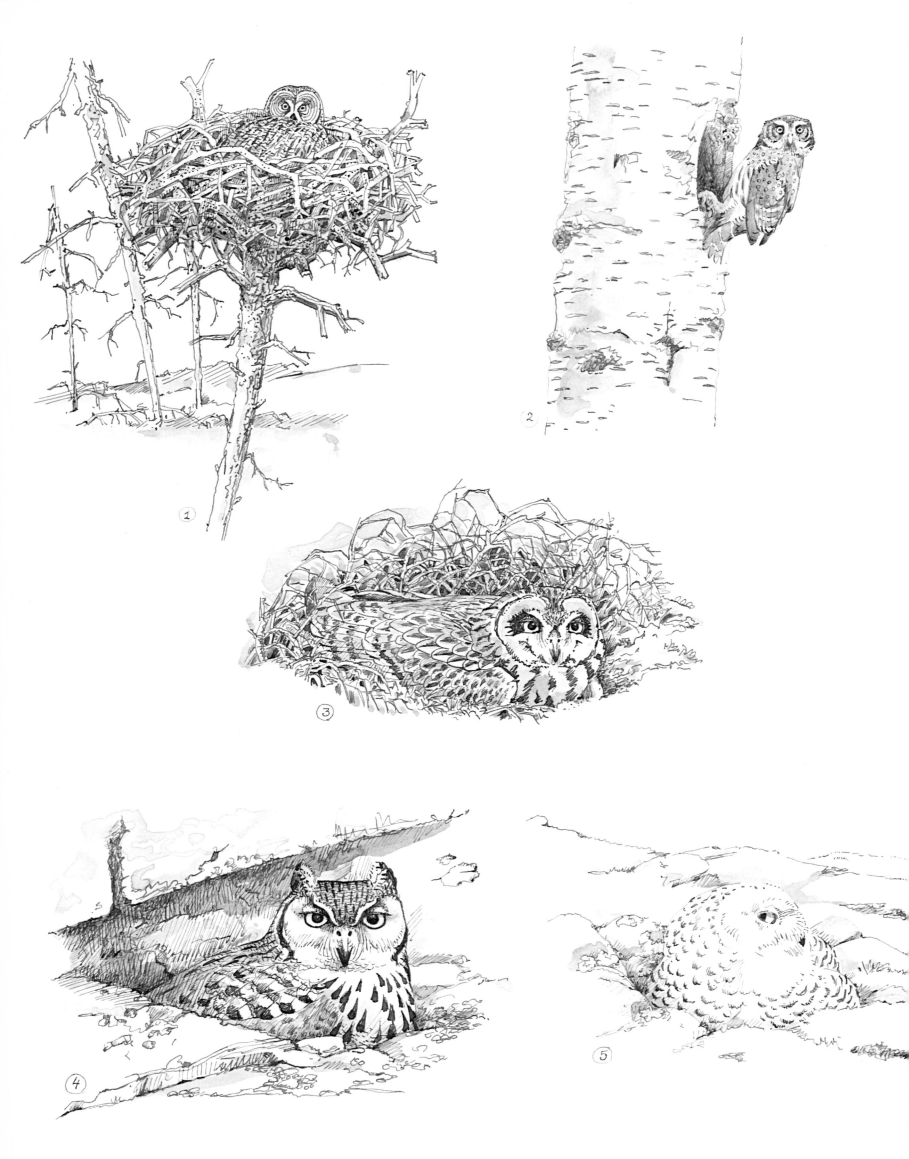

STRUCTURE AND VISION

In spite of its small size the Eurasian Pygmy Owl is a strong and robust bird with a heavy, broad bill and strong legs, feet and claws. Legs and feet down to the claws are densely covered with silky feathers, the Eurasian differing in this respect from the American Boreal Pygmy Owl. The head is small, broad, rounded and without ear tufts; the facial disc is poorly defined and not surrounded by stiffened feathers. The ear openings are uncomplicated, small, slightly oval in shape and symmetrical in form and position on the head (Collet, 1881). The eyes are small, but larger than the ear openings. Irises are yellow, giving the bird a fierce look. The facial expressions are surprisingly varied; in threatening and extreme cryptic postures there are indications of lateral ear tufts. The wing tips are rounded and the tail is short. The outer webs of the primaries lack dented fringes except for two outer primaries in which they are slightly serrated; hence, the flight is not noiseless. In skeletal characteristics the Eurasian Pygmy Owl is very similar to the other medium-sized and small northern owls *Surnia*, *Athene* and *Micrathene* (Ford, 1967).

Vision at night is said to be relatively poor, comparable to that of man, lower limit 145×10^{-6} foot-candles, as against 75×10^{-6} in man, though on a dark forest floor (4×10^{-6} foot-candles) only the Tawny and Ural Owl can still see reasonably well (lower limit $16 \times$ and 24×10^{-8} foot-candles, respectively) (Lindblad, 1967).

BEHAVIOURAL CHARACTERISTICS

Songs and calls The Eurasian Pygmy Owl has a large variety of calls (Wahlstedt, 1959; Bergman & Ganso, 1965; König, 1968; Scherzinger, 1970; Glutz & Bauer, 9, 1980; Schönn, 1980; Thönen, in Cramp, 4, 1985), most of which are based on the low-intensity territorial song, which resembles the mellow somewhat tremulous song of the Bullfinch and consists of a series of *peeu* or *kiu* hoots of ¼ second duration each, with intervals of 1½ seconds. The hoots are more metallic than the Scops Owl's hoots, lacking the soft modulation at the start of that owl's song, and have frequently been confused with the calls of the midwife toad (König, 1968; Thönen, 1968). The female sings like the male but on a higher scale and most frequently in antiphonal duets with the male. Unmated males defending a territory but still soliciting for a mate sing for hours on end, up to approximately 6,000 syllables per day (Klaus *et al*., 1976). Depending on the degree of the owl's excitement or aggressive mood the song varies in pitch and rhythm, the most remarkable variation being the so-called scale-song, a series of ascending notes going up the scale and drawn out with apparent difficulty and neck-twisting. The scale-song is mostly heard in spring at the final peak of territorial disputes and early in the autumn when the boundaries of winter territories have still to be established. The Eurasian Pygmy Owl sings by day. The song can be imitated quite easily and males can be sufficiently aroused by such imitation to attack mimicking humans (see Mikkola, 1983).

Nesting sites. (1) Old World Great Grey Owl *Strix nebulosa lapponica*. (2) Eurasian Pygmy Owl *Glaucidium passerinum*. (3) Short-eared Owl *Asio flammeus*. (4) Desert Eagle Owl or Pharaoh Owl *Bubo bubo ascalaphus*. (5) Snowy Owl *Nyctea scandiaca*.

Circadian rhythm The daily activity pattern is similar to that of most diurnal birds. The bird nests and sleeps at night in the crown of a tree, less frequently in a tree hole or in an abandoned woodpecker nest. It does not rise early in the morning and in spring numerous songbirds start their morning activity 10–30 minutes before the Pygmy Owl appears (Bergmann & Ganso, 1965). Dark days with continuous rain delay its start still further and may reduce the owl's activity by an hour or more. In view of the different light conditions in summer, daylight lasts much longer in boreal forests than in mountain forests further south. In central Finland (at 65° north) the resting period at night in spring lasted 2–3 hours, in south Norway (at 60° north) 4–6 hours and in Austria 7–9 hours (Mikkola, 1970, 1972). Sleeping time in central Europe varied between 5 hours in summer and 10 hours in winter. Though not an early riser, the Eurasian Pygmy Owl often retires at the end of the day at light intensities higher than those at which it wakes in the morning. In captivity females retired to their nesting holes and males stopped singing on average 43 minutes after sunset, to begin again 45 minutes before sunrise (Scherzinger, 1970). Early-morning and late-evening peaks in summer coincide with the bank voles' activity periods. The owl's short mid-winter activity period accords with the daytime activity of the short-tailed vole, and it is not surprising that both voles are important prey items in Scandinavia (Mikkola, 1983).

In central Europe the male Pygmy Owl starts singing in the morning only after 20–30 minutes have elapsed since the last night call of the Tawny Owl; it stops singing in the evening before the Tawny Owl has resumed its nocturnal activity (Schnurre, 1942; Missbach, 1976). In the Bavarian Alps the alternation of the activity of owls has been described as follows: the Pygmy Owl is active and sings as long as 5–38 minutes after sunset, depending on weather conditions; Tengmalm's Owl starts singing on average 20 minutes after sunset, whilst the Tawny Owl begins its song 40 minutes after sunset (Scherzinger, 1970:7).

Antagonistic behaviour In view of its small size the Eurasian Pygmy Owl has to take care to avoid numerous potential predators. When necessary it will hide in the crown of a conifer where it assumes various camouflage or cryptic postures, ranging from pressing its feathers against its body to raising its crown feathers sideways, narrowing its eyes to slits and drawing one wing in front of the body, so that the bird looks like a tree stump in the shade (Scherzinger, 1970). The antagonistic behaviour may also include threatening, flight and the uttering of a staccato alarm call. Under exceptionally grave conditions the Pygmy Owl drops like a stone from its perch (Schönn, 1980) or sinks into a state of akinesis.

Curiously enough, Pygmy Owls do not normally react noticeably when surrounded by a mob of scolding little songbirds. The sight or sound of a Pygmy Owl will elicit agitated alarm calls from Chaffinch, Coal Tit, Crested Tit, Goldcrest and Tree Creeper in particular, though Nuthatches, Ring Ouzels and Great Spotted Woodpeckers may also join the chase (Scherzinger, 1970). Since mobbing behaviour does not appear to be innate but is learned by experience, the reaction of forest birds to human imitation of the Pygmy Owl's song usually indicates whether Pygmy Owls are present or not in the area in question.

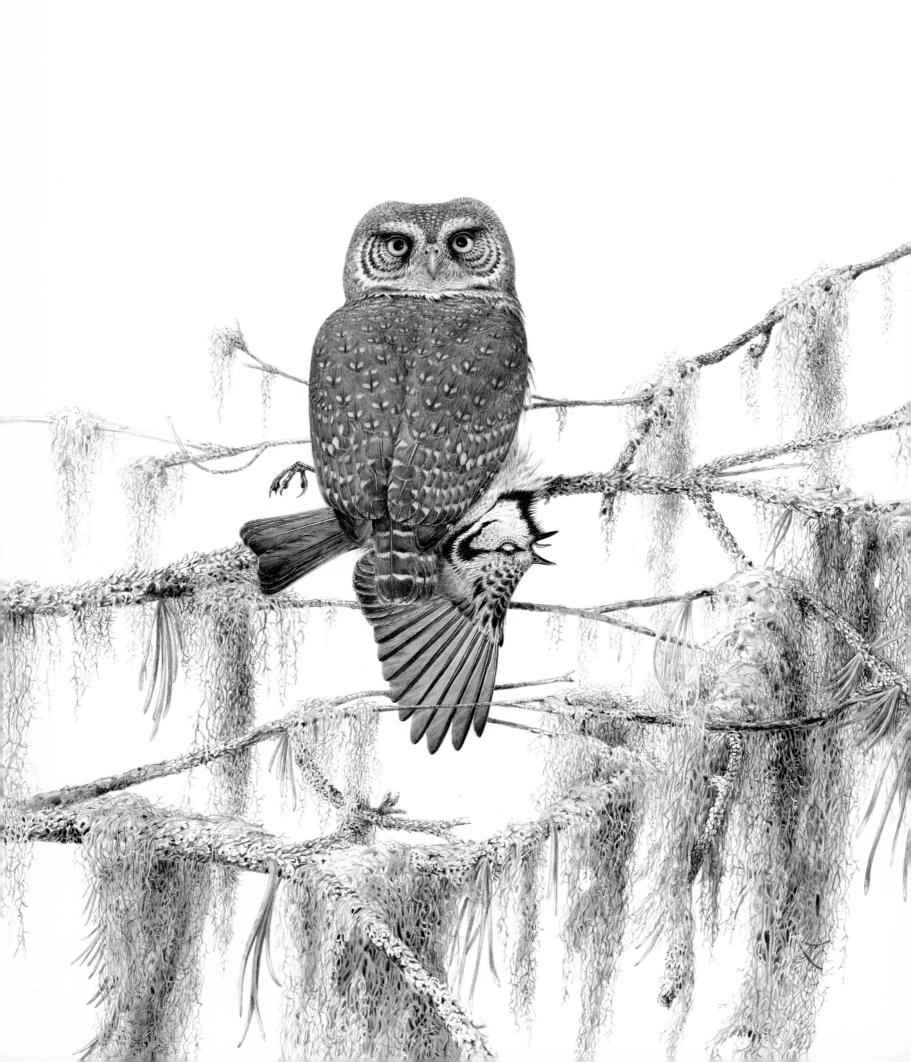

ECOLOGICAL HIERARCHY

Due to its small size (average weight of male 58g, female 73g), the Eurasian Pygmy Owl can fall victim to any other owl living in its habitat, and due to its diurnal habits it is susceptible to predation by diurnal birds of prey as well. In boreal and mountain forests it shares its habitat with Tengmalm's Owl if not also with other owls. In Finland nest holes belonging to Eurasian Pygmy Owls and Tengmalm's Owls have been found in the same woodpecker hole-riddled tree approximately 4m apart (Mikkola, 1983:115). Though Pygmy Owls have been found in Finland among the prey remains of Tengmalm's Owl, these species are rarely active at the same time of day, the Pygmy Owl being virtually diurnal, Tengmalm's Owl mainly nocturnal. When voles were superabundant in Västerbotten, Sweden, 3 pairs of Pygmy Owls were found nesting in an area of 1.5km² alongside 6 pairs of Tengmalm's Owls and 1 pair of Long-eared Owls, without any apparent conflict occurring between the species (Lindberg, 1966).

Known instances of predation by other owls are few and include Eagle Owl (3 ×), Tawny Owl (3 ×), Ural Owl (2 ×), Tengmalm's Owl (2 ×), Long-eared Owl (1 ×) (Mikkola, 1983:379). Of diurnal birds of prey, the following are reported to have taken a Pygmy Owl at one time or another: Goshawk (10 ×), Sparrowhawk (3 ×), Gyrfalcon (1 ×), White-tailed Sea Eagle (1 ×) (Mikkola, 1983:381). The Tawny Owl is considered a particular menace to the Pygmy Owl and with the first evening calls of this owl and of Tengmalm's Owl the Pygmy Owl is said to react immediately by withdrawing (Lindberg, 1966). The recent decline and local disappearance of the Pygmy Owl in some south German mountains has been ascribed to the combined effects of (1) the general increase of Tawny Owls, (2) the decrease of Goshawks, leading to a further increase of Tawny Owls, (3) the decrease of Eagle Owls, followed by the increase of pine martens, a severe predator of the Pygmy Owl (Lenz, 1967; Mebs, 1967). Depredations by the Ural Owl in the northern forests have probably gone largely unnoticed, but it would be interesting to know whether the Pygmy Owl avoids the Ural Owl by selecting a slightly different habitat or by adopting an elusive daily rhythm.

Thanks to its small size the Pygmy Owl is able to enter smaller nest holes than either Tengmalm's or the Tawny Owl. This provides it with some protection against these owls and also against the pine marten. In mountain areas it generally lives above the altitudes frequented by the Tawny Owl.

BREEDING HABITAT AND BREEDING

The Eurasian Pygmy Owl's breeding habitat is very similar to that of Tengmalm's Owl, comprising the coniferous forests of the boreal belt; the Pygmy Owl is most numerous in virgin spruce forests, birch and mixed forests in west Siberia (Johansen, 1956), but elsewhere also in mature timber forest. It inhabits similar mountain forests at 700–1,400m altitude, but also more open, subalpine woodlands of larch and arollo pine, provided the tree crowns offer enough shade (Mattes, 1981). Eurasian Pygmy Owls are territorial throughout the year. Their territories are small, varying between 6.0 and 0.45km², depending on the habitat as much as on the rodent cycle (Scherzinger, 1970; Glutz & Bauer, 9, 1980; Mattes, 1981).

Nests are almost exclusively abandoned woodpecker holes, most frequently those of Great Spotted and Three-toed Woodpeckers, less often the larger Grey-headed and Green Woodpecker holes (see p. 140). The Pygmy Owl can squeeze into nest holes with openings of 43–55mm, even 40mm, and therefore rarely uses the more widely available nest holes of approximately 10 × 15cm made by Black Woodpeckers. In Finland nests were found in spruce (47%), aspen (39%), pine (12%) and birch (2%), but the selection had been made by the woodpeckers rather than by the owls. Nest site competitors are of course the woodpeckers themselves, also Nuthatches and possibly Tengmalm's Owls. The courting male demonstrates the nest opening to the female in a way similar to that employed by hole-nesting songbirds and uses food to lure the female into the hole for inspection (Jansson, 1964). The female cleans the hole before and during incubation and brooding and throws out any leftover and decaying prey material, thereby keeping the nest clean-smelling, but also attracting scavengers and potential predators to the foot of the nest tree. Newly hatched chicks in nest holes in decayed spruce trees have been disturbed and killed by large wood ants *Camponotus herculaneus* (Scherzinger, 1979).

Clutch size is large, 3–10, on average 5.2 in boreal Fennoscandia, 5.4 in subalpine Austria. Nestlings per brood were more numerous in Finland (3–7, average 5.2) than in the Bavarian Alps (average 4.3) (Mikkola, 1983). Clutch size is dependent on temperature and snow conditions in spring, less so on rodent cycles, since the Pygmy Owls' habit of food-caching makes them less dependent on fluctuations in food supply than the other small boreal owls. As a consequence they can permit themselves the ecological privilege of having their young hatching almost simultaneously, differing by 0.5–2.0 days only (Scherzinger, 1971). On the other hand, the chicks have a relatively long nestling period (29–32 days; Jansson, 1964; Scherzinger, 1970) and only leave the nest when able to fly, thus avoiding the dangers to which other young owls, unfledged and vulnerable to predation, are exposed. This is considered a primitive condition (Scherzinger, 1971), a view which is confirmed by the fact that, when hatched, young Pygmy Owls are more helpless than the young of other owls and cannot stand on their feet before their 14th day, while Little Owls, for example, can already stand on the day of hatching. The chicks have a less compact, less fluffy plumage than open-nest breeding owls. This type of plumage accords with the restricted space of the nest hole and, when necessary, allows for rapid heat dissipation (W. Scherzinger).

FOOD AND FEEDING

Considering its small size, the Eurasian Pygmy Owl is a ferocious hunter. Though it is prepared to take anything it can master, small rodents provide its main food. Small birds supplement the diet and can be increased when necessary. The habit of caching and concealing supernumerary prey makes the Pygmy Owl even less vulnerable to temporary or seasonal fluctuations in rodent prey supply. Pygmy Owls often hunt like shrikes from perches on top of small or medium-sized, widely spaced conifers, pouncing on rodents moving on the ground. When hunting

Eurasian Pygmy Owl *Glaucidium passerinum*
European race *G. p. passerinum* with Crested Tit *Parus cristatus* as prey

birds, the owls hide in the shade of a tree crown and take by surprise small birds that come within range. They may also search for prey by flying through the trees with great dexterity and surprising speed. Other prey is killed inside nest holes or nest boxes, perhaps after it has entered the hole by accident; swifts, bats and probably most woodpeckers recorded as Pygmy Owls' prey must have been captured in this way. Nest holes of Pied Flycatcher and tits containing food-begging young appear to be raided deliberately (Solheim, 1984). The *Central European Handbook* (Glutz & Bauer, 9, 1980) mentions 26 species of mammals and 72 species of birds as known prey items of the Eurasian Pygmy Owl. A German author (Schönn, 1980) records 18 species of mammals and 56 of birds taken in north and central Europe, while, of 2,761 preys recorded in the breeding season in Finland, 54% (frequency) were mammals (mainly voles of the genera *Microtus, Clethrionomys* and *Myopus*) and 44% birds and, of 1,297 preys taken in other periods of the year, 68% were mammals and 32% birds (Mikkola, 1983:table 19). Immature vole rats (70g; Scherzinger, 1970), brown rats and hamsters (Siberia) are among the largest prey recorded. Shrews of various species are usually poorly represented (3–12%) and seem to serve as emergency rations only, though in west Russia they amounted to 52% (Grempe, 1965). Other rodents, bats, lizards, fish and insects make up the balance, but are numerically of little importance. In fact, it is doubtful whether the Eurasian Pygmy Owl takes insects at all.

Those species which are most numerous in open conifer forest and at forest edges form the bulk of the avian prey: Chaffinch, Willow Warbler, Coal Tit, Crested Tit, Tree Pipit, Pied Flycatcher, Goldcrest, Redwing and Song Thrush, sometimes also Siskin and Redpoll. When hunting around villages in winter, the Pygmy Owl regularly takes House and Tree Sparrows, Yellowhammers and Great Tits. The list also includes such unlikely birds as Barn Swallow, House Martin, Dipper, Great and Lesser Spotted and Three-toed Woodpeckers, Mistle Thrush, Starling, Hawfinch, Pine Grosbeak and Crossbill. In general the proportion of birds taken throughout the year in central Europe is larger than in northern and eastern Europe (Moscow), being 62%, 26% and 8%, respectively, while rodents figured in the same sequence with 24%, 37% and 85%, respectively (Grempe, 1965). The difference probably reflects the scarcity of small songbirds in boreal forests, especially in winter.

There is ample evidence to suggest that in good rodent years Pygmy Owls feed mainly on mammals, resorting to substantial numbers of small arboreal birds in years of rodent scarcity only. In 1962 and 1966, when voles and mice were abundant in Finland, mammals were represented in the food by 82% and 89%, respectively, while birds figured with a poor 16% and 8%. After the rodent populations had crashed in the years 1963 and 1967, the proportion was almost reversed: 24% and 29% mammals against 51% and 71% birds (Linkola & Myllymäki, 1969; Mikkola, 1970).

One of the Eurasian Pygmy Owl's noteworthy habits is that it creates larders by storing surplus prey in "caches", hiding them in the fork of twigs and among lichen-covered branches high up in the trees or in holes, including former nest holes, recently also in nest boxes. Each individual bird seems to use its own deposit but, when incubating or caring for young, the female may also search for and make use of the male's depot, which may be as far as 70m from the nest site (Scherzinger, 1970). The depots are an essential source of food in periods of adverse weather or food scarcity and a major source in winter. Caches of up to 150 and 200 food items have been found (Solheim, 1984). A cache in a Great Spotted Woodpecker hole in European Russia contained 81 bank voles, 3 common voles and 2 pygmy shrews; others contained voles, tits, Goldcrests, Tree Creepers and other small birds. Food depots have also been described in the Alps, Norway, Sweden and Finland. One cache of 67 small mammals in Norway was built up in 16 days (Solheim, 1984). This habit of surplus killing, i.e. capturing prey without immediate need for food, is of great behavioural interest, being an exception among predators.

The use of stored food during the winter may be the clue to the virtual absence of migratory and nomadic habits in the Eurasian Pygmy Owl, a factor rare among boreal owls. Prey in caches is often frozen solid, sometimes partially desiccated. To thaw it out, the Pygmy Owl holds it in its claws and covers it with its raised body feathers. It took at least 20 minutes before a stored prey was sufficiently thawed in this way for it to be eaten (Solheim, 1984).

Caching prey has the obvious disadvantage that the stored food may not be successfully retrieved, and that other birds, e.g. Nuthatches (Thönen, 1965), or pine martens may get to it first.

MOVEMENTS AND POPULATION DYNAMICS

With its wide-ranging diet and feeding habits, the Eurasian Pygmy Owl rarely has difficulties obtaining food in winter. The species is therefore a resident in most parts of its range and throughout most of its life. Nevertheless, indications of small-scale migrations have been described from the Baltic coast of Poland (Schüz, 1943) and south Siberia, and in the period 1903–72 at least 25 irruptions are known to have occurred in Russia and Fennoscandia (Curry-Lindahl, 1958; Lindberg, 1966; Källander, 1975) Only few of these migrations succeeded in reaching Denmark (33 records up to 1975), even fewer the British Isles. Such irruptions have been far less extensive than those of the Northern Hawk Owl and Tengmalm's Owl, with which they do not seem to coincide. In most of the cases studied the number of young reared the previous season had been extraordinarily large and more young than usual had to leave their birthplace after the unavoidable collapse of the rodent populations. Only 4 Pygmy Owls, as against 92 Tengmalm's Owls and 52 Long-eared Owls, have been captured among migrants passing the Col de Bretolet at 1,900m altitude in Valais, Switzerland, on their way to lower altitudes in France (Winkler, 1975). Similarly, only one straggler from the Alps has ever been recorded as far as Reggio nell'Emilia in the southern Po valley, Italy, some 200km from the owl's nearest breeding places (Capiluppi, 1971). In the Bavarian Alps Pygmy Owls remain in their territories throughout the winter, but population densities fluctuate by a factor 10, the recovery rate being very slow (Scherzinger, 1981).

GEOGRAPHIC LIMITS

The Eurasian Pygmy Owl occurs only marginally outside the belt of boreal forests and the subalpine mountain zones, e.g. in the so-called boreo-nemoral zones of southeast Norway (Solheim, 1984). Why this should be so is not known. It has been

suggested that the Pygmy Owl cannot enter mixed temperate forests because of the presence there of the Tawny Owl and other dangerous predators, but how it is able to survive in the neighbourhood of the no less formidable Ural Owl in the boreal forest remains a mystery, unless the Ural Owl, which has a more restricted food choice and habitat preference than the Tawny Owl, comes across the Pygmy Owl less frequently. Perhaps diurnal predators like the Sparrowhawk are too numerous in the temperate lowlands, or else competition for the use of vacant woodpecker holes is more severe outside the uniformity of the boreal forests. Whatever the reason, it is noteworthy that in Europe at least the Pygmy Owl's range coincides almost exactly with that of the forests in which Norway spruce *Picea abies* predominates. In southern Scandinavia Pygmy Owls are extending their ranges more and more into parks and large gardens in which nest boxes have been provided, but such places attract Tawny Owls too (Mikkola, 1983).

LIFE IN MAN'S WORLD

Unless its forest habitat is destroyed by logging or acid rain, the Eurasian Pygmy Owl has little to fear from man. In the German Black Forest Mountains the Pygmy Owl had disappeared by 1967, following the parcelling of spruce-fir forests by the construction of roads and the clear-cutting of old forest stands, probably also as a result of increased winter-sport activity and the development of tourist roads and ski lifts (König, 1971, 1981). The introduction of captive-bred young and the erection of nest boxes in the more extensive parts of the remaining forests have fortunately reversed the trend so that in 1980, 22, and in 1983, 40 occupied territories were counted (König, 1981; König & Kaiser, 1985). Though mainly of local importance, this example shows how detrimental disturbance of forest habitats can be.

The same applies to the use of pesticides in forestry. The aerial spraying of pesticide against larch leaf roller caterpillars in East Germany inhibited the reproduction of any Pygmy Owl in the area; the few eggs laid were too thin-shelled and too brittle to produce young.

Pygmy Owls have started to accept nest boxes not only in south Germany, but also in Fennoscandia and Siberia (Sonerud *et al.*, 1972; Schönn, 1978; Mikkola, 1983). Even so, Tawny Owls and pine martens have proved to be serious predators of the Pygmy Owls and their broods. The use of anti-marten devices on nest boxes and tree trunks has been recommended by Claus König and other German authors as strongly as in the case of Tengmalm's Owl.

Some Pygmy Owls leave the heart of the forest in winter to visit the neighbourhood of farms or to enter human settlements lower down in mountain valleys. In Switzerland they are known to visit winter feeding stations for small birds, where they catch tits and House Sparrows right in front of the windows. In Siberia they prey in barnyards on sparrows and Yellowhammers. In such unnatural conditions Pygmy Owls have crashed into windows and have also been run over by cars.

On occasion Eurasian Pygmy Owls can be astonishingly tame and cautious observers have touched and taken hold of them in their hands.

With its thick silky feathers growing down to the end of its toes, the Eurasian Pygmy Owl is the species of the genus *Glaucidium* best equipped for boreal life and is no less well adapted to the rigours of the boreal winter than its larger neighbour, Tengmalm's Owl *Aegolius funereus*. Rather than being ecologically intermediate between the Sparrowhawk *Accipiter nisus* and Tengmalm's Owl (Mikkola, 1983), it combines the bird-hunting abilities of the former with the myophagous (rodent-eating) habits of the latter, thus fully mastering two types of food and feeding strategy, each of which it employs according to need. Its habit of storing prey in a larder for later consumption in winter adds to the life chances of this dwarf among boreal owls.

Its interrelations with Tengmalm's Owl would be worth studying in more detail. At the same time it would be interesting to know why the Tawny Owl *Strix aluco* should have prevented the Eurasian Pygmy and not Tengmalm's Owl from expanding into cultivated forests in central Europe, while the Ural Owl *Strix uralensis* shares virtually the whole of the Pygmy Owl's range without apparent detriment to the latter.

NORTHERN PYGMY OWL
Glaucidium gnoma

Somewhat larger than the Eurasian Pygmy Owl *Glaucidium passerinum*, the North American Northern Pygmy Owl (average length of male 162mm, and of female 167mm) is smaller than the Saw-whet Owl *Aegolius acadicus* by 9% and than the Western Screech Owl *Otus kennicottii* and the Whiskered Screech Owl *Otus trichopsis* by 16% and 10%, respectively. Like the Eurasian Pygmy Owl, it is considered a winter-hard resident, but on the whole much less is known about its life style than about that of the Old World species. The two resemble one another to such an extent that it is hard to believe they represent different species. A few authors have regarded these owls as conspecific, like the Old and New World representatives of other northern forest owls. The mysterious relationship between the Northern Pygmy Owl and other Central and South American species of pygmy owls, of which there are four or five, may have been the reason for regarding the Northern and the Eurasian Pygmy Owls as distinct species and for incorporating the Northern and the Least Pygmy Owl *Glaucidium minutissimum* into one species instead (Blake & Hanson, 1942). The question whether the American Pygmy Owl came originally from Eurasia, or the Eurasian Pygmy Owl from North America, can only be decided on fossil evidence. Fossil records of pygmy owls in the Americas are from Pleistocene deposits only (California; Nuevo Leon, Yucatán, Mexico; Brazil; Brodkorb, 1971), as in Europe, and do not contribute much to the reconstruction of the geographic history of American pygmy owls.

The Eurasian species has acquired more specialized characteristics, adapting it to boreal climatic conditions, than the American species, and may therefore represent the most recent addition to the pygmy owl species. Since many more species of the genus occur in the Old World (10 species) than in the New World (6 species) and given the present absence of the North American Pygmy Owl in the lowland boreal forest zone of Canada, it is unlikely that the Eurasian Pygmy Owl is a recent colonist from the Nearctic. Rather, the reverse seems to have been the case, although there is nothing to tell us exactly when this might have happened.

The Eurasian Pygmy Owl has been described as combining the hunting methods of Tengmalm's Owl *Aegolius funereus* with those of a small *Accipiter* hawk, while the more insectivorous diet and omission of food-caching in the Northern Pygmy Owl preclude this species from such a definition. A comparison of the life styles of the North American and the Eurasian Pygmy Owls will probably show up further differences.

The Northern Pygmy Owl nevertheless resembles the Eurasian species in many respects. Like the latter, on either side of its neck it has a dark spot rimmed with white, resembling an additional, dorsal pair of staring eyes. To cite C. W. Michael (in Bent, 1938:426), a bird with "two faces, four eyes and a fighting heart" is too tough for most forest birds to tackle, unless these are themselves formidable predators. Predation by Goshawks *Accipiter gentilis* and other diurnal raptors, and interactions with other owls of the boreal and transition mountain forests and the southern pine-oak zones are important aspects of the Northern Pygmy Owl's life which have yet to be studied.

GENERAL

Faunal type Neomontane rather than Canadian.

Distribution Western North America west of the prairie countries, from the coastal and central mountains of British Columbia, including Vancouver Island, and possibly southernmost Alaska to 56°30' north and the Canadian Rocky Mountains from at least Banff southward, along the Pacific Coast Range, the Cascade Mountains and the Rocky Mountains south to Baja California and the Santa Rita, Huachuca and Chiricahua Mountains in south Arizona, central New Mexico and extreme western Texas, further south along the western and eastern Sierra Madres of north and central Mexico to Chiapas and northern Guatemala (Cóban district at 1,800m on the north shore of Lake Atitlan) and west-central Honduras in Cerro Santa Barbara at 1,980m (Monroe, 1968). Map 12.

Climatic zones Boreal and transition mountain zones; marginally in southern lowlands and Baja California in the subtropical upper Sonoran life zone, covering boreal, temperate and savannah climatic zones.

Northern Pygmy Owl *Glaucidium gnoma*
One of the boreal races *G. g. pinicola* or *G. g. grinnelli*
Left bird is looking over its shoulder, showing occipital eye spots

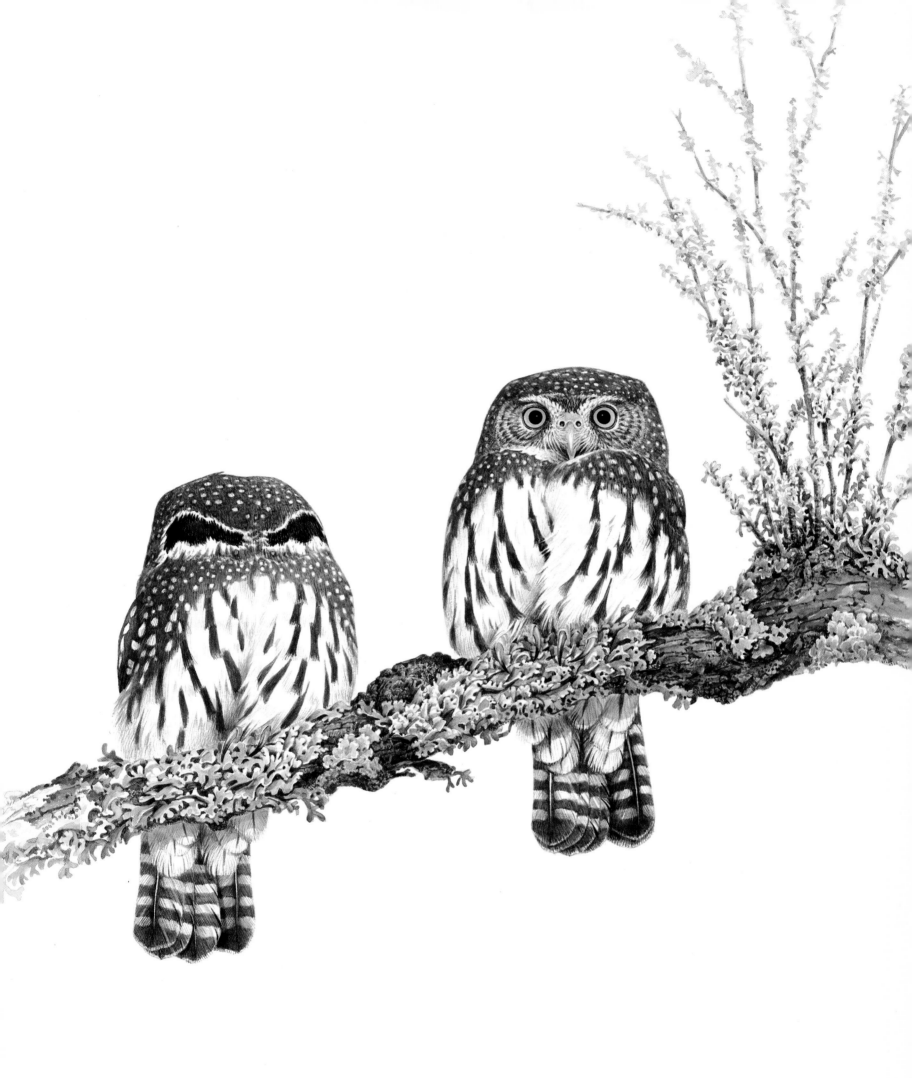

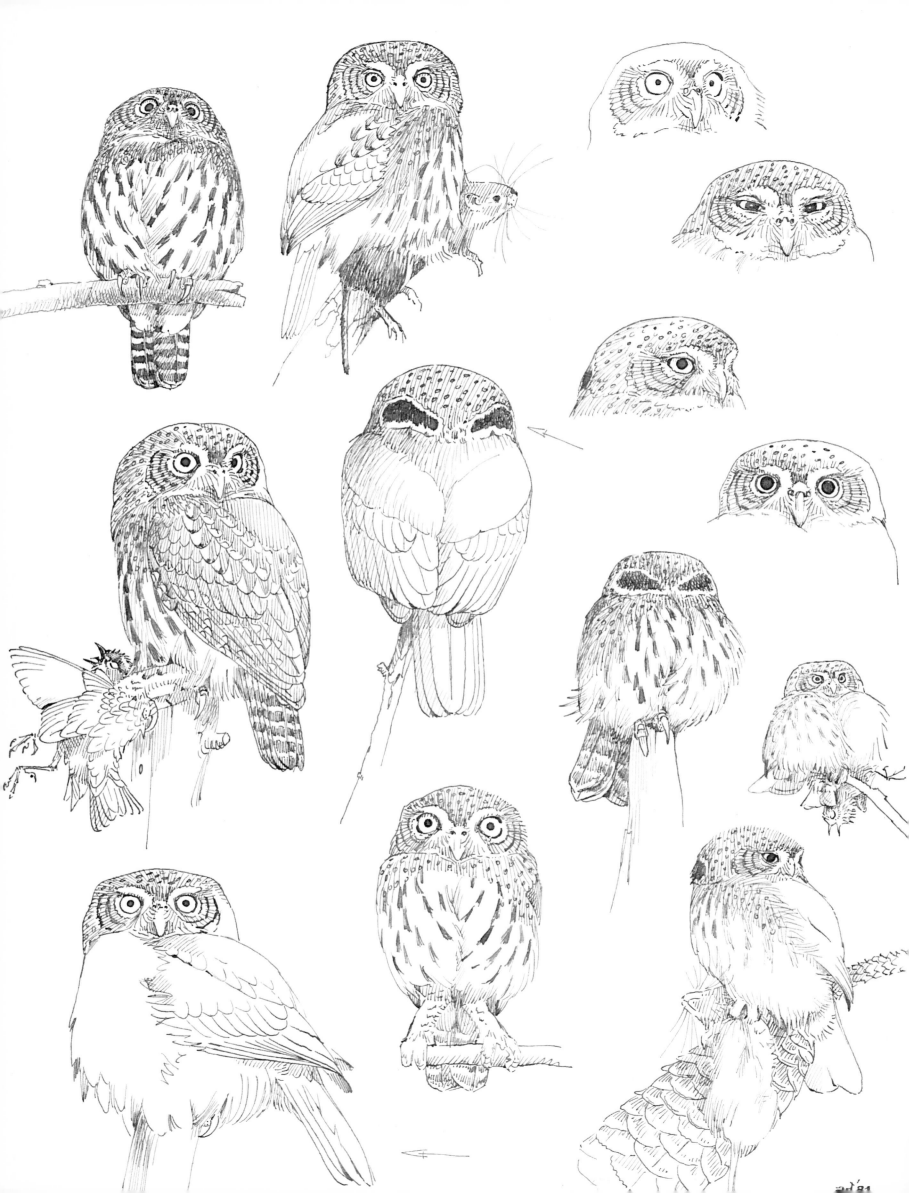

Habitat From mature coniferous mountain forests of spruce and fir and humid coastal forests of Douglas fir, western cedar, redwood and sequoia through a variety of mixed coniferous and broad-leaved forests on humid and arid mountain slopes, including open ponderosa and piñon pine as well as pine-oak and chaparral-oak forests. Also riparian woodlands and bushes and trees in canyon bottoms, and often in forests with adjacent meadows and clearings.

Generally between 400 and over 3,000m altitude, often up to the tree line. The Northern Pygmy Owl thus ranges higher up in the mountains than both the Saw-whet and the Flammulated Owl. It may inhabit rather low trees, but more often lives high up in the canopy, sometimes well over 30m above the ground in the dense foliage of the crowns of redwood and sequoia, surrounded by warblers, kinglets, tits and Red-breasted and Pygmy Nuthatches. The Northern Pygmy Owl is therefore less definitely restricted to boreal and coniferous forests than the Eurasian species.

GEOGRAPHY

Geographical variation Slight, but patterns often obscured by geographically different frequencies of grey and brown colour morphs. Generally the owls living in northern and colder climates are larger than those living in southern and warmer surroundings, while those from humid coastal areas are darker, with more saturated colours than those from arid regions. Largest are the Pygmy Owls from the Rocky Mountains (*Glaucidium gnoma pinicola*) and the Coast Range (*G. g. grinnelli*) and Cascade Mountains (*G. g. californicum*); smallest (by almost 9%), those from the Mexican mountains and mountain slopes (*G. g. gnoma*). The darkest forms are from Vancouver Island (*G. g. swarthi*), though they are barely distinguishable from those of the Coast Range, the difference being possibly one of frequency of morphs, with dark brown predominating on Vancouver Island. The lightest and most rufescent birds are from the Baja Californian mountains (*G. g. hoskinsii*). The Guatemalan and Honduras race (*G. g. cobanense*) occurs predominantly in a hepatic colour morph. Another difference relates to the length of the tail, with the shorter tail occurring in the south (absolutely longer in northern races by 12% in males and 21% in females; relative to body size, longer by 3% in males and 12% in females). Generally seven races are recognized, but these could probably be limited to five.

Related species The North American Pygmy Owl is conspecific, or forms a superspecies, with the Eurasian Pygmy Owl *Glaucidium passerinum*. It probably also forms a superspecies with the Cuban Pygmy Owl *G. siju* and the Least Pygmy Owl *G. minutissimum* from the humid lowland tropical forests (see that species). Its relationship with the Ferruginous Pygmy Owl *G. brasilianum* from the arid subtropical and tropical regions of Central America and southward is more problematical. What geographical and climatic events determined the emergence of pygmy owls and their subsequent separation into a variety of species in Central America remains a mystery.

Northern Pygmy Owl *Glaucidium gnoma*

STRUCTURE

The Northern Pygmy Owl differs structurally from the Eurasian Pygmy Owl only in that the upper surface of the toes is bristly rather than covered with soft, silky feathers. The light crossbars of the tail feathers do not usually reach the shaft and therefore look more like spots. The Northern Pygmy Owl is almost identical in body weight to the Eurasian species; its wing length is on average 8% smaller and it has a relatively longer tail. Similarity in size is also illustrated by the weight of fresh eggs, being on average 7.7g (6.2–9.1g) in a clutch of six eggs from Montana (Norton & Holt, 1982), against an average of 8.4g in Europe (Makatsch, 1976). Northern Pygmy Owls, in particular those from the Rocky Mountains, are therefore hard to distinguish from their Eurasian counterparts. The vocal apparatus, syrinx and bronchi, has been described (Miller, 1934), but apparently never compared with this structure in the Eurasian Pygmy Owl.

BEHAVIOURAL CHARACTERISTICS

Songs and calls Vocalizations do not differ essentially from those of the Eurasian Pygmy Owl, but have been less intensively studied. The territorial song consists of a series of low, monosyllabic, short whistles or widely spaced hoots of a ventriloquial quality, *coo-coo* . . . A high-intensity version, comparable with the corkscrew scale of the Eurasian Pygmy Owl, may also be concluded from a note from California that the song was "modified by attendant grimaces" (Dawson in Bent, 1938:424). Incubating or brooding females are decoyed from the nest hole by a high-pitched whinnying note from the male announcing his arrival with food. Trilling notes, a staccato whistle and a rattle have also been described and may indicate that the bird's vocabulary is as varied as in the Old World species. Northern and western birds have a somewhat different call (Miller, 1955). Other local dialects may exist. Allan R. Phillips found the song in the warmer parts of southern Arizona (subspecies *gnoma*, two notes interspersed with a single note) different from that in the colder habitats of the mountain fir forests (subspecies *pinicola*, hoots evenly spaced, as throughout the north) (Phillips *et al.*, 1964:52).

Circadian rhythm The Northern Pygmy Owl is generally reported to be active and to hunt by day, though it is thought that, more than in the case of the Eurasian Pygmy Owl, most of its activity takes place at dawn and dusk. Essentially diurnal, however, it usually passes the night within the confines of a woodpecker hole (Walker, 1978).

Antagonistic behaviour Antagonistic behaviour in the Northern Pygmy Owl has been less well studied than in the Eurasian species. Flocks of small tree birds mobbing and scolding a Northern Pygmy Owl in the shade of a tree crown have been described as including kinglets, chickadees, Plain and Bridled Titmice, Wrentits, Pygmy Nuthatches, juncos, towhees, various species of sparrows *Zonotrichia*, hummingbirds and quite a number of others. As in the Old World, the agitated reaction of small songbirds can be provoked by imitating the owl's call. Hunters and collectors have made elaborate use of this trick and with remarkable success. When not hunting,

Northern Pygmy Owls hide in a characteristically elongated posture in the shade of thick foliage or take up a relaxed posture in the sun. They have also been observed to conceal themselves from disturbance from the forest floor by flattening themselves on a high horizontal branch.

ECOLOGICAL HIERARCHY

Little is known about the ecological interactions of the Northern Pygmy Owl with other owls and birds of prey. It may share its habitat with Saw-whet Owls, Western Screech Owls, Spotted Owls, Great Horned Owls and Barn Owls, marginally also with the Flammulated Owl and in southern pine-oak forests also with Whiskered Screech Owls. Only the Spotted Owl is reported to have preyed on a Northern Pygmy Owl, near Los Angeles, California (see Bent, 1938:207, 427). In view of what is known of the Eurasian Pygmy Owl, the Northern Pygmy Owl must also face predation from Great Horned Owls, Goshawks and Cooper's Hawks, but precise data are lacking. A gang of Grey Jays – and, on one occasion, probably also a Steller's Jay – is reported to have killed a Northern Pygmy Owl which was hiding in a dense fir tree (see Bent, 1938:426). A pair of Northern Pygmy Owls and a pair of Saw-whet Owls nested simultaneously in small woodpecker holes in the same snag of a ponderosa pine in the Rattlesnake Wilderness area in Missoula, Montana, United States. The Pygmy Owl's nest was 2.45m above the ground facing west, the Saw-whet Owls' at 6.04m facing east. Both species succeeded in fledging their young; the young Saw-whet Owls left the nest 23–25 May, the young Pygmy Owls 5–6 June. Only two interactions were recorded, both involving attacks by the female Pygmy Owl on fledging Saw-whet Owls, without apparent adverse results, however (Norton & Holt, 1982).

As in the Eurasian Pygmy Owl, the sexes differ in size, the female Northern Pygmy Owl being about 18% heavier on average than the male (average body weight 73.0g in the female, 61.9g in the male). The difference is greater in northern than in southern populations (Earhart & Johnson, 1970). The size difference between the sexes is greater than that known for the screech owls *Otus* and the Elf Owl *Micrathene*, but smaller than in the Saw-whet and Tengmalm's Owls *Aegolius*. This indicates that the Northern Pygmy Owl's prey includes a higher proportion of mammals and birds than does that of the former owls and a smaller proportion than that of the latter. In accordance with the larger size of the female, mammals, as the heavier prey, are on average more numerous in the female's prey (52%) than they are in the overall prey of males (37%). Males seem to take more birds, which are smaller and require greater dexterity to catch (24%, as against 21%) (Earhart & Johnson, 1970). A similar distinction – though less well documented – occurs in the European Pygmy Owl.

BREEDING HABITAT AND BREEDING

Only the northenmost populations live in mountain forests comparable to the dense coniferous forests of the boreal belt characteristic of the Eurasian species' habitat. Elsewhere the Northern Pygmy Owl lives in mixed forests and woods of the transition zone, though conifers, mainly firs and pines, seem to be rarely, if ever, absent from its habitat. The breeding habitat includes such diverse forest types as mature coniferous mountain forests of spruce and fir, the heavy and tall redwood, cedar and Douglas fir forests of the humid west coast, mixed, open ponderosa pine forests on mountain slopes in the arid interior, shaded woods in canyon bottoms, pine-oak forests in the southern North American mountains, down to the edges of mesquite grassland and scrub.

Like the Eurasian species, the Northern Pygmy Owl seems to be territorial throughout its life but, unlike in Eurasia, the territories in North America are said to be remarkably large (though one wonders why), at least in southern Arizona, where territory-holding males were usually more than one mile apart (Marshall, 1957).

Nests are almost exclusively located in abandoned woodpecker holes, irrespective of tree species. Those reported belonged to the Northern Flicker, Acorn Woodpecker and Hairy Woodpecker and were situated in, among others, pine, larch, oak, aspen and sycamore. Nest openings were between 2 and 25m above the ground. No sizes have been recorded for the nest openings. Nests have also been found in holes in rotten wood. No records indicate nest-cleaning habits as in the Eurasian Pygmy Owl.

Eggs average 26.6×23.2mm in the Rocky Mountains (Bent, 1938) and have approximately the same volume as those of the Eurasian Pygmy Owl. Clutch size is thought to be usually 3–4, but up to 7 young are reported to have fledged from one nest (see p. 256). Nothing has been published on the possible relationship between clutch size and food availability, but variations in food abundance are probably more significant in the northern than in the southern habitats.

FOOD AND FEEDING

Like the Eurasian Pygmy Owl, the American Northern Pygmy Owl is a ferocious hunter, described as both courageous and savage. It can tackle and master remarkably large prey. In hunting methods and shrike-like appearance and flight it resembles the Old World species. Though a regular but varied proportion of its food consists of mammals and birds, insects and other invertebrates form 61% of all prey items recorded in North America (Snyder & Wiley, 1976) but this does not indicate the actual biomass consumed. Eurasian Pygmy Owls rarely, if ever, eat insects – an essential trait of their ecology. Also expressed in prey numbers, mammals represented 23%, birds 13% and other vertebrates 25% of the Northern Pygmy Owl's overall prey – data which are based on the examination of stomach contents (Snyder & Wiley, 1976). One must suppose that mammals play a more important role in the northern diet – as they do in places where forests border clearings and meadows – whereas birds are more regularly taken in the crowns of coniferous trees, and insects in the ponderosa pine and southern pine-oak woods. Of prey brought to a nest with young in a Douglas fir habitat in Montana, United States, 65% of all deliveries comprised mammals, 32% birds and 3% insects (Norton & Holt, 1982). Insects reported include numerous grasshoppers, crickets and ground beetles, cicadas, katydids, a large dragonfly, butterflies and a very large hawk moth. Reptiles and amphibians include toads, frogs, lizards of various kinds and habits, e.g. fence lizard (Miller, 1955), tree lizard, whiptail, a skink *Eumeces* (Blake & Hanson, 1942), alligator lizard and small snakes.

Most birds taken are of small size, but still remarkably large in relation to the owl's body size. They include nestlings and adults of Sapsuckers and Downy Woodpeckers (Michael, 1927), *Empidonax* flycatchers, House-, Winter- and Marsh Wrens, Eastern Bluebirds, Robins, tits, nuthatches, kinglets, warblers, vireos, Cassin's and Purple Finches, Redpolls, Pine Siskins, towhees, juncos, Tree Sparrows, House Sparrows and Brewer's Blackbirds. Apart from adult woodpeckers, other notably large prey recorded were a Gambel's Quail in Arizona (Kimball, 1925) and an immature California Quail of 119g (the owl itself weighed 52g) in California (Balgooyen, 1969).

Mammals include various kinds of vole *Microtus, Arvicola*, mice *Mus*, meadow mice *Peromyscus*, a pocket gopher *Thomomys*, chipmunks (a.o. *Citellus lateralis*, fully twice the size of the owl) and shrews.

On the whole the diversity of the Northern Pygmy Owl's prey in both species and size is no less, and possibly even greater, than in the Old World species. Nothing is known, however, of the Northern Pygmy Owl's response to or dependence on fluctuations in food supply, which could be significant in boreal conditions. Likewise, nothing definite is known concerning food-caching habits, which are particularly likely in the northernmost and the highest mountain forests. Indications of food-caching have been reported for the Yosemite Valley, California (Charles Michael; Walker, 1978), and half-eaten prey have been observed abandoned on branches high up in the trees where they were discovered and eaten by Steller's and Grey Jays (California, Bent, 1938:420).

MOVEMENTS AND POPULATION DYNAMICS

No migratory movements are known for any of the Northern Pygmy Owl's populations and the species is generally considered a strict resident. Some of the mountain birds (or, indeed, whole populations?) may descend lower into the valleys in winter, as, for example, in the plains of Colorado and on Vancouver Island. Irruptive movements related to an exhausted food supply either do not occur or have simply not been well documented. Nevertheless, in some years the plains of Alberta are the scene of minor irruptions apparently originating from the Rocky Mountain forests and spreading as far east as Sedgewick at 112° west, southeast of Edmonton in the prairie country (e.g. 1932–33). Real stragglers are rare; those reported from Wall Island at 55° north and Wrangell at 56°36' north in Alaska are probably exceptions (Willett, 1921, in Gabrielson & Lincoln, 1959). No population fluctuations have been reported, but these are likely to occur, particularly in the north, where the birds cannot survive the winter in the absence of insects.

GEOGRAPHIC LIMITS

It would be interesting to know why the Northern Pygmy Owl's range does not extend as far north as that of the Old World species and barely reaches the southern border of the boreal forest belt. This may be related to the more insectivorous diet of the New World species and the consequent omission of food-caching, but it is difficult to say which came first: difference in diet or difference in range. Or, again, it may have been the presence of another North American owl of similar size, the Saw-whet Owl, which, together with the circumglobal Tengmalm's Owl, prevented the Northern Pygmy Owl from spreading widely into the boreal forest zone. Apart from differences in length of daylight, the coniferous forests of the Rocky Mountains of Idaho and southern Canada are not unlike those of the Canadian lowlands.

To the south, in Arizona and Mexico, this owl does not even approach, let alone enter, the desert range of its similar-sized vicariant, the Ferruginous Pygmy Owl. It overheats more rapidly at ambient temperatures of over 35°C than, e.g., the Whiskered Screech Owl, but less so than the desert-inhabiting but nocturnal Elf Owl (Ligon, 1969). Clearly, the desert sets the Northern Pygmy Owl its geographic limit. One wonders whether the Northern Pygmy Owl is really more thickly feathered than the Ferruginous species.

LIFE IN MAN'S WORLD

The Northern Pygmy Owl is described as tame and courageous and not easily cowed by danger. It appears to be unperturbed by man and has been caught by hand on more than one occasion. In winter it has been known to frequent farmyards, where it catches mice in the lofts of barns and in cabins. It has been observed in the smaller cities in the plains of Utah (e.g. American Fork at 1,400m) and in as large a city as Boulder, Colorado, at 1,630m, where it gorged on the city's House Sparrows (Johnson, 1903). Elsewhere, in the seclusion of its forest home, it has often been found near isolated cabins, but on the whole it succeeds in remaining inconspicuous and will probably survive therefore as long as the forests and their inhabitants remain undisturbed by man.

No records exist of Northern Pygmy Owls breeding in nest boxes, as commonly occurs in the European species.

While the differences in life style between the North American and Eurasian Pygmy Owls seem to be greater than one might have expected from species that, at least outwardly, would appear to be conspecific, a worthwhile study could be done on possible differences between the populations of North American Pygmy Owls living in the Canadian Rocky Mountain forests and those of the Mexican pine-oak zone. These differences may prove to concern more than different proportions of insect prey and to show that the relatively longer tail in the northern, mainly mammal- and bird-hunting races is an efficient structural difference.

Interactions between Northern Pygmy Owls and Saw-whet Owls in the north and other pygmy owl species in the south may also be worth studying, as is the role of predation by other owls and diurnal birds of prey.

The question remains as to whether the Northern Pygmy Owl was originally an inhabitant of the whole North American boreal forest belt and hence a Canadian faunal type whose range has now become restricted in the north whilst being extended in the south.

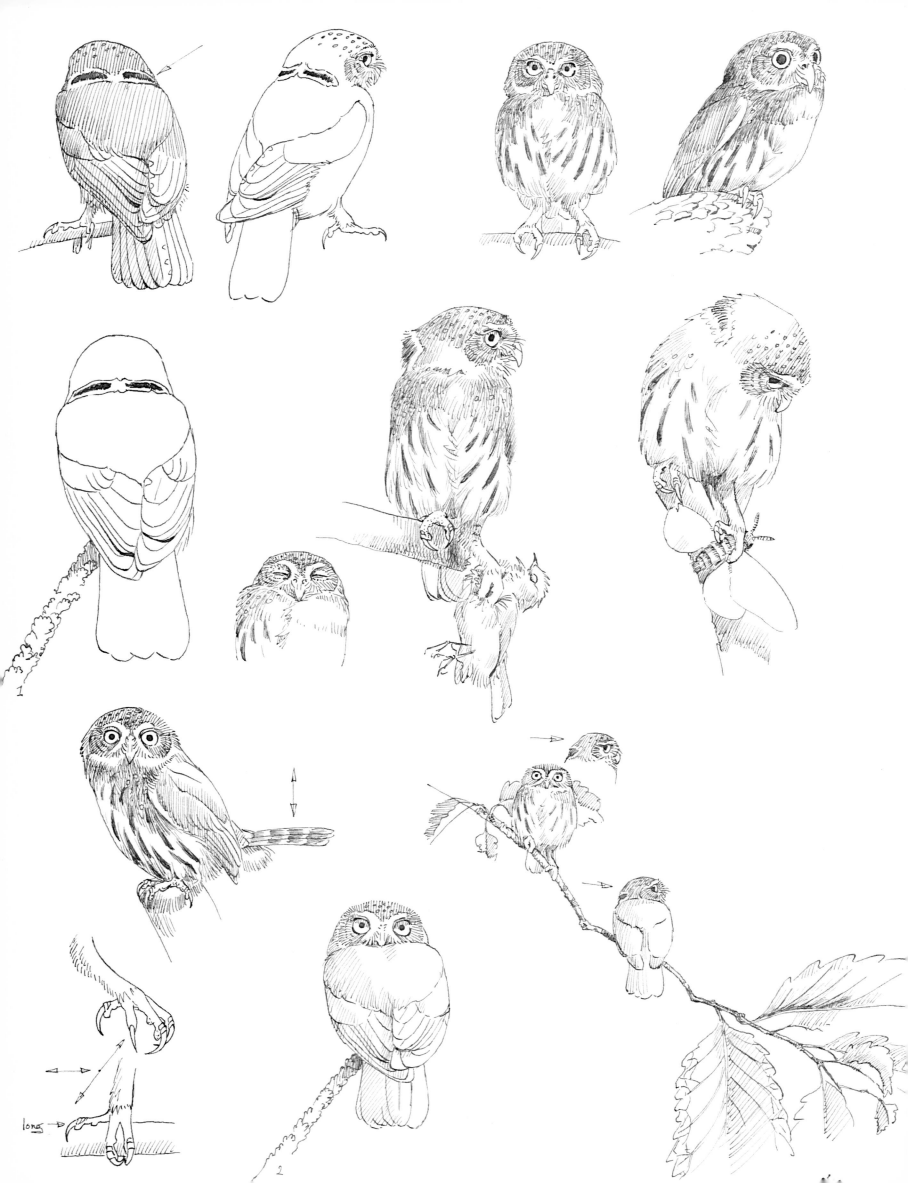

Least Pygmy Owl

Glaucidium minutissimum

With a body length of up to 15cm, the Least Pygmy Owl is almost identical in size to the Elf Owl *Micrathene whitneyi* (12–14cm), with which it shares its habitat in parts of Mexico and Central America, but the Least Pygmy Owl is more robustly built, its body weight being 20% greater than that of the Elf Owl. Least Pygmy Owls seem to have a considerably smaller body weight (average 47.8g; see A. R. Phillips; Charles E. Cochran; Philip M. Walters; Delaware Museum of Natural History) than Ferruginous Pygmy Owls *Glaucidium brasilianum* from the Central American tropical lowlands (average 65.3g) and are smaller in appearance because of their shorter tail.

The question of their ecological segregation is all the more intriguing since nothing is known of the Least's diet and Leasts are considered rare while Ferruginous Pygmy Owls are locally abundant. The two species have invariably been found in different habitats. The Least is possibly not as rare as is generally thought, being perhaps more nocturnal and therefore escaping attention in its less accessible, more forested habitat. It was found to be common in the Caribbean lowlands of Costa Rica (Slud, 1964). By its short-tailed body proportions, the Least Pygmy Owl resembles the insectivorous Elf Owl: percentage of tail length to that of wing length in Central American Least (subspecies *griseiceps*) 55%, Ferruginous (subspecies *ridgwayi*) 64%, Elf Owl 44% (Ridgway, 6, 1914). It is interesting therefore to speculate on the geographical, climatological or other ecological factors which may be responsible for the ecological differentiation and discontinuous distributions of the species of tropical American pygmy owls *Glaucidium*. Were it not for the close but nevertheless enigmatic taxonomic similarity between the Northern and Ferruginous Pygmy Owls, the Least Pygmy Owl would not have been included in this account of northern owls. Only in northern Mexico, in Sinaloa, San Luis Potosi and Tamaulipas do its northern populations approach habitats of definitely Holarctic character and origin.

GENERAL

Faunal type Undecided; originally either Tropical North American or South American.

Distribution Highly discontinuous and sporadic in tropical Central and South America, from central and southern Sinaloa on the Pacific slope of Mexico, and eastern San Luis Potosi and southwestern Tamaulipas on the Gulf–Caribbean slope, south to Belize and Honduras and the Caribbean lowlands of Costa Rica. Further, Panama, northwestern Colombia (Córdoba), western Ecuador and southeastern Peru, central and northeastern Brazil, the Venezuelan–Guianan highlands, Bolivia, Paraguay and northern Argentina (north Córdoba). Map 12.

Climatic zones Upper and lower subtropical and tropical life zones, corresponding to savannah, tropical winter-dry and tropical rain forest climatic zones. The northern boundary in northeast Mexico reaches an estimated average temperature of over 30°C, the southern boundary in central South America over 25°C in the warmest month.

Habitat Humid tropical lowland forest to open woodland and arid scrub in Sinaloa, Mexico, on the northern border of the species' range. Locally tropical cloud forest; also foothill forest and forest edge. From sea level to over 2,000m in Mexico and 2,400m on the high western slopes of the Andes in Ecuador.

Least Pygmy Owl *Glaucidium minutissimum*

GEOGRAPHY

Geographical variation At least seven subspecies described on the basis of different degrees of brown and grey pigmentation, colour difference between head and remaining upperparts, amount of white spotting on tail feathers and relative dimensions (Griscom, 1931), but the differences are slight and the recognition of not more than four or five subspecies is realistic. Populations from southern South America are palest and most rufous. The subspecies approaching Holarctic habitats are *Glaucidium minutissimum oberholseri* in Sinaloa and *G. m. griseiceps* (or *sancheri*) (Lowery & Newman, 1949) in San Luis Potosi, Mexico.

Related species Our knowledge of the taxonomy of Central American pygmy owls is far from complete and there is equal reason to consider both the tropical Ferruginous Pygmy Owl *Glaucidium brasilianum* and the Northern Pygmy Owl *G. gnoma* from the Nearctic as the Least Pygmy Owl's nearest relative. The Least's subspecies *palmarum* of the Pacific humid tropical zone of Mexico and the Northern's subspecies *cobanensis* of the central Mexican temperate high plateaus are intermediate in

coloration between the two species (Griscom, 1931). Relative tail lengths (long in Ferruginous, short in Least) are indicative of the possibly real specific status of the populations mentioned.

STRUCTURE
No structural differences between the Least and the Northern Pygmy Owl are known, unless the relatively shorter tail and the unfeathered toes of the Least Pygmy Owl are to be considered as such. The crown feathers have fine white spots while the remaining upperparts are virtually unspotted; but these are trivial differences. The behavioural significance of the amount of spotting of the upperparts in this and the other species of pygmy owl has not been determined. Whereas extravagant colour morphs regularly occur in the Northern and the Ferruginous Pygmy Owl, the russet-brown, hepatic morph seems to be the only colour morph in the Least.

BEHAVIOURAL CHARACTERISTICS

Songs and calls L. Irby Davis (1972) in Mexico and Paul Slud (1964) in Costa Rica have remarked on the high pitch of the Least Pygmy Owl's territorial call, which consists of a short series of 1–2 *took* sounds, in contrast to the indefinite and slower series produced by the Northern Pygmy Owl and the rapid, repetitive hoots of the Ferruginous species. Also described is a "musical little ripple" (Slud, 1964). The vocalizations seem to have a high specific quality but need to be studied more extensively in various parts of the species' range.

Circadian rhythm The few data available suggest that the Least Pygmy Owl may be active both by day and by night. The diurnal proportion of the activity cycle is not known but may prove to be less than that of the Northern and possibly also that of the Ferruginous Pygmy Owl.

Antagonistic behaviour Nothing has been reported except that this species has often been found by day surrounded by a flock of mobbing small birds.

ECOLOGICAL HIERARCHY
Nothing has been reported regarding either ecological and behavioural interactions with other owls and diurnal birds of prey, or predation suffered by the Least Pygmy Owl. It shares its habitat with the Ferruginous Pygmy Owl in some places, notably in the Chaco of central South America (Short, 1975). Females from Mexico (50.4g) are 12% heavier on average than males (45.2g) (Charles E. Cochran; Allan R. Phillips; Philip M. Walters). Likewise, on the basis of wing length, females in Central America are about 11% larger than males (Ridgway, 6, 1914:796), but nothing is known regarding possible consequences in terms of hunting methods and prey size.

BREEDING HABITAT AND BREEDING
No information.

FOOD AND FEEDING
No information. The relatively short tail is suggestive of a less *Accipiter* hawk-like flight and manoeuvrability than in the Northern and Ferruginous species and may indicate a larger proportion of insect prey.

MOVEMENTS
No information.

GEOGRAPHIC LIMITS
Nowhere do the Northern, Ferruginous and Least Pygmy Owls seem to occur side by side, being apparently segregated by ecological boundaries of which we have no precise details. The Least Pygmy Owl is nevertheless sympatric with the Northern Pygmy Owl (subspecies *gnoma*) in the upper oak woodland zone of Jalisco and with the Ferruginous Pygmy Owl at the upper edge of the tropical thorn forest in Colima, Mexico (Schaldach, 1963), but on the whole the Least is basically a tropical species.

LIFE IN MAN'S WORLD
Although the Least Pygmy Owl leads on the whole an elusive forest life, it does not shun cacao and other shaded plantations. On account of their tame disposition, Least Pygmy Owls have often been adopted as pets by Central and South American Indians in their forest homes.

Least Pygmy Owl *Glaucidium minutissimum*
Brazilian race *G. m. minutissimum*

If it is true that the Least Pygmy Owl is more exclusively insectivorous than the longer-tailed Northern and Ferruginous Pygmy Owls *Glaucidium gnoma* and *G. brasilianum*, this would indicate that it is conspicuously less specialized in the predatory double role for which the northern, American and Eurasian Pygmy Owls *G. gnoma* and *G. passerinum* are known. The question then arises whether an insectivorous diet is an original trait of tropical pygmy owl populations or whether tropical pygmy owls no longer needed and therefore lost the habit of preying on small mammals. In view of its relatively great body weight and disproportionately strong bill, feet and claws, the theory of a northern, basically non-insectivorous origin of the Least Pygmy Owl is certainly worth considering.

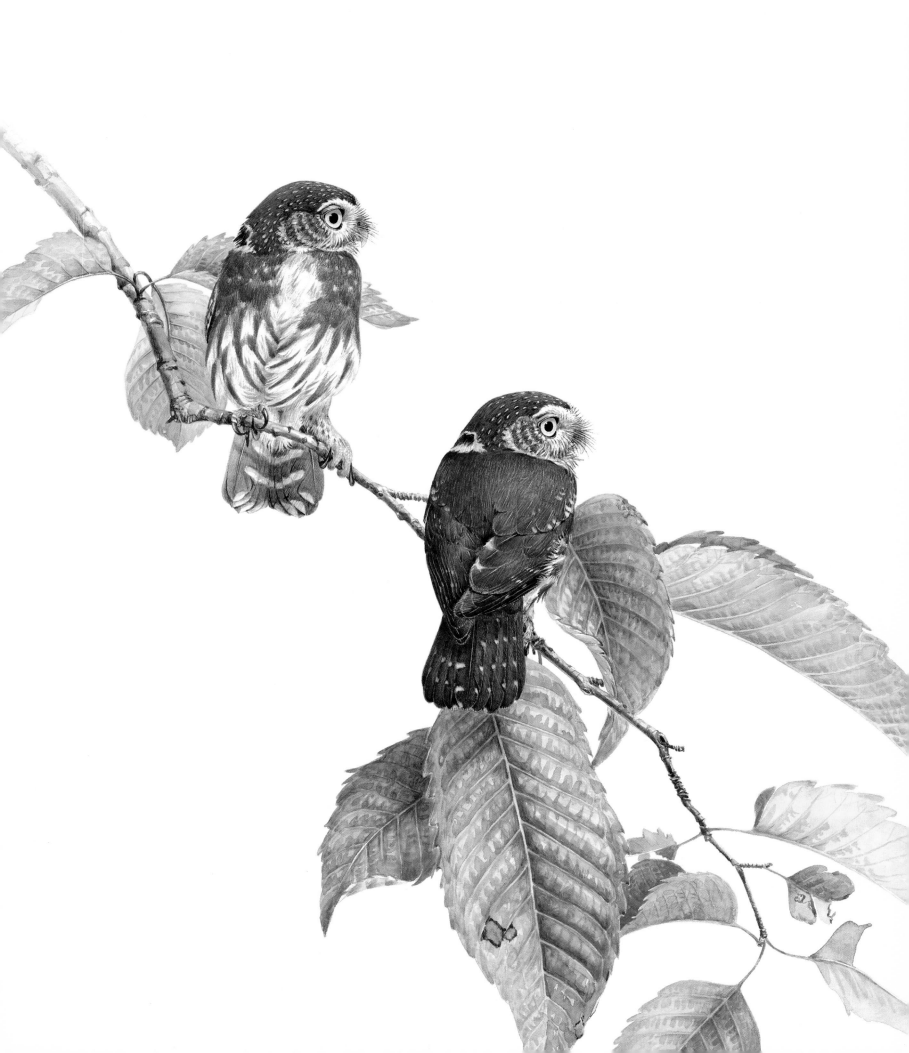

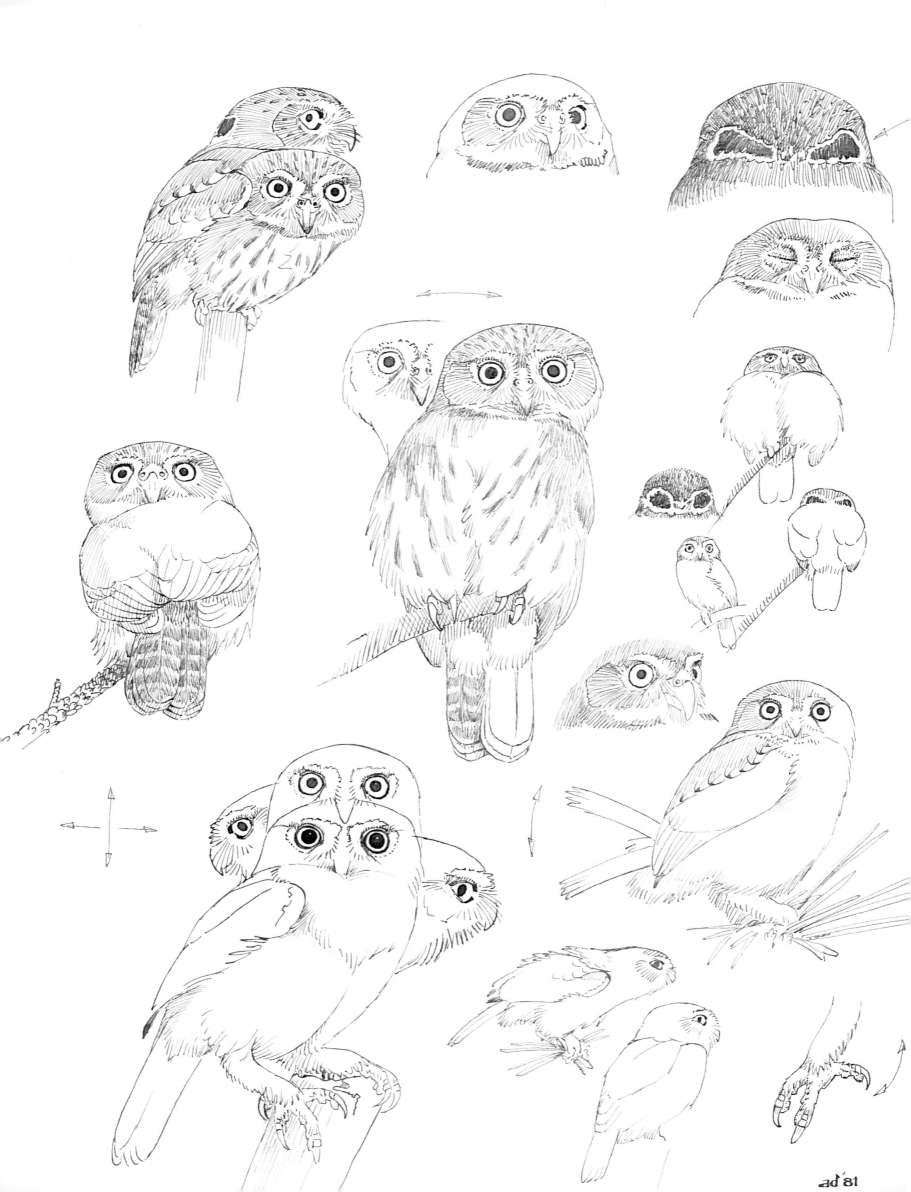

FERRUGINOUS PYGMY OWL

Glaucidium brasilianum

The Ferruginous Pygmy Owl (average length of male 159mm, of female 166mm) is approximately the same size as the Northern Pygmy Owl *Glaucidium gnoma*, and only slightly larger than the Least Pygmy Owl *Glaucidium minutissimum* and the Elf Owl *Micrathene whitneyi*, all of which inhabit, along with the Ferruginous species, parts of the Mexican and Central American subtropics. The Ferruginous Pygmy Owl has a relatively shorter wing and longer tail than these other owls. Its tail is 64% of the length of the wing, as against 59% in the Northern Pygmy Owl and 44% in the Elf Owl. Nevertheless, though something like a miniature *Accipiter* hawk in proportions, the Ferruginous Pygmy Owl is less inclined to hunt birds and mammals than the Northern Pygmy Owl. It is probably also less diurnal than that species with the result that its relation to and dependence on small avian and mammalian prey must also be different.

Although the Ferruginous Pygmy Owl's range is strictly complementary to that of the Northern species, the latter's nearest relative does not seem to be the Ferruginous but rather the Least Pygmy Owl. This does not mean, however, that ecological relations and interactions are closer between one or other pair of species; they are, in fact, virtually unknown and well worth studying.

The Ferruginous Pygmy Owl has a wide, but remarkably discontinuous, range in Central and South America, with numerous subspecies. The Andean Pygmy Owl *Glaucidium jardinii* from the mountains of Costa Rica south to the Andes of Ecuador and Peru and the Austral Pygmy Owl *Glaucidium nanum* from the temperate and cold forests of the Chilean and Argentine Andes and Tierra del Fuego have been included by some authors in this species, but have been kept separate in the present account pending a more detailed knowledge of their vocalizations and life habits.

For the purposes of this study the crucial problem seems to be the relationship between the Ferruginous and Northern Pygmy Owl, which therefore forms the main theme of this chapter.

GENERAL

Faunal type Undecided; originally either Sonoran or South American.

Distribution Discontinuous in Central and South America, from south-central Arizona (Phoenix, Tucson) and Brownsville, Hidalgo County, in the Lower Rio Grande Valley of Texas, south through Sonora, Chihuahua, Coahuila and Nuevo Leon and mainly the arid slopes and lowlands of the Pacific and Caribbean coasts of Central America to western Panama, the arid Caribbean coastal regions of Colombia, Venezuela and Ecuador, including various pockets of open woodland and savannah in Central America, the Guianas and Brazil, south to extreme northern Chile, Bolivia, Paraguay, the Argentine Chaco, Tucuman and Uruguay. Map 12.

Climatic zones Transition to lower Sonoran subtropical and tropical life zones, corresponding to savannah, steppe, desert and tropical winter-dry climatic zones, with estimated average temperatures of up to 40°C in the warmest months at the northern boundary (Phoenix, Arizona) and about 25°C at the southern boundary.

Ferruginous Pygmy Owl *Glaucidium brasilianum*

Habitat Tropical and subtropical dry forest, lowland scrub and thorn forest, wooded savannahs, cottonwood and mesquite grasslands, saguaro deserts, riparian woodland, clearings and second growth in lowland rain forest and rain forest edges and ranch lands. From sea level up to 1,200m in Mexico and El Salvador, 2,000m in Honduras (Monroe, 1968), 1,400m in the subtropical zone of Mt Duida in the Venezuelan–Guianan highlands and over 3,000m in Peru.

GEOGRAPHY

Geographical variation Numerous subspecies described on the basis of different degrees of rufous pigmentation and number and colour of tail bands. The situation is complicated by the existence of extreme colour morphs, some of which are very similar to the dark, greyish-brown forms of the Northern Pygmy Owl, while the hepatic extreme is rufous brown with almost unmarked rufous tail feathers.

North of Panama generally two races are recognized (Peters, 4, 1940). South America has between four and nine races (the species *G. jardinii* and *G. nanum* excluded). The subspecies entering the Holarctic region in the southern United States are *G. brasilianum cactorum* in Arizona and *G. brasilianum ridgwayi* in Texas.

Related species Closest relatives are probably the Andean Pygmy Owl *Glaucidium jardinii* from the cloud forests of Costa Rica to Venezuela (above 2,000m) and Peru (above 3,000m) and the isolated Austral Pygmy Owl *Glaucidium nanum* from the mountain forests of Chile and Argentina and the lowland forests of Tierra del Fuego. The Cuban *Glaucidium siju* and the tropical Least Pygmy Owl *Glaucidium minutissimum* also greatly resemble the Ferruginous species.

STRUCTURE

The strong bill and heavy claws are conspicuous. No differences between the Ferruginous and Northern Pygmy Owl are known in terms of structure, size and weight. The pattern of the tail feathers varies considerably; the 5–6 narrow, light crossbars may be white, rusty brown, a blend between these, or altogether absent. The nape pattern suggesting occipital eyes is elaborately developed (Scherzinger, 1986:53).

BEHAVIOURAL CHARACTERISTICS

Song and calls Vocalizations are of the same type and quality as those of the Northern Pygmy Owl. The hoots of the territorial song are fairly loud and described as either "mellow" or "harsh". The separate *woop* calls follow each other in the fastest succession found in this genus and may amount to 150 per minute in Mexico (Davis, 1972) and 2–3 per second in lowland Costa Rica (Slud, 1980). The song has been heard by day as well as at night and is probably uttered mostly at dusk.

Circadian rhythm Although the Ferruginous Pygmy Owl is described as "active by day", published data are equivocal on the degree of diurnal activity. Activity peaks have been described as occurring at both dawn and dusk, though in Trinidad the owl is mainly nocturnal (ffrench, 1973). Nocturnal song activity, particularly on moonlit nights, is more frequently reported than in the Northern Pygmy Owl, but data are contradictory and according to some authors the species is rarely active at night (Lowery & Dahlquest, 1951; Schaldach, 1963).

Antagonistic behaviour The species is pestered by hummingbirds, vireos, warblers and other small birds and reacts to these in the same way as the Northern Pygmy Owl.

ECOLOGICAL HIERARCHY

Nothing is known regarding ecological interactions between the Ferruginous Pygmy Owl and other owls and diurnal birds of prey and no detailed information has been published on other species of owl sharing its habitat. In the Sonoran and Pacific coastal areas the Ferruginous Pygmy Owl may meet Cooper's Screech Owl *Otus cooperi* and the Elf Owl *Micrathene whitneyi*. As regards possible competition for woodpecker holes, the Ferruginous Pygmy Owl is heavier and stronger than the Elf Owl judging by the egg volume, which is calculated to be 6% larger than that of the Elf Owl.

There are no records of predation on the Ferruginous Pygmy Owl, but potential predators among other owls and birds of prey are numerous in both its Central and South American habitats. In the tropical lowlands of Veracruz, Mexico, it is reported that the first call of the Mottled Wood Owl at night usually silenced all pygmy owls (Lowery & Dahlquest, 1951).

According to a recent summary of data, Central American females are about 22% heavier on average than males (average body weight of male 61.4g, of female 75.1g; see Earhart & Johnson, 1970), but other data from Mexico show different results, viz. average of 36 males 63.4g, of 23 females 67.2g (University of Michigan Museum of Zoology, Ann Arbor; Delaware Museum of Natural History, Greenville), the female being 6% heavier than the male. The difference between the sexes is greater than in the Northern Pygmy Owl and almost as great as in the Saw-whet Owl. Differences between average prey sizes of males and females probably exist, as in the Northern Pygmy Owl, but have not been described.

South American Ferruginous Pygmy Owls have comparable body weights (62.2g in males, 71.3g in females from Paraguay; University of Michigan Museum of Zoology, Ann Arbor) and thus provide the same problems regarding differences in prey size and vulnerability to predation.

BREEDING HABITAT AND BREEDING

Nests have been found in all kinds of open brush and arid woodland, riparian woodland and saguaro desert. Holes in the decayed wood of cottonwoods and other trees and abandoned woodpecker holes (e.g. of Gila Woodpecker) have been described as common nest sites. Eggs average 28.5 × 23.2mm in Mexico; those of Northern Pygmy Owls from California are about 14% larger in volume (data from Bent, 1938). No clutch size larger than 3–4 has been reported, a factor which is in line with tropical conditions of daylight and food availability. The nestlings, whether reared in an open crevice or a closed tree hole, seem to be covered with a more complete and fluffier plumage than in the Northern Pygmy Owl, the latter being reared almost exclusively in the seclusion of a woodpecker hole where there is a constant problem of overheating (W. Scherzinger).

FOOD AND FEEDING

In relation to its small size the Ferruginous Pygmy Owl is a no less strong and fierce hunter than the Northern Pygmy Owl. Published data are scarce and anecdotal, but suggest that the amount of insect prey is larger than that taken by the Northern species. Those recorded as prey are large, crepuscular and nocturnal cicadas, large nocturnal moths, grasshoppers, caterpillars and scorpions. Prairie or fence lizards *Sceloporus* and *Mabuya mabouya* in Surinam have undoubtedly been taken by day, and also the occasional birds. Locally and seasonally, House Sparrows, almost the size of the owls themselves, have been reported as frequent prey, for example in Arizona in winter. Rodents have not been mentioned specifically, but are probably taken along with other small terrestrial animals of subtropical and tropical surroundings. In accordance with a year-round abundance and availability of food in its tropical habitat, no caching habits have been described for this species.

Ferruginous Pygmy Owl *Glaucidium brasilianum*
Mexican and Central American race *G. b. ridgwayi*

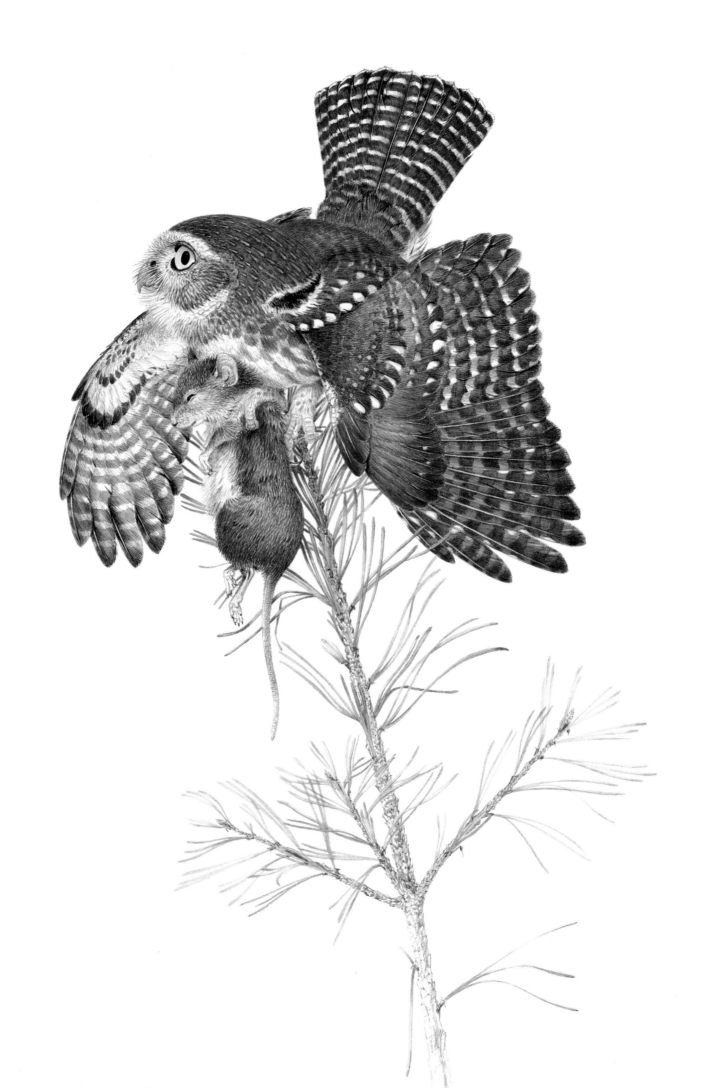

MOVEMENTS AND POPULATION DYNAMICS
No migratory or other seasonal movements have been described and no population fluctuations are known.

GEOGRAPHIC LIMITS
In the north the Ferruginous Pygmy Owl does not penetrate into the range of the Northern species; the ranges have been described as being strictly complementary (Phillips et al., 1964). The same situation occurs in Central and South America in relation to the Least Pygmy Owl from the humid tropical lowland forests and the tropical deciduous forests from higher elevations (Schaldach, 1963), as well as in relation to the Andean or Jardine's Pygmy Owl from the upper subtropical and temperate mountain forests up to the cloud zone. There are no data on habitat adaptation for these species.

LIFE IN MAN'S WORLD
More than any other of the American species of its genus the Ferruginous Pygmy Owl enters coffee fincas and other plantations, and gardens in suburban areas and towns, in order to live and nest, and perches on telegraph wires and other utility lines by day, in both Central and South America. Its mainly insectivorous habits, combined with an innate versatility of prey choice, are favourable to a friendly association with man.

It thus seems that the Ferruginous Pygmy Owl is even more insectivorous than the North American Pygmy Owl *Glaucidium gnoma* and considerably more so than the Eurasian species *Glaucidium passerinum*. It would be interesting to know whether this is an original or a more recent characteristic. The degree and history of its subspeciation are also interesting features of this species which are still far from fully understood. The same applies to the complicated system of colour morphs, the ecological and ethological significance of which – if any – is unknown. The specific adaptations of the Ferruginous Pygmy Owl to its relatives in the less arid and the mountainous tropics are likewise unknown.

A survey of the Ferruginous Pygmy Owl's taxonomic relations, including vocalizations, with the Austral South American *Glaucidium nanum* would be most helpful, if not essential, to an understanding of its zoogeographic position as either the home base or a southern extension of the North American Pygmy Owl. The Ferruginous Pygmy Owl's dark "occipital eye spots", suggesting a dorsal face and considered to be an adaptation to a diurnal life, would be an anomaly if the species were not mainly active by day. The Ferruginous Pygmy Owl must have originated from other diurnal species of its genus while its more extensive nocturnal habits are therefore of a secondary nature.

COLLARED OWLET

Glaucidium brodiei

Between 16 and 17cm long and with a body weight of 50–60g, the Collared Pygmy Owl or Collared Owlet is a miniature of the Cuckoo Owlet *Glaucidium castanopterum* (formerly *G. cuculoides*). In spite of its relatively smaller size, it inhabits colder, montane habitats in a Sino-Himalayan, Chinese and southeast Asiatic range. Though the Cuckoo Owlet is larger than the Collared Owlet by slightly more than 50%, the Jungle Owlet *Glaucidium radiatum* from the arid lowlands of southern Asia is no more than 20% larger, while the boreal Eurasian Pygmy Owl *Glaucidium passerinum* is larger by an average of 10% (8% in body length, 10% in wing length, 13% in weight). Together with the Eurasian and all of the American species of *Glaucidium*, the Collared Owlet is therefore one of the dwarfs of its genus.

The question then arises as to whether it shares its origin with these other dwarfs or whether the tropical pygmy owls from Asia and America represent independent, parallel developments within the genus. The Barred Owlet *Glaucidium capense* of the tropical southern half of Africa, while being about 24% larger than the Collared Owlet, seems to be an offshoot of an Asian–African tropical forest stem of which there are five other species originating in the Afrotropics and two others in south Asia. The Collared Owlet has the same white- or buff-bordered black neck patches suggesting a staring dorsal face, a feature found in all other northern hemisphere and tropical American species and thought to be a protective adaptation in diurnal life. Like these species, the Collared Owlet has discrete rufous, chestnut and dark-grey colour morphs. Smallest of the south Asiatic owls, it is nevertheless a bold and courageous hunter and occasionally captures birds larger than itself. It occurs alongside the large Cuckoo Owlet in the hills above Simla in Himachal Pradesh, India, at about 2,400m altitude, and in the hills surrounding the Red Basin of Szechuan, China, at about 760m altitude (Stresemann, 1923:59). Interactions between the two species have not been recorded, either for this or for the various other habitats where the species meet, e.g. in Thailand, Burma and particularly in China where the Collared Owlet ranges north to the January isotherm of barely 5°C. One wonders how the owl behaves that far north in winter.

The following species account draws comparisons wherever possible between the Collared Owlet and the larger tropical Asian and small boreal species of pygmy owl. Unfortunately, little appears to be known about the life habits of this intriguing dwarf.

GENERAL

Faunal type Sino-Himalayan?

Distribution Southeast Asia. Himalayas and southwest Chinese mountains, from the highlands of eastern Afghanistan (discovered by Puget & Hüe, 1970), Kashmir and Himachal Pradesh, through Nepal, including the Nepal Valley, to Assam and the hill tracts of Bangladesh, Burma, Laos and Vietnam; in China, north to Kiangsu, the northern slopes of the Chinling Mountains in Shensi (Cheng, 1973) and south Kansu, also Hainan and Taiwan; the highlands and hills of Thailand, south in the peninsula to about 9° north; discontinuous mountain ranges in the Malay Peninsula, Sumatra and Borneo. Map 13.

Climatic zones Temperate and tropical winter-dry and tropical rain forest climates and mountain zones.

Habitat Open, submontane, deciduous and mixed forests of oak, fir, deodar and other coniferous trees, from the western *terai* and the eastern rainy *duars* into the foothills of the Himalayas up to at least 3,000m altitude. Any hill and mountain forest elsewhere, up to the rhododendron zone. In the Malay Peninsula at 400–1,800m and in Sumatra at 800–1,650m altitude. In west Szechuan, China, in open woodland and near cultivation as low as 760m. Like all other small pygmy owls, the Collared Owlet seems to be fond of bathing.

GEOGRAPHY

Geographical variation Slight. West Himalayan birds (*Glaucidium brodiei brodiei*) are paler, generally greyer, and less conspicuously barred above. From west Nepal eastward the plumage grows darker and rufous colour morphs predominate, while the most rufous morphs occur in Indo-China, continental

OVERLEAF: **Collared Owlet** *Glaucidium brodiei*
Taiwan race *G. b. pardalotum* with atlas moth *Attacus atlas* as prey

Collared Owlet *Glaucidium brodiei*
Taiwan race *G. b. pardalotum* over his image in the water

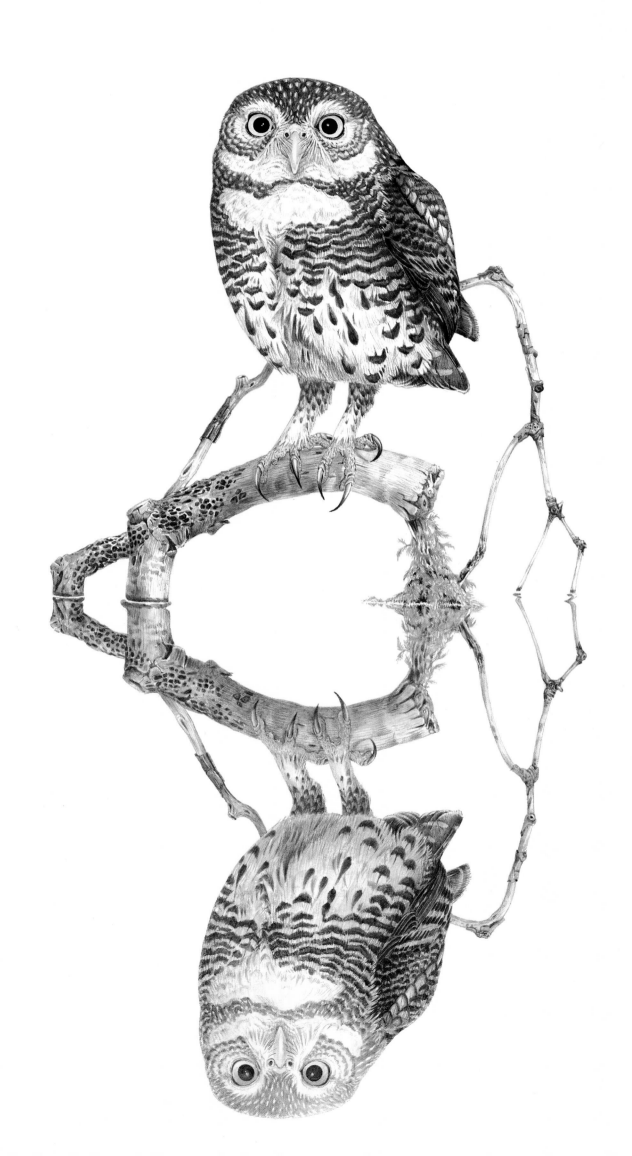

China and Taiwan. Two other insular races (Sumatra, Borneo) differ slightly in coloration.

Related species The Collared Owlet is usually mentioned in direct connection with the other south Asian species, the Jungle Owlet *Glaucidium radiatum* and the Cuckoo Owlet *Glaucidium castanopterum*. From the point of view of ecology and distribution, however, by far its closest relatives are the other dwarfs of the genus, the Eurasian Pygmy Owl *Glaucidium passerinum* and its North American counterparts, all of which may be descendants of the Collared Owlet.

STRUCTURE
Seemingly structurally identical to the Eurasian Pygmy Owl.

BEHAVIOURAL CHARACTERISTICS

Songs and calls The territorial song is transcribed as a mellow and bell-like, syncopated whistle, *hooo hoo-hoo hooo* or *toot-toottoot-toot*, repeated at short intervals. As the singing bird turns its head in all directions, the effect is highly ventriloquial. Small birds often react to its call and Burmese bird-hunters are said to take advantage of this fact by imitating the owl's call, similar cases of imitation also being reported for the Eurasian and North American Pygmy Owls. Some authors state that the hotter the day, the more persistent is the call, while others have remarked that the Collared Owlet's song is a familiar nocturnal sound at most Himalayan hill stations. In the latter case the owl's call may have been confused with the similar call of a green tree frog (Baker, 4, 1927:452), just as the call of the European species has been confused with the bell-like calls of the midwife toad.

Circadian rhythm The Collared Owlet is described as more diurnal than the Cuckoo Owlet, but reports are inconclusive. The owl has been observed while calling and hunting and has been netted frequently (in Malaysia) in broad daylight.

Antagonistic behaviour Like the Eurasian Pygmy Owl, the Collared Owlet cocks, jerks and swings its tail sideways in agitation when mobbed by small birds. It generally succeeds in concealing itself, however, from flocks of arboreal birds.

ECOLOGICAL HIERARCHY
Nothing recorded. In Szechuan, China, and possibly elsewhere, the Collared Owlet shares the Cuckoo Owlet's habitat, but how the two species interrelate is not known.

Females are larger than males by 6% in wing length and 19% in body weight, but no differences in average hunting methods and prey size have been recorded between the sexes.

BREEDING HABITAT AND BREEDING
Nests have been reported in natural holes in trees, but more frequently in the holes bored by woodpeckers or dug by barbets. The rightful owners have often been killed by this pugnacious little owl (Baker, 3, 1934:533). Eggs are about the same size as those of the Eurasian Pygmy Owl (average 28.9 × 23.8mm and 28.6 × 22.8mm, respectively), those of the Collared Owlet being a little larger in volume, perhaps by as much as 10%. The largest clutch found was one of six egs on 15 May 1914, in western Szechuan, China, at 760m (Reiser, 1927:6). This high number is exceptional among tropical owls and reminiscent of more northern conditions.

FOOD AND FEEDING
In spite of its small size the Collared Owlet is a ferocious hunter. Its flight is not noiseless, perhaps indicating that it does not share the need of most other owls for silent flight. Apart from large insects, lizards (including *Draco* in Malaysia), skinks, small rodents and shrews, its prey appears to include a greater number of birds than in the case of the Cuckoo Owlet, though this may be coincidental and the result of uneven publication of data. Authors agree on the fact that fairly large birds can be taken. Those reported are: nestling and adult woodpeckers and barbets (species not detailed), minivets, magpie robins and, on one occasion (in Borneo), as fierce a species as an Ashy Drongo (Smythies, 1960). The Collared Owlet is also said to be an eager predator of nestlings (Baker, 4, 1927:453). Its diurnal habits and possibly high proportion of avian prey are suggestive of a life style similar to that of the Eurasian Pygmy Owl.

MOVEMENTS AND POPULATION DYNAMICS
None recorded and the species is considered resident. Some altitudinal migration is suspected.

GEOGRAPHIC LIMITS
The Collared Owlet is a montane species in mainly tropical surroundings. It is not known what conditions of vegetation and climate determine the geographical range. Its southern present range in the Sunda Islands may have a primarily historical–biogeographic source. Its northern range in the Himalayas and China may be limited by climatic conditions at which we can only guess.

LIFE IN MAN'S WORLD
While the Collared Owlet is mainly a bird of the dense forest and forest edge and seems to live a life far from intrusion by man, it has occasionally been observed in patches of cultivation and human habitation in the Himalayas and the Nepal Valley.

The Collared Owlet's nearest relatives seem to be the Jungle Owlet *Glaucidium radiatum* and the Cuckoo Owlet *Glaucidium castanopterum*, on the one hand, and the Eurasian Pygmy Owl *Glaucidium passerinum*, on the other. The similarities of its behaviour and hunting methods with those of the latter species are particularly worth detailed study. The Collared Owlet may, after all, have remained close to the source from which the Eurasian Pygmy Owl and subsequently all American species of this genus have sprung.

CUCKOO OWLET

Glaucidium castanopterum
FORMERLY KNOWN AS *Glaucidium cuculoides*

With its length of approximately 25cm and body weight of 170g, the Cuckoo Owlet or Asian or Himalayan Barred Owlet is the largest of the Eurasian pygmy owls. It resembles the Indian Barred Jungle Owlet *Glaucidium radiatum* which, however, is 20% smaller in size and over 30% in weight. Its southeast Asian high-altitude vicariant, the Collared Owlet *Glaucidium brodiei*, is smaller by 34% and 68%, respectively. Particularly in the isolated Javan form *Glaucidium c. castanopterum* with its plain reddish-brown upperparts, it is strongly reminiscent of five of the six Afrotropical species of its genus. Together with the tropical Asian owlets these inhabit what may be considered a formerly contiguous belt of African–Asian forests which were broken up at the end of the Tertiary period by the increasingly arid conditions reigning in the Middle East. Rather than figuring at the end of the list of northern hemisphere pygmy owls the Cuckoo Owlet should therefore be considered as one of the earliest members of the genus. Its structural and ecological relations with supposed, increasingly terrestrial relatives of other genera (Forest, Spotted and Little Owls of the genus *Athene*) are in need of study, as are indeed its behavioural characteristics, of which virtually nothing is known. The Jungle Owlet of India, inhabiting arid woodland, thorn scrub, cultivated land, parks and gardens, already almost matches the Spotted Little Owl in life style, being less terrestrial only and scarcely 5% smaller. Compared with the miniature Eurasian Pygmy Owl *Glaucidium passerinum* the Cuckoo Owlet subsists on a general tropical diet of large insects, lizards and the odd small bird. It already possesses the proportionally long tail of the other bird-hunting species of the genus: 58% of the wing length, which is the same as in the Eurasian species, but 8% less than in the North American *Glaucidium gnoma*. However, it does not (yet) seem to have the dark occipital eye spots which are so characteristic of the small, diurnal northern species.

GENERAL

Faunal type Sino-Himalayan and Indo-Chinese, with some Malaysian influence.

Distribution Southeast Asia. The lower levels of the Himalayas from Murree in the Punjab province of Pakistan, Kashmir and Himachal Pradesh, through Nepal to Bhutan, Assam, Burma, most of Thailand and Indo-China, south in the Peninsula to about 11° north. The greater part of lowland China north to Anhwei and the southern slopes of the Chinling Mountains in Shensi below 1,200m altitude, but recently also found in eastern Tibet (Cheng, 1973). Hainan. Also Java and Bali, but not the other Sunda Islands, nor the Malay Peninsula. Map 13.

Climatic zones Temperate, savannah, tropical winter-dry and tropical rain forest.

Habitat Forest, second growth and scrub, from the *sal* (dipterocarp forest) and other climax tropical and subtropical evergreen jungles and swampy *terai* and *duars* low down at the foot of the Himalayas, up into the mountains in oak, pine and rhododendron zones, usually below 2,100m, but up to 2,700m altitude in Nepal (Biswas, 1961). Elsewhere in lowland and hill forests, including bamboo forests, usually below the range of the Collared Owlet, but sharing its habitat to an unknown extent in parts of China, e.g. west Szechuan, as low as at 750m, but not in the Chinling Mountains where the Cuckoo Owlet inhabits the southern, the Collared Owlet probably only the northern forested slopes of this mountain chain, well known as a zoogeographic boundary (Cheng, 1973). In Java and Bali in lowland forests at 600–900m altitude.

GEOGRAPHY

Geographical variation Rather conspicuous, but apparently somewhat chaotic through the occurrence of dark-brown and bright rufous morphs and differences in barring of the plumage irrespective of geographical range. Conservatively, between seven and nine races recognized. The geographical pattern includes dark brown with heavily barred underparts in the western Himalayas east to eastern Nepal (*Glaucidium castanopterum cuculoides*), more distinctly rufous plumage with a tendency to longitudinal streaks rather than bars on the underparts in the east (various races), slightly larger sizes in the eastern Himalayas (*G. c. austerum*) and China (*G. c. whitelyi*) and smaller ones in Thailand (*G. c. deignani*). The insular race from Java and Bali (*G. c. castanopterum*) is distinguished by its unmarked chestnut-brown back. It is sometimes considered a separate species.

Related species In view of the similarity of their plumage, the smaller Jungle Owlet *Glaucidium radiatum* of the more arid, lowland woodlands and jungles of the Indian subcontinent and

Sri Lanka is the Cuckoo Owlet's closest relative. In the high-rainfall lowland forest tracks (*bhabar*) of the valleys known as *duns* at the foot of the Himalayas at 245–915m altitude both species occur side by side in almost equal numbers, but below this zone the Jungle Owlet is rapidly becoming predominant while above it the Cuckoo Owlet prevails (Biswas, 1961:104). Their interaction would be an interesting topic for study. The very small Collared Owlet of montane habitats is another near relative in southeast Asia, but the various forest-inhabiting species of pygmy owl from the Afrotropics are probably equally close relatives, though perhaps of an older date.

STRUCTURE

The Cuckoo Owlet is the largest of the Asiatic pygmy owls and structurally not unlike the little owls of the genus *Athene*. It differs from that genus in having more swollen nostrils and a more softly feathered tarsus, but, as in *Athene*, the toes are covered with bristly hairs. In accordance with its forest habitat, the wings are more rounded than in *Athene*, which inhabits open country. The absence of fringes on the outer edge of the outer primaries, with the result that the flight is not noiseless as in most other owls, may be considered an adaptation to a diurnal life in which tropical insect food is abundant. The absence of dark occipital spots mimicking a dorsal face indicates that diurnal life has not influenced this species as profoundly as in the other pygmy owls of fully or marginally Holarctic distributions.

BEHAVIOURAL CHARACTERISTICS

Songs and calls The territorial song does not particularly resemble the stereotypical monotonous hooting of the smaller pygmy owls, but corresponds rather to a more varied series of barking notes compared by Hugo Weigold in China with the screaming *goohk-goohk* of the Little Owl. Professor Tso-Hsin Cheng (Zheng Zuoxin) (1964) describes it as a "loud and clear *hooloo-hooloo-hooloo*, after which it gradually broadens to a more violent *kok-kok*, to end with a short and shrill *chirr*-tremor". Actually this must be a high-intensity call, part of which may be comparable with the "corkscrew" call of the Eurasian Pygmy Owl. With regard to the "corkscrew" Hugh Whistler (1949) cites B. B. Osmaston who describes it as "a rising crescendo of harsh squawks which sound as if the bird was trying to rise to some great effort, and then end suddenly and unexpectedly". Nighthawk-like rapid trills and weird bubbling and laughing calls have also been described. The owlet may actually combine the vocal characteristics of the genera *Glaucidium* and *Athene*.

Circadian rhythm Authors agree on the fact that the Cuckoo Owlet is largely diurnal, but only those few who have known the species from ample personal experience, like E. C. Stuart Baker and Salim Ali, go so far as to state that it is one of the most diurnal of owls and hunts in bright sunshine. Its period of greatest activity falls before the heat of the tropical day and it has been heard calling regularly at night.

Antagonistic behaviour Nothing is known other than that the Cuckoo Owlet is often surrounded by a mob of small birds uttering alarm cries. When agitated, it swings its tail from side to side in a shrike-like manner that is also found in all the other species of the genus *Glaucidium*.

ECOLOGICAL HIERARCHY

Nothing is recorded regarding species of other owls and diurnal birds of prey with which the Cuckoo Owlet may share its habitat and prey. Locally it is very common (e.g. northern Thailand) (Deignan, 1945), which means that it is a very successful species. Females are only slightly larger than males (barely 3% in wing length) and this difference can hardly affect hunting methods and prey size. It may represent a primitive situation among pygmy owls, suggesting an abundance of tropical non-avian food.

BREEDING HABITAT AND BREEDING

Nests have been found in natural hollows in large trees in forests and woodlands, usually high up in the main trunk, but also in large side branches. In the latter case the holes may originally have been excavated by woodpeckers and barbets, whose nests are often appropriated by sheer violence and murder. Eggs are largest in China (Kwantung, 37.5 × 30.5mm); smallest in Java (32.3 × 28.7mm) (Hoogerwerf, 1949:102). Eggs from Szechuan, China, are more than twice the size of those of the Collared Owlet collected in the same place (Reiser, 1927:6).

FOOD AND FEEDING

Authors agree that most prey is caught on the ground and consists of large, terrestrial insects such as beetles, grasshoppers, locusts and mole crickets and other arthropods and lizards; in addition, mice, rats and small birds are taken, but detailed records are few. Large insects are reported to be caught on the wing (Baker, 4, 1927). Of all authors, Professor Tso-Hsin Cheng in his treatise "China's economic fauna: birds" (1964) is the most informative, mentioning small birds (unspecified), rodents (unspecified), crickets, grasshoppers, mantids, beetles, weevils, dragonflies, ants, caterpillars, frogs, snakes and fish as the Cuckoo Owlet's prey. Frogs (also recorded from Szechuan by Hugo Weigold; see Stresemann, 1923) and fish probably reflect the Cuckoo Owlet's life in wet subtropical areas of rice cultivation. Once a Cuckoo Owlet was seen catching a Quail *Coturnix coturnix* as it flew past, in the manner of a hawk, but this was in January 1900 in the northwest Indian foothills when snow covered the ground and terrestrial food was probably less accessible (Dudgeon, 1900).

MOVEMENTS AND POPULATION DYNAMICS

No actual movements by the Cuckoo Owlet have been described and the species is considered basically resident, but in the west Chinese mountains the birds seem to descend in winter to the more protected and mild lowlands of Szechuan and the river valley bottoms of western Hupeh. More extensive movements are not unlikely in the northernmost Chinese parts of the species' range where winters can be severe. In spite of its wide

Cuckoo Owlet *Glaucidium castanopterum*
Hainan race *G. c. persimile* in an oriental maple

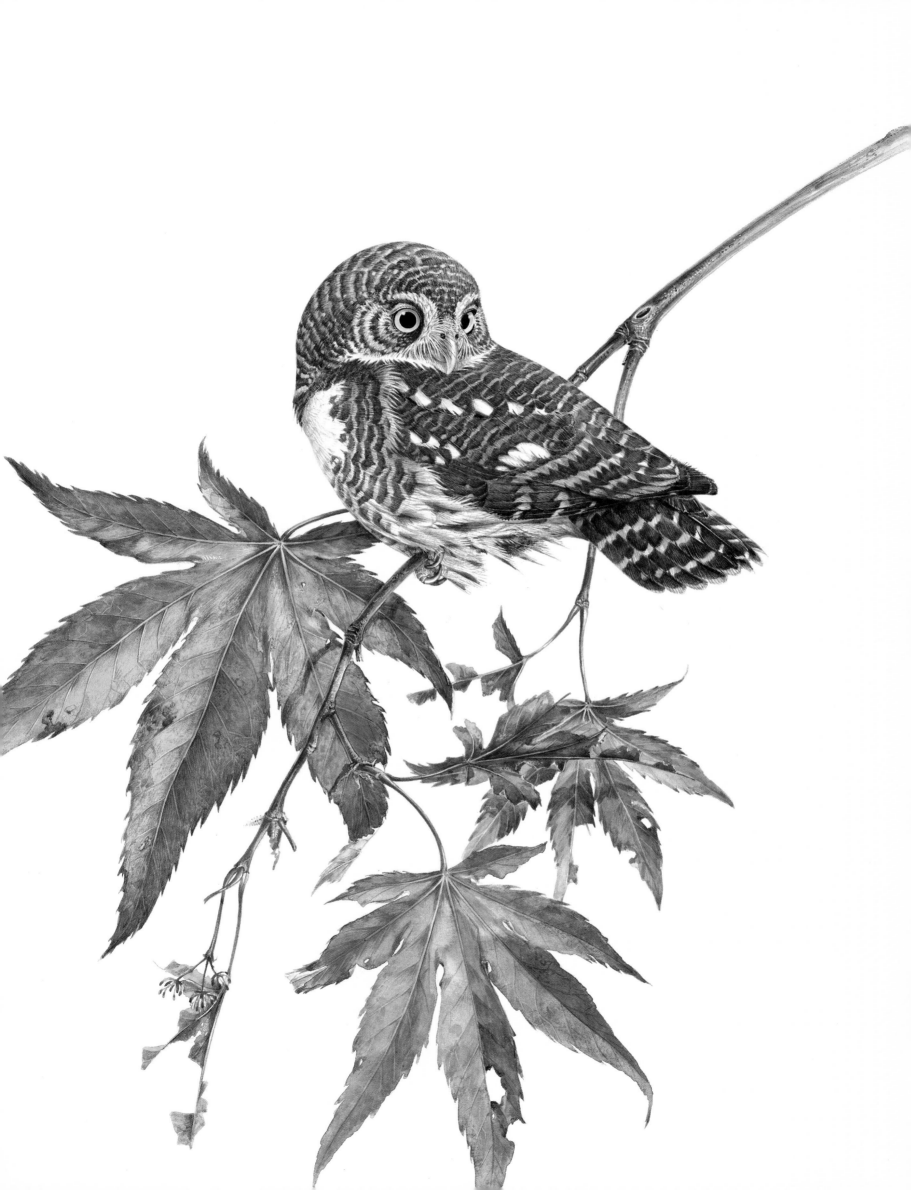

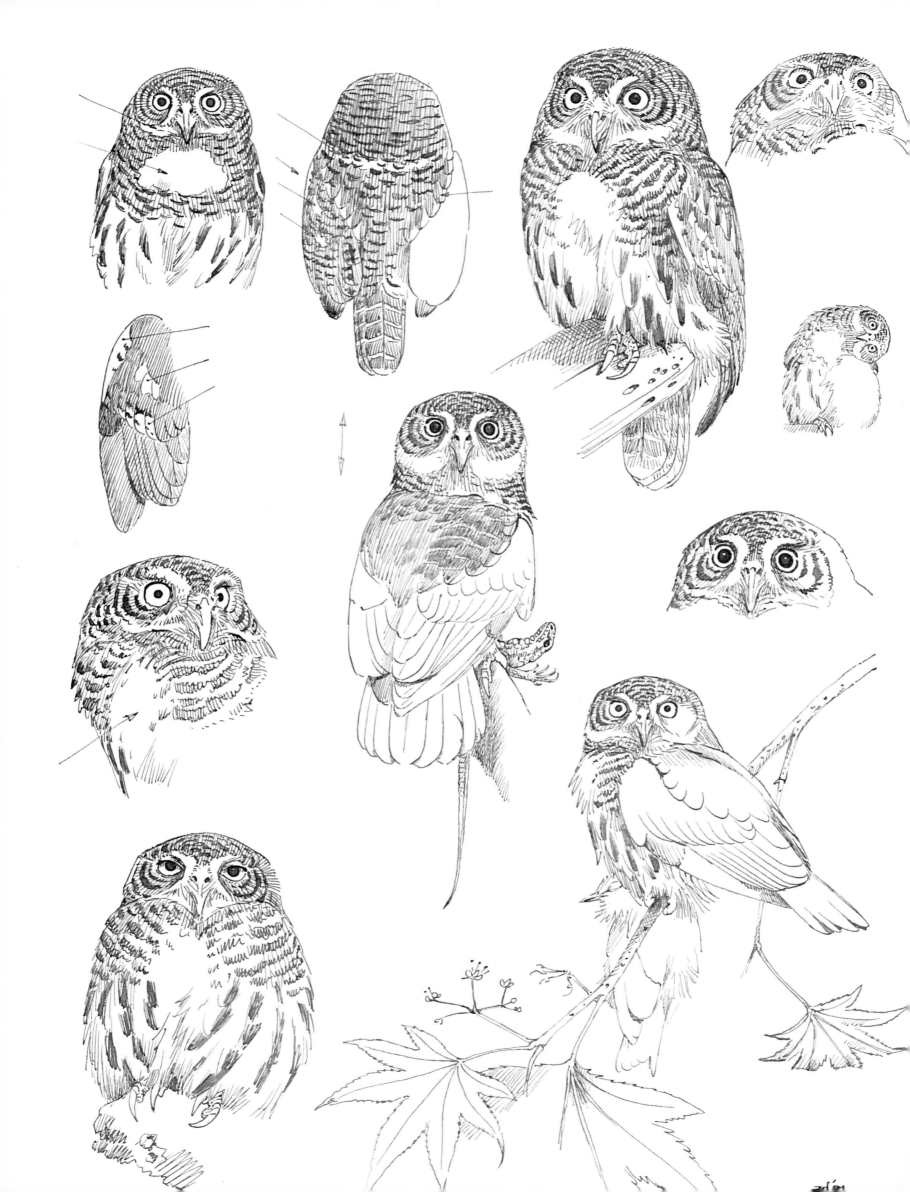

range in the tropics it seems to be able to withstand some substantial snow cover in the western Himalayas at least (e.g. Kangra valley, Punjab, Himachal Pradesh (Dudgeon, 1900). However, restricted vertical movements are expected to occur on all of the southern Himalayan slopes.

GEOGRAPHIC LIMITS

The Cuckoo Owlet has a miniature representative at higher altitudes (Pygmy Owlet) and a medium-sized one in the more arid scrub and open woodland areas of the Indian subcontinent (Jungle Owlet). Whether the presence of these species represents real dispersal limits is not known.

Laboratory experiments have indicated a considerably lower metabolic rate in relation to body weight than the rates obtained from songbirds of comparative size (Johnson & Collins, 1975:44–45). This might mean that the Cuckoo Owlet can stand higher ambient temperatures but is less resistant to cold. Its geographic limit in north-central China around the January isotherm of somewhat above 5°C would seem to confirm this conclusion.

LIFE IN MAN'S WORLD

In view of its forest habitat the Cuckoo Owlet is rarely associated with human activity in tropical southeast Asia. It is known to nest in fruit gardens near Bangkok, Thailand, and has been found in coconut plantations. However, it is mainly in China that the Cuckoo Owlet regularly and characteristically occurs close to human settlements and farmhouses and in bamboo groves and planted trees along roads and footpaths in rice fields and other cultivated areas (Hugo Weigold; Ernst Schäfer).

Cuckoo Owlet *Glaucidium castanopterum*

Life habits and structure of the mainly tropical Cuckoo Owlet (including the virtual absence of an "occipital face" pattern) suggest that the small diurnal pygmy owls of temperate and boreal climates are of a tropical origin similar to that of the Cuckoo Owlet. It may be that these birds – not only the minute Eurasian Pygmy Owl *Glaucidium passerinum*, but, in a wider sense, probably also the relatively much larger Northern Hawk Owl *Surnia ulula* – have evolved from a stem near the present Cuckoo Owlet. The currently widely distributed northern species of *Glaucidium* and *Surnia* have developed, each in its own way, a remarkable versatility of hunting methods enabling them to catch both slow-moving terrestrial rodents and fast-flying birds with equal ease. While these birds have remained arboreal, there is another possible stem leading to the more terrestrial Little Owls of the genus *Athene*. The absence of the otherwise worldwide genera *Glaucidium* and *Athene* in the Australian region may be a sufficient reason for investigating the possibility of a closer relationship between *Glaucidium* and the numerous and widespread species of Australian Hawk Owls *Ninox*.

ELF OWL

Micrathene whitneyi

In contrast to the robust little pygmy owls *Glaucidium*, the Elf Owl is both tiny and dainty, thereby living up to its name. With an average body weight of 40.2g (data supplied by A. R. Phillips, Mexico; Charles E. Cochran and Philip M. Walters, Arizona; Delaware Museum of Natural History, Greenville, and the University of Michigan Museum of Natural History, Ann Arbor), which is 16% less than that of the tropical American Least Pygmy Owl *Glaucidium minutissimum* (47.8g), and a body length of 13.5–14.5cm, which equals that of the Least Pygmy Owl (though the latter has a longer tail), the Elf Owl is the tiniest owl in existence. If one draws a comparison with other owls sharing the Elf Owl's habitat, the biomass of a Mexican or Saguaro Screech Owl *Otus kennicottii cineraceus* equals that of more than two, sometimes even three, Elf Owls and the biomass of the Desert Great Horned Owl *Bubo virginianus pallescens* equals that of at least twenty Elf Owls. The size of the Elf Owl's egg is barely 50% of that recorded for the Saguaro Screech Owl and 12.5% of that of the Desert Great Horned Owl (data from Bent, 1938). One wonders whether it is possible for a smaller owl to exist and still retain the appearance and habits of an owl; indeed, the Elf Owl is not capable of silent flight, a characteristic unnecessary in a small insectivorous predator. The Elf Owl is nevertheless a fierce owl, though in the slenderness of its body structure and legs almost passerine, while its insectivorous habits, its territorial life and systematic aggression in obtaining possession of a nesting hole are strongly reminiscent of certain migrant songbirds, notably the well-studied Pied Flycatcher *Ficedula hypoleuca* of the Old World.

Its tiny size, adaptation to a nocturnal insectivorous life in the deserts, breeding habits and possible evolution from a stem similar to or identical with that of the pygmy owls *Glaucidium* are all topics worthy of study.

GENERAL

Faunal type Sonoran.

Distribution Southern United States, from Joshua Tree National Park in southeastern California and the Colorado valley in extreme southern Nevada through the lowlands of southern Arizona and southwestern New Mexico north to the Gila River and Mohave County in central Arizona; Chisos Mountains in the Big Bend of the Rio Grande Valley in Brewster County in southern Texas and Hidalgo County in the lower Rio Grande delta (James & Hayse, 1963). Southern Baja California and the deserts and live-oak belts in north-central Mexico in the states of Sonora, Chihuahua, Coahuila and Nuevo Leon. Puebla in south-central Mexico (Phillips, 1942). On islands as far apart as Socorro Island and Revillagigedo Archipelago (see Jehl & Parkes, 1982). Map 14.

Climatic zones Temperate, steppe and desert (upper and lower Sonoran life zone); locally in subtropical and tropical surroundings.

Habitat Giant candelabra cactus (saguaro), riparian woodland and canyon bottoms with willow, cottonwood, sycamore and walnut, and arid mountain slopes in the live-oak zone up to about 2,100m where pines grow more abundantly (Marshall, 1957).

GEOGRAPHY

Geographical variation Not very marked. Four races are recognized. *Micrathene whitneyi whitneyi* inhabits northern Mexico and Arizona and adjacent parts of the United States. In Baja California (*M. w. sanfordi*) it is uniformly greyish, on Socorro Island (*M. w. graysoni*) darker and with deeper ochraceous colours. In subtropical lowland Texas and Puebla (*M. w. idonaea*) it is paler and greyer above and with fewer cinnamon-coloured blotches.

Related species The Elf Owl is the only representative of its genus. It is usually associated with the pygmy owls *Glaucidium*. See Structure.

STRUCTURE

The Elf Owl differs from the pygmy owls *Glaucidium* and all other owls in having 10 instead of 12 tail feathers. This is an insignificant distinction, however, and the long, thin and scantily haired or bristled tarsus and bare toes are perhaps a stronger support for its generic separation. Ear openings are small, ovate and symmetrical, as in *Glaucidium*. Skeletal characteristics are likewise similar to those of *Glaucidium*, but the skull is more

Elf Owl *Micrathene whitneyi*
Nesting hole in saguaro cactus *Cereus giganteus*

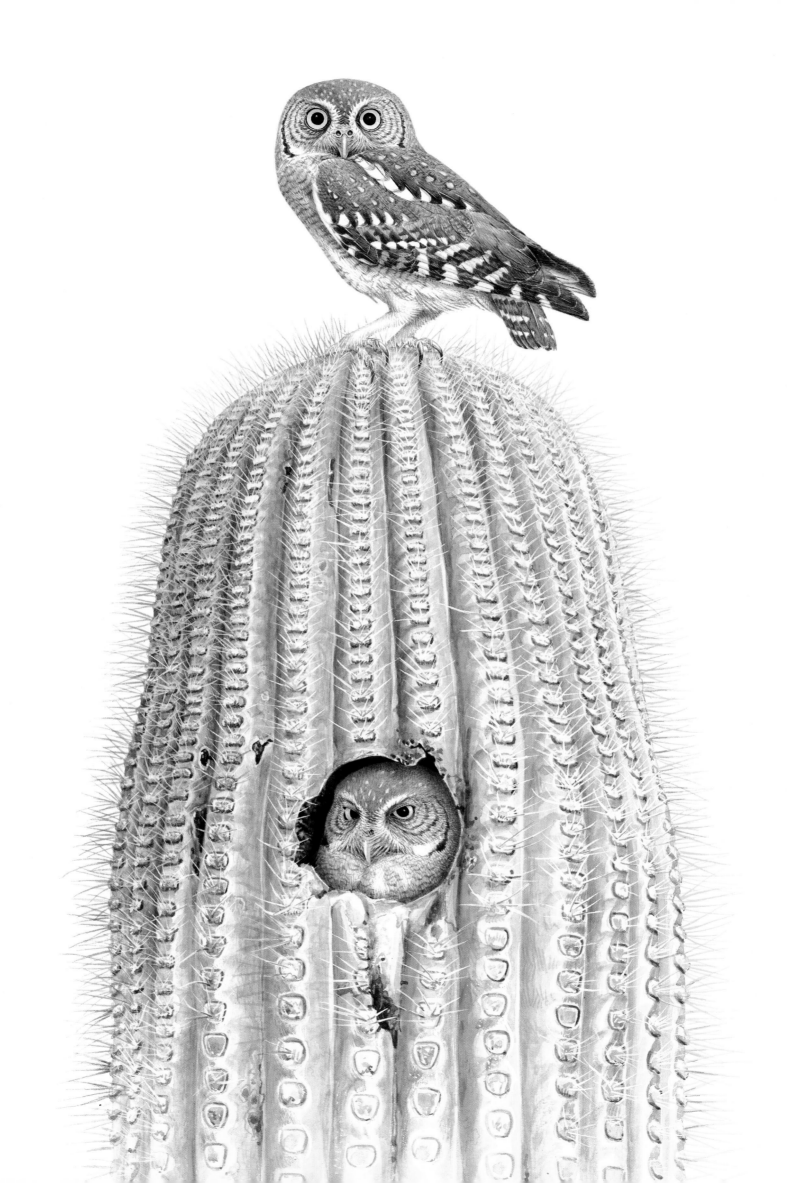

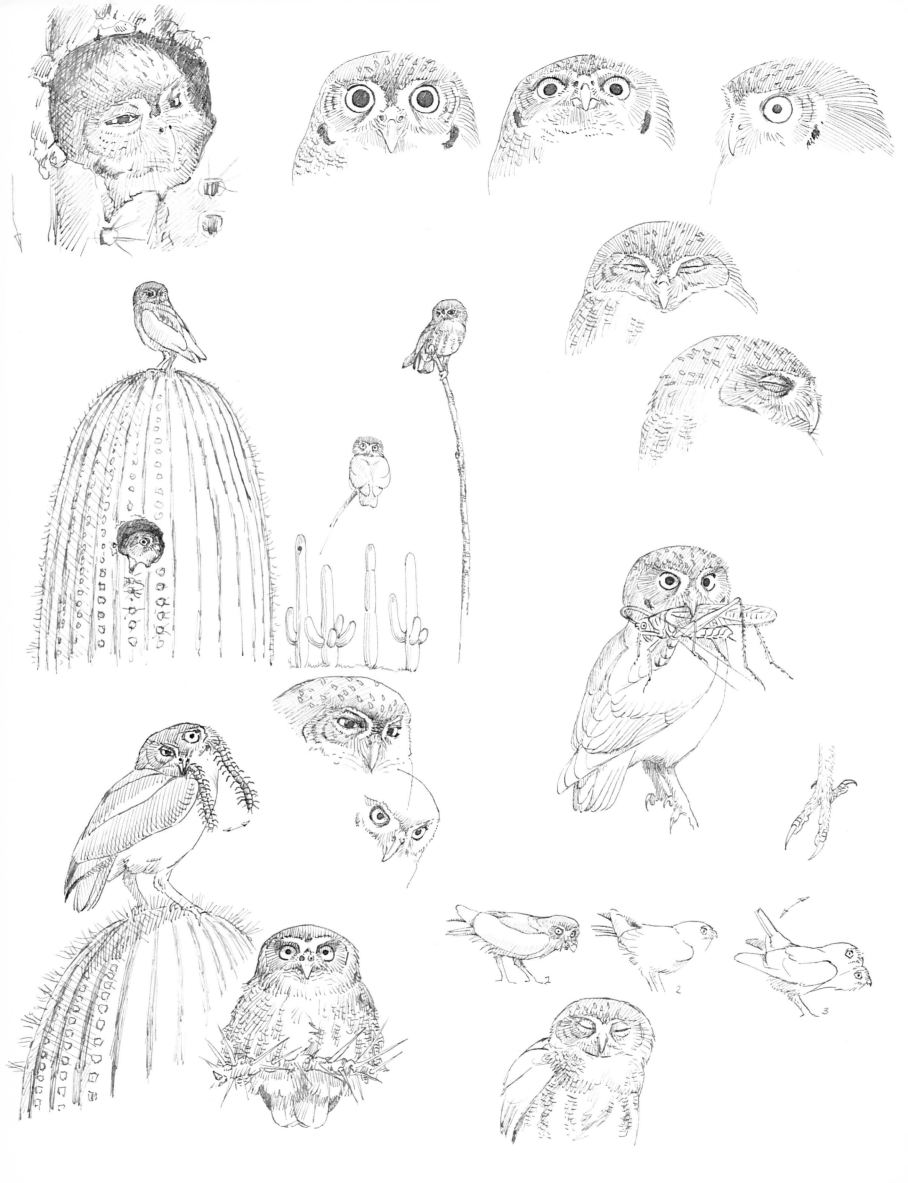

finely built and the forehead higher and more rounded (Ford, 1967). The bill is relatively weak, not proportionally strong as in *Glaucidium*, with an inflated, semibulbous cere. The claws are not as strong as in *Glaucidium*. The tail is notably short. The syrinx is small and slender, but otherwise compares proportionally well with that of the slightly larger North American Pygmy Owl (Miller, 1935).

The Elf Owl does not have, nor does it seem to require, silent flight, and it therefore lacks the necessary feather structure found in most other owls (Walker, 1943).

BEHAVIOURAL CHARACTERISTICS

Songs and calls The vocalizations of the Elf Owl are varied; a dozen different calls have been described (Ligon, 1968). Given the bird's small size, the Elf Owl has a remarkably loud voice. Elf Owls are very vociferous and both the song of the male and the food call of the female (a cricket-like trill) are described as notable nocturnal sounds in the Sonoran cactus deserts. The territorial song of the male is a rapid, high-pitched series of whimpering sounds, variously described as *whi-whi-whi-whi-whi-whi* (Ligon, 1968), *tyew-tyew-tyew-tyew-tyew-tyew* (Edwards, 1972) and *ya-ya-ya-ya-ya-ya* (Davis, 1972). A frequently heard duet by breeding partners consists of "yips, whines and barks like those of a young puppy" (Joe T. Marshall). The structure of the syrinx, the width of the bronchial pipes and the short length of the vibrating membrane (3.1–3.2mm, as against 3.6–3.9mm in the North American Pygmy Owl) account for the high pitch of E flat to E natural of the territorial song (Miller, 1935).

Circadian rhythm The Elf Owl is virtually nocturnal and only exceptionally has daytime activity been recorded; even its territorial song does not seem to start until well after sunset. It passes the day hidden in densely leaved trees or bushes and during the heat of the summer in available woodpecker holes. It largely escapes notice, therefore, particularly in its winter quarters, which have only recently been identified. Peaks of activity by the male feeding the incubating female and the nestlings have been reported to occur shortly after dusk and before dawn (Ligon, 1968).

Antagonistic behaviour The male can be aggressive in defence of a nest, but females, when surprised on their nests, have been reported to go into a state of akinesis, with closed eyes, apparently almost unconscious, if not lifeless (Ligon, 1968). Similar behaviour has been observed in other small owls.

When hiding by day an Elf Owl can assume an erect posture with its plumage pressed against its body, resembling a wooden stump. As in the case of other owls under similar conditions, one wing is drawn forward and the facial disc is narrowed, showing white patterns above the eyes and below the ear coverts which, together with the white lines on the leading edge and over the upper surface of the wing, increase the bird's resemblance to a broken branch (Ligon, 1968:63, fig. 20).

Elf Owl *Micrathene whitneyi*
Nesting hole in saguaro cactus and grasshopper and centipede as prey

ECOLOGICAL HIERARCHY

Being almost a passerine, insectivorous little owl, the Elf Owl does not appear to compete with other owls and diurnal raptors in its arid habitat, except in the fight for nesting holes. Males are smaller than females by an average 7% (38.6g against 41.7g) (Philip M. Walters and Charles E. Cochran and others), but the ecological significance of this difference is not known.

The Elf Owl may share its habitat with the Great Horned Owl, Barn Owl, Burrowing Owl, Western Screech Owl, Whiskered or Barred Screech Owl, Flammulated Owl and Ferruginous Pygmy Owl (Gilman, 1909; Marshall, 1957; James & Hayse, 1963). Thus, Allan R. Phillips describes the fight of an Elf Owl and a Whiskered Owl over a nesting hole in the Madera Canyon of the Santa Rita Mountains in Arizona, but whether or not this is exceptional is not known. Whiskered and particularly Screech Owls are larger than Elf Owls (by about 20% and 55%, respectively) and cannot enter the smaller nesting holes preferred by the Elf Owl. But the higher ranging and more densely feathered, tiny Flammulated Owl may do so. The zone of altitudinal overlap of these owls in the montane pine-oak woodland of northern Mexico is very small, however, and the ranges of the Elf and Flammulated Owls are largely complementary (Marshall, 1957). Predation on the Elf Owl by other owls has not been recorded, but it would be surprising if the Elf Owl did not occasionally fall prey to the ubiquitous Great Horned Owls, if not to a neighbouring, bird-hunting Western Screech Owl. Most remarkably, no predation whatsoever was reported among adults and young from 31 nests studied in Arizona (Ligon, 1968). Competition for food with birds or other animals has not been reported.

Since the Elf Owl, so far as is known, nests exclusively in deserted or otherwise appropriated woodpecker holes, it has to compete with a large number of other hole-nesting birds including the woodpeckers themselves. Potential and actually observed nest site competitors are, apart from those owls mentioned above, the Desert Kestrel, the Coppery-tailed Trogon, the Sulphur-bellied, Wied's Crested, Ash-throated and Olivaceous Flycatchers, the Cactus Wren, the Bridled Titmouse, the White-breasted Nuthatch and several others (Bent, 1938; Ligon, 1968). See Breeding Habitat and Breeding.

BREEDING HABITAT AND BREEDING

The Elf Owl is not restricted to the cactus deserts of Arizona and northern Mexico, but nests equally well in canyon bottoms, patches of open woodland and the live-oak zone, entering the pine-oak belt at its lower altitudes. In deserts and mesquite grasslands it nests exclusively in the nest holes of the Gila Woodpecker and the Gilded Flicker, excavated at 4–10m height in the candelabra-forked stalks of the saguaro cactus. Some of these spiny stalks may be riddled with holes and in the same tree several holes may be simultaneously inhabited by more than one bird species, including the Elf Owl. In Texas the Golden-fronted Woodpecker and the Ladder-backed Woodpecker provide additional nesting holes. In the sycamores, cottonwoods, willows and walnut trees of the shady canyons and in the oaks of the arid mountain slopes the Acorn Woodpecker and the Arizona Woodpecker, in particular, drill nesting holes not only for themselves but subsequently for Elf Owls and numerous other tenants as well.

The Elf Owl is highly territorial and its territory is strictly centred around the nesting hole. Competition for nest sites can be very severe and the Elf Owl has to defend its appropriated home fiercely against conspecifics and other neighbours and intruders. If deserted for some reason, the holes are rapidly reoccupied and in the course of one breeding season occupancy may change more than once (Ligon, 1968).

As a result of the superabundance of insect food in the cactus desert and the arid woodland in summer, territories are small (0.2–0.5ha) (calculated from data supplied by Ligon, 1968) and nests have been reported as close as less than 10m apart (Bent, 1938). As with most other hole-nesting birds the male selects the hole and indulges in intricate and seemingly comic behaviour in an attempt to entice a female to enter the nest hole and familiarize herself with the confined life of incubation one or two weeks before egg-laying (Ligon, 1968).

The number of eggs varies between two and five, being larger in the desert than in shady canyons and in the oak woodland. Loss of eggs and nestlings seems to be very slight and the Elf Owl is therefore a most successful species in its spiny habitat and the commonest owl in south Arizona, if not the most numerous bird species in some deserts. The young remain in their well-protected nest for a considerable period (between 28 and 30 days) and when they do finally leave it they are very competant fliers and are thus, from that moment on, relatively safe. Predation by climbing and otherwise marauding mammals has never been reported. The spiny surface of the saguaro cactus and the confusing multitude of nest holes drilled into the tree trunks of valley bottom trees by Acorn Woodpeckers appear to provide adequate protection.

FOOD AND FEEDING

The Elf Owl's diet consists almost, if not totally, exclusively of insects and other arthropods, including locusts, crickets and grasshoppers (*Tettigoniidae*, *Gryllidae*, *Acrididae*), praying mantids, green lacewings, beetles (*Scarabaeidae*, *Cerambicidae*, *Curculionidae*), sphyngids, large moths, spiders, centipedes and scorpions. On one occasion small reptiles, a lizard (*Sceloporus*) and a blindworm (*Leptotyphlops*) were brought into a nest, but the nestlings rejected them (Ligon, 1968). Small feathers have also been found in nest holes, but there are no actual records of Elf Owls feeding on birds. In captivity Elf Owls have refused to eat birds (Gilman, 1909).

Insects, some of relatively large size and with absurdly long legs in proportion to the owl, are deliberately chased and taken from gorgeously flowering desert plants, such as saguaros, chollas or prickly pears, century plants or agave and *palo verde*; also from mesquite, madrone or laurelwood and other flowering shrubs and trees. The Elf Owl catches insects in flight with its talons, or with its bill in the manner of a flycatcher (Walker, 1943), but the insects are always transported in the bill to the nest. Like Burrowing Owls, Elf Owls have been observed hovering, usually low over the ground (Walker, 1943; Ligon, 1968).

MOVEMENTS AND POPULATION DYNAMICS

Apart from the populations in Baja California and on Socorro Island, the Elf Owl is migratory (Phillips, 1942). The migration routes cover distances of probably up to 1,700–2,000km.

In the Sonoran deserts and elsewhere in northern Mexico and the southern United States the Elf Owl is a summer bird, arriving in March, leaving in September, with extreme dates of 16 January and 13 October in Arizona. Its winter range has long been a mystery (Phillips, 1942) and the recognition of the warm, sheltered Rio Balsas basin in the state of Morelos south of the edge of the Mexican Central Plateau, some 1,700km south of the border of Arizona, as the main wintering area (Ligon, 1968) seems to be only part of the answer (see Ely & Crossin, 1972). During migration it sometimes associates in small flocks and has been reported south to Sinaloa and Michoacan and on the Tres Marias Islands *c.* 100km off the Pacific coast of Nayarit, Mexico (Northern, 1965). Being silent, in winter it merely vanishes from sight. One possibility is that it may cross the Sierra Madre del Sur and enter tropical Central America, from whence, however, there are no records.

In view of its summer breeding season and the extended preliminaries by the female in order to familiarize herself with the narrowness of the nesting hole, there is no time for a second clutch. Nor is there any need for an occasionally large clutch, since the food supply of arthropods is dependable and not subjected to fluctuations as in the case of small rodents. The nesting success therefore appears to be high and the populations relatively stable (Ligon, 1968).

GEOGRAPHIC LIMITS

Like the Burrowing Owl in its subterranean prairie dog warren, the Elf Owl avoids the desert heat during the day by hiding in the shade or remaining in woodpecker holes in giant saguaro cacti, where a much more even microclimate can be enjoyed. Its body temperature of 38.5–40.8°C remains constant at ambient temperatures of 27–30°C, but may vary between 35.4° and 43.6°C when ambient temperatures sink as low as 9°C or rise to 45°C (Ligon, 1968). High temperatures are a prerequisite for a rich arthropod life, but were it not for the fact that even in hot deserts air temperatures may drop to 10–16°C at night, the Elf Owl could probably not survive. In addition, the insulating capacities of the saguaro cactus are considerably higher than those afforded by the wood of deciduous trees in canyons and river bottoms north of the desert. It was nevertheless observed that nestlings huddled deep in the nest cavity, on the shady side of the cactus trunk, and touched the warmer wall exposed to the sun as little as possible (see review by Ligon, 1968).

As the Elf Owl's means of reducing insulation by compressing of body feathers, lifting of wings, panting and gular fluttering are relatively inefficient, the geographic limits of the breeding range are clearly set by the presence of nesting holes inside cool cacti and shady tree trunks and branches. To the north, the presence of other owls and the reduced numbers of large, free-flying nocturnal insects seem to determine further geographic boundaries. Nor is the Elf Owl at home in tropical lowland forests in the south with its more numerous competitors and nest-predators; here a number of species of pygmy owls thrive instead.

LIFE IN MAN'S WORLD

The Elf Owl's arid breeding habitat is an environment hostile to man. As long as this habitat is permitted to remain, either in national parks or undisturbed countryside, the Elf Owl and its

fellow desert denizens will have a considerable chance of survival. It could be endangered, however, by biocide contamination from adjacent cultivation (cotton!) in the Lower Rio Grande Valley in southeast Texas (James & Hayse, 1963). This owl does not seem to shun the presence of man and is often attracted to night-flying insects swarming around electric lights near to its habitat.

Though there are no fossil records to support a theory of the Elf Owl's evolution from a pygmy owl *Glaucidium* stem, there is nothing to counter the notion that the Elf Owl is a passerine-like, insectivorous edition of pygmy owls living in open, arid woodland and cactus desert. The Elf Owl does not need the strong claws, heavy bill and robust structure of skull and jaw musculature which characterize the pygmy owls and which are necessary for killing and tearing apart mammalian prey. Its reduced number of tail feathers is probably in line with its small size and less dense body plumage. Its loud, whimpering song is not unlike that of pygmy owls and differs from the melodious timbre of the songs of screech owls *Otus*. If one looks back in time it seems clear that the Elf Owl's relations with the strong predators that were probably the original, primeval owls must be very distant indeed.

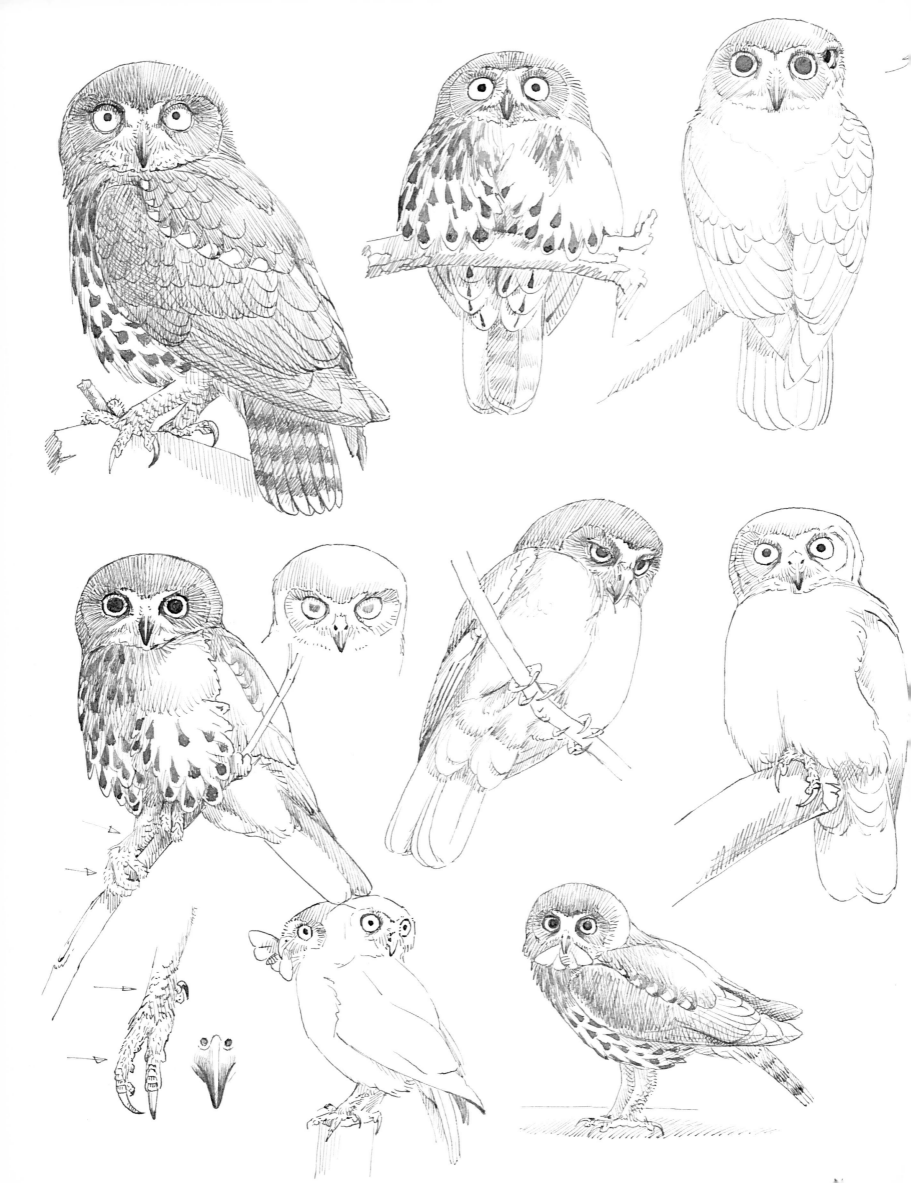

BROWN HAWK OWL

Ninox scutulata

With its relatively small, rounded head, virtual absence of facial disc and long, pointed wings, the Brown Hawk Owl has a greater resemblance to a diurnal bird of prey than any other owl. Sitting upright on its perch, or flighting swiftly over the treetops at dusk, it is said to resemble an *Accipiter* hawk or falcon hunting insects at night, or a nightjar in hawking flight. Its orange-yellow eyes with enormously enlarged pupils can be of an astonishing size and piercing brightness. In its skeletal characteristics it resembles not only the other members of its genus, but also the Northern Hawk Owl *Surnia ulula* (Ford, 1967), which is probably the Brown Hawk Owl's nearest relative in Palaearctic Asia, though one and a half times as heavy.

With an overall length of 28–32cm and a body mass of an estimated 200g, the Brown Hawk Owl is somewhat larger than the Collared Scops Owl *Otus bakkamoena* and more than twice as heavy as the Oriental Scops Owl *Otus sunia* (all three of them being of Indo-Malayan origin and occurring marginally in the Palaearctic). Competition for food during winter shortages in their east Asiatic ranges rarely occurs between these three species since the Brown Hawk Owl is a long-distance migrant, the Oriental Scops Owl a non-compulsory short-distance migrant and the Collared Scops Owl a virtual resident. When there is a superabundance of food in summer, all three have been found in the richly varied lowland forests bordering the Bikin River in Ussuria in the Far Eastern USSR (Pukinsky, 1977). Here the Collared Scops Owl feeds relatively more frequently on mice and other terrestrial prey, the Oriental Scops Owl on arboreal insects and the Brown Hawk Owl on insects flying among and over the treetops.

No less interesting than the question of its ecological relations is that of the Brown Hawk Owl's geographical origin. Either it is a direct descendant from the east Asiatic stock from which all of the 15 other, mainly Papuan–Australian species of *Ninox* have derived, or it immigrated to the Asiatic mainland after a remarkable species diversification of the genus in tropical southeast Asia and Australia. In Australia *Ninox* represents the wood owls *Strix*, scops owls *Otus* and eagle owls *Bubo* of the northern hemisphere. Clearly it is a specialized species with a mode of life highly differentiated from that of other Palaearctic owls of comparable size.

GENERAL

Faunal type Indo-Malayan.

Distribution Indo-Malayan and marginally east Palaearctic. Most of southern Asia, from west Pakistan to Indonesia as far as Borneo, west Java, the Philippines, Andaman and Nicobar Islands, Indo-China, China, Hainan, Taiwan, Japan from Hokkaido southward, Korea, northern China (Heilungkiang) and the Soviet Far East, east of the Ussuri River and west of the Sikhote Alin mountain range, to about 50° north. Map 15.

Climatic zones Tropical rain forest, tropical winter-dry, savannah and temperate climatic zones. The northern boundary reaches towards the July isotherm of 17°C.

Habitat Evergreen and deciduous tropical and subtropical forests, tropical plantations, open woodland, mangroves, gardens with tall trees in villages and towns; along the foothills of the Himalayas up to about 1,000m in Nepal; also up to 1,000m in Japan, 1,200m in Thailand and Sumatra, even at 1,300–1,800m

Brown Hawk Owl *Ninox scutulata*

in Sri Lanka. Mixed, deciduous woods and clumps of trees in cultivated lowlands and temple gardens in China and Japan, often with tall, shady *Cryptomeria*; old, mixed riverine woods in Ussuriland, often with oak, lime, Siberian pine and silver fir (Panov, 1973), but not in boreal spruce forest.

GEOGRAPHY

Geographical variation Quite conspicuous in colour and size. Up to 9 (Peters, 4, 1940), 11 (Vaurie, 1965) or 12 (Ecke & Busse, 1973) geographical races have been recognized. The pattern of the variation itself is clear, but the use of subspecific names for it has given rise to confusion, a confusion which began with the question of whether Sir Thomas Stamford Raffles's type specimen of *Ninox scutulata* (1822) from southern Sumatra at approximately 4° south was an indigenous breeding bird or a wintering specimen from the far north. I follow those authors (see Mees, 1970) who assign the name *scutulata* to a tropical, insular form. Geographical variation relates to degree of grey, brown or rufous colorations, darker or lighter colours on the head, whitish or more saturated colours on the underparts, and overall size. The largest birds by at least 20% are from

Ussuria (wing 222–245mm), the smallest from Java (wing 178–183mm) (Hoogerwerf, 1946) and Borneo (*Ninox scutulata javanensis* and *N. s. borneensis*). The darkest forms are from Java and the Andaman and Nicobar Islands (the latter *N. s. obscura* and *N. s. isolata*), the palest from north Japan and Ussuria (*N. s. japonica* and *N. s. ussuriensis*, though this differentiation is uncertain).

Related species Apart from a smaller and darker species *Ninox affinis* living alongside the Brown Hawk Owl on the Andaman and Nicobar Islands, the Brown Hawk Owl is the only representative of its genus in the Indo-Malayan and Palaearctic regions. Another 15 species occur in the Papuan and Australian areas and in Madagascar, where they exhibit a remarkable differentiation in size, structure and ecology. The widespread Boobook Owl or "More-pork" *Ninox novaeseelandiae* is a genuine geographical vicariant of the Brown Hawk Owl, occurring from the island of Sumba in southeastern Indonesia to Tasmania and New Zealand, but its head is too thick and rounded, its wing too pointed at the tip and its life style too *Strix*-like for it to be a member of a superspecies including itself and the Brown Hawk Owl.

STRUCTURE

The Brown Hawk Owl shares relatively uncomplicated ear openings (small, rounded, symmetrical in shape and position) with species of the genera *Surnia*, *Glaucidium*, *Scops* and *Bubo*. The ear opening is about the size of the diameter of the eyelids (Pycraft, 1898). The shape of the skull and the nasal fossa are the same as in the scops owls *Otus*, but the interorbital septum and the jugal bones are somewhat different. On the basis of detailed osteological studies, a subfamily Surniinae has been proposed, including the genera *Surnia* (Northern Hawk Owl), *Ninox*, *Uroglaux* (one species in New Guinea) and *Sceloglaux* (one species in New Zealand) (Ford, 1967).

The Brown Hawk Owl's other structural characteristics are the smallness of its facial disc, the elongated, stiff feathers surrounding the base of the bill, the thinly feathered legs, sparse, strong bristles covering the toes and bristles and horny spicules on the underside of the toes, the latter facilitating the owl's grip on the hard chitinous plates of large insect prey. Nestlings in the Soviet Far East had not yet grown bristles on their toes, but the latter were covered with soft feathers down to the claws (Pukinsky, 1976).

BEHAVIOURAL CHARACTERISTICS

Songs and calls The territorial call is a soft, mellow disyllabic whistle, the second note, in southern Asia, being uttered in a higher pitch and the complete song described as *koo-lick*. Between 6 and 20 calls, with a duration of a second each, form a structural series which is followed by a break of a few seconds before the next series of calls. In northern populations the call is more monotonous and described as *hoo-hoo* or *coo-coo*. Calling may last for several hours and male and female probably perform duets. Other, less musical, calls have been described. The whole range of vocalizations is not dissimilar to that of the Northern Hawk Owl and resembles the pattern of songs and calls of the Old World scops owl species.

Circadian rhythm Despite its resemblance to a diurnal bird of prey, the Brown Hawk Owl is mainly nocturnal in its habits. During the day it may be found hiding in a shady treetop. In its winter home in northern Sulawesi (Celebes) the German explorer Gerd Heinrich found one sleeping in a tree hole during the day (Stresemann, 1941:82). Two activity peaks have been reported during the owl's summer stay in Ussuriland: one immediately after sunset, lasting a couple of hours, and one before sunrise, lasting till an hour after. Shortly after midnight the owl is said to rest for 2–3 hours (Pukinsky, 1976). In the long northern twilight it has been observed hawking over the darkening treetops like a nightjar. During migration through east Asia it often seems to be active and to hunt by day.

Antagonistic behaviour No data.

ECOLOGICAL HIERARCHY

The Brown Hawk Owl shares its habitat with numerous other owls, some of similar size or smaller, most larger than itself: for example, the Collared Scops Owl (10–25% smaller than the Brown Hawk Owl) and the Brown Wood Owl (50% larger than the Brown Hawk Owl). When food is abundant in summer in the southern Soviet Far East, serious interspecific competition with the Collared Scops Owl and the Oriental Scops Owl seems unlikely (Pukinsky, 1976). Near Vladivostok a Brown Hawk Owl nest was found in the same tree hole in which a Collared Scops Owl had been nesting the previous year (Panov, 1973). A Brown Hawk Owl is also reported to have incubated two of its own eggs in a tree hole, together with one egg belonging to an Indian Roller (Baker, 3, 1934:535). The Roller, whose remains were found under the tree, may have been evicted by the owl.

Size differences between male and female Brown Hawk Owl are slight, or non-existent, and no differences between the sexes in average diet or hunting methods have been reported. Competition between individuals of different size may occur in the tropics where the larger northern owls winter alongside their resident smaller conspecifics. In Malaya and Sumatra, where northern winter birds seem to outnumber the indigenous Brown Hawk Owls, the northern birds are 10–15% larger. However, a superabundance of food may obviate competition. In Sulawesi (Celebes) wintering Brown Hawk Owls are 40% larger than the indigenous Speckled Hawk Owl and in the Philippines at least 35% larger than *Ninox philippensis*.

BREEDING HABITAT AND BREEDING

Eggs have been found in tree holes, usually high above the ground in the forest (in Ussuria, 10–14m; Knystautas & Sibnev, 1987); the only tree species recorded as having been used for this purpose in the tropics are mango and durian. The owl has been reported to nest in a pile of wood and among ornamental garden stones in Japan (Jahn, 1942). Clutch size is relatively small, being 3–4 in south Asia and 3–5 in Japan. Eggs in continental south Asia measure on average 35.1×29.5mm (Baker, 3, 1934), which is 17% larger than those of the Collared Scops Owl

Brown Hawk Owl *Ninox scutulata*
Tropical race *N. s. javanensis* from Java, Indonesia (above)
Northern island race *N. s. totogo* from Taiwan (below)

and 10% smaller than those of the Cuckoo Owlet. Eggs from Ussuriland (41.5 × 30.7mm; Panov, 1973) and Japan (37 × 31mm; Jahn, 1942) are 28% and 16% larger on average than those from tropical Asia and are approximately equal in size to Northern Hawk Owl eggs (40.0 × 31.4mm; Makatsch, 1976). Fledglings bearing the fluffy remains of their downy feathers and sitting in the branches outside the nest look even more like white-breasted *Accipiter* hawks than do young Northern Hawk Owls (Knystautas *et al.*, 1982:figs. 325, 326).

FOOD AND FEEDING HABITS

The Brown Hawk Owl usually hunts like a diurnal bird of prey, darting over and through the treetops, but it can also resemble a flycatcher sitting night after night on an exposed perch and making sallies to catch a passing insect. Its diet is very varied, principally comprising night-flying insects, including large beetles such as carabids, water beetles, buprestids, darkling or ground beetles, dorbeetles and rhinoceros beetles, cockroaches, cicadas, large and small moths (including lackeys and eggars), butterflies and dragonflies; also caterpillars, such as the pine caterpillar *Dendrolimus punctatus*. Nine tenths of the food brought to nestlings in the Soviet Far East consisted of insects, mainly large moths. Additional important prey include bats, caught with great dexterity while in flight, small tropical arboreal lizards, frogs, terrestrial rodents, flying squirrels and small songbirds of the woods. Birds brought to nestlings were usually decapitated and fairly well plucked (Pukinsky, 1976, 1977).

MOVEMENTS

The Brown Hawk Owl is resident in the greater part of its range, but the northern populations, from the Soviet Far East, northern China and Japan, winter in the tropics as far south as Sumatra, Java, Borneo, the Philippines, Sulawesi (Celebes), the Moluccas (Buru) and the Lesser Sunda Islands (Flores, Wetar), covering distances of 6,000km or more on each flight. During migration they have appeared on most of the small islands south of the main islands of Japan, on rocks and lighthouses in the Straits of Malacca and on islands in the Indian Ocean off the west coast of Sumatra (17 Feb. 1981, Siberut, Mentawai Islands; 3 Dec. 1963, Mega Island). One was caught on board a ship 780km east of Honshu in the north Pacific Ocean, probably driven eastward by a strong gale (Nakamura, 1975). Some birds may stay throughout the winter in South Korea and Japan (Austin & Kuroda, 1953), but on the whole they are known there as summer birds, arriving in Honshu by late April and in Hokkaido by early May. In the Soviet Far East they stay from mid-May to September or October, exceptionally as late as 5 November (1912) (Panov, 1973).

GEOGRAPHIC LIMITS

The owl's geographic limits appear to be defined as much by climate and vegetation as by the presence of other owl species. The Brown Hawk Owl does not enter boreal coniferous forests and does not overlap therefore with the fierce Northern Hawk Owl. For an owl depending mainly on large flying insects the breeding season in boreal forests is too short and the food supply too limited in comparison with deciduous woodlands further south. Beyond the zoogeographical dividing line of Wallace in east-central Indonesia, other members of the genus *Ninox*, some of similar size to the Brown Hawk Owl, some smaller, some larger, make their appearance and probably restrict the Brown Hawk Owl's range in these islands.

LIFE IN MAN'S WORLD

Throughout its range in tropical continental Asia the Brown Hawk Owl often occurs in plantations and gardens and frequently enters villages and towns to breed. It nests in wooded city parks and temple groves in Japan (Jahn, 1942) and China and is known to accept nest boxes in Japan. It is successful and numerous in east Asia, but considerably less common in the tropics where other owls are more plentiful and varied.

No Brown Hawk Owl fossils are known to exist, nor is there any indication that the owl has ever occurred much further westward in the Palaearctic than at present. Its genus, with its greatest species diversity in the Papuan–Australian region, must have had a long and eventful history since, together with a few other oriental elements, it occurs within the confines of the Indian Ocean as far west as Madagascar (Madagascar Hawk Owl *Ninox superciliaris*, Lesser Cuckoo *Cuculus poliocephalus*, Magpie Robin *Copsychus albospecularis*, Black Bulbul *Hypsipetes madagascariensis*).

Whereas in Australia the genus *Ninox* has representatives resembling members of the wood owls *Strix*, scops owls *Otus* and eagle owls *Bubo*, the marginally Palaearctic Brown Hawk Owl has the characteristics of a diurnal bird of prey. With its enormous eyes and uncomplicated ears, it seems primarily to hunt by means of vision. Its range is complementary to that of the larger, mainly day-hunting Northern Hawk Owl *Surnia ulula* and the equally northern, but strictly nocturnal, Tengmalm's Owl *Aegolius funereus*. The Brown Hawk Owl probably never meets these species, though in the Soviet Far East their ranges may be separated by less than a few hundred kilometres. The breeding behaviour and feeding ecology of the Brown Hawk Owl, scops owls *Otus* and pygmy owls *Glaucidium* in east Asia would repay comparative study.

LITTLE OWL
Athene noctua

In spite of its name the Little Owl is not the smallest species of owl in Europe nor anywhere within its range in the Old World. Though it is at least 12 times lighter than the Eurasian Eagle Owl, it is twice the weight of the Scops Owl and three times that of the Pygmy Owl. The Barn Owl is on average almost twice as heavy again (180–205%) and the Long-eared Owl hardly less than this (165–185%). The Little Owl *is* a small owl, but it is nevertheless a strong bird, capable of taking surprisingly large prey. Its compact structure and general behaviour reflect a semi-terrestrial life and origin. It shuns dense woods and forests, and may have found its way into central and western Europe only after the destruction of the mature lowland forests during the agricultural revolution in the Middle Ages. This fact and its small size and strictly sedentary habits determine the Little Owl's relationship to its habitat, its food and its competitors and predators among other owls and diurnal birds of prey. These relationships, and the geographic and systematic origin of Little Owls, form the subject matter of the following account.

GENERAL

Faunal type Turkestanian–Mediterranean.

Distribution Trans-Palaearctic, from the Atlantic to the Pacific Ocean, with isolated populations in the central Saharan mountains and oases of the Ahaggar, Aïr and Tibesti, and with a limited extension in the arid northeastern part of the Afrotropical region. In Europe north to Denmark and the Baltic countries, south to virtually all islands in the Mediterranean Sea. Common in southern and central Europe, though its population is markedly decreasing at present in central Europe. It has spread throughout England and Wales to Scotland, after several attempts at introduction in the late nineteenth century, the ultimate and only successful ones being in the years 1880–1890 (Witherby *et al.*, 2, 1938; Sharrock, 1976). Map 16.

Climatic zones Mediterranean, steppe and desert; also widely in the temperate and marginally in the boreal zone. Distribution limits approach the July isotherm of 17°C in the north and 37°C in the south.

Habitat Open country, steppes and semi-deserts, oases in sand deserts, macchia, parklands, cattle pastures, vineyards, orchards and other cultivated land with grasslands and scattered trees, mostly in sunny and arid conditions and often near human habitation.

In Europe the Little Owl is a lowland species, rarely nesting in the Swiss and Austrian Alps above 600m (Glutz, 1962:319; Juillard, 1980), but once as high as 980m in East Tyrol (Scherzinger, 1981). In wide mountain valleys in the Caucasus and central Asia it ascends to heights of between 2,000 and 3,000m and on the east Tibetan highland plains it lives as high as 4,600m (Schäfer, 1938).

GEOGRAPHY

Geographical variation Conspicuous in depth of coloration; less marked in body size. Paler in hot, arid regions; darkest, with extensive dark barring of feathers, in humid temperate regions, especially the Atlantic mountain slopes of northwestern Spain (*A. n. vidalii*) (Harrison, 1957), and in bogs in central Asian highland plains (*A. n. ludlowi*). Variation gradual, probably mostly clinal; average wing length between 139 and 183mm (Vaurie, 1960). The distinction of geographical races is difficult and between 12 (Vaurie, 1960, 1965) and 17 (Peters, 4, 1940) are recognized, 7 in the West Palaearctic (Roselaar, in Cramp, 4, 1985), 3 in Asia and 2 in Africa. The latter, occurring in the most arid regions and rocky plains of coastal Sudan (*A. n. spilogaster*) and Ethiopia and Somalia bordering the Red Sea (*A. n. somaliensis*), are almost dwarfish races (wing length 76% of large Asiatic races) with thinly bristled, elegant legs and pale desert colorations.

Related species The Spotted Little Owl represents a pale, tropical Asian extension of the Little Owl's range and the two species may form a superspecies. The Burrowing Owl is its closest relation in America. Closest relatives among other owls seem to be the hawk owls of the genus *Ninox* which, in an extensive area of southeast Asia and Australasia, have developed a remarkably wide range of ecological radiation (16–18 species), though none is as terrestrial as the Little Owl. Only in northwest India, north China and Korea do the ranges of *Ninox* and *Athene* marginally overlap, and even there the habitats are very different.

STRUCTURE, HEARING AND VISION

The Little Owl is a species of owl *sui generis*, quite different from the long-winged, silently sailing Barn Owl and Long-eared Owl

with which it often shares its range, flying, rather, in woodpecker-like bounding flight. When hunting it sometimes moves on floating wings, but its flight is less silent than that of other owls. At times the Little Owl is as clamorous as the Tawny Owl and occurs as close to human habitation. It is among the least specialized of owls, having small, almost circular and uncomplicated external ear openings (Pycraft, 1898), while the outer ear tubes do not have spacious cavities. The number of auditory nerve cells, which are supposed to transmit acoustic information through the *medulla oblongata* at the back of the brain, is comparable to that found in diurnal birds of similar body size (e.g. Jay), being 11,200 on each side, as against 47,600 in the much more sensitive Barn Owl (Schwartzkopff, 1963). The hearing capacity of the Little Owl is not significantly different therefore from that of diurnal birds.

As for its visual acuity, there do not seem to be conspicuous differences between the histology of the retina of the Little Owl and that of diurnal birds and it lacks the horizontal ramifications of the axonic terminals (nerve cells) for covering large areas of the retina as in other owls (Gallego *et al.*, 1975). Colour vision, of no use in nocturnal life, seems to be as good as in the Song Thrush, as is the owl's sensitivity to light intensities (Meyknecht, 1941).

The Little Owl's anatomy is well suited to its terrestrial habits. It has a compact body shape, adaptive coloration and long legs. The Barn Owl is the only species within the Little Owl's range whose legs are longer, in relation both to body size (4.8 times the length of the breastbone, as against 4.4 times in the Little Owl and 4.3 times in the Long-eared Owl) and to the length of the femur (88% of the length of the tarsus, as against 111% in the Little Owl and other owl species; Winde, 1970).

BEHAVIOURAL CHARACTERISTICS

Songs and calls At least eight types of calls have been described; they all carry well and resound over plains and valleys. The territorial song of the male is a fluid *hoo-ee*. It can gradually merge into a friendly *gook*; this may also be a primary call, but is more probably a contact call between male and female (Exo, 1984). Eventually these calls may be followed by a loud chattering when territorial claims can no longer be proclaimed by singing but are reinforced with aggression. Frequently the *gook* call suddenly turns into an emotional, almost yelping and far-ringing, angry *wherrow* or *wee-ow* when the birds are disturbed either by day or at night. Lesser alarm is indicated by a questioning *kee-oo*, whereas the start of any activity may be announced by a commanding *koo-wit*, which in Middle European languages is rendered as *kum-mit* or *kom-met*, meaning "follow me" (to disaster or death, according to legend). During courtship and copulation many soft and loud calls merge into each other. Other calls can be described as barking, laughing, chattering, rattling, trilling and snorting. Fierce cries uttered in or on top of human dwellings, as much as in isolated places, have reinforced superstitious dislike of this little owl. The subspecies of Little Owl from the desert regions of Sinai and the arid Middle East has been named *Athene noctua lilith* (Hartert, 1913) after the age-old desert demon Lilith, now usually associated with Hume's Tawny Owl. Calls by young begging for food are also weird and described as a harsh, snorting *schree*.

Circadian rhythm The Little Owl is crepuscular and partly diurnal. Indeed, where it occurs it is the owl most frequently seen by day as it seems to delight in sunbathing, not only in temperate regions with their cold weather and chilly rains, but also in hotter countries in the south of its range. It is most active from shortly before to a few hours after sunset, and again late in the second half of the night towards sunrise (Exo & Hennes, 1978). When it has young to feed it may hunt at any time of day.

Antagonistic behaviour Raising itself up on its feet, bobbing and moving its head up, down and sideways are activities particularly suited to terrestrial conditions where distances to prey and potential dangers must be estimated in a horizontal rather than in a vertical or oblique plane, and mostly at ground level. This means that the bird can look over low ground vegetation or rocks and boulders by raising itself as high as possible, then crouching down to hide. Little Owls perform the same sort of antics on top of a pole or fence post, barn or farmhouse roof. By raising up its body the Little Owl may also have found a suitable means of avoiding the heat of sun-scorched desert soil or rock. In its threatening posture the Little Owl is exceptional in that it raises itself up to present the underside of its half-spread wings (Scherzinger, 1971).

ECOLOGICAL HIERARCHY

Body weight, which is one measure of predation strength, varies between about 115–200g in males and 140–215g in females in central Europe and somewhat smaller amounts in southern Europe. Greatest average weights in females have been reported after favourable winter seasons just before the breeding season (*c.* 220g, January–April); smallest average weights are found towards the end of, or after, the breeding season (*c.* 160g, June–August). Males are 8–20% (average 10.6%) lighter than females (calculated from various sources). Wing length of males is 97%, tail 98%, bill 99%, tarsus 93% of that of females, but differences between the sexes in food and feeding have not been recorded. The total length of claws, another measure of the strength of predation, reaches 44mm in one foot, being slightly less than that found in the Barn Owl and about the same as that of the Kestrel. The Little Owl lives and hunts in the same open places as the Barn Owl, Kestrel and Lesser Kestrel and may take as large or occasionally even larger prey.

At forest edges it has frequently fallen victim to the Goshawk by day and to the Tawny Owl by night, and, throughout its range, to the Eagle Owl. The number of recorded instances of larger owls eating Little Owls is impressive: Eagle Owl 40, Tawny Owl 23, Barn Owl 7, Long-eared Owl 2 (Mikkola, 1983). In central and western Europe Little Owls tend to avoid Tawny Owls and are disappearing where these owls are increasing in numbers (Koning, 1982; Schönn, 1986). The list of diurnal birds of prey taking Little Owls includes at least 9 species, from Steppe Eagles and Booted Eagles to Peregrine, Lanner and Sparrowhawk; the Goshawk with 32 out of 48 cases is prominent (Mikkola, 1983).

Little Owl *Athene noctua*
Syrian desert race *A. n. lilith* (above)
West European race *A. n. vidalii* with earthworm as prey (below)

Little Owls are nevertheless known to have nested in the same tree as Barn Owls and Kestrels, as well as, in the Netherlands, one with Green Woodpeckers; in the latter case one of the owls eventually raided the woodpecker's nest and took its young. In spite of its small size the Little Owl is reported to have eaten a freshly killed immature Sparrowhawk (Glue & Scott, 1980) and to have taken young Kestrels from their nests (Meinertzhagen, 1959).

BREEDING HABITAT AND BREEDING

In most of the leading textbooks descriptions of the Little Owl's habitat refer to central and western Europe, a small and probably rather recent part of the species' range. Thus, the habitat in Britain is described as "more or less open, especially agricultural, country, where hedgerow or other old timber, pollard willows, orchards, or farm out-buildings provide breeding-sites" (Witherby et al., 2, 1938:322). In a German handbook it is said to comprise "open, tree-covered lands, preferably with fruit trees and gardens, parks, copses, churchyards, often in villages and towns, pollard willows and stately avenues" (Niethammer, 2, 1938:102, translated). The Little Owl was found in Britain in 74% of cases on farmland, in 12% in woodland and in 10% in gardens and close to or in human habitation (Glue & Scott, 1980). The same kind of habitat, including cattle pastures in hilly country, is described from East Germany (Schönn, 1986). However, these descriptions do not cover the main parts of the Little Owl's range and the more widely inhabited, warm and arid habitats of rocky, semi-desert regions and steppes should be added.

Territory size is often remarkably small and in optimal habitats the pairs live in loose colonies. In central Europe the hunting territory may be as small as 0.5km² and the nests may be less than 100m apart (Mebs 1980; Schönn, 1986).

Nest sites are holes and crevices in rocks and earthen walls, among heaps of stones, often on roadsides, in recesses in stone houses, barns, mills, garden walls, ruins, gates and poles, in deep wells in desert areas, in holes and tunnels of terrestrial mammals such as foxes, badgers, steppe-polecats (Grote, 1940), rabbits, susliks and other ground squirrels, jerboas and other rodents of steppe and desert, abandoned nests of rock-nuthatches, bee-eaters and rollers, even in holes dug by land tortoises and holes used by desert cobras *Walterinnesia* and other snakes; in temperate Europe most frequently in holes in trees, particularly pollard willows, oaks, ash and old, gnarled fruit trees; also in deserted nest holes belonging to Green and Great Spotted Woodpeckers and in holes originally used by Stock Doves, Jackdaws and others; in northeast Africa often in termite hills. Of 316 nests recorded in East Germany, 54% were in trees, 28% in buildings and the balance in various other places (Schönn, 1986). Recently the owls have also accepted special nest boxes.

Clutch size is relatively small and fairly constant, usually 4–5, on average in Britain 3.6, in France 4.0, in Germany 4.2 (Cramp, 4, 1985). Eggs are relatively large, in central Europe on average 33.7 × 29.1mm (Makatsch, 1976), and heavier than those of the Scops Owl and the Pygmy Owl by 20% and 84%, respectively, and smaller than those of the Barn Owl by almost 30%. In contrast to most other owls, young hatch almost simultaneously (Scherzinger, 1971). The first down is short, dense, white or greyish; the second plumage (*mesoptile*) is feather-like, less downy and softer than in wood owls *Strix* and *Asio*. Young leave the nest at the late date of 30–35 days. They are cared for by the adults for another month or so (Scherzinger, 1971; Juillard, 1979).

FOOD AND FEEDING HABITS

In central Europe most food items are insects and other arthropods, mainly carabid, cetoniid, scarabaeid (dung and dor beetles and chafers) and staphilinid beetles of 2–5mm and more, earwigs (sometimes in large numbers), grasshoppers, locusts, mole crickets, even large numbers of ants. However, in terms of weight (biomass), small mammals, particularly microtine voles – common vole in central Europe, Savi's pine vole in Italy (Lovari, 1974; Zerunian et al., 1982) – and murine mice – house mouse and long-tailed field mouse – sometimes form a substantial part of the Little Owl's food, though they may account for as little as 10% of biomass and 1.5% of numbers (Netherlands; Valentijn, 1984). Numerous authors have reported on feeding remains and pellet contents under various conditions (Uttendörfer, 1939, 1952; Glue, 1972; Glutz & Bauer, 9, 1980; Cramp, 4, 1985). The owl's diet is said to comprise at least 15 species of mammal, including shrews, moles and young rabbits, 60 species of bird, lizards, slow worms, frogs and toads, numerous groups of insect, spiders, scorpions (Vachon, 1954), millipedes, slugs and snails – large helicid *Theba pisana* in tree nursery in Israel (Mienis, 1971) – and earthworms. It may even eat berries and other fruits, corn and green plants (Thiollay, 1968).

Though mainly insectivorous in its warm, southern haunts, the Little Owl is a formidable predator when necessary and no less powerful than Barn Owls and Long-eared Owls with which it may share its hunting grounds. The mean weight of its vertebrate prey in Spain was calculated at 32.1g, as against 23.6g in the Barn Owl, being 21% and 8%, respectively, of the owl's body weight (Jakšić, 1983). It is capable of handling larger and far more dangerous prey than are either the Long-eared or Tengmalm's Owl. It is, however, less dependent on voles and mice as staple food than the large owls are and Little Owls do not therefore follow the well-known and dramatic population fluctuations of rodents. Like the Tawny Owl it easily shifts to other prey, mainly birds, but also shrews. Starlings and Skylarks rank first among bird prey recorded, indicating that the Little Owl's main hunting excursions are in open grasslands. Other frequently caught birds include House Sparrow, Blackbird and Song Thrush. The Little Owl also raids the nests of songbirds, and at least once it is known to have raided all the Barn Swallow nests in a farmyard stable in Croatia, Yugoslavia, eating both adults and young (Ingolffy, 1949). The largest prey items seem to be taken in temperate climates, particularly when the owls are feeding young in early summer or if they are starving in winter. It is during long and snowy winters that Little Owls in Europe have been known to take to preying on domestic pigeons in their lofts, on other birds larger than themselves and on the formidable adult brown rats. Unexpectedly large prey also include young Jay, Cuckoo, Woodpigeon, Lapwing, Moorhen (Glue, 1972; Glue & Scott, 1980), Common Tern (4 adult

Little Owl *Athene noctua*
Pale Syrian desert race *A. n. lilith* and dark West European race *A. n. vidalii*

terns, together with one almost full-grown Black-tailed Godwit, found in a nest box with 4 Little Owl chicks in the Netherlands; Buker *et al.*, 1984) and almost full-grown rabbit. More exceptional, but clearly showing the species' adaptability, is the case of a pair of Little Owls preying largely on Storm Petrels on Skokholm Island (Lockley, 1938). They have also specialized on young gulls and terns (Sharrock, 1976).

The majority of prey is taken from the ground, usually by surprise, from slightly elevated lookout posts; but prey is also located after short bouts of inelegant and sometimes laborious hovering, when the evening light is fading (Brouwer, 1938). The fact that hovering is performed only a few metres from the ground does not detract from the apparent success of this frequently used hunting technique. Little Owls also take their prey by running over flat terrain, and they can extract earthworms from grassland in the manner of thrushes as often at dusk and dawn as in bright daylight (Tricot, 1968; Baumgart, 1980).

MOVEMENTS AND MORTALITY

As a rule Little Owls remain in their breeding ranges for life. Even post-juvenile dispersion is limited to a maximum of a few kilometres. When the cold is extreme or the snow cover heavy they are more likely to starve to death than to move. Their resistance to hunger in winter, measured as the relation between minimal starvation weight and net weight (without body fat), is comparable to that of the Barn Owl and much less than that of the Long-eared and Tawny Owls (see Glutz & Bauer, 9, 1980:240). Nevertheless, the greatest average mortality in Britain seems to occur in July–August, immediately following the breeding season, whereas in the similarly cold-sensitive Barn Owl January–April is the period of heaviest mortality. Mortality due to human causes is relatively high in Europe and pine martens and other mustelid predators are known to have raided Little Owl nests (Schönn, 1986), though not to the extent suffered by Tengmalm's Owl.

Dispersion of whatever kind rarely exceeds a few hundred kilometres and the birds do not appear at well-known concentration points of migration. On the Col de Bretolet, a focal point of migration in the southwest Swiss Alps at 1,923m above sea level, Little Owls have been recorded twice; but there have been numerous cases of most other European owls moving over this pass to lowland France. From the island of Malta, where until recently no unfamiliar bird could pass unnoticed without being shot, only three or four Little Owls are known from the period 1850–1970, having occurred at intervals of 40, 60 and 13 years (Bannerman & Vella-Gaffiero, 1976).

Longevity in Little Owls, once they have passed the vulnerable first-year period, is relatively high and has reached 9½ years in birds ringed in Switzerland (Glutz & Bauer, 9, 1980) and 17 years in Denmark (Rosendahl, 1973).

GEOGRAPHIC LIMITS

Winter conditions set a clear limit to the Little Owl's northern range. To the south, warm steppes and deserts are uninhabitable only when animal life has become too scarce to sustain a family of Little Owls, and this is rarely the case. Like other animals in steppes and deserts Little Owls hide by day to escape the heat; they must therefore compete with ground squirrels, other rodents and small mammalian predators for underground burrows by day and for prey at dusk and at night. Although the Little Owl's steppe habitat is comparable to that of its American counterpart, the Burrowing Owl, no mention has been made of any form of symbiosis between Little Owls and burrowing animals. On the Tibetan highland steppes underground cities excavated by the steppe marmot *Arctomys himalayensis* provide the only nesting places of Little Owls above 4,100m, and where these animals are absent there is no place (and probably no food) for Little Owls either (Schäfer, 1938).

LIFE IN MAN'S WORLD

Although the Little Owl has benefited from the cultivation of large areas of temperate Europe, considerable numbers of these owls have been destroyed by man's actions. Chemical pollution is a major threat (Fuchs & Thissen, 1981). Road casualties and collisions with trains accounted for at least 22% of known mortality cases in Britain, with 3% due to collision with overhead wires and 5% due to shooting or trapping (Glue, 1971).

Thanks to its sudden cries and blood-curdling screams the Little Owl has always evoked superstition and fear throughout its range and, even more than the Tawny Owl, it has come to be known in central Europe as the "bird of death" (Runte, 1951; Haller, 1951). Known in Russia as "Domestic Owlet" because of the close association of its nesting sites with man, it has been persecuted by the peoples of central Asia no less than in Europe (Grote, 1940). The Little Owl's introduction into Britain has often aroused strong feelings. As late as 1938 a renowned nature publicist professed thoroughly to dislike the Little Owl, considering it "an undesirable alien . . ., quite apart from its destructiveness to small birds" (Pycraft, 1938).

Fortunately, man has been involved more recently in helping Little Owls to survive the severe months of the European winter by providing shelter and food in open barns and secluded lofts, and by offering the owls artificial hiding and nesting places (the latter all the more necessary after the felling of tall fruit trees and their replacement by low-stem breeds). The most promising wooden nest boxes have been designed in Switzerland (Schwarzenberg, 1970, 1984; Juillard, 1980). They consist of a pipe 80–100cm long, hung parallel to a horizontal branch of a low tree and ending in a spacious nesting chamber, specially protected from martens and other climbing predators. Where these boxes have been provided in ample numbers, as in west Switzerland and particularly around Friedrichshafen, south Germany (Knötzsch, 1978), all or virtually all of the local Little Owls have left their natural cavities and re-established themselves in these artificial homes, to a density of six inhabited boxes per square kilometre, as little as 120m apart. With the help of 75 of the Schwarzenberg nest boxes a community of Little Owls had increased from 4 pairs in 1972 to 20 pairs in 1977, marking a great success story (Knötzsch, 1978; see also Schwab, 1972; Ullrich, 1973, 1980; Mebs, 1980). Nest boxes are accepted even when of simple design and erected on poles in treeless grasslands in the Netherlands (Fuchs, 1982, 1983). Some authors have suggested that in order to help Little Owls nest boxes for the ubiquitous Tawny Owl should no longer be provided in places where Little Owls also occur (Schönn, 1980). This is one of the delicate cases of bird conservation measures whereby one species is deliberately favoured over another.

The Little Owl's life recalls that of the long-legged, strictly terrestrial Burrowing Owl *Athene cunicularia* of the American plains. Adaptations to a terrestrial locomotion were more prominent in a Middle Pleistocene form of Little Owl described by Cécile Mourer-Chauviré (1975) as *Athene noctua lunellensis*. This extinct form lived in southern France together with mediterranean species like Bonelli's Eagle *Hieraaetus fasciatus*, Lesser Kestrel *Falco naumanni* and rock partridges *Alectoris*. It was at least 4% larger than recent Little Owls and seems to have had longer legs. Especially long legs, in both absolute and relative terms, were a feature of the equally extinct *Athene cretensis* described from Pleistocene cave deposits on Crete (Weesie, 1982, 1987). In this species the sum of the wing bones was on average 5.6% larger and that of the leg bones 13.8% larger than in recent Little Owls, which still occur on Crete at present. Tarsal length was 18% larger than in recent Little Owls and only 7% smaller than in Burrowing Owls from North America. The terrestrial life of *Athene cretensis* probably came to an end after the rich mammalian fauna of the Pleistocene had been exterminated by the cold of the extending northern glaciations and the simultaneous reduction of landmasses in the area of the Aegean Sea.

The Little Owl's relatively small size determines the species' relation to other, diurnal as well as nocturnal predators; but its robust body and fierce temperament make it less vulnerable than it might otherwise seem. By being a late breeder the Little Owl avoids too close interspecific contact with its most dangerous competitor and predator, the Tawny Owl *Strix aluco*. Its relations with this species and with the Barn Owl *Tyto alba*, and the differences in their visual and acoustic capabilities, still require detailed study. Since the Little Owl is not as strongly dependent on voles and other terrestrial rodents, its populations do not fluctuate as dramatically as in Long-eared and Short-eared Owls *Asio otus* and *A. flammeus* and the young do not need to hatch asynchronously in order to ensure the greatest possible breeding success, under favourable as well as adverse conditions.

SPOTTED OWLET
Athene brama

The Spotted Owlet is the south Asian representative of the Little Owl *Athene noctua*. The differences between this owl and the Palaearctic Little Owl are slight and relate primarily to colour, colour pattern, vocalizations and breeding and feeding behaviour. On the evidence of specimens collected (Vaurie, 1965), the Spotted Owlet and the Little Owl are thought to occur sympatrically in Pakistan and south Iran, from Baluchistan through Luristan to Khuzistan and the southern Zagros range at the head of the Persian Gulf. The area of overlap, however, estimated at 3% of the Little Owl's range and 10–15% of the Spotted Owlet's range, is located in an ornithologically little-known region of the continent and one which, for political reasons, is practically inaccessible for field studies at the present time. Remarkably small Little Owl specimens collected in the Zagros range (Paludan, 1938:626; Vaurie,1960:9) may indicate some degree of interbreeding. The desert populations of Little Owl in northeast Africa (wing 129–147mm) are even smaller than the smallest Spotted Owlets from south India (wing 140–150mm), but Spotted Owlets never match the Little Owl in its larger forms. Whether or not it actually represents a separate species, the Spotted Owlet seems to have its origin in arid tropical south Asia, whence the Palaearctic Little Owl and its Nearctic derivative, the Burrowing Owl *Athene cunicularia*, may ultimately also have spread.

GENERAL

Faunal type Indian.

Distribution South Asia, from the southern Zagros Mountains in southern Iran eastward; south of the main Himalayan ranges, but including the Kathmandu Valley in Nepal at 1,300–1,500m altitude, to northeastern Assam and the discontinuously distributed dry lowland areas of Burma and the greater part of non-peninsular Thailand, Lower Laos, Cambodia and southern Vietnam. Somewhat remarkably, it does not occur in Sri Lanka. Locally it is very common. In the Lower Punjab, Pakistan, in 1931, "almost every suitable acacia tree housed a pair" (Koelz, 1940). Map 16.

Climatic zones Tropical winter-dry, savannah, steppe and desert zones. The boundaries of the range are approximately defined by the isotherm of 33°C in the hottest months in south India (Madras, May), 31°C in Baluchistan (July), 30°C in southern Indo-China (May) and 26°C in Nepal (Kathmandu, July). Lowest average temperatures are 24°C in south India (January), 25°C in Thailand (December), 26°C in Indo-China (January) and 10°C in Nepal (January).

Habitat As in the Little Owl. Open country in "the neighbourhood of villages and cultivation, mango (topes) groves of ancient trees, and ruins . . . in semi-desert areas . . . the sides of ravines and earth cliffs" (Ali & Ripley, 3, 1969:300). The Spotted Owlet is as much at home in villages as in towns, but in the eastern parts of its range selects dry-zone towns such as

Spotted Owlet *Athene brama*

Mandalay, Meiktila and Shwebo in Burma. In hot and damp Rangoon its place is taken by the Barred Owlet (Smythies 1953:384).

GEOGRAPHY

Geographical variation Relates to depth of coloration, degree of dark barring on the underparts and particularly white spotting on the upperparts; also to body size. The Spotted Owlet is palest, with an isabelline desert coloration and reduced barring, in hot, arid regions, such as the Gangetic Plain in north India and the semi-desert regions of Pakistan (*Athene brama indica*) and southern Iran (*A. b. albida* or, palest extreme, *A. b. indica*). It is darkest and largest in east Assam (*A. b. ultra*), more clay-coloured and with heavier white spots on the upperparts in Thailand and adjacent Indo-China (*A. b. mayri*). The birds are largest in Thailand and east Assam (wing 147–168mm) and smallest in south India (*A. b. brama*, wing 141–158mm) and Burma (wing 138–152mm) (Hall, 1957). Apart from discontinuities of occurrence in Bangladesh, Burma and north Thailand, geographical variation is clinal. At least five races are recognized (Abdulali, 1972).

Related species The Palaearctic Little Owl *Athene noctua* is its closest relative. Another relative is the Forest Owlet *Athene blewitti*, a rare species of which little is known. Half a dozen specimens have been collected, the most recent in October 1914 by Colonel Richard Meinertzhagen near Mandvi on the Tapti River north of Bombay, in the northwest of the state of Maharashtra. The Forest Owlet is thought to have occurred in "patches of tropical moist deciduous and subtropical wet forest

along the foothills of the Satpuras... in mid-continental India" (Ripley, 1976:4), mainly in the states of Madhya Pradesh and Orissa, but it is not known whether any members of the species still survive. It has a proportionately shorter wing and tail than the Spotted Owlet, "slightly larger bill, longer tarsus and more massive feet" (Ripley, 1976:4). Whether the Forest Owl represents an originally forest-inhabiting stock of the genus *Athene* remains a matter of conjecture.

STRUCTURE AND HEARING

Structurally the Spotted Owlet is virtually identical to the Little Owl, minor differences in plumage providing the principal distinguishing feature. In both species the ear openings are somewhat elongated and lack an operculum. In four Spotted Owlets obtained from Thailand by the Zoological Laboratory of the Free University of Amsterdam, Netherlands, the average dimensions of the ear openings measured in life were 5.5×7.1mm for the left ear and 5.5×7.0mm for the right ear (Gerda van Keulen, 1974), as against 6.8×7.2mm and 5.3×8.0mm in four Little Owls from the Netherlands. The position of the ear, measured to the nearest distance to the eye, was on average 5.8mm (left) and 6.4mm (right) in the Spotted Owlets and 5.4mm and 4.4mm, respectively, in the Little Owls. Thus, both in shape and in position on the head, the ear openings of the Spotted Owlet showed less asymmetry than those of the Little Owl. This might indicate a less acute directional hearing and therefore a slighter degree of specialization in the owlet.

Hearing capacity in four Spotted Owlets and four Little Owls was measured by Mrs Gerda van Keulen by establishing threshold values following the same methods as used in earlier experiments on Tawny and Long-eared Owls (van Dijk, 1973). With sound pressures of -65 to -90 decibels, there was good sensitivity at frequency ranges of 0.25–4.0kHz in the Spotted Owlet and of 0.25–8.0kHz in the Little Owl, which means a difference at the higher frequencies of one octave in favour of the Little Owl. In each species the sensitivity diminished steeply at the higher frequencies. Thus, the hearing range was smaller and the sensitivity at frequencies above 1kHz slighter in the Spotted Owlet than in the Little Owl. At high frequencies (6–10kHz) the Spotted Owlet heard almost nothing whereas, under the same conditions and at -50 to -60 decibels, perception by Little Owls was still either very good or reasonable.

BEHAVIOURAL CHARACTERISTICS

Songs and calls The Spotted Owlet's calls have been described as "a medley of harsh screeching, chattering and chuckling notes – *chirurrr, chirurrr, chirurrr*... combined or interlarded with *cheevàh, cheevàh, cheevàh*... sometimes given as discordant duets" (Ali, 1977:59). Another author describes the territorial song as "plew-plew, a plaintive double whistle with the tone of a hammer on an anvil, uttered with great persistence" (Smythies, 1953:384). In general, contact, alarm and territorial calls are basically not very distinct from those of the Little Owl and about one third of an octave lower (Gerda van Keulen).

Circadian rhythm The Spotted Owlet is somewhat less crepuscular and diurnal than the Little Owl, and is primarily active during the hours of darkness. It is known to sleep in tree holes by day and couples basking in the sun dive into the safety of their holes at the approach of danger. The owls emerge in the late afternoon, and a bout of screeching advertises the presence of a territorial pair. In Calcutta the first calls announcing the start of the Spotted Owlet's nocturnal activity were almost without exception between a few minutes and 20 minutes past sunset. This remained the same throughout the year, irrespective of the season and the weather conditions (Brahmachary *et al.*, 1972). Spotted Owlets, like Little Owls, seem to enjoy basking in the sun at the entrance to their holes, at all times of the day, but particularly during the cool periods of the year.

Antagonistic behaviour The Spotted Owlet indulges in the same clownlike antics as the Little Owl, bobbing and ducking on exposed perches, alternately rising on its feet and crouching, and glaring at the intruder with its piercing, yellow eyes. Such behaviour can only occur on the ground and is therefore considered to indicate the Spotted Owlet's basically terrestrial or semi-terrestrial life.

ECOLOGICAL HIERARCHY

No information.

BREEDING HABITAT AND BREEDING

Nests have been found in holes in trees as frequently as in earthen and stone walls, in chimneys and under ceilings and the roofs of houses, in lofts and even in the eaves of palaces in Kathmandu, Nepal (Rand & Fleming, 1957:80). Spotted Owlets are known to evict parakeets, rollers and mynahs from their nesting holes in trees and to assume ownership of these sites (Baker, 3, 1934:525). In all these aspects the Spotted Owlet shows its similarity to the Little Owl.

FOOD AND FEEDING HABITS

The Spotted Owlet has the same undulating flight as the Little Owl and occasionally hovers (Allen, 1919; Whistler, 1949:348) in the same manner before stooping on its prey. Its diet differs from the Little Owl's only in so far as mammals seem to play an even less prominent role. The proportionately large preys which the northernmost Little Owls are known to collect have not been recorded for the Spotted Owlet. Most frequently recorded prey includes insects, mainly beetles, locusts, praying mantids, moths, winged termites, also small birds and their nestlings, small rodents, bats and small lizards, including wall and tree geckos. The diversity of the food in relation to available potential prey, conditions of the wet and dry seasons, and raising of young, still needs to be studied before a useful comparison with the Little Owl can be made. This applies in particular to the area of alleged overlap in southern Iran.

MOVEMENTS

The Spotted Owlet is considered strictly sedentary.

Spotted Owlet *Athene brama*

GEOGRAPHIC LIMITS
Nothing known, but see under Climatic zones.

LIFE IN MAN'S WORLD
In most parts of its range the Spotted Owlet lives in as close proximity to man as does the Little Owl. It occurs in almost any patch of sacred banyan, tamarind and mango in and around villages, where it shares the available tree holes with Collared Scops Owls, Barred Jungle Owlets and sometimes another pair of its own species. In mango orchards it may meet the Eagle Owl and in village huts, houses and bungalows it may rub shoulders with a pair of Barn Owls. The interrelations of these species of owl and their dependence on man would be a worthwhile topic for study. Many authors have remarked upon the Spotted Owlet's utter indifference to human activity as it calls from the roofs of houses or hunts for insects attracted by street lights or illuminated verandahs around bungalows and houses in the lowlands. At times the owls may even attack and wound humans moving around their houses if they have chosen to nest close by (Gupta, 1967).

Provided the peoples of south Asia continue to adopt their wise attitude to the natural world, and the use of biocides is restricted, the future of Spotted Owlets looks promising.

Structural characteristics, vocalizations, hearing, general behaviour and distribution seem to indicate such a close relationship between the Spotted Owlet and the Little Owl *Athene noctua* that their specific distinction has yet to be proven. In every characteristic the Spotted Owlet is the less specialized of the two. It may be that the *Athene* species originated in the Indian subcontinent when arid conditions began to prevail. Whether the nearest relatives of the *Athene* species are the hawk owls *Ninox*, or the jungle and pygmy owls *Glaucidium*, is uncertain. The enigmatic (and possibly extinct) Forest Owlet *Athene blewitti* might provide a clue to understanding these relationships, though the Forest Owlet may already be too close to the Spotted Owlet for that purpose.

Comparative studies between the Spotted Owlet and the Little Owl promise to be interesting at all levels of taxonomy, systematics, vocalizations and ecology. The same applies to the ecological differences between the Spotted Owlet and the almost equal-sized Collared Scops Owl *Otus bakkamoena* and the Barred Jungle Owlet *Glaucidium radiatum*. A further question is to what owls and diurnal predators the Spotted Owlet falls victim, and to what extent.

BURROWING OWL
Athene cunicularia

The Burrowing Owl, formerly assumed to be the sole member of an exclusively American genus *Speotyto*, but now recognized as a long-legged, terrestrial Little Owl *Athene*, has long attracted attention by its semi-colonial terrestrial habits and its close association with life in black-tailed prairie dog "towns" in the short-grass prairies of North America. The complicated social life which the Burrowing Owl shares with these numberless rodents gave rise to the romantic interpretation of an alleged symbiosis with these underground animals and the formidable prairie rattlesnake *Crotalus viridis viridis*.

In the southern hemisphere Darwin had already been impressed, during his world voyage on the *Beagle* (1833), by the conspicuous presence of these friendly and comic owls in the underground colonies of viscachas, which had undermined large stretches of level Patagonian pampas with their burrows. And ever since, visitors to Argentina, Uruguay and Chile have remarked on the bobbing antics and blinking yellow eyes of these well-known birds, sunning themselves, the mates close together, at the entrances to their burrows. Now also known as *Lechucita de las viscacheras*, the Burrowing Owl must have played a role in Indian folklore, as is testified by the belief of Uruguayan countrymen that "the flesh of the burrowing owl is served as a delicacy to those convalescing from illness in the belief that it produces appetite for other food" (Wetmore, 1926:202).

In the following species description (see Zarn, 1974), emphasis will be laid on the relationship of the Burrowing Owl to the Old World Little Owl and the degree of its dependence on burrowing colonial rodents. In particular, the question of whether the Burrowing Owl is a long-legged Little Owl or whether the Little Owl has developed as a short-legged Burrowing Owl will be discussed.

GENERAL

Faunal type Pan-American.

Distribution In non-forested areas, throughout the whole length of the Americas, from arid southern British Columbia and the prairies of southern Alberta, Saskatchewan and Manitoba, Canada, at 52–53° north, through the Midwestern, western and southern United States, east to central Texas, Mexico, south-central Florida, most of the Bahama Islands, isolated localities in Cuba (first known nesting in 1973) (González & Garrido, 1979) and Hispaniola, formerly other islands in the West Indies and, currently still, some outlying islands throughout their range; discontinuous in South America from Colombia to southern Argentina and Chile, formerly (up to the 1920s) as far south as the northernmost part of Isla Grande, the largest island of Tierra del Fuego, at 52°30′ south (see Short, 1975: 234). Map 16.

Climatic zones Temperate, mediterranean, tropical winter-dry, savannah, steppe, desert and alpine. Distribution limits reach approximately the isotherm of 23°C in the warmest month (July) in Canada and almost 12°C (January) in humid-cool Tierra del Fuego, South America.

Habitat Open country, originally natural grasslands from the short-grass prairies in the north, through sagebrush heath, semi-desert, lowland desert, llanos and savannahs in subtropical and tropical environments and pampas in the south; also alpine grasslands of the paramo zone in the central Andes as high as 4,000m and over around Lake Junin, central Peru (Fjeldså, 1983). At present also farmland and grazing country, fallow lands, extensive forest clearings, airports, golf courses, often close to buildings, sometimes in quiet, spacious suburbs.

GEOGRAPHY

Geographical variation Conspicuous in depth and intensity of coloration, and presence of dark bars and spots on underparts of the body, and in size. Some 18–20 subspecies are currently recognized, but this number is probably too high. Paler, more sandy-coloured and less strongly marked in arid tropical areas such as coastal Venezuela and the islands of Margarita and Aruba and the littoral of Ecuador and Peru. Darkest on West Indian islands and Florida. Most heavily barred and spotted in Andean highlands and southern South America (*Athene cunicularia cunicularia*), where the birds are also largest (wing length up to 195mm and over). The smallest birds occur in the north Brazilian and probably south Guianan savannahs (average wing length 142.5mm) (Cory, 1918:40). Legs are less densely covered with thin feathers and bristles in warm tropical than in cold southern South American plains and Andean surroundings. Throughout North America only one medium-sized and fairly heavily

marked subspecies is found (*A. c. hypugaea*), with the exception of a small area in Florida where the birds are darker, of a warmer brown and smaller (*A. c. floridana*). Midwestern North American birds have an average weight (155g) of 62% of the weight of Burrowing Owls from Chile (250g) (Jaksić & Marti, 1981).

Related species Closest relative is the Old World Little Owl *Athene noctua*, which is less advanced in terrestrial life, however. The Elf Owl *Micrathene whitneyi* is probably its nearest living relative in North America.

STRUCTURE AND VISION

The Burrowing Owl shares most of the structural characteristics of the Little Owl. It has a plumage of a similar colour and pattern, bulbous nostrils and scantily feathered legs and toes, but, unlike the Little Owl, the back of the tarsus is almost bare. The facial ruff is imperfectly developed and the ear openings are small, nearly oval in shape, symmetrical in size and position and non-operculate. Even in details of pterylography (the distribution of feathers over the body), nothing has been found to distinguish the Burrowing Owl from *Athene* (Pycraft, 1898), but it was not until the mid-1950s that the Burrowing Owl was ultimately placed in the genus *Athene* (Meinertzhagen, 1951; Voous, 1960; Mayr & Short, 1970; AOU Checklist, 1983). The Burrowing Owl is the most terrestrial and at the same time fossorial species of owl, with conspicuously long legs, the tarsus of which is more than twice as long as the middle toe without claw (222%, as against 180% in the Little Owl). Another long-legged terrestrial, but not fossorial, species is the Grass Owl.

Unfortunately, no special studies appear to have been devoted to the structure and abilities of the sense organs in the Burrowing Owl. In view of its crepuscular and at times diurnal habits one would expect most prey-location to be made by sight, but hearing must also play a certain and as yet unquantified role (Marti, 1974). Of all North American owls examined experimentally, the Burrowing Owl showed the least ability to locate immobilized prey in the dark, i.e. not darker than 11×10^{-5} (Marti, 1974) or 26×10^{-6} foot-candles (Dice, 1945), corresponding with the same ability to see in dim light as man. This is in line with life in the plains where nights are brighter than in forested surroundings where owls with better vision live.

BEHAVIOURAL CHARACTERISTICS

Songs and calls The vocalizations of the Burrowing Owl differ remarkably from those of the Little Owl (Thomsen, 1971; Martin, 1973). Probably because of its semi-colonial habits, territorial and contact calls are not as loud or far-reaching as those of the Little Owl, which has to project its voice widely over rocky plains and arid river beds. Instead, the song consists of a mellow *coo-coo*, which has provided the bird with its local name of *el cucú* and *cou-cou-terre* in some parts of the West Indies, *chocó* on the South Caribbean island of Aruba and *corujá* in Brazil. Rattling calls and fierce cackling denote the reaction to disturbance and aggression.

Burrowing Owl *Athene cunicularia*
North American race *A. c. hypugaea*

Circadian rhythm Though often considered a daytime hunter, the Burrowing Owl hunts most actively around sunset and sunrise, the periods most appropriate for hunting small rodents. In the breeding season another activity peak is usually noted around noon or a few hours before midday, which is a favourable time for catching insects and lizards. Burrowing Owls are nevertheless known to be active both by day and by night, though on the whole they are probably less nocturnal even than Little Owls. Only in the North American winter do they appear to hunt mainly at night, probably forced to do so by the activity pattern of their, in North America, exclusively mammalian prey. Consequently, they are less often noticed then and erroneously reported to be absent during that season. The same applies to conditions in the plains in high summer, at ambient temperatures of over 40°C, when the owls retreat into the buffered ecoclimate of their burrows (Coulombe, 1971).

Antagonistic behaviour A familiar sight, wherever Burrowing Owls occur, are pairs or families gathered on any elevated ground – hummock, prairie dog mound or fence post – or simply at the entrance of their hole in level ground, blinking against the bright sunlight. At such a moment these owls appear as diurnal as any ordinary bird. Apart from elaborate bobbing and bowing movements, which can result in antics even more comic than those of the Little Owl, the only antagonistic behaviour which the Burrowing Owl is known to exhibit is the occasional, rather fierce attack on mammals or humans disturbing the nest. These attacks are usually accompanied by harsh rattling calls. For a possible case of acoustic mimicry by nestlings hissing and rattling inside their earthen burrow in imitation of a rattlesnake, see Breeding Habitat and Breeding.

ECOLOGICAL HIERARCHY

The Burrowing Owl is of about the same size and weight as the Little Owl. Body weight in western North America varies between 120–228g (average 158.6g) in males and 129–185g (average 150.6g) in females (Earhart & Johnson, 1970), providing an overall average in North America of 172.0g in males and 168.0g in females (Thomsen, 1971). Unlike the Little Owl, the male Burrowing Owl is somewhat larger and heavier than the female, which is exceptional in owls in general and in North American owls in particular (see, however, also Flammulated Owl). Body weight of males is 103–105%, wing length 101%, tail 103%, bill 102%, tarsus 105% of that of females. Hence, there is no female dominance. As these owls are mainly insectivorous and, particularly in the breeding season, prey relatively infrequently on birds, the male, in spite of its somewhat larger size, does not pose a potential threat to the young, and less still to the female, and no differences in average prey size between males and females have been found.

Measured according to body weight and total length of the claws, the North American Burrowing Owl has a rather greater strength of predation than the equally mainly insectivorous American Kestrel (body weight of male 110g, of female 120g) with which it may share its habitat. The force necessary to open "firmly clenched talons" was found to be 500g in the Burrowing Owl, 1,350g in the Long-eared Owl and 13,000g in the Great Horned Owl (Marti, 1974). The Burrowing Owl is therefore a very mild predator and does not pose a threat to other

diurnal and nocturnal avian predators. In North American desert and grassland habitats it shares its range with the Great Horned and Short-eared Owls and, among diurnal birds of prey, with the Swainson's, Red-tailed and Ferruginous Hawks, the Golden Eagle and the Prairie Falcon.

It seems that Barn Owls sometimes prey on Burrowing Owls, though no published records have been found. All raptors of the plains mentioned above should probably be considered as potential predators of the Burrowing Owl, but the only records of predation concern the Great Horned Owl (Errington et al., 1940:794) and also the Prairie Falcon, which is known to have preyed upon the Burrowing Owl in some numbers in California (F. H. Fowler, 1931, cited by Bent, 1938). What species behave as competitors and/or predators of the Burrowing Owl in the South American pampas has not been verified.

Predators which pursue the owls into the safety of their burrows or excavate their nests include the rattlesnake, opossums, bobcats, weasels, skunk, silver badger, coyote and, formerly, black-footed ferret and plains wolf.

In xerophytic scrub country at 875m altitude in central Chile the American Kestrel, the Barn Owl and the Great Horned Owl were the only other raptors recorded besides the Burrowing Owl (Jaksić & Marti, 1981). Here the Burrowing Owl is about twice as heavy as the Kestrel (average weights 250g and 120g, respectively), but smaller than the Barn Owl (310g). Hence the average weight of mammalian prey (about 10 species available) was heavier than that taken by the Kestrel (64.5g against 28.1g), but lighter than that taken by the Barn Owl (109.0g).

No owl or diurnal bird of prey is known to have been taken by a Burrowing Owl either in North or in South America.

BREEDING HABITAT AND BREEDING

Classic breeding sites are burrows 2–3m long in prairie dog "towns" in the short-grass prairies of former times. One of these immense rodent colonies in Texas allegedly extended over 65,000km^2 and counted over 100,000,000 black-tailed prairie dogs. Slightly smaller colonies existed as late as 1918. In Oklahoma too prairie dog towns are said once to have covered "millions of acres", but in 1968 "9,522 acres" (3,800ha) of these were left (much less than 1%), with a density of one pair per 9.6 acres (3.8ha), against 5,683 acres (2,275ha) per pair outside dog towns (Butts, 1973; Butts & Lewis, 1982).

Burrowing Owls are much less common in the colonies of white-tailed prairie dogs because these colonies are less open and the vegetation is higher. In 1978–82, 426 white-tailed prairie dog towns were investigated in the plains of Wyoming, covering an area of 14,349ha. Burrowing Owls were present in no more than 34 colonies (8%), with an average density of one pair per 345ha (Martin, 1983).

Other, equally classic breeding sites are the pampas of Argentina, where the owls live in the much wider and longer holes (up to 10m) of the hare-sized viscacha and share the colony life of these and other subterranean and fossorial rodents. Of the vast numbers of both mammals and owls which still existed a century ago, a mere fraction now remains.

Prairie dogs, no less than viscachas, are considered competitors to grazing sheep and cattle. Moreover, by the density of their underground holes and the fact that the burrows run just below the root layer of the grass cover, they pose a threat to the lives of cattle and horses and to those of their riders. Prairie dogs have consequently been destroyed with poison and explosives to the point, at one time, of virtual extermination. All the plant and animal communities, including that of the Burrowing Owl, have simultaneously suffered. The impact of the "Predator and Rodent Control", formerly set up by the United States Department of the Interior at a cost of millions of dollars, has been enormous and detrimental. At present, small colonies of Burrowing Owls exist in all kinds of extensive grasslands, semi-deserts and deserts where burrowing mammals provide nesting holes. Apart from black-tailed prairie dogs, the latter include ground and rock squirrels, woodchucks and marmots, plains and northern pocket gophers, silver badgers, skunks, swift foxes, coyotes and formerly wolves in the western plains; also raccoons, gopher tortoises in Florida, viscachas, armadillos and great anteaters, together with toads, snakes and the underground nesting miners of the bird family *Furnariidae*.

When necessary, Burrowing Owls are able to excavate holes of up to 2.5m length without the assistance of mammals, as, for example, in the sand flats of Florida where burrowing mammals are absent (Kennard, 1915), on the South Caribbean island of Aruba, in the Magdalena valley in Colombia (Miller, 1974), and also in California (Thomsen, 1971). Burrows dug by owls in sandy soil have also been found in Chile, where some had a length of over 10m (Johnson, 1967). Burrowing Owls dig using their legs and beak. Even in captivity in Europe they excavate extensive systems of tunnels in level ground (Scherzinger, 1981).

Burrowing Owls and prairie dogs, though sharing the same habitat, are not always on friendly terms, and the Burrowing Owls usually have to occupy vacant burrows or else fight for the possession of their own underground home. In general, prairie dogs are the inferior combatants. In California, on the other hand, Burrowing Owls and round-tailed ground squirrels tended for the most part to ignore one another, even when moving close together (Coulombe, 1971). In addition to using the burrows of these mammals, Burrowing Owls regularly prey on young prairie dogs and other animals encountered in and around their burrows.

Eggs are laid in a dark recess of one of a system of 2–10 underground tunnels, often on a lining of dry grass stems and other plant material and particularly dried horse and cow dung, pieces of which usually mark the entrance of an occupied hole. Although these nests are relatively safe from predators, substantial predation of both nestlings and adults by coyotes, badgers, skunks, weasels, bobcats, and occasionally also by rattlesnakes, has been recorded. The regular occurrence of desert rattlesnakes in prairie dog towns gave rise to the old belief of a *symbiosis à trois*, but this romantic notion masks the true situation, which is one of ruthless predation. This situation was already accurately described by Elliott Coues (1874:321–327) in 1874 and by M. A. Trécul (1876) in 1876. Young Burrowing Owls make hissing and rasping sounds when disturbed and these noises, coming from deep inside a burrow, may simulate the presence of a rattlesnake and eventually discourage a prowling carnivore. Although undoubtedly exhibiting here a kind of "vocal mimicry", young Burrowing Owls are not the only young owls to produce a defensive "rattlesnake rasp"; North-

Burrowing Owl *Athene cunicularia*

ern Saw-whet Owls and Western Screech Owls do the same, though such sounds seem rather out of place coming from their arboreal nests.

It is exceptional for owls to transport nest-lining materials. The only owl, apart from the Burrowing Owl, which is known to do this is the ground-nesting Short-eared Owl. In the case of the Burrowing Owl the materials are probably intended to camouflage the presence of owls lower down in the burrow to would-be predators. On more than one occasion when research workers removed pieces of dung from a burrow entrance and the chamber adjoining it, these items were promptly replaced by the owls (Martin, 1973).

In spite of the protection provided by a colonial life, the annual mortality in Burrowing Owls must be considerable, for, in North America at least, clutch size in this species exceeds that of all other raptors, being 6–12 (Henny & Blus, 1981), with an average of 6.48 eggs in 439 clutches reported (Murray, 1976).

Prairie dog towns attract Burrowing Owls only when they are active and inhabited; when uninhabited, soil debris and grass start to fill up the burrows and deserted towns become unsuitable within 1–3 years (Butts, 1973; Butts & Lewis, 1982).

FOOD AND FEEDING

Though arthropods, mainly insects, form the majority of the Burrowing Owl's prey, the proportion of other animals in the owl's diet varies according to season and site. An overall picture of the diet in western North America, calculated from 3,564 prey items, includes 90.9% invertebrates (mainly insects), 6.9% mammals, 2.0% reptiles and other lower vertebrates (snakes, lizards, toads) and 0.3% birds (Snyder & Wiley, 1976).

Seasonal variation in a short-grass prairie region in north-central Colorado shows most rodents to be taken in April (and probably in the winter months), most mole crickets in June, most locusts in July, most dung beetles in August, while ground beetles were taken in quantity (42–67%) in every month of the non-winter period (Marti, 1974).

Mammals include young prairie dogs and ground squirrels, pocket gophers, voles, deer mice, jumping mice, harvest mice, eastern and desert cottontails and young jackrabbits (Earhart & Johnson, 1970); in Chile, a variety of cricetine rodents, rather large rabbits, the murine opossum and bats (Jaksić & Soriguer, 1981). Birds include quantities of shore larks; also meadowlarks, lark buntings, chestnut-collared longspurs and vesper sparrows, all of which are characteristic birds of the grass plains. Other prey recorded are snakes, scorpions (e.g. in Brazil) (Dekeyser & Dekeyser, 1976), centipedes, millipedes, spiders, crabs (e.g. Chonos Islands, southern Chile; Charles Darwin), prawns and other crustaceans. Earth worms, so frequently taken by Little Owls, do not appear to feature on the Burrowing Owl's menu, its habitat probably being too arid.

Although the Burrowing Owl, like the Little Owl, may take unexpectedly large prey (e.g. 6 freshly decapitated mourning doves, averaging 127g, around a burrow in California) (C. T. Collins), most of its prey is small. In Colorado only 0.1% of the food items were heavier than the owl's own body weight; 91.2% weighed 1g or less (most insects) (Marti, 1974). Similar results have been obtained from central Chile (Schlatter et al., 1980).

Prey is captured from an elevated perch on the ground, a prairie dog mound or a fence post; sometimes the owl hovers first, at a height of anything up to 15m (mostly when pursuing mammals), using a technique not unlike, but more elaborate than, that demonstrated by the Little Owl. Flying insects are taken on the wing and some prey are run down on foot.

MOVEMENTS AND POPULATION DYNAMICS

Unlike the Little Owl which is an exceptionally stubborn, sedentary bird, the Burrowing Owl is migratory in the northernmost and probably also the southernmost parts of its range. Elsewhere it is sedentary. It could hardly behave otherwise, for when swept by blizzards, covered with snow or frozen over, the North American plains do not allow access to rodent burrows, nor do they provide insects to feed on. Though some individual birds may linger on (less than 1% in the Oklahoman panhandle; Butts, 1976) and probably subsist on much larger prey than that caught in summertime, the bulk of the populations appears to retreat to warmer countries from September onwards. The owls probably travel mainly to Mexico, but have been reported south in tropical Central America and accidentally in Chiriqui, Panama (13 December 1900; Wetmore, 1968:174).

Migratory movements have been documented and relate to a nesting female, ringed 26 June 1970 in Beaver County, Oklahoma, and shot 1 November 1971 at Zapotlanejo, Jalisco, west-central Mexico (Butts, 1976). Another Burrowing Owl landed 11 November 1943 on a formation of naval vessels in the Pacific Ocean 130 miles from Cape Lucas, Baja California, and 185 miles from Cape Corrientes, Mexico, where it flew from one ship to another. This owl may have been on its way from Baja California southwards (Patterson, 1946).

Little is known regarding starvation in winter, mortality and population fluctuations in general, but interesting data have started to come in from California (Thomsen, 1971).

Accidental occurrences far beyond the limits of the owl's normal range, such as on Wolfe Island in eastern Lake Ontario, in New Brunswick, New York City and North Carolina, and off the coast of Virginia (22 Oct. 1918; Strong, 1922), either indicate dispersal movements through which new areas are being explored, or represent extended migrations or vagrancy. A Burrowing Owl found dead in November 1945 in West Falkland proves the ability of this species to cross stretches of open sea (Woods, 1975).

GEOGRAPHIC LIMITS

At first sight the geographic range of the Burrowing Owl appears to be conditioned by the presence of open grasslands and arid plains harbouring an abundance of small burrowing mammals. Its dependence, however, on climatic factors seems to be even more rigid. In laboratory experiments Burrowing Owls suffered rapid and substantial respiratory water losses as soon as the ambient temperatures approximated or exceeded the owl's body temperature. Such temperatures frequently occur in mid-continental grasslands and semi-deserts in summer. Like other North American semi-desert owls, the Whiskered Screech Owl and the Elf Owl, the Burrowing Owl responded by extensive gular fluttering which stimulates respiration and evaporation and hence acts as an efficient cooling mechanism (Ligon, 1969; Coulombe, 1970, 1971; Mosher, 1976). Under natural conditions Burrowing Owls retreat in periods of excess-

ive heat into their underground burrows where temperature and humidity remain more or less constant. Under experimental conditions oxygen consumption already increased considerably at ambient temperatures of 23°C and lower. Hence climatic tolerance in the Burrowing Owl is remarkably limited. Apparently, only the safety and reliability of the underground eco-climate allow Burrowing Owls the large distributional range of 104° latitude which they occupy today. While Burrowing Owls are dependent on colonially burrowing mammals, the latter can only exist in semi-arid and arid climates. Extinction of Burrowing Owls on some of the Bahama Islands (e.g. Exuma) and the West Indian islands of Antigua, St Kitts, Nevis and Marie Galante in historical times and earlier extinctions on Jamaica (Cruz, 1985), Cayman Brac, Mona and Barbuda may, therefore, have been primarily caused by climatic changes (from dry to humid), rather than solely by the interference of man, the rat and the mongoose (Olson, 1982), though in certain cases man may have altered the environment too drastically and rapidly for an easy adaptation (Steadman et al., 1984).

LIFE IN MAN'S WORLD

Government-subsidized campaigns to destroy prairie dogs and other burrowing rodents in the United States as part of the "Predator and Rodent Control" programmes set up in the first half of this century greatly affected and locally almost annihilated Burrowing Owl populations alongside their mammalian hosts. The Burrowing Owl was placed, as a result, on the "early warning" list ("Blue List") of North American species (Evans, 1982). Serious decrease has occurred in South America as well, where early in the 19th century numbers had already perceptibly diminished. Similarly, Burrowing Owls have currently disappeared from Tierra del Fuego's Isla Grande, apparently due to the trampling of their burrows by sheep first introduced by early colonists (Humphrey et al., 1970).

On the other hand, forest-cutting and the extension of forest clearings, grasslands and eroding arable lands in South America, as well as land-clearing and cattle industry in Florida (Ligon, 1963), have provided new habitats for both burrowing mammals and owls. Any gain, however, has probably been immediately counteracted by subsequent land development and rodent control. Freeway banks, golf courses and airports (as studied at Oakland Municipality Airport, Alameda County, California; Thomson, 1971) appear to provide ideal habitats for Burrowing Owls, but their presence there is rarely appreciated. The saving of a colony in the grassy areas between the runways of Miami International Airport, Florida, for which volunteers raised a sum of $10,000, marked a high point in owl conservation.

The conservation measures considered by the Bureau of Land Management of the United States Department of the Interior (Zarn, 1974) are grounds for optimism as is the reintroduction schemes which the Canadian Wildlife Service began in 1982 in the arid pockets of the Okanagan, Similkameen and Kamloops Valleys and the Nicola Valley in southern British Columbia, which first produced young in 1986. Experiments with artificial nesting pipes in California, originally to replace ground squirrel burrows as nest sites in road shoulders, have not only served scientific research but have also notably furthered the conservation and management of the Burrowing Owl, now almost an endangered species (Collins & Landry, 1977).

When no other nest sites were available, Burrowing Owls have nested in old Inca ruins and in earthen walls along roadsides, even in abandoned and derelict houses on the outskirts of Lima, Peru (Griswald, 1943), and have lived for years in an unused utility pipe in the street of a residential area on Aruba, Netherlands Antilles, oblivious to passers-by (Voous, 1983).

In both its prey and its method of catching it the Burrowing Owl shows all the characteristics of a genuine terrestrial life. Trees apparently figure rarely in its life and hunting techniques.

One may wonder how in the New World the Burrowing Owl could perfect its terrestrial adaptations, while in the Old World the Little Owl *Athene noctua* failed to develop further in this way. Possibly the large, grazing ungulates of the Late Tertiary and Pleistocene ages, which survived longer in America than in Eurasia, provided the habitat suited to the Burrowing Owl's life and development. At present the plains buffalo, the pronghorn antelope, the black-tailed prairie dog, the silver badger, the black-footed ferret and the Burrowing Owl all appear to be well adapted to life in common.

Fossils of Burrowing Owls, described as *Speotyto megalopera*, somewhat larger and more robust than the present species, have been found in Upper Pliocene deposits in Idaho and Kansas (Ford, 1966; Ford & Murray, 1967). Apparently, terrestrial *Athene* owls have lived in North America for a considerable time. It seems not unlikely that the Little Owl of the Old World is an early descendant and colonist from North America. The Little Owl's present habits exhibit features reminiscent of a former terrestrial life, rather than demonstrating a stage of development towards such conditions, but this is difficult if not impossible to prove and the presence of Middle Pleistocene fossils in Europe would indicate that Little Owls arrived in the Old World earlier than other North American plains animals such as the camels. The absence of representatives of the genus *Athene* in the savannahs of the Afrotropics and in the arid regions of Australia is consistent with this bold, somewhat unusual, and only tentative, theory. Further physiological and behavioural studies of both the Burrowing and the Little Owl are required to ascertain the nature and degree of relations that exist between these two species, their terrestrial and fossorial habits and dependence on burrowing and grazing mammals. After all, a slight basis for the idea of early post-Tertiary, intercontinental range expansion may be found in a similar emigration of North American llamas and the camels. Both the latter, though in later glacial stages, travelled likewise from North to South America and from North America into Asia rather than migrating in the reverse direction, from Asia to America.

Although the Burrowing Owl has adapted well to cultivated lands, its survival under genuine conditions depends on the preservation of adequate areas of prairie country as nature reserve or national park in North America and of pampas in South America inhabited by viscachas, maras, guanacos, pampas deer and rheas.

MOTTLED OWL

Strix virgata

The Mottled Owl is the most widespread and most numerous of the wood owls of the American subtropics and tropics. Its range touches the Nearctic in northeastern Mexico where it meets the Spotted Owl *Strix occidentalis*. It is strictly nocturnal. Hence very little is known of its life and habits. This species raises two particular problems. The first of these concerns the main division of the family *Strigidae* into the subfamilies *Buboninae* and *Striginae*, as accepted by James-Lee Peters (1938) and Kelso (1940) and other authors before them. The second problem relates to the zoogeographic implications of a faunistic similarity between the tropical American and Afrotropical faunas, as demonstrated by Léon Croizat (1958).

One of the fundamental questions raised by the Mottled Owl is whether it is a member of the mainly tropical genus *Ciccaba* or of the mainly temperate and boreal *Strix*. This throws us back to the more general question of whether a distinction exists at all between the genera *Ciccaba* and *Strix*, and, if so, what the phylogenetic relations between the two species are. A structural comparison of the outer ear assigns *Ciccaba* to the subfamily *Buboninae* and *Strix* to that of the *Striginae*. By positing a relationship between members of *Ciccaba* and *Strix* either we invalidate their identification with *Buboninae* and *Striginae*, or the distinction between the two subfamilies must itself be seen as false.

The hawk eagles of the genus *Spizaetus* and the *Ciccaba* wood owls together represent the key groups of birds whose circumtropical, or at least tropical American and African, distributions have lent unacceptable biogeographical weight to the theory of continental drift, for a faunal similarity on both sides of the mid-Atlantic Ocean should not be restricted to hawk eagles and wood owls only. In subsequent publications (Kelso, 1940; Voous, 1964) the less complicated structure of the outer ear in *Ciccaba* has been linked to conditions in tropical forests rather than being considered the result of direct relationship. *Ciccaba* is therefore thought to be a heterogenous assemblage, and the only African representative of *Ciccaba*, the tropical African Wood Owl *"Ciccaba" woodfordii*, is more directly related to members of *Strix* from Europe and Asia than to species on the other side of the Atlantic Ocean in South America.

The relationship of the Mottled Owl to northern wood owls of the genus *Strix* and the life of wood owls in the tropics in general are the main themes of the following species account.

GENERAL

Faunal type Neotropic.

Distribution Most of tropical America, from the Pacific lowlands of southern Sonora and Chihuahua and the Caribbean lowlands of southern Nuevo Leon and Tamaulipas, to southern Brazil (Rio Grande do Sul) and tropical northern Argentina (Misiones); also tropical and subtropical Andean mountain zones in Colombia and Ecuador, but not the savannah highlands of Venezuela and Brazil. Map 17.

Climatic zones Subtropical and tropical, between the isotherms of about 27°C in the warmest months north and south of the equator, perhaps somewhat lower on the Central American slopes.

Habitat Dense forests and woodlands, mostly in humid lowlands, but also montane cloud forests up to 1,500m in Honduras, 2,200m in Guatemala and 1,900m in the Venezuelan coastal range; also semi-deciduous and tropical dry forest in the lowlands and semi-arid montane forests in Central America.

GEOGRAPHY

Geographical variation Apart from the presence of light and dark morphs in local populations – a well-known phenomenon in Old World representatives of *Strix* – geographical variation is apparent in the degree of darkness of the plumage, but hardly in size. Populations in northwestern South America are darkest, with almost black, unspotted upperparts (*Strix virgata virgata*), those in northwestern Mexico are lightest, buff brown (*S. v. squamulata*), whereas the southernmost birds in South America are most heavily spotted with white or light buff above (*S. v. borelliana*). Generally, seven or eight geographical races are recognized (Kelso, 1932; Peters, 1938; Eck & Busse, 1973).

Related species The Mottled Owl is usually associated with the other members of the traditional *Ciccaba* complex, such as the Black-and-White Owl *C. nigrolineata* from lowland, mainly swampy forest in Central America and northwestern South America, the Black-banded Owl *C. huhula* from most of tropical

Mottled Owl *Strix virgata*
South Brazilian race *S. v. borelliana*

South America and the Rufous-banded Owl *C. albitarsus* from the Andean mountain forests, as well as with a few little-known *Strix* owls in central and southern South America. These assumed relationships have never been proved, however. Ecologically the Mottled Owl is the tropical representative of the northern wood owls, more particularly of the Barred Owl and its montane Mexican and Central American relative, the Fulvous Owl. A comparative study of structural and eco-ethological characteristics of the Mottled and Fulvous Owls would help to solve the question of the relationship between the genera *Ciccaba* and *Strix*. The obvious similarity between the Mottled and African Wood Owl is probably the result of parallel development. If this is the case, all or some of the *Ciccaba* owls could represent the tropical offshoots of northern *Strix*, rather than being the stem from which the highly developed *Strix* have arisen; the latter, however, seems to be the more likely theory and South America the more likely and only continent of origin.

STRUCTURE AND HEARING

The Mottled Owl is a large- and round-headed wood owl with large, black or deep-brown eyes, which often have a purplish shine, and completely developed, round facial discs surrounding each eye. Its defining structural characteristic is its outer ear, which is a small to moderately large opening without additional complicated structures. In this respect, the Mottled Owl is a real "bubonine" *Ciccaba* and in no way resembles the northern "strigine" *Strix*. An area of raised skin, 2mm wide on average, supporting a ridge of small, stiff feathers, surrounds the orifice and suggests a rudimentary dermal flap. It is negligibly wider than in the tropical American Black-banded and Black-and-White Owls (*Ciccaba*) and corresponds to similar characteristics found in *Strix* species from the Old World tropics (Brown Wood Owl, Spotted Wood Owl). The Mottled Owl shares, however, the highly pronounced asymmetry of members of *Strix* in that the vertical axis of the right ear opening (average 20mm) is about one and a half times longer (59%) than that of the left side (average 13mm) (Peters, 1938; Kelso, 1940; Voous, 1964; Norberg, 1977). In a female from Veracruz, Mexico, the right ear opening (length 22mm) "appeared to include approximately twice the area of the left one" (length 15mm) (Wetmore, 1943). The absence in all tropical wood owls of enlarged and complicated ear openings and mobile pre-aural dermal flaps has been correlated with the often "deafening" nocturnal choir of stridulent insects and frogs in tropical humid forests and the presence there of a rich food supply, on the move at night and easily available throughout the year, making specialized hearing faculties unnecessary (Kelso, 1940; Voous, 1964; Nieboer & van der Paardt, 1977).

BEHAVIOURAL CHARACTERISTICS

Songs and calls Mottled Owls indulge in a great deal of calling, as do North American Barred Owls. Their territorial song is invariably described as a series of deep, often guttural and slightly modulated hoots rendered as *bru bru* and *bu bu bu* (Panama; Wetmore, 1968), *keeoowééyo* or *cowooáwoo* (Panama, Ridgeley, 1976), or *whoó-oo* (Venezuela; de Schauensee & Phelps, 1978), all of the same character and quality as the call of the Spotted Owl (Miller, 1963). In addition, a long-drawn-out "whistled screech" and a call resembling "the crying of a child" have been described in both adults and young. Undoubtedly, numerous other vocalizations occur. Dickey and van Rossem (1938) state that the male's call is noticeably higher pitched than the female's.

The proximal part of each bronchus is enlarged to form a kind of elongated sound box with a dorsal vibrating membrane almost three times the width of the subsequent tubular part of the bronchus (Miller, 1963). This structure enables the Mottled Owl to produce barking sounds of a remarkably deep quality relative to the bird's size.

Circadian rhythm All authors agree that the Mottled Owl is a remarkably nocturnal bird, but no specific studies have been devoted to its circadian rhythm. Holes in trees and the shade of thick foliage and tangled vines have been mentioned as roost sites by day.

Antagonistic behaviour No data.

ECOLOGICAL HIERARCHY

Nothing has been reported concerning interactions between the Mottled Owl (weight 235–305g) and other species of owl and raptor, but Mottled Owl specimens have been collected in the same place and habitat as the tropical Black-banded Owl of somewhat larger size and weight (female 397g) (Surinam; Haverschmidt, 1968), the much stronger Spectacled Owl (weight 600–1,000g) and the Great Horned Owl (weight over 1,000g), in addition to several species of the much smaller screech owls *Otus* and pygmy owls *Glaucidium*. Extensive interspecific relations must therefore exist between the Mottled Owl and the wealth of tropical and subtropical owls and birds of prey, mammals and reptiles in their role of competitors, predators and prey. Probably due to a rich supply of prey of different size, the Mottled Owl has apparently not needed to develop a noteworthy sexual dimorphism in size, which is small and amounts to 5–10% in favour of the female.

Although the Mottled Owl is generally reported to be a strikingly territorial species, nothing is known concerning degree of territorial defence and aggressiveness.

BREEDING HABITAT AND BREEDING

Mottled Owls have been observed in a variety of forests and woods and it has usually been supposed that all of these places represent breeding habitats. The locations range from evergreen lowland rain forests and cloud forests to winter-dry deciduous forests, second growth and thickets and "gallery forested streamsides in arid plateaus" in Costa Rica (Slud, 1964), to coffee fincas and other plantations, dense bamboo stands and mangroves. Only one reference to a nest site has been made, viz. an abandoned bird's nest in Trinidad, located in a hole in a tree (Belcher & Smooker, 1936:18).

Mottled Owl *Strix virgata*
South Brazilian race *S. v. borelliana* in Osage orange or bow wood tree *Maclura pomifera*, originally from southeastern North America

FOOD AND FEEDING

Only scarce data, compiled from an inspection of stomach contents of collected specimens, are available and these range from small mammals, including the nocturnal and often arboreal spring pocket mouse *Heteromys anomalus* in Trinidad (Buchanan, 1971) to a small snake, a salamander, and large insects (*Orthoptera*, *Coleoptera*) in Panama (Wetmore, 1968). The data suggest a great versatility in food and feeding habits, as in other *Strix* owls.

MOVEMENTS

The Mottled Owl is considered strictly sedentary.

GEOGRAPHIC LIMITS

The Mottled Owl's range appears to extend through the whole of the American tropical lowlands, from Mexico to Argentina. In the northwest it meets the Spotted Owl and on the Mexican and Central American mountain slopes the Fulvous Owl *Strix fulvescens*, both of which may impede the Mottled Owl's northward extension. In the south the presence of the Rufous-legged Owl *Strix rufipes* may be a factor delimiting an extension in southern South America. Nothing is known, however, of specific adaptations by the Mottled Owl to tropical and subtropical forest surroundings. It has the naked, unfeathered toes (but feathered tarsus) of most of the tropical owls, but this is also a characteristic of owls of other climatic regions (Kelso & Kelso, 1936).

LIFE IN MAN'S WORLD

Apart from its occurrence in small towns in the lowlands of Mexico and Central America, and in coffee, cacao, nutmeg and other plantations, the Mottled Owl hardly comes into contact with man. As long as this situation continues, and as long as the owl's forest habitat remains undisturbed, the Mottled Owl is not endangered by man, nor by man's domestic animals.

A study of the life history of the Mottled Owl in lowland tropical rain and cloud forests will undoubtedly produce numerous surprises. Opportunities for such studies exist in Central America where the Mottled Owl is one of the commonest of the medium-sized species of owl. Current political unrest may hinder these studies, however, as it has in tropical South America where the species appears to occur much more sporadically and where nocturnal animals are all equally elusive. This much seems to be certain at present: that the Mottled Owl is a tropical representative of the virtually universal wood owl genus *Strix*, that the Black-and-White (*nigrolineata*) and Black-banded (*huhula*) Owls are possibly the only members of a rather vaguely defined, tropical American genus *Ciccaba*, and that the subfamilies *Buboninae* and *Striginae* cannot be recognized (Voous, 1964; Norberg, 1977).

BROWN WOOD OWL
Strix leptogrammica

As in the case of all tropical wood owls, an apparent but somewhat puzzling relationship exists between the Brown Wood Owl and the better-known northern species of the genus. A bold, dark-eyed hunter of the woods, like other wood owls, the Brown Wood Owl nevertheless lacks the complicated and enlarged outer ear of northern owls and should therefore be considered a member, not of *Strix*, but of the circumtropical genus *Ciccaba* – if one may regard the latter as a genus in the familiar sense. Recognition of a genus *Ciccaba* disrupts, however, any presumed relationship between tropical and northern wood owls (Voous, 1964; Norberg, 1977). Consequently, the history and present status of the Brown Wood Owl, with its marginal occurrence in the Palaearctic, should be compared in the first place with subtropical and tropical wood owls in Africa and America. Such comparison forms the basis of the following account of this not uncommon though still little-known wood owl. For comparative details and a general theory on the genera *Strix* and *Ciccaba*, see under Mottled Owl *Strix virgata*.

GENERAL

Faunal type Indo-Malayan.

Distribution The Indian subcontinent, from Pakistan (western Punjab) and Garhwal in the west, the southern Himalayan montane zone, up to 2,600m, exceptionally over 4,000m in Nepal; south through the hill ranges of India and Burma to Sri Lanka up to 2,100m; east to southeastern China from Kwangsi and Fukien to Anwhei and the islands of Hainan and Taiwan, the forested hill tracts of Thailand, Indo-China, Malaya, Sumatra, Borneo and Java. Map 18.

Climatic zones Temperate, winter-dry tropical and tropical rain forest; subtropical and temperate mountain zones.

Habitat Deep tropical forests and dense jungle on hill tracts, subtropical submontane forests up to the oak-rhododendron zone in the Himalayas and lowland primary rain forests in the Sunda region.

GEOGRAPHY

Geographical variation Considerable; 9–17 subspecies have been recognized by various authors (see Ripley, 1977). Geographical variation relates to body size, depth of coloration, colour of facial disc and conspicuousness of white supercilium, barring of upperparts ("ultraventral" design) and barring of tail feathers. Wing length of birds in southern India (*Strix leptogrammica indranae*) and Sri Lanca (*S. l. ochrogenys*) is 83–84% of that of birds from the north; the smallest form with the most distinctively rufous colouring occurs on the island of Nias off the west coast of Sumatra (*S. l. niasensis*, wing length 70% of the North Indian form). The degree and pattern of geographical variation is not unlike that of the Serpent Eagle *Spilornis cheela*.

Related species The Spotted Wood Owl *Strix seloputo* of southeast Asia (the colour plate in Burton, 1973:136, erroneously represents the Spotted Wood Owl and not *Strix leptogrammica*) and the African Wood Owl *Strix woodfordii*. The relationship between the Brown Wood Owl and these tropical owls, and also the Tawny Owl *Strix aluco*, has not been detailed.

STRUCTURE

Structurally the Brown Wood Owl resembles other wood owls of the genera *Strix* and *Ciccaba*. The outer ear openings are asymmetric in size and also, to some extent, in position; the vertical axis of the right orifice is 21.9mm on average, that of the left one is smaller: 17.2mm (Voous, 1964; Norberg, 1977). These data are similar to those collected for the North American Spotted Owl. In the last-named species, however, a pre-aural dermal flap averaging 13mm in width is present – a characteristic of the northern *Strix* owls – while in the Brown Wood Owl the ear opening is bordered by a rim of no more than c. 2mm width – formerly considered a typical characteristic of *Ciccaba*.

Nothing is known regarding hearing and vision in the Brown Wood Owl.

OVERLEAF: **Brown Wood Owl** *Strix leptogrammica*

Brown Wood Owl *Strix leptogrammica*
Northern island race *S. l. caligata* from Taiwan

BEHAVIOURAL CHARACTERISTICS

Songs and calls The Brown Wood Owl is said to be vocal during moonlit nights, as are all other wood owls. Its territorial song resembles theirs and has been described as a sonorous *huhu-hooo* in Sri Lanka (Henry, 1971) and "a low double hoot, *tu-whoo*" on the Indian subcontinent (S. L. Whymper). Also described is a barking *wow wow*, undoubtedly signifying alarm, and a variety of "weird, eerie shrieks and chuckles", which in wood owls usually denote aggression.

Circadian rhythm The Brown Wood Owl is said to be virtually nocturnal.

Antagonistic behaviour The Brown Wood Owl is known to seek camouflage, much like northern wood owls, by "compressing itself into the semblance of a stub of wood", "with half-closed eyelids" (Sri Lanka, Henry, 1971). When attacked or alarmed it will resort to snapping its bill in a fierce manner – again, a frequent characteristic of other wood owls.

ECOLOGICAL HIERARCHY
Nothing known.

BREEDING HABITAT AND BREEDING
The few data available (Baker, 4, 1927; Ali & Ripley, 3, 1969; Henry, 1971) all indicate nesting habits characteristic of all other wood owls. Nests have been found in large cavities in big forest trees and the forks of massive tree trunks, under the shady overhang of cliff faces and sometimes, as in the case of northern wood owls, on the ground between the roots of a tree or half-hidden under a rock. Clutch size is small (2).

FOOD AND FEEDING HABITS
The Brown Wood Owl's diet includes an unspecified variety of mammals (rats and other rodents), birds and small and medium-sized lizards. Nothing has been published regarding its hunting methods.

GEOGRAPHIC LIMITS
As a tropical species with little-developed outer ear modifications, the Brown Wood Owl is presumably less well adapted to the dramatic seasonal variations of habitat and food to which forest owls are subjected in temperate and boreal regions. Its geographic limits may therefore be defined by climatic conditions of latitude and altitude. Its northern distribution limit touches the border of the Palaearctic region where it meets the Tawny Owl above the oak-rhododendron forest zone in the Himalayas over 2,300m. Its situation resembles that of the Mottled Owl in Central America and Mexico, where the latter is restricted by the Barred and Spotted Owls in their northern woods.

LIFE IN MAN'S WORLD
More than most other owls in the Indian and Malaysian subcontinents, the Brown Wood Owl appears to shun direct contact with man and avoids cultivated land, though it has been sighted in a dense temple grove at Kathmandu, Nepal (Fleming & Traylor, 1961).

The Brown Wood Owl is a truly tropical representative of the wood owl genus *Strix* with non-complicated auricular development and unspecialized feeding habits. Its life style, hearing and visual abilities are all worth studying and, as far as is known, resemble those of the tropical American Mottled Owl *Strix virgata*.

TAWNY OWL
Strix aluco

The Tawny Owl is one of the best-known wood owls *Strix*, of which there are 13 species in all. It is an exclusively Old World species living in mainly temperate climates. In many parts of Europe it is the most numerous owl, sharing its habitat with, for example, the Long-eared Owl *Asio otus* and Barn Owl *Tyto alba* and driving away or killing Little Owls *Athene noctua* and Scops Owls *Otus scops*. With its average body weight of 474g in males and 583g in females, it is about 70% heavier than Long-eared Owls and 60% heavier than Barn Owls, although in size and wingspan these owls all look much the same. The wings of the Tawny Owl are broad and rounded, rather than long and slender as in the other two species, and are adapted to life in woodland and forest, where Tawny Owls move with the agility of *Accipiter* hawks.

A characteristic feature of the wood owls of temperate and boreal regions are the large and complicated outer ears, which have stimulated fantasy and serious physiological research alike. The eyes are large, dark and very conspicuous; their functioning has been the subject of inconclusive theories and of physiological laboratory experiments and physical research. The most thorough studies of structure and functioning of eyes and ears in the Tawny Owl have been undertaken by Graham R. Martin and Ian A. Gordon of the University of Exeter, later of Birmingham. After rejecting the theory that Tawny Owls are capable of observing infrared waves and hence can move easily in what we would consider impenetrable forest darkness and can recognize warm-blooded prey animals by sight (Vanderplank, 1934), Graham Martin concluded that Tawny Owls possess only restricted colour vision, which "may be mediated by either a dichromatic or an anomalous trichromatic visual system" (Martin, 1974:133; see also Ferens, 1948). Recently Martin explained how his behavioural studies had shown "that in the eye of the Tawny Owl both absolute visual sensitivity and maximum spatial resolution at low light levels are close to the theoretical limit dictated principally by the quantal nature of light and the physiological limitations on the structure of vertebrate eyes" (Martin, 1986:266). In an earlier paper the same author had already concluded that, assuming "a normal distribution of individual thresholds, there must be some individual humans who are, in fact, more sensitive than some individual owls!" (Martin, 1978:74). His assumption seems to be wrong, however, for individual owls with less than optimal hearing abilities cannot be considered to survive for long.

Martin attributes the Tawny Owl's ability to move and hunt in the dark less to an extraordinarily high sensory sensitivity than to a detailed knowledge of local topography. Despite their apparent soundness, however, his physical calculations fail to account for the extraordinary ability of this and other owls to move in the darkness of *unknown* surroundings, for not all owls are anywhere near as resident as the Tawny Owl. Anyone who has experienced the pitch-darkness that descends below the closed canopy of any forest at night must wonder how owls and other nocturnal birds, hunting small prey moving among the dense and varied vegetation, succeed at all in picking up the visual and auditory signals needed for capturing their prey.

Martin's theoretical findings can probably be applied in part but not in full to the perfection of directional hearing in the Tawny Owl, and its exact location of moving prey. Directional hearing is made possible by the structural asymmetry of the ears, the direction of the main axis and the movable skin folds of the outer ears (discussed in detail under Barn Owl *Tyto alba* and Tengmalm's Owl *Aegolius funereus*). Among members of the wood owl genus *Strix* noteworthy differences exist in the complexity of the outer ears, in particular between tropical and boreal species. The tropical owls have minute, the boreal owls wide ear folds (Kelso's Rule, 1940). The supposed consequences of these specific differences in hearing sensitivity of the species concerned and taxonomic implications have been discussed under Mottled Owl *Strix virgata*, but apply equally well to the African Wood Owl *Strix woodfordii* (Nieboer & van der Paardt, 1977). The ecological differences between the Tawny Owl and its relatives in other parts of the world, and between the Tawny Owl and the sympatric Long-eared and Barn Owls, form the main themes of the following species account. The relation of the Tawny Owl to the northern Ural Owl *Strix uralensis* and the history of their origin as species is discussed under Ural Owl.

GENERAL

Faunal type Palaearctic, with distinct European and Sino-Himalayan elements.

Distribution Trans-Palaearctic, from Britain (not Ireland) to Korea, with separate European and central and east Asiatic ranges, almost adjoining one another in western Kazakhstan. In Europe, from Fennoscandia and Russia south to the wooded

parts of Morocco, Algeria and Tunisia and the Caucasus Mountains. Not included are most of the boreal forests where, apart from a marginal overlap in northern Europe, the Tawny Owl is replaced by the Ural Owl. With the retreat of the northern forests and the extension of cultivation the Tawny Owl has expanded its range incidentally to over 66° north in Norway, 63° north in Sweden and somewhat over 65° north in Finland, where it was first found nesting in 1878 (Mikkola, 1983). In west Siberia it has spread outside the dense taiga forest to the Irtysh River at about 75° east.

It occurs sporadically in deciduous forest remnants in the hills of Asia Minor; also Lebanon and Hebron in the Judaean hills of Israel (Bodenheimer, 1935), where it meets Hume's Owl. Iraq, Azerbaijan, southwest Iran (Zagros Mountains) and the South Caspian mountains east to the Kopet Dag. The Asiatic ranges include the Tien Shan and other mountains in Kirghizistan, Tadzhikistan, Afghanistan, northern Baluchistan, Kashmir and the Himalayas to northern Burma (Chin Hills), south to Mt Victoria and the eastern Kachin and Shan States (Thompson & Cradock, 1902), most of southern and eastern China, wherever there are still forests, parks and sacred temple gardens, and, with possible discontinuities, north to southern Manchuria and Korea; also Taiwan. Map 19.

Climatic zones Mainly temperate, but extending into southern boreal, mediterranean and marginally steppe climatic zones and mountain regions. The northern limit approximates the annual mean temperature of 2–4°C, which means an overlap with the more northern Ural Owl, whose range extends south to areas with annual mean temperatures of 6°C.

Habitat Deciduous and mixed forests with old trees, open woodlands, parks and gardens, gnarled oak woodland in the Mediterranean countries, subalpine coniferous forests in the Gredos and Guadarrama Mountains in central Spain (Bernis, 1956), mature coniferous forests in the boreal north, tall conifer forests interspersed with birch and poplar in Siberia and montane forests of oak, pine and fir at 1,800–4,200m in the Himalayas (Baker, 4, 1927). Generally not higher than 1,600–1,800m in the Alps and mainly in the montane zone with beech predominating (Scherzinger, 1981), but it has been observed as high as 2,650m on Piz Lagrev, Graubünden, Switzerland (Glutz & Bauer, 9, 1980:588). Up to 2,350m on Mt Ararat on the border between Armenia and Turkey and 2,000–2,275m in the central Asiatic Tien Shan (Dementiev & Gladkov, 1, 1951). In Burma in cloud forest at 2,600–2,800m (Stresemann, 1940). Provided spacious nest boxes are available, it readily settles in Europe in relatively young, otherwise unsuitable forest plantations.

GEOGRAPHY

Geographical variation Moderately conspicuous in colour, colour pattern and size. Except in the colder habitats, where the owls are of a cold-grey coloration, distinct rufous-brown and grey colour morphs occur in most regions, often connected by a variety of intermediates. While brown morphs predominate in the more humid parts of western Europe, the grey morph is more numerous in continental areas. Siberian and central Asiatic mountain races are dull grey and white almost without exception. All North African Tawny Owls are a dark grey-brown. Himalayan and east Asiatic Tawny Owls (*nivicola* subspecies group) differ from the European subspecies (*aluco* group) by having underparts more or less strongly barred rather than striped, and showing fine concentric dark lines on the facial disc surrounding the eyes. Siberian and Scandinavian birds are larger by about 12% and heavier by about 40% than Tawny Owls from central and western Europe and Britain, excluding seasonal variation in weight. Compared with the latter (*Strix aluco aluco* and *S. a. sylvatica*), the average wing length of Siberian birds (*S. a. siberiae*) is 113%, of northwest Himalayan birds (*S. a. biddulpii*) 97%, central and east Himalayan birds (*S. a. nivicola*) 108%, North African birds (*S. a. mauritanica*) 105% and that of Tawny Owls from Taiwan (*S. a. yamadae*) 103%.

Apparently the Tawny Owl is in a flexible stage of subspecies formation, probably relating to the colour tone of the habitat by day, mean ambient temperature and size of available prey. Thus, the number of subspecies recognized varies among authors between 10 (Vaurie, 1965) and 15 (Eck & Busse, 1973).

Related species For relationship with the marginally overlapping Ural Owl *Strix uralensis* and the North American Barred Owl *Strix varia*, see under Ural Owl. A close relationship between Tawny and Ural Owls has been proved by fertile hybrids raised in captivity (Tawny female × Ural male) and is fully discussed in the chapter on the Ural Owl (Scherzinger, 1983). The relationship with Hume's Owl *Strix butleri* appears to be even closer (see that species). The Afrotropical Wood Owl *Strix woodfordii*, though sometimes ascribed to the genus *Ciccaba*, seems to be another close relative, as recently confirmed by a comparison of vocalizations in wood owls from Morocco and Senegal, West Africa (van der Weyden, 1972).

STRUCTURE AND HEARING

The Tawny Owl is a short-tailed, broad-winged owl with a complete, circular facial disc, large, round, dark eyes and a notably robust body. Legs and toes are heavy and the claws are strong. Osteologically, neither this species nor the other members of its genus were found to differ from members of the tropical wood owl genus *Ciccaba* (Ford, 1967). The breastbone is short, as in birds of prey with aerial hunting methods (*Accipiter*, *Falco*).

The outer ear openings are large and complicate, asymmetrical in size as well as in the structure of the pre-aural skin flap, but no asymmetry of the skull has been found. The ear orifice is similar to that in the Ural Owl and less complicate than in the Long-eared and Short-eared Owls. The left ear slit is reported to be on average 21mm (Voous, 1964) and 23mm (Norberg, 1977) wide, the right one 22.5mm and 26mm, as compared with 24mm (left) and 27mm (right) in the Ural Owl and nearly double the size in the Long-eared Owl. The movable pre-aural skin flap was on average 9.5mm (Voous, 1964) and 10.5mm (Norberg, 1977), as against 13mm in the Ural Owl and 8.5mm

Tawny Owl *Strix aluco*
European race *S. a. aluco*, red-brown morph (lower left) and grey morph (upper right) at nesting hole with downy chick in English oak *Quercus robur*

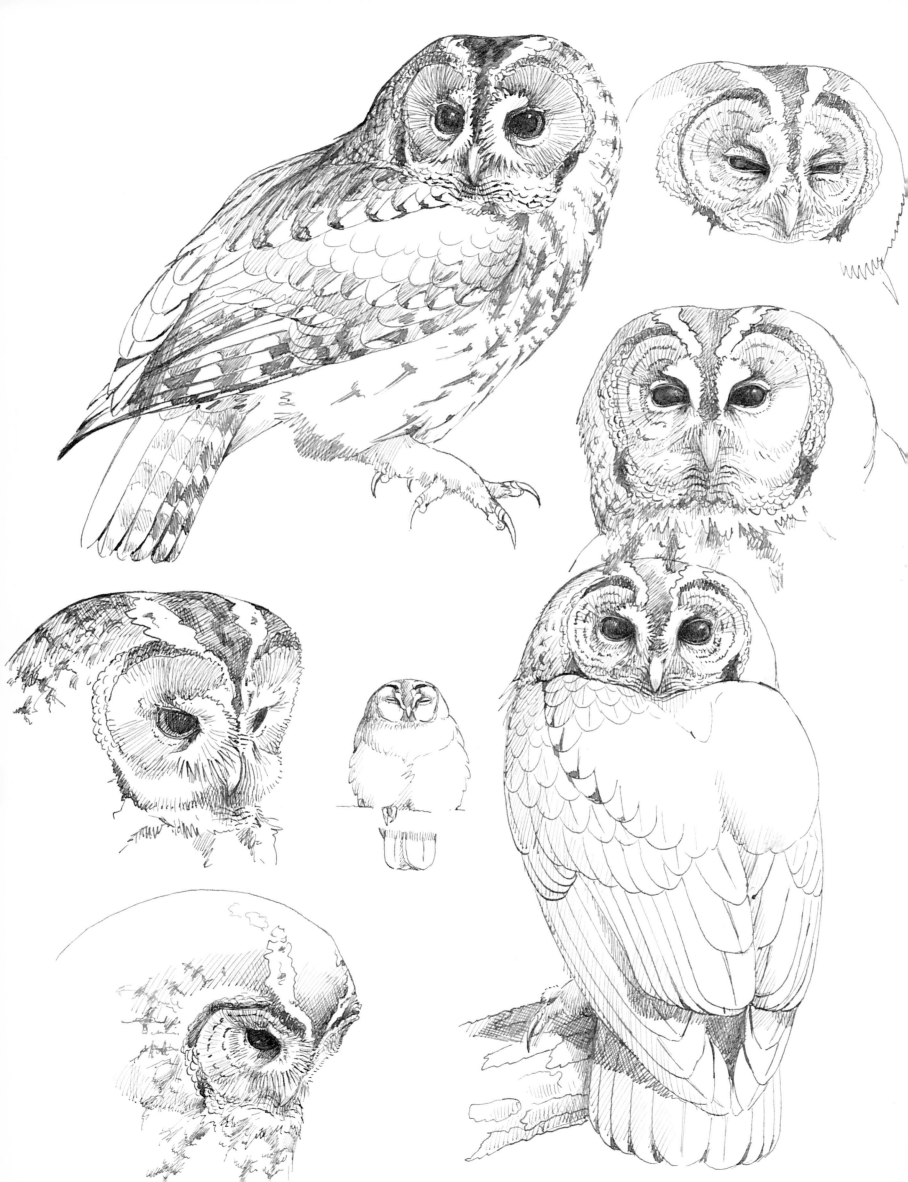

in the Long-eared Owl. I found the right ear larger than the left one in three fresh specimens and in five out of seven study skins (Voous, 1964); the right ear was larger in all six birds examined by R. Å. Norberg. The average ratio of asymmetry found was 7% and 13%, respectively, which is relatively small.

Based on the asymmetrical structure of the outer ear, directional hearing in the Tawny Owl is thought to be highly developed, but not better than in the Long-eared Owl. However, relevant experiments do not seem to have been carried out. Hearing ability is thought to be acute, but less so than in the Long-eared Owl, particularly relative to the higher sounds (8kHz and beyond), but also to medium-pitched sounds (4–6kHz), though individual variation was quite considerable. The range of maximum sensitivity was found to lie at 3–6kHz, in the Long-eared Owl at 6kHz and in the European Eagle Owl at 1kHz (van Dijk, 1973). Similarly, the number of auditory nerve cells (neurons) processing acoustic information in the brain stem is less than in the Long-eared Owl, much less than in the Barn Owl, but more than in the Eagle Owl and the Little Owl (Schwartzkopff, 1963). The physical properties of hearing and vision, including mainly yellow- and red-absorbing visual pigments in the cone receptors in the retina, have been described and discussed by Graham R. Martin (1982, 1986; Bowmaker & Martin, 1978), who considers that they do not exceed those of other nocturnal and diurnal vertebrates, including even performances by man.

BEHAVIOURAL CHARACTERISTICS

Songs and calls Vocalizations are as varied as in the Barred and Ural Owls and are surpassed in this respect only by the Long-eared Owl. The owl's songs and most of its calls are sonorous, deep and mostly musical to human ears. At least ten basic calls in adults and five in young have been described by numerous authors (T. Andersen, P. A. D. Hollom, J. Lindblad, W. Scherzinger, H. N. Southern, V. Wendland). The well-known territorial, advertising and courtship songs have been rendered as *hooo-huhuhohooo*, the final note prolonged, resonant and vibrating. Individual owls can be recognized by their own, constant pitch and tremolo. The female song is similar, less clearly phased, somewhat incomplete and slightly higher in pitch. Male and female can sometimes perform a duet in order to reconfirm possession of their territory and to strengthen the pair bond. More often the female answers with a melodious *koowee* or *keewick* or even with the neutral contact or position call *kewick* used by both sexes. When the male or female are slightly annoyed they utter a more impressive *koo-ik koo-ik*. In territorial disputes or when genuinely alarmed the birds indulge in a loud, discordant, barely describable "caterwauling", which is quite spine-chilling when heard unexpectedly at close quarters in the dark. The warning call, comparable to the impressive "belling" of the Ural Owl, is a rapid *weck-weck* or *wick-wick* by the male, or a softer and higher-pitched *ooweck-weck* or *owui* by the female. Various trills at different pitches are uttered, probably mainly by the female, during courtship and territorial disputes between neighbouring females. The hunger and position call of young outside the nest is a wailing, high *sziii-ii* or *su-ip*, sometimes repeated monotonously throughout the night.

Circadian rhythm Generally nocturnal. Around Berlin, in East Germany, nocturnal activity started on average 18–22 minutes earlier and return to day-roosting sites occurred on average 10 minutes later than was observed in nearby Long-eared Owls (V. Wendland, in Wille, 1972). Elsewhere Tawny Owls may start becoming active later than Long-eared Owls. Two activity peaks, one at the beginning of the night and one just before sunrise, are reported for winter and breeding seasons alike. Where the northern summer lasts only a few hours, there is a single peak around midnight and hunting activity often continues well after sunrise. Particularly when older young need to be fed, male Tawny Owls have been reported to hunt well on into the day in all parts of Europe, extending their active period up to 11 hours, 2 hours more than usual.

The observation in England of a Tawny Owl mixing with Black-headed Gulls catching earthworms and arthropods in upturned soil in the wake of a plough is a noteworthy, but probably exceptional, event (Beven, 1965).

Antagonistic behaviour When mobbed by small passerines and other birds by day, pressed against a tree trunk on its roosting place or hidden in evergreen vegetation, the Tawny Owl usually assumes a sleek, erect posture with eyes closed to narrow slits and head showing knob-like protuberances above the eyes. In this "freezing" posture it resembles a large Tengmalm's Owl and simulates as effectively as that owl a dead tree stump. It escapes the notice of passing humans in the same way. In cases of alarm or self-defence the Tawny Owl appears to expand in size by raising its feathers and thrusting one half-outstretched wing as a shield between itself and the source of danger (Scherzinger, 1971) and snapping its bill ferociously.

Though they usually retire when harassed by intruders, individual Tawny Owls have been known to behave like furies in the neighbourhood of their nests, particularly early in the night and at dawn, though some have attacked passers-by at other times of the day. There are numerous reports of Tawny Owls terrorizing humans, dogs and cats in parks and around houses in all parts of Europe (Boswall, 1965; Mooy, 1982:89), and public parks have been temporarily closed because of unprovoked attacks by nesting Tawny Owls, e.g. in May 1979 at Mönchengladbach, West Germany (Steinbach, 1980:171). Tawny Owls attack from behind, but may also fly right into the intruder's face, concentrating on the eyes, sometimes with fatal results to the latter (Hosking & Newberry, 1945:115). Bold behaviour towards man appears to be more frequent in urban and suburban areas than in the woodland, possibly as a result of more frequent disturbances and a closer acquaintance with human activity on the part of the owls. This has been confirmed in Britain, central Europe and Finland, but near Simla, out in the wilds of the western Himalayas, a Tawny Owl nesting in "a fairly large cavern in a small cliff" was once found clinging to the chest of an observer, while on another occasion the same bird made a most determined attack, knocking off the man's hat and drawing blood from his scalp and face (Baker, 1934:501). In its aggressive behaviour the Tawny Owl differs little from its similarly powerful and vicious relatives, the Ural Owl and the Barred Owl, and other members of its genus.

Tawny Owl *Strix aluco*
Dark-brown morph of European race *S. a. aluco*

ECOLOGICAL HIERARCHY

In its temperate European range the Tawny Owl is the strongest of the medium-sized owls, surpassing the Long-eared Owl by 72% of body mass and the Barn Owl by 57%. With its body weight of on average 474g in males and 583g in females, it is almost three times heavier than the Little Owl, but five times slighter than the Eagle Owl. Expressed in skeletal proportions, the breastbone (average length 42.5mm) is about 10% longer than that of the Long-eared Owl and 9% longer than the Barn Owl's, while the bones of arm and hand combined (266mm) are 14% and 6% longer, respectively (Winde, 1970). As a result of the short, rounded wing, the wing-loading ($0.40g/cm^2$) is larger than that recorded for the Long-eared Owl ($0.31g/cm^2$) and the Barn Owl ($0.29g/cm^2$) (Mikkola, 1983:350). Due to its great weight and strength, *Accipiter*-like surprise attacks and general feeding habits, the Tawny Owl handles larger prey more frequently than do other owls. As an example, in Spain, 23% of prey numbers consisted of rabbits, as against 0.3% in the Long-eared Owl and less than 0.1% in the Barn Owl. In comparison, the Eagle Owl took 49% rabbits and the Buzzard 19.5% (Jaksić & Soriguer, 1981).

Though Tawny, Long-eared, Barn and even Little Owls frequently nest rather close together, their hunting habits differ qualitatively: the short- and broad-winged Tawny Owl usually remains within the limits of forest, wood and parkland and rarely extends its hunting forays into open fields and hedge country as the Long-eared and Barn Owls do. As a result, the Tawny Owl catches, proportionately, considerably more wood mice *Apodemus* than voles *Microtus*, in addition to a larger variety of prey than either the Long-eared or the Barn Owl (Erlinge *et al.*, 1984). Consequently, whereas the Long-eared Owl leaves the area when the vole supply is exhausted and the Barn Owl relies when necessary on shrews and birds, the stubbornly resident Tawny Owl rarely faces a food shortage, and even less interspecific competition (Rockenbauch, 1978).

In recent years the Tawny Owl has been invading towns and cities in continental Europe as well as in Britain. Wherever this occurs the Tawny Owl seems to evict the Barn Owl from its traditional breeding sites in and around buildings and human habitation (Glutz & Bauer, 9, 1980:590).

Where the Tawny Owl meets the equally sedentary Ural Owl in the narrow zone of overlap in central Sweden both species feed on ground vole (relatively less in Tawny Owl) and short-tailed vole (relatively less in Ural Owl), but they are mostly segregated by habitat, the Tawny Owl preferring cultivated parklands, the Ural Owl mostly keeping to boreal coniferous forest (Lundgren, 1980).

The Tawny Owl is, after the Eagle Owl, the strongest European predator of other owls (6 species recorded), the main victims being the Little Owl (60.5% of 38 instances), followed by Tengmalm's Owl (16%), while the Long-eared Owl figures with 8% (Mikkola, 1983:379). Several authors in Germany have stressed that the Tawny Owl is a threat to nesting Tengmalm's and Pygmy Owls, particularly where its presence is supported by the erection of nest boxes (C. König, S. Schönn). The Tawny Owl is also strong enough to kill and eat diurnal birds of prey, sometimes of considerable size, but most often nestlings. In this respect too it is second to the Eagle Owl. Of 33 instances recorded, Sparrowhawk and Kestrel each figured with 45%, while one Goshawk was taken (Mikkola, 1983:380).

The Tawny Owl has been preyed upon in its turn by the Ural Owl and 286 times by the Eagle Owl (22% of 1,288 cases recorded). Goshawk and Common Buzzard have also frequently taken Tawny Owls (Mikkola, 1983:381). Of 1,611 bird preys taken by the Eagle Owl in central Europe and summarized by Otto Uttendörfer (1952), 39 were Tawny Owls (2.4%), which is far fewer than Long-eared Owls (14%); of 8,309 bird preys taken by Goshawk, 46 were Tawny Owls (0.6%), again less than Long-eared Owls (2%).

Despite their vigour, a number of Tawny Owls in several places in the Netherlands failed to prevent Jackdaws from entering their nesting hole and dumping branches and twigs on top of the breeding owl in order to begin their own nest construction. Not only the owl's eggs and young, but also the persistent brooding owl, were covered and either suffocated under the new load or starved to death (Buker & Hartog, 1985; Koning, 1986).

By habitually nesting in nest boxes the Tawny Owl has become vulnerable to attack and predation by pine marten, e.g. in northeastern France. Nest boxes are much more obvious than natural holes and can hardly be missed, and the marten has learned the value of examining any nest box in its territory. Of 209 bird preys recorded for the marten in montane oak and beech forest in the Côte d'Or, nine were Tawny Owl eggs and nine Tawny Owl young (Baudvin *et al.*, 1985). However, a Tawny Owl is fully capable of chasing a marten through the trees when it accidentally meets one by day (Szomjas, 1955), as well as driving foxes, dogs and cats from the vicinity of its nest. It preys on stoats and weasels when the opportunity arises.

Female European Tawny Owls are heavier by 20–40% than males; their wings are longer by 5–10%. In the Netherlands the sum total of their claws is 7% longer (on average 142.5mm), in Sweden 7.5% longer (on average 143.3mm) than in males. Females are therefore the stronger predators, but it is not known whether this results in their taking larger prey on average.

BREEDING HABITAT AND BREEDING

The Tawny Owl usually nests in spacious tree holes of 1–3m depth in mature deciduous forest and open woodland, but it is sufficiently adaptable that it will accept other nest sites. Thus, it has been found nesting, like many other owls, in large, unused tree nests belonging to birds of prey, such as Buzzards, Goshawks, Sparrowhawks, Black Kites and others; also in the nests of Crows and Magpies, and even in the small ones of Jays and Woodpigeons, in squirrel dreys, on top of a witches' broom in tree crowns (Meeus, 1981), in stick nests abandoned by Buzzards and Ravens on cliffsides, even on bare cliff ledges, hidden between the roots of heavy tree trunks, in rabbit holes, in the earths of fox and badger, on the bare forest floor and, in Scotland, among heather (Donald Watson). It has also nested in recesses in stone walls, under roofs and in the chimneys of large buildings, in cabins and sheds, in dovecotes, church towers and, recently, in spacious nest boxes and other artificial nests erected for its use, preferably with entrance holes of at least 15 × 20cm width. I have found only one published record of a Tawny Owl

Tawny Owl *Strix aluco*
Iranian pale desert race *S. a. sanctinicolai* with Desert Lark *Ammomanes deserti* as prey

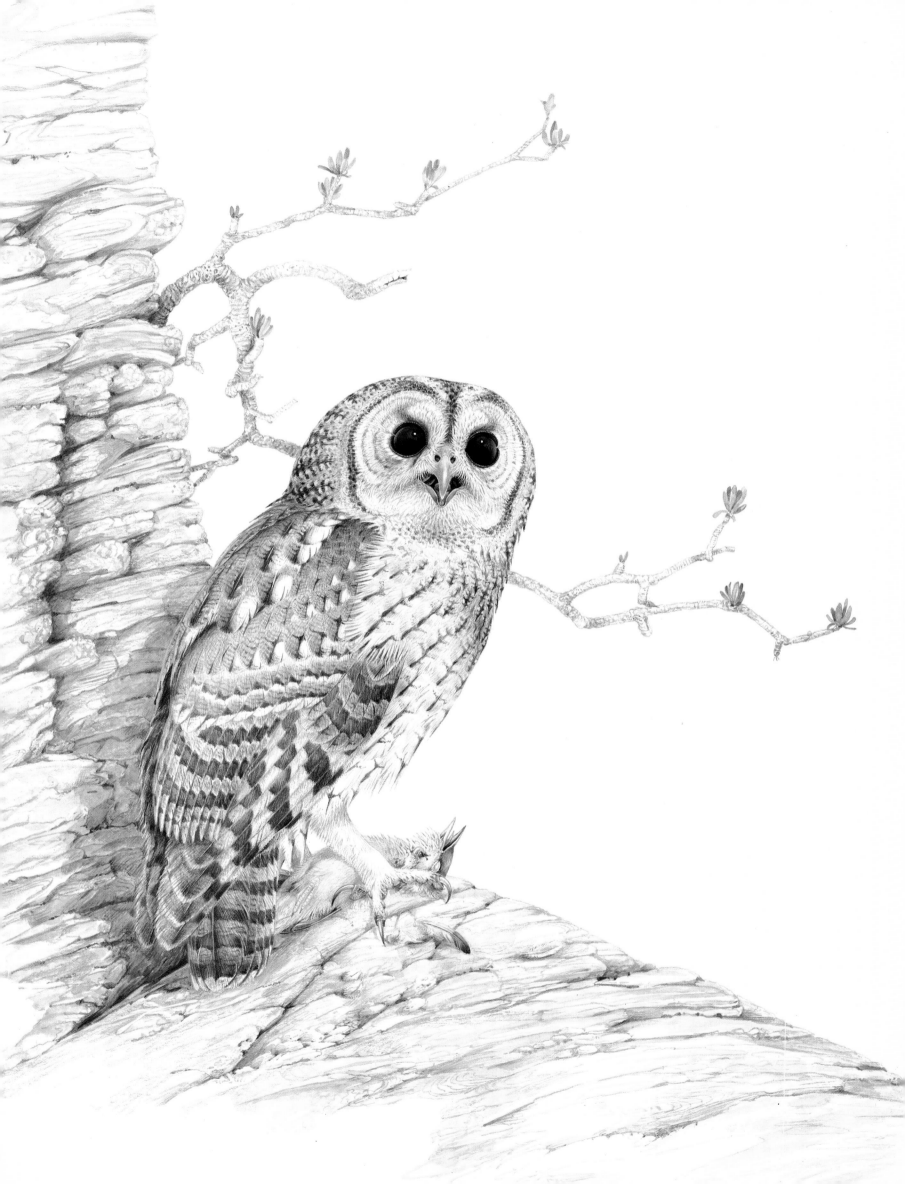

nesting in a woodpecker hole (Black Woodpecker, in pine, Tegeler Forest, West Berlin; Wille, 1972). Nest boxes, particularly those of a tube-shaped design (H. N. Southern), are strongly favoured. In south Finland the use of nest boxes increased from 33% of 46 nests found in 1940–59 to 95% of 123 nests in 1970–75. In the same period tree hole nests decreased from 48% to 3%, nests on top of broken tree stumps from 4% to 1% and nests in buildings from 15% to 1% (Mikkola, 1983:364). Tree holes used were in aspen, birch, lime, pine and spruce.

In contrast to the Long-eared Owl, which of all owls most frequently shares the Tawny Owl's habitat, the Tawny Owl is strictly sedentary and as a rule pairs stay together in their chosen territory for the whole of their life. Individual owls are known to have lived in their territories for 10 years (Russia; Dementiev & Gladkov, 1, 1951) and 13 years (Berlin; Wendland, 1972), and there are other similar reports. While the male apparently selects the territory, the female seems to make the final choice of the nest site (V. Wendland). Food supply and accessibility are the crucial factors in the selection of habitat and determine whether or not the birds will proceed to breed. Evidently, moist, mature deciduous forest is preferred to dry mixed or coniferous forest. However, when nest boxes are provided any forest type will do. Villages, towns and cities have been invaded at the expense of the Barn Owl, and there seems no end to the Tawny Owl's adaptability in terms of habitat choice.

Territories have to supply nesting sites and food for the whole year. Hence they can be smaller when conditions are optimal, such as in Britain in deciduous forest (average 18.2ha), but are larger in mixed farmland (37.4ha) and larger still in mature spruce forest (46.1ha). In open parkland near Oxford, with a fairly sparse ground cover and mice and voles easily accessible, territories could be as small as on average 7.3ha (G. M. Hirons); where a dense ground cover provided more shelter for young rodents, the average territory size was larger (13.8ha) (Southern, 1970). However, territories of 8ha and smaller were not viable for breeding. In central Europe average territory size is larger: 25–30ha in Germany and 65–75ha in beech wood in Belgium, while in Scandinavia it is larger still: 90–150ha (Glutz & Bauer, 9, 1980). Nests are usually a kilometre or more apart, but in the Tegeler Forest in West Berlin two nests were found as close to each other as 100m (Wille, 1972). Little is known about display and courtship in natural surroundings, though the male has been observed to perform a spiralling courtship flight well after sunset. Pair formation and reconfirmation of existing pair bonds start in early autumn with a liberal amount of territorial hooting and *kewick* contact calls. Even throughout the winter male and female often roost close together.

Breeding starts in mid-March in Britain (first egg recorded 25 March), after mid-March in continental Europe and end March to early April in Sweden. This is distinctly earlier than is usual in the Barn Owl (first egg in Britain 7 May, but data are irregular and contradictory) and the Little Owl (first egg in Britain 22 April) and also the Long-eared Owl (usually April). Depending on the food situation in winter, breeding can be advanced (from mid-February onwards in Schwabian Alps, south Germany; Rockenbauch, 1978), or delayed, or pairs may not breed at all after long winters with much snow (Britain, Scandinavia) or in poor vole years (Finland; Linkola & Myllymäki, 1969; Mikkola, 1983:150). Probably as a result of favourable and reliable food conditions (house mice, rats) and a somewhat higher ambient temperature, breeding in towns often starts remarkably early: end December, Amsterdam, Netherlands (date calculated from observed fledglings; K. H. Voous); first egg 9 January 1965, Munich, and 10 January 1975, Michelfeld, West Germany (Rockenbauch, 1978); late January, Riga, Estonia (Strazds & Strazds, 1985).

Clutch size is relatively small and fairly constant: 3–5, rarely 1–2, or more, up to 8. Average clutch size in Britain is given as 2.67, in central Europe 3.29, in Switzerland 3.3, in Denmark 3.65, in Finland 3.81 (Smeenk, 1969), in Sweden 4.04 (Mikkola, 1983, after data from Makatsch, 1976). In vole peak years the average reported in Finland was 4.2, the next year 3.1 (Mikkola, 1983). Average egg size shows little geographic variation: 46.7×39.1mm in Britain, 47.6×39.2mm in central Europe and 46.6×38.5mm in Sweden (Makatsch, 1976), 47.5×39.2mm in Russia (Dementiev & Gladkov, 1, 1951). Fresh egg weights are different, being 31.3g in Britain and 39.1g in central Europe (Makatsch, 1976), which is a difference of as much as 26%. Ural Owl eggs have an average weight of 44.8g, which is 15% heavier than in the Tawny Owl. Tawny Owl eggs from central Europe are 75% heavier than Long-eared Owl eggs (22.4g; Makatsch, 1976), marking the considerable difference in size and predation potential of the two birds.

Only the female incubates and broods the chicks; the male supplies food for his mate and young, delivering the prey inside the nest hole. The incubation period is approximately 29 days (Scherzinger, 1980). The young hatch synchronously, but the differences among the nest siblings are usually less than in the Long-eared and Barn Owls. Apparently, incubation does not always start with the first egg, but probably depends on weather and food conditions at the time of laying. Young cease to be continuously brooded by the female sometime between the 7th and 15th day, when she resumes hunting, the exact date being earlier when food is scarce than in years of plenty. Young leave the nest at the age of 25–30 days, but, particularly in shallow nest holes, the older young explore the nest entrance earlier and frequently fall out of the nest. Nestlings that have fallen to the foot of the tree often succeed in climbing back up and are cared for at all events by the parent birds. After fledging, the young fly at the age of 32–37 days and are fed by the parents for another 2–3 months, during which they utter their monotonous and melancholic contact and food call *sjiii-ii*. The whole breeding season covers a period of almost five months (March–August), which is longer than in the Long-eared Owl. This probably relates to the fact that it is hard for the young to find a suitable vacant territory (H. N. Southern; V. Wendland). Occasionally distraction display (broken-wing act) has been observed in the female, particularly when newly hatched young are in danger, but the display is considerably less dramatic than that exhibited by both sexes of the Long-eared Owl. Breeding success is relatively low as a rule: in Berlin 2.1, in south Germany on average 2.8 young per successful nest. It was higher in top vole years (3.2) than in poor years (2.7) (Rockenbauch, 1978). The literature includes numerous similar data (e.g. Linkola & Myllymäki, 1969), but in view of the different methods of calculation applied they are hard to compare.

Tawny Owl *Strix aluco*
Iranian pale desert race *S. a. sanctinicolai*

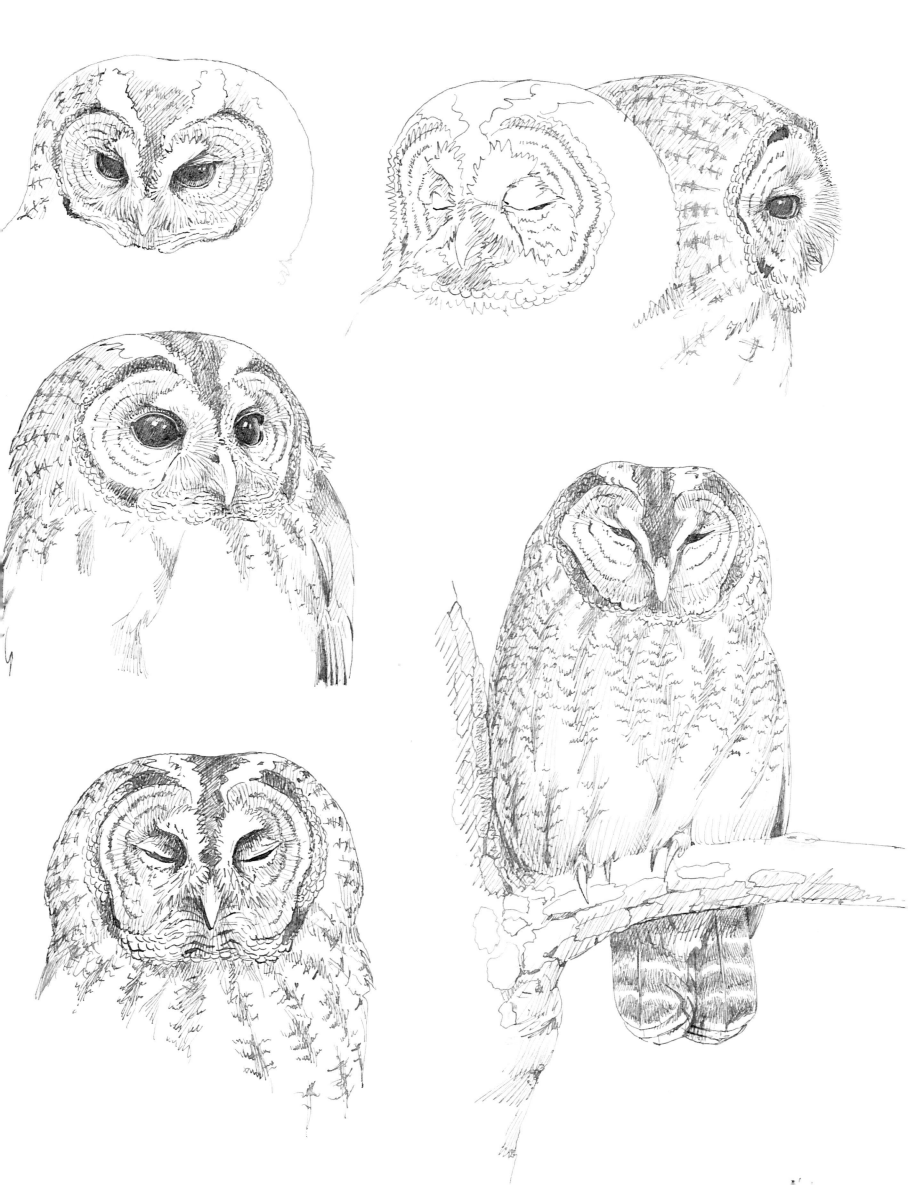

FOOD AND FEEDING

In contrast to the Long-eared Owl, which is basically a "restricted feeder", the Tawny Owl is a "general feeder" like the Eagle Owl. It hunts in a similar fashion to a *Buteo* hawk, perching on a branch or pole in its woodland habitat and pouncing upon passing prey, which can be as variable in size as that caught by the larger Buzzards. By employing high initial speed and manoeuvring among trees and shrubs with great dexterity, it surprises relatively large prey, resembling in this respect a Goshawk rather than a Buzzard. However, its hunting techniques are varied and it can quarter low over bushes, marsh and grasslands; examine tree holes and nest boxes; hover in front of bushes, dense foliage and evergreen conifers in order to terrorize and chase out small birds sleeping there at night; catch bats, large beetles and large moths in flight; take fish by skimming the water's surface, and extract earthworms from grassland in the manner of thrushes, or catch voles by waiting and jumping on them like a fox.

Since it is strictly resident and remains in its territory for probably the whole of its life, the Tawny Owl is dependent on the territory's food supply for better or for worse, in both good years and bad. Its feeding strategy is adapted accordingly. When its staple diet – small terrestrial rodents of the woodland floor – is scarce or inaccessible it escapes starvation by turning to either remarkably small prey, like insects, snails and slugs, or large ones like squirrels, half-grown rabbits and hares (up to 300–350g), or occasionally stoats, weasels, other owls and birds of prey. Though it may eat a fair proportion of shrews (on average 13%), it takes these musky-tasting animals less frequently than does the equally sedentary Barn Owl (32%), while, apart from in towns and cities, birds do not as a rule constitute emergency rations to the same extent as in the nomadic Long-eared Owl: 10%, as against 14% (Mikkola, 1983). The Tawny Owl's food is thus as varied as that of any other owl or bird of prey. This variation has fascinated many authors and the literature on the subject is very extensive. The main trends are summarized below, without reference to all authors consulted.

For central Europe Otto Uttendörfer (1952) listed 43,000 mammal prey items, representing 45 species, ranging from pygmy shrew (2.5–7.0g) and Etruscan shrew (1.0–2.5g) to fair numbers of bats (at least 16 species) and rodents, including those taken from trees and shrubs, such as red and grey squirrels, garden dormouse, edible dormouse, common dormouse, also common hamster, wood lemming, muskrat and small carnivores like weasel and stoat (Smeenk, 1974). Top scorers in Uttendörfer's list were voles (small *Microtinae*) with 26,807 specimens (62%), followed by small mice (mainly wood mice *Apodemus*) with 9,791 specimens (23%) and shrews with 2,583 specimens (6%). Birds accounted for 6,000 specimens from about 100 species. The House Sparrow (33%) was the top bird prey, followed by Greenfinch (11%), Chaffinch (9%), Blackbird (4%) and Tree Sparrow (4%). Uttendörfer further lists 5 species of reptiles (most frequently grass snakes *Natrix*), 11 species of amphibians, 10 species of fish and numerous arthropods, molluscs and others. Local variations are almost infinite. Of woodland rodents, field mice or wood mice are more frequently taken than the somewhat diurnal bank vole. In order to catch common and short-tailed voles, the Tawny Owl has to hunt in the open fields, something it appears to do infrequently and only where woodland and arable lands are largely intermingled.

Uttendörfer's data are inclined to conceal annual and seasonal variations, which subsequent authors show to be impressive (Southern, 1954; Southern & Lowe, 1968; Smeenk, 1972; Mikkola, 1983). On the open forest floor in winter any small moving animal (including carabid and dung beetles) is fair game for the Tawny Owl, but when the forest floor is covered with bracken, other ferns, or brambles, the Tawny Owl has to change its main hunting tactics. In England the beginning of May proved the crucial period for shifting to a diet of larger mammals and beetles, mainly cockchafers *Melolontha*, though representatives of at least 35 beetle genera have been recorded during April and May in the Netherlands (Smeenk, 1972). Later on, in the wet late-summer season, August–October, the owl catches earthworms, the chitinous bristles of which form fibrous, brown-coloured pellets (Southern, 1954). The Tawny Owl is not affected by the population cycle of voles and mice to the same extent as Long-eared and Barn Owls, but annual variations are nevertheless noteworthy, voles, wood mice and birds often alternating in its diet. Expressed in prey units of 20g, as proposed by H. N. Southern (1954), Tawny Owls in England consumed 34% birds (against 4% by Long-eared Owls in the same locality), 20% voles (against 87%), 9% amphibians (against nil), 8.5% shrews (against 2%), 8% mice and rats (against 1%), 7% moles (against nil), 7% wood mice (against 7%), 6% rabbits (against nil) (summarized by Smeenk, 1974:40). Tawny Owls living in cities and towns have adapted to different food and feeding habits. Thus, in eight European towns small voles were represented by 0–22%, average 8% (35% in rural areas), larger mammals, mainly brown rats, by 2–45%, average 16% (18%, mainly other species, in rural areas) (summarized by Cramp, 4, 1985), birds by 34–93%, average 63% (9% in rural areas). In central London (Kensington) 96% of the food consisted of birds, mainly House Sparrows and Starlings, the balance being made up largely of brown rats and house mice (Harrison, 1960).

Mean prey weight in different regions of Europe ranged from 29.1 to 39.9g, which is higher and also more varied than in the Long-eared Owl (22.5–22.7g). In the coastal dunes of the Netherlands the average prey weight taken by Tawny Owls was 130g (rabbits!), as against 25g in the Long-eared Owl (no rabbits) (Koning, 1982). Similarly, in Mediterranean Spain, rabbits were taken at a frequency of 23% (Jaksić and Soriguer, 1981).

Daily food requirements vary with the season and the ambient temperature; they are given as an average of 73.5g, as compared to 63–73g in the Long-eared Owl and 70–104g in the Barn Owl. This is an estimated average of 14% of the Tawny Owl's weight, 23% of the Long-eared Owl's and 26% of the Barn Owl's (data from Cramp, 4, 1985). It thus appears that, as a relatively northern-ranging territorial hunter, the Tawny Owl makes more efficient use of its body energy than do either the nomadic Long-eared or the more southern-ranging Barn Owl. More than any other owl, except perhaps the Great Horned Owl, the Tawny Owl is inclined to eat carrion, including fish washed ashore and animals and birds found in the field or caught in a trap; this is another habit that enables the Tawny Owl to survive yearlong in its restricted territory.

Little is known about the diet of the Asiatic Tawny Owl populations; small rodents, including jerboas or jumping mice, ground squirrels and birds of various sizes up to Hazelhen and Partridge have been reported from Siberia (Dementiev & Gladkov, 1, 1951).

MOVEMENTS AND POPULATION DYNAMICS

Like all other wood owls of the genus *Strix*, the Tawny Owl is strictly resident. Even the post-breeding dispersal of young, extending at random in all directions, is limited to some ten to maximally a few hundred kilometres. Displacements in Finland over more than 100km are rare. The majority of young in Sweden moved over less than 50km, 12% over 50–100km and only 4% over more than 100km; one ringed bird travelled over 745km NNW, from Västergötland to Västerbotten (Olsson, 1958). All long-distance movements by Tawny Owls ringed elsewhere in Europe are considerably shorter than in other owls and range from 270 to 450km (Glutz & Bauer, 9, 1980). Even in central Asian mountain ranges the Tawny Owl is said to be strictly sedentary; only during extremely cold winters does it descend in the Pamirs to lower elevations (Ivanov, 1955).

Mortality is high in the first year of life, when young leave the parental territory (August–October) (Glue, 1973); all instances of starvation reported July–November referred to young birds (Hirons *et al.*, 1979). Life expectancy in the first year is nevertheless higher than in the Barn and Long-eared Owls. In Switzerland it was found to be about 2.6, 1.4 and 1.2 years, respectively (Glutz & Bauer, 9, 1980). For the third year the figures are 3.6, 3.3 and 1.8 years. Of the three species, Tawny Owls live the longest. The oldest central European Tawny Owl recorded was 18 years 7 months, the oldest Swedish Tawny Owl 13 years 9 months; in captivity one owl reached over 27 years (Glutz & Bauer, 9, 1980).

As the Tawny Owl is less dependent on voles and mice than the Barn Owl, it shows considerably slighter population fluctuations than that species and than most other owls (Blondel, 1967).

GEOGRAPHIC LIMITS

The northern limit of the Tawny Owl's range is most probably defined by the presence of other owls of its genus, notably the Ural Owl (see that species). The lack of suitable habitats in the continental desert belt sets a limit to the Tawny Owl's range in the south. Beyond these uninhabitable arid regions, tropical owls of the same or larger size and similar habits prevent it from extending into sub-Saharan Africa and sub-Himalayan Asia. Winter mortality among Tawny Owls in Scandinavia is probably considerably higher than in the Ural Owl (Edberg, 1955). Hunger resistance, expressed as the percentage of minimal starvation weight to average weight, is better in the Tawny Owl (average 64.7%) than in the equally sedentary Barn Owl (76.2%) (Glutz & Bauer, 9, 1980:240). The effect is enhanced by a reduced food requirement and by a higher and therefore more efficient caloric use of food by the Tawny Owl in comparison with the Barn Owl: fresh food 17% and dry weight 4.9% of body weight per day in the Tawny Owl, as against 23.9% and 7.8% in the Barn Owl (Ceska, 1980). These physiological data mean that the Tawny Owl can extend further north in winter than the Barn Owl without succumbing to cold and undernourishment. Mortality in Russia and Siberia is nevertheless high in severe winters (Dementiev & Gladkov, 1, 1951).

LIFE IN MAN'S WORLD

The Tawny Owl has adapted itself to man's world by settling in parks and gardens in villages and towns, even in the centre of London, where for a long time one bird had adopted the habit of roosting by day on top of a streetlight (Beven, 1965, 1982; Sparks & Soper, 1970:95, 111). Not only in Europe, but also east of the Urals, in Siberia, Tawny Owls are known to nest year after year in churches, e.g. in Tobolsk (Johansen, 1956); also in unused chimneys, though adults and young have died when entering the wrong chimney shaft. Nesting in nest boxes is now a frequent occurrence throughout Europe, particularly in Scandinavia, where nest boxes have become the major nest site, e.g. in south Finland, where they constituted 33% of known breeding sites in 1940–59 and 95% in 1970–75 (Mikkola, 1983). Fatal collisions on roads and railways and with overhead wires are frequent causes of death in Britain (Glue, 1973) and continental Europe, particularly among first-year birds in late summer and autumn. Contamination with organic biocides, mercury compounds and other heavy metals applied in agriculture and forestry has also been reported, but the extent of the damage is not known (Conrad, 1977).

The Tawny Owl is a master of vision and hearing when moving through its territory to hunt for prey. Indeed, intimate knowledge of the nutritional potential of every corner of its territory is the clue to its very existence. When successful, it lives longer than the nomadic Long-eared Owl *Asio otus*, which regularly changes hunting grounds and affects open spaces with more nocturnal light than can penetrate the Tawny Owl's woodland and forest. With its almost outsized eyes of 16–17mm diameter, the Tawny Owl is probably more sensitive to light than the Long-eared Owl, which has eyes of about 11mm diameter. Conversely, the relatively small-eyed Long-eared Owl has even better hearing than the large-eyed Tawny Owl; at the medium level of 6kH and more the Long-eared Owl can observe sounds as soft as −91 decibels and beyond, somewhat better than the Tawny Owl and about ten times better than the average human. It is a general fact that in heavy wind and rain Tawny Owls have difficulty in catching prey or else do not hunt at all; noise interference is probably too strong. Graham Martin (1986) is certainly right, therefore, when he says that the minimum ambient sound level dictates the efficiency of physical hearing capacity.

There are clear indications that Tawny and Long-eared Owls and their relatives have developed along separate lines. This was brought home to me most clearly when in 1972 in our laboratory in Amsterdam within 24 hours all our 20 Long-eared Owls and our Short-eared Owls *Asio flammeus* succumbed to a probable *Hepatosplenitis infectiosa strigum* infection, together with one Forest Eagle Owl *Bubo nipalensis* and one Spotted Eagle Owl *Bubo africanus*, while in contrast all Tawny Owls, one Mottled Owl *Strix virgata* (from Venezuela) and all our Barn Owls *Tyto alba* (from Europe and the West Indies), kept in aviaries in the same or adjacent laboratory rooms, survived without any sign of illness. This appears to prove that basic immunochemical differences and hence different relationships exist between various groups of owls.

Hume's Owl

Strix butleri

That the group of *Strix* wood owls should have produced a desert-inhabiting offshoot is almost unbelievable, but this is exactly what Hume's Tawny Owl or Hume's Owl appears to be. With its golden-buff and white plumage, almost as soft and silky as a Barn Owl's, and the soft feathering of the underside of its toes, as if designed to protect the feet from being burnt by hot desert rock, Hume's Owl could hardly have evolved further in the direction of a desert-inhabiting owl. Allan O. Hume, British administrator in India and the "father and founder of the Indian National Congress", described it (1878) in 1878 on the basis of a specimen sent to him by Captain E. A. Butler from the eastern extremity of the forbidding Mehrakan (Makran) coast of Baluchistan (Ormara, now western Pakistan). For a long time Hume's Owl remained an extremely rare and enigmatic species. This situation was little altered when, immediately after Hume's publication, a second specimen, allegedly coming from Mt Sinai (Gebel Musa), 3,000km distant from Baluchistan, was found by Canon H. B. Tristram in his collection at Durham (now in the Liverpool Museum, Merseyside County Museums), where it had been kept undescribed for ten years. Tristram's specimen was probably identical to the one collected by C. W. Wyatt (1870) in 1864 in Wadi Feiran, then considered a specimen of African Marsh Owl *Asio capensis*. No further specimens were collected until 23 September 1911 (Le Roi, 1923) and then 31 March 1914 (Phillips, 1915). These also came from the Sinai Peninsula (Wadi Feiran, at the foot of the legendary Mt Serbal, claimed by some to be the mountain of the Hebraic Law Giving). Thanks principally to the work of Israeli ornithologists, starting with J. Aharoni (1931), and of explorers in Saudi Arabia, Hume's Owl is now known to occur in numerous places throughout the whole of the Middle East. Its occurrence in southern Iran, however, has simply been accepted in the literature without other evidence than Hume's original specimen. Even now, little is known about the life of this deserticolous wood owl.

Hume's Owl did not escape the notice, however, of the early desert nomads, being well known to Sinai nomads as the evil spirit *Hoodhood* (Le Roi, 1923) and subsequently identified by Yossi Leshem (1979) as the *Lilith Midbar*, the Desert Lilith, the female demon supposed to have existed before Adam and Eve and to have haunted wild places such as desolate wadis, gorges and, in later years, the old ruins found scattered in the desert. *Lilith Midbar* is mentioned in the Old Testament in Leviticus (11:16) and by Isaiah (34:14). The owl's demonic calls, heard and feared at night in the Judaean–Arabian deserts, have earned it the reputation of an evil spirit or *djinn*.

The fact, discovered by Yossi Leshem, that Hume's Owl has honey-yellow, instead of dark-brown, eyes raises two particular questions. The first of these relates to the functioning of eye colour in light sensitivity or vision; the second is whether Hume's Owl really is a branch of the widespread *Strix* owls, which generally inhabit forests and which have the darkest eyes of all owls. A comparison of Hume's Owl with its nearest geographical neighbour, the Tawny Owl *Strix aluco*, therefore forms the main theme of the following species account.

GENERAL

Faunal type Palaeoxeric, or, more strictly, Arabian.

Distribution Middle East, in the arid Egyptian Red Sea mountains near the Roman ruins of Medinet Nugrus in Wadi Nugrus (24°37′N, 34°27′E), where the species was discovered on 16 February 1982 (Goodman & Sabry, 1984), the Sinai Peninsula (at such famous places as St Catherine's mountaintop monastery and at the foot of Mt Serbal), the Negev and other rocky desert regions in Israel and Jordania (Leshem, 1979, 1981), discontinuously or sporadically to the arid coastal plain and mountains of northern Hejaz and the Asir Mountains in western Saudi Arabia, the Tuwaiq Escarpment, including the Mahd Dhahab gold mining area in central Saudi Arabia (Jennings, 1981); Oman (Gallagher & Rogers, 1980; Gallagher & Woodcock, 1980; Walker, 1981) and possibly all of southern Iran and the Makran coast of Baluchistan to Ormara in western Pakistan, where the species has not been recorded, however, since Hume's time. For a review of all specimens known, see S. M. Goodman and H. Sabry (1984). Map 20.

Climatic zones Desert and steppe.

Habitat Gorges in rocky deserts, semi-deserts and arid mountains with springs or slow-draining rain pools and palm groves in oases (Mendelssohn *et al.*, 1975).

Hume's Owl *Strix butleri*

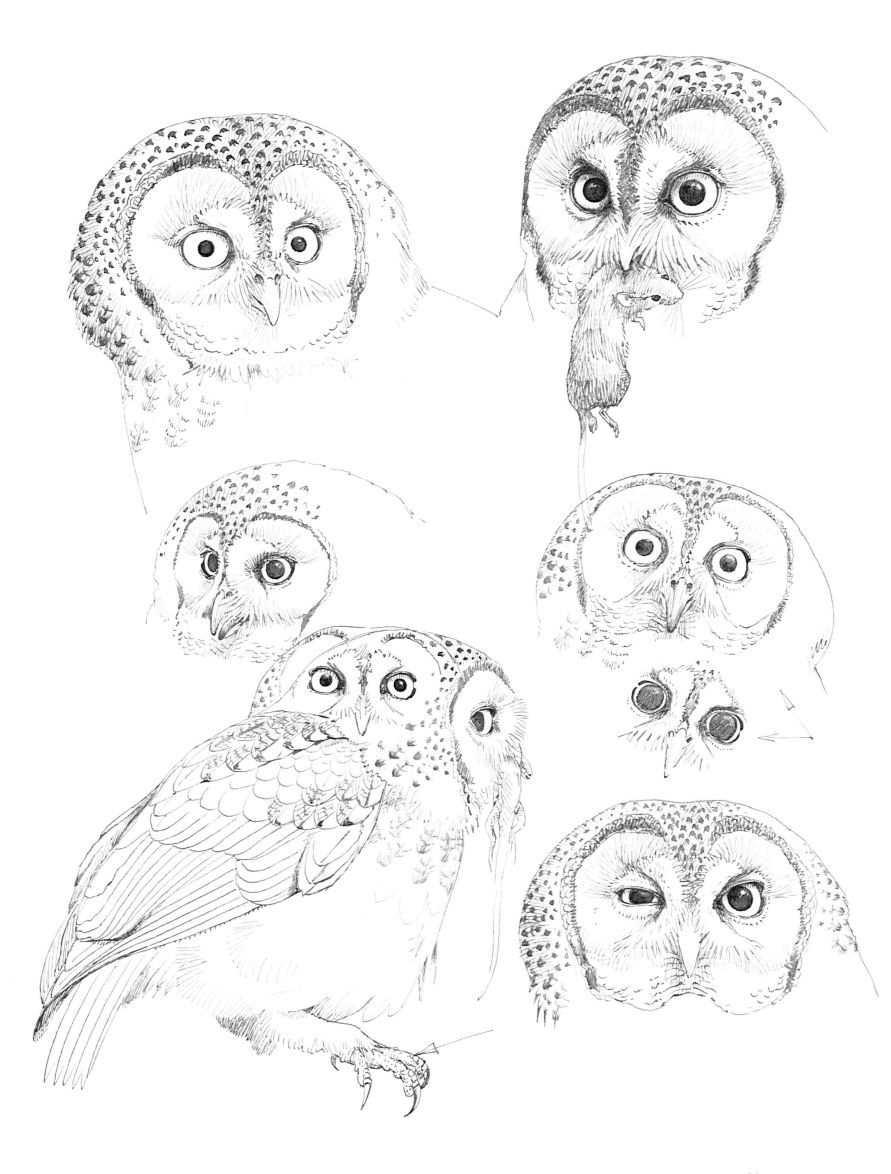

GEOGRAPHY

Geographical variation None known.

Related species Usually considered a desert offshoot of the widespread temperate and boreal Tawny Owl *Strix aluco*, but this is perhaps too simple a theory. As a possible member of the Old World palaeoxeric fauna, it may have had a similar history to that of the Arabian Woodpecker *Dendrocopos dorae*, or, more probably, to that of the Egyptian Nightjar *Caprimulgus aegyptius*, some desert wheatears, larks and rock sparrows, particularly the Pale Rock Sparrow *Petronia brachydactyla*, though all of these birds, with the exception of the Arabian Woodpecker, have a much wider distribution around the Mediterranean and in the central Asian deserts. Alternatively, Hume's Owl may once have spread as far as the western sub-Saharan deserts in Morocco, as has at present the House Bunting *Emberiza striolata*.

STRUCTURE

Though nothing is known regarding the structure of the outer ear and asymmetry of the ear openings and of the temporal part of the skull (all of which require study), the data that have been collected suggest a resemblance, hence a relationship, between Hume's Owl and the *Strix* owls, in particular the Tawny Owl.

Hume's Owl has eyes of an astonishing and idiosyncratic lightness, a bright orange or orange-yellow, which has been vividly captured by Mrs Jillian D. Silsby (1980) in a photograph from central Saudi Arabia. The owl's eye colour was first recorded by Yossi Leshem (1979) in 1979, though in the colour plate by E. N. Fischer accompanying John C. Phillips's description (1915) of the third known specimen of Hume's Owl from Sinai the eyes were already depicted as bright yellow, and they were mentioned as being yellow in a specimen from Sinai collected by Schrader (Le Roi, 1923).

Another noteworthy feature of this owl is the fine, silky texture of its feathers, which may represent an adaptation to life in arid surroundings, as has been assumed in the Barn Owl.

The legs are long and slender (tarsus 51–60mm, average 56.4mm; Goodman & Sabry, 1984; as against 44–53mm in the Tawny Owl) and the feet are small. Unlike the Barn Owl with its bristly legs and toes, Hume's Owl has a white-, thinly feathered tarsus and bare toes and a thin, silky-feathered covering on the underside of the toes (Hüe & Etchécopar, 1970:415), but this last feature has not been adequately depicted or described.

BEHAVIOURAL CHARACTERISTICS

Songs and calls The territorial song, now relatively well known, has been described (Mendelssohn *et al.*, 1975; Jennings, 1977; Gallagher & Rogers, 1980) as one long call followed by two double notes, *hoo huhu-huhoo* and *whoo whoohoo*, which is not unlike the Tawny Owl's territorial song. It was first described by Meinertzhagen (1930, 1954) as a long-drawn-out *huu* uttered at intervals, sometimes varied by a tremulous and more throaty hoot as in the Tawny Owl.

Circadian rhythm Considered nocturnal. A breeding pair in the Negev desert, Israel, hunted mainly from nightfall till 20.00h and again from 1.00–2.00h in the morning (Subah, 1983).

Antagonistic behaviour No data.

ECOLOGICAL HIERARCHY

No interactions with other owls or diurnal birds of prey have been reported, but one may safely assume that Hume's Owl frequently shares its habitat with the Desert Eagle Owl, Barn Owl and Little Owl, a fact confirmed by Yossi Leshem for Israel. Slightly smaller than the Barn Owl (weight of male 214–220g; Mendelssohn *et al.*, 1975; wing length 243–256mm; Goodman & Sabry, 1984; as against 281–312mm in local Barn Owls), Hume's Owl has remarkably feeble toes and claws and one wonders how the Barn Owl and Hume's Owl can survive alongside one another unless the latter is built for capturing smaller prey among stones and rocks and in crevices and fissures. How this species avoids predation by Eagle Owls and by falcons and eagles nesting and hunting in similar desert-like surroundings is not known and would be worth studying. Indeed, the male of a breeding pair studied in the Negev desert was found at the end of the nesting season in a neighbouring Eagle Owl's nest (Aziz Subah, in Mikkola, 1983). The absence of the Little Owl on the Tuwaiq Escarpment in central Saudi Arabia has been ascribed to competition from (or possibly predation by?) Hume's Owl (Jennings, 1983).

BREEDING HABITAT AND BREEDING

Hume's Owl has been reported to nest in cavities and caves in the walls of steep gorges in arid mountains (Aharoni, 1931; Mendelssohn *et al.*, 1975; Leshem, 1979) and once in a cistern in the Negev desert dating from the Nabatean–Byzantinian period (Subah, 1983). Most data come from valleys in the Judaean desert that drain into the lower Jordan valley and the Dead Sea, where over 30 sites have now been reported (Leshem, 1981; Frumkin, 1983). In Saudi Arabia, just north of the North Yemen border, the occurrence of Hume's Owls has been recorded (King, in Mikkola, 1983) in less arid surroundings supporting quite large juniper trees, oleander and wild lavender. In the nest in the Negev desert (see above), both sexes incubated a clutch of five eggs.

FOOD AND FEEDING

Pellets collected in several places in Israel (Mendelssohn *et al.*, 1975; Leshem, 1979, 1981; Aronson, 1980; Mikkola, 1983:table 32) have revealed that the main food consists of terrestrial rodents (48 specimens), followed by grasshoppers (29 specimens), tenebrionid beetles and other arthropods (12 specimens) and scorpions. Among reptiles, only two geckos and an agama lizard have been recognized, and the birds recorded were one Desert Lark, a House Sparrow and an unidentified species. Most of the mammals were gerbils, *Gerbillus dasyurus* (22) and *G. henleyi* (5), sandmice or jirds (at least 14); further, a few

Hume's Owl *Strix butleri* with emerald lizard *Lacerta viridis* as prey (should have been three-lined emerald lizard *Lacerta trilineata*)

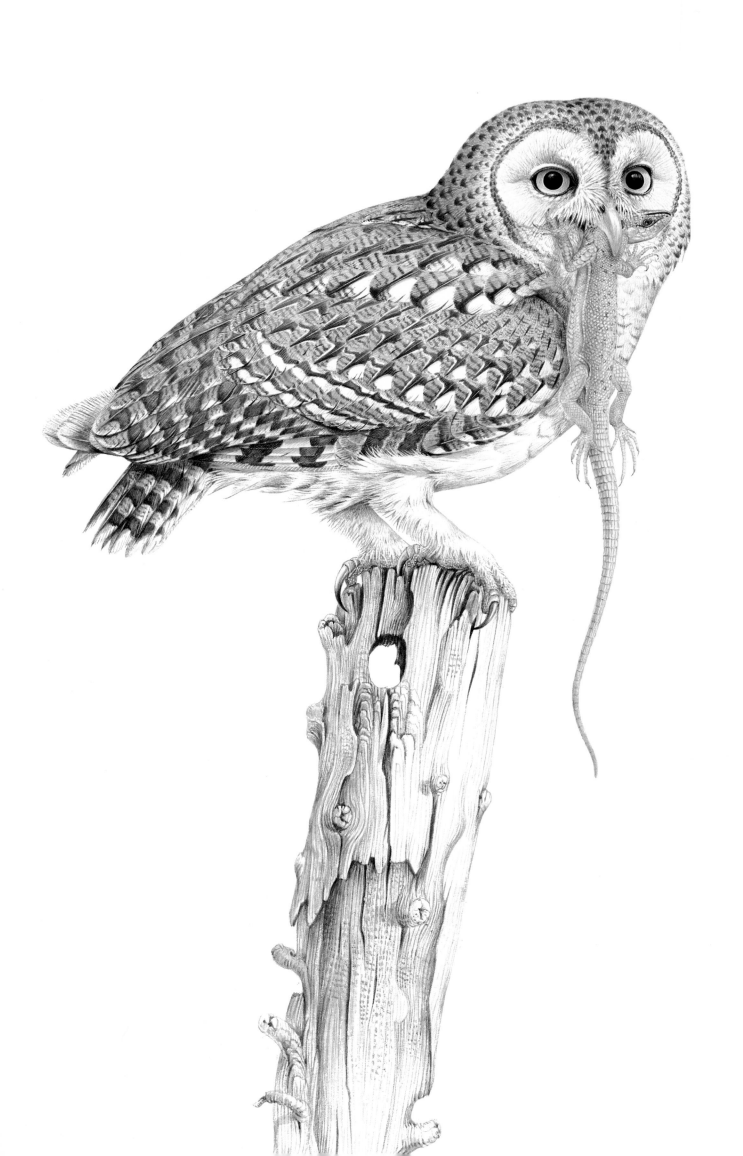

bushy-tailed jirds, one or two spring mice and two shrews. It thus seems that Hume's Owl, like the other *Strix* owls, preys on every available terrestrial mammal that it can handle.

MOVEMENTS
Considered sedentary.

GEOGRAPHIC LIMITS
Hume's Owl has not been recorded outside its rocky desert habitat, an environment which could scarcely be more arid. It would be interesting to know what prevents this owl from spreading into less desolate habitats. It has been found (Mendelssohn et al., 1975) at a distance of about 20km from the nearest Tawny Owls in Israel, in Hebron in the Judaean Hills, 26km south of Jerusalem, the southernmost place where the Tawny Owl has been seen and heard (Leshem, in corresp.). This formidable relative may perhaps set the limit to Hume's Owl's geographic range.

LIFE IN MAN'S WORLD
Hume's Owl can rarely have come into contact with man except where the latter is present around springs and in the palm groves in secluded wadis. As long as the rocky deserts of the Middle East remain undisturbed and biological life is not threatened by biocides and encroaching human activity, Hume's Owl can continue to lead its secretive life. Modern motor traffic in Israel, however, has already caused the death of numerous Desert Liliths. As many as 15 were found killed by motorcars between 1973 and 1978 (Aronson, 1980). Evidently the road from En Gedi to Sodom and the notorious one down from Jerusalem to Jericho are at present as dangerous for the owls as the latter road was for "the man who fell into the hands of robbers" (Luke 10:25–37).

None of the facts that have been gathered about Hume's Owl casts serious doubt on its resemblance to the Tawny Owl *Strix aluco*, and the two species appear to be related, though to what extent is not known. How, when and where Hume's Owl developed its unmistakable adaptations to desert life is also not known. Geographic indications of eco-geographical isolation processes are almost non-existent in the area inhabited by Hume's Owl, but a small Tawny Owl-like population could have become "stranded after a Pleistocene glacial retreat followed by progressive desiccation of the area concerned" (Lees-Smith, 1986:73). Two distal ends of a tibiotarsus found in early Middle Pleistocene deposits (Mindel Glaciation) in Ubeidiya in the Jordan valley, Israel, agree in size and show affinities with Hume's Owl (Tchernov, 1980). Hume's Owl has probably had a most fascinating and hazardous evolutionary history. Thanks to its yellow eyes and pale-buff plumage, it is not unlike a larger edition of the Buff-fronted Owl *Aegolius harrisii* from the dry savannah woodland of tropical America, though the significance of this fact remains uncertain. In this connection it is worth mentioning that early specimens collected in Sinai (Kaiser, 1891; Le Roi, 1923:66) were at first erroneously identified as Tengmalm's Owl *Aegolius funereus*.

BARRED OWL

Strix varia

The Barred Owl is the commonest of the medium-sized owls of eastern North America. In all aspects of structure, size, habitat, food and feeding habits it resembles the Old World Tawny Owl *Strix aluco*. Taxonomically it is thought to be closer to the large Ural Owl *Strix uralensis* and some authors (Eck, 1968, 1971) have included the Barred Owl and the Ural Owl in one species of wide distribution in North America and Eurasia. The Barred Owl has a characteristic pattern of crossbars on the throat, but in body size, ear structure and ecology it occupies an intermediate position between the Tawny and the Ural Owl.

The presence of another species, the Spotted Owl *Strix occidentalis*, in southwestern North America, of similar size and comparable habits to the Barred Owl, makes it difficult to consider the Barred Owl and the Ural Owl as conspecifics without taking the Spotted Owl into account. The Spotted Owl has a complicated colour pattern and a geographical relict area and must have lived in North America for some considerable time. The branching-off of the Spotted and Barred Owls as species must therefore date far back into Pleistocene times. A further geographical problem is that, like other originally eastern North American bird species, the Barred Owl has succeeded in crossing the grassland barrier of the Midwest and is now extending its range westwards into the area of the Spotted Owl, first in southern Alberta (Boxall & Stepney, 1982) and now already further west almost to the coast (Taylor & Forsman, 1976). The Barred and Spotted Owls cannot be expected to live alongside each other for any length of time and it now already seems that the Barred Owl is gaining ground at the expense of the Spotted Owl in areas with temperate climates.

Other geographical problems relate to the Barred Owl's ecological relationship and possible competition with the Great Grey Owl *Strix nebulosa* in the northern woods and with the small Fulvous Owl *Strix fulvescens* in the mountain forests of northern Central America south to Honduras and El Salvador. Some authors have considered the Fulvous Owl as the Barred Owl's southernmost mountain race, a view dating back to that admirable naturalist and ornithologist Elliott Coues (1874:309) in the early days of zoological exploration in western North America.

Apart from being in itself a most fierce and fascinating owl, the wealth of geographical and comparative ecological problems posed by the Barred Owl make it a wonderful subject for observation and study.

GENERAL

Faunal type Southeast Nearctic.

Distribution Eastern North America, extending into montane habitats in Mexico and, in a narrow belt, through southern Canada into and beyond the Canadian Rocky Mountains, as far north as Fort St Johns at 56°15' north in northeast British Columbia (Siddle, 1984), and south and west to northern Montana, Idaho, Washington, Oregon and north California. Map 19.

Climatic zones Temperate and low boreal, including the corresponding temperate zones in the Mexican mountain ranges and the montane zones in the northern Rocky Mountains; reaching subtropical winter-dry areas in the south. The northern limit coincides more or less with the July isotherm of 17°C, as in the Old World Tawny Owl's range.

Habitat Mature mixed deciduous and uniform coniferous forests, often in river bottomlands and near swamps, and corresponding habitats in mountain zones. In the south also in cabbage palm stands, cypress swamps and on prairie live-oaks.

GEOGRAPHY

Geographical variation Rather conspicuous in size, coloration and feathering of tarsus and toes. Generally four races recognized. The southeastern race *Strix varia georgia*, south of North Carolina and Georgia, is about 3% smaller than the northern *S. v. varia* and has reduced tarsal feathering. In the warm and dry areas of Texas and adjacent lowland Mexico *S. v. helveola* is much paler cinnamon or even yellowish, and, in the words of one of the earlier ornithologists of the region (Bangs, 1899), as conspicuously different from the Barred Owls from Florida as are the pale southern prairie Great Horned Owls from the dark Atlantic seaboard ones. Barred Owls from montane Mexico are darkest of all. Of all races, the northernmost *S. v. varia* most closely resembles the Old World Tawny Owl in size and shape; in coloration it is closest to the east Asiatic and north Japanese races of the Ural Owl.

Related species Closest relative to the Barred Owl in America is the Fulvous or Guatemala Barred Owl *Strix fulvescens* from the humid upper tropical and temperate pine-oak forests of southern Mexico and northern Central America.

The Fulvous Owl is smaller by about 20% than the Mexican races of Barred Owl and separated from them by a stretch of only 50–100km of the central mountains of Oaxaca, south Mexico. Though the Fulvous Owl is clearly a southern member of the northern wood owls, its hooting calls seem to resemble those of the western Spotted Owl *Strix occidentalis* more than those of the Barred Owl (Dickey & van Rossem, 1938; Monroe, 1968). Hence the Fulvous Owl is listed in the sixth edition of the *American Ornithologists' Union Check-list* (1983) as a separate species rather than as a race of *Strix varia* as advocated by other authors (Peters, 4, 1940; Eck, 1971).

The Rufous-banded Owl *Strix* (or *Ciccaba*) *albitarsus* from the temperate forests of the northern high Andes in South America resembles the Fulvous Owl to a remarkable degree (Kelso, 1940) and is either an offshoot of northern *Strix* origin (which is the most likely), or else represents an old branch of a southern stem from which all present members of the genera *Strix* have derived.

The Barred and Spotted Owls form a species pair of distinct eastern and western Nearctic distribution types, of which there are several other examples among North American birds: e.g. Red-cockaded and Nuttall's Woodpecker *Dendrocopos borealis* and *D. nuttallii*, Brown-headed and Pygmy Nuthatch *Sitta pusilla* and *S. pygmaea*, Blue and Steller's Jay *Cyanocitta cristata* and *C. stelleri*, Baltimore and Bullock's Oriole *Icterus galbula* and *I. bullockii*.

Siegfried Eck (1968, 1971) has called attention to the fact that North American owls of Holarctic distribution tend to show some dark cross-barring on the underparts. He refers to the Great Horned Owl *Bubo virginianus* versus the Eurasian Eagle Owl *B. bubo*, the American versus the Eurasian Long-eared Owl *Asio otus wilsonianus* and *A. o. otus* and the American versus the Eurasian Great Grey Owl *Strix nebulosa nebulosa* and *S. n. lapponica*. A further example could be the Barred Owl versus the Old World Ural Owl *Strix uralensis*.

STRUCTURE

In structure and asymmetry of the outer ears the Barred Owl is somewhat closer to the Ural Owl than to the Tawny Owl and a slight asymmetry of the temporal region of the skull has been noted (Simonetta, 1967:27, fig. 10).

According to my own measurements (1964), the left ear opening is a sickle-shaped oval with a length of on average 25mm (24mm in the Ural Owl and 21mm in the Tawny Owl); the length of the right ear is 27mm (27mm in the Ural Owl and 22.5mm in the Tawny Owl). Width of the pre-aural flap is 12mm (13mm in the Ural Owl and 9.5mm in the Tawny Owl). There is probably no transverse ligamentous bridge in the outer ear opening (Kelso, 1941), which is in contrast with European members of the genus. The Barred Owl's relatively shorter tail and small claws suggest a closer ecological similarity to the Tawny than to the Ural Owl.

In the southern population groups the amount of feathering of tarsus and toes is noticeably reduced and the toes are only sparingly covered with bristles, rather than with feathers.

BEHAVIOURAL CHARACTERISTICS

Songs and calls The Barred Owl is the noisiest of North American owls and renowned for its loud and tremulous territorial song, described as *hóo-hoo-to-hóo-ooo, hoo-hoo-too-to-whóoo-ooo* (Bent, 1938), and generally transcribed as "who-cooks-for-you, who-cooks-for-you-all?" These calls may end in sudden demonic laughter or be performed by the territorial pair in long bouts of antiphonal hooting. The calls are of the same kind and quality as the Tawny Owl's, but the cat-like screams and prolonged outbursts of cackling and laughing during courtship seem to be a Barred Owl idiosyncrasy, while the deep, barking alarm calls are not unlike those of the Ural Owl. In general the Barred Owl is as talkative and noisy as most of the world's other wood owls.

Circadian rhythm The Barred Owl is nocturnal like the Tawny Owl. It roosts by day hidden in dense foliage, usually at 5m or more above the ground, close to a massive tree trunk or in a natural tree hole. Only exceptionally has it been observed hunting in bright daylight. In laboratory experiments the lower limit of illumination at which a Barred Owl was able to see a dead prey close at hand was the same as that for the Long-eared and Barn Owls (Dice, 1945).

Antagonistic behaviour Nothing of any significance recorded.

ECOLOGICAL HIERARCHY

With an average weight of 800g in females and 630g in males (Earhart & Johnson, 1970), the Barred Owl is 30–50% short of the predatory bulk of the Great Horned Owl with which, more often than not, it is compelled to share its range. Though the Barred Owl is more a bottomland and forest bird than the Great Horned Owl, which occurs more regularly in uplands and open forest, it is nevertheless known to have been killed and eaten by its formidable relative (Errington *et al.*, 1940). Registration by telemetry of the movements of a Barred Owl in a forest complex in Minnesota showed that this particular bird apparently deliberately avoided a Great Horned Owl which had recently invaded the area (Fuller *et al.*, 1973). On the other hand, the Barred Owl is not averse to preying on owls smaller than itself. One such act of predation was described by Milton B. Trautman (1940:278) in Ohio: "Once when a Screech Owl answered my call a Barred Owl captured it, flew to an adjacent tree, pulled off and ate the head, and carried the body away in its talons." The hierarchy of predation was demonstrated even more forcibly by Edward Howe Forbush (1927, cited by Bent, 1938:91) upon opening the stomach of a Barred Owl which he had shot in New England: it contained the remains of a Long-eared Owl, in the stomach of which were the remains of an Eastern Screech Owl.

Less dramatic is the interaction between the Barred Owl and diurnal birds of prey, more particularly the Red-shouldered Hawk which inhabits similar swampy bottomland forests and preys on similar prey to the Barred Owl. These species seem to get along very well together and have been found nesting as

Barred Owl *Strix varia*

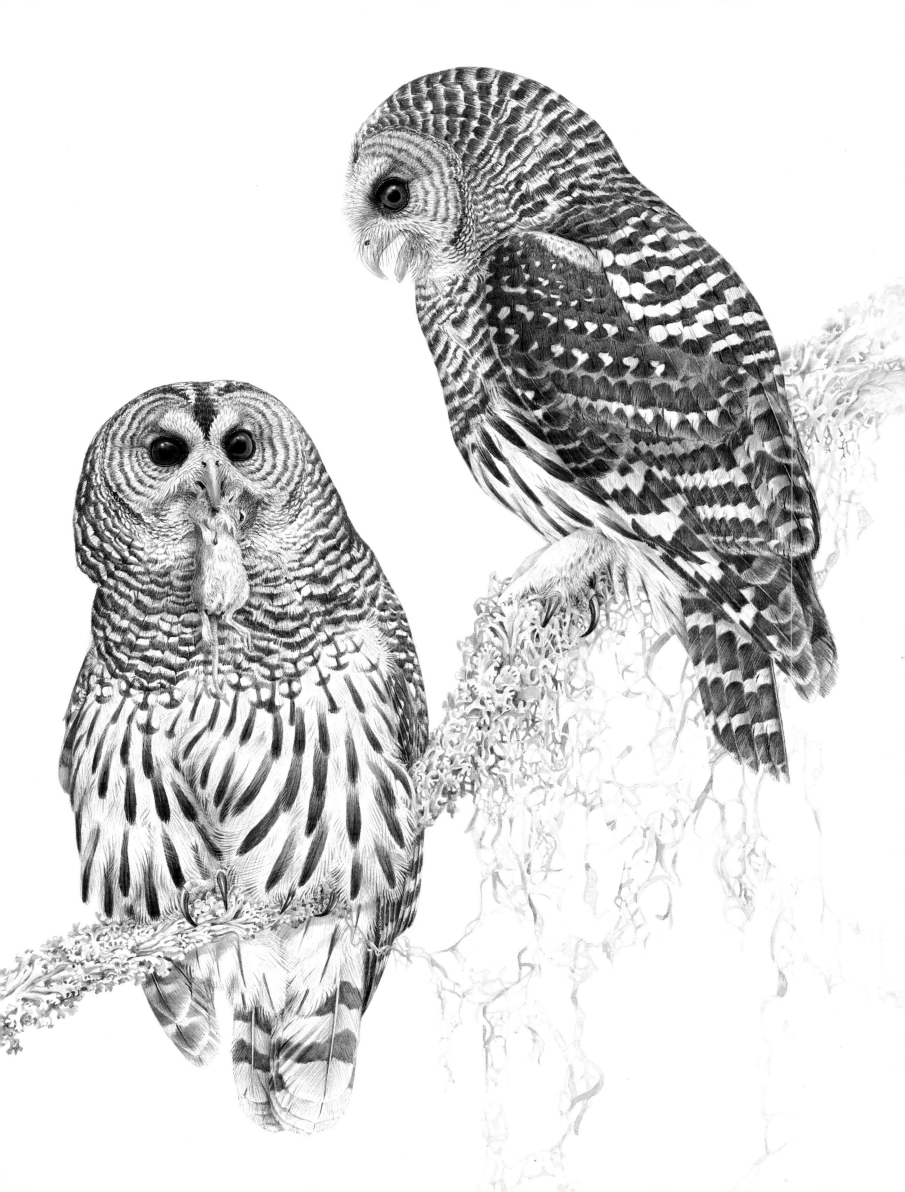

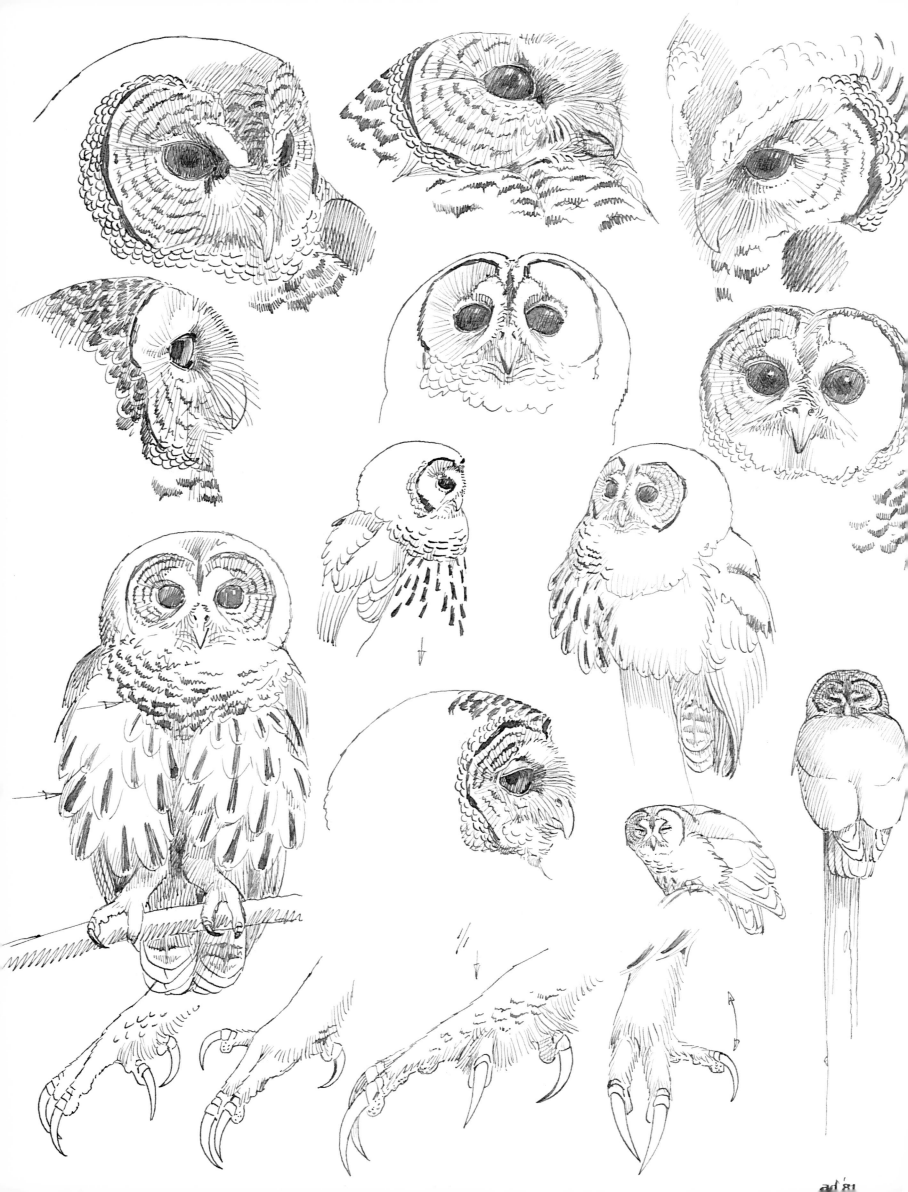

close as 24 yards apart (Bent, 1938:183). Contacts with the Red-tailed Hawk and Cooper's Hawk are less friendly, though the Barred Owl regularly uses their nests and remains in their territories. There is no doubt that the Barred Owl occasionally falls victim to the Goshawk, as does the Tawny Owl in the Old World, but the only published record I am aware of describes a fight between these birds ending with the death of both parties (C. W. G. Eifrig, 1927, cited by Bent, 1938:134).

BREEDING HABITAT AND BREEDING
Traditional and favoured nest sites seem to be natural holes in trees in deep, dark woods, though the vacant nests of hawks and crows and squirrels' dreys high in treetops are used no less frequently. In southern habitats Barred Owls nest between the fronds of palmetto palm leaves, in the holes of broken palm stems and rotten snags and, more frequently, in hollow live-oaks. Also on the ground at the foot of a lookout tower in the Everglades National Park, Florida (Robertson, 1959). In the choice of its nest site the Barred Owl is hardly less adaptable than the Tawny Owl in the Old World. Alternate use of open stick nests by Barred Owls and Red-shouldered Hawks is particularly well documented and nests containing the eggs of both species have been reported (Bent, 1938). The Broad-winged Hawk and Cooper's Hawk are other species known to have provided Barred Owls with suitable nests. The Red-tailed Hawk usually builds its nest in smaller and more isolated groves and more open forests than the other hawks and is a more dangerous nest competitor, but its nest too is sometimes used by the Barred Owl. For a picture of a nestling see page 256.

Sound triangulation methods for counting Barred Owls in Mississippi (Bell, 1964) and radio telemetry for following the movements of individual owls in Minnesota (Fuller et al., 1973) revealed overall densities of one pair per 226ha (565 acres) in mixed hardwood–conifer habitats.

FOOD AND FEEDING HABITS
Mature woods free of a dense understorey, with adjoining river banks and swamps, are the hunting habitats most frequently affected by Barred Owls. They usually hunt from a lookout post in the forest at five or six metres above the ground and rarely venture into the open field (Fuller et al., 1973). Thanks to their sedentary habits they come to know every corner of their forest territory and catch and eat whatever is available. Like the Old World Tawny Owl's, the Barred Owl's diet is therefore extremely varied, though it selects small rodents whenever possible. A summary of the diet extracted from all the literature sources (Snyder & Wiley, 1976) revealed 2,234 prey items, 76% of which consisted of mammals, 6% of birds, 2.5% of other vertebrates and 16% of insects and other non-vertebrates. The list of mammal species taken comprised a variety of voles, mice and rats, including the destructive cotton rats in the south, besides shrews, moles, chipmunks, squirrels, cottontails, hares, opossums, weasels, mink and bats. At least 30 species of bird are known to be taken by the Barred Owl (Bent, 1938), including flickers, kingfishers, crows, jays, thrushes, warblers and swallows, in addition to owls and other large birds and occasionally poultry (Cahn & Kemp, 1930). Lizards, snakes, terrapins, salamanders, fish, grasshoppers, beetles, other large insects, spiders, crayfish, crabs, including fiddler crabs in the south, snails and slugs make up the balance. Some Barred Owls have learned to fish and seem to practise the art more regularly than others, e.g. in February 1982, St John's River, Florida (Smith et al., 1983).

MOVEMENTS
The Barred Owl is basically sedentary. Being familiar with the whole of its relatively small territory and therefore able to exploit its food resources to the full, it is only forced to leave its otherwise year-round home under exceptional conditions. "Winter flights", impressive in former decades, are known to have occurred in New England, but details of these have not been described and their causes have never been fully understood.

GEOGRAPHIC LIMITS
The northern limits of the Barred Owl's range seem to be set by the exploitability of the food resources of the northern mixed deciduous and southern boreal forests throughout the year. This can be critical in winter when snowfall is heavy and mammal prey scarce. In laboratory experiments (Duke et al., 1980) starving ("sub-maintenance fed") Barred Owls were able to survive on an intake of lower caloric values than usual by increasing the efficiency of the digestion of their scanty meals through a longer digestion time. This remarkable trick, which is not exclusive to the Barred Owl, is probably effected by deliberately increased lethargic behaviour, minimizing energy expenditure at low winter temperatures. But what metabolic processes are actually involved and to what degree and for how long the Barred Owl can survive low temperatures is not known.

Towards the south the distributional limits are probably determined by the presence of other, smaller and more insectivorous species of wood owl.

Towards the north, in east and midwest Canada, and more particularly in the west, the expansion of the Barred Owl into the range of the Spotted Owl is probably the result of man-induced habitat changes.

LIFE IN MAN'S WORLD
Though common in eastern North America, the Barred Owl has suffered from the logging and slashing of mature mixed forests, whereas the present new, but even-aged forest types, though sometimes already of a considerable age, do not seem to provide a sufficiently large number of natural cavities for the owl to nest in (Bosakowski et al., 1987:135–143). Under these new conditions the Barred Owl has not become as familiar with man as has the Tawny Owl in the Old World. I am not aware of Barred Owls nesting regularly in city parks or making use of nest boxes on a scale comparable to that of Tawny Owls in Europe, though in recent years they have frequently nested in nest boxes in Canada (e.g. Nova Scotia; Cyril K. Coldwell). The Barred Owl can nevertheless be almost as tame and, at times, as dangerously aggressive towards human intruders near its nest as are the

Barred Owl *Strix varia*
Lower left bird and toes represent the related Central American Fulvous Owl *Strix fulvescens*

Tawny Owl and the Ural Owl in similar circumstances. The degree to which Barred Owls accept nest boxes depends very much on the boxes' siting. In Minnesota nest boxes are accepted most frequently when they are placed rather high up in the trees and have a side entrance no smaller than 18cm in diameter (Johnson, 1987:129–134).

The Barred Owl is about 35% heavier than the Tawny Owl *Strix aluco*, about 10% smaller than the Ural Owl *Strix uralensis* and intermediate between the two in coloration and structure, but its genealogical relations are still far from understood. Its ecological position, including breeding behaviour and diet, most closely resembles that of the Tawny Owl. It has profited from the early stages of deforestation in the eastern United States (Trautman, 1940) and has occupied areas left free by the retreating Great Horned Owl *Bubo virginianus*. When the remnants of the virgin woods had finally disappeared in Ohio and Michigan, few places remained, even for the Barred Owl. The Barn Owl *Tyto alba* and the Screech Owl *Otus asio* entered these areas instead. This is the condensed history of what has happened in Europe over a much longer period of time.

SPOTTED OWL
Strix occidentalis

Although the western counterpart of the widespread eastern North American Barred Owl *Strix varia*, the Spotted Owl possesses characteristics which are noticeably different from those of the Barred Owl. It appears to have survived the rigours and catastrophes of the last Ice Age in southwest North American forest refuges, together with such species as the Flammulated Owl *Otus flammeolus*, Northern Pygmy Owl *Glaucidium gnoma*, Lewis' and White-headed Woodpeckers *Asyndesmus lewis* and *Dendrocopos albolarvatus*, Chestnut-backed Chickadee *Parus rufescens*, Pygmy Nuthatch *Sitta pygmaea*, Townsend's Solitaire *Myadestes townsendii*, Clark's Nutcracker *Nucifraga columbiana* and others, though not always sharing the same habitats as these birds.

Of all North American owls, the Spotted Owl, together with the Flammulated and Northern Pygmy Owls, has one of the most restricted geographical ranges. The Spotted Owl has retained the dense feathering of boreal birds and this has probably prevented it from spreading much beyond the borders of the glacial refuge area. Its behavioural and ecological reaction towards other owl species, whether similar or related ones, may well have played a major role in restricting its present distribution.

Thanks to its secretive life style, the Spotted Owl was for a long time one of the most elusive western birds, but since its habitat has become better known and its presence can be ascertained by reproducing the bird's registered calls, the Spotted Owl appears to be more numerous and widespread than was originally suspected. After the destruction of large parts of its primeval coniferous coastal forest habitat by excessive lumbering and other human encroachments, the Spotted Owl is now a potentially endangered species in many coastal areas. Presumed interference competition with the larger Barred Owl, which has now spread as far west as Oregon (Taylor & Forsman, 1976) and western Washington, poses a further threat to its continued existence.

The Spotted Owl is a typical representative of the medium-sized *Strix* wood owls and is as versatile in choice and size of prey as its widespread eastern relative, the Barred Owl, and the Old World Tawny Owl *Strix aluco*. As a rule, however, it is much less aggressive towards human and other intruders of its nest area than these other species, even to the extent of being described as "docile" and "stupid", though such behaviour might equally indicate fearlessness and the Spotted Owl is known to be able to defend its nest no less impressively than the Barred and Tawny Owls.

The following account principally aims at comparing the life of the Spotted Owl with that of other *Strix* owls and attempting to describe the main ecological and zoogeographical problems surrounding this species.

GENERAL

Faunal type Southwestern Nearctic.

Distribution Western North America, from southwestern British Columbia, including the Lower Fraser Valley and the Manning Provincial Park, south through the coastal and Cascade mountain ranges of Washington (Baker Lake south of Mt Baker), Oregon and California at least as far as San Diego County, the western slopes of the Sierra Nevada and the southern Rocky Mountains and isolated mountains, from the Zion Canyon National Park and Navajo Mountains in Utah and central Colorado through the mountains of Arizona, New Mexico (at an altitude of between 1,900 and 2,700m) (Ligon, 1926), extreme western Texas and Nuevo Leon (Cerro Potosi) and the upper Sonoran and transition life zones of central Mexico south to the Mexican state of Michoacan, where it occurs at an altitude of 2,000m and over. Map 19.

Climatic zones Temperate; also low boreal in some of the mountain areas. The climatic characteristics of the northern and southern limits are difficult to define, given the species' specialized need of microclimates where temperatures in the warmest period of the year only occasionally rise over 27°C.

Habitat Humid, old-growth and mature, multi-layered, mixed coniferous forests in which Douglas fir and coast redwood of impressive height often predominate, from near sea level up to submontane and montane zones. Also dark forest patches of live-oak, cottonwood, willow, sycamore and alder in the shade of deep, often hanging canyon walls.

GEOGRAPHY

Geographical variation Slight, relating to density of plumage, coloration and amount of white spotting on upper- and

underparts. Birds from the humid coastal range are darkest (*Strix occidentalis caurina*), those from the Arizona and Mexican mountain ranges are lightest and most profusely spotted with white. Generally three or four geographical forms are recognized (see Swarth, 1910).

Related species Closest relative of the Spotted Owl is the somewhat larger and stronger Barred Owl *Strix varia*. Both species seem to have arisen from the same stem by periods of geographical isolation during subsequent ice ages in the Pleistocene. They are similar and probably closely related to the Old World species pair of Ural and Tawny Owls *Strix uralensis* and *S. aluco*. For possible relations with Central and South American species of *Strix* and *Ciccaba*, see under Barred Owl and Mottled Owl *Strix varia*.

STRUCTURE

In terms of structure, size and degree of asymmetry of the outer ears, the Spotted Owl is a distinctive member of the northern *Strix* owls and resembles the Barred Owl. The left ear opening was found to average 17.5mm in length and the right one 22mm (in the Barred Owl, 25mm and 27mm, respectively). Width of the pre-aural dermal flap was 13mm, which is wider even than in the Tawny Owl (Voous, 1964).

As regards the density of its plumage and the thick feathering of tarsus and toes, the Spotted Owl shows the characteristics of a boreal rather than a temperate-climate species, more so even than the Barred and Saw-whet Owls (see Barrows, 1981).

BEHAVIOURAL CHARACTERISTICS

Songs and calls The territorial song or location call is a series of three or four deep hoots rendered variously as *who who-who whoooo* (John T. Marshall) or *hoo-hoo-hoo-hoo* (Eric D. Forsman). The contact call uttered by male and female alike is a series of terrifying rising whistles (J. T. Marshall) ending with a siren-like echo, whereas the alarm or scolding calls are dog-like barks. All of these calls are described as nerve-racking for a human listener at night. The female's voice is noticeably higher pitched than the male's (Marcot & Gardetto, 1980) and, because of the smaller size of the female syrinx, quieter (Miller, 1934). The whole repertoire is easily recognizable as belonging to a *Strix* owl.

Circadian rhythm The Spotted Owl hides by day in thick cover, usually close to a tree trunk, where its colouring of warm buff-brown and black, dotted with white spots, blends admirably with its surroundings. It is generally reported as being hard to flush by day and appears very sleepy and unperturbed even when surrounded by a host of scolding forest birds including Steller's Jays and Acorn Woodpeckers (see Grinnell & Storer, 1924). Hunting by day was once observed in California, when a female hunted continuously, probably because her young were apparently still begging for food away from the nest (Mallette & Gould, 1976). Such a case may be exceptional.

Antagonistic and heat resistance behaviour Numerous records, from Arthur H. Bent's superb summary (1938) onwards, mention the "tame, unsuspicious, cursory or stupid" disposition of the Spotted Owl. Spotted Owls have been clubbed to death, stroked and caught by hand; and when disturbed they have been known to move to an adjacent branch or tree and to continue dozing, though all these factors may have been based on some kind of antagonistic behaviour ultimately leading to a high survival rate. One or two instances of attacks in defence of a nest have been described (Bent, 1938, 1963; Smith, 1963); these produced ambiguous results and were probably more dangerous for the owls than for the intruders. Nevertheless, such behaviour proved the formidable strength of these owls in spite of their friendly appearance.

Other interesting behavioural features, designed to counteract the effects of high ambient temperatures apparently experienced as unpleasant or even intolerable, have been described from Mendocino County, coastal North Carolina (Barrows & Barrows, 1978). At air temperatures of over 27°C, which occur in summer in western North America even in the coastal rain forest belt, Spotted Owls were invariably found on the north side of mountain slopes and canyon walls where they sought the deep shade of a thick canopy, gradually moving in such a way as to remain on the shady side of tree trunks. They exposed their legs and feet and lifted their bright-pink, strongly vascularized footpads from the perch in order to intensify heat evaporation; they let their wings droop, raised their dorsal feathers and started gular fluttering, with a partly opened beak to allow rapid evaporation. Whether this behaviour also occurs in other owls (even in boreal forests summers can be hot) and why the Spotted Owl cannot stand temperatures easily tolerated by other owls are interesting subjects for further research.

ECOLOGICAL HIERARCHY

Few other owls venture into the heavily forested habitat of the Spotted Owl, but when this habitat has been destroyed by fire, logged or cut, the Spotted Owl is known to meet the ever-opportunistic Great Horned Owl. Averaging 635g in the female and 580g in the male, the Spotted Owl is no match for the Great Horned Owl, which is approximately twice as heavy. Instances in which Spotted Owls avoided Great Horned Owls, either by leaving the area or by keeping silent, have been described by various authors (e.g. Phillips *et al.*, 1964), but no case of direct predation has been reported, though a juvenile Spotted Owl is said to have been taken by a Great Horned Owl in California (Marcot & Gardetto, 1980). In some places, such as the Yosemite National Park, California, the Spotted Owl may meet the Great Grey Owl and the Long-eared Owl, but nothing has been reported regarding interspecific encounters.

Conversely, the Spotted Owl is known to have preyed upon Western Screech Owl, Saw-whet Owl and Northern Pygmy Owl (Richardson, 1906; Dawson, 1923; Marshall, 1942; Zarn, 1974), while the Flammulated Owl appears to avoid the presence of the Spotted Owl in the same way as the latter avoids the Great Horned Owl. On the whole, however, the Spotted Owl appears to be a much less formidable hunter than its eastern cousin, the Barred Owl. The latter may become a serious competitor of the Spotted Owl whenever and wherever their ranges meet more extensively in the future.

Spotted Owl *Strix occidentalis*

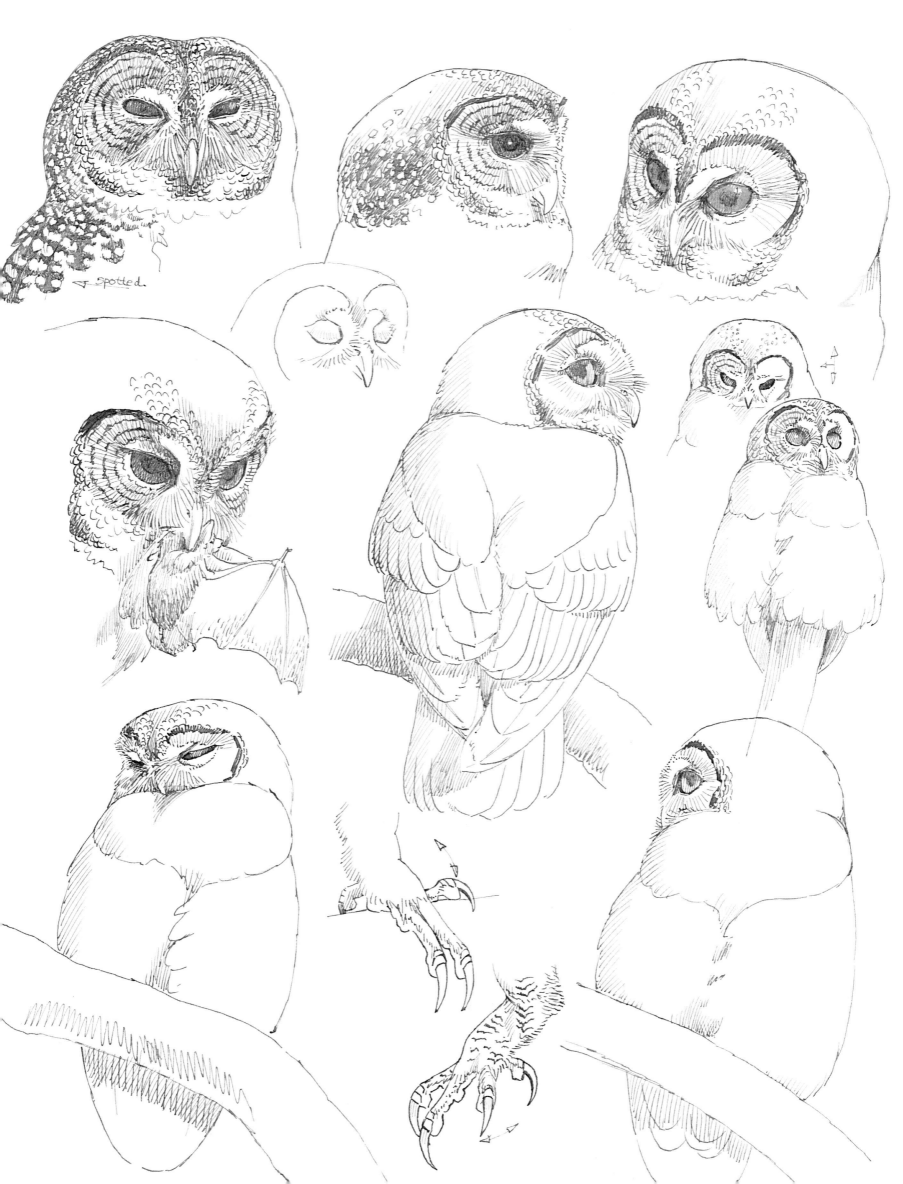

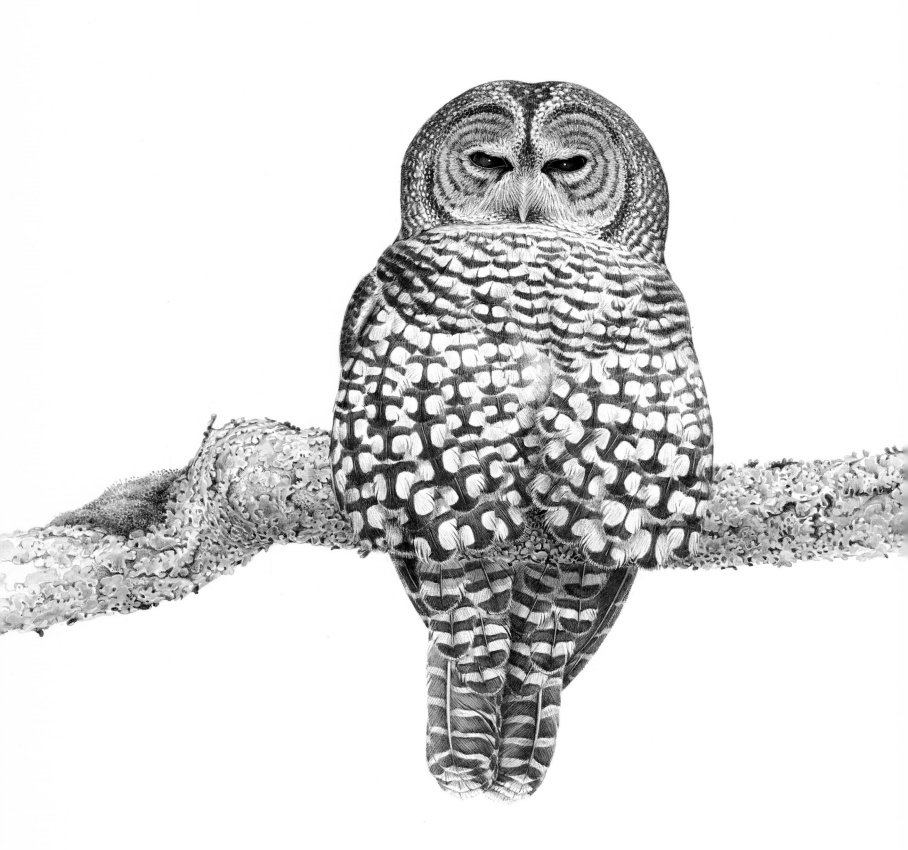

To what extent the Spotted Owl is predated upon by diurnal raptors such as Goshawks and Cooper's Hawks, or by arboreal mammalian predators, is virtually unknown, but the potential occurrence of such predation may be an important factor in the Spotted Owl's life. Simultaneous active nests belonging to a Goshawk and a Spotted Owl were located 120m apart in a coastal forest in Oregon without any apparent mutual disturbance (Zarn, 1974).

In the hierarchy of predation the Spotted Owl seems to occupy a similar, if more modest, place to that of the Barred Owl in eastern North America and the Tawny Owl in Eurasia. Like these species, it is a strong, fighting athlete and equally unspecialized as regards the choice and size of its prey. It rarely comes into interspecific conflict over food therefore with the ever-present Long-eared Owl, which, being primarily a ground rodent-eater and thus basically nomadic, is forced to give way to the *Strix* owls in times of relative food shortage. The Spotted Owl appears to suffer only mild pressure from interspecific competition, as the sexual dimorphism in size is smaller than in most other species of its genus (female approximately 9% heavier than male; wing length approximately 2% greater; Earhart & Johnson, 1970).

BREEDING HABITAT AND BREEDING

Throughout its life the Spotted Owl remains a highly territorial species in dark or well-shaded mature, humid coastal, multi-layered, mixed evergreen forest, lower and upper montane forests on mostly humid mountainsides in the interior and heavily forested creek bottoms with canyon live-oak and other shade-giving trees growing deep down in narrow gorges. Forest types range from those growing in Sonoran to those of boreal (Canadian) life zones, but do not include subalpine forest communities, which are probably too open. Altitudes are from near sea level in western coastal ranges to almost 2,700m in the interior. In the Cascade and coastal ranges the characteristic habitat consists of climax western hemlock forests (with western red cedar, coast redwood and incense cedar), and subclimax forests in which stately Douglas fir, 65m and more in height, predominates and where the huge trees tend to be festooned with lichen and climbers. In the interior the main habitats are montane forests with ponderosa pine, sugar pine, Douglas fir, white fir and other evergreen wide-spreading or at least shade-giving trees (Gould, 1977). Tall trees, distinct canopy layers, an absence of sunlight and proximity of water, and cool ambient temperatures, seem to provide the necessary or preferred microclimates (Forsman, 1976).

Roost sites are invariably shielded from direct sunlight and, at least in summer, occur in shady places where air temperatures are 3–4° cooler than in the open canopy. The difference in temperature between shady spots near forest creeks or streams and areas where sunlight penetrates to the forest floor may be as much as 7–8°C (Barrows, 1981). Spotted Owls usually roost high up in the trees, though they remain under the top canopy of the coastal forest giants. In summer they roost much lower, apparently searching for the coolness of the forest floor.

Nests have been found in holes and cavities in trees (e.g. oaks and sycamores) and particularly tree stumps; also in potholes and cavities in sandstone cliffs, on the rocky ledges of wider caves, in steep walls and deep down in narrow canyons. Some of the nest sites found in cliff faces had served earlier as nesting sites for Raven and Golden Eagle. Eggs have also been found in abandoned nests built by Red-tailed Hawks, Cooper's Hawks and Goshawks, 30m up at least in the crowns of tall trees. Whatever the site, nests are always inaccessible, located in cool places and well shaded against sunlight. In all these respects the Spotted Owl behaves like the Barred, Ural and Tawny Owls and exhibits a distinctly boreal life style.

FOOD AND FEEDING

The list of food items collected from an analysis of stomach and pellet contents of Spotted Owls is impressively large and comparable to that recorded for the Barred and Tawny Owls. To a greater extent than either of the latter, however, the Spotted Owl appears to hunt through the medium strata of the forest rather than preying on animals living on the forest floor or in the open field. This habit is demonstrated by the larger number of flying squirrels and woodrats of various species, and of arboreal birds such as Crossbills, Evening Grosbeak, Red-breasted Nuthatch and Saw-whet Owl, recorded among the Spotted Owl's prey. Terrestrial prey species include California mole, shrew, deer mice and jumping mice, brush rabbit and pika; and once a scorpion. At least three species of bat have been recorded, including the hoary bat, and these may have been caught on the wing or taken from their sleeping places in forest trees. Beetles, crickets, noctuid moths and other large insects have also been recorded, but the calculated 57.4% invertebrate food, as against 37.5% mammals, 4.5% birds and 0.6% frogs and toads, mentioned by Snyder and Wiley (1976), seems excessively high and probably accounts for numbers rather than biomass. One may conclude that the Spotted Owl, like the other strictly sedentary *Strix* species, feeds on anything it can catch in the restricted territory where it lives and hunts the year round.

MOVEMENTS

The Spotted Owl is sedentary and territorial and no movements have ever been observed for this species. Exceptional occurrences in the middle of Los Angeles and San Diego have been interpreted as cases of post-juvenile dispersal (Mallette & Gould, 1976). The same probably applies to a Spotted Owl captured in the streets of Vancouver with a domestic pigeon in its talons, apparently taken on top of the old Post Office Building at the corner of Granville and Hastings (Guiguet, 1960:40–41).

GEOGRAPHIC LIMITS

Why the Spotted Owl, as a species clearly adapted to boreal surroundings, does not occur in the humid coastal forests of British Columbia north of its present breeding range is not well understood. These forests may lack the varied, well-shaded strata, and in winter mammalian food may be too scarce. Alternatively, other predators may prevent the occurrence of Spotted Owls in these mountain forests. Similarly, in the Rocky Mountains north of central Colorado the upper montane and subalpine forests, with species of fir and spruce predominating, probably do not provide enough shade.

Spotted Owl *Strix occidentalis*

To the south ambient temperatures of over 27°C set a clear distributional limit (see under Breeding Habitat and under Antagonistic... behaviour). In the light of this, it is all the more remarkable that other species of *Strix* (or *Ciccaba*) are able to thrive in subtropical and tropical lowland forest surroundings.

LIFE IN MAN'S WORLD

The unrestricted exploitation, logging and clear-cutting of age-old climax forests of trees of majestic size and height pose a serious threat to the continued existence of the Spotted Owl. Though it leads a secretive life, the Spotted Owl by no means avoids the presence of man. Even now, when many thousands of visitors annually invade the Yosemite Valley and Muir Woods National Monument, California, the Spotted Owls remain, though as a rule they escape attention when dozing by day 30 or more metres above the heads of tourists moving along carefully selected footpaths through the cathedral-like atmosphere of the silent woods (Gould, 1977).

Recently it has been suggested (Marcot & Gardetto, 1980) that the erection of nest boxes for Spotted Owls in young or subclimax forests in which a sufficient supply of natural holes is lacking might help to maintain or build up declining populations. Reference is made to results obtained with respect to the Ural Owl in Scandinavia and the Tawny Owl in west and central Europe.

The Spotted Owl is a most impressive boreal species which has survived post-glacial times in the southwestern North American forest refuges and humid coastal forest belt. It is the wood owl *par excellence*, leading a strictly nocturnal life in the middle and lower storeys of tall, old-growth forests where the sunlight even by day is notably dimmed. Its vocal qualities appear to be less extravagant than those of the Barred and Ural Owls. Nevertheless, its shadow in the night embodies great powers of predation, while John T. Marshall, from ample personal experience, relates how, like other *Strix* owls, "Spotted Owls are easily imitated [at night], with hair-raising results when the great bird finally answers from just over your shoulder" (in R. H. Pough, *Audubon Western Bird Guide* 1957:140).

If the Spotted Owl is allowed to survive in its restricted range, throughout which primeval forests are being carelessly destroyed by clear-cut logging, it will be mainly thanks to those few who, like Eric D. Forsman, Mark Zarn and Gordon J. Gould, Jr, and others, have sounded a timely warning (Bibliography: Campbell *et al.*, 1984).

URAL OWL

Strix uralensis

If Linnaeus had possessed a better knowledge of the owls of Sweden, the Ural Owl would probably now be known by a more appropriate name. Only 13 years after the publication of the famous tenth edition of Linnaeus' *Systema Naturae* in 1758, the Russian traveller Petrus Simon Pallas described *Strix uralensis* on the basis of a specimen collected by chance in the southern Ural Mountains, where it was common ("copiose"), and from then on the species was known as Ural Owl, though in Russian it is called "Long-tailed Owl", in Swedish *Slaguggla*, meaning "Attacking Owl", and in Germany *Habichtskauz* or "Goshawk-Owl" – all names which refer to real characteristics of the bird.

The Ural Owl is the second largest of the group of wood owls *Strix*. It ranges widely through the whole of the boreal coniferous forest belt, generally north and east of the smaller Tawny Owl *Strix aluco*, which is considered to be a close relative. Measured in body weight, the Ural Owl in Europe is 50–60% larger than the Tawny Owl; at the other extreme of its range, in China, the figure is about 20% measured in wing length. Finn Salomonsen (1931) was the first to hypothesize on the origins of the Ural and Tawny Owl species. He suggested that the Pleistocene continental glaciations divided a southwestern or southern group inhabiting temperate, mixed deciduous forests from an eastern one inhabiting cold, boreal environments. The Ural Owl would have developed from the latter group, the Tawny Owl from the former. This geographic mechanism has subsequently been called "glacial species formation" or "glacial speciation". According to this mechanism, other well-known species pairs in Europe would have evolved in a similar way, e.g. the more southern European Green Woodpecker *Picus viridis* and the more northern transcontinental Grey-headed Woodpecker *Picus canus*. The history of the Grey-headed Woodpecker is comparable with that of the Ural Owl, that of the Green Woodpecker with that of the Tawny Owl. After the retreat of the devastating continental ice masses the Ural Owl and the Grey-headed Woodpecker penetrated into the ranges of their pre-stadial conspecifics. The marginal overlap of the ranges of the Ural and Tawny Owls and the wider overlap of the Grey-headed and Green Woodpeckers provide favourable opportunities to study the degree of genetically based specific differences in reproductive behaviour and habitat preference and of interspecific competition. These subjects will be treated in the following species account.

In contrast to the Grey-headed Woodpecker, the Ural Owl has unmistakable relatives in North America, viz. the Barred Owl *Strix varia* and the Spotted Owl *Strix occidentalis*. Of these, the Barred Owl has been treated by some authors as forming one circumpolar species with the Ural Owl (Eck, 1968). In the following species account special attention will also be paid therefore to the ecological similarity between the Ural Owl and the Barred and Spotted Owls. In the northern parts of its range the Ural Owl may also meet the Great Grey Owl *Strix nebulosa*, the largest and probably most specialized of all wood owls.

GENERAL

Faunal type Siberian.

Distribution Eurasia, from Norway to Japan, with isolated populations in the mountains of central and southeast Europe and the high mountains of Transbaicalia (Kentei, Changai) and west China (Szechuan). In Europe the range includes Russia, Fennoscandia and lowland Poland; further, the Carpathian Mountains and the Bohemian Forest, south through the Transylvanian and Julian Alps to the Balkan mountains of Rila and Rhodope and probably Mt Olympus in northern Greece. The Ural Owl disappeared from the eastern Bavarian Alps around 1926. The Bavarian Forest National Park Authorities have been attempting to reintroduce the Ural Owl into mountain forests where the occurrence of five other resident species of owl (Eagle, Tawny, Long-eared, Tengmalm's and Pygmy Owl; Scherzinger, 1974) indicates both a diversity of habitat and a continuous food supply. Recent records from the Harz Mountains (Becker & Ritter, 1969) could indicate an old settlement or represent one of the rare instances in this species of a westward vagrancy. The distribution of the Ural Owl in the central European mountains thus resembles somewhat that of Tengmalm's Owl, though the Ural Owl does not occur as far westward, probably due to its size and prey preference. Map 19.

Climatic zones Almost exclusively boreal climatic and mountain zones, with southern extensions in temperate regions only on the islands of Shikoku and Kyushu, Japan. The northern limit approximates the July isotherm of 12°C, whereas in the south the range reaches the July isotherms of 20–22°C and somewhat further south of these in Japan.

Habitat Tall, but fairly open taiga of spruce, fir and pine, forest glades with edges of alder and birch wood, sometimes bogs sparsely surrounded by low, decaying trees, as well as riverine forests with birch and poplar in the taiga; also montane mixed beech-spruce or fir forests (montane taiga) and real mixed forests in lowland Ussuria and in Japan.

GEOGRAPHY

Geographical variation In the main region, not very conspicuous and clinal. Lighter, with a reduced dark pattern, in west-central Siberia (*Strix uralensis uralensis*); darker both in the west (*S. u. liturata*) and in the east (*S. u. nikolskii*), so that these populations are almost indistinguishable. It is largest and slightly darker in southeastern Europe (*S. u. macroura*) (Kohl, 1977); smallest, with most saturated, brownish colours, in Japan (3 or 4 races). Wing length in south Japan (*S. u. fuscescens*) is some 15% smaller than in southeast Europe. In total, some 10–12 races are generally recognized.

Related species Otto Kleinschmidt (1934) in particular and, following him, Siegfried Eck have postulated a close relationship between the Ural Owl and the New World Barred Owl *Strix varia*. These authors even include the small Fulvous Owl *Strix fulvescens* from the mountains of Mexico and Central America in one *Formenkreis* or nominal species (coloured "geogram" in Eck & Busse, 1973:plate II). Although they may form a superspecies on the basis of morphology, it is hard to see when and under what conditions of land and sea in the Bering Strait area these owls could have formed continuous populations. Ecologically the Barred Owl appears to be closer to the Tawny Owl than to the Ural Owl; at most it is intermediate between them. Hence, the Asiatic and American populations are better treated as separate species (Mayr & Short, 1970:52).

The Szechuan Wood Owl (*S. u. davidi*), named after the famous French missionary Père Armand David, is darkest of all and has indications of concentric dark lines on the facial disc, like the Great Grey Owl. It was first recognized as a member of the Ural Owl species by E. Stresemann (1923), but is still often considered a separate species. It is evidently a glacial relict in the mountain forests of west China where plant and animal life are often reminiscent of pre-glacial conditions. According to the German explorer and naturalist Hugo Weigold, Père David's Owl shares at least part of its mountain habitat with the Himalayan Tawny Owl *Strix aluco nivicola* (see Stresemann, 1923). Finn Salomonsen's theory of the "glacial speciation" of Ural and Tawny Owls in Europe therefore needs to take account of more complicated situations in the whole of Eurasia.

As for the history of the species in Europe, it is interesting to note the occurrence of Middle Pleistocene fossils, described as *Strix intermedia* in Czechoslovakia (Stránká Skalá) and Hungary (Tarkö) (Janossy, 1972), and later also found in Austria (Janossy, 1978) and in the cave named Escale à Saint-Estève-Jason in the Bouches-du-Rhône department in southern France in Mindel glacial deposits among an otherwise typically recent south-central European fauna (Mourer-Chauviré, 1975). Leg and wing bones of *Strix intermedia* are intermediate in size and structure between those of the Ural and the Tawny Owls. In Early Pleistocene deposits in Sardinia, where no *Strix* owls occur at present, Ural Owl remains have been identified by Cécile Mourer-Chauviré and in Middle Pleistocene deposits in the Carpathian basin of Hungary by Janossy (1981), but among Late Pleistocene deposits it is *Strix aluco* and not *Strix uralensis* which has turned up in continental France. Again, the Ural Owl and not the Tawny Owl was found in a Neolithic fauna in canton Bern, Switzerland (Becker & Pieper, 1982). One must conclude that either the mutual precursor of Ural and Tawny Owls was intermediate between the present species, or that *Strix intermedia* represents an intermediate stage in the process of species formation which has ultimately led to a larger Ural Owl and a smaller Tawny Owl. Pre-Pleistocene fossils found in south Germany and Hungary and named *Strix brevis* (Ballmann, cited by Janossy, 1978) and which are somewhat larger than and have slightly different proportions from those of present-day Tawny Owls lend support to the theory that the species differentiation between Ural and Tawny Owls was more complicate than originally supposed by Finn Salomonsen (1931).

This much is certain, however: that Ural and Tawny Owls are still capable of hybridization. Wolfgang Scherzinger (1983) raised young in captivity from a German Tawny Owl mother and a Swedish Ural Owl father. The two hybrids (male and female) showed maternal and paternal as well as intermediate characters and the male at least proved fertile in backcrosses with both parental species. The vocabulary of the hybrids was more varied than that of either parental species, adding new inventions to the original parental repertoire.

STRUCTURE

The Ural Owl has a longer tail than the Tawny Owl, which renders its flight not unlike that of a Goshawk. The facial disc is round and large, an impression which is enhanced by the smallness, characteristic almond shape and lighter colour of the eyes. The outer ear openings, hidden behind the stiff feathers of the rim of the facial disc, are among the largest known in owls and asymmetrical in size (height on average 24mm on the left and 27mm on the right; Collett, 1881; Voous, 1964). The pre-aural dermal flap is wide, about 13mm. The skull shows a slight asymmetry in the squamosal region, indicating a somewhat differently directed and differently shaped external part of the outer ears (Norberg, 1977). The extensive facial disc with its almost completely circular rim, the wide pre-aural dermal flap and the asymmetry of the outer ear opening all co-operate to give the Ural Owl considerable hearing and sound-locating capacities. The importance of these in boreal surroundings has already been stressed by various authors (Kelso, 1940; Voous, 1964). It is noteworthy that the Barred Owl resembles the Ural Owl in this respect, while the Great Grey Owl surpasses it. None of these owls, however, is as highly developed in terms of ear structure and skull asymmetry as is Tengmalm's Owl, while the Barn Owl shows a different type of ear asymmetry altogether.

Ural Owl *Strix uralensis*
Scandinavian race *S. u. liturata* from Finland

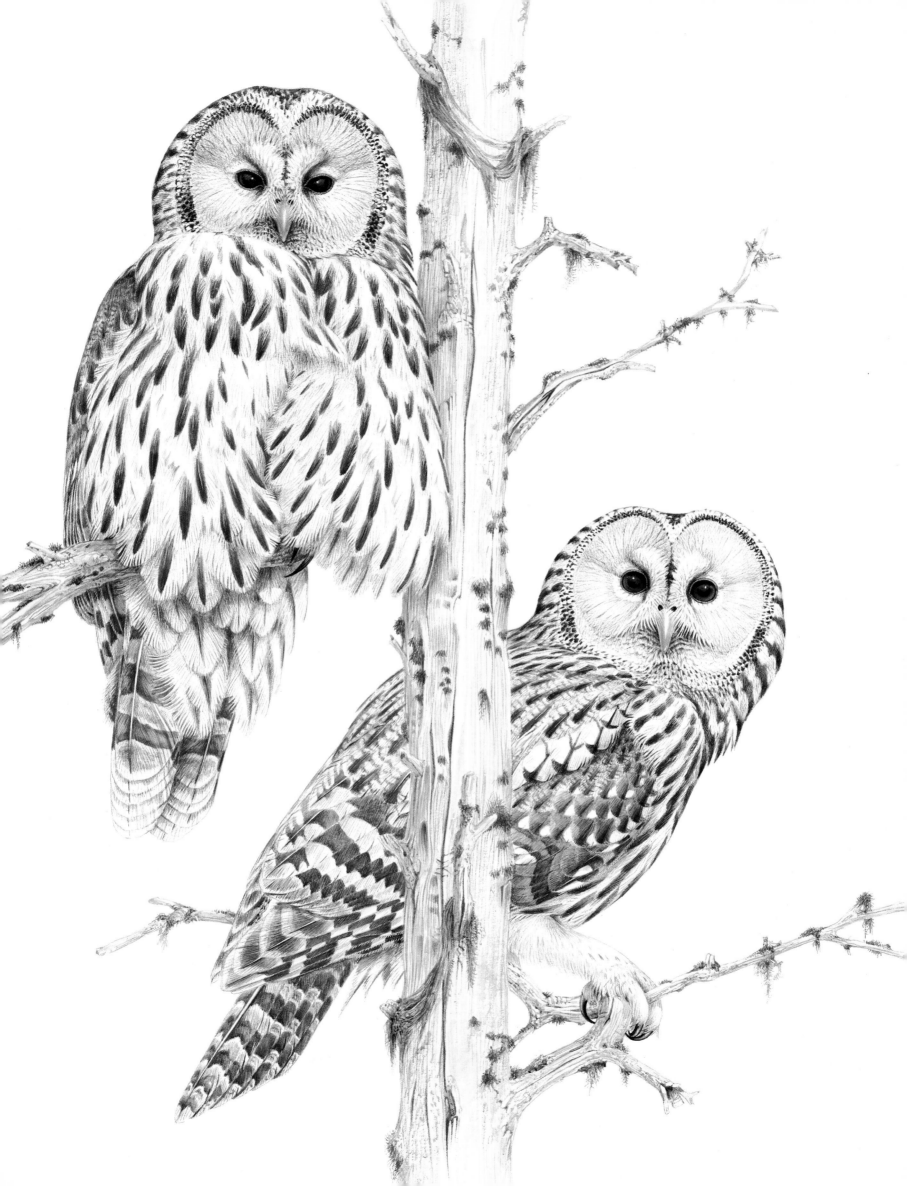

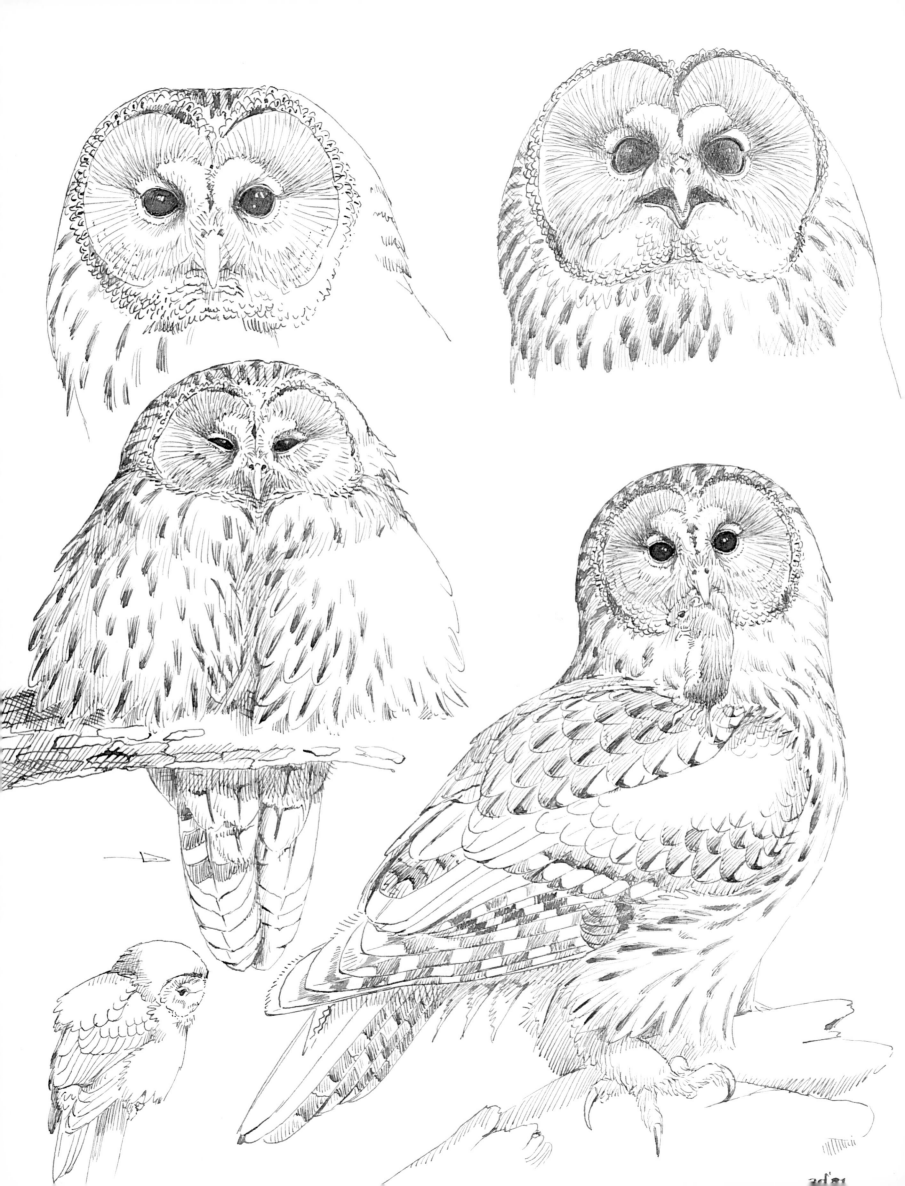

BEHAVIOURAL CHARACTERISTICS

Songs and calls At least nine kinds of songs and calls have been described for Swedish Ural Owls (Linblad, 1967; Holmberg, 1974; Scherzinger, 1980). They resemble those of the Tawny Owl, but are stronger, wilder and even more impressive, not unlike the hooting of the North American Barred Owl. The territorial song of the male has been rendered as *woho-woho-wohoho* (Lindblad, 1967) and *wohu-woho-huwohu* (Holmberg, 1974). A comparable hooting call uttered by the female is harsher and her answering call to the male is usually a barking note. Communication and duetting between a pair of Ural Owls carry a great distance, particularly over mountainsides. The female's barking alarm call is most impressive: an explosive, hair-raising sound. The call of fledgling Ural Owls begging for food is similar to that of Tawny Owls, but slightly hoarser and lower pitched (Mikkola, 1983).

Circadian rhythm The Ural Owl is known to be active by day far more frequently than the Tawny Owl, particularly in Siberia, where its appearance by day may resemble that of an immature Goshawk (Dementiev & Gladkov, 1951).

Antagonistic behaviour The Ural Owl is one of the fiercest owls in the defence of its nest and young and can inflict bloody wounds on human intruders. Its Scandinavian names, *slaguggla* in Swedish and *slagugle* in Norwegian, referred to earlier, are most appropriate. A rich vocabulary of defensive calls and fierce bill-snapping has been described; and a pseudo-sleeping posture, functioning as a displacement action, was observed in an apparently frustrated female which had failed to drive away a human intruder from her nest (Otto-Sprunck, 1967). A similar pseudo-sleeping displacement posture is also recorded for Tengmalm's Owl. Other cryptic and threatening postures resemble those of the Tawny Owl (Scherzinger, 1980:42, fig. 17).

ECOLOGICAL HIERARCHY

Formidable though the Ural Owl is (weight of male 720g, of female 870g), it is surpassed in its northern forest habitat by the Great Grey Owl (20–40% heavier) and the Eagle Owl (210–250% heavier) (Mikkola, 1983). At least five or six other owl species smaller than the Ural Owl occur in the northern forests too, but the Ural Owl's relations with the smaller Tawny Owl (weight of male 475g, of female 585g) and the larger Great Grey Owl are of particular interest.

There are very few places where the Ural Owl and the Tawny Owl meet, and A. Lundgren (1980) was perfectly justified in entitling one of his papers "Why are the Ural Owl *Strix uralensis* and the Tawny Owl *S. aluco* parapatric in Scandinavia?" The answer was hardly to be found in a different utilization of food, since in the marginal areas where both species occurred they preyed mainly on ground vole and short-tailed vole (Ural Owl 32.0% and 30.5%, respectively; Tawny Owl 26.0% and 42.3%, respectively). As for differences in habitat use in Fennoscandia, the Ural Owl occurred more frequently in the real boreal coniferous forest with open spaces formed by mires and clear-felling, whereas the Tawny Owl was more often found in patches of mixed or deciduous forest and on farmland. These differences reflect the geographical origin of the two species, but why they still need to keep within such geographic boundaries and hence occur parapatrically rather than sympatrically is not understood. Finnish authors state more or less categorically that in contact between the two species the ". . . problem is normally solved by the Ural Owl killing or at least driving away any Tawny Owl which comes into its territory", though they also mention cases of these owls nesting "peaceably near each other"; on one occasion only 300m apart (Mikkola, 1983:165). The Ural Owl needs much larger nesting areas than the Tawny Owl. In Sweden an estimated 3,000 pairs of Ural Owl occur in 150,000km² of suitable habitat, whereas the number for the Tawny Owl is three times larger (10,000) in one sixth of the Ural's habitat range (25,000km²) (Ulfstrand & Högstedt, 1976).

The Great Grey Owl's food is less varied than that of the Ural Owl and in spite of its immense appearance its claws are shorter and less formidable than the Ural Owl's.

In size and strength the Ural Owl is of course no match for the Eagle Owl. With its wingspan of on average 160cm in males and 180cm in females, as against 115cm in male and 125cm in female Ural Owls, the Eagle Owl belongs to a different class and catches a wider range of prey than the Ural Owl, some of it of remarkable size. The Eagle Owl is also a terrible predator of other owls. Of 1,288 instances of such predation mentioned by Heimo Mikkola (1983:table 56), more than half relate to the Long-eared Owl, but only six to the much larger Ural Owl. Existing records show that a Ural Owl has fallen victim once to a Great Grey Owl and twice to a Goshawk. In return, 18 owls are known to have been killed by Ural Owls, including 12 Tengmalm's Owls and 2 Tawny Owls. The number of diurnal birds of prey known to have been taken by Ural Owls is negligible.

Female Ural Owls (average 870g) are about 21% heavier than males, as against 23% in the Tawny Owl and 43% in the Great Grey Owl. Nothing is known of average or actual size differences of prey taken by male and female Ural Owls.

BREEDING HABITAT AND BREEDING

The Ural Owl's breeding habitat is not unlike the Goshawk's. It is characterized by open, tall conifer forests, often near bogs and clearings or by mixed forest stands in the mountains. Nests have been found in natural tree holes and cavities formed where tree trunks have fallen or thick branches have broken off the main stem; in the European mountains nests are almost exclusively in large tree nests taken over from Buzzard, Goshawk, Lesser Spotted Eagle, Black Stork, Raven and other large birds. Ornithologists in Finland (Mikkola, 1983) and Sweden (Lundgren, 1980) have noted that modern forestry in their countries has seriously depleted the number of potential nest sites in tree holes, causing the Ural Owl to retreat in favour of the Tawny Owl or to use alternative nest sites (Lundberg & Westman, 1984). The Fennoscandian Ural Owls now seem regularly to be using the tree nests of big raptors, mainly Goshawk and Buzzard (Lahti, 1972), and also of smaller ones such as those of Sparrowhawks and Crows, and even squirrel dreys. The Ural Owl has taken, in addition, to nesting on ledges and in fissures in rock faces, wooden and stone buildings and, progressively, in

Ural Owl *Strix uralensis*

nest boxes. In south Norway a nest was found in a large hole in a dead and broken aspen *Populus tremula*, while a Goosander was nesting in another hole in the same tree trunk (Mysterud, 1969).

The incubation period is considerably longer than in the Tawny Owl, viz. 35 as against 29 days (Scherzinger, 1980). Other differences from the Tawny Owl, including early development and hopping locomotion of chicks, have also been described. A juvenile plumage is shown on p. 256.

FOOD AND FEEDING

The Ural Owl's diet is extremely varied. Mammals inhabiting moors and forest clearings predominate throughout its range, while those living on the forest floor are less prominent as prey species. Since Ural Owls are sedentary, they have to exploit the potential food supply in their territories efficiently in order not to starve during periods of rodent scarcity and deep snow cover. Hence, the variety in size and kind of prey is as large as or even larger than the Tawny Owl's. Heimo Mikkola (1972, 1983) has summarized most of the food data available for the breeding period and found that, of 3,433 food items from Fennoscandia and Poland, 30% were voles *Microtus*, 17% water and ground voles *Arvicola*, 17% bank voles *Clethrionomys* and 8% shrews. Other prey consisted of mice and rats (2.5%), squirrels (2.4%) and birds (15%). Outside the breeding season shrews increased to almost 18% and hares from a scanty 0.5% to almost 2.7%. Similarly, in Norway the main prey consisted of short-tailed voles (34%), grey-sided voles (15%), bank voles (10%) and shrews, mainly common shrew (14%) (Mysterud & Hagen, 1964).

In the Carpathian Mountains of Slovakia 70% of the food items were microtine rodents (43% common vole), 11% were shrews and moles and 16% were birds (Sladek, 1961–62). Russian authors also stress the fact that small rodents form the Ural Owl's main prey, commenting, however, that in winter a great number of birds – often of considerable size – may be taken, including: Willow Grouse, Hazel Hen, Black Grouse, Partridge, domestic chicken and pigeon, Woodcock, Great Spotted Woodpecker, Daurian Jackdaw, Nutcracker, Magpie, Common and Siberian Jay and others (Pukinsky, 1977).

Japanese data include grey-sided *Clethrionomys* voles in Hokkaido (58%) (Matsuoka, 1977) and *Microtus* voles in Honshu (68%) (Imaizumi, cited by Mikkola, 1972), in addition to 12% and 22% birds, respectively.

In total at least 32 species of mammal and 22 birds, in addition to various frogs, lizards, fish and insects, have been recorded.

The Ural Owl's food spectrum is not as different from that of the Tawny Owl as one might perhaps expect. In Uppland, Sweden, where both species occur, though usually in slightly different habitats, short-tailed voles represented 21% of the total weight of the Ural Owl's prey, as against 17% in the Tawny Owl, the larger ground voles 59% (against 56%), wood mice 0.2% (against 3%), birds 10% (against 14%), amphibians 1% (against 2%) (Lundgren, 1980).

Russian authors have recorded a Siberian Ural Owl pouncing upon full-grown mink, but the latter succeeded in catching, killing and eating the owl (Knystautas & Sibnev, 1987).

The above data show the Ural Owl to be a genuinely versatile and opportunistic hunter. As a resident bird, this is how it survives the vagaries of food supply in the boreal forests throughout the year (see Linkola & Myllymäki, 1969).

MOVEMENTS AND MORTALITY

Although it is considered non-migratory to the same extent as the Tawny Owl, the Ural Owl is known to wander south, particularly in north-central Siberia, but whether this is a regular occurrence is not stated (Dementiev & Gladkov, 1951). North European Ural Owls are not known to wander over any considerable distance; nest site fidelity in Finland amounted to 98–100% in males and 90–95% in females (Saurola, 1987:81–86). The species has never been recorded in the Netherlands, Belgium, France or the British Isles. The mountain-inhabiting Ural Owls in Europe are more subject to straggling and lone birds have been reported from West Germany at least 4 times (Glutz & Bauer, 9, 1980:618–619) and from northern Italy at least 16 times (up until 1965). Although food scarcity can impose heavy constraints in winter, adult survival in Sweden (89% in breeding females; Lundberg & Westman, 1984) and Finland (80–90%; H. Pietiäinen) was high.

GEOGRAPHIC LIMITS

Exactly what confines the range of the Ural Owl to the belt of boreal coniferous forests is not known. The wooded steppes in central Asia may be uninhabitable for a taiga bird because of their heat in summer. In Europe the Tawny Owl may be a species more readily adapted to occupying open deciduous woods, parklands and farmlands because of its smaller size and consequently more restricted nutritional needs. In the wooded areas of east Asia there were originally probably fewer limitations of this kind than in Europe and the variety of owls living at present alongside the Ural Owl in Japan is greater and markedly different from that in Europe. To what extent the Great Grey Owl limits the Ural Owl's distribution to the north is not known, but the two species occur alongside each other over most of their ranges, though the Great Grey extends farther north.

LIFE IN MAN'S WORLD

The Ural Owl is less likely than many other owls to live close to human habitation, but it does not seem actually to shun the presence of man. There are numerous recorded instances of these owls living and nesting close to and even in farmhouses and loggers' cabins in the wooded areas of the north. Russian authors mention Ural Owls turning up in parks and gardens in winter at least in Chkalov, Kirov, Barnaul, Krasnoyarsk and Irkutsk, even in Leningrad and Moscow. It may be in just such a way that the Tawny Owl became accustomed to a permanent life in European villages and cities. The Ural Owl's life in northern forest tracts would not have brought it into close contact with man, were it not for the owl's large-scale acceptance of nest boxes of the most varied kinds, but preferably with entrance holes of up to 16cm diameter (Hannu Pietiäinen, Helsinki). In south Finland nest boxes are now said to constitute 42–49% of all recorded nest sites (Lahti, 1972). This is a most promising development and unless the great northern woods are threatened by clearing and over-exploitation or suffer the effects of a mondial disaster, the Ural Owl has a good chance of survival.

The Ural Owl is a bold and highly specialized representative of one of the largest groups of owl. Its origin from other, probably ultimately tropical, species of wood owl, its evolutionary relationship with the North American Barred and Spotted Owls *Strix varia* and *S. occidentalis* and the degree and manner of its specialization are its most notable characteristics. Its clashes and possible competition with the formidable Great Grey Owl *Strix nebulosa* and the powerful Goshawk *Accipter gentilis* and its behaviour towards smaller owls probably constitute other crucial aspects of the Ural Owl's life. The Ural Owl's immediate future will be decided by its ability to adapt to man's increasing intrusion into the southern fringes of its range and to the transformation of its northern forest home into agricultural lands and open parklands.

GREAT GREY OWL

Strix nebulosa

With a body length of 63–66cm, average wingspan of 130–140cm and wing length of 44–45cm, the Great Grey Owl appears to be the largest and most massive of the northern forest owls. In effect, however, it is greatly surpassed by the Eurasian Eagle Owl *Bubo bubo* and the American Great Horned Owl *Bubo virginianus*, which have body weights of 250% and 120%, respectively, of that of the Great Grey Owl and correspondingly higher powers of predation. The Great Grey Owl ranges further north than any of the other wood owl species, almost reaching the northern forest limits, so that the question arises of how it is able to survive the hardships of boreal continental winters better than the other wood owls. The present account will therefore compare the Great Grey Owl with the Ural and Tawny Owls *Strix uralensis* and *Strix aluco* and analyse its ecological relations with the *Bubo* owls in as much detail as is at present possible.

The insulating capacity of the owl's long, soft feathers, the relatively small energy output of its minute body and its highly developed acoustic and visual properties are what probably equip the Great Grey Owl for a northern forest life which no other owl of its size is able to lead. Its bulky round head of over 50cm diameter forms a reflecting disc which apparently directs sound waves to the enormous ear openings, while its small, piercing yellow eyes seem to be adapted to diurnal rather than nocturnal vision. Robert W. Nero (1980:20) was surprised, however, by photographs of the Great Grey Owl taken at night and showing fully extended pupils, wholly adapted to night vision; they gave the owls an unexpectedly soft look. The Great Grey Owl has a slow, almost effortless, heron-like flight; its wing-loading is $0.35g/cm^2$, which is low in comparison with the Eurasian Eagle Owl ($0.71g/cm^2$), lower also than in the Tawny Owl ($0.40g/cm^2$). Only the Ural Owl and the Long-eared Owl *Asio otus* have a smaller wing-loading, viz. $0.34g$ and $0.31g/cm^2$, respectively. With its relatively light body weight the Great Grey Owl displays a "perfected low-speed, silent, manoeuverable flight as a way of life" (Dalton Muir, cited by Nero, 1980:34), finding passages between tree trunks in dense and heavy forest which are seemingly too small for so large a bird. "Occasionally their wings do strike branches or twigs, but because the pinions are so soft and flexible, no serious harm seems to result . . . Observations of birds with one or more broken flight feathers, however, suggest that accidental collisions sometimes cause harm."

Its inquisitive look, its boldness and fierceness in defence of its nest against intrusion by both man and beast (including black and brown bear), and its secretive life in the northern forest, mosquito infested in summer and almost lifeless in winter under an icy snow cover, have made this one of the most enigmatic of owl species, highly sought after by bird watchers and listers. It is all the more remarkable, therefore, that Great Grey Owls were found to turn up more or less regularly in the countryside of southern Manitoba (Winnipeg) in winter, and that Robert Nero and his enthusiastic collaborators, wading in deep snow, succeeded in catching and ringing hundreds of these huge owls with an artificial mouse as bait on rod and reel and the help of a large fishing net.

GENERAL

Faunal type Siberian–Canadian.

Distribution Holarctic. Northern forest belt of Eurasia and North America, north and south to the limit of coniferous forest, with southern extensions in some central Asiatic mountain areas (Salair, Kuznetsk Alatau in the northern Altai and the Kentei Mountains in northeastern Mongolia at 54° south) and the North American Rocky Mountains south to northern Idaho, western Montana, northwestern Wyoming, probably also the Uinta Mountains in northern Utah (July 1962) (Wagner, 1981), and the Sierra Nevada of California south to the Stanislaus National Forest (Winter, 1982), Yosemite National Park and Madera County at 37° south. Beyond the mountains the southern limit is very vague and unstable; it reaches Swedish Lapland, incidentally Jämtland and Ångermanland, central Finland, formerly the Baltic countries, at present Belorussia in the regions of Pskov, Smolensk and Yaroslavl, also the Bialowieza forests, but there are probably no breeding records since 1953 (Borowski, 1961), and occasionally the Carpathians in western Ukraine (Strautman, 1963). It has nested beyond the eastern Canada–United States border in northwest Minnesota (Roseau; Nero, 1970), northwest Wisconsin and the Pickle Lake area in south-central Ontario (Don G. Follen James, 1977). Map 21.

Climatic zones Boreal forest belt and corresponding boreal mountain zones.

Habitat Old and high, mostly lichen-covered forest of spruce,

fir and pine, often intermixed with larch and poplar, in North America also tall, mixed black ash and basswood forests, sometimes even mature aspen stands, in east Asia also birch and poplar woodland, and always with neighbouring swampy meadows, sphagnum bogs, muskegs, tamarack bogs and other open spaces. Northward into stunted, transition forest of a subarctic type and in the mountains up to subalpine conditions with open meadows. In the California Sierra Nevada up to 2,400m and in Utah to 3,200m. The same habitat in winter, but more often at forest edges, on frozen and snow-covered swamps, in cultivated fields bordering roads, in grasslands and even on golf courses, sometimes close to farms and other human habitation.

GEOGRAPHY

Geographical variation Conspicuous differences between the populations of the Old and New World: the races *Strix nebulosa lapponica* and *S. n. nebulosa*, respectively. North American Great Grey Owls are minutely, but distinctly, barred on the underparts rather than almost exclusively longitudinally streaked, have darker marmorations above and a less prominent white loral crescent and superciliary line (Oberholser, 1922:75–76). The American birds are approximately 4% larger in body weight and wing length than the Eurasian ones and their eggs are approximately 10% larger.

Related species The other large northern wood owls, viz. the Ural Owl *Strix uralensis* and the Barred Owl *Strix varia*.

STRUCTURE

Most impressive morphological characteristics are the enormous, rounded head with its – for owls – small, piercing eyes, and the unusually long, fluffy feathers hiding a remarkably small body. The body feathers have relatively few rami and rudimentary radii and are silky and soft as a result; the breast feathers reach a length of 10–20cm. The facial disc almost forms a complete circle of 50cm width or more, with the eyes set closely together near the centre of the circle. The rictal feathers are white or whitish, long, soft and fur-like, and conceal all but the tip of the bill; they form conspicuous, opposite-facing crescents and partly surround the eyes, particularly as superciliaries.

The eyes are small, 12–14mm in diameter, as against 15–16mm in the Ural Owl, 16–17mm in the Tawny Owl and as much as 23–24mm in the huge Eurasian Eagle Owl; in the slim, relatively small Long-eared Owl the eye diameter is almost as large as in the Great Grey Owl, being 11mm (own measurements and Piechocki, 1965). The fierce yellow iris and small pupil are considered adaptations to daylight hunting, though this remains unproven. They give the Great Grey Owl a fearsome facial expression, unlike that of any other *Strix* owl.

The external ear openings are large and complicated, with a transverse skin trabeculum and a wide pre-aural rim, not unlike those of the Ural Owl, Tengmalm's Owl, Long-eared Owl and Barn Owl. They mark an extreme structural development in *Strix* owls. The vertical height of the orifice in Norwegian Great Grey Owls was 28mm (left) and 30mm (right) (Collett, 1881) and 27mm on average on both sides in eight museum specimens (Voous, 1964); the width varies according to the movements of the skin. The dermal flap is wide, 15–17mm, as against 13mm in the Ural Owl (various authors). All structures are well hidden behind the outer disc feathers. The relatively small, bilateral asymmetry recorded by observant Professor Robert Collett from Christiania (now Oslo) is enhanced by the asymmetry of the base of the postorbital processes and the tympanic wings of the skull (Collett, 1881; Ford, 1967; Norberg, 1977). The asymmetry of the skull is more marked than in the Ural Owl and the Barred Owl, but not as conspicuous as in Tengmalm's Owl. The whole asymmetry results in the left external ear opening being directed further upwards than the right – the reverse of the situation found in Tengmalm's Owl. For the effect of this asymmetry and the role played by the movable pre-aural dermal flap in precise directional hearing, see under Barn Owl and Tengmalm's Owl.

The owl's feet are relatively small. Its claws are less curved and much less formidable than in other large owls, but are thin and needle-sharp and have a wide reach. Apart from the distal scutes the toes are covered with dense, fur-like feathers, which conceal the basal parts of the claws; the soles are bare.

BEHAVIOURAL CHARACTERISTICS

Songs and calls The territorial song is a remarkably soft and deep, mellow hooting *hoo-hoo-hoo-hoo*, unhurried and regularly spaced over 5–8 seconds. It is repeated ten or more times and is answered by the female with a soft, mellow *whoop*. As a threat to rivals and intruders the song modulates into a series of rapid double notes *ho-oo*, which can be shortened, or accentuated, and as additional warning, the female may also join in. This particular call may be repeated more than a hundred times in succession. The calls are far less loud and less terrifying than those of the Ural and Tawny Owls. The variety of calls, however, is as large and includes a high-intensity alarm call by the female *kjäh-kjäh-kjäh* and rasping, screeching, cooing and whistling calls during courtship, as well as harsh and rasping calls by the female and young begging for food. No differences between songs and calls of Old World and New World Great Grey Owls have been decribed (Mikkola, 1981; Nero, 1980).

Circadian rhythm The Great Grey Owl is usually considered to have a biphasic daily rhythm, hunting around dawn and dusk and sleeping during the middle of the night and the brightest part of the day. Its daytime roosts are high up in evergreen coniferous trees, in California at an average height of 9.3m (Winter, 1982). Even during the breeding season, when the northern night is almost as bright as the day, most food is brought to the nest during the hours of night. When there are young to be fed the male hunts by day as well. During the short winter days in southern Canada Great Grey Owls hunted actively throughout the day, even over ice and snow cover glistening in the sun, though they were most active when the light was dim (Nero, 1980). The owl's small yellow eyes probably represent an adaptation to a partially diurnal life.

Antagonistic behaviour Perched close to the bare trunk of an aspen, or hidden high up in a spruce, the Great Grey Owl almost disappears from sight thanks to the long, slender shape of its body and the shadowy, grey and black pattern of its plumage.

When sitting motionless on a snag or tree stump the owl is easily lost to view since, in Robert Nero's words, "the woods are full of owl-like shapes" (Nero, 1980).

In defensive situations the wings are partly spread to make the bird look even more massive, but never raised or brought forward as in *Bubo* and *Asio* owls. Bill-snapping, however, is impressive. Even more impressive are the direct attacks on man or any other intruder at the nest site. With unblinking, penetrating eyes and the white feathers around the bill and over the eyes fully raised, the birds assume a fearsome appearance and strike with precision and force. Females can be particularly savage in defending small nestlings and on more than one occasion the nest could only be examined by those wearing a helmet and a face mask. Heimo Mikkola, Finnish ornithologist and author of *Owls of Europe*, claims to know of several instances in which people have lost an eye or received blows and suffered wounds and bone fractures from attacks by Great Grey Owls. The better nourished the owls are in optimum vole years, the more aggressive they seem to be.

ECOLOGICAL HIERARCHY

The Great Grey Owl shares its forest habitat with at least five other relatively large owls: Eurasian Eagle Owl and Great Horned Owl, Ural Owl and Barred Owl, Northern Hawk Owl, Long-eared Owl and Short-tailed Owl, and also with Golden Eagles, White-tailed and Bald Sea Eagles, Common Buzzards, Red-tailed Hawks and Goshawks. Although the Great Grey Owl is longer and larger in appearance than the *Bubo* owls, its body mass is only 84% of that of the Great Horned Owl and 40% of that of the Eurasian Eagle Owl. The length of the breastbone is 71% of that of the Great Horned Owl, wing bones together 89%, legs and toes 86% and claw length of the middle toe 76% of those of the Great Horned Owl. In spite of its impressive size the Great Grey Owl takes relatively small prey and is unlikely ever to enter into real competition with the *Bubo* owls. It may compete for nest sites, however, and was found to flourish in Alberta, Canada, mainly in years when low population densities among other raptors left an abundance of vacant nests for its use (Archibald Henderson, cited by Nero, 1980). This took place in years following the decline of population highs of snowshoe hare and grouse. Apparently, in the same years the Great Grey Owl also suffered less from predation by Great Horned Owls (Oeming, 1955) and Goshawks, though the extent of the predation has never been summarized. Elsewhere in North America the Great Grey Owl has also been killed and eaten by Golden Eagle, lynx (Nero, 1980) and fisher marten. In Europe Great Grey Owls have been preyed upon by Golden Eagle (Sweden 2 ×, Finland 4 ×), Eagle Owl (Finland 1 ×) and Goshawk (Finland 1 ×) (Mikkola, 1981), but this refers to the few instances noted and published. Conversely, a Tengmalm's Owl and a young Ural Owl have been recorded as victims of the Great Grey Owl in Finland (Mikkola, 1981).

In their nesting ranges Great Grey Owls are, nevertheless, remarkably tolerant towards other owls and diurnal birds of prey. Around Oulu in Finland Goshawks have nested as close as 100m from a Great Grey Owl's nest, a Common Buzzard at 150m, Ural Owl and Tengmalm's Owl at 200m (Mikkola, 1981). Great Grey Owls can be very fierce and vigorous, however, when defending their nests and have been reported to drive away brown bears in Asia and black bears in America (Pukinsky, 1977; Oeming, 1955).

Most of the boreal owls seem to profit from an abundance of voles and other microtine rodents. In 1966 73% of the Great Grey Owl's prey in central Finland consisted of field vole; for the Short-eared Owl the figure was 97%, for the Northern Hawk Owl 82%. A further 15%, 0% and 13%, respectively, consisted of bank voles and 7%, 2% and 0%, respectively, of common shrews (Mikkola, 1981). Barely any interspecific competition could be expected to have occurred; instead there were specific differences between the three species in exploitation of habitat and in hunting methods. Interspecific competition and predation has been apparent, however, on those rare occasions when three species of wood owl *Strix* occur alongside each other, e.g. in southern central Finland. Differences in size and corresponding predatory power are demonstrated by claw size, which, for all the claws together, is 182.4mm in the Great Grey Owl, 161.6mm in the Ural Owl and 154.4mm in the Tawny Owl; the dimensions of the massive hind claw alone are 23.8mm, 20.6mm and 19.6mm, respectively (Höglund & Lansgren, 1968). The ecological relationship between these owls may be described as follows. The Ural Owl kills and eats any Tawny Owl it is able to catch; both leave the Great Grey Owl in peace, and the Great Grey Owl does not as a rule molest either of the others. During the six months of spring and summer the Great Grey Owl consumed a total of 27kg biomass or 715 prey items; the Ural Owl 23kg biomass or 338 prey items; the Tawny Owl 18kg or 389 prey items. In spite of its smaller size the Ural Owl preys on larger prey on average than the Great Grey Owl, which specializes in small rodents. The Tawny Owl catches more birds and is most nocturnal, while the Great Grey Owl is the most diurnal of the three (Mikkola, 1981). Interspecific competition and differences in exploitation of habitat must be even more apparent during winter conditions.

Sexual dimorphism in terms of size is relatively large and conspicuous even in the field. In Eurasia females weigh on average 135% of the weight of males (878g); the dimorphism index based on weight is 11.8 (Mikkola, 1981). In North America body weight of females is on average 127% of that of males (935g), while the overall dimorphism index of weight and dimensions is calculated at 6.3, which is smaller than in Tengmalm's Owl (8.2) and much smaller than in the Goshawk (8.6) and Sharp-shinned Hawk (20.4) (Snyder & Wiley, 1976). Average prey weight taken by males during the breeding season in Finland was 20g, and by females 34g (Mikkola, 1981). Whether these differences in predatory power also lead to differentiated winter movements and survival rates between the sexes is not known and would be worth investigating. Bob M. Fisher (1975) mentions one apparent case of a Great Grey Owl eating another in Jasper National Park, Alberta, on 23 January 1974; one wonders whether the predator was a female and the victim a male. Pulliainen and Loisa (1977) theorized that the relatively small size of the male allows for greater speed and manoeuvrability during hunting in the breeding season, whereas the greater body mass and longer feathers of the female enhance thermoregulation during incubation.

Great Grey Owl *Strix nebulosa*
European race *S. n. lapponica* with common shrew *Sorex araneus* as prey

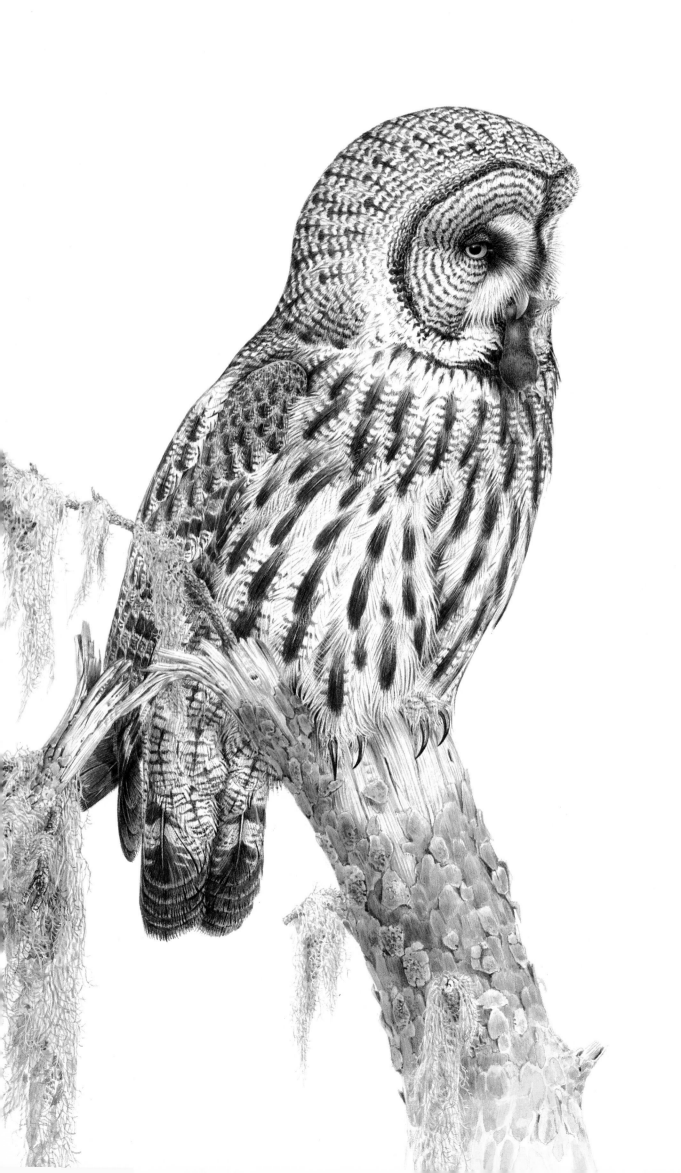

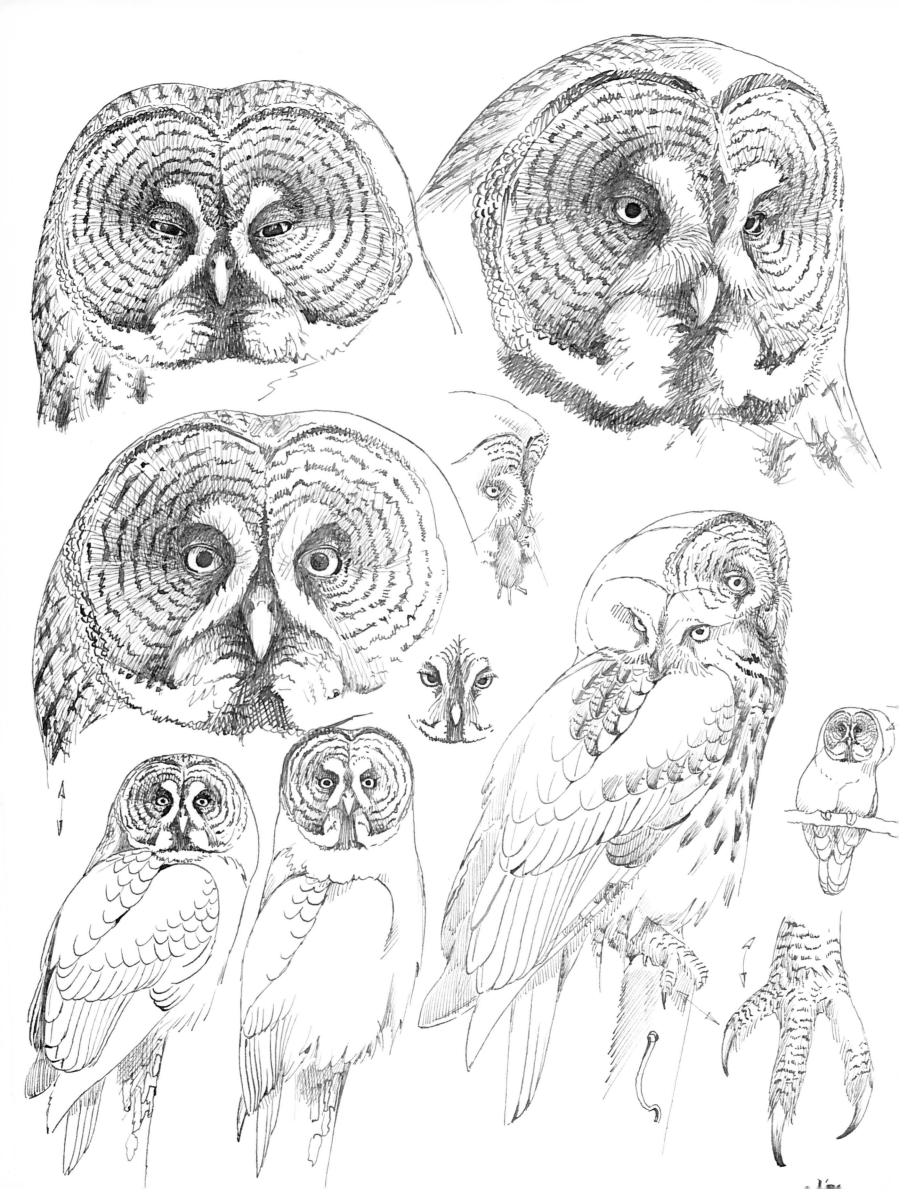

BREEDING HABITAT AND BREEDING

The Great Grey Owl usually nests in heavy coniferous forest, selecting spots not far removed from trails, roads, forest edges, bogs and other open spaces. In Finland 56% of the nests were in dry or boggy pine forest, 35% in spruce bogs, 6% in trees growing on moors and 3% in other types of forest (Mikkola, 1981). In most cases the owl appropriates tree nests belonging to birds of prey, as was the case in 84% of 168 nests recorded in Finland; other nest sites were on top of broken or rotten snags (12%), on the ground (2%), on rocks (1%), even on the roof of cabins and sheds (1%) and on one occasion on a haystack (Mikkola, 1981). Tree nests occupied in Europe belonged to Goshawk, Common and Rough-legged Buzzard, Osprey, Raven and Magpie; in North America, to Goshawk, Red-tailed and Broad-winged Hawk, American Crow and Raven. No nest repair is undertaken and the nest cavity is usually as flat as that in any old or demolished nest, so that the incubating bird can easily be observed from the ground (see p. 140). Ural Owls, by contrast, make a depression in any nest they occupy and can hardly be seen from the ground. The Great Grey Owl is strong and persistent enough to oust a breeding Goshawk from its nest (Mikkola, 1981). In contrast to other *Strix* owls, there are no reports of a Great Grey Owl ever nesting in a tree hole and it is hard to imagine a bird of its bulk and with such an elongated tail either entering or accommodating itself to a small and narrow nest hole.

Nesting territories vary in size considerably; sometimes they are larger than the average territory of Ural and Tawny Owls, viz. 10–25km² (Mikkola, 1981), but they can also be much smaller: 2.6km² in North America (Craighead & Craighead, 1956), or as small as three nests to a distance of 400m or 0.47km² in Quebec (cited by Winter, 1982).

Courtship includes the transfer of prey by the male and much mutual nibbling of feathers of head and neck, even of the legs and toes; the male also combs the female's breast feathers with his talons (Nero, 1980). From the moment that pairs are formed or reinforced the male provides the female with food and continues to do so throughout the whole breeding period.

Nesting may start early, so that often young are surrounded by heavy, wet snow in mid-May in Manitoba (Nero, 1980), but it can also be much later, starting in April or early May, apparently depending on the quality of the habitat and the availability of rodent food. Clutch size is relatively large: 2–9 in Europe, average 4.4, and usually 3 in North America. Following a year of food abundance in Finland in 1966, when the average clutch size was 4.6, the number dropped to 3.3 the next year. When food is scarce the birds may not breed at all.

Egg size in Europe and North America is virtually the same, being on average 53.2 × 42.4mm in northern Europe (Mikkola, 1983) and 54.2 × 43.4mm in North America (Bent, 1938). The eggs are longer, more ovoid than in the other *Strix* owls, and do not roll so easily out of flat, open nests. The average clutch of 227g corresponds with 19% of the female's body weight, which is comparable to the 17% found in the Ural Owl (average clutch size 3.0) and 20% in the Tawny Owl (average clutch size 3.3). By contrast, the clutch size as percentage of female body weight for the tiny Eurasian Pygmy Owl (usual clutch size 4–6) is as much as 67% (Glutz & Bauer, 9, 1980).

Great Grey Owl *Strix nebulosa*
European race *S. n. lapponica*

Strix owls are apparently able to conserve their body energy very efficiently by relying on the hunting success of the males. The female barely moves: one female in Finland left her nest for no longer than 0.63% of the total period of incubation (Mikkola, 1981). The male sometimes brings large quantities of food to the nest, usually transferring the prey from his bill to the female's. On one occasion in Finland 14 voles were found on the rim of a nest (Pulliainen & Loisa, 1977). There is no indication of food-caching.

Nestlings and fledglings have a wonderfully cryptic, grey and white coloration (see p. 256), which camouflages them well in their forest environment where large shadows play over bark, lichen and mouldy tree trunks. Hole-nesting owls do not need a camouflaging juvenile plumage and Great Grey Owls have probably deviated from what may have been their ancestral habit of nesting in holes (W. Scherzinger).

FOOD AND FEEDING

All food analyses in Eurasia and North America indicate that both in summer and in winter the Great Grey Owl's main food consists of voles and other microtine and relatively small terrestrial rodents. Thus, of 5,177 prey items listed from various sources in Fennoscandia (Mikkola, 1983) during the breeding seasons of 1955–74, 71% were voles *Microtus*, mainly short-tailed vole, while all rodents together formed 96% of total prey numbers and 94% of total prey weight. Stomach contents of birds collected in Finland in winter revealed 50% voles, 49% shrews and 1% birds. Comparable data from Sweden showed 79%, from Canada 77%, from the contiguous United States 84% and from interior Alaska 94% rodents. Local and annual variations, however, are considerable. Correspondingly, the number of prey species recorded is large; those known from Europe include 19 species of mammals, 53 of birds (e.g. Fieldfare, Redwing, Great Tit, Common Jay), a few frogs and large beetles. From North America, voles, mice, rats, pocket gophers, squirrels, shrews, moles, weasels, birds and frogs have been recorded. The largest items include Norwegian or brown rat, squirrel, stoat (Canada) (Brunton & Reynolds, 1984), American Crow, duck, Willow Grouse (Finland) and other grouse, including one Sharp-tailed in Canada. One bird shot in Finland had its stomach filled up with one field vole, one bank vole, one pygmy shrew, 13 common shrews and one frog; one shot on 11 April 1868 in Nulato, Alaska, had just devoured 18 Redpolls (cited by Bent, 1938).

The Great Grey Owl hunts from a perch, which may be either the top of a tree, a suitable branch, a dead tree stump, a post, telegraph pole or powerline (see p. 14). The length of its stoops for prey have been calculated in California at 9–60m (Winter, 1982), but they may be as much as 100m (Nero, 1980). Quite recently devoted owl watchers in Finland (Eero Kemilä) and Canada (Robert W. Nero) discovered the extraordinary way in which Great Grey Owls succeed in hunting voles below a substantial snow cover. From a perch or while hovering overhead, the owl first fixes intently the spot where it has located the noise of a vole moving and eating in its tunnel under the snow, then plunges headfirst through the snow crust and seizes the unseen prey with a rapid final thrust of its feet. Thanks to these spectacular dives the owl has succeeded in reaching voles and mice as deep as 45cm below the snow surface. Sometimes it

almost disappears from sight or it may "swim" with wings outstretched on the surface while the long legs grasp deeply downwards. All Great Grey Owls around Winnipeg, Manitoba, hunted almost exclusively in this way. It is almost certain that the prey is located by hearing since owls hunting in this fashion can hardly be distracted, even by humans, while they are staring down and busily directing their facial disc towards the source of the noise below the snow. Great Grey Owls are also able to spot a vole running over the glittering snow cover at a great distance and to seize it without fail. Robert Nero (1980) and his collaborators have successfully exploited this particular hunting method in order to catch Great Grey Owls for ringing purposes. Using a rod with a thin cord attached, a dummy mouse is thrown down on the icy snow cover and the huge owls are caught with a fishing net as they approach. Exceptionally developed directional hearing, keen eyesight over glistening snow and long, powerful legs, as well as talons which can grasp an area at least 10cm wide, are the characteristics which enable the Great Grey Owl to adopt this sensational kind of winter hunting. This behaviour has been graphically described and brilliantly photographed in Robert W. Nero's and Robert R. Taylor's fascinating book *The Great Gray Owl, Phantom of the Northern Forest* (1980).

MOVEMENTS AND POPULATION DYNAMICS

The Great Grey Owl is probably nomadic thoughout its life, choosing to nest wherever and whenever there is an abundance of voles. Accordingly, when food is lacking it may be absent for years, but return to the same spot when there is another rodent peak (as proved by ringing results in Sweden and Finland). It was virtually absent in Finland and Sweden from 1938 until 1955, with no nesting record at all in Finland between 1942 and 1954 and a total of 4 recorded nest finds from 1955 to 1964. Suddenly, in 1966, 25 nests were found, followed by 20 in 1967, none in 1968 and probably as many as 1,500 in 1985 (Hildén & Solonen, 1987). Prime nesting years in Finland were 1966, 1970, 1974, 1976 (Mikkola, 1981), 1985; prime years in Sweden 1974, 1977, 1981 (74 breeding records), 1982 (60 breeding records) and 1984 (70 certain, plus 60 possible, breeding records). All these birds must have originated from immigrants from Russia.

Mass movements in late autumn and winter have led to irruptions with invasion characteristics, as noted in Finland, Sweden, Poland and the Ukraine, though so far none have reached Denmark. Examples of invasion years are 1911–12, 1912–13, 1928–29, 1935–36, 1939–40, 1942–43, 1951–56, 1962–63, 1968–69, 1974–75, 1980–81, 1983–84. Following these invasions some pairs have stayed to nest in exceptionally southern locations. Similar irruptions have been recorded from southern Canada and the United States, e.g. 1889–90 (hundreds shot and mounted, Ontario and southwest Quebec), 1922–23 (Winnipeg), 1965–66, 1968–69 (hundreds, southeast Manitoba and north Minnesota), 1977–78 (Minnesota), 1978–79 (unprecedented numbers around Winnipeg, where 88 were captured and ringed) (Nero, 1980). This last invasion also reached south Ontario, Michigan, Massachusetts, Connecticut and New York State, including Long Island, with a total of approximately 334 individuals observed (Vickery & Yunich, 1979; Bell *et al.*, 1979). Summaries have been published for Manitoba (1968–83; Nero *et al.*, 1984) and Saskatchewan (1974–83; Harris, 1984). The migrant birds were lean and hungry, though their plumage made them look huge. In spite of the hardships to which they are subjected, a number of Great Grey Owls have reached a great age; the oldest bird recorded had worn its ring for 6 years 11 months (Cramp, 4, 1985), though Great Grey Owls have lived in captivity for 27 years at least (Glutz & Bauer, 9, 1980).

GEOGRAPHIC LIMITS

We will probably never know what this large and magnificent owl is searching for in its inhospitable and unpredictable boreal forest home. Some summers may bring an abundance of food, but in others the owl almost starves to death, and there are always mosquitoes and black flies which bite the young, causing swollen eyelids and sometimes death (Mikkola 1981:111). In winter food is rarely plentiful and it has been suggested that at least 20% of the owl's mortality results from starvation. In winter the birds apparently survive lean body weights of 280 and 340g (Bent, 1938; Nero, 1980), which is around 30% of the normal body weight. The birds then appear lethargic and are usually extraordinarily tame towards man, though they may in fact be too weak to move around and be concentrating exclusively on food. Thus, northern as well as southern limits of the Great Grey Owl's range, though apparently coinciding with the limits of the unbroken taiga zone, are conditioned by the owl's adaptations. These render the Great Grey Owl less successful outside the forest where it has to compete with other, more versatile owls and birds of prey able to withstand greater summer heat. Even the nestlings seem to avoid the warmth of the sun during the boreal summer and hide outside the nest in the shade of the tree crown or on the ground, climbing back into the nest as soon as it is cool enough for them to do so (Höglund & Lansgren, 1968). Robert Nero was surprised to find that all Great Grey Owls caught in the cold Manitoba winter had remarkably warm soles on their feet (Nero, 1980:83). The underwing apteria most probably serve in summer as a significant means of dissipating body heat. Being a forest owl in structure and life style, the Great Grey Owl leaves the arctic tundra to the Snowy Owl, though why it is absent from the greater, forested, part of northeastern Siberia and Kamchatka remains a mystery to me.

LIFE IN MAN'S WORLD

The Great Grey Owl does not come into any real conflict with man. As long as its northern forest home remains undisturbed and unaffected by clear-logging, acid rain, mining and other forms of development, it will have a good chance of survival. Trappers in Canada and probably also in Siberia have killed hundreds of these owls as they suspected them of destroying and eating trapped fur animals (see also Siddle, 1984). In fact, Great Grey Owls often follow humans on their way through the northern woods, apparently tame and very curious. Contact with man is closest when the owls winter in cultivated areas and occasionally enter villages and towns where they are known to have stayed for weeks. Recently such birds have attracted the attention of hundreds of bird watchers. A single bird living on a farm at Gill, Massachusetts, from 29 January to March 1973 attracted at least 3,000 people, 2,000 of whom enjoyed a glimpse of the bird. Similarly, some 40 of these owls, together with over 100 other owls of 9 species, wintering during the invasion year 1978–79 on Amherst Island in the St Lawrence River

near Kingston, Ontario, were visited by thousands of bird watchers, mostly at weekends (Bell *et al.*, 1979; Nero, 1980). Great Grey Owls have benefited on the whole from telegraph poles, overhead wires and roadside posts as easy lookout perches for passing prey. Increasing concern has led conservationists to construct artificial stick nests in trees and on top of tree stumps and to repair dilapidated hawks' nests. This has been done in Sweden as well as in Canada and most of these nests have been accepted by the owls (Wahlstedt, 1974; Nero, 1980). Artificial platforms with various kinds of nest box erected in trees in Oregon, United States, at a height of 15m from the ground were preferred to platforms erected at lesser heights (Bull *et al.*, 1987:87–90). In Sweden acceptance of a nest box (of undisclosed type) has also been recorded (Wahlstedt, 1974). Nevertheless, in spite of the concern of naturalists, 32% of 122 mortality cases studied in Europe related to shooting or trapping, 16% to collisions with motorcars and trains, 9% to collision with overhead wires and to electrocution (Mikkola, 1981). Man is thus in effect more a fiend than a friend to the Great Grey Owl, though times may be changing in this respect.

The Great Grey Owl is the ultimate wood owl of the north, a bundle of insulating feathers hiding a fierce hunter. Its evolutionary counterparts in the south are the virtually black Black-banded Owl *Ciccaba huhula* and the Black-and-White Owl *Ciccaba nigrolineata*, avian black panthers, almost invisible in the shadowy dark of their forest habitats and therefore the ultimate wood owls of the tropical American lowland forests. The Great Grey Owl and the *Ciccaba* species could not fare better in their respective boreal and tropical environments. The Great Grey Owl has small, light-yellow eyes, set in a bulky disc of feathers. The outer ear openings, on the other hand, are enormous, equipped with movable, wide pre-aural dermal flaps, capable of detecting and locating the slightest noise in the otherwise deep silence of the northern forest. The Great Grey Owl seems to hunt by ear rather than by sight. In contrast, the tropical *Ciccaba* owls have a remarkably thin plumage and large, dark eyes, set in a poorly developed facial disc. They have very small outer ear openings, almost, or wholly, devoid of a dermal rim. In the midst of the perpetual, stridulous and at times confusing noise made by the hordes of insects and frogs in the tropical forest, they probably hunt by sight rather than by ear (Kelso, 1940; Voous, 1964; Norberg, 1977). As a result, these tropical wood owls have been recognized, not without some hesitation, as a separate genus *Ciccaba*. Perhaps we should do the same for the boreal bird and recognize a separate genus, *Scotiaptex*, as former authors have done (Ridgway, 6, 1914; Kelso & Kelso, 1934; Bent, 1938). The intermediate position of the Ural Owl *Strix uralensis*, however, may speak against this.

There is another interesting eco-ethological question: whether the Great Grey Owl's avoidance of tree holes for nesting purposes – in contrast to the other *Strix* owls – provides the grounds for its ecological success in the boreal forests, in which, particularly in the far north, sufficiently large tree holes are scarce or virtually non-existent.

LONG-EARED OWL

Asio otus

With its long ear tufts the Long-eared Owl, whose colloquial American names, Lesser Horned Owl and Cat Owl, are obvious references to its appearance, resembles a miniature *Bubo* owl. The Long-eared Owl has a considerably larger and much more complicated outer ear opening than the *Bubo* owls, however, and different skeletal and cytotaxonomic characteristics (Belterman & de Boer, 1984), proving that *Asio* and *Bubo* owls cannot be closely related.

The adaptive significance of ear tufts has never been fully understood. Ear tufts do not appear to be essential in the life of owls, for among the 130–140 known species, only about 50 (35%) have more or less developed ear tufts. It is not very likely that ear tufts facilitate species recognition since they are not easily seen in the dark and owls appear to recognize one another by voice and behaviour rather than by shape. None of the owl models used in field experiments to evoke mobbing reactions from songbirds had ear tufts (Hartley, 1950). There is a theory that "eared" or "horned" owls basically mimic mammals, notably cats. This seems highly feasible to anyone who has seen eagle owls or any other "horned" species in a tree by day or on moonlit nights; and yet ear tufts are rarely raised at night when the owls are at ease or out hunting, so that the theory is scarcely convincing. Nor is the theory (Perrone, 1981) that ear tufts serve primarily as camouflage. They certainly do, but this can hardly be why they ever developed in different groups of owls and in different positions relative to the upper rim of the facial disc.

The Long-eared Owl breeds in open nests; this, and its uncanny ability to conceal itself by day, are among the important factors regulating its life. Equally important and characteristic is its preference for voles and mice of the open country, which makes it a virtual nomad and a long-winged hunter with buoyant, moth-like flight, resembling a nocturnal harrier *Circus*. Its nesting habits, migratory or, rather, nomadic behaviour and hunting methods all preclude any serious competition with the Barn Owl *Tyto alba*, the Tawny Owl *Strix aluco*, Barred Owl *Strix varia* and smaller Screech Owls *Otus asio* and *Otus kennicottii*. Its interspecific ecological relations with these and other owls and diurnal birds of prey are nevertheless worth studying as they seem to be highly influential in most aspects of the Long-eared Owl's life. Above all, the Long-eared Owl is a fierce, cat-like mouser with its own methods for coping with periods of food shortage.

GENERAL

Faunal type Holarctic.

Distribution Holarctic. North America, from near the tree limit in Canada at 62° north in the Northwest Territories, south to the mountains of southern California and northern Baja California up to 2,800m, the arid lands of Arizona to Texas and Nuevo Leon, Mexico, and the deciduous woodlands in the east (Oklahoma, Arkansas, Virginia). In the Old World, throughout the wooded areas of Europe and Asia, from Ireland in the west to Japan in the east, north to the limit of the closed forest, exceptionally at 69° north in Finland (E. Merikallio), but not northeast Siberia and Kamchatka. South to northern Morocco, Algeria and Tunisia, northwestern Italy (Boano, 1980), Asia Minor (Cilicia), northern Israel, Baluchistan (Quetta), Kashmir (2,700m) (Shelley, 1895), possibly other places in the Himalayas, northern and western China. Also the Canary Islands and the Azores. In Africa, the eastern and central mountains: Ethiopian Highlands, Mt Kenya and the Ruwenzori Mountain chain that runs south from Uganda into Zaire, along the west coast of Lake Tanganyika, to 5° south. Map 22.

Climatic zones Breeding in boreal, temperate, mediterranean and steppe climatic zones; in Arizona, even in the lower Sonoran zone of the desert (Phillips *et al.*, 1964). The northern limit approaches the July isotherm of 15°C, including a fair amount of boreal forest, but does not extend as far north as in the typically boreal owls.

Habitat The edges rather than the deep interior of coniferous forests and deciduous woods; often willow, poplar and alder growths along rivers in the taiga zone, but also other riparian forests in prairies, steppes and deserts, more particularly the coulees in rolling prairie country and aspen woods in the Midwest of North America. Parks and large gardens in and around villages and towns and isolated copses and small pine plantations on cultivated land and in natural and cultivated steppe country. The presence of shady trees, mostly conifers, where it can spend the day, is often preferred, but the Long-eared Owl has also been found roosting in the crowns of date palms and in orchards, gardens and oases of a southern or mediterranean type. Any kind of wooded country is suitable, as long as it has adjacent open or semi-open areas on either fertile, boggy or arid sandy soil in lowlands and mountains, including juniperus-pine forests

in western North America, up to virtually the forest line in the mountains, viz. 2,100m in the Alps (Glutz & Bauer, 9, 1980) and 2,000m in Szechuan, China (Meise, 1934). In subalpine forest it is more numerous than the Tawny Owl, but only occurs there in years of food abundance (Scherzinger, 1981). Dark highland cedar *Podocarpus* forests up to 3,000m in the East African mountains.

GEOGRAPHY

Geographical variation The geographical differences between Eurasian and North American Long-eared Owls are comparable with those between the Eurasian Eagle Owl and the Great Horned Owl, but as the average size does not seem to vary, Old and New World Long-eared Owl populations are considered conspecific (Oberholser, 1922), in contrast to the *Bubo* owls which are kept specifically distinct. The American Long-eared Owls *Asio otus wilsonianus* are mostly heavily barred below rather than longitudinally streaked as in the Old World, while the golden-brown tinge of the facial disc contrasts conspicuously with the remaining plumage. The tufts of white feathers to the left and right of the base of the bill are less conspicuous and extend further below than above the eyes. The eyes are yellow or orange-yellow instead of fiercely orange or orange-red as in the Old World birds. Western North American birds west of southwestern Manitoba, first recognized in 1947 (*A. o. tuftsi*; Godfrey, 1947), are somewhat paler and greyer throughout. Body size is smallest in the Canary Islands (average wing length c. 90% of that of European birds). These birds are also somewhat darker brown and considered subspecifically distinct (*A. o. canariensis*). The largest Long-eared Owls occur in eastern Asia (average wing length 4% greater than in European birds), but the differences do not warrant a formal subspecific distinction. With the exception of the Canary Islands birds, all Eurasian Long-eared Owls can be treated as *Asio otus otus*. The African Long-eared Owl is darker still, more sooty brown and more strongly barred with dark below, and larger by 18–19%; its relatively much heavier claws and bill suggest a different diet from that of its holarctic relatives and one probably comprising larger mammals. They were formerly considered a separate species. Ethiopian Long-eared Owls are now known as *Asio otus abyssinicus*; those from Mt Kenya and the Ruwenzori Mountains are smaller by 7% and darker still (*A. o. graueri*).

Related species The Madagascar Long-eared Owl is distinguished as a species *Asio madagascariensis* but is a member of the same superspecies or species group (Voous, 1960; Mayr & Short, 1970; Snow, 1978). It has long ear tufts and an extremely strong bill and claws. In the American tropics the Stygian Owl *Asio stygius* is another member of the superspecies. The Striped Owl *Asio clamator*, also from the American tropics and subtropics, is more distantly related.

STRUCTURE AND HEARING

Characteristic structural features of the Long-eared Owl are the wide shape of the skull, flat cranial roof, relatively thick orbital septum, small orbits and relatively small eyes, long cere and elongated weak bill and fully developed facial disc which

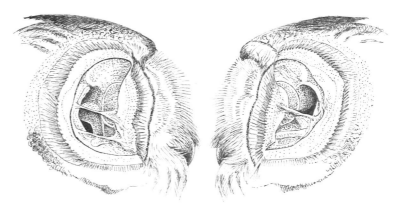

Outer ear of Long-eared Owl, showing asymmetry in structure and in the placement of the ear opening on the skull, being below (left) and above (right) the transverse ligament. Facial disc feathers have been lifted and removed forward. Right-hand side (left) and left-hand side (right).

extends widely above the eyes. The legs are long and thin, the feet weak and the claws fine and needle-sharp (Ridgway, 6, 1914:653–654). The most obvious characteristics, however, are the long ear tufts and the excessively large outer ear openings.

The mystery surrounding the ear tufts' evolutionary origin was indicated above. In describing a remarkably tame pet Long-eared Owl Heinrich Schneider in his *Freundschaft mit Waldtieren* (1971) makes the following important remark: "It allowed me to scratch its head gently, which apparently gave it pleasure. While being scratched it turned its head sideways and closed its eyes. It did not let me touch its ear tufts, however. If I did, it immediately seized my finger, piercing the skin with its claws, and eventually drawing blood" (cited by Steinbach, 1980:147, translated). This indicates that the ear tufts are more than mere head adornments for either mimicry or concealment, but rather that they somehow function as tactile organs or as a means of emotional expression.

The ear slits hidden behind the facial disc are complicate and asymmetrical structures and occupy nearly the full height of the skull (Collett, 1881; Schwartzkopff, 1962, 1963; Norberg, 1977). They are about 38mm long, but are extensible to over 50mm. Movable skin flaps, bordered by a row of short, stiff feathers, act as outer ears as in mammals, but the larger flap is in front (pre-aural, 8.5mm), not behind, so that the bird can concentrate on noises in front as well as behind it. On the left side the outer ear opening leading into the tympanic region of the skull is situated above a ligamentous dermal septum; on the right it is situated below the same. Consequently, the positioning and orientation of the opening differ between left and right. On the left side below, on the right side above the intra-aural septum, flat temporal parts of the skull form the background of a kind of conspicuous auditory *cavernum* or *vestibulum*, where sound waves may be reinforced. Norberg did not describe any asymmetry in the length of the ear slit and the width of the dermal flaps, but measurements made by me on freshly dead specimens indicate an asymmetry of about 13% in favour of the right ear slit, whereas the left *pre*-aural flap was about 27% *wider* and the left *post*-aural 50% *narrower* than the right one. No asymmetry in the bony skull was found.

Hearing capacity in Long-eared Owls is highly developed. The total range of hearing does not seem to differ greatly from

that of the human ear, but Long-eared Owls can probably hear low (2kHz) and medium-pitched sounds (6kHz) about ten times better than we can (Tj. van Dijk, 1973). Highest sensitivity is at approximately 6kHz, which is somewhat higher pitched than in the Tawny Owl (3–6kHz) and considerably higher than in diurnal birds like Starlings (2kHz) (Schwartzkopff, 1973:461) and than in man (3–4kHz).

As a consequence of the asymmetry between left and right ears directional hearing in the Long-eared Owl is considered to be as perfected as in other owls with similar complicated outer ears like the Barn Owl and Tengmalm's Owl, the hearing capabilities of which have been studied in greater detail. In the Long-eared Owl the *minimum separabile* was found to be as small as 1° (in man 1–3°) (Schwartzkopff, 1962), which must represent a tremendous advantage in locating and catching small prey in the dark. Physical experiments, however, have failed to establish the extent of the directional hearing because during electrophysical research the functioning of the dermal ear flaps is inhibited. It is not clear whether the hearing of the Long-eared Owl is more acute than that of the more simply built species such as the eagle owls and the screech and scops owls.

BEHAVIOURAL CHARACTERISTICS

Songs and calls The Long-eared Owl's vocabulary is probably richer and more varied than that of any other northern owl. In Michigan, United States, one listener recorded 23 different calls (Armstrong, 1958). Nevertheless, the male's territorial call is quite simple and remarkably soft, but carries further than one might expect, though over a distance measured in hundreds of metres rather than kilometres. It consists of a prolonged series of low hoots *hooo-oo-oo*, evenly spaced and in North America known to resemble the cooing note of the Band-tailed Pigeon. The female's answering call is still softer, 4–5 half-tones higher, and has been described as *whoof-whoof-whoof*. Among numerous other calls, the low-intensity alarm call may be rendered *kwik-kwik*, not unlike the *koo-ick* call of the Tawny Owl. The full, sudden alarm is an exploding *wuck-wúck-wuck* or *weh-wéh-weh* with a strong accent on the second syllable. The female's contact call from the nest is a soft and nasal *pèh-eh*, but the noises during courtship and copulation can be most varied, cat-like and disturbing. Threatened nesting birds can make an awful noise, like humans screaming in distress. Nestlings and particularly fledglings, when following their parents through the crowns of trees, have a characteristic, tedious and melancholic hunger and position call, *psee-ee* or *pee-e-pee-e*, uttered at regular intervals of 5–10 seconds, sometimes all through the summer nights.

Bill-snapping is often heard during bouts of mild aggression and when the birds are suddenly disturbed at the nesting site. During courtship flights, which can be elaborate, the wings are slapped very audibly below the body, usually once on a downstroke.

Circadian rhythm The Long-eared Owl is considered one of the most nocturnal of the common medium-sized owls. There are indications that Long-eared Owls are more nocturnal than Tawny and Barred Owls, and even than Barn Owls. In laboratory experiments (Marti, 1974) a Long-eared Owl required as little as 70×10^{-8} foot-candles of light to find a dead mouse of light-grey colour, whereas a Barred Owl needed 13×10^{-6} foot-candles, a difference, however, which the human eye is not able to perceive, as it is near to total darkness. Comparable results had been found earlier (Dice, 1945), when the lower limit of illumination at which an American Long-eared Owl was able to see a dead prey close at hand appeared to lie between 25×10^{-8} and 8×10^{-8} foot-candles.

The Long-eared Owl's activity during the breeding season differs according to latitude, cloudiness of the sky and appetite. In the far north it hunts in daylight, but elsewhere it starts hunting 25–30 minutes after sunset and retires 30–45 minutes before sunrise, with a first activity peak of 3 hours' duration and another pre-morning one of 2½ hours. Real flight time in the Netherlands reached an annual average of 2½ hours per 24 hours, but the male increased that in the breeding season to 5½ hours (Wijnandts, 1984). In the Netherlands the owl leaves its roost in winter between 20 and 40 minutes after sunset, but somewhat earlier in summer (van Gasteren, 1986). When food is in exceptionally short supply at the end of the winter, Long-eared Owls are sometimes forced to hunt by day. Thus, after a very successful summer in south Finland in 1962, numerous Long-eared Owls stayed over the winter, but met with a sharp food decline towards the winter's end so that they were seen hunting over fields and in gardens in bright sunlight, even entering the centre of the city of Turku (Soikkeli, 1964).

Antagonistic behaviour Although they lead an inconspicuous life, Long-eared Owls are as fierce as wild cats and the aggressive self-defence already exhibited by nestlings and fledglings is most impressive. Parent Long-eared Owls are vigorous in the defence of eggs or young, opposing any intruder with feathers raised and wings half-spread and hissing vehemently. Long-eared Owls have sometimes been known to attack human intruders with sharp claws while screaming ferociously, but they are usually less bold than Tawny Owls. Above all, they often indulge in a spectacular show of broken-wing behaviour while screaming and caterwauling and distracting intruders from the nest site. Where pairs nest close together two or more pairs have been observed performing a remarkable display of distraction techniques near the same nest (Idaho, United States; Marks, 1985).

Long-eared Owls are no less adept at hiding by day in cryptic postures than the screech and scops owls *Otus*. Stretching and making itself unbelievably slim, with a wing held in front, facial mask retracted, eyes reduced to mere vertical slits and ear tufts raised like little twigs, the owl looks like a piece of decayed wood or a broken branch. The grey, buff, blackish and whitish tones of the plumage merge with the tough grey bark in the tree's shade. It is often hard to believe that this indolent "owl-stick" can metamorphose itself on the spot into a round-headed and large-eyed owl with an inquisitive and friendly disposition (Scherzinger, 1969).

ECOLOGICAL HIERARCHY

Though of apparently similar size, the Long-eared Owl is in fact a much smaller and less athletic species than the Tawny Owl,

Long-eared Owl *Asio otus*
European race *A. o. otus* with a vole as prey

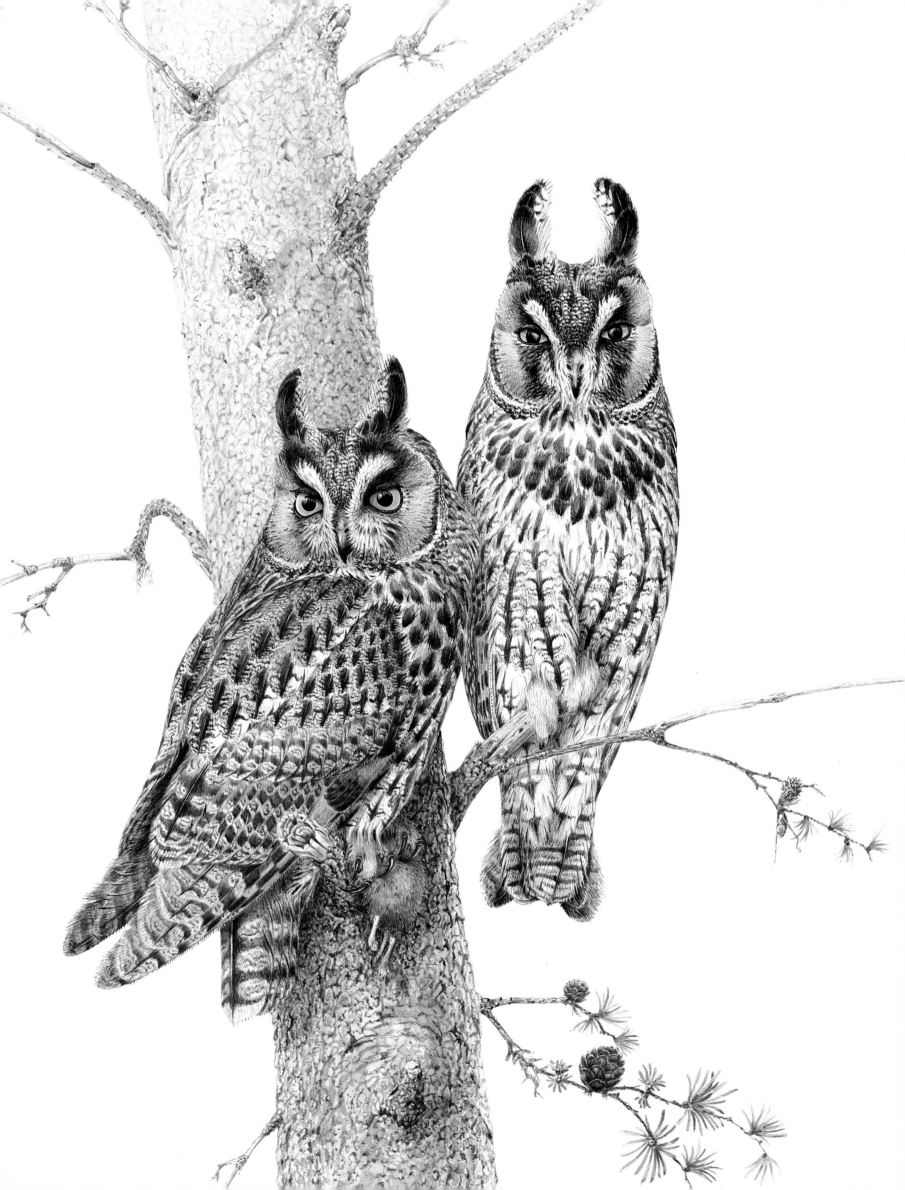

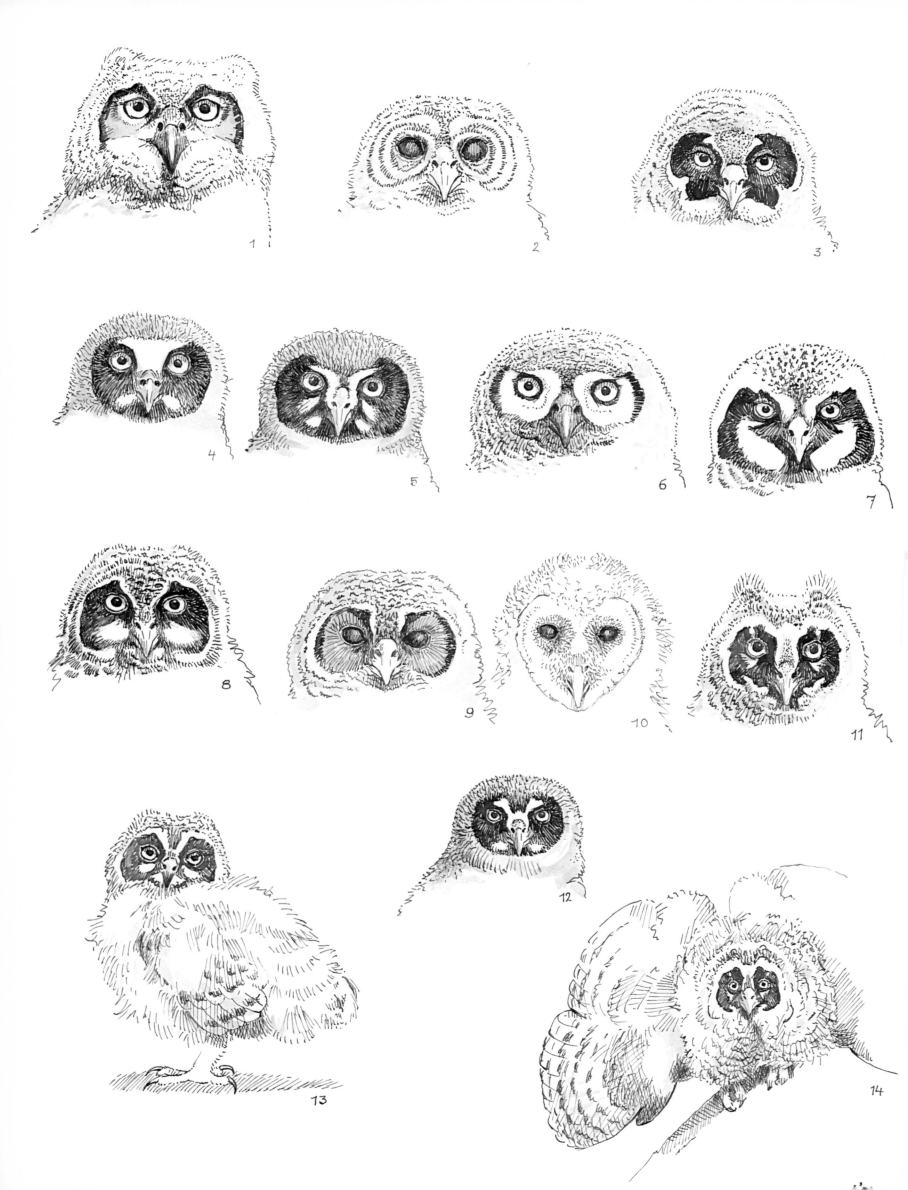

with which it shares most of its breeding range in Europe, or than the Barn Owl, which occupies the southern part of the Long-eared Owl's range in Europe and North America. Its body weight is approximately 55–60% of that of the Tawny Owl and 90–92% and 55–57%, respectively, of that of the Barn Owl in Europe and North America. Its body mass is 11–14% of that of the Eurasian Eagle Owl and 16–19% of that of the Great Horned Owl. Consequently, in the ecological hierarchical scale it occupies a weaker position than either of these species. It is heavier by 134% (male) and 95% (female), respectively, than the forest-inhabiting Tengmalm's Owl from Europe and by 67% (male) and 87% (female) than the Little Owl of the open fields. The sum total of claws in Europe reaches 113mm on average in males and 125mm in females, as against 128mm and 138mm, respectively, in the sympatric Tawny Owl and 132mm in both sexes of the Barn Owl.

Although it shares the same habitat as the Tawny Owl, the Barred Owl and the Great Horned Owl by day, the Long-eared Owl hunts at night at the forest edge and in the open field rather than in the woods, thereby avoiding direct confrontation with these much stronger owls. The Long-eared Owl has relatively long wings with a small wing-loading permitting an extremely buoyant flight and efficient hunting over open fields. Wing-loading in North American birds was $0.22g/cm^2$ of wing surface, as against $0.28g/cm^2$ in the Barn Owl (Marti, 1974); in Europe the following values have been calculated: Long-eared Owl $0.31g/cm^2$, Barn Owl $0.29g/cm^2$, Tawny Owl $0.40g/cm^2$, Eagle Owl $0.71g/cm^2$ (Mikkola, 1983:350). In some respects the Long-eared Owl may be classified as a nocturnal Northern or Hen Harrier, both species specializing in hunting common and short-tailed voles in the Old World and meadow voles in the New World.

The Long-eared Owl is preyed upon by other owls and diurnal raptors probably more than any other owl of the northern hemisphere. Of 1,611 bird prey items (Uttendörfer, 1952) taken in Europe by the Eurasian Eagle Owl, 69 (14%) were Long-eared Owls, and of 8,309 taken by the Goshawk, 179 (2%) were Long-eared Owls, a large number of them probably fledglings. Heimo Mikkola (1983) lists 768 Long-eared Owls taken by the Eagle Owl in Europe, which is 60% of its 1,288 owl prey items, and 317 taken by the Goshawk, which is 55% of its owl prey items. The Tawny Owl in Europe and the Great Horned Owl (Errington et al., 1940) in North America are other well-known serious predators of the Long-eared Owl. Others reported in Europe are Common Buzzard, Black Kite, Red Kite and Peregrine Falcon (Mikkola, 1983). Conversely, few cases have been reported of Long-eared Owls having taken and fed upon other owls: in Europe, Little Owl (2 ×), Tengmalm's Owl (1 ×), Pygmy Owl (1 ×).

Female Long-eared Owls are slightly larger and heavier than males, but have much stronger and heavier talons. The body mass (327g) is 114% of that of the male, wing (299mm) 102%, breastbone length (39.3mm) 106%, pelvis length (39.5mm) 106%, total of arm bones (248mm) 104% and of leg bones (without toes, 174mm) 105% (Winde, 1977). This could signify a heavier wing-loading and less manoeuvrability in females. A differential use of prey and hunting niches between male and female can thus be expected, but has not yet been proved.

BREEDING HABITAT AND BREEDING

Long-eared Owls nest in the vacant nests of birds of prey, herons, crows, magpies, jays, even in flimsy Wood Pigeons' nests and squirrels' dreys located at any height in trees of all kinds and sizes. Nests are usually found in isolated copses, often of young pine and spruce, on moors, bogs and farmlands, frequently also in riparian woods and scrub and any other suitable piece of forest or woodland. Occasionally Long-eared owls have been found nesting on the ground, among heather, bracken and bramble (Britain, the Netherlands, northern Italy; Glue, 1977; Grünwald, 1972; Mingozzi, 1980), even in nests made of reeds in a reed bed (illustration in Hosking & Newberry, 1945:55), in rabbit warrens (W. Makatsch), in wicker baskets placed in trees for ducks in the Netherlands (F. Haverschmidt) and in semi-open nest boxes. Exceptionally, shallow cavities in hollow willows or oaks, tree stumps or holes in cliffsides have been used, but as a rule the Long-eared Owl is not a hole-nester. There are indications that in some cases male Long-eared Owls have added to the construction of a nest by bringing back to it twigs and branches (Glue, 1977). Long-eared Owls have also been known to take over the nests of *Buteo* hawks and *Accipiter* hawks (Eurasian Sparrowhawk, Cooper's Hawk, Sharp-shinned Hawk) and others after chasing off the previous occupant – an indication of the fierceness and tenacity which some of these owls exhibit.

Unlike most other owls, the Long-eared Owl has no territorial hunting grounds, while nesting territories are small and densities have amounted to 20 pairs per 100km² of nesting and hunting grounds combined. One copse or patch of forest may harbour more than 2 pairs breeding per 1km². General density in Sweden is estimated at 0.2 pairs/km² (Ulfstrand & Högstedt, 1976). "Colonies" of as many as 3–10 pairs have been reported with nests as close together as 16m (Idaho, United States); in these circumstances fledged young may have been fed by adults other than their parents.

Breeding does not generally start as early in the season as in the case of Tawny and Barn Owls. It starts rarely in February, usually in March or early April, but later still in the north. Only in Spain have eggs been found much earlier, viz. 21 December 1976 and 3 January 1978 (Corral et al., 1979). On the whole breeding activity is correlated with the available food supply. In periods of food shortage the birds either do not nest at all or they leave the area. Thus, in 15km² in southern Germany no nests were found after the cold spring of 1965 when voles and mice were in short supply. A year later (1966), when the spring weather was favourable and the number of common voles had increased, there were 19 breeding pairs (Rockenbauch, 1978). It seems to be the female that selects the nest site, and only she incubates, while the male hunts for her and the young until these are nearing two months of age. Only the female has an incubation patch (R. Drent).

Juvenile plumages. (1) Great Horned Owl *Bubo virginianus*. (2) Barred Owl *Strix varia*. (3) Great Grey Owl *Strix nebulosa*. (4) Northern Saw-whet Owl *Aegolius acadicus*. (5) Tengmalm's Owl *Aegolius funereus*. (6) Snowy Owl *Nyctea scandiaca*. (7) Northern Hawk Owl *Surnia ulula*. (8) Short-eared Owl *Asio flammeus*. (9) Ural Owl *Strix uralensis*. (10) Barn Owl *Tyto alba*. (11) Long-eared Owl *Asio otus*. (12) Northern Pygmy Owl *Glaucidium gnoma*. (13) Short-eared Owl *Asio flammeus*. (14) Long-eared Owl *Asio otus*.

Clutch size is extremely variable: 1–7, usually 3–5, on average 3.9 in Britain (Glue, 1977) and 5.5 in south Germany (Rockenbauch, 1978); similar values are indicated for North America. In vole years clutches of 8 have been reported from Sweden, and in the vole plague year of 1891 a clutch of 10 was found in Kazan, east Russia (Dementiev & Gladkov, 1, 1951). Eggs in central Europe average 40.4 × 32.3mm in size (Makatsch, 1976) and in North America 40.0 × 32.5mm (Bent, 1938). Like all free-nesting owls the chicks have a dense downy coat, greyish and heavily shaded (see p. 256). The female continues to brood them for a long time: at least until the 14th day (Scherzinger, 1971).

Young leave the nest at the early age of 18–25 days in Europe (Glutz & Bauer, 1980) and 20–26 days in Michigan, United States (Armstrong, 1958). They do not return to the nest as a rule, but follow the parents through the tree crowns, uttering their monotonous, wailing hunger cries, thereby indicating their position throughout the night. They fly by 33–50 days of age. On rare occasions a second clutch has been reported (Glue, 1977; Glutz & Bauer, 9, 1980). Accelerated growth and a short nestling period characterize the open-nest species and the Long-eared Owl is no exception.

FOOD AND FEEDING

The Long-eared Owl specializes in hunting voles and mice of the open fields adjacent to its day-roosts and breeding sites in copses and woods. Unlike the Tawny Owl and the large *Buteo* hawks, in cases of food shortage most of the owls leave the area to breed or winter elsewhere. Hunting and hovering at 0.5–150m or higher over open moors, pastures and fields, rather than surveying the forest floor, the Long-eared Owl resembles both the Northern or Hen Harrier and the Kestrel (Smeenk, 1972). Of roughly 57,500 prey items from central Europe analysed by Otto Uttendörfer (1952), 82% consisted of voles (76% common vole), locally, particularly in the breeding season, reaching over 90% and even 100%. Of another sample of 26,346 prey items from seven countries in Europe (Britain, France, Germany, Sweden, Finland, Spain, Roumania; Mikkola, 1983: 370), an average 94% consisted of mammals, of which 70% were voles and 21% mice and rats (numerous long-tailed field mice). The Long-eared Owl's preferred food is the more gregarious common vole, rather than the less sociable short-tailed or field vole. Following the common vole's population cycle in the 12 consecutive winters between 1961–62 and 1972–73 in the Hungarian plains (Schmidt, 1975), yearly prey numbers varied between 85.1% at a population high and 18.1% at a population low; the proportion of long-tailed field mouse varied inversely between 12.8% and 56.2%, that of the house mouse between 1.0% and 37.8%. Other mammalian prey recorded includes shrews, moles, bats, the dormice *Glis* and *Muscardinus*, squirrels, harvest mice, young rabbits and hares.

Birds in the continental European diet amounted to 8% (52 species), as against 15% (100 species) in the Tawny Owl and 3% (11 species) in the Barn Owl (Uttendörfer, 1952). At least 20 more bird species have been listed as well, including such remarkable ones as Penduline Tit, Nightjar and Common Snipe and such large ones as Lapwing, Moorhen, Red-legged Partridge, Jackdaw, Magpie, young Kestrel and a Little Owl. In poor vole years Long-eared Owls take a higher proportion of birds than in years of vole abundance. Thus, in the winter of 1962–63 only 20% common voles were reported in central Germany, compensated for by 33% birds. The next winter, 1963–64, the number of voles had increased and 93% were recorded in the owl's food, together with no more than 2% of birds (Heitkamp, 1967). Only fractions of other prey – frogs, fish and insects – have been recorded throughout the Long-eared Owl's range, but in the southern areas, including the Canary Islands, the proportion of birds is generally larger (e.g. Spain; Corral *et al.*, 1979), as is the number of insects (beetles, locusts, noctuid moths).

Of 23,888 prey items from North America (Marti, 1976), small rodents made up 98.2% (mainly meadow voles and white-footed mice; also pocket gophers, bog lemmings and chipmunks), whereas birds occurred in a mere 1.7%, though in a remarkably large variety of 35 species, including Blue Jays and Red Cardinals. Average prey weights (Craighead & Craighead, 1956) were almost the same on both sides of the ocean, viz. 32.2g in Europe and 30.7g in North America (Marti, 1974). Comparing sympatric owls in Colorado, United States, Carl D. Marti calculated an average prey weight of 30g in Long-eared Owls and 46g in Barn Owls. Apparently, the Barn Owls take the larger voles, mice and rats. Two years later the same author differentiated between the mean prey weight taken in North America (37.0g) and in Europe (32.2g) (Marti, 1976), but another author found the mean weight of vertebrate prey taken in Michigan to be 31.6g and in Wisconsin 31.8g (Jaksić, 1983).

In their European winter area Long-eared Owls often concentrate on House Sparrows, Chaffinches, Greenfinches, Starlings, thrushes and other birds gathering in communal sleeping places, often in or close to villages and towns. Like Barn Owls, they hover around the bushes trying to disturb the sleeping birds and to provoke them to fly out of the shelter of the bush right into their talons. In Iraq up to 51% of the winter prey consisted of such birds (Hartley, 1947). In other places the owls make a habit of visiting dumps or refuse pits and feasting on the multitude of rats, including the large brown or Norwegian rats, and mice which live there the year round.

As a restricted feeder the Long-eared Owl is at the same time a migrant and a nomadic wanderer, also an irregular breeding bird in most parts of its range. It is partly sedentary in Great Britain, Ireland and Spain at least. It is common whenever there is an abundance of food, rare or absent in years of scarcity, and able to shift to other prey only when this is available in great numbers and easily caught (House Sparrows, Starlings).

Ethiopian Long-eared Owls in montane heath at 3,940m with heavy frost at night were also found to have fed on shrews *Crocidura* and seven species of rodent including the giant mole rat *Tachyorectes splendens* (estimated at 200g), with an average prey weight calculated at 84g (Yalden, 1973), which is considerably higher than in the Holarctic.

MOVEMENTS AND POPULATION DYNAMICS

Unlike the Barn Owl and the wood owls *Strix*, the Long-eared Owl is not a resident bird everywhere. Birds breeding in northern parts of the range with a heavy snow cover in winter migrate

Long-eared Owl *Asio otus*
European race *A. o. otus*

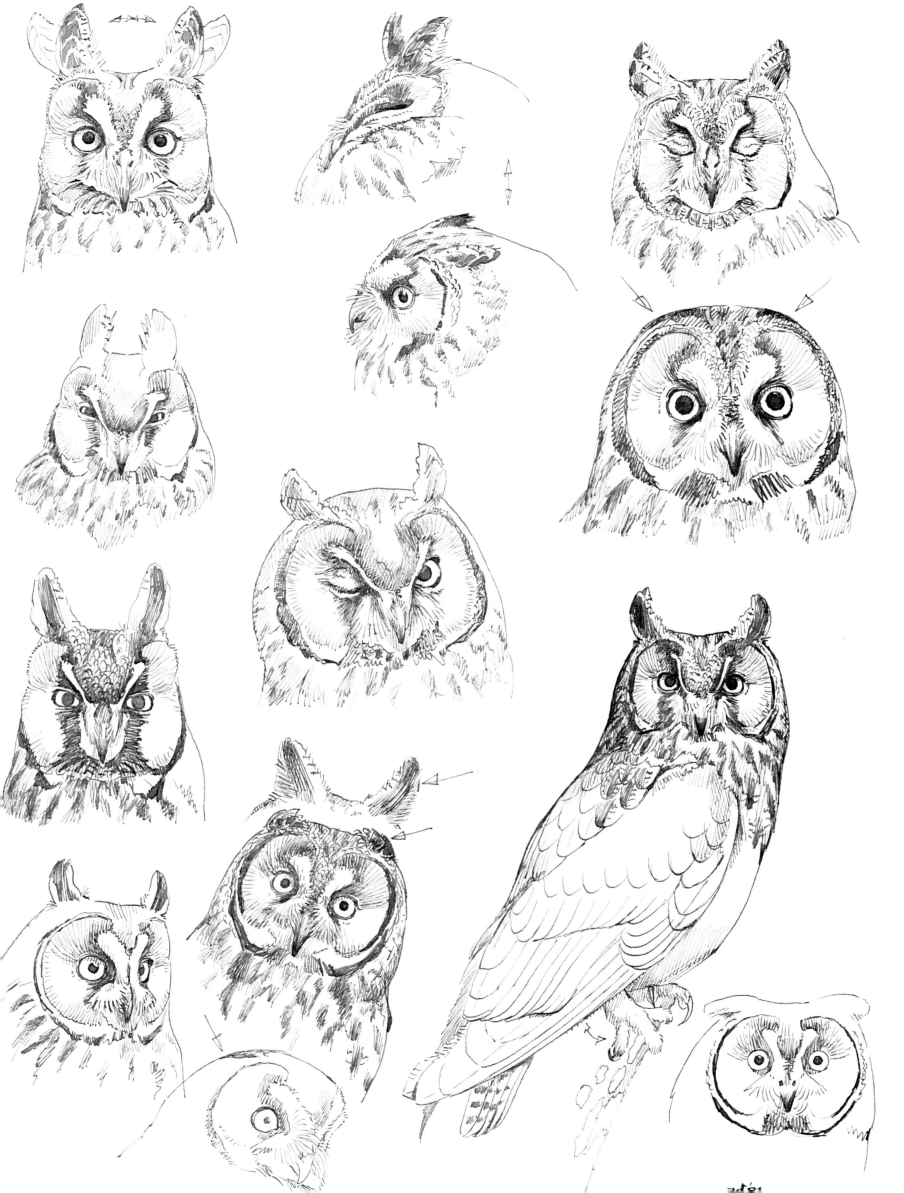

to areas with more favourable winter climates. There are, thus, few Long-eared Owls left in winter in Fennoscandia, Russia and Siberia north of 50° north. The same applies to virtually the whole of Canada. The northern limit of the winter range in North America runs from the Okanagan Valley in British Columbia to South Dakota, southern Minnesota, southern Michigan and southern Ontario and Massachusetts. Sometimes Long-eared Owls leave wide areas completely and appear in large numbers elsewhere. This may occur in America as well as in Europe and Asia. Of birds ringed in western Eurasia, those that had travelled the furthest were one ringed in south Germany in February and recovered in Yaroslavl, central Russia, 38°21′ east, in May (distance 2,050km) and one ringed in east Germany in March and recovered in Kazan, east Russia, 48°18′ east, in August (distance 2,410km) (cited by Glutz & Bauer, 9, 1980:400). Long-eared Owls regularly cross the North Sea to winter in the British Isles and such owls have often appeared on ships at sea. Those landing on the tiny island of Heligoland in the eastern North Sea bight usually appeared between October and December and were for the most part first-year birds (Moritz & Schonart, 1976). Large influxes in Britain occurred in the winters of 1975–76 and 1978–79, simultaneously with mass appearances of Short-eared Owls and Hen Harriers. Most of the visitors to Britain still gather at communal winter roosts when local breeding birds are already incubating in March or early April (Glue, 1977).

Day-roosting groups in winter may be composed of 10–30, even 100–150 or more birds, remaining close together in one or a few neighbouring trees or a small grove. They hide in shady conifers, or among ivy, or remain fully conspicuous on the naked branches of deciduous winter trees and are often found in odd places, such as town parks, cemeteries and village gardens.

Winter areas outside the owls' breeding ranges include the whole of the Mediterranean region and its islands, Arabia, Iran, Sind, Kutch and the Punjab in Pakistan and northwest India, south China, Korea and the Ryu Kyu Islands. The owls have also appeared in the Faroes, Iceland, Madeira and the Bermudas. In North America Long-eared Owls winter south to Florida and to Jalisco and Puebla in central Mexico, though most of them do not fly so far. As stragglers they have appeared at 58° north at the Taku River in Alaska, but they may also have nested this far north.

Population growth in years of food abundance is not as large as in the Barn Owl. The mortality rate of first-year Long-eared Owls is nevertheless high and has been calculated in Germany at 52% and 31% on average in subsequent years (Glutz & Bauer, 9, 1980). The oldest ringed Long-eared Owls on record in Europe are one of 27 and another of 14 years of age (Hückler, 1970).

GEOGRAPHIC LIMITS

Since it specializes in catching voles and other rodents of the open country, the southern limit of the Long-eared Owl's range is set by the abundance of its open-grassland-inhabiting food species. Those warm climatic regions (mediterranean and arid, hot climes) where terrestrial insects and reptiles prevail over small, sociable rodents mark the Long-eared Owl's southern limit and constitute the principal range of the Barn Owl. The northern limit runs through the boreal forests, but remains much further south than the limits of the exclusively boreal forest owls. In open bogs, farther north, the Short-eared Owl takes over from the Long-eared Owl. In terms of energy output the Long-eared Owl does not seem to differ materially from the Short-eared Owl, their standard metabolic rate in natural conditions being 532kcal/kg/day, and 522kcal/kg/day, respectively. The Long-eared Owl requires 159kcal/bird/day, as against 59kcal in the Saw-whet Owl and 188kcal in the Short-eared Owl (Graber, 1962). Thanks to its size, the Saw-whet Owl needs much less food than the Long-eared Owl and can probably range further north therefore in regions where food is not plentiful as a rule. The Short-eared Owl needs somewhat more food, but being a stronger predator and an open-land bird has an advantage over the Long-eared Owl in open bogs much further north.

The minimum hunger weight is on average 188g in males and 200g in females, and the "hunger resistance" (hunger weight in percent of fat-free weight) is 28.3 and 28.8, respectively, which is less than in the Short-eared Owl (34.2 and 31.8) and the Tawny Owl (34.4 and 36.1), but higher than in the Barn Owl (22.2 and 25.3) (Glutz & Bauer, 9, 1980:240). These data agree with the more southern limits of the Tawny and with the sedentary habits of the Barn Owl versus the migratory and nomadic habits of the Long-eared Owl.

LIFE IN MAN'S WORLD

In Europe as well as in North America Long-eared Owls, like most other owls, have been badly persecuted by man. Alexander Wetmore (1935:222) describes the situation in North America as follows: "Though formerly abundant, the long-eared owl has suffered at the hands of hunters and bounty systems, so that in many sections of the East it is now rare." It may also have been exterminated already on Tenerife, Canary Islands (Deppe, 1984).

Where Long-eared Owls have been feeding close to human habitation, as they often do, lethal contamination with heavy metals (e.g. mercury), organic biocides, including insecticides, fungicides and rodenticides and PCBs has been recorded. The ultimate effect on the population seems to have been less severe than in other species of owl and bird of prey, probably because, unlike *Buteo* hawks, Long-eared Owls do not eat carrion.

The Long-eared Owl does not nest in standard nest boxes. It has, however, accepted wicker baskets put up in trees and bushes for domestic duck (F. Haverschmidt) and has nested in open-sided wooden nest boxes designed for the use of Kestrels. The ubiquitousness of the Long-eared Owl was demonstrated in the flat, treeless, often vole-infested, newly reclaimed polders of the former Zuiderzee (Ysselmeerpolders) in the Netherlands, where these owls nested in nest boxes placed conspicuously on top of high poles (Cavé, 1968).

Recently, during prolonged cold winters with heavy snow cover in Europe, when considerable numbers of Long-eared Owls had sought refuge in towns and cities in various parts of Switzerland, West Germany and the Netherlands, the owls were fed daily in some places with white or grey laboratory mice, put at their disposal in wide washing tubs. The hunting activity of Long-eared Owls, often operating in the light of street lamps, has thus been watched with enjoyment by numerous bird lovers from only a couple of metres' distance (e.g. Zürich, Switzerland; Zimmerli, 1964).

Upper Pleistocene *Asio* owls resembling the modern Long-eared and Short-eared Owls have been described from Kansas and Idaho, United States (*Asio brevipes*) and the Rancholabrean Pleistocene, California, United States (*Asio priscus*) (Ford & Murray, 1967). Their existence might support the theory that the *Asio* owls originated in the Americas, as does the fact that the Long-eared Owl has representatives in South America and Africa but not in the Indo-Malayan and Australian regions. Its geographic origin remains uncertain, however, and is not likely ever to be revealed.

As for the question of whether the Long-eared Owl is a kind of specialized "restricted feeder" or not, I tend to conclude that the Long-eared Owl is by no means a "generalist feeder" as was formerly suggested (Tinbergen, 1933). Except during unfavourable winter conditions, when the Long-eared Owl escapes the restrictions of a specialized diet by preying heavily on small, sociable birds, its life is dominated by sociable voles in the open field, more than by mice on the forest floor, or indeed by summer birds in woodland and bush. The Long-eared Owl is a "restricted feeder" throughout most of its life, though in winter it sometimes behaves as a "generalist feeder" like the Tawny Owl *Strix aluco* and the Barn Owl *Tyto alba*, taking then whatever prey is available and accessible.

The Long-eared Owl is a nomadic bird, wandering wherever and whenever it needs to and staying wherever it suitably can, even to the extent of behaving like a sedentary bird. Its ecological conflicts with the *Strix* and *Tyto* owls are negligible owing to different strategies of hunting and breeding. In all aspects relating to food, feeding habits, hunting grounds outside the forest, open nest sites, breeding densities and nomadism, the Long-eared Owl falls only slightly short of the ecological extreme of its open-country relative, the Short-eared Owl *Asio flammeus*.

STYGIAN OWL

Asio stygius

The Stygian Owl is a geographical representative of the Long-eared Owl *Asio otus* in the dark forests of Central and South America. It has rarely been observed and few specimens have been collected. In plumage it is no less dark than the tropical African forms of the Long-eared Owl, but in size it is less formidable and it lacks the heavy bill and claws of the latter. With its body length of 40–45cm and wing length of 292–349mm in its northern continental populations, it is larger by 15–20% than North American Long-eared Owls. Virtually nothing is known about the Stygian Owl's life style. The distance between the northernmost Stygian Owls and the southernmost Long-eared Owls is not known either, but is now estimated at 550km between northwest Sinaloa, Mexico, and Tombstone, south Arizona. The principal question concerning the Stygian Owl is whether it is a southern descendant or the tropical ancestor of the northern Long-eared Owl.

GENERAL

Faunal type South American or tropical North American.

Distribution Incompletely known and based on relatively few specimens. Sporadically through Central and South America, from the Sierra Madre Occidental in southern Chihuahua, northern Sinaloa and Durango, Mexico, south through Central and South America east of the Andes, to Rio Grande do Sul, Brazil, Paraguay and the tropical northern provinces of Argentina south to Tucuman. Also known in the West Indies in Cuba, the Isle of Pines, Hispaniola and Gonave Island. It has been recorded in only one place in Guatemala (Cobán), but there are no records for Costa Rica, Panama, most of Colombia and Venezuela, the Guianas and Bolivia. Map 22.

Climatic zones Probably mainly tropical rain forest and tropical winter-dry climates, but in the mountains locally as high as the upper subtropical and temperate altitudinal zones (eastern Colombia and Sierra de Périja, Venezuela).

Habitat Poorly studied. The Stygian Owl has been collected in humid and semi-arid forests, from deep rain forests to thorn bush (Magdalena valley, Colombia). It has been observed hunting in Belize in open pineland (Russell, 1964). Up to almost 3,000m in western Mexico (Volcán de Tacaná, Chiapas), over 3,000m in northern Colombia, 2,400m in Ecuador, 2,600m in western Venezuela and 1,200m in Hispaniola.

GEOGRAPHY

Geographical variation Generally five or six subspecies recognized, but probably no more than one or two are realistic. The northernmost birds (*A. stygius lambi*) are lighter, more buff coloured and somewhat larger; West Indian birds (*A. s. siguapa* and *noctipetens*) are variously lighter, greyer and somewhat smaller. The birds are darkest in central South America (*A. s. stygius*). The southernmost Stygian Owls (*A. s. barberoi*) are larger by about 10% than those from Brazil; in Central America (*A. s. robustus* and *lambi*) they are c.5% larger and in the West Indies c.8% smaller.

Related species Long-eared Owl *Asio otus*.

STRUCTURE

Probably not dissimilar to that of the Long-eared Owl, but few details are known. In contrast to the Long-eared Owl, where the toes are completely covered with fur-like feathers, the Stygian Owl's toes are sparsely feathered, if at all; the outer toes are covered with bristles down to the middle of the terminal joints. Stygian Owls from Central America probably have more highly feathered toes than their relatives in South America, although there are little data concerning this.

BEHAVIOURAL CHARACTERISTICS

Songs and calls Imperfectly known. A *hu-hu*, *hoo* and *hoo-hoo* (James Bond; Edwards, 1972) have been recorded, probably to describe the territorial song of the male.

Circadian rhythm The few data available suggest that the Stygian Owl is a strictly nocturnal bird (possibly explaining in part its apparent rareness).

Antagonistic behaviour Nothing known.

Stygian Owl *Asio stygius*
Cuban race *A. s. siguapa*

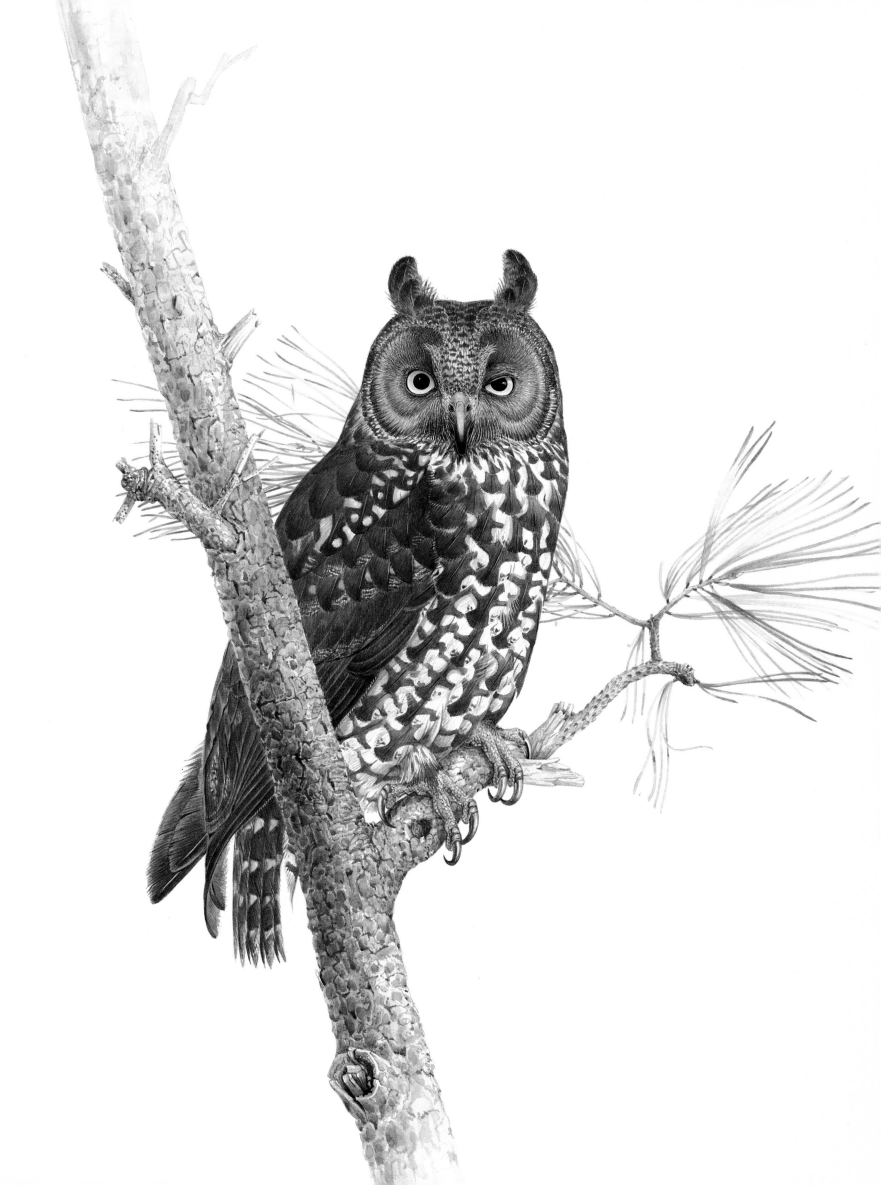

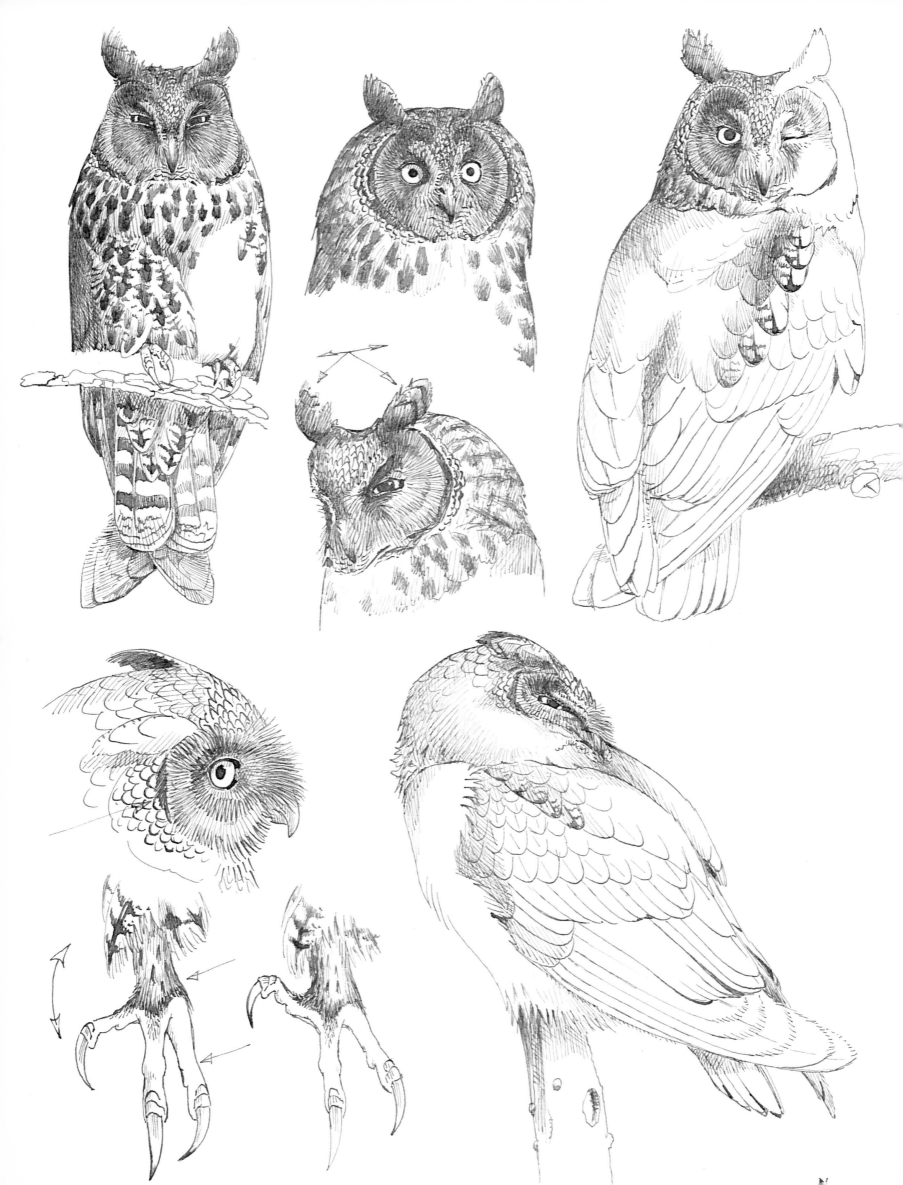

ECOLOGICAL HIERARCHY

Virtually nothing known, but there are numerous owls of the genera *Strix*, *Ciccaba*, *Pulsatrix*, *Lophostrix* and *Tyto* with which the Stygian Owl may compete. In the upper Magdalena valley, Colombia, a large female (675g, with full stomach?; Miller, 1952) was observed as it was chased by a Roadside Hawk *Buteo magnirostris*. A male from Belize weighed much less (391g; Russell, 1964), which suggests a considerable sexual dimorphism in size. The few data from the Greater Antilles indicate that the wing length of females is about 10% greater than that of males (Ridgway, 6, 1914; Wetmore & Swales, 1931).

BREEDING

Virtually nothing known. No eggs appear to have been collected or described. The Stygian Owl is thought to use open nests in trees in the manner of the Long-eared Owl. Orlando H. Garrido described a nest found in Cuba in late 1965 as "a comparatively large nest on a tree"; another one was found on the ground (cited by James Bond).

Stygian Owl *Asio stygius*
Cuban race *A. s. siguapa*

FOOD

Apart from a casual remark that it "feeds on bats" (de Schauensee & Phelps, 1978:120), I have been able to find only one record relating to the Stygian Owl's diet, viz. a bird shot on Gonave Island, Haiti, was found to have a ground dove *Columbigallina* in its stomach (Bond, 1928).

MOVEMENTS

Considered resident.

GEOGRAPHIC LIMITS

Nothing particular known. In the north the Stygian Owl may meet, and its range may be restricted by, the Long-eared Owl. In the south it does not extend beyond the lowland tropics, although the reasons for this are unclear.

LIFE IN MAN'S WORLD

The Stygian Owl depends for its survival on the continued existence of primary forests. It has disappeared in those areas in Cuba where forests have been extensively cut.

The few available data seem to support the theory that in life style and habits the Stygian Owl is a tropical representative of the northern Long-eared Owl *Asio otus*. Its range is a southern continuation of that of the Long-eared Owl in North America. Here the Long-eared Owl is barred below like the Stygian Owl, rather than longitudinally streaked like the Long-eared Owl in the Old World. The absence of the Stygian Owl in the old southern beech *Nothofagus* forests of southern South America might indicate that it is not originally a South American species.

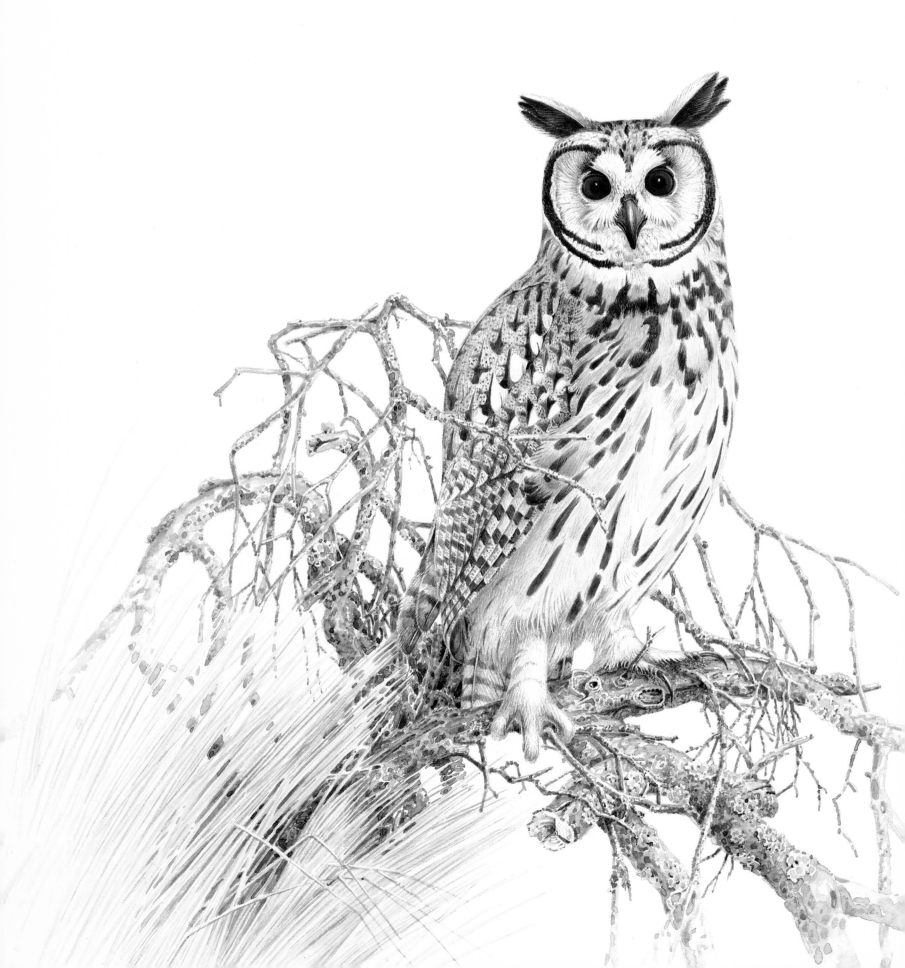

STRIPED OWL
Asio clamator

The tropical American Striped Owl has the appearance of an extremely "long-eared", robust, white-faced Long-eared Owl *Asio otus*. Its underparts carry a striped pattern as in the Short-eared Owl *Asio flammeus* and the Long-eared Owl of Europe and Asia. Its terrestrial habits and roosting sites are reminiscent of those of the Short-eared Owl. Its body length of 35–40cm is about 5% greater than that of the Long-eared Owl, but its weight of approximately 400g in males and 515g in females (northern South America) exceeds that of the Long-eared Owl by *c.* 63% and 85%, respectively.

The Striped Owl does not entirely fit the geographic scope of this book. The gap between its northern limit and the Long-eared Owl's southern one is almost 2,000km and the distance between the Striped Owl and the nearest Short-eared Owl is even greater. The reason for including a species account of the Striped Owl here is to provide further background information on the geographic origin and ecological differentiation of the species of the genus *Asio*. The Striped Owl's geographic range resembles that of the forest-inhabiting Stygian Owl *Asio stygius* and it is possible that this species relates to the Striped Owl in the American tropics in the same way as the Long-eared to the Short-eared Owl in the northern hemisphere. Alternatively, the Striped Owl may represent an intermediate, tropical stage between a Long-eared and a Short-eared Owl. A female Striped Owl and a male Barn Owl *Tyto alba* produced three clutches of eggs at the St Louis Zoological Gardens; two eggs from the first clutch of four developed until the 15th day of incubation, after which the embryo died (Flieg, 1971): events which have been (erroneously) interpreted as if the cross had been a fertile one. Remarkable though this hybridization between members of the two existing owl families *Strigidae* and *Tytonidae* was, it does not indicate that the Striped Owl is a link between these families. The Striped Owl is a genuine member of the genus *Asio*; the recognition by previous authors of a special monotypic genus *Rhinoptynx* is untenable. The species' geographic history, like that of the sympatric Stygian Owl, remains a mystery, however.

GENERAL

Faunal type South American or Tropical North American.

Distribution Not fully known, though data are more complete than for the Stygian Owl. Discontinuous, in Central America, northern and central South America. From southern Mexico (northern Oaxaca, Chiapas, Veracruz) along the Caribbean, but mainly the Pacific, slopes south to the Canal zone of Panama. In South America, from eastern Colombia, Venezuela and the Guianas and northern Brazil south to eastern Peru. One record exists from the island of Tobago (but not Trinidad), West Indies (endemic subspecies?). Further, eastern Bolivia, Mato Grosso and southeastern Brazil south to Paraguay, Uruguay and northern Argentina (Tucuman, Buenos Aires). Considered rare in Central America and probably most numerous in northern South America. Map 22.

Climatic zones Almost exclusively tropical. Tropical rain forest, tropical winter-dry, savannah, steppe and subtropical or temperate climates; almost exclusively in lowlands.

Striped Owl *Asio clamator*
Central South American race *A. c. midas* from Paraguay

Habitat Open grassy and bushy areas, savannahs, xerophytic scrub, but more often open marshes, clearings and other openings in the interior of evergreen and seasonal forests, swamps, plantations, open cultivated fields, forest edges and gallery forests. Up to almost 1,000m in southern Mexico and Venezuela, but usually much lower. The Striped Owl roosts by day, mostly well hidden on the ground, but it has also been found in low trees and thickets. In Venezuela and Surinam social roosts of 10–15 individuals have been observed.

GEOGRAPHY

Geographical variation Conspicuous in size. Four subspecies recognized in four discontinuous areas. The owls are smallest in Central America (*A. c. forbesi*, average wing length of male/female 228mm/239mm), intermediate in northern South America (*A. c. clamator*, wing length 236mm/251mm), largest in southern South America (*A. c. midas*, wing length 267mm/273mm; Lowery & Dalquest, 1951). The darkest and most heavily streaked forms are in northern South America. The owl's enigmatic occurrence on Tobago is based on a single specimen found in August 1878 by the well-known collector F. A. Ober (*A. c. oberi*, wing length, depending on method of measuring, 284mm; Kelso, 1936; or 276mm; Lowery & Dalquest, 1951).

Related species Long-eared and Short-eared Owls.

STRUCTURE
The Striped Owl resembles a Long-eared Owl in all structural characteristics. It is very stoutly built, has long ear tufts and densely feathered legs and toes down to the subterminal phalanges. The iris is dark brown, hazel (Wetmore, 1968), "chrome" (Dickey & van Rossem, 1938), or dark orange (Krahe, 1981), but always appears dark from a distance, and contrasts with the light-orange or yellow eyes of other *Asio* species. Skeletal characteristics resemble those of the Long-eared Owl, but the orbits are larger and the tympanic cavity is proportionally the narrowest found in *Asio* (Ford, 1967).

The outer ear openings are very large, operculate and asymmetrical. The first description (Norberg, 1977:391) stressed the similarity with the Long-eared Owl. The left ear slit was 37.0mm high, the right 39.5mm. In a fresh specimen from Surinam (1964) I found somewhat larger dimensions and a reversed asymmetry, viz. 42.0mm left and 37.5mm right. The pre-aural flap was found by Norberg to be 5.7mm (left) and 11.0mm (right) wide, and by me, 9.0mm on both sides, with post-aural skin folds of 5.5mm (left) and 4.0mm (right), respectively. In short, no recent authors (Voous, 1960; Ford, 1967; Mayr & Short, 1970; Norberg, 1977) found evidence for recognizing a monotypic genus *Rhinoptynx* for the Striped Owl.

BEHAVIOURAL CHARACTERISTICS

Songs and calls The territorial song of captive breeding birds was recorded as a *whoo*, repeated 6–7 times and answered by the female with similar, but higher-pitched notes. A barking alarm call was rendered as *wou-wou* (Krahe, 1981). In Venezuela Schwartz noted a staccato series of barking *ow ow ow ow*. Other calls, of unknown function, have been described (Davis, 1972).

Circadian rhythm Nocturnal and thus little known.

Antagonistic behaviour No data.

ECOLOGICAL HIERARCHY
There are no known records of interactions between the Striped Owl and other owls or diurnal birds of prey. On the basis of weight, Striped Owl females are approximately 28% heavier than males (male 347–408g, female 480–546g; Haverschmidt, 1968). On the basis of wing length, the difference is slighter: 2–7%. Total claw length found by me in a male from Surinam was 172.0mm, against an average 124.5mm in four male Long-eared Owls from North America and 123.5mm in male Short-eared Owls from Europe. This indicates a greater predatory power, possibly relating to larger mammalian prey.

BREEDING HABITAT AND BREEDING
Nests have been found on a piece of dry ground in a citrus grove in Panama (Wetmore, 1968) and on the ground amidst grass and bushes in the coastal lowlands of Surinam (Haverschmidt, 1968). Unlike in the Short-eared Owl, these nests were a mere scrape. In captivity too the male made shallow scrapes at each nesting (Goodman & Fisk, 1973).

Clutch size is 2–4. Eggs measured on average 43.7 × 37.6mm (Panama), *c.* 45.0 × 36.0mm (Surinam) and 44.7 × 36.5mm (Paraguayan birds in captivity; Krahe, 1981). In comparison with North American Long-eared and Short-eared Owls this represents about 115% and 129% of egg volume, respectively. R. G. Krahe (1981), who bred Paraguayan birds in Canada, obtained a total of 83 eggs over a period of several years and found that the male hunted for the female and the young, as in the Long-eared Owl and other owl species. In another captivity pair from Peru the incubating and brooding female was "fed on demand by the male" (Goodman & Fisk, 1973); the latter was not involved in incubating. The chicks had a thick, grey-white down, which was later replaced by a buff-brown second downy plumage, no doubt serving as camouflage on the ground.

FOOD AND FEEDING
Striped Owls have been seen quartering open marshes at dusk, like a Short-eared Owl, but it is also thought to hunt from suitable vantage points such as the top of bushes or a pole in a field. Prey items recorded from Surinam include spiny pocket mice, the cricetine mice and the rice rats, the Cayenne spiny rats and the rat-tailed opossum (Haverschmidt, 1968).

MOVEMENTS
Considered resident.

GEOGRAPHIC LIMITS
In the extreme north and south and in the mountains of South America this species is replaced by the Short-eared Owl.

LIFE IN MAN'S WORLD
No interrelations with man have been recorded other than the owl's occurrence in suburban areas in Venezuela. The single specimen found on Tobago (August 1878), has led Estelle Kelso (1936) to remark that the Striped Owl "may have become extinct with the advent of man, as have three owls on other islands".

Striped Owl *Asio clamator*

The few data available appear to confirm the notion that the Striped Owl, rather than being a tropical vicariant of the Short-eared Owl, is a species combining the structural characteristics and habits of the Short-eared and Long-eared Owl. It is probably primarily a mammal-hunter and takes larger prey on average than the northern Short-eared Owl. Like the Stygian Owl, it may have had a South American origin, but the geographic evidence for this is meagre.

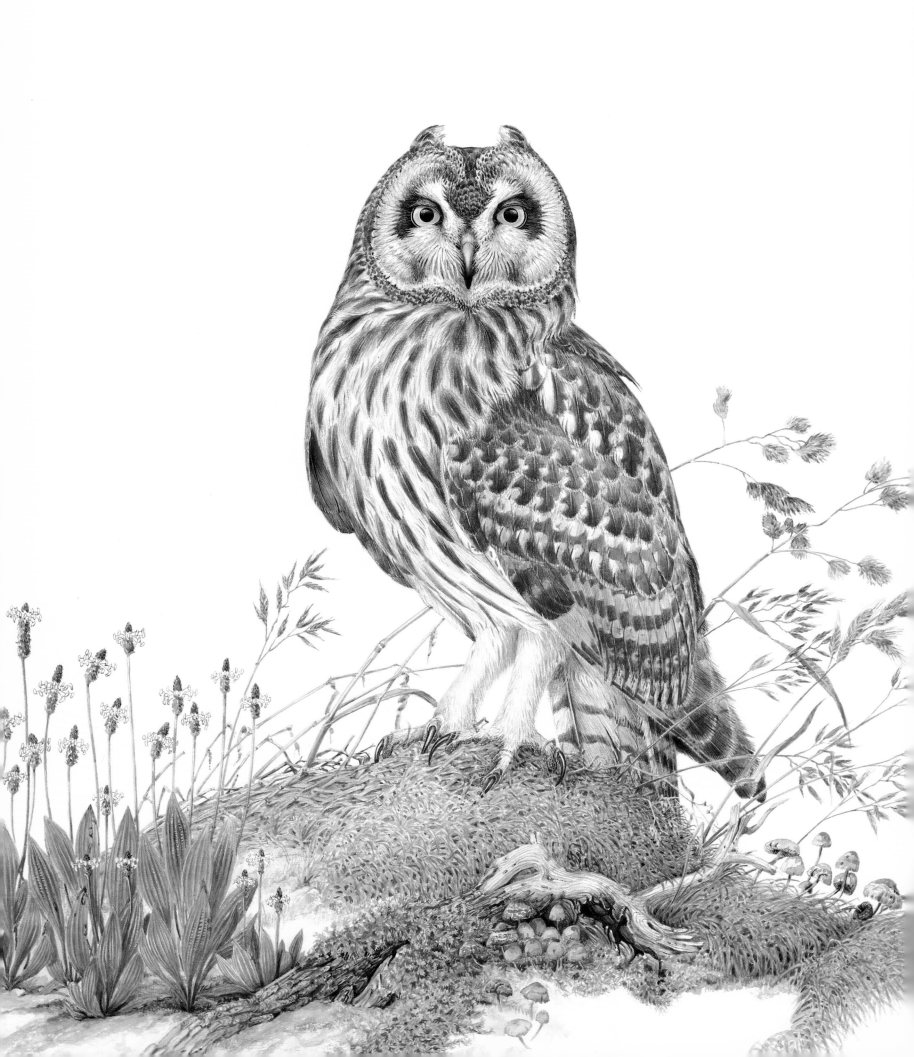

SHORT-EARED OWL

Asio flammeus

The Short-eared Owl has advanced ecologically along the same path as the Long-eared Owl *Asio otus*. They are roughly the same size, but the Short-eared Owl is decidedly heavier (about 20% in Eurasia and 32% in North America) and even more of an open-country species, usually spending considerable periods of time away from bushes and trees.

In all stages of its life it is primarily a terrestrial owl, lying up in grass and low plants. In arid parts of the Middle East it is known to spend the day in large rodent burrows (Bodenheimer, 1935). It is also a "restricted feeder" in so far as it occurs and nests most frequently where microtine voles and lemmings are abundant, which means that it is even more nomadic than the Long-eared Owl. As it nests on the ground its nestlings are still more vulnerable to terrestrial predators, and this affects the colour of the downy plumage, the behaviour of the chicks, and the time they leave the nest. In comparison with the Long-eared Owl, the wings are relatively longer and the flight is more buoyant and moth-like. When diurnal birds of prey are scarce or absent the Short-eared Owl is a daytime or crepuscular rather than nocturnal hunter like the Long-eared Owl. Like the latter, if necessary, it can take other prey, sometimes of considerable size. Apart from average differences in diurnal rhythm, the Short-eared Owl shows even stronger ecological similarities than the Long-eared Owl with the Northern or Hen Harrier *Circus cyaneus* of the northern continents and with the Ashy or Cinereous Harrier *Circus cinereus* in South America and may behave as their food competitor. The relationship between Short-eared and Long-eared owls, geographic origin, probable significance of the short or shortened ear tufts and the Short-eared Owl's ecological relationship with the harriers form the substance of the following species account.

GENERAL

Faunal type Holarctic.

Distribution Holarctic, with disjunct extensions in South America and isolated, insular populations in Micronesia (Ponape or Pohnpei and formerly possibly Kusaie or Kosrae in the Caroline group; Baker, 1951; and possibly formerly Guam in the northern Mariana Islands) and the Hawaiian Islands. North America, from the coastal tundras on the Arctic Sea coasts of Alaska, Yukon and Mackenzie, Hudson Bay, Labrador, Banks Island, southernmost Victoria Island and incidentally other Canadian Arctic islands in years of lemming abundance, but not Greenland; south to California (37° north), some of the Midwest states, New York and New Jersey. Puerto Rico (where thought to have become extinct, but now recovering), Hispaniola and recently Cuba (Bond, 25th Suppl. 1984).

There are discontinuous ranges in South America in (1) the tropical savannahs in the states of Apure and Anzoátegui, Venezuela (Friedmann, 1949), (2) the arid temperate Sabana de Bogotá at about 2,600m and, possibly geographically separated, high Andean habitats of Colombia, Ecuador and Peru, at least to Lake Junin at 11° south (Fjeldså, 1983) and (3) the chaco, pampas, temperate and cold areas of central and southern South America from Bolivia, Gran Chaco and Rio Grande do Sul south

Short-eared Owl *Asio flammeus*
European race *A. f. flammeus*

to Tierra del Fuego, while there are insular populations on (4) at least 16 of the Galápagos Islands, on (5) Masatierra (Robinson Crusoë Island) in the Juan Fernandez group, and on (6) the Falkland Islands.

In Eurasia north of the Mediterranean and southern countries, throughout the whole of the temperate and boreal regions to northern Manchuria, Ussuria, Sakhalin, Kamchatka, the northern Kurile Islands and most of the Aleutian Islands, but not Japan or most of China, nor the Yamal and Taimyr Peninsulas and the islands in the Arctic Ocean. It has nested on Iceland since the 1920s and on the Faroes, but there are no breeding records from Ireland. Southern as well as northern limits are very flexible and shift north and south depending on the food situation and the ever-changing marshy conditions of the available habitats. In central Europe and the eastern United States most of the marsh habitats have been drained and cultivated and the Short-eared Owl has accordingly disappeared as a breeding bird. Map 23.

Climatic zones Breeding in arctic, subarctic, boreal and temperate climatic and mountain zones; to a much lesser extent in mediterranean, winter-dry tropical and arid tropical regions. In the north it may reach the isotherms of 10–15°C in the warmest month (July) and in the south 10°C (January).

Habitat Swamps, grasslands, bogs in coniferous forests, often in the boreal taiga and in the birch-willow zone of the Subarctic; also lowland tundra in the Low Arctic. Salt marshes, reed beds

and swamps in coastal dunes, but also marram grass on dry sand dunes. Flooded meadows and extensive wheat fields and other cultivated and arable land. Short-grass steppes, even semi-deserts, in central Asia. In general in the lowlands, in central Europe not above 650–1,000m and, curiously, absent in the Alps, but in the Altai Mountains in central Asia up to 2,000–2,350m and in the Andes of South America as high as 4,080m at Lake Junin in Peru (Fjeldså, 1983). South American habitats include the spiny grasslands and swamps of the paramo and *puna* zones of the Andes, all kinds of temperate swampy grasslands and pampas, the chaco swamps and cattle ranges, subantarctic tussock grass and rushes; also subtropical and tropical savannahs and xerophytic vegetation in northern South America and the Galápagos Islands. Non-breeding season habitats do not differ as a rule from breeding habitats. In Burma Short-eared Owls have been found wintering in paddy stubble and large pea fields which were riddled with rat holes.

GEOGRAPHY

Geographical variation Slight. Not apparent in the whole of the northern hemisphere (*A. flammeus flammeus*), possibly as a result of extensive nomadism. South American Short-eared Owls have a larger bill and stronger feet and claws. Otherwise, those from southern South America (*A. f. suinda*) are indistinguishable in colour and size from northern birds (Steinbacher, 1962), but those from the Falkland Islands are smaller (*A. f. sanfordi*). Short-eared Owls from northern South America (*A. f. bogotensis* and *A. f. pallidicaudus*) are darker brown and smaller, as are those from the Greater Antilles (*A. f. portoricensis*, smaller by about 12% than North American birds), while those from the Galápagos Islands (*A. f. galapagoensis*) are also darker, more heavily marked and banded on the underparts and on the leg feathering. Short-eared Owls from Hawaii (*A. f. sandwichensis*) and Micronesia (*ponapensis*) have shorter wings (c. 93% of east Asiatic birds). In total, nine or ten races are recognized.

Related species The Short-eared Owl's nearest relative is probably the Long-eared Owl *Asio otus*, rather than the African Marsh Owl *Asio capensis*. In chromosome pattern, shape and numbers Short-eared and Long-eared Owls resemble each other more closely than they do any other owls so far examined (Belterman & de Boer, 1984:70). The Short-eared Owl is no more closely related than the Long-eared to the equally more or less terrestrial Striped Owl *Asio clamator* from the American tropics.

STRUCTURE AND HEARING

The Short-eared Owl appears to be identical to the Long-eared Owl in all its structural characteristics, but the breastbone keel is shorter than in that species. Its wing bones are relatively longer: taking the humerus as 100%, the bones of the lower arm and the hand are 7% longer in the Short-eared Owl, as against 1.5% in the Long-eared Owl (Winde, 1970). In absolute measurements the total length of the wing bones is 276mm on average in the Short-eared, as against 234mm in the Long-eared Owl; the length of the leg bones (without toes) is 178.5mm and 162mm, respectively (Winde, 1970). In the Short-eared Owl the tarsus in particular is longer, which is in line with its more terrestrial habits.

The shortness of the Short-eared Owl's ear tufts seems to indicate that the function of these feathers in terrestrial, grassland-inhabiting owls is negligible. But how and why this is so remains a mystery.

The outer ear openings are as complicate and asymmetrical in structure as in the Long-eared Owl and of approximately the same size. In vertical length in five specimens they averaged 38.0mm (right) and 37.7mm (left), as against 37.3mm and 35.6mm in six Long-eared Owls (Brussaard, Biology Dept, Free University, Amsterdam). The right ear is not always larger than the left one: taking the height of the left ear slit in each of the above-mentioned species as 100%, the right one was 91.0%, 92.5%, 101.4%, 107.9% and 112.2%, respectively. In a specimen measured by R. Å. Norberg (1977) it was 102.7%, and in another fresh specimen which I myself examined 90.9%. The right outer ear opening has usually been found above the transverse dermal septum and the left one below, but I have discovered that the reverse can also be true, as has been confirmed in a specimen from Japan (Kuroda, 1967). Nagahisa Kuroda even stresses the presence of a slight asymmetry in the temporal and occipital part of the skull. Personally, I found the width of the dermal flaps bordering the ear slits smaller than in the Long-eared Owl: pre-aural skin 8.5mm (right) and 9.0mm (left), and post-aural skin 7.5mm and 9.0mm, respectively. Similar dimensions were recorded by R. Å. Norberg (1977): left ear slit 37.0mm, right one 38.0mm, pre-aural flaps 8.5mm.

The hearing capacity in the Short-eared Owl was studied by L. Brussaard using the same methods and instruments as in an earlier study of the Long-eared Owl (Tj. van Dijk, 1973). Highest sensitivity was at approximately 6kHz, as in the Long-eared Owl, but at higher frequencies the Long-eared was better and could be tested to 10kHz, as against 8kHz in the Short-eared Owl. In this range of high sounds the Long-eared Owl could perceive much lower sound pressures than the Short-eared Owl. The Short-eared Owl thus seems to be somewhat less dependent on its hearing capacities than the Long-eared Owl, though, in its turn, the Short-eared Owl can hear much better than the Northern or Hen Harrier which was studied for comparison.

Eyesight by day seems to be as good as in any diurnal bird. In the receptor cells of the retina, however, no red droplets or other histological characteristics of diurnal birds have been found (Gallego et al., 1975).

BEHAVIOURAL CHARACTERISTICS

Songs and calls Apart from the more or less subdued, low-pitched territorial and courtship song *voo-hoo-hoo-hoo-hoo* and a rapidly repeated alarm and aggression call *chè-chè-chè* or *wak-wak-wak*, mostly uttered by the male against intruders at the nest site, there are a few other calls which are heard only infrequently. There is a barking *kee-ow* or *keeyow*, which acts as a contact call between male and female and is more often uttered by the female, and there are other barking and hissing sounds, but the owl's repertoire cannot compare with the rich vocabulary of

Short-eared Owl *Asio flammeus*
European race *A. f. flammeus*

the Long-eared Owl. In its open habitat the Short-eared Owl is apparently too vulnerable to allow for conspicuous vocal demonstrations. Even the calls of the young begging for food at night from their dangerous positions on the ground are remarkably soft, higher pitched and much thinner than the snoring food calls of the Barn Owl, which they resemble, and quite unlike those of the Long-eared Owl. In winter the Short-eared Owl is one of the most silent species of owl.

Instrumental sounds include a highly perfected and somewhat rattling wing-clapping and an aggressive and warning bill-snapping.

Circadian rhythm In contrast to the Long-eared Owl, the Short-eared Owl is one of the most diurnal of the medium-sized owls. In fact, it can be found hunting or flying around at any time of the day, though it is usually crepuscular rather than diurnal. Short-eared Owls vacate their winter roosts one by one just before sunset when Northern or Hen Harriers are coming in to roost. When, as rarely occurs, there are no diurnal birds of prey to be avoided, the owls seem to be more active by day and are more regularly so in the nesting season when the growing young have to be provided and cared for. Courtship flight and song may also occur at any time of the day and there are indications that in spring and summer rest periods of a few hours take place in the middle of the day and the middle of the night.

Antagonistic behaviour Short-eared Owls are often very aggressive at their nesting sites. Territorial clashes occur frequently at the beginning of the breeding season. The owls chase one another with challenging wing-clapping, hover face to face, grasp one another's talons, and display other aggressive behaviour. In the course of the breeding season territorial aggression gradually subsides. Short-eared Owls can react very fiercely towards terrestrial predators and man, the male sometimes inflicting bloody wounds on the intruder's head and neck. The female tends to remain on the nest, well hidden by her protective covering, which is usually somewhat paler than the male's. When young are small, females are known to display broken-wing behaviour as dramatically, and to yelp as loudly, as the Long-eared Owl. This is after all a behavioural tendency of ground-nesters rather than of tree-nesters. Outside the breeding season the owls rely on their cryptic coloration and remain hidden among grass and sedges or stay in the open among clods of earth or grain stubble where they are equally hard to locate. The facial disc is fully contracted, the eyes form vertical slits and the ear tufts are raised so as to create short, but pointed, devilish ears, which are aligned with the vertical grass stems. As in the Long-eared Owl this satanic face can change in a moment into a rounded head with no evidence whatsoever of ear tufts.

ECOLOGICAL HIERARCHY

Although it resembles the Long-eared Owl in appearance and size, the Short-eared Owl is 21.6% (male 350g) and 25.7% (female 411g) heavier than the Long-eared in Eurasia and 28.6% and 35.5%, respectively, in North America. In its breeding and winter range it rarely comes into direct contact with other owl species, other than the Snowy Owl, though a few individuals may join a Long-eared Owl's communal roost in winter when, as an exception, they perch in low trees or shrubs. In Germany one Short-eared Owl was found roosting 1.5m from the nearest of three Long-eared Owls, while two others were seen among a roosting group of about 50 Long-eared Owls. Short-eared Owls are strong, if rather restricted, predators. The sum total of their claws in Europe reaches 123.5mm on average in males and 133.0mm in females, as against 113.0mm and 138.0mm, respectively, in Long-eared Owls. Their average prey size in Europe is estimated at about 35g, compared with 32g in the Long-eared Owl, but the differences in North America seem to be much greater.

One would have expected that due to its extremely long wings, a characteristic of open-country birds, the Short-eared Owl's wing-loading would be smaller even than that in the Long-eared Owl, but this is not the case: a value of $0.34g/cm^2$ has been calculated for the Short-eared Owl, $0.31g/cm^2$ for the Long-eared Owl and $0.29g/cm^2$ for the Barn Owl (Brüll, 1977). Nevertheless, its flight seems lighter, more buoyant and moth-like than that of the Long-eared Owl. The Northern or Hen Harrier and the Cinereous Harrier in South America, with which the Short-eared Owl most frequently shares its habitat and often most of its prey, have a wing-loading of $0.31g/cm^2$.

The Northern Harrier is 7% (male) and 51% (female) heavier than the Short-eared Owl in Europe and 11% and 40%, respectively, in North America. Both species hunt low over the vegetation and take most of their prey by surprise. It appears that where Hen Harriers are numerous, Short-eared Owls avoid them and hunt less frequently by day. The two species may even exchange places on the same communal roosting site at the end of the day. Nevertheless, Short-eared Owls are known to have been preyed upon by Hen Harriers in Europe at least twice (Mikkola, 1983). Such a small record is negligible when compared with the 66 instances of predation on Short-eared Owls by Goshawks, 17 by Peregrine Falcons and 14 by Golden Eagles. Other known predators are Rough-legged Buzzard (5 ×), Gyrfalcon (4 ×), Common Buzzard (2 ×), White-tailed Eagle (1 ×), Imperial Eagle (1 ×), Long-legged Buzzard (1 ×), Black Kite (1 ×), Pallid Harrier (1 ×) (Mikkola, 1983:381). In North America the Red-tailed Hawk is a diurnal predator of the Short-eared Owl (Craighead & Craighead, 1956:405).

The Short-eared Owl seems to fall victim to other owls less often than the Long-eared Owl, and is mostly preyed upon by Eagle Owls, and once by a Snowy Owl (Mikkola, 1983) (more often in Canada; Murie, 1929; Lein & Boxall, 1979) but its most frequent predator is the Great Horned Owl. Of 4,838 pellets and stomachs belonging to Great Horned Owls examined from the north-central United States, 90 (or 1.9%) contained owl remains, among which were 13 Short-eared Owls (Errington *et al.*, 1940). Few owls have been preyed upon by Short-eared Owls; none has ever been recorded by Heimo Mikkola (1983), though other authors (Herrara & Hiraldo, 1976; Myrberget & Aandahl, 1976) mention Northern Hawk Owl, Long-eared Owl and Barn Owl.

Clearly, Short-eared Owls had to avoid Snowy Owls (five times heavier than the Short-eared Owl) and Pomarine Skuas (more than twice as heavy) when they were nesting in large numbers in the coastal tundras of Point Barrow, Alaska, in 1953 (Pitelka *et al.*, 1955). Apart from incidentally preying on Short-eared Owls, Snowy Owls more often try to rob them of their prey, and frequently succeed, particularly on their communal wintering grounds (Lein & Boxall, 1979).

Interrelations between the Short-eared Owl and other predators are relatively uncomplicated in the tropics of the Galápagos Islands. The Short-eared Owl meets the Barn Owl, which is somewhat smaller and lighter here than the Short-eared Owl. Both are ubiquitous to a high degree and share the majority of more than 40 prey species. A recent study showed the Short-eared Owl's food to consist of 51% (biomass) birds and 47% mammals, mainly rats, as against 3% and 85% in the Barn Owl. Locally the Short-eared Owl was a strong predator on Hawaiian Petrels (11% biomass), whereas Barn Owls rarely took these or other sea birds (1% biomass) (Tj. de Vries; de Groot, 1983). The Short-eared Owl was also crepuscular to a certain extent, while Barn Owls were strictly nocturnal.

Female Short-eared Owls in Europe have a body mass of 411g on average, which is 117% of that of males. The dimorphism index of the cube root of the body weight is 5.4, that of the wing length 0.8 (Mikkola, 1983). Comparable values in North America are 6.1 and 0.5, respectively (Earhart & Johnson, 1970). A difference between the sexes in wing-loading, manoeuvrability and predation power can thus be expected, but no data are available.

Being ground-nesting birds, Short-eared Owls are on the whole highly vulnerable to terrestrial predators, particularly fox, American mink and brown rats (Glutz & Bauer, 9, 1980). This is the price Short-eared Owls have to pay for exploiting an ecological niche available to only a few species of owl. Ravens and crows are major predators of the owl's eggs and chicks, and in Germany a White Stork was observed to take all the young from a Short-eared Owl's nest (Drescher, 1930, cited by Gerber, 1960:50).

Interspecific encounters between Short-eared Owls and harriers, *Buteo* hawks and falcons, including the small, vole-eating Kestrel, occur regularly, and each species may rob either of the others of its prey.

BREEDING HABITAT AND BREEDING

Short-eared Owls nest on the ground, scraping a shallow nest site in sandy soil or on a dry spot on a moor or in a bog, usually under a protective cover of heather, grass, sedge, growing wheat or corn, or other plants and tundra moss, and always in open country (see p. 140). In North America 55% of nest sites were on grassland, 24% in grain stubble, 14% on hayland and 6% in low perennial vegetation (Clark, 1975). The incubating female, and exceptionally the male, gathers and adds to the nest grass stems, stalks and thin twigs. Very rarely, nests have been found in places other than on the ground, e.g. on top of a broken tree stump in a clearing and even in old crows' nests.

Unlike the Long-eared Owl, the Short-eared defends a nesting territory of some considerable size. It has an un-owl-like courtship flight, ranging from a few to 50m in distance, but up to 350m in height, and usually performed at dusk, though it has been observed at other times of the day too. The flight consists of exaggerated, deep wing beats and underwing display accompanied by audible wing-clapping below the body and a courtship song *voo-hoo-hoo-hoo* which can be heard throughout the day and night (Dubois, 1924). By flying high the performing bird, probably always a male, avoids attack from aggressive harriers, hawks, skuas or jaegers, or even Snowy Owls inhabiting the same area. Nesting territories vary considerably in size, ranging from 0.09 to 0.22km² in central Europe and 0.18 to 1.37km² in Scotland, and reaching 2km² in Finland (Glutz & Bauer, 9, 1980; Cramp, 4, 1985). Territory size depends, however, on the available food supply: it is larger in years of food shortage and may shrink to 0.03km² during vole plague years. This applies to temperate and arctic conditions equally. While no Short-eared Owl was observed nesting in the coastal tundra of Point Barrow, Alaska, in the years 1949–52, 28 nests were found and probably more were present in the same location in 1953. Territories were well defended and were as small as 0.02km² or even smaller (Pitelka et al., 1955). As in the case of the Long-eared Owl, Short-eared Owls have been found nesting close enough together to suggest the existence of nesting "colonies", a situation which results from food abundance rather than social inclination or pressure. Shortest distances recorded between nests are 145m in Germany and 300m in Finland.

Breeding starts whenever and wherever food is in unlimited supply and the weather is mild enough to stimulate reproductive behaviour. Thus, in the vole plague years of 1906–07 in the Ukraine, south Russia, Short-eared Owl nests were found in considerable numbers from the second half of November and early December 1906 onwards (Brauner, 1908), and on newly reclaimed polders of the Ysselmeer in the Netherlands, when common voles were superabundant, nests with eggs and young were reported in December 1951 (Noordoostpolder) and again on 7 December 1959 (Oostelijk Flevoland) (Bakker, 1957; Cavé, 1961), when hundreds of Short-eared Owls were present alongside an equal number of Hen Harriers. Where they occur more or less regularly and rely on a fairly constant food supply, Short-eared Owls are not particularly early nesters. They start at least two weeks later than Long-eared Owls, completing their nest by the end of March or early April in Britain, and hardly before May or early June in Finland.

As in the Long-eared Owl, the male Short-eared Owl hunts for the female when she is laying her eggs and while she incubates, broods and cares for the young. Presentation of food by the male often occurs during the day. This is a spectacular affair, similar to the exchange between male and female Northern or Hen Harrier, whereby the female flies from the nest to encounter the male. Clutch size is even more variable than in the Long-eared Owl. Clutches as large as 12 and 16 have been reported in vole years, but the size is 6.9 on average in central Europe, 6.8 in Sweden and 7.4 in Norway and Finland (Glutz & Bauer, 9, 1980). In North America it is 5.1 in the south and 6.4 in the north (Murray, 1976). Eggs average 40.25 × 31.9mm in central and northern Europe (Makatsch, 1976), 40.1 × 31.8mm in Britain (F. C. R. Jourdain), 39.0 × 31.0mm in North America (Bent, 1938) and 42.5 × 35.1mm in Chile (Johnson, 1967).

The young initially have a dense downy coat of a light-buff coloration, whereas the second down is darker brown, each plume being tipped buff and marked with dark bars (see p. 256). They are brooded by the female for about 12 days and leave the nest, scattering around in the safety of the vegetation, at the early age of 12–17 days (an adaptation to ground-nesting) when the female resumes hunting. In years of food shortage the female may start hunting half a week earlier, on the 9th day. When food is plentiful surplus prey is often "cached" at the rim of the nest, which may diminish the tendency by older chicks to eat their younger nest mates. The chicks wander far from the nest, making "runs" under cover of the vegetation, and disperse

often as far as 50–200m within four days (Clark, 1975). They indicate their presence to their food-bearing parents by a quivering wing-flapping recognition display, in which they show the white underside of their growing wings and conspicuous black-and-white facial pattern. When the young are older the parents sometimes drop their prey for them to retrieve.

The chicks are fairly safe from predators from the air, though eggs are taken by crows and Pomarine Skuas, but they are more vulnerable to terrestrial prowlers such as fox and mink. In one fox den in Scotland the remains of 8 adult and 68 young Short-eared Owls were found (Watson, 1972, cited by Cramp, 4, 1985). Young Short-eared Owls cannot afford to utter a loud hunger cry like Long-eared Owls and other tree-nesting owls, so their calls are soft, long-drawn-out and high, making them difficult to locate by any but their parents.

The young fly by 24–27 days of age, which is 10–20 days earlier than in the Long-eared Owl, but they continue begging for food from their parents even weeks later and are not fully independent before about 50 days of age. The number of young reaching independence is conditioned by the food supply. Second clutches and the raising of two broods have been recorded in Finland, but this seems to be rare, even in vole plague years (Mikkola, 1983).

FOOD AND FEEDING

The Short-eared Owl specializes in catching voles, lemmings and mice of open country and marshland. During its nomadic wanderings or on more regular migrations it tends to remain wherever it meets high vole populations, often gathering there by the hundreds and staying to nest as long as the food abundance lasts. Nomadic movements and flocking are more apparent than in the Long-eared Owl, as is, however, the Short-eared Owl's ability to adapt to a variety of other prey, particularly birds of different sizes and habits, when local food situations require. Since it is approximately 24% heavier than the Long-eared Owl in Eurasia and 32% heavier in North America, its prey in general tends to be larger. Its hunting methods have been compared with those of the Northern or Hen Harrier or Marsh Hawk, and it often shares the same hunting grounds as these birds. It hunts low over grasslands and moors, quartering the fields and leisurely hovering or remaining motionless in the air on still or slightly vibrating wings (see p. 14).

Of 4,455 prey items collected at the breeding sites in northern and central Europe and summarized by Heimo Mikkola (1983:table 45; see also Thiollay, 1968:258), 80.4% consisted of voles and 97.6% of small mammals in general, while 1.3% were birds, 1.5% insects (mainly dorbeetles, but also cockchafers and water beetles) and a fraction only frogs and lizards. At the owls' winter sites in Britain, France and Germany 82.8% of 6,638 food items consisted of common and short-tailed voles, at least 7.4% of field mice, 7.3% of brown rats (many more when hunting on city dumps), 4.8% of birds and 2.7% of other items. Expressed in gram biomass, microtine rodents were represented in Great Britain and Ireland by 46.3%, brown rats by 31.5%, field mice by 6.7%, rabbits by 5.2% and birds by 7% (Glue, 1977). Other mammal prey recorded in Europe are ground voles, shrews, moles, hamster, rabbit, weasel, stoat and pipistrelle bat. In central Asia suslik and numerous other mammals of the steppes have been recorded. When voles are scarce relatively more birds are taken, particularly during severe winter conditions. Thus, in south-central Finland in 1958–67 microtine voles varied between 91% and 50% (1967), and birds between 0.8% and 28% (1967) (Mikkola & Sulkava, 1969).

Richard J. Clark (1975) has summarized details of approximately 16,100 prey items from North America recorded throughout the seasons by at least 33 authors in 23 publications. This resulted in 60.6% *Microtus* species, 94.8% mammals in general and 5.1% birds. Mammalian prey included pocket gophers, deer mice, pocket mice, brown lemmings and numerous other small terrestrial species. Short-eared Owls only appear in the Low Arctic tundra in years of peak lemming populations, e.g. in the coastal tundra at Point Barrow, Alaska, at 71° north, feasting alongside large numbers of Snowy Owls and Pomarine Skuas on superabundant brown lemmings. The number of insects taken varies considerably (e.g., locally, sand crickets *Stenopelmatus*, and also noctuids). Birds in continental Europe amounted to 1.2% (45 species) of the Short-eared Owl's diet, as against 8.0% (52 species) of the Long-eared Owl's. Most birds are taken in winter, e.g. 3.8% at the breeding site in summer, 14.5% in winter (Glue, 1977). The total number of birds recorded in Europe by various authors exceeds 70 species, varying in size between a Goldcrest and a Wigeon, but including mostly open-land birds such as larks, pipits, Reed Buntings and Starlings, and also waders (e.g. Dunlins) (Glue, 1977). Also included are such remarkable species as young Black-headed Gulls, Lapwing, Moorhen, Water Rail, Storm Petrel and Kingfisher. Locally Short-eared Owls concentrate in the breeding season on sea bird colonies, taking considerable numbers of the larger chicks of Common Tern and Black-headed Gull, e.g. on the East Frisian island of Borkum (Kumerloeve, 1968; R. Chestney, cited by Cramp, 4, 1985:592) and on Scolt Head Island, Norfolk, England.

In North America at least 60 species of bird have been recognized in the Short-eared Owl's diet, mainly Passerines, including Red-winged Blackbird, Meadowlark and kingbirds; also several kinds of wader, e.g. Killdeer, Dowitcher and Black-bellied Plover, Virginia Rail, Sora and large numbers of Common Tern chicks on Muskeget Island off the coast of Massachusetts (Bent, 1938:175) (Kumerloeve, 1968).

Average prey weight, calculated from various sources, was 35g, as against 30–32g in the Long-eared Owl. On Borkum, large ground voles (c. 75g) were taken almost four times as frequently as field mice (c. 20g) (Kumerloeve, 1968).

In their South American haunts Short-eared Owls feed primarily on mammals, but on the Galápagos Islands birds, particularly Darwin's geospizine ground finches, were prominent in the Short-eared Owl's diet, while on some islands adults and young of small and medium-sized petrels, shearwaters and terns and the nestlings of the White-tailed Booby and the Greater Frigate Bird have been recorded as important food items (R. Levêque; Abs *et al.*, 1965; de Groot, 1983). Large centipedes and grasshoppers complete the Galápagos Owl's known diet. On the Falkland Islands Short-eared Owls are reported to eat large numbers of Grey-backed Storm Petrels and diving petrels, apart from other, smaller birds and rats (Woods, 1975).

MOVEMENTS AND POPULATION DYNAMICS

Although the Short-eared Owl can be found the year round in suitable inland and coastal marshes throughout temperate Eura-

sia and North America, these habitats are becoming increasingly rare and the species is an unpredictable migrant in most of its range. The owls leave all breeding grounds in the boreal and steppe regions of Europe and Asia, travelling as frequently south as east and west, to winter in any temperate and mediterranean area where they happen to find an ample food supply. One can never be sure, as a result, where and when Short-eared Owls will appear, either for wintering or for nesting purposes. In Europe and Asia they winter usually south to the Mediterranean countries and northern Africa, north Pakistan and India, south China, the Ryu Kyu Islands and Taiwan; in North America south to Florida and southern Mexico. Less regularly they have reached the southern Sahel countries, Kenya, south Arabia and Sri Lanka, Burma and Singapore Island. Probably as stragglers they have arrived in Guatemala (Volcán de Agua), the Bahamas, Lesser Antilles (St Bartholomew), Bermuda, the Azores, the Selvagens Islands (e.g. on the remarkable date of 2 June 1981; den Hartog et al., 1984:135), Madeira, the Canary Islands, the Maldive Islands, Borneo and the Philippines (Luzon). Northwards they have travelled as far as 75° 30' north to Hochstetter Forland in Greenland, Jan Mayen Island, Bear Island, Spitsbergen and Wrangel Island at 71° north. On their extensive travels they regularly cross wide stretches of sea and ocean and it must have been on one such journey that they straggled to the tiny islands of Pagan and Tinian in the northern Mariana Islands (Baker, 1951) and subsequently settled and stayed as breeding birds on Ponape and other atolls further south in the Carolines, Micronesia. Those now living on the Hawaiian Islands must have descended from vagrants from the American continent (Olson & James, 1982:37). There are substantive records of Short-eared Owls observed far out at sea landing on ships' riggings, e.g. in October 1900, some 900km east of the Hawaiian Islands (Bryan, 1903); in early October 1902, some 1,200km west of Puget Sound, Washington, in the Pacific Ocean (Bryan, 1903); on 19 October 1935, four hours' steaming west of Bombay, in the Indian Ocean (McCann, 1935); on 5 January 1971, 3km off the mouth of the Mida Creek, Kenya, at 3° 22' south in the Indian Ocean (Britton 1980:80).

Where voles or mice are superabundant in autumn and winter Short-eared Owls assemble in large numbers. They gather in communal roosts of a few to a hundred or more birds, usually on dry patches of marsh, grassy fields or arable land, where their spotted, brown plumage merges with the surroundings. The appearance of large flocks of Short-eared Owls crowding in the air in moth-like flight when they start to hunt around sunset or are flushed in the middle of the day is a spectacular sight. These influxes often coincide with the appearance of other vole- and mouse-eating predators such as Barn Owls, Snowy Owls (exceptionally in Europe), sometimes Long-eared Owls and usually also Northern or Hen Harriers (e.g. 1978–79, western Europe; Davenport, 1982). When the food supply lasts they stay to nest, sometimes wholly out of season. Thus, in 1948–49, in the newly reclaimed Noordoostpolder in the Netherlands over 2,000 Short-eared Owls appeared, together with hundreds of Marsh and Hen Harriers, Common and Rough-legged Buzzards and other species of bird of prey (Bakker, 1957). The majority of these birds disappeared after proliferating for a few years and have never returned in similar numbers since. Owls ringed as nestlings have turned up in later years nesting at distances of thousands of kilometres, as in the case of one young owl ringed on 11 December 1959 in Oostflevoland, Netherlands, which was recovered the next breeding season, on 12 May 1960, at Arckangelsk, northern USSR (distance 3,350km), while nestlings from England and France have been recovered after two to six years in Astrakhan (4,375km) and Vologda (3,000km), USSR.

No data on recruitment and mortality rate have been recorded, but due to the large number of young produced in vole plague years populations grow considerably in some years. Increased mortality in irruption years and the occurrence of non-breeding years probably counterbalance any substantial growth. The oldest ringed Short-eared Owl on record in Europe was one of 12 years and 9 months (Glutz & Bauer, 9, 1980).

GEOGRAPHIC LIMITS

The Short-eared Owl occurs and nests as far north as the available food supply of colonial voles and lemmings allows. Thus, it nests close to the Arctic Ocean or even on Canadian Arctic islands when brown lemmings are particularly abundant. This probably also happens in the northeast Siberian tundras where so far this owl has not been reported. Its occurrence as a breeding bird on Iceland is a relatively recent event (1920s) and is probably connected with the spread of the wood mouse after the latter's introduction by man. The southern limit in North America and Eurasia is as flexible as the northern one, but does not extend beyond the continental arid zone. In between these limits Short-eared Owls are intrepid nomads, making a home for themselves in any suitable habitat.

Short-eared Owls are, perhaps surprisingly, virtually absent in swampy parts of subalpine and alpine habitats in the Alps (but see Scherzinger, 1981) and other Eurasian and North American mountains, though food conditions there may be too unpredictable even for this owl. Its occurrence in South American high mountain zones may well relate to a different food supply. Its ultimate southern South American limit probably extends right to the coast.

Hunger resistance (hunger-body-weight in percent of fat-free weight) is much less than in sedentary species like the Barn Owl and Little Owl, less even than in the owl's woodland counterpart, the Long-eared Owl (see that species). In comparison with the Long-eared Owl, hunger weights are 16.0% higher in males (219g) and 23.5% (247g) in females. Though the standard metabolic rate under natural conditions is the same for both owls, the Short-eared Owl needs more food per day, viz. 188kcal per bird per day, as against 159kcal in the Long-eared owl (Graber, 1962). In order to meet its dietary needs, the Short-eared Owl must therefore travel more frequently over long distances and maintain a nomadic life style.

LIFE IN MAN'S WORLD

Drainage and cultivation of marshes and natural wet grassland habitats have caused a gradual diminution of Short-eared Owl populations in Europe and North America. Where Short-eared Owls have started to nest on extensive farmlands, as in Canada, numerous nests and young are destroyed by mechanical farming operations. Similar losses have undoubtedly occurred in the extensive cultivated areas of southern Russia and western

Siberia. The extent of such losses is not known, but the total diminution of the species appears to be considerable.

Particularly in Canada, but probably elsewhere too, Short-eared Owls have discovered the rich food supply of voles in the grasslands and unmown fields surrounding airports and have become a hazard to incoming and outgoing aircraft (Blokpoel, 1976). At Vancouver International Airport no less than 426 out of 543 rodent-eating hawks and owls trapped between January 1965 and May 1967 were Short-eared Owls. A number of these owls found dead on the airport runways were believed to have been victims of collisions with aircraft (Hughes, 1967). At Toronto International Airport voles as well as hawks and owls have been attracted by runways and taxiways kept snow-free in winter. Roosts of up to 67 Short-eared Owls have been found in the grasslands surrounding the airport in the winters of 1974–76. At both Vancouver and Toronto airports Short-eared Owls have been ringed and removed to a distance of 15–60km or more by enthusiastic bird-ringers to try and reduce the very real danger of a bird strike: an obvious improvement on casual or enforced shooting of the birds.

The Short-eared Owl's nomadic behaviour is closely related to its specialist diet of voles and other colonially living terrestrial rodents. It has been described as the open-country representative of the Long-eared Owl *Asio otus*. Like all fierce plains nomads, the Short-eared Owl has alternative means of survival and is as good at catching marsh and sea birds and other unlikely prey as any other owl of its size, while its activity range covers both night and day. It may not necessarily have originated, however, in windswept plains and tundras during the Pleistocene glaciations, since other terrestrial owls have originated outside these areas, and also at other times. The Short-eared Owl may nevertheless have had a northern holarctic origin, though this remains unproven as long as little is known about the correlation between its food and habitat in southern South America. Similarities, in terms of food and feeding ecology, with the Northern or Hen Harrier *Circus cyaneus* and the South American Cinereous Harrier *C. cinereus*, possibly also of northern origin, could provide important eco-geographical clues. In the meantime the theory that the Long-eared Owl is the Short-eared's nearest living relative remains unchallenged, though even here the evidence is slight. As in the case of other terrestrial owls the ear tufts are small and inconspicuous; the Striped Owl *Asio clamator* with its long feather tufts is the only exception to this rule. In the Short-eared Owl the ear tufts appear to indicate behavioural intentions and moods, but they are so short that they can hardly play a role in cryptic attitudes or antagonistic behaviour. The Short-eared Owl's relationship with the equally short-eared African Marsh Owl *Asio capensis* remains a further enigma.

AFRICAN MARSH OWL
Asio capensis

The similarity of their terrestrial habitats, behaviour and flight have led ornithologists to suppose that the African Marsh Owl and the Short-eared Owl *Asio flammeus* are close relatives if not conspecifics. With an average weight of about 273g in males and 334g in females, the African Marsh Owl is around 20% smaller than the northern Short-eared Owl. Wingspan is about 80% and total claw length 97% of those of the Short-eared Owl (data after Biggs *et al.*, 1979). Curiously enough, egg volume is larger by about 9%, indicating a basically different metabolic rate. The Marsh Owl's different coloration, colour pattern and vocalization, greater serration on the outer webs of the primary tips, as well as its possibly more insectivorous habits, could indicate an origin from some arboreal *Asio* species independent of that of the Short-eared Owl. The occurrence in Madagascar of a distinct, strong-billed form of Marsh Owl might indicate that the species is in fact already rather old. It is questions such as these which will be discussed in the following species account. The Marsh Owl's relations with the similarly terrestrial and grassland-inhabiting African Grass Owl *Tyto capensis* and the African Marsh Harrier *Circus ranivorus* will also be reviewed (Benson, 1981).

GENERAL

Faunal type Afrotropical.

Distribution Savannah, steppe and grassland regions of most of Africa, from Ethiopia and Vom in northern Nigeria (V. W. Smith, 1962; Smith & Killick-Kendrick, 1964) to southernmost South Africa and Madagascar. There is a small isolated range in western Morocco (de Naurois, 1981) and there was formerly also one in northern Algeria (Victor Loche). Records from Portugal and Spain probably refer to non-breeding migrants or stragglers, though the species may have nested there in the past and may do so again in the future as the habitat would appear to be very suitable. Map 23.

Climatic zones Savannah, steppe, desert, tropical winter-dry and mediterranean zones.

Habitat All kinds of open grassland, upland short grass and acacia savannahs, *dambos* (narrow drainage strips in woodland savannahs), moorlands, grassy swamps, vleis, locally reed beds (e.g. river deltas in the Namib Desert; Peter Steyn), floodplains, meadows, freshly ploughed rice fields, other grain fields and coastal salt marshes, from sea coasts up to 2,000m in the northern Cameroon Highlands (William Serle) and 1,800–2,750m in Ethiopia (Urban & Brown, 1981) and including the impenetrable *sudd* or Upper Nile marshes in Sudan. Apart from their climate, the habitats are not unlike those inhabited by the northern Short-eared Owl. Though often found in swampy areas, the Marsh Owl usually occurs in less moist surroundings than the African Grass Owl, which is the more specialized of these two marsh-inhabiting owls and thus more specific in its habitat requirements.

GEOGRAPHY

Geographical variation Slight on the African continent; conspicuous in Madagascar. Currently three races recognized. Moroccan and West African Marsh Owls are somewhat darker, more rufous brown and more strongly marked with white spots (*A. c. tingitanus*). Sub-Saharan birds are lighter, more grey-brown, and have fewer markings (*A. c. capensis*) whilst Madagascan birds are more conspicuously spotted and barred; they are larger by about 43% in weight and 5% in wing length and have a much larger and stronger bill (*A. c. hova*). Among other Madagascan predators, large-billed endemics are not uncommon either (e.g. Madagascar Buzzard *Buteo brachypterus*); they are considered adaptations to large, mammalian preys.

Related species Usually considered as closely related to the Short-eared Owl *Asio flammeus* and treated by some authors as conspecific with it (Eck & Busse, 1973). I am personally inclined, however, to doubt that the species are as closely related as to form a superspecies.

STRUCTURE

The Marsh Owl differs from the Short-eared Owl in having larger, dark-brown rather than yellow eyes, sometimes with an inner circle of dark red. The ear tufts are even smaller and more pointed, and the comb-like serrations on the outer webs of the outer three primaries, considered to reduce flight noise, are larger and more curved than in the Short-eared Owl (C. S. Roselaar, in Cramp, 4, 1985). The outer ears are similar to those of the Short-eared Owl in complexity, asymmetry and shape (Norberg, 1977:392) and can also be compared favourably with those of the Long-eared Owl.

BEHAVIOURAL CHARACTERISTICS

Songs and calls Incompletely known, but it seems that few similarities exist with those of the Short-eared Owl. The display song is a croaking *kaaa-kaaa* or *quark-quark*, resembling the African White-necked Raven's or a large frog's. An unmusical, rasping bark, expressing threat or alarm, is not unlike a similar call by the Short-eared Owl. Other croaking calls have been described, as well as a squealing noise uttered when feigning injury at the nest site. The position call of hungry chicks is described as *too-eeee*; it is soft and musical, with a rising inflection (Smith & Killick-Kendrick, 1964).

Circadian rhythm Like the Short-eared Owl and unlike the Grass Owl, the Marsh Owl has often been observed hunting by day, but it does not usually emerge from its daytime roost much before sunset or continue for more than one or two hours before sunrise. Hunting by day seems to occur most frequently under overcast skies and in dull weather. In contrast to Short-eared Owls, Marsh Owls' display flights are nocturnal rather than diurnal. When flushed by day the Marsh Owl is very inquisitive, but once it has settled again, it cannot readily be disturbed a second time.

Antagonistic behaviour Few details reported. Distraction display when nests or young are threatened is similar to that performed by Short-eared Owls. It may include a dramatic broken-wing act after a simulated crash in which the owl lands in the surrounding vegetation, and is sometimes accompanied by squeals and mews which help to lure any terrestrial predator away from the nest site. As in Short-eared and Long-eared Owls, pairs from neighbouring territories have been observed harassing, chasing and distracting mammalian and human intruders without engaging in territorial conflicts.

ECOLOGICAL HIERARCHY

In its southern and eastern Afrotropical range the Marsh Owl frequently shares its habitat with the Grass Owl. With an average body weight of 419g, the Grass Owl is larger and 35% heavier than the Marsh Owl, which weighs 310g on average (Biggs *et al.*, 1979). In Zimbabwe nests belonging to the two species have been found as close as 20m apart (Steyn, 1984:41). Though the Grass Owl occurs more regularly and more exclusively in swampier grassland, the coexistence of the two species in Zimbabwe has been described as follows: "Both species feed almost wholly on small rodents taken on the same ground and it is not clear how they are separated ecologically" (Irwin, 1981:171). A comparison of the food of Marsh Owls living in sedge beds bordering drying pools in Namibia with that of Barn Owls roosting in calcrete cliffs nearby showed the Marsh Owls' prey to be more varied: pellets collected contained 17 small birds and 4 rodents, whereas Barn Owl pellets contained rodents (gerbils) only (Vernon, 1971). Like the Short-eared Owl in the north, the Marsh Owl shares its habitat with a species of harrier, in this case the African Marsh Harrier. With an average body weight of 497g or 60% more than that of the Marsh Owl, the Marsh Harrier hunts in a similar way over the Marsh Owl's habitat and catches the same or similar preys. The ecological relations of the nocturnal and crepuscular owl and the diurnal harrier, complementing one another in their circadian activity, are worth studying and comparing with similar relations between the Short-eared Owl and the Northern Harrier in Eurasia and North America. Mammalian and reptilian predators of the Marsh Owl and its eggs and young are probably more numerous and more effective than those which prey on the Short-eared Owl.

Sexual dimorphism in the Marsh Owl is relatively small. Estimated body mass of the female is 334g, which is about 22% more than that of the male. Wing length is approximately 6% greater in the female. Though females are bigger and probably stronger than males, differences in hunting methods and average prey size have not been reported.

BREEDING HABITAT AND BREEDING

African Marsh Owls nest on the ground, in tall grass or sedges, often at the end of a tunnel leading through the vegetation. "The nest is simply a pad of flattened grass in a deep hollow, although sometimes the surrounding grass stems are pulled over to form a canopy" (Steyn, 1984:41). It is not clear whether these owls deliberately add some plant material to their nests. Only once, in Morocco, was a nest found in an old corvid nest, in a low shrub 4m above the ground (de Naurois, 1961).

Like the Short-eared Owl, the Marsh Owl defends a nesting territory established by specific display flights. These are similar to those performed by the Short-eared Owl. The owls fly with slow wing beats in wide circles while uttering raven-like croaks *quark-quark* and clapping their wings below their body. Around dusk the air may be filled for hours with the harsh calls of displaying owls. Dozens of pairs have been found nesting together, but these nesting colonies seem to have resulted first and foremost from the scarcity and restricted size of suitable grassland habitats rather than from a social tendency towards colony breeding. Nevertheless, Marsh Owls rarely nest in isolation. Nesting territories are small. They have been estimated in northern Nigeria at $0.03km^2$ and areas of similar size are thought to occur in South Africa. In the Orange Free State nests have been found as close as 75m apart (Steyn, 1983).

In southern Africa at least, eggs have been found throughout the year except in June, which is a dry month, but most breeding activity falls between February and May, after the main rains and before the winter drought. Similarly, on the north Nigerian plateau of Vom Marsh Owls nest at the end of the wet season (April–October), from mid-October to January when swamps have not yet dried up (Vernon & Killick-Kendrick, 1964). In the Serengeti, Tanzania, they nest in May–June, when the grass is tall and the food supply large after the rains. Dependence on rainfall patterns for nesting and food, rather than on rodent population cycles, leads to some nomadism if not regular intertropical migration in the Marsh Owl. Clutch size is 2–6, usually 3, and highest in years of vole abundance (e.g. in Zambia; Tree, 1963). Eggs average $40.0 \times 34.1mm$ in size in southern Africa (Steyn, 1983) and $40.8 \times 33.2mm$ in Morocco (F. C. R. Jourdain). The first downy plumage of the young is pale buff (Steyn, 1984) or pale fawn and resembles that of the Short-eared Owl. The young grow rapidly; when they leave the nest and start hiding in the surrounding vegetation at 10 days (Nigeria) or

African Marsh Owl *Asio capensis*

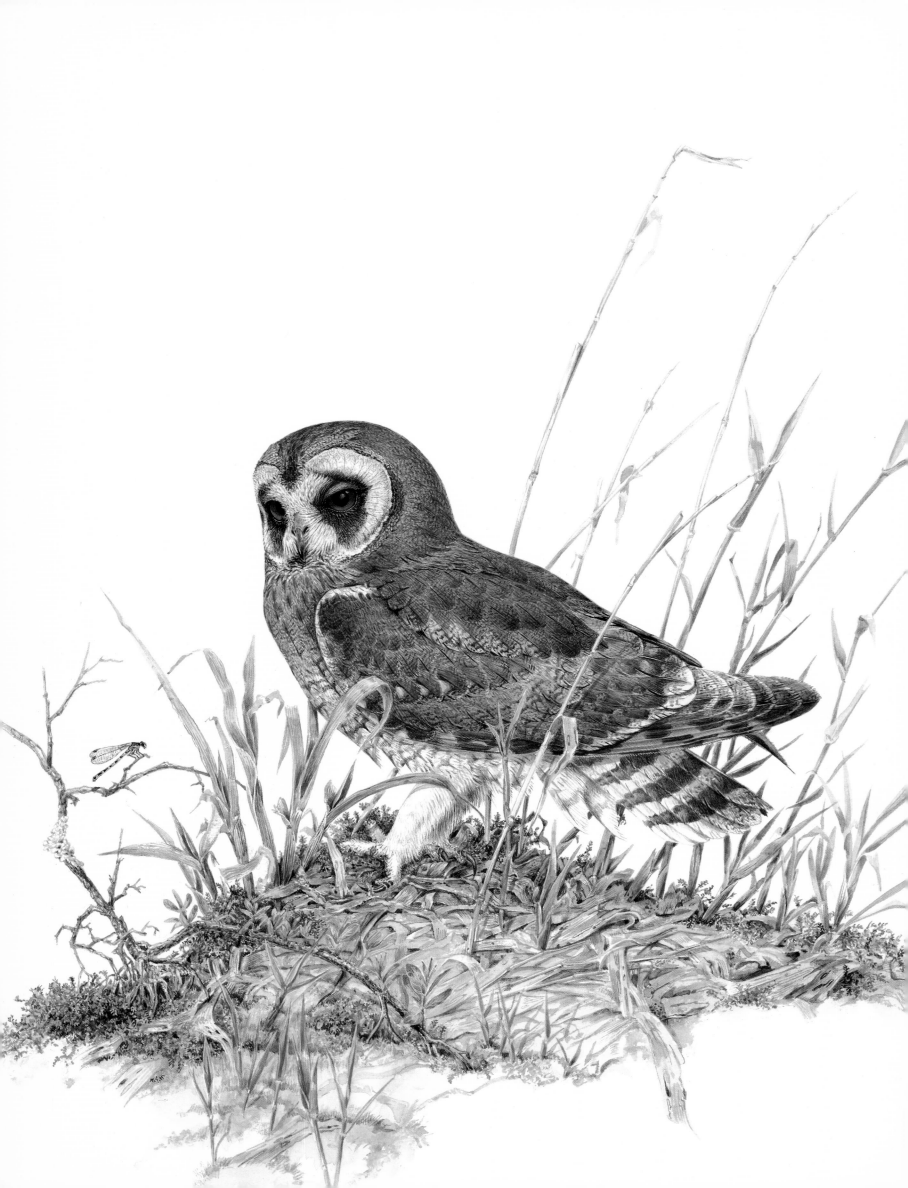

18 days (South Africa), the female also leaves the nest and helps the male to procure food for the family. The young have a soft, wheezing *too-eeee* food call with a ventriloquial effect which can be heard at a considerable distance. To aid discovery by the parents, they perform what has been called a little "tap-dance" (Steyn, 1984), the function of which is apparently similar to the wing-quivering of Short-eared Owl chicks. Family parties remain together for a relatively long period.

FOOD AND FEEDING HABITS

Like the Short-eared Owl, the Marsh Owl hunts by quartering fields and marshes in an erratic, buoyant flight one or a few metres above the vegetation. It has been seen hovering for short periods, as well as perching on a low pole by the side of the road, probably on the lookout for prey crossing the road. It is said to be attracted by recently harvested grain and corn fields and particularly by grass fires when insects and all kinds of terrestrial animals are on the move. Concentrations of owls have been reported catching termites fleeing from such fires. In general the Marsh Owl's food consists of considerably more insects and other arthropods than in the case of the Short-eared Owl, but on the whole the diet is varied, with rodents dominating in certain places and at certain times, insects in other places and at other times. Thus, in arid grasslands beetles, locusts, scorpions and lizards may be the principal food (e.g. most seasons, Morocco), but in other places gerbils and other nocturnal rodents of steppes and deserts form the main diet. In swamps and vleis a large variety of rats and mice (numerous of the nocturnal multimammate mice *Mastomys*, but few of the diurnal striped mice *Rhabdomys*; John Mendelssohn), shrews and frogs are taken, together with any small available bird, but also larger birds up to the size of quails, button quails (Madagascar), small grebes (Dabchick, Zimbabwe), duck (full-grown Hottentot Teal, Kenya; Meinertzhagen, 1959) and terns. Other preys recorded are bats, brown rat (Madagascar) and the Cape polecat or zorilla. The average prey size calculated over three years at Barberspan, western Transvaal, was 42–50g (Dean, 1978).

MOVEMENTS AND POPULATION DYNAMICS

The African Marsh Owl is probably more an intertropical migrant than an irregular nomad, but as rains do not always fall regularly, a certain amount of irregularity in the species' occurrence is inevitable. In Morocco it is perhaps more or less resident, but in most of tropical West Africa it seems to be mainly a non-breeding wet-season visitor. On the other hand, on the Serengeti grass plains, Tanzania, and in Mashonaland, Zimbabwe, concentrations are most frequently seen in the dry winter months, December–January and late May–August, respectively. However, since no ringed birds have been recovered, it remains uncertain what inter-African movements, if any, occur. Probably as a straggler the Marsh Owl has reached Tenerife, Canary Islands (March–April 1983; Deppe, 1984), as well as Spain and Portugal (Bernis, 1967), where the owl falls into the same category as another Afrotropical element, the Black-shouldered Kite, and might previously have nested too, as this bird does today. Unlike in the Short-eared Owl, rodent cycles do not appear to regulate African Marsh Owl numbers, except perhaps in the highlands.

GEOGRAPHIC LIMITS

The wide desert zone of the Sahara seems to represent the northern limit of the Marsh Owl's continuous distribution. The present Moroccan and former Algerian population is probably a relic from a Late Pleistocene climatic phase during which part of the western Sahara was less arid and more hospitable than it is today. Elsewhere, deserts and rain forests determine the limits of the species' present range.

LIFE IN MAN'S WORLD

The African Marsh Owl does not readily come into conflict with man. Apart from draining marshlands and vleis (excessively in Morocco, Algeria and South Africa) man rarely encroaches on the owl's habitat. Marsh Owls are frequently killed, however, by motor traffic in grassland areas, where they are attracted by the presence of insects and rodents on roads and verges. Biocide residues have only been found in small quantities in the bodies of dead specimens (Peakall & Kemp, 1980); such contamination may have been caused by insects rather than rodents. The Marsh Owl does not shun the presence of man. Recently, in tropical Tananarive (Antananarivo) (about 400,000 inhabitants), the capital of Madagascar, one was seen hawking insects at night around street lights in the town centre, and another perched on top of a roof, carrying a large brown rat (Langrand & Meyburg, 1984).

African Marsh Owl *Asio capensis*

The African Marsh Owl is less strictly a "restricted feeder" than the Short-eared Owl *Asio flammeus*, which it otherwise resembles in many respects. On the whole, all its structural and behavioural characteristics, including the protective coloration of the chicks, rapid development of nestlings, elaborate distraction display at the nest site and tendency towards flocking and nomadism, could be interpreted as convergent evolutions due to similar responses to the owl's relatively dangerous terrestrial life and its vulnerability to prowling mammalian and reptilian predators and trampling by herds of large herbivores. It is for this reason that I no longer consider the Marsh Owl and Short-eared Owls as members of one superspecies. They are nevertheless fine examples of ecological counterparts.

TENGMALM'S OWL

Aegolius funereus

Tengmalm's Owl, scientifically known by a name given to it more or less accidentally by Linnaeus in 1758, is named in the vernacular after the renowned Swedish doctor and scientist of that time, Peter Gustav Tengmalm (1754–1803), who discovered the species in Sweden in 1783 and provided the basis for J. F. Gmelin's superfluous description of *Strix tengmalmi* in the 13th edition of the *Systema Naturae* in 1788. In North America the species is known as the Boreal Owl, being one of three typically boreal owl species. Until recently Americans called it Richardson's Owl, after Sir John Richardson (1787–1865), a Scottish naval surgeon, naturalist and explorer of the Canadian Arctic to whom the species was dedicated by Prince Charles Lucien Bonaparte in 1838 as *Nyctale richardsoni*.

There are few bird species so characteristic of the belt of mainly coniferous boreal forests which runs across the northern hemisphere. Throughout its whole range Tengmalm's Owl shares this enormous habitat with species like the Three-toed Woodpecker, Bohemian Waxwing and Pine Grosbeak, all highly specialized birds. Just as the Three-toed Woodpecker ranks high in its species group in terms of structure and feeding habits, so does Tengmalm's Owl with regard to the structure of its ear openings and the asymmetry of that part of its skull encasing the external ear tube, and hence the perfection of its hearing ability.

Tengmalm's Owl, the Three-toed Woodpecker and Bohemian Waxwing each has a sibling species endemic to North America. These are Northern Saw-whet Owl, Black-backed Woodpecker and Cedar Waxwing, respectively. It is usually thought that Tengmalm's Owl and the analogous species mentioned above, after having ventured into the Old World and acquired a high degree of specialization, came back in late glacial times over the temporarily emerged Bering Sea bridge and succeeded in overlapping partially with the ranges of their less adventurous American counterparts. A representative of the genus *Aegolius* was already present in the Upper Pliocene of Hungary and remains of Tengmalm's Owl itself have been reported from there too from the lower Upper Pleistocene onward (Janossy, 1981), but also from a fossil boreal avifauna from the Late Pleistocene in Tennessee (Parmlee & Klippel, 1982).

A number of important questions remain unanswered, however. What was it that made Tengmalm's Owl so successful in the dark northern forests which, in some summers, may be teeming with life, but in most winters seem almost totally lifeless and hostile? Can we be sure that Tengmalm's Owl originated as a species in the Old World, and entered America secondarily, or did it happen the other way round? From what stock did the species of *Aegolius*, of which there are two others in Central and South America, derive? Do they represent a culmination in the development of wood owls, genus *Strix*, and are they therefore nothing but small, yellow-eyed super-*Strix*? These issues of historical and ecological zoogeography form the background of the following discussion.

GENERAL

Faunal type Siberian–Canadian.

Distribution Holarctic, from at least 69° north in Scandinavia, continuously through Russia and Siberia to Alaska and Canada and occasionally just over the border in the United States (e.g. Minnesota; Matthiae, 1982) and, perhaps continuously, in the Rocky Mountains from Idaho, Montana and Wyoming to Colorado (Baldwin & Koplin, 1966; Hayward & Garton, 1983; Palmer & Ryder, 1984; Palmer, 1986), as far south as Wolf Creek Pass, 80km from the New Mexican border (Ryder *et al.*, 1987:169–174); probably also in northeast Washington. There are isolated populations in the Pyrenees, Vosges, Alps, Carpathians and other central and southeastern European mountains and in the Caucasus Mountains. The discovery of Tengmalm's Owl at an altitude of barely 100m in the Lüneburger Heide, northern West Germany, in 1938 (Kuhk, 1938, 1939) was little short of sensational, as was its rediscovery at Font-Romeu in the Eastern Pyrenees in 1963 (van der Vloet, details in Glutz & Bauer, 9, 1980) and in the Western Pyrenees in 1984 (Dick A. Jonkers *et al.*). In the late 1960s and the 1970s it reached northeast and east central France (Lorraine, Côte d'Or; Frochot & Frochot, 1963; Thiollay, 1968), east Belgium (1963; Francotte, 1965; Dambiermont *et al.*, 1967; Jottrand & Tricot, 1969; Scheuren, 1968) and the Netherlands (1971; Groen & Voous, 1973; Boerma *et al.*, 1987). Further, the Caucasus, northwestern Himalayas (Lahul, Himachal Pradesh, India; Koelz, 1939), Russian and Mongolian Altai, Kentei and Changai

Tengmalm's Owl *Aegolius funereus*
European race *A. f. funereus*

Mountains, northwestern China (south Tatung Range, northwest Kansu, province Tsinghai; Stresemann, 1928). Map 24.

Climatic zones Almost exclusively boreal, reaching north to the July isotherm of 12°C and only ranging beyond the July isotherm of 20–21°C in the south in isolated pockets. It is generally confined to the cooler montane and subalpine mountain zones where July temperatures may be as low as 10°C (Palmer, 1986). In winter temperatures may sink to below −25°C and −30°C.

Habitat Coniferous forest of the Siberian–Canadian belt and corresponding mountain zones interspersed with fast-growing deciduous trees – such as birch, willow, alder, poplar and aspen of various kinds – and open spaces and secluded marshy meadows. In the European Alps up to 1,800–1,900m, in central Asia up to 2,000m and in the mature forests of Engelman spruce and balsam and subalpine fir in the Rocky Mountains at 2,900–3,300m altitude.

GEOGRAPHY

Geographical variation Moderately conspicuous and generally clinal. In Eurasia growing paler and, underneath, lighter, more profusely spotted with white above, and increasing by some 10% in size from north Scandinavia eastward to Yakutia and Kamchatka. In this continuous range up to five, and as few as three, races have been recognized, including, from west to east, *Aegolius funereus funereus*, *pallens* (incl. *sibericus*) and *magnus* (incl. *jakutorum*). Tengmalm's Owls are some 8% smaller in the isolated southern mountain populations, described as *A. f. caucasicus* (Caucasus), *A. f. juniperi* (northwest Himalayas) and *A. f. beickiani* (northwest China), respectively, and bearing no marked differences from one another. In North America Tengmalm's Owl (*A. f. richardsoni*) is still darker brown and of similar size to its pale east Siberian counterparts.

Related species No other species of *Aegolius* exists in Eurasia or elsewhere in the Old World. In North America, however, the Northern Saw-whet Owl *Aegolius acadicus* is a closely similar but smaller relative with a wide range in south boreal and mixed forests in Canada and part of the United States and upland Mexico and a narrow zone of overlap with Tengmalm's Owl over the whole breadth of southwestern Canada. Further still to the south, in the upper tropical zone of montane forests of south Mexico to Costa Rica, is the habitat of the Unspotted Saw-whet Owl *Aegolius ridgwayi*, of which little is known. Almost unknown is the Buff-fronted Owl *Aegolius harrisii*, found in discrete arid temperate areas and paramo regions of South America. The question remains of whether these virtually unknown species represent the source of *Aegolius*, or whether they are extreme southern colonists of northern origin.

STRUCTURE AND HEARING

As in all northern owls, the plumage of Tengmalm's Owl has a remarkably soft and silky quality. It effectively conceals the small body, from which the deceptively bulky, roundish head emerges (hence the species' Italian name of *civetta capogrosso*), with its large facial disc and relatively small, enquiring yellow eyes.

The soft feathers of the head, which form a moderately developed facial disc (Ilyichev, 1961), hide two large and complicated ear openings, the structure, physical properties and functions of which have all been well described (Collett, 1881; Pycraft, 1898; Kelso, 1940; Norberg, 1968, 1973, 1977, 1978). In contrast to the Barn Owl, the ear openings are bilaterally symmetrical in position and size, but not in shape. They are slot-like, about 24mm long, and equal to the height of the skull. When open, the apertures are broadly oval and appear to be surrounded by a continuous skin flap not more than 6mm wide and bordered by a fringe of specialized feathers. The pre-aural part of the skin flap carries facial disc feathers of a specialized, delicate structure to admit sound waves. The feathers growing on the post-aural flap form the dark border of the facial ruff. It is because of a most impressive bilateral asymmetry of the temporal part of the skull, affecting even the shape of the palatines (Simonetta, 1967), that the external ears of Tengmalm's Owl exhibit a greater degree of asymmetry than those of any other known owl. On the left side, the ear is directed upwards and situated lower in relation to the eye and the jugal bar of the skull, whereas on the right side the ear opening is directed downwards and situated about 6.5mm higher than the left one. Middle and inner ears are encased in the temporal part of the skull and are fully symmetrical, except in the extent and form of surrounding and connecting airsacs. Middle ear cavity and connecting air spaces are very large: about 730mm^3 on each side – slightly less than the volume of the external auditory meatus, which is 830mm^3. Together with the large eardrum and the broad footplate of the elongated earbone or stapes, these structures allow for a highly developed range detection of sounds of low frequencies, such as the rustling sounds of prey moving on the ground among withered leaves and frozen undergrowth. Directional hearing in a vertical plane (provided by the vertical asymmetry of the shape of the ear opening), combined with a binaural comparison in a horizontal plane (provided by the time lag of sound waves reaching the left and right ear at the same directional angle), give Tengmalm's Owl an almost uncanny ability to locate prey signals without tilting its head. (For further physical aspects of directional hearing, see under Barn Owl.) On the whole, the specialized deformations of the outer ear are more of the *Asio* than of the *Strix* type (Norberg, 1977). This tends to suggest that *Aegolius* species did not originate from *Strix*-like ancestors. *Aegolius* may, indeed, have developed its specialization independently. The visual ability of Tengmalm's Owl has still to be studied.

BEHAVIOURAL CHARACTERISTICS

Songs and calls At least 12 discrete sounds have been described. The territorial song is a liquid or staccato series of 5 to 8 "hoops" of an ocarina quality. Although it may start cautiously and hesitantly in early autumn, this song reaches its climax in early spring, the exact timing depending on weather

Tengmalm's Owl *Aegolius funereus*
European race *A. f. funereus* with probable root vole *Microtus ratticeps* as prey

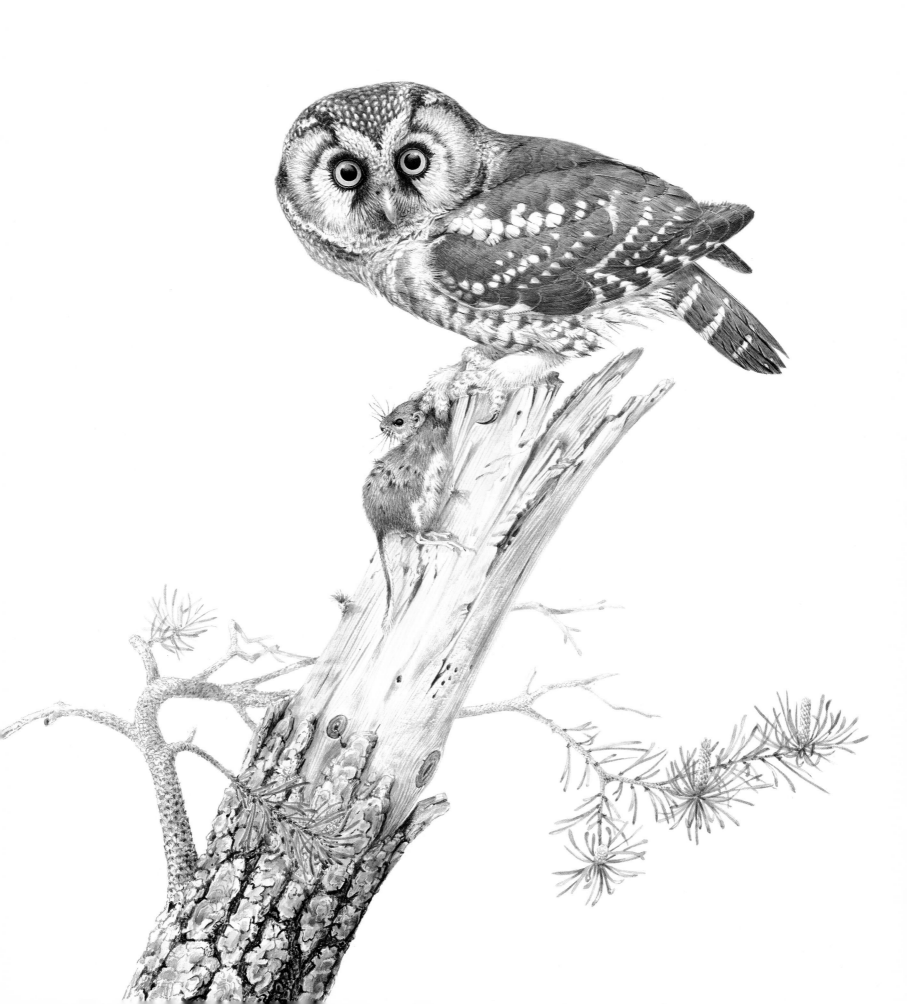

conditions and geographical latitude or altitude. It may continue well into June and, in the far north, into early July. It is performed by the male usually from inside the crown of a coniferous tree and advertises the presence of an unmated male or an established breeding territory. Males which have not succeeded in attracting a partner are among the most persistent of nocturnal singers, and have been heard to deliver 1,559 hoot sequences between 20.17 and 21.39h in Finland in early spring (von Haartman, 1967, *fide* Mikkola, 1983), while in Norway a male was estimated to have hooted 4,000 times in one night (Hagen, 1952). Vocal activity of the male usually ceases after the female has laid her eggs. Only exceptionally have Tengmalm's Owls been heard calling by day. The song resembles to some extent that of the Hawk Owl, which, however, has a sharper, more metallic or xylophonic tone. The vocalizations of Tengmalm's Owl are markedly distinct from those of both *Asio* and *Strix* species, though some calls described resemble those of the Long-eared Owl – notably a barking alarm call – whereas the *psee* hunger call of young resembles the corresponding calls of Tawny Owl fledglings (König, 1968).

Circadian rhythm Although Tengmalm's Owl is generally considered a strictly nocturnal species, in some places its range extends close to or beyond the Arctic Circle into the land of the midnight sun in summer and of 24 hours of darkness in winter. Even so, except in North America (Palmer, 1986:21, 50), it has seldom been seen active in daylight. Even in early spring males rarely start calling before sunset. In the Lüneburger Heide, West Germany, it was first heard, on average, 40 minutes after sunset (Kuhk, 1953).

Nocturnal activity of Tengmalm's Owl is as a rule biphasal, but in Oulu, Finland, at 65° north, one activity period in May was recorded as lasting the full four hours of the night between 23.00 and 03.00h, though there were peaks at the beginning and at the end of the short night (Klaus *et al.*, 1975). At Jena, East Germany, the same authors recorded an activity period lasting the full 12 hours of the night, though with a two-hour activity burst immediately after sunset and one of the same duration before sunrise. Other authors have recorded similar biphasal activity patterns, but these situations are complicated by the presence of a great number of subordinate bursts of activity resulting from external and internal stimuli and by the fact that summer nights are short, if there are any hours of darkness at all, and winter nights are very long (Erkinaro, 1972, 1973). The biphasal nocturnal activity rhythm of Tengmalm's Owl often seems to coincide with the activity pattern of its main prey species, voles. It may also be a protection against predators.

Antagonistic behaviour Except when encountered on its roosting site by day, Tengmalm's Owl always seems to show an expression of relaxed surprise or enquiry. By making itself long and thin, however, and by closing its eyes to narrow slits, it can hide on a branch against a tree trunk as effectively as a Long-eared Owl. Its temporal feathers may be raised to form small horns and enhance the cryptic effect of its appearance. At the approach of danger a pseudo-sleeping posture has occasionally been recorded. But Tengmalm's Owl is not known to cover its body with one camouflaging wing as the Long-eared Owl does, nor does it raise its wings arch-wise in ultimate defence as do both the Long-eared and eagle owls *Bubo*.

For roosting in North America it selects less dense cover than the Saw-whet Owl and the Western Screech Owl, though it hides in the highest timber of the surroundings and always has a greater amount of cover above than below, probably for thermal economy and avoidance of predators. Average roost height in Colorado was 4.7m (Palmer, 1986). Tengmalm's Owl has not been found sleeping in natural cavities or in nest boxes.

ECOLOGICAL HIERARCHY

Body weight varies around, on average, 101g in males and 160g in females in central Europe (Lüneburger Heide, West Germany; Glutz & Bauer, 9, 1980:537) and averages of 101g and 139g in North America (Snyder & Wiley, 1976). According to Storer's (1966) mean dimorphism index, the sexual dimorphism in measurable characters of North American owls is largest in Tengmalm's Owl (8.2), being larger even than that in the Great Horned Owl *Bubo virginianus* (7.0) and the Great Grey Owl *Strix nebulosa* (6.2). At the beginning of the nesting period in Finland females were 43% heavier on average than males, but their wings were only 5% longer. The significance of these statistics in the life of Tengmalm's Owl has been sought in the greater striking force of females, which catch more voles, whereas the small males can also take more agile prey, such as birds (Korpimäki, 1987:157–161). Remarkable though this may sound, this theory has not yet been confirmed by facts.

Tengmalm's Owls are thus heavier in both sexes than the Pygmy Owls *Glaucidium* (average 62g) and considerably lighter than Long-eared Owls (average 275g), Northern Hawk Owls (average over 300g), the pan-global wood owls *Strix* (over 400g) and the eagle owls *Bubo* (over 1,100g), all of which occur over virtually the whole range of Tengmalm's Owl. Tengmalm's Owls could consequently be expected to take less heavy prey than their larger relatives, but interspecific differences in mammalian prey seem primarily to exist in efficiency of hunting methods and preference of hunting grounds, rather than in absolute prey size. Tengmalm's Owls have the ability to manoeuvre between dense stands of trees, and hunt equally in the depth of the forest, in glades and over moors. Northern Hawk Owls prefer to hunt in subarctic birch woods and on moors, Long-eared Owls in more open country. The Pygmy Owl species tend to hunt in the crowns of trees, besides being more active by day, while wood owls are stronger and more opportunistic hunters by night. Tengmalm's Owls are therefore less conspicuous predators than any of the other species of owl. They have, however, twice been reported to hunt and take Eurasian Pygmy Owls where their ranges and habitats overlap, and to react immediately on hearing their songs (Kuhk, 1966; Schönn, 1978). It is perhaps because of this that Pygmy Owls stop calling towards dusk when Tengmalm's Owls are becoming active.

The secretive life of Tengmalm's Owl does not prevent it from occasionally falling prey to large owls or diurnal raptors hunting at dusk. Out of a total of 1,363 instances of owls killed (and probably eaten) by other owls in Europe (Mikkola, 1983:table 5b), Tengmalm's Owl features with 59 fatalities, most of these caused by Eagle Owls (36 cases recorded), Ural Owls (12 cases) and Tawny Owls (6 cases). Of 752 known cases of owls killed in Europe by diurnal birds of prey, 32 involve Tengmalm's Owl (Mikkola, 1983:table 5c). The Goshawk,

sharing its forest habitat, is its main predator (26 cases recorded) as it is of other owls, of which no less than 9 species are recorded in a total of 541 cases. Data from North America are lacking. Apart from directly preying on Tengmalm's Owl, the Tawny Owl is its main nest site competitor in Europe. The pine marten in Europe, and probably other arboreal mustelids as well in Siberia and Canada, are no less serious predators and nest site competitors (Baudvin et al., 1985). Selective predation pressure by pine martens on female Tengmalm's Owls breeding in tree holes may account for the noteworthy preponderance of males in most of the central European populations (König, 1965; Scherzinger, 1981).

BREEDING HABITAT AND BREEDING

Dense coniferous forest of the whole Siberian–Canadian taiga belt – including Canadian muskeg – together with comparable forest in montane and subalpine mountain zones constitute the main habitat of Tengmalm's Owl. Throughout its range it is very partial to spruce, but the presence of broad-leaved trees such as willow, poplar and birch, and of beech in montane fir-beech forest, seems to be essential for the provision of a rich supply of woodpecker holes in which this owl usually nests. Altitude does not appear to be of great importance, though most forests inhabited by Tengmalm's Owl in central Europe are situated above 500m. It nests as low as 200m in the Lüneburger Heide, West Germany, and even at 15m above sea level in the Netherlands (Groen & Voous, 1973; Boerema et al., 1987). It should be noted that the pine forests in the lowlands of the Lüneburger Heide form a kind of cold pocket with climatological characteristics of the taiga zone (Niebuhr, 1971). Similarly, the upper reaches of mountain forests at 1,800m in the European Alps, 2,000m in the Altai and Tien Shan mountains in central Asia and over 3,000m in the Rocky Mountains of Colorado are as cold, and have as short a breeding season, as any place in the far northern forests. Acceptance of oak-beech forests in France suggests either the exploitation of a new ecological resource or the response to an emergency situation.

Nests have been found most frequently in abandoned or disused woodpecker holes, in the Old World mainly those of Black Woodpecker, and in Canada of the Pileated Woodpecker. The entrance holes average 13.0×8.5cm (Glutz & Bauer, 9, 1980) and 11.5×8.5cm (Short, 1982), respectively. Other nests with smaller entrances have also been recorded, mostly the holes of Grey-headed and Green Woodpecker (6.0×5.5cm and 6.5×6.5cm, respectively) in Eurasia, and of Flickers (7.5×7.0cm) (see also Palmer, 1986) in North America. The use of nest holes of even smaller species (Great Spotted Woodpecker, 5.5×4.5cm, and Three-toed Woodpecker, 4.5×4.0cm) has occasionally been recorded. For Tengmalm's Owl to squeeze its 42mm-wide head and its long wings through the narrow entrance of a Great Spotted Woodpecker's nest may be inconvenient and even dangerously time-consuming, but the small size of the nest reduces competition with larger and stronger owls and other bird and mammal species which use holes. It may also be useful for the attending female to be able to camouflage the black hole and defend the nest by blocking up the opening with her head and bill (Norberg, 1964). Though most Tengmalm's Owls are very tolerant, even timid, at their nest site (sitting females may be lifted from their eggs and put back without any apparent disturbance), some are known to have defended their nests in most aggressive ways (Meylan & Stadler, 1930). Woodpeckers, particularly the large and pugnacious Black Woodpecker, but also Stock Doves and Jackdaws are serious competitors for nest sites. However, Black as well as Green Woodpeckers are known to have nested and raised young in holes a short distance higher up in the same tree (e.g. in Switzerland; Ravussin & Sermet, 1975; and in the Netherlands), while one female Tengmalm's Owl incubated her eggs for some weeks with a pine marten as a neighbour 2m below her before the marten finally destroyed the eggs (Schönn, 1978). Nests in natural holes and cavities have been much less frequently recorded than those in woodpecker holes and are probably much harder to find. The use of open tree nests, such as those of Crows and Magpies, is even rarer; an old Magpie nest in Norway, 7–8m high in a fir tree, contained five Tengmalm's Owl young (Ree, 1963).

In recent years Tengmalm's Owls have come to accept nest boxes with increasing frequency. In Sweden they have started, in large numbers, to use boxes put up for Goldeneyes (Mikkola, 1983). In West Germany they have adopted Tawny Owl nest boxes, but here as well as in France special nest boxes have been designed (Gasow, 1958, 1959; Przygodda, 1969; König, 1969; Baudvin et al., 1985). In Omsk, Siberia, boxes erected for Starlings were used as early as 1913 (Hermann Johansen, 1928). In some places more Tengmalm's Owls were found breeding in nest boxes than in natural holes (e.g. in Kainuu, Finland, where 43 out of 45 nests studied were in nest boxes, and in West Germany, where all 85 breeding cases recorded in 1977–83 were in nest boxes (Schwerdtfeger, 1984). In many places in Europe the owls have become as dependent on man as they are on woodpeckers elsewhere.

In Finland Tengmalm's Owl starts laying its eggs earlier on average than other owls. The breeding season in Swedish Lapland is early April to early June (Lindke, 1966). Breeding activity is correlated with the spring abundance of voles, mainly short-tailed vole. Early clutches are larger than later ones and young reared from these have more time to accumulate fat reserves for the next winter, thus a better chance of survival. Early nesting females have a better chance of raising a second brood, or else more time to moult and restore fat reserves after the hardships of breeding (Korpimäki, 1987).

Eggs measure on average 33.3×27.2mm in Europe (Rosenius, in Makatsch, 1976) and 32.3×26.9mm in North America (Bent, 1938). Fresh egg weight is about 11.2g, which is 33% heavier than that of the Eurasian Pygmy Owl (8.4g), 46% lighter than that of the Northern Hawk Owl (20.8g), half the weight of a Long-eared Owl's egg and less than one third of that of a Tawny Owl's egg (Makatsch, 1976). Chicks have a dark chocolate-brown juvenile plumage with white facial markings and fiery-yellow eyes, not unlike, and possessing a similar function to, similar characteristics in the Eurasian and North American Pygmy Owls (see p. 256).

The male Tengmalm's Owl supplies the incubating female with all her food. Dead and decaying prey gather in the nest hole in remarkable quantities, though not to the same extent as with Pygmy Owls. But, unlike the latter species, Tengmalm's Owls never clean up their nests, and numerous authors have reported on the cloacal stench in which the owlets happily grow up (e.g. Kuhk, 1969).

As in all predators that feed largely on voles and mice, clutch size and breeding results are highly dependent on food supply, hence on population cycles of the owls' prey (Linkola & Myllymäki, 1969) and the weather in spring (König, 1967). Normal clutch size seems to be 3–5, but in some years clutches as large as 7–11 have been recorded and large numbers of young have been raised. In the Black Forest and the Schwabian Alps (König, 1969; Korpimäki, 1987) in 1966 – a year of plenty – 18 clutches were found to average 5.2 eggs from which, in 15 nests, 3.6 young per nest fledged with a total of 54 young. The next year was a year of food shortage in which only 11 clutches were found, with an average of 3.3 eggs per nest, while from only 4 nests 2.7 young per nest fledged (total of 11 young). In the period 1977–83 (good years) average clutch size was 6.5; in years of food shortage it was only 3.8 (Schwerdtfeger, 1984). In the Kaufunger Forest in West Germany up to 47 young were raised in years of plenty, against no more than 2 in years of prey scarcity (Schelper, 1972). Similar results are reported from an East German site (Ritter et al., 1978) where, in a good year (1975), 65 young were produced, compared with only 25 in a bad one (1977). Food scarcity has led females to devour weak or dead nestlings and has led the older, stronger owlets to eat weaker nest mates (e.g. Saermann, 1974). In poor years a number of Tengmalm's Owls do not seem to start breeding at all. In years of plenty, on the other hand, the occurrence of bigamy has been recorded (Kondratzki & Altmüller, 1976) as well as of second broods in the form of overlapping breeding (*Schachtelbruten*) whereby a female abandons her brood of chicks at an age at which they can maintain their body temperature by themselves, leaving them to be fed and raised by the male parent alone, while she goes off to start a new clutch and raise a new family with a neighbouring male (Solheim, 1983).

FOOD AND FEEDING HABITS

More is known regarding the food consumed by Tengmalm's Owls in the breeding season than of their winter diet. Norberg (1970), describing the hunting method in a subarctic birch forest in Sweden, was struck by the ability of these long-winged owls to move low through dense forest, virtually without touching the vegetation. The owls regularly perched on low branches and carefully scanned the ground for prey, apparently more by ear than by eye. They dived through a 20cm-thick ground cover of blueberry bushes or a thin layer of snow after locating voles tunnelling to the surface (Palmer, 1986).

In the summer diet the preponderance of microtine voles, inhabiting the forest floor and bush, has been stressed by all authors. In Europe and Asia this prey includes short-tailed vole, bank vole, red-backed vole and other small rodents. Common voles from the open fields are less frequently taken, but long-tailed field mice, more numerous in the southern part of the owl's range than in the cold north, have also been recorded as locally common prey. In North America white-footed wood-mice and red-backed voles (Palmer, 1986) are common prey species, but meadow voles inhabiting open fields have been recorded less frequently. Voles may amount to 40–60% and mice up to 40% of total prey numbers. The balance consists of shrews which constitute up to 10–30% in Europe (5 species recorded, mostly common shrew), although it is not known whether shrews are taken by preference or in the absence of more palatable food. Other food items (for details of diets in Europe, see Uttendörfer, 1952; Gasow, 1968; Haase, 1969; König, 1969; Schelper, 1972; Klaus et al., 1975; Zang, 1981) include bats, ground vole, wood lemming, harvest mouse, dormouse, garden dormouse, flying squirrel and even house mouse; but variations and numbers are not well known and there are conflicting reports on the number of birds taken. There is a minor proportion of insects, mainly large dung beetles. The diet in North America, less well known than the European one, has been summarized (Snyder & Wiley, 1976:table 1; see also Palmer, 1986) as consisting of 93.6% mammals and 6.4% birds, no other prey items having been recorded.

Only in the absence of voles, mice and shrews can Tengmalm's Owl be expected to take small forest birds as an emergency source of food (König, 1969; Klaus et al., 1975). Data from central and northern Europe show amounts of less than 10% in most cases, but up to 50% (11 species) and even 70% (22 species) in the upper reaches of the Harz Mountains, West Germany. These data may be highly biased, however, due to research methods. Bird species recorded include, in order of quantity, Chaffinch, Brambling, Robin, Song Thrush, Goldcrest, Dunnock, as well as (not in order of quantity) woodpeckers, larks, pipits, warblers, tits, nuthatches, tree creepers, finches and buntings. Russian authors are also remarkably positive regarding the large amount of bird prey taken in their country, though details are scarce and mainly thrushes and House Sparrows are mentioned. Data from North America are not very detailed, but include red-backed voles which climb in blueberry cover and other low shrubs in winter and *Microtus* voles in open spaces, as well as some forest birds (Palmer, 1986).

To summarize, Tengmalm's Owl does not match the Long-eared Owl in the range of its diet though it does come fairly close to it. In contrast to the Long-eared Owl, however, it caches food in winter in tree holes – a strategy profitable to resident species but not to migrants and wanderers such as the Long-eared Owl. Recently it has been found in Finland caching prey (mainly voles) in nest holes during the breeding season, an activity which was regarded as a buffer against temporary food shortage caused by snow storms in late spring (Körpimaki, 1987).

MOVEMENTS AND POPULATION DYNAMICS

Generally considered a resident, Tengmalm's Owl is nevertheless also a partial migrant and at times a nomadic and irruptive traveller. Radio-equipped owls in Colorado, United States, showed that males are inclined to be resident, whereas females are nomadic throughout their lives (Palmer, 1986). Migratory movements are better documented in North America than in Europe. In North America long-phase, irruptive movements were already described in the 19th century, when numerous birds of this otherwise rarely seen species turned up in the most extraordinary places well south of their normal range (e.g. in Nebraska, Illinois, Pennsylvania and New Jersey; Bent, 1938). Noteworthy invasion years were 1889–90, 1903–04, 1922–23, 1959–60 (Houston, 1960), 1968–69 and 1981–82 (Eckert, 1982).

Similar irruptive movements from Siberia have led Tengmalm's Owls far outside the protective northern forests, right into the south Siberian steppes (Johansen, 1956), Japan (Hokkaido, Honshu) and the Kurile (Kumashiri) and Pribilof

Islands (a number of the east Siberian race *magnus* have been recorded on St Paul Island; Eversmann, 1913).

In the European part of Tengmalm's Owl's range Swedish and Finnish ornithologists have noted irruptions in 1904–05, 1907–08, 1931–32, 1964–65, 1967–68, 1971–72, 1974–75 and 1975–76 (Svensson, 1978). In the early autumn of 1967 large numbers turned up in the Åland Islands (172 ringed) and in Falsterbo, south Sweden (231 ringed) (summary by Mysterud, 1970, and Schelper, 1972). Others have travelled as far as Heligoland (Vauk & Bindig, 1959) and the British Isles (Sharrock & Sharrock, 1976; Carnairs, 1983). Recoveries of birds ringed as nestlings in east and central Europe at distances of up to 1,220km from the nest site and one nestling ringed in June 1980 near Vang, Hedmark, Norway, and recovered in 1981 in Durham, England (Rogers *et al.*, 1985), have confirmed the occurrence of long-distance flights (März, 1968). In the Alps a real autumn exodus of Tengmalm's Owls has been observed in certain years – in 1959 and 1972, for example – when large numbers flew into mist nets put up at night at over 1,900m near Champéry, Valais, Switzerland, on the Bretolet Pass leading to southeastern France (92 captured, as against 52 Long-eared Owls in the period 1956–74; Winkler, 1975). Others have found their way to the lowlands of northern Italy (e.g. 1950–51). These birds had probably abandoned their native mountain forests because of food shortage.

Being mainly dependent on terrestrial rodents, Tengmalm's Owls have to adjust themselves to the population fluctuations of the latter; they feast in years of abundance but starve when populations have crashed and rodents are practically absent. The well-known population cycles of 3–4 years of the different small northern mammal species, though in part based on weather characteristics affecting the growth and seed production of plants and trees, do not always coincide and are not necessarily synchronized over large areas. This results in what has been called "multi-annual" movements (Mysterud, 1970) of northern rodent-predators like Tengmalm's Owl, which multiply in times of abundance, but leave the area when the food supply has been depleted, in search of more favourable conditions elsewhere, and in due course have to abandon that place too. The owls continue on more or less fixed circular routes and finally return after so many years of rotation to the original place, by which time rodents there have reached another of their high population levels. This means that, in theory, northern Tengmalm's Owls living west of the Ural Mountains rarely have to leave their western range, but wander around in multi-annual cycles. Other species with irruptive tendencies such as the Northern Hawk Owl, and possibly the Great Grey Owl, may adjust themselves in a similar way to the fluctuations of their food supply.

In central Europe too the majority of Tengmalm's Owls may be forced to leave their breeding grounds after periods of food abundance. Not only Tengmalm's Owls ringed as nestlings, but also one four-month-old female, are known to have settled at up to almost 500km distance from the breeding grounds. Some adults appear to survive, however, without moving on and they form the nucleus of the next population. Owls aged between two and five years comprise the bulk of resident populations in West German forests (Schwerdtfeger, 1984).

To what extent the dangers of irruptive flights affect the strength of Tengmalm's Owl's total population potential has never been assessed, but in some years the losses may be expected to be heavy. Equally unknown are the losses caused by starvation and exhaustion under adverse weather conditions in the long northern winters. In spite of all dangers, some Tengmalm's Owls have reached relatively advanced ages: 8 years and 2 months in Siegerland, West Germany (Glutz & Bauer, 9, 1980), for instance.

GEOGRAPHIC LIMITS

Other than the Great Grey and the Northern Hawk Owl, there are few birds as characteristic of the taiga zones of the Old and New Worlds, and as restricted to this habitat in all periods of their life, as Tengmalm's Owl. The northern limit of its range is the climatological tree line about 69° north in the open birch woods of northern Europe and Siberia, but in North America (Alaska) it barely extends beyond the Arctic Circle. To the south the gradual increase in numbers and species of broad-leaved deciduous trees offers possibilities for the infiltration of other owls such as the Tawny Owl in Europe and the Barred Owl in North America, with which Tengmalm's Owl seems unable to compete, besides which the openness of a deciduous forest in winter probably does not suit Tengmalm's Owl's specialized ways of hunting and hiding. Here the Tawny Owl must pose a far more constant threat than can the Ural Owl and the dangerous Great Horned and Eagle Owls in the darkness and seclusion of a boreal habitat.

To what extent Tengmalm's Owl and its lesser sibling, the Saw-whet Owl, replace, exclude or avoid each other in the narrow zone of distributional overlap in North America is unknown, as is the extent to which they affect their respective altitudinal and geographical ranges.

LIFE IN MAN'S WORLD

In its extensive boreal home Tengmalm's Owl rarely comes into contact, let alone conflict, with man, though some owls have been killed in traplines set for fur-bearing mammals in British Columbia, Canada, and probably elsewhere. Direct contact with man may start from the moment that Tengmalm's Owls concentrate around lumberers' and trappers' camps in winter in order to prey on the inevitable mice which follow in the wake of man, or when they shelter in Inuit igloos, as described by A. W. Anthony in the record of his travels on the Seward Peninsula of Alaska during the winter of 1904–05. Contact with man has increased since the owls accepted nest boxes as breeding sites, in preference even to woodpecker holes and natural cavities in trees. Tengmalm's Owls confidently settle close to human habitats in Germany (Schelper, 1972) and nest in boxes in trees bordering well-used roads in the country and through forests. Though Tengmalm's Owls are not selective about the type and size of nest boxes they use, some are more appropriate than others: those, for example, where zinc, tin or plastic shields are placed around the trunk of the tree to discourage martens and squirrels, or where small entrance holes (80mm or less; Schönn, 1980) prevent the access of competitors such as the Tawny Owl (Gasow, 1964; König, 1968; Baudvin *et al.*, 1985). The situation in North America is unclear, as none of the nestings recorded south of the Canadian forests in the United States (e.g. Minnesota) were in nest boxes (Matthiae, 1982).

Tengmalm's Owl has the general characteristics and appearance of a small wood owl, genus *Strix*. It is a highly specialized, rodent-eating, strictly boreal and nocturnal resident, though at times a nomadic traveller. The fleshy part of the ear openings shows an asymmetry similar, but opposite, to that found in *Strix*. The piercing quality of its yellow-coloured eyes also occurs in some species of *Strix*. The degree of its specialization, its irruptive movements, particularly in Siberia and Canada, its ecological relationship with its North American sibling, the Saw-whet Owl *Aegolius acadicus*, and, above all, its conflicts with other, larger owls, have still to be studied in detail. In its feeding strategy Tengmalm's Owl somewhat resembles the Long-eared Owl *Asio otus* but it is less nomadic than that, more southern, species.

Tengmalm's Owl is perhaps the most highly developed owl species and of considerable distributional power in its proper habitat. Fortunately, the ecological conditions in its boreal forest home are still of a primeval quality over large tracts, though these woods remain essentially vulnerable. Most remarkable is Tengmalm's Owl's acceptance of, if not preference for, nest boxes in Europe, whereby its numbers may have increased in a similar way to that observed in the populations of the Pied Flycatcher *Ficedula hypoleuca* inhabiting taiga and birch forests of Europe and Asia.

NORTHERN SAW-WHET OWL

Aegolius acadicus

The North American Saw-whet Owl is a smaller representative of the more widespread Siberian–Canadian Tengmalm's or Boreal Owl. Lighter than Tengmalm's by as much as 30% body weight and a little larger than the Flammulated and Pygmy Owls, it has a somewhat less "northerly" appearance than Tengmalm's, being less fluffy and having less heavily feathered toes. It is restricted to North America where it meets Tengmalm's Owl in a 200km-wide zone of overlap in southern Canada and the northern Midwest United States, with an altitudinal overlap in the mountains from central British Columbia probably to southern Colorado. How these two species can live happily together without the larger harming the smaller remains a mystery. Clarification of their differences in habitat preference and diet would increase our understanding of the Saw-whet Owl enormously, though the thesis by David A. Palmer (1986) from Colorado State University and the work by Richard J. Cannings (1987) in southern interior British Columbia already provide some very illuminating data on this subject.

The Saw-whet Owl resembles Tengmalm's Owl to such a surprising degree that differences between the two are hard to establish. The "two-syllable call, a rasping *skreigh-aw* that resembles the sound of a saw being filed" (Wetmore, 1965:445), though much higher pitched, does not seem to differ from the excitement call of Tengmalm's Owl, both calls being heard mainly before and in the early stages of pair formation. The territorial songs too are of the same type. A detailed comparison of the undoubtedly rich vocabulary of both these owls will probably reveal some interesting facts from both an evolutionary and an ethological point of view.

Problematical for an understanding of the Saw-whet Owl are its relations with species in Central and South America. Does the Unspotted Saw-whet Owl *Aegolius ridgwayi* of the pine-oak mountain forests of Central America represent a kind of neotenic Northern Saw-whet Owl in which juvenile characteristics have been retained (Briggs, 1954), or does this little-known species represent the root from which the Northern Saw-whet and Tengmalm's Owls have sprung? Only research in the field can answer this question conclusively, but the following species account attempts to elucidate as far as possible the origin of what has been considered structurally the most advanced genus of strigid owls.

GENERAL

Faunal type Boreal nearctic.

Distribution Across the North American continent, from southern Alaska and central British Columbia east to Nova Scotia and south to the northern Midwest of the United States with southward extensions in the western and eastern mountain ranges, sparingly through the highlands of Mexico to Veracruz and Oaxaca. Map 24.

Climatic zones Boreal and temperate climatic and mountain zones, reaching the July isotherm of somewhere between 15 and 20°C in the north and 20–25°C in the south.

Habitat Every type of woodland habitat south of the deep boreal and below the subalpine spruce zone, and all riparian trembling aspen and willow thickets in arid grasslands. Coniferous forests of the Canadian taiga and the Oregonian Pacific slopes, including tamarack bogs, cedar swamps, mixed boreal woods and alder, willow and osier dogwood groves. Also montane spruce-fir forests of the Sierra Cascade and Rocky Mountains up to 2,700m or above and more open ponderosa pine forest on arid mountainsides and pine-oak woods on Mexican mountain slopes at 1,800–2,800m altitude. Deciduous forests in eastern temperate North America, often of a dense and swampy type, appear to represent day-roost habitats, mainly used in the non-breeding and winter seasons.

GEOGRAPHY

Geographical variation Slight or non-existent over the main part of the range. A dark, brown and more saturated coloration has been described in Saw-whet Owls resident on the humid Queen Charlotte Islands (*Aegolius acadicus brooksi*; Fleming, 1916). Those from the Pacific slopes of British Columbia and Washington are almost as dark. Another, paler form, less spotted on primaries and tail feathers, was discovered at 2,100m at Amapetec, Cerro San Felipe, Sierra Madre de Oaxaca, southern Mexico, and described as *A. a. brodkorbi* (Briggs, 1954).

Related species The problem of the relationship between the Central and South American forms of *Aegolius* and the northern

species has been discussed under Tengmalm's Owl. An interesting theoretical slant has been added by the discovery of a Saw-whet Owl in Oaxaca, southern Mexico, which is intermediate between the Northern Saw-whet Owl and the tropical Unspotted Saw-whet Owl *Aegolius ridgwayi*. Consequently there is now a tendency to consider Northern and Unspotted Saw-whet Owls as representatives of one polytypic species (Mayr & Short, 1970:52). In view of the similarity of *Aegolius ridgwayi* to the Northern Saw-whet Owl, the juvenile plumage of which is equally unspotted, the theory has been advanced that the unspotted Central American forms have retained a juvenile plumage until adulthood and reproductive age and can therefore be regarded as neotenic forms comparable with the almost legendary Mexican axolotl (Briggs, 1954). The validity of this theory can only be established by experiments. The derivation of the northern Saw-whet and Tengmalm's Owls from less marked tropical American species is an equally possible and perhaps more likely theory, though *Aegolius* may equally well have originated in the north.

STRUCTURE

Apart from less densely feathered legs and barely feathered toes the Northern Saw-whet Owl does not appear to differ structurally from Tengmalm's Owl. Ear and skull characteristics and asymmetry of outer ear openings and skull seem to be the same in both (Norberg, 1978); the conspicuous temporal asymmetry was described as early as 1870 (Streets, 1970).

BEHAVIOURAL CHARACTERISTICS

Songs and calls John James Audubon's description (1834, 2:567) of the song of the Saw-whet Owl "bearing a great resemblance to the noise produced by filing the teeth of a large saw" was an appropriate one for his time when tree-cutting and lumbering were a common affair and the sounds of sawing and saw-sharpening were familiar to most. It is less relevant today. In fact the territorial song is not unlike the rhythmic song of Tengmalm's Owl and is particularly close to the metallic notes of the Ferruginous Pygmy Owl, but the tempo is slower and the intervals are more regular (Davis, 1972). The separate whistles follow each other at a frequency of about 130 per minute (Wetmore, 1965). The excitement call, which has more of a hammer-on-an-anvil or bell-like quality, comes perhaps closest to what we now associate with saw-filing. The whole vocabulary of the Saw-whet Owl is very varied; some notes have a distinct ventriloquial effect.

Circadian rhythm The Northern Saw-whet Owl is considered a strictly nocturnal bird in terms of both hunting activity and territorial song. In laboratory experiments on metabolic range distinct activity peaks were located in the evening and just before dawn (Graber, 1962), which is a pattern familiar in other nocturnal birds. A radio-tagged Saw-whet Owl followed 29 October–17 November 1965 in the Cedar Creek Natural History Area north of Minneapolis, Minnesota, seemed to forage at irregular intervals throughout the night, starting on average 22 minutes after sunset and retreating to its daytime roost on average 18 minutes before sunrise (Forbes & Warner, 1974).

Antagonistic behaviour Northern Saw-whet Owls hide by day in dense patches of forest, much closer to the ground than Tengmalm's Owls, usually not more than 3–4m, sometimes as low as a few feet or even 15cm above the ground (Taverner & Swales, 1911; Mumford & Zusi, 1958; Richard J. Cannings). No Saw-whet Owls have been found roosting by day in natural cavities or nest boxes. By remaining motionless they generally escape the attention of intruders. Like Tengmalm's Owls they have a relaxed posture in which the feathers are fluffed up and body and head together assume a roundish shape. When a Saw-whet Owl is alarmed it presses its feathers against its body and straightens up, raising the side feathers at the upper rim of the facial disc so as to form two horns, and holding one wing in front of its body and directing it towards the intruder. In this posture it resembles the Long-eared Owl in its cryptic attitude even more than does Tengmalm's Owl (Catling, 1972). There are numerous instances of these little owls being approached and even being picked up and handled by humans.

ECOLOGICAL HIERARCHY

The Northern Saw-whet Owl is one of the smallest boreal owls. In southern British Columbia and Idaho, at 1,000–1,500m altitude, it has been found alongside the other small North American owls, the Flammulated Owl, Northern Pygmy Owl and Tengmalm's Owl (Hayward & Garton, 1983). The body weights of these owls show a remarkably smooth gradient: in males, Flammulated on average 53.9g, Pygmy 61.9g, Saw-whet 74.9g, Tengmalm's 101.6g; in females, 57.2g, 73.0g, 90.8g and 139.5g, respectively (Snyder & Wiley, 1976). On the higher forested slopes of the Okanagan Valley in British Columbia it meets these owls again, sometimes also in the breeding season (Steve & Richard J. Cannings, Penticton). In Montana a pair of Saw-whet Owls successfully raised a family in the same ponderosa pine snag as did a pair of Pygmy Owls. The Pygmy Owl female was twice seen to attack one of the Saw-whet Owl fledglings, knocking it down to the ground once, apparently without hurting it (Norton & Holt, 1983). The Saw-whet Owl generally shares only parts of its western and Rocky Mountain range with the Flammulated and Northern Pygmy Owls. The overlap with Tengmalm's Owl is much larger. Being smaller than Tengmalm's but with similar feeding habits, the Saw-whet Owl might be expected to avoid the presence of its larger relative both in winter and in summer, but in fact singing males of both species have been found in Colorado as close as 200m apart and at an elevation difference of 70m (Palmer, 1986). Both species are vulnerable to attack by other, larger owls, notably the Barred Owl, but the Saw-whet Owl is known to retreat to denser forest and thicker undergrowth. Unfortunately, nothing comparable to Heimo Mikkola's (1983) summary of predation on owls in Europe exists for North America. Definite cases of predation on the Northern Saw-whet Owl include the Eastern Screech Owl (Clark, 1985), the Spotted Owl and the Great Horned Owl (Errington et al., 1940:794), the Broad-winged Hawk (Rosenfield, 1979) and possibly Cooper's Hawk.

Differences between males and females with respect to average size of the prey and feeding habits are not known but

Northern Saw-whet Owl *Aegolius acadicus*
North American race *A. a. acadicus*

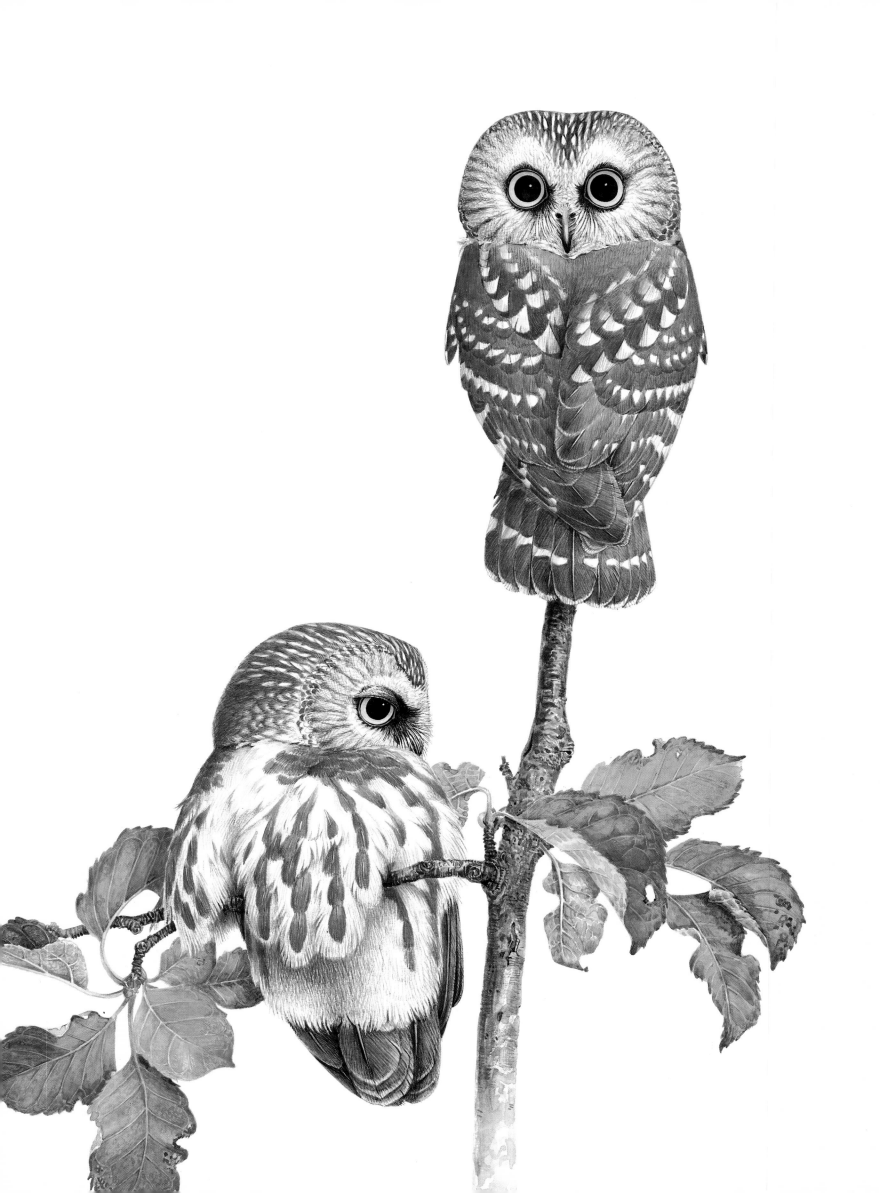

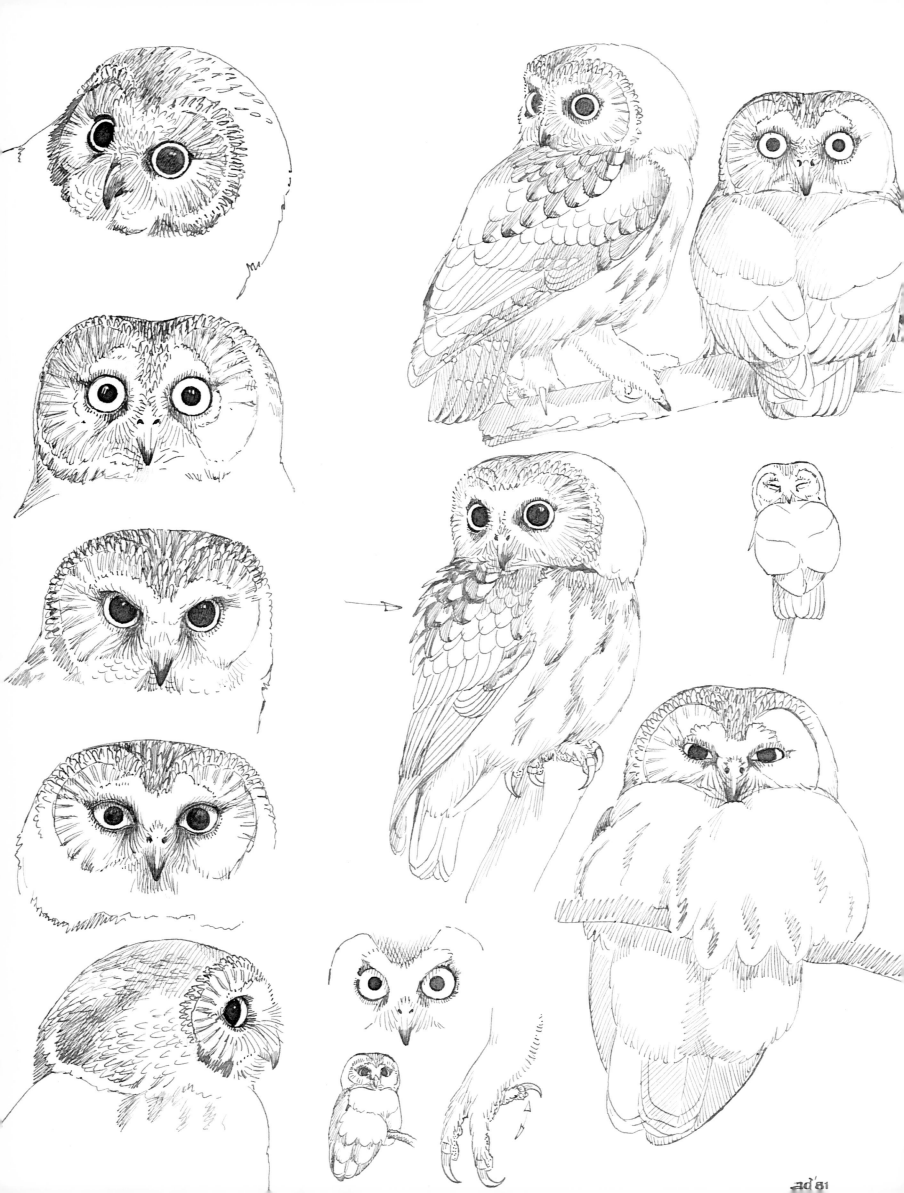

are probable since female Saw-whet Owls are on average 21% heavier than males (see also Buckholtz *et al.*, 1984) and in laboratory experiments needed more food per day than males (125.5kcal versus 94.3kcal; Collins, 1963).

BREEDING HABITAT AND BREEDING

Few studies have been undertaken on qualitative differences between the breeding habitats and breeding of the Saw-whet and Tengmalm's Owls. Notable contributions are from north-central Colorado, United States (Palmer, 1986), and the Okanagan Valley, British Columbia, Canada (Cannings, 1987). One factor is that the Saw-whet inhabits the more southern boreal forests with more deciduous cover and smaller trees and montane forests below 2,500m altitude. It apparently also nests in the northern parklands to the south and in dense woods in prairie coulees and river valleys and riparian willow thickets (Salt & Salt, 1972:232).

Nests have been found in unused woodpecker holes, notably Flicker's, with small nest openings (e.g. 73mm; Palmer, 1986), but also Pileated Woodpecker cavities, preferably in Nova Scotia, Canada (Cyril K. Coldwell); also in natural tree cavities and snags and in nest boxes (Palmer, 1986; Cannings, 1987), including the spacious ones intended for Wood Duck (Follen & Haug, 1981). Once a pair was found nesting in a small woodpecker hole 6m above the ground in a ponderosa pine snag in Missoula County, Montana, in which a pair of Northern Pygmy Owls were also nesting at 2.5m. Six young Saw-whet Owls fledged 23–25 May 1981, six young Pygmy Owls two weeks later, on 5–6 June (Norton & Holt, 1983). I have found no data on nest site competition with other owls, nor on competition and possible predation by arboreal mustelids, so notorious in Tengmalm's Owls in Europe. Arthur C. Bent (1938) cites instances in which Saw-whet Owls occupied holes previously inhabited by flying squirrels, white-footed mice and other small rodents, and a pair probably once shared a hole in a hollow oak with a red squirrel in Germantown, New York (Coues, 1874:317). Competition for nest boxes between Saw-whet Owls and flying squirrels has also been described in British Columbia (R. J. Cannings). Though the birds rarely seem to roost by day in high treetops, preferring low shrubs or the density of the canopy at mid-levels (2–4m), nest holes, mainly woodpecker cavities, have been found rather high up in trees (6–19m). A fledgling is shown on p. 256.

Average egg size is 29.9 × 25.0mm (Bent, 1938:232), which is about 80% of the egg volume of Tengmalm's Owl. Clutch size is relatively large, 4–7, with an average of up to 6.5 north of 40° north latitude and 3.8 or less south of 49° north and a general decrease in clutch size towards the west (Murray, 1976). Polygamy has been recorded in a ponderosa pine forest near Vaseux Lake, British Columbia (Cannings, 1987), and in Idaho (three breeding females with one male; Jeff Marks).

FOOD AND FEEDING HABITS

Like Tengmalm's Owl, the Saw-whet Owl seems to be primarily a predator of small terrestrial mammals, mostly woodland mice, particularly deer mice (Palmer, 1986; Cannings, 1987), voles and shrews. When hunting in riparian thickets and adjacent grasslands, the owl takes mainly pocket mice, voles and wandering shrews (Cannings, 1987). Little is known about hunting methods, and the majority of authors merely repeat that Saw-whet Owls hunt low, in or near bush and forest (Graber, 1962), where the owl's light wing-loading allows for great manoeuvrability (Palmer, 1986). More detailed study reveals that the Saw-whet Owl hunts in more humid and leafy vegetation than Tengmalm's Owl, with a more varied ground cover in which grasses and herbs predominate (Palmer, 1986). On average 96.8% of prey numbers consists of mammals, 1.6% of birds, 0.2% of lower vertebrates (frogs) and 1.4% of insects (Snyder & Wiley, 1976). Mean vertebrate prey weight in Wisconsin was calculated at 20.3g (Jaksić, 1983) and in southern British Columbia at 21.9g (Cannings, 1987), which is less than that found in any other North American owl, closest mean weights being those of the Eastern Screech Owl (28.6g) and the Long-eared Owl (31.8g) (Jaksić, 1983). The winter diet in Connecticut comprised white-footed mouse (45%), meadow vole (21%), house mouse (15%), short-tailed shrew (3%) and in addition two other species of shrew and one bird (Dark-eyed Junco) (Smith & Devine, 1982). Data from Maine and New Jersey confirmed the high proportion of woodland mice and voles, but included some shrews and some songbirds and on one occasion a frog (Smith & Devine, 1982). In his *Life Histories*, Arthur C. Bent (1938) mentions as occasional prey small rats, young red and flying squirrels, chipmunks and bats, but the record of a Saw-whet Owl having killed domestic pigeons probably referred to another species of owl, though in the southern Okanagan Valley, British Columbia, what also appeared to be pigeon remains were found in a Saw-whet Owl's pellet (Cannings, 1987). Insect prey is rare. Only once did Richard J. Cannings (1987) find a pellet full of insects (mainly Jerusalem crickets), coughed up by the female of a bigamous pair.

MOVEMENTS AND POPULATION DYNAMICS

The Saw-whet Owl appears to be a regular, though inconspicuous, migrant and not a mainly resident bird like Tengmalm's Owl. The sudden appearance of large numbers of these basically tame owls in unexpected places outside the breeding season has given many a thrill to astonished bird watchers. Rather than irregular irruptive movements as in Tengmalm's Owl, these occurrences are now regarded as accidental and due to adverse weather conditions on normal migratory flights. Early authors have noted considerable concentrations of Saw-whet Owls at Point Pelee, Lake Erie, in October and November (Taverner & Swales, 1911), and have called attention to severe losses of Saw-whet Owls on the shores of the Great Lakes in autumn. In more recent years these owls are known to have turned up regularly and simultaneously with heavy passerine migrations at Prince Edward Point, Long Point Peninsula, on the north shore of Lake Ontario (Weir *et al.*, 1980). Saw-whet Owls are now caught practically each year in varying and sometimes large numbers at the Cape May Point Raptor Banding Station, New Jersey, together with other migratory or dispersing owls (Barn, Long-eared and Short-eared Owls) (Clark, 1976). As Saw-whet Owls are very inconspicuous in winter it is not known how far they migrate south, though they have been recorded in Florida and

Northern Saw-whet Owl *Aegolius acadicus*
North American race *A. a. acadicus*

south California. They have been taken captive on board fishing boats in the Atlantic Ocean off New Jersey at 2 and 11 miles from land, appearing suddenly out of the coastal fog, apparently quite exhausted (5 November 1981; Soucy, 1982). It seems that under similar conditions some have found their way as far as Bermuda (12 January 1849; Bent, 1938:241).

GEOGRAPHIC LIMITS AND ZOOGEOGRAPHICAL PROBLEMS

The geographic limits of the Saw-whet Owl seem to be principally defined by the occurrence of natural forests of a south boreal type, in addition to similar forests on high mountains and in north temperate lowlands. The owl's soft plumage, though less dense than in Tengmalm's Owl, ensures a high degree of insulation and appears to prevent the Saw-whet Owl from living in warm lowland climates. It has been found nesting, however, in alder and willow thickets in the warm southern Okanagan Valley in British Columbia. Similarly, in laboratory experiments its body temperature rose less spectacularly with increasing ambient temperatures than was the case in other small owls with the exception of the Western Screech Owl (Ligon, 1969). However, of all the physiological data collected by various authors, no comparative data are available for Tengmalm's Owl, so that the real significance of these data remains obscure.

Few bird species of south boreal distribution have ranges resembling that of the Saw-whet Owl. Those coming closest are the Veery, Solitary Vireo, Pine Siskin and Evening Grosbeak, but most of these extend much further north and penetrate far into the exclusive range of Tengmalm's Owl. Other species form species pairs with separate southern and northern ranges comparable to the relationship between Saw-whet and Tengmalm's Owls. Among these are Willow and Alder Flycatchers, Cedar and Bohemian Waxwings and Golden-crowned and Ruby-crowned Kinglets. Again, other species have boreal ranges similar to those of the Saw-whet and Tengmalm's Owls combined: e.g. Sharp-shinned Hawk, Ruffed Grouse, Hermit Thrush, Swainson's Thrush, Red-breasted Nuthatch and Grey Jay. Where the Saw-whet Owl occurs as a breeding bird in the spruce-fir forests of the south Appalachian Range, such as in the Great Smoky Mountains National Park, Tennessee, it lives in a kind of Canadian environment together with the Olive-sided Flycatcher, Winter Wren, Veery, Red-breasted Nuthatch and Junco (Stupka, 1965).

The above-mentioned data appear to confirm the existence of a south boreal/north temperate forest faunal type, of which the Saw-whet Owl may be a member, though it is not clear to what extent this type is primarily ecologically or historical-zoogeographically defined. In the case of the Saw-whet Owl it would indicate that the owl's original habitat was more boreal than temperate and that the possibility should be seriously considered that the Saw-whet Owl was gradually pushed south by the presence of its larger congener, Tengmalm's Owl, in the heart of the boreal forests. After all, Tengmalm's Owl is thought to be probably a rather recent, Late Pleistocene invader from the Old World, but fossil remains of both Tengmalm's and Saw-whet Owls have been discovered in Late Pleistocene strata in Tennessee, together with other boreal birds such as the Northern Hawk Owl, Grey Jay and Pine Grosbeak (Parmelee & Klippel, 1982).

LIFE IN MAN'S WORLD

There is no reason to assume that Saw-whet Owls avoid the presence of man. The species should survive therefore wherever its habitat is maintained and the bird is left in peace. Under such conditions it has been found nesting close to human habitation and in nest boxes near busy roads and highways. On migration and in winter it has turned up in city gardens and parks, e.g. on "a low branch of a thorny bush about two feet above the ground and within thirty feet of the principal highway which leads through Rouge Park, Detroit, early on the morning of March 23 1930" (Wilson, 1931). Its acceptance of nest boxes of various kinds has opened up possibilities for closer contact with man. In addition, radio-tagged young and adults currently offer unprecedented opportunities for studying the ecological needs and mode of life of this otherwise elusive species.

The life style of the Northern Saw-whet Owl has been less well studied than that of most other North American owls. Its secretive existence in fly- and mosquito-infested forests, tamarack bogs and alder swamps in summer and its mysterious habits in winter have not encouraged detailed study. The data gathered by David A. Palmer (1986) in Colorado and by Richard Cannings (1987) in British Columbia, and by others elsewhere in Canada, have shown that all aspects of the Saw-whet Owl's life, from courtship, nesting, feeding and migration to winter behaviour, are quite fascinating. Its genetic and ecological relations with Tengmalm's Owl in the boreal north and Rocky Mountain heights, and with the Unspotted and Buff-fronted *Aegolius harrisii* Saw-whet Owls in the tropical south, would no doubt provide interesting data of more than specific importance. David A. Palmer concludes that the segregation of the Saw-whet and Tengmalm's Owls is not based on interference competition but rather on habitat choice, but I find reason to doubt that view. Differences in body size and the "agonistic behaviour" of a Saw-whet Owl described by Palmer himself when a tape recording of a Tengmalm's Owl's songs was played in its vicinity point to a different conclusion, that of mainly interference competition.

Map Section

Owl distributions, like all bird ranges, are subject to continual change and whilst every effort has been made to ensure the accuracy of these maps, this should be taken into account when reading the maps.

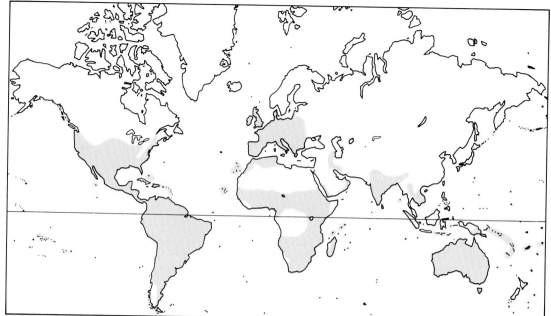

Map 1
Barn Owl *Tyto alba*

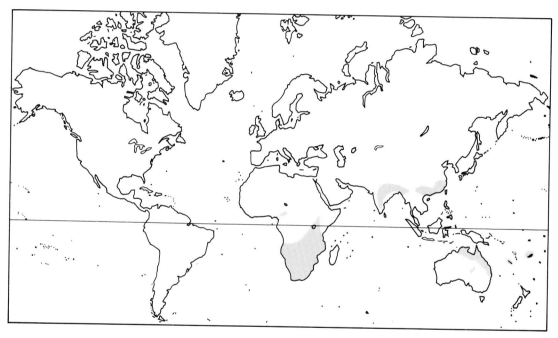

Map 2
Grass Owl *Tyto capensis*

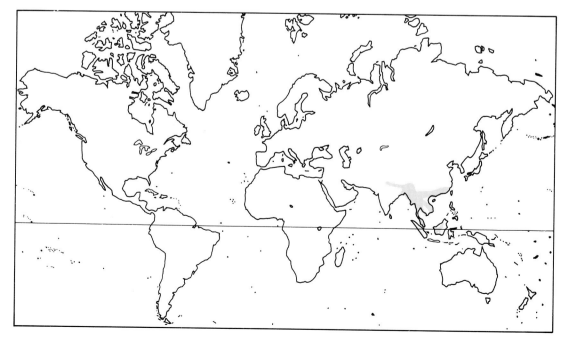

Map 3
Mountain Scops Owl *Otus spilocephalus*

MAP SECTION

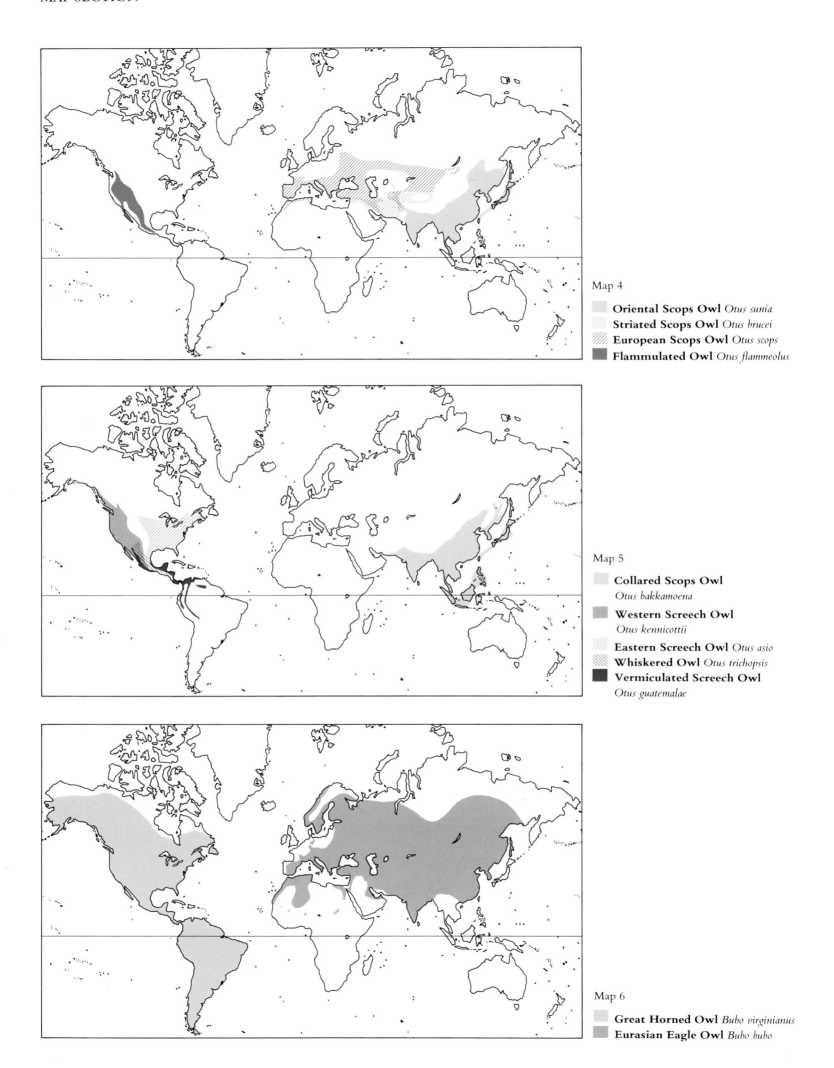

MAP SECTION

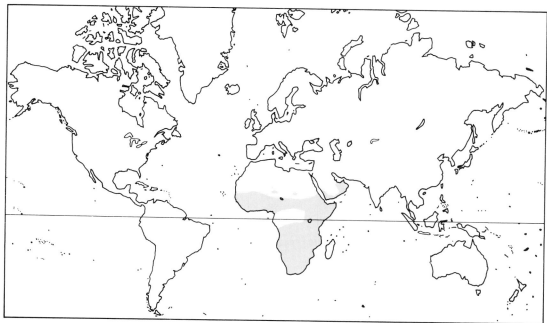

Map 7
Spotted Eagle Owl *Bubo africanus*

Map 8
Forest Eagle Owl *Bubo nipalensis*

Map 9
Blakiston's Fish Owl *Ketupa blakistoni*
Brown Fish Owl *Ketupa zeylonensis*
Tawny Fish Owl *Ketupa flavipes*

MAP SECTION

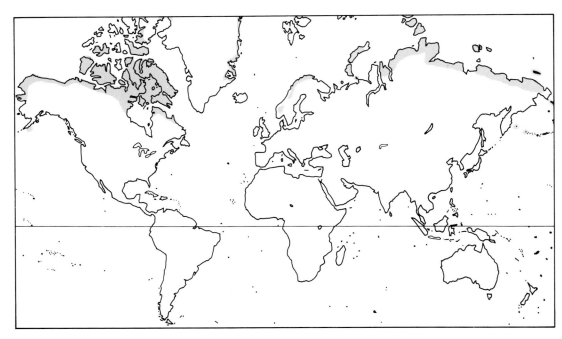

Map 10
Snowy Owl *Nyctea scandiaca*

Map 11
Northern Hawk Owl *Surnia ulula*

Map 12

Eurasian Pygmy Owl
Glaucidium passerinum

Northern Pygmy Owl

Least Pygmy Owl
Glaucidium minutissimum

Ferruginous Pygmy Owl
Glaucidium brasilianum

MAP SECTION

Map 13
Collared Owlet *Glaucidium brodiei*
Cuckoo Owlet
Glaucidium castanopterum

Map 14
Elf Owl *Micrathene whitneyi*

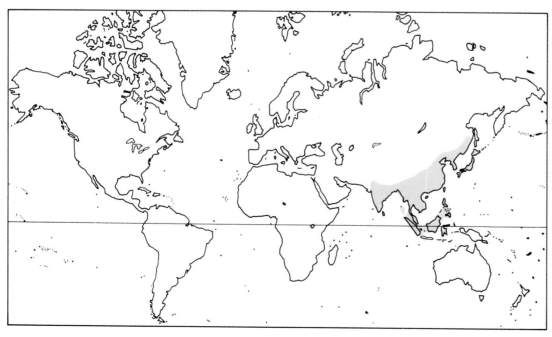

Map 15
Brown Hawk Owl *Ninox scutulata*

MAP SECTION

Map 16
Little Owl *Athene noctua*
Spotted Owlet *Athene brama*
Burrowing Owl *Athene cunicularia*

Map 17
Mottled Owl *Strix virgata*

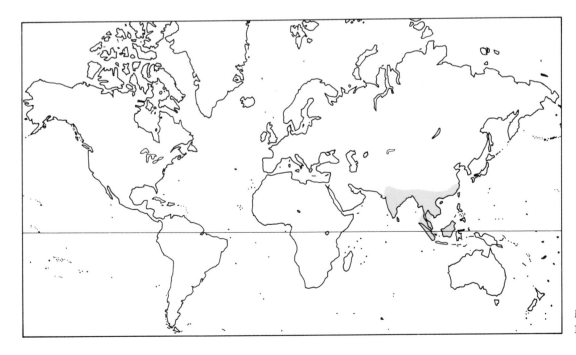

Map 18
Brown Wood Owl *Strix leptogrammica*

MAP SECTION

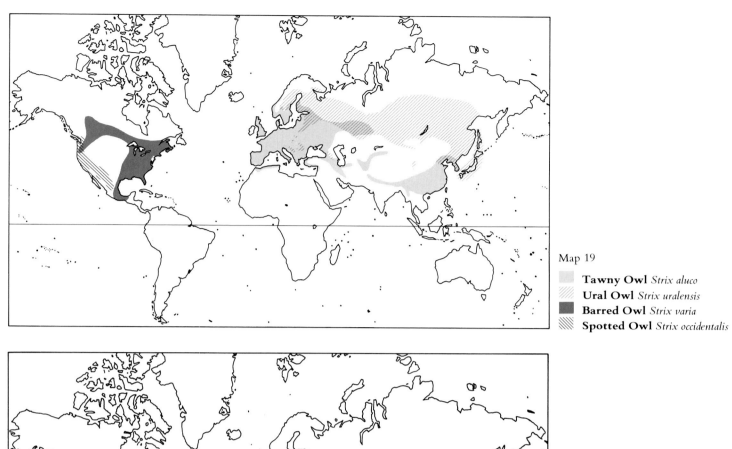

Map 19
Tawny Owl *Strix aluco*
Ural Owl *Strix uralensis*
Barred Owl *Strix varia*
Spotted Owl *Strix occidentalis*

Map 20
Hume's Owl *Strix butleri*

Map 21
Great Grey Owl *Strix nebulosa*

MAP SECTION

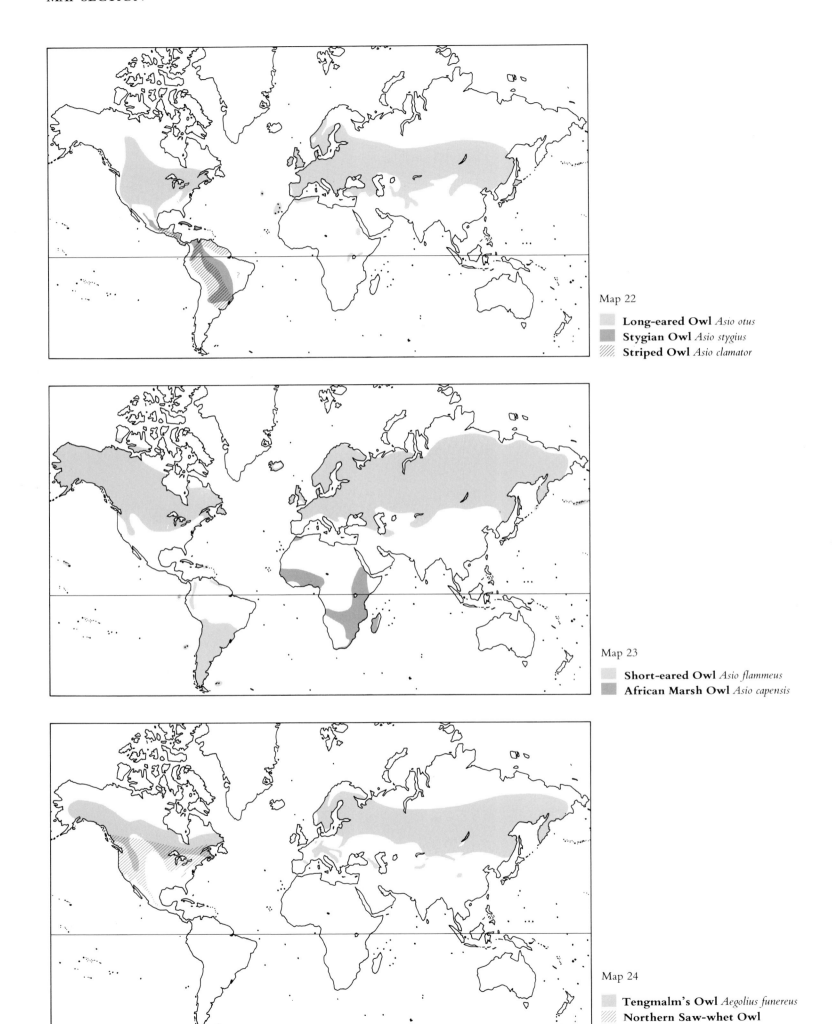

Appendix I

A SYSTEMATIC LIST OF OWL SPECIES MENTIONED IN THIS BOOK

The species which have been treated in full are highlighted in bold

Madagascar Barn Owl *Tyto soumagnei* (Milne-Edwards) 1878
Barn Owl *Tyto alba* (Scopoli) 1769
Celebes Barn Owl *Tyto rosenbergii* (Schlegel) 1866
Minahasa Barn Owl *Tyto inexpecta* (Schegel) 1879
Masked Owl *Tyto novaehollandiae* (Stephen) 1826
New Britain Barn Owl *Tyto aurantia* (Salvadori) 1881
Sooty Owl *Tyto tenebricosa* (Gould) 1845
Grass Owl *Tyto capensis* (A. Smith) 1834
Eastern Grass Owl *Tyto (capensis) longimembris* (Jerdon) 1839
Mountain Scops Owl *Otus spilocephalus* (Blyth) 1846
Javan Mountain Scops Owl *Otus angelinae* (Finsch) 1912
Oriental Scops Owl *Otus sunia* (Hodgson) 1836
Striated Scops Owl *Otus brucei* (Hume) 1873
European Scops Owl *Otus scops* (Linnaeus) 1758
African Scops Owl *Otus senegalensis* (Swainson) 1834
Collared Scops Owl *Otus bakkamoena* Pennant 1769
Rajah's Scops Owl *Otus brookii* (Sharpe) 1892
Flammulated Owl *Otus flammeolus* (Kaup) 1853
Western Screech Owl *Otus kennicottii* (Elliot) 1867
Eastern Screech Owl *Otus asio* (Linnaeus) 1758
Lamb's Screech Owl *Otus lambi* Moore and Marshall 1959
Tropical Screech Owl *Otus choliba* (Vieillot) 1817
Cooper's Screech Owl *Otus cooperi* (Ridgway) 1878
Balsas Screech Owl *Otus seductus* Moore 1941
Rufescent Screech Owl *Otus ingens* (Salvin) 1897
Bare-shanked Screech Owl *Otus clarkii* Kelso and Kelso 1935
White-throated Screech Owl *Otus albogularis* (Cassin) 1848
Whiskered Screech Owl *Otus trichopsis* (Wagler) 1832
Santa Barbara Screech Owl *Otus barbarus* (Sclater and Salvin) 1868
Cloud-forest Screech Owl *Otus marshalli* Weske and Terborgh 1981
Vermiculated Screech Owl *Otus guatemalae* (Sharpe) 1875
South American Vermiculated Screech Owl *Otus (guatemalae) vermiculatus* (Ridgway) 1887
Puerto Rico Screech Owl *Otus nudipes* (Daudin) 1800
Great Horned Owl *Bubo virginianus* (Gmelin) 1788
Eurasian Eagle Owl *Bubo bubo* (Linnaeus) 1758
Indian Eagle Owl *Bubo (bubo) bengalensis* (Franklin) 1831
Desert Eagle Owl *Bubo (bubo) ascalaphus* Savigny 1809
Cape Eagle Owl *Bubo capensis* A. Smith 1834
Spotted Eagle Owl *Bubo africanus* (Temminck) 1823
Fraser's Eagle Owl *Bubo poensis* Fraser 1853
Akun Eagle Owl *Bubo leucostictus* Hartlaub 1855
Forest Eagle Owl *Bubo nipalensis* Hodgson 1836
Malay Eagle Owl *Bubo sumatranus* (Raffles) 1822
Shelley's Eagle Owl *Bubo shelleyi* (Sharpe and Ussher) 1872
Verreaux's Eagle Owl *Bubo lacteus* (Temminck) 1820
Dusky Eagle Owl *Bubo coromandus* (Latham) 1790
Phillipine Eagle Owl *Bubo philippensis* (Kaup) 1844
Blakiston's Fish Owl *Ketupa blakistoni* (Seebohm) 1884
Brown Fish Owl *Ketupa zeylonensis* (Gmelin) 1788
Malay Fish Owl *Ketupa ketupu* (Horsfield) 1821
Tawny Fish Owl *Ketupa flavipes* (Hodgson) 1836

African Fish Owl *Scotopelia peli* (Bonaparte) 1850
Spectacled Owl *Pulsatrix perspicillata* (Latham) 1790
Snowy Owl *Nyctea scandiaca* (Linnaeus) 1758
Northern Hawk Owl *Surnia ulula* (Linnaeus) 1758
Eurasian Pygmy Owl *Glaucidium passerinum* (Linnaeus) 1758
Northern Pygmy Owl *Glaucidium gnoma* Wagler 1832
Cuban Pygmy Owl *Glaucidium siju* (d'Orbigny) 1839
Least Pygmy Owl *Glaucidium minutissimum* (Wied) 1821
Ferruginous Pygmy Owl *Glaucidium brasilianum* (Gmelin) 1788
Andean Pygmy Owl *Glaucidium jardinii* (Bonaparte) 1855
Austral Pygmy Owl *Glaucidium nanum* (King) 1828
Pearl-spotted Owlet *Glaucidium perlatum* (Vieillot) 1818
Barred Owlet *Glaucidium capense* (A. Smith) 1834
Collared Owlet *Glaucidium brodiei* (Burton) 1836
Jungle Owlet *Glaucidium radiatum* (Tickell) 1833
Cuckoo Owlet *Glaucidium castanopterum* (Horsfield) 1821 formerly *Glaucidium cuculoides* (Vigors) 1831
Elf Owl *Micrathene whitneyi* (Cooper) 1861
Powerful Owl *Ninox strenua* (Gould) 1838
Boobook Owl *Ninox novaeseelandiae* (Gmelin) 1788
Brown Hawk Owl *Ninox scutulata* (Raffles) 1822
Madagascar Hawk Owl *Ninox superciliaris* (Vieillot) 1817
Phillipine Boobook Owl *Ninox philippensis* Bonaparte 1855
Speckled Hawk Owl *Ninox punctulata* (Quoy and Gaimard) 1830
Little Owl *Athene noctua* (Scopoli) 1769
Spotted Owlet *Athene brama* (Temminck) 1821
Forest Owlet *Athene blewitti* (Hume) 1873
Burrowing Owl *Athene cunicularia* (Molina) 1782
Black-and-white Owl *Ciccaba nigrolineata* Sclater 1859
Black-banded Owl *Ciccaba huhula* (Daudin) 1800
Rufous-banded Owl *Ciccaba albitarsus* (Bonaparte) 1850
Mottled Owl *Strix virgata* (Cassin) 1850
Brown Wood Owl *Strix leptogrammica* Temminck 1831
Spotted Wood Owl *Strix seloputo* Horsfield 1821
Tawny Owl *Strix aluco* Linnaeus 1758
Hume's Owl *Strix butleri* (Hume) 1878
African Wood Owl *Strix woodfordi* (A. Smith) 1834
Barred Owl *Strix varia* Barton 1799
Fulvous Owl *Strix fulvescens* (Sclater and Salvin) 1868
Spotted Owl *Strix occidentalis* (Xantus de Vesey) 1859
Rufous-legged Owl *Strix rufipes* King 1828
Ural Owl *Strix uralensis* Pallas 1771
Great Grey Owl *Strix nebulosa* J. R. Forster 1772
Long-eared Owl *Asio otus* (Linnaeus) 1758
African Long-eared Owl *Asio (otus) abyssinicus* (Guérin-Méneville) 1843
Stygian Owl *Asio stygius* (Wagler) 1832
Striped Owl *Asio clamator* (Vieillot) 1808
Short-eared Owl *Asio flammeus* (Pontoppidan) 1763
African Marsh Owl *Asio capensis* (A. Smith) 1834
Tengmalm's Owl *Aegolius funereus* (Linnaeus) 1758
Northern Saw-whet Owl *Aegolius acadicus* (Gmelin) 1788
Unspotted Saw-whet Owl *Aegolius ridgwayi* (Alfaro) 1905
Buff-fronted Owl *Aegolius harrisii* (Cassin) 1849

BIBLIOGRAPHY

For a complete bibliography on owls, see Clark *et al.* (1978)

ABDULALI, H. 1972. A catalog of the birds in the collection of the Bombay Natural History Society. 2. *Strigidae* and *Caprimulgidae*. *J. Bombay Nat. Hist. Soc.* 69:102–129. ABS, M. & CURIO, E., KRAMER, P. & NIETHAMMER, J. 1965. Zur Ernährungsweise der Eulen auf Galapagos. Ergebnisse der Deutschen Galapagos-Expedition 1962/63. IX. *J. f. Ornith.* 106(1965):49–57. AHARONI, J. 1931. Drei neue Vögel für Palästina und Syrien. *Orn. Monatsber.* 39: 171–173. ALI, S. 1977. *Field Guide to the Birds of the Eastern Himalayas*. Delhi. ALI, S. & DILLON RIPLEY, S. 1969. *Handbook of the Birds of India and Pakistan*. 3. Bombay-London. ALLEN, G. O. 1919. Hovering habit of the Spotted Owlet (*Athene brahma*). *J. Bombay Nat. Hist. Soc.* 26:1,045. ALTMÜLLER, R. 1976. Schachtelbrut eines Schleiereulen-Weibchens (*Tyto alba*). *Vogelk. Ber. Niedersachs.* 8:9–10. ARLETTAZ, R. 1987. Statut de la population relictuelle du Hibou Scops en Valais central. *Stat. Orn. Suisse*, Sempach:1–32. ARMSTRONG, W. H. 1958. Nesting and food habits of the Long-eared Owl in Michigan. *Pub. Michigan State Univ. Biol. Ser.* 1:63–96. ARONSON, L. 1980. Hume's Tawny Owl *Strix butleri* in Israel. *Dutch Birding* 1:18–19. ARREDONDO, O. 1975. Distribución geográfica y descripción de algu nos huesos de *Ornimegalonyx oteroi* Arredondo, 1958, del Pleistoceno superior de Cuba. *Mem. Soc. Cienc Nat. La Salle* 35(101):133–190. ARREDONDO, O. 1976. The great predatory birds of the Pleistocene of Cuba. *Smithson. Contr. Paleobiol.* 27:169–187. ASPINWALL, D. R. 1979. Bird notes from Zambesi district, North-West Province. *Occ. Pap. Zambian Orn. Soc.* 2. AULT, J. W. 1982. A quantitative estimate of Barn Owl nesting habitat quality. Doct. Thesis, Oklahoma State Univ., Lawton, Oklahoma. AUSTIN, O. L. 1948. The birds of Korea. *Bull. Mus. Comp. Zool. Harvard Coll.* 101:1–301. AUSTIN, O. L. & KURODA, N. 1953. The birds of Japan, their status and distribution. *Bull. Mus. Comp. Zool. Harvard Coll.* 109:277–637. AUSTING, G. R. & HOLT, J. B., JR. 1966. *The World of the Great Horned Owl*. Lippingcott Co., Philadelphia, New York. (3rd printing.) AVERY, G. & ROBERTSON, A. S., PALMER, N. G. & PRINS, A. J. 1985. Prey of Giant Eagle Owls in the Lee Hoop Nature reserve, Cape Province. *Ostrich* 56. BAILEY, A. F. 1948. Birds of arctic Alaska. *Pop. Ser. Colorado Mus. Nat. Hist.* 8:1–317. BAKER, E. C. S. 1927. *The Fauna of British India. Birds*. IV. London. BAKER, E. C. S. 1934. *The Nidification of Birds of the Indian Empire*. III. London. BAKER, J. A. & BROOKS, R. J. 1981. Raptor and vole populations at an airport. *J. Wildl. Manag.* 45:390–396. BAKER, J. K. 1962. The manner and efficiency of raptor depredations on bats. *Condor* 64:500–504. BAKER, R. H. 1951. The avifauna of Micronesia, its origin, evolution, and distribution. *Publ. Univ. Kansas Mus. Nat. Hist.* 3:1–359. BAKKER, D. 1957. De Velduil in de Noordoostpolder. *Lev. Nat.* 60:104–105. BALDWIN, P. H. & KOPLIN, J. R. 1966. The Boreal Owl as a Pleistocene relict in Colorado. *Condor* 68:299–300. BALGOOYEN, T. G. 1969. Pygmy Owl attacks Caifornia Quail. *Auk* 86:358. BALLMANN, P. 1973. Fossile Vögel aus dem Neogen der Halbinsel Gargano (Italien). 1. *Scripta Geol.* 17:1–75. BALLMANN, P. 1976. Fossile Vögel aus dem Neogen der Halbinsel Gargano (Italien). 2. *Scripta Geol.* 38:1–59. BANGS, O. 1899. A new Barred Owl from Corpus Christi, Texas. *Proc. New England Zool. Cl.* 1:31–32. BANKS, R. C. 1964. An experiment on a Flammulated Owl. *Condor* 66:79. BANNERMAN, D. A. & BANNERMAN, W. M. 1968. *History of the Birds of the Cape Verde Islands. Birds of the Atlantic Islands*. 4. Edinburgh. BANNERMAN, D. A. & VELLA-GAFFIERO, J. A. 1976. *Birds of the Maltese Archipelago*. Museums Dept, Valletta. BARROWS, C. W. 1981. Roost selection by Spotted Owls: an adaptation to heat stress. *Condor* 83:302–309. BARROWS, C. W. & BARROWS, K. 1978. Roost characteristics and behavioural thermoregulation in the Spotted Owl. *Western Birds* 9:1–8. BARTH, E. K. 1949. Sneugleobservasjoner fra Hardangervidda, Norge. *Vår Fågelv.* 8:145–156. BARTHOS, G. 1957. Breeding Scops Owl in southwestern Hungary. *Aquila* 63–64 (1956–57):344–345. BATES, G. L. 1937. Descriptions of two new races of Arabian birds. *Bull. Brit. Orn. Cl.* 57:150–151. BATZLI, G. O. & PITELKA, F. A. 1983. Nutritional ecology of microtine rodents: food habits of lemmings near Barrow, Alaska. *J. Mamm.* 64:648–655. BATZLI, G. O. & PITELKA, F. A. & CAMERON, G. N. 1983. Habitat use by lemmings near Barrow, Alaska. *Holarctic Ecol.* 6:255–262. BAUDVIN, H. 1976. Erfolg starker Bruten der Schleiereule (*Tyto alba*). *Orn. Mitt.* 28:106–108. BAUDVIN, H. & DESSOLIN, J.-H. & RIOLS, C. 1985. L'utilisation par la martre (*Martes martes*) des nichoirs à chouettes dans quelques forêts bourguignonnes. *Ciconia* 9:61–104. BAUMGART, W. 1975. An Horsten des Uhus (*Bubo bubo*) in Bulgarien. II. Der Uhu in Nordostbulgarien. *Zool. Abhandl. Staatl. Mus. Tierk. Dresden* 33:251–275. BAUMGART, W. 1980. Wodurch ist der Steinkauz bedroht? *Falke* 27:228–229. BAUMGART, W. & SIMEONOV, S. D., ZIMMERMANN, M., BUNSCHE, H., BAUMGART, P. & KUHNAST, G. 1973. An Horsten des Uhus (*Bubo bubo*) in Bulgarien. I. Der Uhu im Iskerbruch (Westbalkan). *Zool. Abhandl. Staatl. Mus. Tierk. Dresden* 32:203–247. BAUMGARTNER, F. M. 1939. Territory and population in the Great Horned Owl. *Auk* 56:274–282. BAYLE, P. & ORSINI, P. & BOUTIN, J. 1987. Variations du régime alimentaire du Hibou grand-duc *Bubo bubo* en période de reproduction en Basse-Provence. *Ois. Rev. Fr. Orn.* 57:23–31. BECKER, C. & PIEPER, H. 1982. Zum Nachweis des Habichtskauzes *Strix uralensis* in einer neolithischen Seeufersiedlung der Schweiz. *Orn. Beob.* 79:159–162. BECKER, P. & RITTER, H. 1969. Habichtskauz (*Strix uralensis*) im Harz nachgewiesen. *Vogelk. Ber. Niedersachs.* 1:55–56. BELCHER, C. & SMOOKER, G. D. 1936. Birds of the colony of Trinidad and Tobago. III. *Ibis* 13th Ser. (6):1–35. BELL, G. P. & PHELAN, F. J. S. & WYPKEMA, R. C. P. 1979. The owl invasion of Amherst Island, Ontario, January–April 1979. *Amer. Birds* 33:245–246. BELL, R. E. 1964. A sound-triangulation method for counting Barred Owls. *Wilson Bull.* 76:292–294. BELTERMAN, R. H. R. & BOER, L. E. M. DE. 1984. A karyological study of 55 species of birds, including karyotypes of 39 species new to cytology. *Genetica* 65:39–82. BENSON, C. W. 1962. The food of the Spotted Eagle-Owl *Bubo africanus*. *Ostrich* 33:35. BENSON, C. W. 1981. Ecological differences between the Grass Owl *Tyto capensis* and the Marsh Owl *Asio capensis*. *Bull. Brit. Orn. Cl.* 101:372–376. BENSON, C. W. & IRWIN, M. P. S. 1967. The distribution and systematics of *Bubo capensis* Smith. *Arnoldia* 3:1–19. BENT, A. C. 1938. Life histories of North American birds of prey. 2. *Bull. US Nat. Mus.* 170:1–482. BERGER, A. J. 1972. *Hawaiian Birdlife*. Hawaii. BERGMAN, S. 1935. *Zur Kenntnis nordostasiatischer Vögel*. Stockholm. BERGMANN, H. H. & GANSO, M. 1965. Zur Biologie des Sperlingskauzes. *J. f. Ornith.* 106:255–284. BERNIS, F. 1955. Prontuario de la avifauna Española. *Ardeola* (Spec. No.): 1–77. BERNIS, F. 1967. Aves migradoras ibericas. 3. *Publ. Esp. Soc. Esp. Orn. Madrid*. BEVEN, G. 1965. The food of Tawny Owls in London. *London Bird Rep.* 29:56–72. BEVEN, G. 1982. Further observations on the food of Tawny Owls in London. *London Nat.* 61:88–94. BEZZEL, E. & SCHÖPF, H. 1986. Anmerkungen zur Bestandsentwicklung des Uhus (*Bubo bubo*) in Bayern. *J. f. Ornith.* 127:217–228. BIGGS, H. C. & KEMP, A. C., MENDELSOHN, H. P. & MENDELSOHN, J. M. 1979. Weights of southern African raptors and owls. *Durban Mus. Novit.* 12(17):73–81. BILLE, R.-P. 1972. Auprès d'un nid de Chouette chevêchette *Glaucidium passerinum* dans les Alpes valaisannes. *Nos Oiseaux* 31:141–149, 173–182. BISWAS, B. 1961. The Birds of Nepal. 3. *J. Bombay Nat. Hist. Soc.* 58:63–134. BJURHOLM, P. 1980. Rovfågelcentral – en arbetsrapport om uppbyggnad av en uppfödningsanläggning för utrotningshotade rovfåglar. *Statens Naturvärksverk*, Solna. BLAKE, E. R. & HANSON, H. C. 1942. Notes on a collection of birds from Michoacan, Mexico. *Pub. Field Mus. Nat. Hist. Zool. Ser.* 522:513–551. BLAKERS, M. & DAVIES, S. J. J. F. & REILLY, P. N. 1984. *The Atlas of Australian Birds*. Melbourne. BLOKPOEL, H. 1976. *Bird Hazards to Aircraft*. Ottawa. BLONDEL, J. 1967. Réflexions sur les rapports entre prédateurs et proies chez les rapaces. I. *Terre et Vie* 114:5–32. BLONDEL, J. & BADAN, O. 1976. La biologie du Hibou grand-duc en Provence. *Nos Oiseaux* 33:189–219. BLUS, L. J. & PATTEE, O. H., HENNY, C. J. & PROUTY, R. M. 1983. First records of chlordane-related mortality in wild birds. *J. Wildl. Manag.* 47:196–198. BOANO, G. 1980. Casi di nidificazione del Gufo comune *Asio otus* (L.) in Piemonte. *Riv. Piem. St. Nat.* 1:149–160. BODENHEIMER, F. S. 1935. *Animal Life in Palestine*. Jerusalem. BOERMA, E. & GROEN, L. G., VOOUS, K. H. & WIGHT, H. J. 1987. Eerste Ruigpootuilen *Aegolius funereus* in Nederland. *Limosa* 60:1–8. BOHNSACK, P. 1966. Über die Ernährung der Schleiereule, *Tyto alba*, insbesondere ausserhalb der Brutzeit, in einem westholsteinischen Massenwechselgebiet der Feldmaus, *Microtus arvalis*. *Corax* 1:162–172. BOND, J. 1928. The distribution and habits of the birds of the republic of Haiti. *Proc. Acad. Nat. Sci. Philadelphia* 80:483–521. BOND, J. 1982. Comments on Hispaniolan birds. *Publ. Parque Zool. Nac. Santo Domingo, Rep. Dominicana* 1:1–4. BOND, J. 1984. Twenty-fifth supplement to the check-list of birds of the West Indies (1956). *Proc. Acad. Nat. Sci. Philadelphia*:1–22. BOND, J. & MEYER DE SCHAUENSEE, R. 1941. Descriptions of new birds from Bolivia. IV. *Notulae Naturae. Acad. Nat. Sci. Philadelphia* 93:1–7. BONNOT, P. 1928. An outlaw Barn Owl. *Condor* 30:320. BORELL, A. E. 1937. Cooper Hawk eats a Flammulated Screech Owl. *Condor* 39:44. BOROWSKI, S. 1961. Some observations on the passerine owlet and Great Grey Owl in Bialowiska National Park. *Przegl. Zool.* 5:59–60. BOSAKOWSKI, T. & SPEISER, R. & BENZINGER, J. 1987. Distribution, density, and habitat relationships of the Barred Owl in northern New Jersey. In Nero *et al.*, 1987:135–143. BOSWALL, J. 1965. An unusually aggressive Tawny Owl. *Brit. Birds* 58:343–344. BOWMAKER, J. K. & MARTIN, G. R. 1978. Visual pigments and colour vision in a nocturnal bird, *Strix aluco* (Tawny Owl). *Vision Res.* 18:1,125–1,130. BOXALL, P. C. & LEIN, M. R. 1982. Territoriality and habitat selection of female Snowy Owls (*Nyctea scandiaca*) in winter. *Canad. J. Zool.* 60:2,344–2,350. BOXALL, P. C. & STEPNEY, P. H. R. 1982. The distribution and status of the Barred Owl in Alberta. *Canad. Field-Nat.* 96:46–50. BRAAKSMA, S. & BRUIJN, O. DE. 1976. De Kerkuilstand in Nederland. *Limosa* 49:135–187. BRAHMACHARY, R. L. & BASU, T. K. & SENGUPTA, A. 1972. On the daily screeching time of a colony of Spotted Owls *Athene brama* (Temminck). *J. Bombay Nat. Hist. Soc.* 69:649–651. BRAUNER, A. 1908. Vom Winternisten der Sumpf-

Ohreule. *Orn. Jahrb.* 19:55. BRAZIL, M. 1985. Owl of the setting sun. *BBC Wildlife* (March 1985):110–115. BRAZIL, M. & YAMAMOTO, S. 1983. Nest boxes as a practical means of conservation of Blakiston's Fish Owl (*Ketupa blakistoni*) in Japan and notes on breeding behaviour. *Proc. 2nd East Asian Bird Prot. Confer.* (Taichung, Taiwan):80–86. BRIGGS, M. A. 1954. Apparent neoteny in the saw-whet owls of Mexico and Central America. *Proc. Biol. Soc. Washington* 67:179–182. BRITTON, P. L. (ED.). 1980. *Birds of East Africa, their Habitat, Status and Distribution.* East Afr. Nat. Hist. Soc., Nairobi. BRODKORB, P. 1971. Catalogue of fossil birds. 4. *Bull. Florida State Mus. Biol. Soc.* 15:163–266. BRODKORB, P. & MOURER-CHAUVIRÉ, C. 1984. Fossil owls from Early Man sites of Olduvai Gorge, Tanzania. *Ostrich* 55:17–27. BROOKE, R. K. 1973. Notes on the distribution and food of the Cape Eagle-Owl in Rhodesia. *Ostrich* 44:137–139. BROUWER, G. A. 1938. Over het bidden van *Athene noctua vidalii* A. E. Brehm. *Ardea* 27:260–261. BROWN, LESLIE H. 1970. *African Birds of Prey.* London. BRUCE. J. A. & LONG, C. A. 1962. Nesting of the Barn Owl, *Tyto alba*, on San Juan Island, Washington. *Murrelet* 43:3. BRUIJN, O. DE. 1979. Voedseloecologie van de Kerkuil *Tyto alba* in Nederland. *Limosa* 52:91–154. BRÜLL, H. 1977. *Das Leben europäischer Greifvögel.* 3rd edn. Stuttgart. BRUNTON, D. F. & REYNOLDS, W. D. 1984. Winter predation on an ermine by a Great Gray Owl. *Blue Jay* 42:171–173. BRYAN, W. A. 1903. The short-eared owl (*Asio accipitrinus*) taken far out at sea. *Auk* 20:212–213. BUCHANAN, O. M. 1971. The Mottled Owl *Ciccaba virgata* in Trinidad. *Ibis* 113:105–106. BUCKHOLTZ, P. G. & EDWARDS, M. H., ONG, B. G. & WEIR, R. D. 1984. Differences by age and sex in the size of Saw-whet Owls. *J. Field Ornith.* 55:204–213. BÜHLER, P. 1964. Brutausfall bei der Schleiereule und die Frage nach dem Zeitgeber für das reproduktive System von *Tyto alba.* *Vogelwarte* 22:153–158. BÜHLER, P. 1965. Experimental ausgelöste Frühbruten bei der Schleiereule (*Tyto alba*). *J. f. Ornith.* 106:347. BÜHLER, P. 1972. Sandwichstrukturen der Schädelkapseln verschiedener Vögel. *Mitt. Inst. leichte Flächentragwerke (IL) Univ. Stuttgart*:40–50. BÜHLER, P. 1981. Functional anatomy of the avian jaw apparatus. In King, A. S. & Mchelland (eds.), *Form and Function in birds.* 2:439–468. BÜHLER, P. & EPPLE, W. 1980. Die Lautäusserungen der Schleiereule (*Tyto alba*). *J. f. Ornith.* 121:36–70. BUKER, J. B. & HARTOG, A. 1985. Kauw *Corvus monedula* trekt in bij Bosuil *Strix aluco.* *Limosa* 58:74. BUKER, J. B. & WIT, J. N. DE & ZUILEN, W. A. VAN. 1984. Forse prooien van Steenuil *Athene noctua. Limosa* 57:118. BULL, E. L. & HENJUM, M. G. & ANDERSON, R. G. 1987. Nest platforms for Great Gray Owls. In Nero et al., 1987:87–90. BUNN, D. S. 1976. Eyesight of Barn Owl. *Brit. Birds* 69:220–222. BUNN, D. S. & WARBURTON, A. B. & WILSON, R. D. S. 1982. *The Barn Owl.* Calton. BURCHAK-ABRAMOVICH, N. J. 1965. A new species of fossil owl (*Bubo binagadensis* sp.n.) from Azerbaijan Province, Caucasus. *Ornitologiya* 7:452–454. BURTON, J. A. (ED.). 1973. *Owls of the World.* Peter Lowe, Eurobook Ltd. BUTTS, K. O. 1971. Observations on the ecology of Burrowing Owls in western Oklahoma. A preliminary report (M.S. Thesis, 1973). *Proc. Okla. Acad. Sci.* 51:66–74. BUTTS, K. O. 1973. *Life history and habitat requirements of burrowing owls in western Oklahoma.* MS Thesis, Oklahoma State University, Stillwater, Oklahoma. BUTTS, K. O. 1976. Burrowing Owls wintering in the Oklahoma Panhandle. *Auk* 93:510–516. BUTTS, K. O. & LEWIS, J. C. 1982. The importance of prairie dog towns to Burrowing Owls in Oklahoma. *Proc. Okla. Acad. Sci.* 62:46–52. CAHN, A. R. & KEMP, J. T. 1930. On the food of certain owls in east-central Illinois. *Auk* 47:323–328. CALBURN, S. & KEMP, A. 1987. *The Owls of Southern Africa.* Cape Town. CAMERON, A. & PARNALL, P. 1971. *The Nightwatchers.* New York. (2nd and 3rd edn 1972.) CAMPBELL, B. Bird notes from southern Arizona. 1934. *Condor* 36:201–203. CAMPBELL, R. W. & FORSMAN, E. D. & RAAY, B. M. VAN DER. 1984. *An Annotated Bibliography of Literature on the Spotted Owl.* Ministry of Forests, Victoria, British Columbia. CAMPBELL, R. W. & MACCOLL, M. D. 1978. Winter foods of snowy owls in southwestern British Columbia. *J. Wildl. Manag.* 42:190–192. CANNINGS, R. J. 1987 The breeding biology of northern Saw-whet Owls in southern British Columbia. In Nero et al., 1987:193–198. CANNINGS, R. J. & CANNINGS, S. R., CANNINGS, J. M. & SIRK, G. P. 1978. Successful breeding of the Flammulated Owl in British Columbia. *Murrelet* 59:74–75. CAPILUPPI, M. 1971. Notizie ornitologiche dalla provincia di Reggio Emilia (1967–1970). *Riv. Ital. Ornit.* 41:122–126. CARNEGIE, A. J. M. 1961. The stomach contents of a Spotted Eagle-Owl (*Bubo africanus*). *Ostrich* 32:97. CARSTAIRS, J. 1983. The Spurn Tengmalm's Owl. *Brit. Birds* 76:416–417. CATLING, P. M. 1972. A behavioral attitude of Saw-whet and Boreal Owls. *Auk* 89:194–196. CATLING, P. M. 1973. Food of Snowy Owls wintering in southern Ontario, with particular reference to the Snowy Owl hazards to aircraft. *Ontario Field Biol.* 27:41–45. CAVÉ, A. J. 1961. De broedvogels von Oostelijk Flevoland in 1958–1960. *Limosa* 34:231–251. CAVÉ, A. J. 1968. The breeding of the Kestrel *Falco tinnunculus* L., in the reclaimed area Oostelijk Flevoland. *Netherl. J. Zool.* 18:313–407. CESKA, V. 1980. Untersuchungen zu Nahrungsverbrauch, Nahrungsnützung und Energiehaushalt bei Eulen. *J. f. Ornith.* 121:186–199. CHAPLIN, S. B. & DIESEL, D. A. & KASPARIE, J. A. 1984. Body temperature regulation in Red-tailed Hawks and Great Horned Owls. *Condor* 86:175–181. CHAPMAN, F. M. 1926. The distribution of bird-life in Ecuador. *Bull. Amer. Mus. Nat. Hist.* 55:1–784. CHAUVIRÉ, C. 1965. Les oiseaux du gisement magdalénien du Morin (Gironde). *C. R. 89ᵉ Congr. Soc. Savantes, Lyon*: 255–266. CHENG, T.-H. (ED.). 1964. *China's Economic Fauna: Birds.* Transl.: Joint Pub. Res. Serv., Washington, D.C.

CHENG, T.-H. 1973. *Status of Bird Species in the Chinling Mountains.* Peiping. CHENG, T.-H. 1976. *Distributional List of Chinese Birds.* Peiping. CHOUSSY, D. 1971. Etude d'une population de Grand-Ducs *Bubo bubo* dans le Massif Central. *Nos Oiseaux* 31:37–56. CLARK N. 1985. *Eastern Birds of Prey.* CLARK, R. J. 1975. A field study of the Short-eared Owl, *Asio flammeus*, in North America. *Wildlife Monogr.* 47. CLARK, R. J. & MYERS, D. J., STANLEY, B. L. & KELSO, L. H. 1980. The relationship between the microanatomical development of auricular/conch feathers (limbus facials) of owls and their foraging ecology. *Act. XVII Congr. Int. Ornith.* (Berlin, 1978):625–630. CLARK, R. J. & SMITH, D. G. & KELSO, L. H. 1978. *Working Bibliography of Owls of the World.* National Wildlife Federation Raptor Information Center, Technical Series. 1. CLARK, T. W. 1985. The Meeteetse Black-footed Ferret conservation studies. *Nation. Geogr. Res.* 1(2):299–302. CLARK, W. S. 1976. Cape May Point Raptor Banding Station – 1974 Results. *North Amer. Bird Bander*:5–13. CLAY, T. 1966. The species of *Strigiphilus* parasitic on the Barn Owls *Tyto*. *J. Entom. Soc. Queensland* 5:10–17. COLLETT, R. 1881. Craniets og Oreaabningernes Bygning hos de nordeuropaeiske Arter af Familien Strigidae. *Forhandl. Christiania Videnskabsselskabs* 3:1–38. COLLINS, C. T. 1963. Notes on the feeding behavior, metabolism, and weight of the Saw-whet Owl. *Condor* 65:528–530. COLLINS, C. T. 1979. The ecology and conservation of Burrowing Owls. In Schaeffer, P. P. & Ehlers, S. M. (eds.), *Proc. Nat. Audubon Soc. Symp. Owls of the West* (Tiburon, California): 6–17. COLLINS, C. T. & LANDRY, R. E. 1977. Artificial nest burrows for Burrowing Owls. *North Amer. Bird Bander* 2:151–154. CONRAD, B. 1977. *Die Giftbelastung der Vogelwelt Deutschlands.* Vogelk. Bibl. 5. Greven. CORRAL, J. F. & CORTÉS, J. A. & GIL, J. M. 1979. Contribución al estudio de la alimentación de *Asio otus* en el sur España. *Acta Vertebr.* 6(2):179–190. CORRAL, J. F. & CORTÉS, J. A., GIL, J. M. & CORRAL, J. M. GILL. 1979. Nidificación invernal de *Asio otus. Acta Vertebr.* 6(2):227–228. CORY, C. B. 1918. Catalogue of birds of the Americas. 2(1). *Zool. Ser. Field Mus. Nat. Hist.* 13:1–315. COUES, E. 1874. Birds of the Northwest. *Misc. Pub. US Geol. Surv. Territories.* 3:1–791. COULOMBE, H. N. 1970. Physiological and physical aspects of temperature regulation in the Burrowing Owl *Speotyto cunicularia. Comp. Biochem. Physiol.* 35:307–337. CRAIGHEAD, J. J. & CRAIGHEAD, F. C. 1956. *Hawks, Owls and Wildlife.* Harrisburg, Pa, & Wildlife Management Institute, Washington, DC. CRAMP, S. (ED.) 1985. *Handbook of the Birds of Europe, the Middle East and North Africa.* 4. Oxford. CROIZAT, L. 1958. *Panbiogeography.* Caracas. CRUZ, A. 1985. Records of fossil birds from Jamaica. *Gosse Bird Cl. Broadsheet* 45:4–7. CURRY-LINDAHL, K. 1958. Photographic studies of some less familiar birds. 85. Pygmy Owl. *Brit. Birds* 51:72–74. DAMBIERMONT, J. L. & DEMARET, A. & FRANCOTTE, J.-P. 1967. A propos de la première nidification en Belgique de la Chouette de Tengmalm, *Aegolius funereus. Gerfaut* 57:43–49. DAVENPORT, D. L. 1982. Influxes into Britain of Hen Harriers, Long-eared Owls and Short-eared Owls in winter 1978/79. *Brit. Birds* 75:309–316. DAVIDSON, J. H. & BIGGS, H. C. 1974. Grass Owl chicks: weight recordings. *Ostrich* 45:31. DAVIS, J. 1959. The Sierra Madrean element of the avifauna of the Cape district, Baja California. *Condor* 61:75–84. DAVIS, L. J. 1972. *A Field Guide to the Birds of Mexico and Central America.* Austin, Texas. DAWSON, W. L. 1923. *The Birds of California.* DAY, D. H. 1987. Birds of the Upper Limpopo river valley. *Southern Birds* 14:1–76. DEAN, W. R. J. 1978. An analysis of avian stomach contents from southern Africa. *Bull. Brit. Orn. Cl.* 98:10–13. DEIGNAN, H. G. 1945. The birds of northern Thailand. *Bull. US Nat. Mus.* 186. DEIGNAN, H. G. 1950. The races of the Collared Scops Owl, *Otus bakkamoena. Auk* 67:189–200. DEIGNAN, H. G. 1963. Checklist of the birds of Thailand. *Bull. US Nat. Mus.* 226:1–263. DELACOUR, J. 1941. On the species of *Otus scops. Zoologica* 26:133–142. DEMENTIEV, G. 1933. Sur la position systématique de "*Bubo*" *doerrisi* Seebohm. *Alauda* 5:383–388. DEMENTIEV, G. & GLADKOV, N. A. (EDS.). 1951. *Birds of the Soviet Union (Ptitsy Sovetskogo Soyuza).* 1. Moscow. (Transl.: Jerusalem, 1966.) DEMETER, A. 1981. Small mammals and the food of owls (*Tyto* and *Bubo*) in northern Nigeria. *Vertebrata Hungarica* 20:127–136. DEMETER, A. 1982. Prey of the Spotted Eagle-Owl *Bubo africanus* in the Awash National Park, Ethiopia. *Bonn. Zool. Beitr.* 33:283–292. DEPPE, H. J. 1984. Kapohreule (*Asio capensis*) auf Teneriffa. *Orn. Mitt.* 36:35–36. DESFAYES, M. 1951. Nouvelles notes sur le Grand-duc. *Nos Oiseaux* 21:121–126. DEXTER, R. W. 1978. Mammals utilized as food by owls in reference to the local fauna of northeastern Ohio. *Kirtlandia* 24:1–6. DICE, L. R. 1945. Minimum intensities of illumination under which owls can find dead prey by sight. *Amer. Nat.* 79:385–416. DICKEY, D. R. & ROSSEM, A. J. VAN. 1938. The birds of El Salvador. *Zool. Ser. Field Mus. Nat. Hist.* 23:1–609. DIETERICH, L. E. 1975. On the retinal pigment epithelium of the Barn Owl (*Tyto alba*). *Albr. Graefes Arch. Klin. Exp. Ophthal.* 196:247–254. DIJK, T. VAN 1973. A comparative study of hearing in owls of the family Strigidae. *Netherl. J. Zool.* 23:131–167. DOWNHOWER, J. F. 1963. Food of the Barn Owl and development of its young in southeastern Kansas. *Bull. Kansas Orn. Soc.* 14:25–26. DUBOIS, A. 1924. A nuptial song-flight of the Short-eared Owl. *Auk* 41:260–263. DUDGEON, G. C. 1900. The Large Barred Owlet (*Glaucidium cuculoides*, Vigors) capturing Quail on the wing. *J. Bombay Nat. Hist. Soc.* 13:530–531. DUKE, G. E. 1978. Raptor physiology. In Fowler, M. E. (ed.), *Zoo and Wild Animal Medicine* (Philadelphia, 1978):225–231. DUKE, G. E. & FULLER, M. R. & HUBERTY, B. J. 1980. The influence of hunger on meal to pellet intervals in Barred Owls. *Comp. Biochem.*

BIBLIOGRAPHY

Physiol. 66A:203–207. EARHART, C. M. & JOHNSON, N. K. 1970. Size dimporphism and food habits of North American owls. *Condor* 72:251–264. EARLÉ, R. A. 1978. Observations at a nest of the Grass Owl. *Ostrich* 49:90–91. EATES, K. R. 1938. A note on the resident owls of Sind. *J. Bombay Nat. Hist. Soc.* 40. ECK, S. 1968. Der Zeichnungsparallelismus der *Strix varia*. *Zool. Abhandl. Staatl. Mus. Tierk, Dresden* 29:283–288. ECK, S. 1971. Katalog der Eulen des Staatlichen Museums für Tierkunde Dresden. *Zool. Abhandl. Staatl. Mus. Tierk. Dresden* 30:173–218. ECK, S. & BUSSE, H. 1973. *Eulen*. Neue Brehm-Büch. 469. Wittenberg–Lutherstadt. ECKERT, K. R. 1982. An invasion of Boreal Owls. *Loon* 54:176–177. EDBERG, R. 1955. Invasionen av hökuggla (*Surnia ulula*) i Skandinavien 1950–51. *Vår Fågelv.* 14:10–21. EDBERG, R. 1958. Om dödligheten under vinterhalvåret hos kattugglor (*Strix a. aluco* L.) i Mellansverige. *Vår Fågelv.* 17:273–280. EDWARDS, E. P. 1972. *A Field Guide to the Birds of Mexico*. EISENTRAUT, M. 1963. *Die Wirbeltiere des Kamerungebirges*. Hamburg–Berlin. ELY, C. A. & CROSSIN, R. S. 1972. A northerly wintering record of the Elf Owl (*Micrathene whitneyi*). *Condor* 74:215. EMERSON, N., EMERSON, K. C. & ELBEL, R. E. 1959. The taxonomic position of an Asiatic species of *Otus* as indicated by the Mallophaga. *Proc. Oklah. Acad. Sci.* 39:76–78. ERKERT, H. G. 1969. Die Bedeutung des Lichtsinnes für Aktivität und Raumorientierung der Schleiereule (*Tyto alba guttata* Brehm). *Zeitschr. Vergl. Physiol.* 64:37–76. ERKINARO, E. 1972. Precision of the circadian clock in Tengmalm's Owl, *Aegolius funereus* (L.), during various seasons. *Aquilo Ser. Zool.* 13:48–52. ERKINARO, E. 1973. Seasonal variation of the dimensions of pellets in Tengmalm's Owl, *Aegolius funereus*, and the Short-eared Owl, *Asio flammeus*. *Aquilo Ser. Zool.* 14:84–88. ERLINGE, S. & GORANSSON, G. et al. 1984. Can vertebrate predators regulate their prey? *Amer. Nat.* 123:125–133. ERRINGTON, P. L. & HAMERSTROM, FRANCES & HAMERSTROM, F. N. 1940. The Great Horned Owl and its prey in north-central United States. *Res. Bull. Agric. Exper. Station Iowa* 277:757–850. EVANS, D. L. 1980. Vocalizations and territorial behavior of wintering Snowy Owls. *Amer. Birds* 34:748–749. EVERMANN, B. W. 1913. Eighteen species of birds, new to the Pribilof Islands, including four new to North America. *Auk* 30:15–18. EXO, K.-M. 1984. Die akustische Unterscheidung von Steinkauzmännchen und -weibchen (*Athene noctua*). *J. f. Ornith.* 125:94–97. EXO, K.-M. & HENNES, R. 1980. Beitrag zur Populationsökologie des Steinkauzes (*Athene noctua*). *Vogelwarte* 30:162–179. FELLOWES, E. C. 1967. Kestrel and Barn Owl sharing entrance to nest sites. *Brit. Birds* 60:522–523. FENTON, M. B. & FLEMING, T. H. 1976. Ecological interactions between bats and nocturnal birds. *Biotropica* 8:104–110. FERENS, B. 1948. On the ability of colour-discrimination of the Tawny Owl (*Strix aluco aluco* L.). *Bull. (Int.) Acad. Polon. Cracovie Sc.* Ser. BII:309–336. FFRENCH, R. 1973. *A Guide to the Birds of Trinidad and Tobago*. Wynnewood, Pa. FISHER, A. K. 1893. The hawks and owls of the United States in their relation to agriculture. *Bull. US Dept. Agr. Div. Ornith. Mammal.* 3:1–210. FISHER, B. M. 1975. Possible intra-specific killing by a Great Gray Owl. *Canad. Field-Nat.* 89:71–72. FITE, K. V. 1973. Anatomical and behavioral correlates of visual acuity in the Great Horned Owl. *Vision Res.* 13:219–230. FITZGERALD, B. M. 1981. Predatory birds and mammals. In Bliss, L. C. et al. (eds.), *Tundra Ecosystems*:485–508. FJELDSÁ, J. 1983. Vertebrates of the Junin area, central Peru. *Steenstruppia* 8:285–298. FLACK, J. A. D. 1976. Bird populations of aspen forests in western North America. *Orn. Monogr.* 19:1–97. FLEAY, D. 1968. *Nightwatchmen of Bush and Plain*. New York. FLEMING, J. H. 1916. The Saw-whet Owl of the Queen Charlotte Islands. *Auk* 33:422. FLEMING, R. L., SR & FLEMING, R. L., JR & BANGDEL, L. S. 1976. *Birds of Nepal*. Kathmandu. FLEMING, R. L. & TRAYLOR, M. A. 1961. Notes on Nepal birds. *Fieldiana: Zool.* 35(8):441–487. FLEMING, R. L. & TRAYLOR, M. A. 1968. Distributional notes on Nepal birds. *Fieldiana: Zool.* 53(3):145–203. FLIEG, G. M. 1971. Tytonidae × Strigidae cross produces fertile eggs. *Auk* 88:178. FLINT, P. R. & STEWART, P. F. 1983. The birds of Cyprus. *BOU Check-List* 6. FOLLEN, D. G. & HAUG, J. C. 1981. Saw-whet Owl nest in Wood Duck box. *Passenger Pigeon* 43:47–48. FORBES, J. E. & WARNER, D. W. 1974. Behavior of a radio-tagged Saw-whet Owl. *Auk* 91:783–795. FORD, N. L. 1966. Fossil owls from the Rexroad Fauna of the Upper Pliocene of Kansas. *Condor* 68:472–475. FORD, N. L. 1967. *A systematic study of the owls based on comparative osteology*. Doct. Thesis, Univ. of Michigan, Ann Arbor. FORD, N. L. & MURRAY, B. G. 1967. Fossil owls from the Hagerman local fauna (Upper Pliocene) of Idaho. *Auk* 84:115–117. FORSMAN, E. 1976. A preliminary investigation of the Spotted owl in Oregon. M.S. Thesis, Oregon State Univ., Corvallis. FRANCOTTE, J. P. 1965. Première observation en Belgique de la nidification de la Chouette de Tengmalm *Aegolius funereus* (L.). *Aves* 2:43–45. FREEMEYER, M. & FREEMEYER, S. 1970. Proximal nesting of Harris' Hawk and Great Horned Owl. *Auk* 87:170–171. FREY, H. 1973. Zur Ökologie niederösterreichischer Uhupopulationen. *Egretta* 16:1–68. FRIEDMANN, H. 1949. A new heron and a new owl from Venezuela. *Smithson. Misc. Coll.* 111:1–3. FRIEDMANN, H. & DEIGNAN, H. G. 1939. Notes on some Asiatic owls of the genus *Otus*, with description of a new form. *J. Washington Acad. Sc.* 29:287–288. FROCHOT, B. & FROCHOT, H. 1963. La Chouette de Tengmalm (*Aegolius funereus*) retrouvée en Côte d'Or. *Alauda* 31:246–255. FRUMKIN, R. 1983. Division of ecological niches between owls in the Hula valley. *Torgos* 3:104. FUCHS, P. 1982. Hoogstamboomgaarden en Steenuilen. *Vogeljaar* 30:241–250. FUCHS, P. 1983. Analysis of factors which determine distribution, population density, and reproduction of the little owl. *Ann. Rep. Res. Inst. Nat. Manag.*:47–49. FUCHS, P. & THISSEN, J. B. M. 1981. Die Pestizid-und PCB-Belastung bei Greifvögeln un Eulen in den Niederlanden usw. *Ökol. Vögel (Ecol. Birds)* 3:181–195. FULLER, M. R. & NICHOLLS, T. H. & TESTER, J. R. 1973. Raptor conservation and management applications of bio-telemetry studies from Cedar Creek Natural History Area. *Conf. Raptor Cons. Techn.* Colorado State Univ. GABRIELSON, J. N. & LINCOLN, F. C. 1959. *The Birds of Alaska*. Wildlife Management Institute, Washington, DC. GALLAGHER, M. D. 1977. Birds of Jabal Akhdar. *J. Oman Studies. Spec. Rep.*:46–47. GALLAGHER, M. D. & ROGERS, T. D. 1980. On some birds of Dhofar and other parts of Oman. *J. Oman Studies. Spec. Rep.* 2. (*Otus sunia pamelae*, pp. 369–370.) GALLAGHER, M. D. & WOODCOCK, M. W. 1980. *The Birds of Oman*. London. GALLEGO, A. & BARON, M. & GAYOSO, M. 1975. Horizontal cells of the avian retina. *Vision Res.* 15:1,029–1,030. GALUSHIN, V. M. & PERERRA, V. I. 1982. Status of rare raptors in the USSR. *Acta XVIII Congr. Int. Ornith.* (Moscow):320–322. GARGETT, V. & GROBLER, J. H. 1976. Prey of the Cape Eagle Owl *Bubo capensis mackinderi* Sharpe 1899, in the Matopos, Rhodesia. *Arnoldia* 8:1–7. GARRIDO, O. H. 1978. Nuevo record de la lechuza norteamericana, *Tyto alba pratincola* (Bonaparte) en Cuba. *Misc. Zool. Inst. Zool. Acad. Cienc. Cuba* 7:2. GASOW, H. 1958. Der Rauhfusskauz Brutvogel im Kreis Olpe (Westfalen). *Natur u. Heimat* 18:14–16. GASOW, H. 1958. Rauhfusskäuze in Nisthöhlen und Nistkästen. *Natur u. Landsch.* 4:69–72. GASOW, H. 1959. Zur Ansiedlung des Rauhfusskauzes (*Aegolius funereus* (L.)) in künstlichen Niststätten. *Vogelring* 28:33–37. GASOW, H. 1964. Beitrag zur Kenntnis des Rauhfusskauzes (*Aegolius funereus*): Brutvorkommen und Ansiedlung in Südwestfalen. *Schriftenr. Landesstelle Naturschutz Landschaftspflege Nordrhein-Westfalen* 1:41–62. GASOW, H. 1968. Über Gewölle, Beutetiere und Schutz des Rauhfusskauzes (*Aegolius funereus*). *Schriftenr. Landesstelle Naturschutz Landschaftspflege Nordrhein-Westfalen* 5:37–59. GASTEREN, H. VAN 1986. Ransuilen in West-Friesland: aanstallen, uitvliegtijden enz. *Graspieper* 6:29–34. GAVRIN, V. F. & DOLGUSHIN, J. A., KORELOV, M. N. & KUZHMINA, M. A. 1962. *Birds of Kazachstan*. 2. Alma Ata. GERBER, R. 1960. *Die Sumpfohreule*. Neue Brehm-Büch. 259. Wittenberg– Lutherstadt. GESSAMEN, J. A. 1972. Bioenergetics of the Snowy Owl (*Nyctea scandiaca*). *Arctic & Alpine Res.* 4:223–238. GESSAMEN, J. A. 1978. Body temperature and heart rate of the Snowy Owl. *Condor* 80:243–245. GILMAN, M. F. 1909. Some owls along the Gila River in Arizona. *Condor* 11:145–150. GLASGOW, L. L. & GRESHAM, C. H. & HALL, S. 1950. The Flammulated Screech Owl, *Otus f. flammeolus*, in Louisiana. *Auk* 67:386. GLUE, D. E. 1972. Bird prey taken by British owls. *Bird Study* 19:91–95. GLUE, D. E. 1973. Seasonal mortality in four small birds of prey. *Ornis Scand.* 4:97–102. GLUE, D. E. 1977. Breeding biology of Long-eared Owls. *Brit. Birds* 70:318–331. GLUE, D. E. & SCOTT, D. 1980. Breeding biology of the Little Owl. *Brit. Birds* 73:167–180. GLUTZ VON BLOTZHEIM, U. N. (ED) 1962. Die Brutvögel der Schweiz. *Aargauer Tagbl.* (Aarau, Switzerland). GLUTZ VON BLOTZHEIM, U. N. & BAUER, K. M. 1980. *Handbuch der Vögel Mitteleuropas*. 9. Wiesbaden. GLUTZ VON BLOTZHEIM, U. N. & SCHWARZENBACH, F. H. 1979. Zur Dismigration junger Schleiereulen *Tyto alba*. *Orn. Beob.* 76:1–7. GODFREY, W. E. 1947. A new Long-eared Owl. *Canad. Field-Nat.* 61:196–197. GONZÁLEZ, H. & GARRIDO, O. H. 1979. Nuevo reporte de nidificacion de *Speotyto cunicularia* para Cuba. *Misc. Zool. Inst. Zool. Acad. Cienc. Cuba* 8:4. GOODMAN, A. E. & FISK, E. J. 1973. Breeding behaviour of captive Striped Owls (*Rhinoptynx clamator*). *Avicult. Mag.* 79:158–162. GOODMAN, S. M. & SABRY, H. 1984. A specimen record of Hume's Tawny Owl *Strix butleri* from Egypt. *Bull. Brit. Orn. Cl.* 104:79–84. GORE, M. E. J. & WON, PYONG-OH. 1971. *The Birds of Korea*. Royal Asiatic Soc., Korea Branch, Seoul. GOULD, G. I. 1977. Distribution of the Spotted Owl in California. *Western Birds* 8:131–146. GRABER, R. R. 1962. Food and oxygen consumption in three species of owls. *Condor* 64:473–487. GRAHAM, R. R. 1934. The silent flight of owls. *J. Roy. Aeronaut. Soc.* 38:837–843. GREMPE, G. 1965. Beiträge zur Ernährungsbiologie des Sperlingskauzes (*Glaucidium passerinum*) im östlichen Europa. *Orn. Mitt.* 17:197–199. GRINNELL, J. & STORER, T. J. 1924. *Animal Life in the Yosemite*. Berkeley, California. GRISCOM, L. 1931. Notes on rare and little-known neotropical pygmy owls. *Proc. New Engl. Zool. Cl.* 12:37–43. GRISCOM, L. 1932. The distribution of bird-life in Guatemala. *Bull. Amer. Mus. Nat. Hist.* 64:1–439. GROEN, L. G. & VOOUS, K. H. 1973. Ruigpootuil *Aegolius funereus* in Nederland. *Limosa* 46:199–204. GROOT, R. S. DE 1983. Origin, status and ecology of the owls in Galápagos. *Ardea* 71:167–182. GROSS, A. O. 1947. Cyclic invasions of the Snowy Owl and the migration of 1945–1946. *Auk* 64:584–601. GROTE, H. 1940. Beiträge zur Kenntnis einiger Vögel des unteren Syr-Darja-Gebiets. *Beitr. Fortpfl. Biol. Vögel* 16:205–213. GRÜNWALD, K. 1972. Waldohreule (*Asio otus*) brütet am Boden. *Orn. Mitt.* 24:80–81. GUIGUET, C. J. 1960. The birds of British Columbia. 7. *Handbook Brit. Col. Prov. Mus.* 18:1–62. GUPTA, K. K. 1967. Aggressive behaviour of a Spotted Owlet (*Athene brahma*). *J. Bombay Nat. Hist. Soc.* 63:441–442. GÜTTINGER, H. 1965. Zur Wintersterblichkeit schweizerischer Schleiereulen, *Tyto alba*, mit besonderer Berücksichtigung des Winters 1962/63. *Orn. Beob.* 62:14–23. HAASE, W. 1969. Beutetiere und Lebensraum von Rauhfusskäuzen (*Aegolius funereus*) im Kaufunger Wald. *Beitr. Naturk. Niedersachs.* 21:28–31. HAGEN, Y. 1952. *Rovfuglene og Viltpleien*. Gyldendal:1–603. HAGEN, Y. 1956. The irruption of Hawk-Owls (*Surnia ulula* (L.)) in Fennoscandia 1950–51. *Sterna* 24:1–22.

310

HAGEN, Y. 1960. Snøugla på Hardangervidda sommeren 1959. *Medd. Statens Viltunders.* 2. HALL, B. P. 1957. Taxonomic notes on the Spotted Owl, *Athene brahma*, and the Striated Weaver, *Ploceus manyar*, in Siam, including a new race of the latter. *Bull. Brit. Orn. Cl.* 77:44–46. HALLER, H. 1978. Zur Populationsökologie des Uhus *Bubo bubo* im Hochgebirge: Bestand, Bestandsentwicklung und Lebensraum in den Rätischen Alpen. *Orn. Beob.* 75:237–265. HALLER, W. 1951. Zur "kièwitt"-Frage (Steinkauz oder Waldkauz?). *Orn. Mitt.* 3:199–201. HANNA, W. C. 1941. Nesting of the Flammulated Screech Owl in California. *Condor* 43:290–291. HANNEY, P. 1963. Observations upon the food of the Barn Owl (*Tyto alba*) in southern Nyasaland, with a method of ascertaining population dynamics of rodent prey. *Ann. Mag. Nat. Hist.* Ser. 13(6):305–313. HARRISON, C. J. O. 1960. The food of some urban Tawny Owls. *Bird Study* 7:236–240. HARRISON, J. M. 1957. Exhibition of a new race of the Little Owl from the Iberian Peninsula. *Bull. Brit. Orn. Cl.* 77:2–3. HARTERT, E. 1912–21. *Die Vögel der paläarktischen Fauna.* 2. Berlin. HARTERT, E. 1929. On various forms of the genus *Tyto. Nov. Zool.* 35:93–104. HARTERT, E. & STEINBACHER, F. 1932–38. *Die Vögel der paläarktischen Fauna.* Suppl. Berlin. HARTLEY, P. H. T. 1947. The food of the Long-eared Owl in Iraq. *Ibis* 89:566–569. HARTLEY, P. H. T. 1950. An experimental analysis of interspecific recognition. *Symp. Soc. Exper. Biol.* 4:313–336. HARTOG, J. C. DEN & NØRREVANG, A. & ZINO, P. A. 1984. Bird observations in the Selvagens Islands. *Bol. Mus. Mun. Funchal* 36:111–141. HASENYAGER, R. N. & PEDERSON, J. C. & HEGGEN, A. W. 1979. Flammulated Owl nesting in a squirrel box. *Western Birds* 10:224. HAVERSCHMIDT, F. 1962. Beobachtungen an der Schleiereule, *Tyto alba*, in Surinam. *J. f. Ornith.* 103:236–242. HAVERSCHMIDT, F. 1968. *Birds of Surinam.* Edinburgh-London. HAVERSCHMIDT, F. 1970. Barn Owls hunting by daylight in Surinam. *Wilson Bull.* 82:101. HAYWARD, G. D. & GARTON, E. O. 1983. First nesting record for Boreal Owl in Idaho. *Condor* 85:501. HEINTZELMAN, D. S. 1984. *Guide to Owl Watching in North America.* Piscataway, NJ. HEITKAMP, U. 1967. Ernährungsökologie der Waldohreule (*Asio otus*). *Orn. Mitt.* 19:139–143. HEKSTRA, G. P. 1982. Description of twenty-four new subspecies of American *Otus. Bull. Zool. Mus. Univ. Amsterdam* 9:49–63. HEKSTRA, G. P. 1982. A revision of the American Screech Owls (*Otus*). Doct. Diss., Free Univ., Amsterdam. HENNY, C. J. & BLUS, L. J. 1981. Artificial burrows provide new insight into Burrowing Owl nesting biology. *Raptor Res.* 15:82–85. HENRY, G. M. 1971. *A Guide to the Birds of Ceylon.* 2nd edn. London. HERRERA, C. M. & HIRALDO, F. 1976. Food-niche and trophic relationships among European owls. *Ornis. Scand.* 7:29–41. HERRLINGER, E. 1973. Die Wiedereinbürgerung des Uhus *Bubo bubo* in der Bundesrepublik Deutschlands. *Bonn. Zool. Monogr.* 4:1–151. HICKEY, J. J. (ed.). 1969. *Peregrine Falcon Populations.* Wisconsin. HILDEN, O. & SOLONEN, T. 1987. Status of the Great Grey Owl in Finland. In Nero *et al.*, 1987:115–120. HIRALDO, F. & ANDRADA, J. & PARREÑO, F. F. 1975. Diet of the Eagle Owl (*Bubo bubo*) in Mediterranean Spain. *Acta Vertebr.* 2:161–177. HIRONS, G. & HARDY, A. & STANLEY, P. 1979. Starvation in young Tawny Owls. *Bird Study* 26:59–63. HOEKSTRA, B. 1975. Twee gevallen van kannibalisme bij de Kerkuil *Tyto alba. Limosa* 47:118–120. HOESCH, W. & NIETHAMMER, G. 1940. Die Vogelwelt Deutsch-Südwestafrikas. *J. f. Ornith.* (Spec. No.) 88:1–404. HOFFMANN, R. 1927. *Birds of the Pacific States.* HÖGLUND, N. H. & LANSGREN, E. 1968. The Great Grey Owl and its prey in Sweden. *Viltrevy, Swedish Wildlife* 5:363–421. HOLMBERG, T. 1974. En studie av slagugglans *Strix uralensis* läten. *Vår Fågelv.* 33:140–146. HOOGERWERF, A. 1946. Aanteekeningen inzake enkele ondersoorten van *Ninox scutulata. Limosa* 19:44–47. HOOGERWERF, A. 1949. Een bijdrage tot de oölogie van het eiland Java. *Limosa* 22:1–279. HOSKING, E. J. & NEWBERRY, C. W. 1945. *Birds of the Night.* London. HOUSTON, C. S. 1971. Brood size of the Great Horned Owl in Saskatchewan. *Bird-Banding* 42:103–105. HOUSTON, C. S. 1975. Close proximity of Red-tailed Hawk and Great Horned Owl nests. *Auk* 92:612–614. HOUSTON, C. S. 1978. Recoveries of Saskatchewan-banded Great Horned Owls. *Canad. Field-Nat.* 92:61–66. HOUSTON, S. 1960. 1960 – The year of the owls. *Blue Jay* 18(3):105–110. HOWIE, R. R. & RITCEY, R. 1987. Distribution, habitat selection, and densities of Flammulated Owls in British Colombia. In Nero *et al.*, 1987:249–254. HUBBARD, J. P. 1965. The summer birds of the forests of the Mogollon Mountains, New Mexico. *Condor* 67:404–415. HUBBARD, J. P. & CROSSIN, R. S. 1974. Notes on northern Mexican birds. *Nemouria*, Delaware Mus. Nat. Hist. 14:1–41. HÜCKLER, U. 1970. Ringfunde der Waldohreule (*Asio otus*). *Auspicium* 4:111–137. HÜE, F. & ETCHÉCOPAR, R. D. 1970. *Les Oiseaux du Proche et du Moyen Orient.* Paris. HUEY, L. M. 1913. Nesting notes from San Diego County. *Condor* 15:228. HUGHES, W. M. 1967. Birds trapped on Vancouver Airport banded & released January 1964–May 15, 1967. *Canad. Wildlife Serv. Field Note* 47:1–20. HUME, A. O. 1878. *Asio butleri* Sp. Nov.? *Stray Feathers* 7:316–318. HUMPHREY, P. S. & BRIDGE, D., REYNOLDS, P. W. & PETERSON, R. T. 1970. Birds of Isla Grande (Tierra del Fuego). Lawrence, Univ. Kansas Mus. Nat. Hist. IGALFFY, K. 1949. Swallows exterminated by a pair of Little Owls. *Larus* 3:371. ILYICHEV, V. D. 1961. On the morphology and function of the facial disc in birds. *Dokl. Akad. Nauk* 137:1,241–1,244. IRWIN, M. P. ST. 1981. *The Birds of Zimbabwe.* Salisbury. IVANOV, A. I. 1955. The birds of the Pamirs–Alai mountain system in the winter season. *Acta XI Congr. Int. Ornith.* (Basel, 1954):470–475. JACOB, J. & POLTZ, J. 1974. Chemical composition of uropygial gland secretions of owls. *J. Lipid. Res.* 15:243–248.

JACOB, J. & ZISWILER, V. 1982. The uropygial gland. *Avian Biol.* 6:199–324. JACOT, E. 1931. Notes on the Spotted and Flammulated Screech Owls in Arizona. *Condor* 33:8–11. JAHN, H. 1942. Zur Oekologie und Biologie der Vögel Japans. *J. f. Ornith.* 90:3–302. JAKSIĆ, F. M. 1983. The trophic structure of sympatric assemblages of diurnal and nocturnal birds of prey. *Amer. Midland Nat.* 109:152–162. JAKSIĆ, F. M. & GREENE, H. W. & YÁÑEZ, J. L. 1981. The guild structure of a community of predatory vertebrates in central Chile. *Oecologia* 49:21–28. JAKSIĆ, F. M. & MARTI, C. D. 1981. Trophic ecology of *Athene* owls in mediterranean-type ecosystems: a comparative analysis. *Canad. J. Zool.* 59:2,331–2,340. JAKSIĆ, F. M. & MARTI, C. D. 1984. Comparative food habits of *Bubo* owls in mediterranean-type ecosystems. *Condor* 86:288–296. JAKSIĆ, F. M. & SEIB, R. L. & HERRERA, C. M. 1982. Predation by Barn Owl (*Tyto alba*) in Mediterranean habitats of Chile, Spain and California: a comparative approach. *Amer. Midland Nat.* 107:151–162. JAKSIĆ, F. M. & SORIGUER, R. C. 1981. Predation upon the European rabbit (*Oryctolagus cuniculus*) in mediterranean habitats of Chile and Spain: a comparative analysis. *J. Anim. Ecol.* 50:269–281. JAKSIĆ, F. M. & YÁÑEZ, J. L. 1980. Differential utilization of prey resources by Great Horned Owls and Barn Owls in central Chile. *Auk* 96:895–896. JAMES, P. & HAYSE, A. 1963. Elf Owl rediscovered in Lower Rio Grande Delta of Texas. *Wilson Bull.* 75:179–182. JAMES, R. D. 1977. First nesting of the Great Gray Owl in Ontario. *Ontario Field Biol.* 31:55. JANOSSY, D. 1963. Die altpleistozäne Wirbeltierfauna von Kövesvárad bei Répáshuta (Bükk-Gebirge). *Ann. Hist.-Nat. Mus. Hung.* 55:109–140. JANOSSY, D. 1972. Die mittelpleistozäne Vogelfauna der Stránská Skála. *Anthropos* 20:35–64. JANOSSY, D. 1978. Plio-Pleistocene bird remains from the Carpathian Basin. III. *Aquila* 84:9–36. JANOSSY, D. 1981. Plio-Pleistocene bird remains from the Carpathian Basin. IV. Systematical and geographical catalogue. *Aquila* 87:9–22. JANOSSY, D. & SCHMIDT, E. 1970. Die Nahrung des Uhus (*Bubo bubo*). Regionale und erdzeitliche Änderungen. *Bonn. Zool. Beitr.* 21:25–51. JANSSON, E. 1964. Anteckningar rörande häckande sparvuggla (*Glaucidium passerinum*). *Vår Fågelv.* 23:209–222. JEHL, J. R. & PARKES, K. C. 1982. The status of the avifauna of the Revillagigedo Islands, Mexico. *Wilson Bull.* 94:1–19. JENNINGS, M. C. 1977. More about "desert Liliths", Hume's Tawny Owl. *Israel Land and Nature*:168–169. JENNINGS, M. C. 1981. *The Birds of Saudi Arabia: A Check-List.* Cambridge. JOHANSEN, Hermann 1928. Erreichtes und Unerreichtes. *Beitr. Fortpfl. biol. Vogel* 4:13–22. JOHANSEN, H. 1956. Die Vogelfauna Westsibiriens. III. *J. f. Ornith.* 97:206–219. JOHNSON, A. W. 1967. *The Birds of Chile.* 2. Buenos Aires. JOHNSON, D. H. 1987. Barred Owls and nest boxes – Results of a five-year study in Minnesota. In Nero *et al.*, 1987:129–134. JOHNSON, H. C. 1903. Pigmy owl in town. *Condor* 5:81. JOHNSON, N. K. 1963. The supposed migratory status of the Flammulated Owl. *Wilson Bull.* 75:174–178. JOHNSON, N. K. 1965. The breeding avifaunas of the Sheep and Spring Ranges in southern Nevada. *Condor* 67:93–124. JOHNSON, N. K. 1973. The distribution of boreal avifaunas in southeastern Nevada. *Occ. Pap. Biol. Soc. Nevada* 36:1–14. JOHNSON, N. K. & RUSSELL, W. C. 1962. Distributional data on certain owls in the western Great Basin. *Condor* 64:513–514. JOHNSON, W. D. 1974. The bioenergetics of the Barn Owl. Doct. Thesis, California State Univ., Long Beach. JOHNSON, W. D. & COLLINS, C. T. 1975. Notes on the metabolism of the Cuckoo Owlet and Hawk Owl. *Bull. South Cal. Acad. Sci.* 74:44–45. JONG, J. DE 1983. *De Kerkuil.* Utrecht-Antwerp. JOTTRAND, L. & TRICOT, J. 1969. Un cas de nidification en 1963 de la Chouette de Tengmalm (*Aegolius funereus*) en Belgique. *Aves* 6:29–30. JUILLARD, M. 1979. La croissance des jeunes Chouettes chevêches, *Athene noctua*, pendant leur séjour au nid. *Nos Oiseaux* 35:113–124. JUILLARD, M. 1980. Répartition, biotopes et sites de nidification de la Chouette chevêche, *Athene noctua*, en Suisse. *Nos Oiseaux* 35:309–337. KADOCHNIKOC, N. P. 1963. On the breeding biology of the Scops Owl in the Voronesh Region. *Ornitologiya* 6:104–110. KAISER, A. 1891. Zur Ornis der Sinaihalbinsel. *Orn. Jahreb.* 3:207–248. KÄLLANDER, H. 1975. Invasionen av sparvuggla *Glaucidium passerinum* i Skåne hösten 1974. *Anser* 14:183–190. KEHOE, M. 1982. Nesting Hawk Owls in Lake of the Woods County. *Loon* 54:182–184. KEITH, S. & TWOMEY, A. 1968. New distributional records of some East African birds. *Ibis* 110:537–548. KELSO, E. H. 1936. A new Striped Owl from Tobago. *Auk* 53:82. KELSO, L. 1932. *Synopsis of the American Wood Owls of the Genus Ciccaba.* Lancaster, Pa.:1–47. KELSO, L. 1940. Variation of the external ear-opening in the *Strigidae. Wilson Bull.* 52:24–29. KELSO, L. 1941. That ligamentous bridge. *Biol. Leaflet* 13:1. KELSO, L. & KELSO, E. H. 1934. *A Key to Species of American Owls and a List of the Owls of the Americas.* Washington, DC. KELSO, L. & KELSO, E. H. 1936. The relation of feathering of feet of American owls to humidity of environment and to life zones. *Auk* 53:51–56. KENNARD, F. H. 1915. The Okaloacoochee Slough. *Auk* 32:154–166. KENNEDY, A. J. 1981. Snowy Owl prey on Prince of Wales Island, Northwest Territories. *Canad. Nat.* 108:195–197. KENYON, K. W. 1947. Cause of death of a Flammulated Owl. *Condor* 49:88. KEULEN-KROMHOUT, GERDA VAN. 1974. Een vergelijkend gehooronderzoek aan *Athene noctua* en *Athene brama.* (Unpubl.) Rep. Syst. Zool., Biol. Lab., Free Univ., Amsterdam. KEYES, C. R. 1911. A history of certain Great Horned Owls. *Condor* 13:5–19. KIMBALL, H. H. 1925. Pigmy owl killing a quail. *Condor* 27:209–210. KLAUS, S. & KUCERA, L. & WIESNER, J. 1975. Zum Verhalten unverpaarter Männchen des Sperlingskauzes (*Glaucidium passerinum*). *Orn. Mitt.* 28:95–100. KLAUS, S. &

BIBLIOGRAPHY

MIKKOLA, H. & WIESNER, J. 1975. Aktivität und Ernährung des Rauhfusskauzes *Aegolius funereus* (L.) während der Fortpflanzungsperiode. *Zool. Jahrb. Syst.* 102:485–507. KLEINSCHMIDT, O. 1934. *Die Raubvögel der Heimat.* Leipzig. KÖRPIMAKI, E. 1987. Prey caching of breeding Tengmalm's Owls *Aegolius funereus* as a buffer against temporary food shortage. *Ibis* 129:499–510. KNIGHT, R. L. & JACKMAN, R. E. 1984. Food-niche relationships between Great Horned Owls and Common Barn-Owls in eastern Washington. *Auk* 101:175–179. KNIGHT, R. L. & SMITH, D. G. & ERICKSON, A. 1982. Nesting raptors along the Columbia River in north-central Washington. *Murrelet* 63:2–8. KNÖTZSCH, G. 1978. Ansiedlungsversuche und Notizen zur Biologie des Steinkauzes (*Athene noctua*). *Vogelwelt* 99:41–54. KNUDSEN, E. J. 1980. Sound localization on the neuronal level. *Acta XVII Congr. Int. Ornith.* (Berlin, 1978):718–723. KNUDSEN, E. J. 1981. The hearing of the Barn Owl. *Scient. Amer.* 245(6):112–125. KNUDSEN, E. J. & KONISHI, M. 1980. Monaural occlusion shifts receptive-field locations of auditory midbrain units in the owl. *J. Neurophysiol.* 44:687–695. KNYSTAUTAS, A. J. V. & SIBNEV, J. B. 1987. *Die Vogelwelt Ussuriens.* Hamburg–Berlin. KOELZ, W. 1939. New birds from Asia, chiefly from India. *Proc. Biol. Soc. Washington* 52:61–82. KOELZ, W. 1940. Notes on the winter birds of the Lower Punjab. *Pap. Michig. Acad. Sci. Arts & Letters* 25:323–356. KOENIG, A. 1936. *Die Vögel am Nil. 2. Die Raubvögel.* Bonn. KOENIG, L. 1973. Das Aktionssystem der Zwergohreule *Otus scops scops. J. Comp. Ethol.* (Suppl.):13:1–124. KOHL, S. 1977. Über die taxonomische Stellung der südosteuropäischen Habichtskäuze, *Strix uralensis macroura* Wolf, 1810. *Stud. Comm. Muz. Bruckenthal* 21:309–344. KONDRATZKI, B. & ALTMÜLLER, R. 1976. Bigamie beim Rauhfusskauz (*Aegolius funereus*). *Vogelwelt* 97:146–149. KÖNIG, C. 1965. Bestandsverändernde Faktoren beim Rauhfusskauz (*Aegolius funereus*) in Baden-Württemberg. *Ber. Int. Rat Vogelsch., Deutsche Sekt.* 5:32–38. KÖNIG, C. 1967. Einfluss des nasskalten Frühjahrs 1967 auf die Fortpflanzungsrate des Rauhfusskauzes (*Aegolius funereus*) in Baden-Württemberg. *Ber. Int. Rat Vogelsch., Deutsche Sekt.* 7:37–38. KÖNIG, C. 1968. Lautäusserungen von Rauhfusskauz (*Aegolius funereus*) und Sperlingskauz (*Glaucidium passerinum*). *Vogelwelt* (Suppl.) 1:115–138. KÖNIG, C. 1968. Zur Unterscheidung ähnlicher Rufe von Zwergohreule (*Otus scops*), Sperlingskauz (*Glaucidium passerinum*) und Geburtshelferkröte (*Alytes obstetricans*). *Orn. Mitt.* 20:35. KÖNIG, C. 1969. Sechsjährige Untersuchungen an einer Population des Rauhfusskauzes, *Aegolius funereus. J. f. Ornith.* 110:133–147. KÖNIG, C. 1981. Die Wiedereinbürgerung des Sperlingskauzes (*Glaucidium passerinum*) im Schwarzwald. *Forschungsber. Nationalpark Berchtesgaden* 3:17–20. KÖNIG, C. & KAISER, H. 1985. Der Sperlingskauz (*Glaucidium passerinum*) im Schwarzwald. *J. f. Ornith.* 126:443. KONING, F. J. 1982. Aantekeningen over de verdeling en de ruimte en de voedselbronnen onder de roofvogels en uilen in onze duinen. *Graspieper* 2:43–53. KONING, F. J. 1986. Hoe Kauwen *Corvus mondedula* door Bosuilen *Strix aluco* bewoonde nestkasten veroveren. *Limosa* 59:91–93. KONISHI, M. & KENUK. A. S. 1975. Discrimination of noise spectre by memory in the Barn Owl. *J. Comp. Physiol.* 97:55–58. KORPIMAKI, E. 1987. Sexual size dimorphism and life-history traits of Tengmalm's Owl: a review. In Nero et al., 1987:157–161. KRAHE, R. G. 1981. Breeding the Striped Owl *Rhinoptynx clamator. Avicult. Mag.* 87:242–248. KRASNOV, Y. V. 1985. On the biology of the Snowy Owl (*Nyctea scandiaca*) on the east Murman Coast. In Birds of prey and owls in the nature reserves of the RSFSR (Central Scient. Res. Lab. Agric. and Nature Res., Moscow):110–116. KUHK, R. 1938. Der Rauhfusskauz, *Aegolius funereus* (L.), Brutvogel in der Lüneburger Heide. *Orn. Monatsber.* 46:112–113. KUHK, R. 1939. Gehäuftes Brutvorkommen des Rauhfusskauzes, *Aegolius funereus* (L.), in der Lüneburger Heide. *Orn. Monatsber.* 47:76–77. KUHK, R. 1953. Lautäusserungen und jahreszeitliche Gesangstätigkeit des Rauhfusskauzes (*Aegolius funereus*). *J. f. Ornith.* 94:83–93. KUHK, R. 1966. Aus der Sinneswelt des Rauhfusskauzes (*Aegolius funereus*). *Anz. Orn. Ges. Bayern* (Spec. No.) 7:714–716. KUHK, R. 1969. Schlüpfen und Entwicklung der Nestjungen beim Rauhfusskauz (*Aegolius funereus*). *Bonn. Zool. Beitr.* 20:145–150. KUMERLOEVE, H. 1968. Gewöllstudien an einem Sumpfohreulen-Brutpaar auf der Insel Amrum. *Orn. Mitt.* 20:33–34. KUMERLOEVE, H. 1970. Zum Stimmrepertoir der Zwergohreule (*Otus scops*). *Orn. Mitt.* 22:21. KURODA, N. 1967. A note on the asymmetric ears in *Asio flammeus. J. Yamashina Inst. Ornith.* 5:106–109. LAHTI, E. 1972. Nest sites and nesting habitats of the Ural Owl *Strix uralensis* in Finland during the period 1870–1969. *Ornis Fenn.* 49:91–97. LAND, H. C. 1970. *Birds of Guatemala.* Wynnewood, Pa. LANGRAND, O. & B.-U. MEYBURG. 1984. Birds of prey and owls in Madagascar: their distribution, status and conservation. *Proc. 2nd Symp. African Predatory Birds*, Natal Bird Club, Durban. LEES-SMITH, D. T. 1986. Composition and origins of the south-west Arabian avifauna: a preliminary analysis. *Sandgrouse* 7:71–92. LEIN, M. R. & BOXALL, P. C. 1979. Interactions between Snowy and Short-eared owls in winter. *Canad. Field-Nat.* 93:411–414. LENTON, G. M. 1984. The feeding and breeding ecology of Barn Owls *Tyto alba* in Peninsular Malaysia. *Ibis* 126:551–575. LENZ, M. 1967. Zur Verbreitung des Sperlingskauzes (*Glaucidium passerinum*) im Rachelgebiet (Bayerischer Wald). *Orn. Mitt.* 19:213–216. LEOPOLD, A. S. 1950. Vegetation zones of Mexico. *Ecology* 31:507–518. LESHEM, Y. 1979. Humes Waldkauz (*Strix butleri*) – die Lilith der Wüste. *Natur u. Mus. Senckenb. Naturf. Ges.* 109:375–377. LESHEM, Y. 1981. Israel's raptors – the Negev and Judean Desert. *Ann. Rep. Hawk Trust* 11:30–35. LESHEM, Y. 1981. The occurrence of Hume's Tawny Owl in Israel and Sinai. *Sandgrouse* 2:100–102. LEVIN, S. A. & LEVIN, J. A. & PAINE, R. T. 1977. Snowy Owl predation on Short-eared Owls. *Condor* 79:395. LIGON, J. D. 1963. Breeding range expansion of the burrowing owl in Florida. *Auk* 80:367–368. LIGON, J. D. 1968. The biology of the Elf Owl, *Micrathene whitneyi. Misc. Publ. Mus. Zool. Univ. Michigan* 136:1–70. LIGON, J. D. 1969. Some aspects of temperature relations in small owls. *Auk* 86:458–472. LIGON, J. S. 1926. Habits of the Spotted Owl (*Syrnium occidentale*). *Auk* 43:421–429. LINDBERG, P. 1966. Invasionen av sparvuggla (*Glaucidium passerinum*) i södra Skandinavien 1963–64. *Vår Fågelv.* 25: 106–142. LINDBLAD, J. 1967. *I Ugglemarker.* Stockholm. LINDKE, U. 1966. En undersökning av pärlugglans (*Aegolius funereus*) bytesval i SV Lappland. *Vår Fågelv.* 25:40–48. LINKOLA, P. & MYLLYMÄKI, A. 1969. Der Einfluss der Kleinsäugerfluktuationen auf das Brüten einiger kleinsäugerfressender Vögel im südlichen Häme, Mittelfinnland 1952–1966. *Ornis Fenn.* 46:45–78. LOCKLEY, R. M. 1938. The Little Owl inquiry and the Skokholm Storm-Petrels. *Brit. Birds* 31:278–279. LOEWIS, O. VON. 1883. Livland's Eulen, wildlebende Hühnerarten und Watvögel. *Zool. Garten* 24:113–116. LÖHRL, H. 1965. Nistplatz-Demonstration der Schleiereule (*Tyto alba*). *J. f. Ornith.* 106:113–114. LOURENÇO, W. R. & DEKEYSER, P. L. 1976. Deux oiseaux prédateurs de scorpions. *Ois. Rev. Fr. Orn.* 46:167–172. LOVARI, S. 1974. The feeding habits of four raptors in central Italy. *Raptor Res.* 8:45–57. LOVARI, S. Sex differences in the diet of the Barn Owl. *Avocetta* 1:61–63. LOVARI, S. & RENZONI, A. & FONDI, R. 1976. The predatory habits of the Barn Owl (*Tyto alba* Scopoli) in relation to the vegetation cover. *Boll. Zool.* 43:173–191. LOWERY, G. H. & DALQUEST, W. W. 1951. Birds from the State of Veracruz, Mexico. *Univ. Kansas Publ. Mus. Nat. Hist.* 3:533–649. LOWERY, G. H. & NEWMAN, R. J. 1949. New birds from the state of San Luis Potosi and the Tuxtla Mountains of Veracruz, Mexico. *Occ. Pap. Mus. Zool. Louisiana State Univ.* 22:1–10. LUNDBERG, A. & WESTMAN, B. 1984. Reproductive success, mortality and nest site requirements of the Ural Owl *Strix uralensis* in central Sweden. *Proc. 4th Nordic Orn. Congr. 1983*: 265–269. LUNDGREN, A. 1980. Why are the Ural Owl *Strix uralensis* and the Tawny Owl *S. aluco* parapatric in Scandinavia? *Ornis Scand.* 11:116–120. MACLEAN, G. L. 1985. *Roberts' Birds of Southern Africa.* Cape Town. MADGE, G. 1985. Threatening behaviour by Barn Owl. *Brit. Birds* 78:665. MAKATSCH, W. 1976. *Die Eier der Vögel Europas.* 2. Leipzig. MALIEVSKY, A. S. & PUKINSKY, Y. B. 1983. *Birds of the Leningrad Region and Bordering Areas.* Leningrad. MALLETTE, R. D. & GOULD, G. J. 1976. *Raptors of California.* Dept Fish and Game, Sacramento, California. MANNES, P. 1982. Zehn Jahre Bruterfolg bei wiedereingebürgerten Uhus an einem Brutplatz im Harz. *Ber. Int. Rat Vogelsch., Deutsche Sekt.* 22:35–37. MANNING, T. H. & HÖHN, E. O. MACPHERSON, A. H. 1956. The birds of Banks Island. *Bull. Nat. Mus. Canada* 143:1–136. MARCOT, B. G. & GARDETTO, J. 1980. Status of the Spotted Owl in Six Rivers National Park, California. *Western Birds* 11:79–87. MARKS, J. S. 1985. Yearling male Long-eared Owls breed near natal nest. *J. Field Ornith.* 56:181–182. MARSHALL, J. T. 1939. Territorial behaviour of the Flammulated Screech Owl. *Condor* 41:71–78. MARSHALL, J. T. 1942. Food and habit of the Spotted Owl. *Condor* 44:66–67. MARSHALL, J. T. 1957. Birds of pine-oak woodland in southern Arizona and adjacent Mexico. *Pacific Coast Avif. Cooper Orn. Soc.* 32:1–125. MARSHALL, J. T. 1966. Relationships of certain owls around the Pacific. *Nat. Hist. Bull. Siam Soc.* 21:235–242. MARSHALL, J. T. 1967. Parallel variation in North and Middle American screech owls. *Monogr. West. Found. Vertebr. Zool.* 1:1–72. MARSHALL, J. T. 1978. Systematics of smaller Asian night birds based on voice. *Orn. Monogr.* 25:1–58. MARTI, C. D. 1969. Renesting by Barn & Great Horned Owls. *Wilson Bull.* 81:467–468. MARTI, C. D. 1973. Ten years of Barn Owl prey data from a Colorado nest site. *Wilson Bull.* 85:85–86. MARTI, C. D. 1974. Feeding ecology of four sympatric owls. *Condor* 76:45–61. MARTI, C. D. 1976. A review of prey selection by the Long-eared Owl. *Condor* 78:331–336. MARTI, C. D. & WAGNER, P. W. & DENNE, K. W. 1979. Nest boxes for the management of Barn Owls. *Bull. Wildlife Soc.* 7(3):145–148. MARTIN, D. J. 1973. A spectrographic analysis of Burrowing Owl vocalizations. *Auk* 90:564–578. MARTIN, D. J. 1973. Selected aspects of Burrowing Owl ecology and behavior. *Condor* 75:446–456. MARTIN, D. J. 1974. Copulatory and vocal behavior of a pair of Whiskered Owls. *Auk* 91:619–624. MARTIN, G. R. 1974. Color vision in the tawny owl (*Strix aluco*). *J. Comp. Physiol. Psychology* 86:133–141. MARTIN, G. R. 1978. Through an owl's eye. *New Scientist* (12 Jan. 1978):72–74. MARTIN, G. R. 1982. An owl's eye: schematic optics and visual performance in *Strix aluco* L. *J. Comp. Physiol.* 145:341–349. MARTIN, G. R. 1986. Sensory capacities and the nocturnal habit of owls. *Ibis* 128:266–277. MARTIN, S. J. 1983. Burrowing Owl occurrence in white-tailed prairie dog colonies. *J. Field Ornith.* 54:422–423. MÄRZ, R. 1968. *Der Rauhfusskauz.* Neue Brehm-Büch. 394. Wittenberg-Lutherstadt. MASTERSON, A. 1973. Marsh Owls and Grass Owls. *Honeyguide, Rhod. Orn. Soc.* 73:17–19. MATSUOKA, S. 1977. Winter food habits of the Ural Owl *Strix uralensis* Pallas in the Tomakomai Experiment Forest of Hokkaido University. *Res. Bull. Coll. Exp. For., Hokkaido Univ.* 34:161–174. MATTES, H. 1981. Zur Ökologie eines Sperlingskauz-Paares *Glaucidium passerinum* im subalpinen Lärchen-Arven-Wald. *Orn. Beob.* 78:103–108. MATTHIAE, J. M. 1982. A nesting Boreal Owl in Minnesota. *Loon* 54:212–214. MAUERSBERGER, G. & WAGNER, S., WALLSHLÄGER, D. & WARTHOLD, R. 1982. Neue

Daten zur Avifauna Mongolien. *Mitt. Zool. Mus. Berlin* 58:11–74. MAYR, E. & PHELPS, W. H., JR. 1967. The origin of the bird fauna of the South Venezuelan Highlands. *Bull. Amer. Mus. Nat. Hist.* 136(5):269–327. MAYR, E. & SHORT, L. L. 1970. Species taxa of North American birds. *Publ. Nuttall Orn. Cl.* 9:1–127. MCCANN, C. 1935. The Short-eared Owl (*Asio flammeus* (Pontopp.)) out at sea. *J. Bombay Nat. Hist. Soc.* 38:623–624. MCINVAILLE, W. B. & KEITH, L. B. 1974. Predator–prey relations and breeding biology of the Great Horned Owl and Red-tailed Hawk in Central Alberta. *Canad. Field-Nat.* 88:1–20. MEBS, T. 1960. Die Zwergohreule (*Otus scops*) als Brutvogel an der Halburg bei Volkach/Main. *Anz. Orn. Ges. Bayern* 5(6):584–590. MEBS, T. 1967. Der Sperlingskauz, *Glaucidium passerinum*, in Bayern, sein Vorkommen in älterer und neuer Zeit. *Bayer. Tierw.* 1:85–94. MEBS, T. 1972. Zur Biologie des Uhus (*Bubo bubo*) im nördlichen Frankenjura. *Anz. Orn. Ges. Bayern* 11:7–25. MEBS, T. 1980. *Eulen und Käuze*. 5th edn. Stuttgart. MEDWAY, LORD & WELLS, D. R. 1976. *The Birds of the Malay peninsula*. 5. Witherby & Univ. Malaya. MEES, G. F. 1964. A revision of the Australian owls (Strigidae and Tytonidae). *Zool. Verhandl. Rijksmus. Nat. Hist. Leiden* 65:1–62. MEES, G. F. 1970. Notes on some birds from the island of Formosa (Taiwan). *Zool. Meded. Ryksmus. Nat. Hist. Leiden* 44 (20):285–304. MEEUS, H. 1981. On the increase in numbers of the tawny owl (*Strix aluco*) in the Turnhout Kempen. *Wielewaal* 47:130–132. MEINERTZHAGEN, R. 1930. *Nicoll's Birds of Egypt*. 2. London. MEINERTZHAGEN, R. 1948. On the *Otus scops* (Linnaeus) group, and allied groups, with special reference to *Otus brucei* (Hume). *Bull. Brit. Orn. Cl.* 69:8–11. MEINERTZHAGEN, R. 1951. On the genera *Athene* Boie 1822 and *Speotyto* Gloger 1842. *Bull. Brit. Orn. Cl.* 70:8–9. MEINERTZHAGEN, R. 1954. *Birds of Arabia*. Edinburgh–London. MEINERTZHAGEN, R. 1959. *Pirates and predators*. Edinburgh–London. MEISE, W. 1933. Zur Systematik der Fischeulen. *Orn. Monatsber.* 41:169–173. MEISE, W. 1934. Die Vogelwelt der Mandschurei. *Abhandl. Ber. Mus. Tierk. Völkerk. Dresden* 18(2):1–86. MENDELSOHN, H. & YOM-TOV, Y. & SAFRIEL, V. 1975. Hume's Tawny Owl *Strix butleri* in the Judean, Negev and Sinai deserts. *Ibis* 117:110–111. MENGEL, R. M. 1965. The birds of Kentucky. *AOU Ornith. Monogr.* 3:1–581. MERIKALLIO, E. 1958. Finnish birds, their distribution and numbers. *Soc. Fauna Flora Fenn., Fauna Fennica*. 5. MERSON, M. H. & LETA, L. D. & BYERS, R. E. 1983. Observations on roosting sites of Screech-Owls. *J. Field Ornith.* 54:419–421. MEYKNECHT, J. T. V. 1941. Farbensehen und Helligkeitsunterscheidung beim Steinkauz (*Athene noctua vidallii* A. E. Brehm). *Ardea* 30 (Suppl.):1–46. MEYLAN, O. & STADLER, H. 1930. Aus der Brutgeschichte des Rauhfusskauzes (*Aegolius funereus* (GM.)). *Beitr. Fortpfl. Biol. Vögel* 6:9–16. MEYLAN, O. & STADLER, H. 1930. Contribution a l'étude des mœurs et de la voix de la Chouette tengmalm, *Aegolius t. tengmalmi* (GM.). *Bull. Murithienne* 47:135–148. MICHAEL, C. W. 1927. Pigmy Owl: the little demon. *Condor* 29:161–162. MIENIS, H. K. 1971. *Theba pisana* in pellets of an Israelian Owl. *Basteria* 35:73–75. MIKKOLA, H. 1970. On the activity and food of the Pygmy Owl *Glaucidium passerinum* during breeding. *Ornis Fenn.* 47:10–14. MIKKOLA, H. 1970. Zur Ernährung des Sperlingskauzes (*Glaucidium passerinum*) zur Brutzeit. *Orn. Mitt.* 22:73–75. MIKKOLA, H. 1971. Zur Ernährung der Sperbereule (*Surnia ulula*) zur Brutzeit. *Angew. Ornith.* 3:133–141. MIKKOLA, H. 1972. Hawk Owls and their prey in Northern Europe. *Brit. Birds* 65:453–460. MIKKOLA, H. 1972. Neue Ergebnisse über die Ernährung des Uralkauzes (*Strix uralensis*). *Orn. Mitt.* 24:159–163. MIKKOLA, H. 1972. Zur Aktivität und Ernährung des Sperlingskauzes (*Glaucidium passerinum*) in der Brutzeit. *Beitr. Vogelk.* 18:297–309. MIKKOLA, H. 1976. Owls killing and killed by other owls and raptors in Europe. *Brit. Birds* 69:144–154. MIKKOLA, H. 1979. On the eye structure and vision of the Eagle Owl. (Finnish; summary in English.) *Lounais-Hämeen Luonto* 62:47–50. MIKKOLA, H. 1981. *Der Bartkauz*. Neue Brehm-Büch. 538. Wittenberg-Lutherstadt. MIKKOLA, H. 1983. *Owls of Europe*. Calton. MIKKOLA, H. & SULKAVA, S. 1969. On occurrence and feeding habits of Short-eared Owl in Finland 1964–68. *Ornis Fenn.* 46:188–193. MIKULICA, V. & HALOUZKA, K. & TILC, K. 1981. Hepatosplenitis infectiosa strigum bei Eulen in den Zoologischen Gärten Dvůr Králové nad Labem und Brno. *Verhandl. XXIII. Int. Symp. Erkrankungen Zootiere*:407–413. MILLER, A. H. 1934. The vocal apparatus of some North American owls. *Condor* 36:204–213. MILLER, A. H. 1935. The vocal apparatus of the Elf Owl and the Spotted Screech Owl. *Condor* 37:288. MILLER, A. H. 1947. The structural basis of the voice of the Flammulated Owl. *Auk* 64:133–135. MILLER, A. H. 1952. Supplementary data on the tropical avifauna of the arid Upper Magdalena Valley of Columbia. *Auk* 69:450–457. MILLER, A. H. 1955. The avifauna of the Sierra del Carmen of Coahuila, Mexico. *Condor* 57:154–178. MILLER, A. H. 1963. The vocal apparatus of two South American owls. *Condor* 65:440–441. MILLER, A. H. 1965. The syringeal structure of the Asiatic owl *Phodilus*. *Condor* 67:536–538. MILLER, A. H. & MILLER, L. 1951. Geographic variation of the screech owls of the deserts of western North America. *Condor* 53:161–177. MILLER, L. H. 1916. The owl remains from Rancho la Brea. *Bull. Dept Geol. Univ. Calif.* 9:97–104. MILLER, L. 1933. A Pleistocene record of the Flammeolated Screech Owl. *Trans. San Diego Soc. Nat. Hist.* 7(19):209–210. MINGOZZI, T. 1980. Nidification terrestre chez le Hibou moyen-duc, *Asio otus*, en Piemont. *Nos Oiseaux* 35:369–371. MISSBACH, K. 1976. Beobachtungen zum Vorkommen und zur Tagesaktivität des Sperlingskauzes. *Falke* 23:388–389. MITCHELL, B. L. 1964. Owl prey. *Puku* 2:129. MOLTONI, E. & RUSCONE, G. G. 1940. *Gli uccelli dell'Africa Orientale. Italiana*. 1. Milan. MONES, A. & XIMÉNEZ, A. & CUELLA, J. 1973. Analisis del contenido de bolos de regurgitacion de *Tyto alba tuidara* (J. E. Gray) con el hallargo de un nuevo mamifero para el Uruguay. *Trab. V. Congr. Latinoamer. Zool.* 1:166–167. MONROE, B. L. 1968. A distributional survey of the birds of Honduras. *AOU Ornith. Monogr.* 7:1–458. MOOIJ, J. H. 1982. *De Bosuil*. Utrecht–Antwerp. MOORE, R. T. & PETERS, J. L. 1939. The genus *Otus* of Mexico and Central America. *Auk* 56:38–56. MOREL, G. J. 1972. Liste commentée des oiseaux du Sénégal et de la Gambie. *Off. Rech. Sc. Techn.* Outre-Mer, Dakar. MORITZ, D. & SCHONART, E. 1976. Bemerkenswertes über die Vogelwelt Helgolands im Jahr 1975. *Vogelwelt* 8:107–118. MOSHER, J. A. 1976. Raptor energetics: a review. *Raptor Res.* 10:97–107. MOSHER, J. A. & HENNY, C. J. 1976. Thermal adaptiveness of plumage color in Screech Owls. *Auk* 93:614–619. MOURER-CHAUVIRÉ, C. 1975. *Les oiseaux du Pleistocène moyen et supérieur de France*. Doct. Thesis, Univ. Claude Bernard, Lyons. MOURER-CHAUVIRÉ, C. 1987. Les Strigiformes des phosphorites du Quercy (France): systématique, biostratigraphie et paléobiogéographie. *Docum. Lab. Geol. Lyon* 99:89–135. MOURER-CHAUVIRÉ, C. & ALCOVER, J. A., MOYA, S. & PONS, J. 1980. Une nouvelle forme insulaire d'effraie géante, *Tyto balearica* n. sp., du Plio-Pleistocène des Baléares. *Géobios* 13:803–811. MOURER-CHAUVIRÉ, C. & WEESIE, P. D. M. 1986. *Bubo insularis* n. sp., forme endémique insulaire de Grand-duc du Pleistocène de Sardaigne et de Corse. *Rev. Paléobiol.* 5:197–205. MUMFORD, R. E. & ZUSI, R. L. 1958. Notes on movements, territory, and habitat of wintering Saw-whet Owls. *Wilson Bull.* 70:188–191. MURIE, O. J. 1929. Nesting of the Snowy Owl. *Condor* 31:1–12. MURRAY, G. A. 1976. Geographic variation in the clutch sizes of seven owl species. *Auk* 93:602–613. MYRBERGET, S. & AANDAHL, A. 1976. Jordugle og haukugle som predatorer på lirype. *Fauna* 29:93–94. MYSTERUD, I. 1969. Biotop og reirforhold ved en hekking av Slagugle ved elverum i 1967 (*Strix uralensis* Pall.). *Sterna* 8:369–382. MYSTERUD, I. 1970. Hypotheses concerning characteristics and causes of population movements in Tengmalm's Owl (*Aegolius funereus* (L.)). *Nytt Mag. Zool.* 18:49–74. MYSTERUD, I. & HAGEN, Y. 1969. The food of the Ural Owl (*Strix uralensis* Pall.) in Norway. *Nytt Mag. Zool.* 17:165–167. NAKAMURA, K. 1975. A record of a Brown Hawk Owl in the North Pacific. *Tori* 23:37–38. NAUROIS, R. DE 1961. Recherches sur l'avifaune de la côte atlantique du Maroc, du détroit de Gibraltar aux iles de Mogador. *Alauda* 29:241–259. NAUROIS, R. DE 1982. Le statut de l'effraie de l'archipel du Cap Vert, *Tyto alba detorta*. *Riv. Ital. Orn.* 52:154–166. NECHAEV, V. A. 1971. On the distribution and biology of some birds in Southern Primorye territory. In Ivanov, A. I., *Ornithological Researches in the South of the Far East* (Trudy Acad. Sc. USSR, Far-Eastern Center, Inst. Pedol. Biol., Vladivostok, 6):193–200. NERO, R. W. 1970. Great Gray Owls nesting near Roseau. *Loon* 42:88–92. NERO, R. W. 1980. *The Great Gray Owl*. Washington, DC. NERO, R. W. & CLARK, R. J., KNAPTON, R. J. & HAMRE, R. H. (EDS.). 1987. *Symp. Proc. Biology and Conservation Northern Forest Owls*, General Techn. USDA Forest Service RM-142. NERO, R. W. & COPLAND, H. W. R. & MEZIBROSKI, J. 1984. The Great Gray Owl in Manitoba, 1968–83. *Blue Jay* 42:130–151. NIEBOER, E. & PAARDT, M. VAN DER. 1977. Hearing of the African Woodowl *Strix woodfordii*. *Netherl. J. Zool.* 27:227–229. NIEBUHR, D. 1971. Worauf ist das Brutvorkommen des Rauhfusskauzes (*Aegolius funereus* (L.)) in der Lüneburger Heide zurückzuführen? *Vogelk. Ber. Niedersachs.* 3:35–42. NIETHAMMER, G. 1938. *Handbuch der deutschen Vogelkunde*. 2. Leipzig. NIETHAMMER, G. 1957. Ein weiterer Beitrag zur Vogelwelt des Ennedi-Gebirges. *Bonn. Zool. Beitr.* 8:275–284. NORBERG, R. Å. 1964. Studier över pärlugglans (*Aegolius funereus*) ekologi och etologi. *Vår Fågelv.* 23:228–244. NORBERG, R. Å. 1968. Physical factors in directional hearing in *Aegolius funereus* (Linné), with special reference to the significance of the asymmetry of the external ears. *Ark. Zool. Ser.* 2(20):181–204. NORBERG, R. Å. 1970. Hunting technique of Tengmalm's Owl *Aegolius funereus*. *Ornis Scand.* 1:51–64. NORBERG, R. Å. 1973. Riktningshörsel hos människa en och uggla med bilateralt asymmetriska ytteröron. *Svensk Naturvetenskap*:89–101. NORBERG, R. Å. 1977. Occurrence and independent evolution of bilateral ear asymmetry in owls and implications on owl taxonomy. *Philos. Trans. Roy. Soc. London, Biol. Sc.* 280(973):375–408. NORBERG, R. Å. 1978. Skull asymmetry, ear structure and functions, and auditory localization in Tengmalm's Owl, *Aegolius funereus*. *Philos. Trans. Roy. Soc. London, Biol. Sc.* 282(991):325–410. NORTHERN, J. R. 1965. Notes on the owls of the Tres Marias Islands, Nayarit, Mexico. *Condor* 67:358. NORTON, W. D. & HOLT, D. W. 1983. Simultaneous nesting of Northern Pygmy Owls and Northern Saw-whet Owls in the same snag. *Murrelet* 63 (winter 1982):94. OBERHOLSER, H. C. 1904. A revision of the American Great Horned Owls. *Proc. US Nat. Mus.* 27:177–192. OBERHOLSER, H. C. 1922. Notes on North American birds. XI. *Auk* 39:72–78. ODSJÖ, T. & OLSSON, V. 1975. Kvicksilverhalter i en population av berguv *Bubo bubo* i sydöstra Sverige efter 1966 års alkylkvicksilverförbud. *Vår Fågelv.* 34:117–124. OEMING, A. F. 1955. In quest of the rare Great Gray Owl. *Canad. Geogr. J.* 73:236–243. OLENDORFF, R. R. & MILLER, A. D. & LEHMAN, R. N. 1981. Suggested practices for raptor protection on power lines. *Raptor Res. Rep.*, Raptor Res. Found, St Paul, Minnesota. 4. OLSON, S. L. 1978. A paleontological perspective of West Indian birds and mammals. *Spec. Pub. Acad. Nat. Sci. Philadelphia* 13:99–117. OLSON, S. L. 1984. A very large enigmatic owl from the late Pleistocene at Ladds, Geor-

BIBLIOGRAPHY

gia. *Spec. Pub. Carnegie Mus. Nat. Hist.* 8:44–46. OLSON, S. L. & JAMES, H. F. 1982. Prodromus of the fossil avifauna of the Hawaiian Islands. *Smithson. Contr. Zool.* 365:1–59. OLSON, S. L. & JAMES, H. F. 1984. The role of Polynesians in the extinction of the avifauna of the Hawaiian Islands. In Martin, P. S. & Klein, R. G., *Quarternary Extinctions* (Tucson, Arizona):768–780. OLSON, S. L. & PREGILL, G. K. 1982. Introduction to the paleontology of Bahaman vertebrates. In Olson (ed.), Fossil vertebrates from the Bahamas. *Smithson. Contr. Paleobiol.* 48:1–65. OLSSON, V. 1958. Dispersal, migration, longevity and death causes of *Strix aluco*, *Buteo buteo*, *Ardea cinerea* and *Larus argentatus*. *Acta Vertebr.* 1:85–189. OLSSON, V. 1972. Äggsamlarrazzian 1971. *Vår Fågelv.* 31:32–44. OLSSON, V. 1979. Studies on a population of eagle owls, *Bubo bubo*, in southwest Sweden. *Viltrevy, Swedish Wildlife* 11:1–99. OTTO-SPRUNCK, A. 1967. Übersprungschlafen beim Habichtskauz (*Strix uralensis*). *Ornis Fenn.* 44:78. OWEN, D. F. 1963. Polymorphism in the Screech Owl in eastern North America. *Wilson Bull.* 75:183–190. OWEN, D. F. 1963. Variation in North American Screech Owls and the subspecies concept. *Syst. Zool.* 12:8–14. PACKLAND, R. L. 1954. Great Horned Owl attacking squirrel nests. *Wilson Bull.* 66:272. PALMER, D. A. 1986. Habitat selection, movements and activity of Boreal and Saw-whet Owls. Doct. Thesis, Colorado State Univ., Fort Collins. PALMER, D. A. & RYDER, R. A. 1984. The first documented breeding of the Boreal Owl in Colorado. *Condor* 86:215–217. PALUDAN, K. 1938. Zur Ornis des Zagrossgebietes, W. Iran. *J. f. Ornith.* 86:562–638. PANOV, E. N. 1973. *The Birds of South Ussuriland*. Novosibirsk. PARKES, K. C. & PHILLIPS, A. R. 1978. Two new Caribbean subspecies of Barn Owl (*Tyto alba*) with remarks on variation in other populations. *Ann. Carnegie Mus.* 47:479–492. PARMELEE, D. F. 1972. Canada's incredible arctic owls. *Beaver* 303:30–41. PARMELEE, D. F. & MACDONALD, S. D. 1960. The birds of west-central Ellesmere Island and adjacent areas. *Bull. Nat. Mus. Canada* 169, *Biol. Ser.* 63:1–103. PARMELEE, D. F. & STEPHENS, H. A. & SCHMIDT, R. H. 1967. The birds of southeastern Victoria Island and adjacent small islands. *Bull. Nat. Mus. Canada* 222:1–229. PARMELEE, P. W. & KLIPPEL, W. E. 1982. Evidence of a boreal avifauna in Middle Tennessee during the Late Pleistocene. *Auk* 99:365–368. PASCOVISCHI, S. & MANOLACHE, L. 1970. In problema pozitiei sistematice a bufnitei *Bubo bubo* (L.) din România. *Stud. Com. Muz. Stiint. Naturii, Bacau*:245–250. PATTERSON, R. L. 1946. Burrowing Owl at sea. *Wilson Bull.* 58:53. PAYNE, R. S. 1962. How the Barn Owl locates prey by hearing. *The Living Bird* 1:151–159. PAYNE, R. S. 1971. Acoustic location of prey by Barn Owls (*Tyro alba*). *J. Exp. Biol.* 54:535–573. PEAKALL, D. B. & KEMP, A. C. 1980. Organochlorine levels in owls in Canada and South Africa. *Ostrich* 51:186. PERRONE, M., JR. 1981. Adaptive significance of ear tufts in owls. *Condor* 83:383–384. PETERS, J. L. 1938. Systematic position of the genus *Ciccaba* Wagler. *Auk* 55:179–186. PETERS, J. L. 1940. *Check-List of the Birds of the World*. 4. Cambridge, Mass. PETTIGREW, J. D. & KONISHI, M. 1976. Neurons selective for orientation and binocular disparity in the visual Wulst of the Barn Owl (*Tyto alba*). *Science* 193:675–678. PHILLIPS, A. R. 1942. Notes on the migrations of the Elf and Flammulated Screech Owls. *Wilson Bull.* 54:132–137. PHILLIPS, A. R. & MARSHALL, J. & MONSON, G. 1964. *The Birds of Arizona*. Tucson. PHILLIPS, J. C. 1915. Some birds from Sinai and Palestine. *Auk* 32:273–289. PIECHOCKI, R. 1965. Augenkatalog der Vögel Europas. *Der Präparator* (Special No.) 1. PIECHOCKI, R. 1968. Beiträge zur Avifauna der Mongolei. I. Non-Passeriformes. *Mitt. Zool. Mus. Berlin* 44:149–292. PIECHOCKI, R. & MÄRZ, R. 1985. *Der Uhu*. Neue Brehm-Büch. 108. 5th edn. Wittenberg-Lutherstadt. PITELKA, R. A. & TOMICH, P. Q. & TREICHEL, G. W. 1955. Breeding behavior of jaegers and owls near Barrow, Alaska. *Condor* 57:3–18. PITELKA, R. A. & TOMICH, P. Q. & TREICHEL, G. W. 1955. Ecological relations of jaegers and owls as lemming predators near Barrow, Alaska. *Ecol. Monogr.* 25:85–117. POLIVANOV, V. M. & SHEBAJEV, J. V. & LABSHUK, V. J. 1971. On the ecology of *Otus bakkamoena ussuriensis* But. In *Ecology and Fauna of Birds in the South of the Far East* (Trudy Acad. Sc. USSR, Far-Eastern Center, Inst. Pedol. Biol., Vladivostok, 2):85–91. PORTENKO, L. A. 1972. *Die Schnee-Eule*. Neue Brehm-Büch. 454. Wittenberg-Lutherstadt. PRZYGODDA, W. 1969. Die Bestandsentwicklung des Rauhfusskauzes (*Aegolius funereus*) in den letzten Jahren in Westfalen. *Natur u. Heimat* 29:1–4. PUGET, A. & HÜE, F. 1970. La Chevêchette *Glaucidium brodiei* en Afghanistan. *Ois. Rev. Fr. Orn.* 40:86–87. PUKINSKY, Y. B. 1973. To the ecology of the eagle owl (*Ketupa blakistoni doerriesi*) in the basin of the river Bikin. *Byull. MOTP Otd. Biol.* 78:40–47. PUKINSKY, Y. B. 1976. A study of trophic relations in nocturnal and crepuscular birds. *Trans. Petergofski Biol. Inst., Univ. of Leningrad* 24:66–78. PUKINSKY, Y. B. 1977. *The Life of Owls*. Leningrad. PULLIAINEN, E. 1978. Nesting of the Hawk Owl, *Surnia ulula*, and Short-eared Owl, *Asio flammeus*, and the food consumed by owls on the island of Ulkokrunni in the Bothnian Bay in 1977. *Aquilo Ser. Zool.* 181: 17–22. PULLIAINEN, E. & LOISA, K. 1977. Breeding biology and food of the Great Grey Owl, *Strix nebulosa*, in northeastern Finnish Forest Lapland. *Aquilo Ser. Zool.* 17:23–33. PURCHASE, D. 1972. A report on the banding of Barn Owls. *Austr. Bird Bander* 10:74–75. PYCRAFT, W. P. 1898. A contribution towards our knowledge of the morphology of the owls. I. *Trans. Linn. Soc. Sec. Ser. Zool.* 7:223–275. PYCRAFT, W. P. 1938. The Little Owl: an "undesirable alien". *Illustr. London News* (12 Oct. 1938):732. QUINE, D. B. & KONISHI, M. 1974. Absolute frequency discrimination in the Barn Owl. *J. Comp. Physiol.* 93:347–360. QUINN, D. 1929. "Framing" the birds of prey. Pamphlet. New York. RADLER, K. 1986. Polymorphism and genetic control of a plasma esterase in the eagle owl. *Heredity* 56:65–67. RAND, A. L. 1950. A new race of owl, *Otus bakkamoena*, from Negros, Philippine Islands. *Nat. Hist. Misc. Chicago Acad. Sc.* 72:1–5. RAND, A. L. & FLEMING, R. L. 1957. Birds from Nepal. *Fieldiana: Zool.* 41(1):1–218. RANDIK, A. 1959. A distribution of the Scops Owl in the Carpathian Basin. *Aquila* 66:99–106. RAVUSSIN, P. A. & SERMET, E. 1975. Nidification simultanée du Pic noir *Dryocopus martius* et de la Chouette de Tengmalm *Aegolius funereus* sur le même arbre. *Nos Oiseaux* 33:60–63. REE, J. 1963. Perleugle hekker i gammalt skjorereir. *Sterna* 5:219. REISER, O. 1927. Zoologische Ergebnisse der Walter Stötznerschen Expeditionen nach Szetschwan, Osttibet und Tschili. 4(1). Vogeleier. *Abhandl. Ber. Mus. Tierk. Völkerk. Dresden* 17:1–6. REYNOLDS, R. T. & LINKHART, B. D. 1987. The nesting biology of Flammulated Owls in Colorado. In Nero et al., 1987:239–248. RICHARDSON, C. H. 1906. Cannibalism in owls. *Condor* 8:57. RIDGELY, R. S. 1976. *A Guide to the Birds of Panama*. Princeton, NJ. RIDGWAY, R. 1914. The birds of North and Middle America. 6. *Bull. US Nat. Mus.* 50:1–882. RIPLEY, S. D. 1976. Reconsideration of *Athene blewitti*. *J. Bombay Nat. Hist. Soc.* 73:1–4. RIPLEY, S. D. 1977. A revision of the subspecies of *Strix leptogrammica* Temminck, 1831. *Proc. Biol. Soc. Washington* 90:993–1,001. RIPLEY, S. D. 1982. *A synopsis of the Birds of India and Pakistan*. 2nd edn. Bombay. RISDON, D. H. S. 1951. The rearing of a hybrid Virginian × European Eagle-Owl at Dudley Zoo. *Avicult. Mag.* 57:199–201. RITTER, F. & HEIDRICK, M. & ZIENERT, W. 1978. Statistische Daten zur Brutbiologie Thüringer Rauhfusskäuze, *Aegolius funereus* (L.). *Thür. Orn. Mitt.* 24:37–45. ROBERTS, T. J. & KING, B. 1986. Vocalizations of the owls of the genus *Otus* in Pakistan. *Ornis Scand.* 17:299–305. ROBERTS, T. S. 1932. *The Birds of Minnesota*. Minneapolis. ROBERTSON, M. & BECKER, C. D. 1986. Snowy Owls on Fetlar. *Brit. Birds* 79:228–242. ROBERTSON, W. B. 1959. Barred Owl nesting on the ground. *Auk* 76:227–230. ROCKENBAUCH, D. 1978. Brutbiologie und den Bestand steuernde Faktoren bei Waldkauz (*Strix aluco*) und Waldohreule (*Asio otus*) in der Schwabischen Alb. *J. f. Ornith.* 119:429–440. ROGERS, M. J. & RARITIES COMMITTEE. 1985. Report on rare birds in Great Britain in 1984. *Brit. Birds* 78:529–589. ROI, O. LE. 1923. Die Ornis der Sinai-Halbinsel. *J. f. Ornith.* 71:65–66. ROSENDAHL, S. 1973. Ugler i Danmark. Skjern. ROSENFELD, R. N. 1979. Broad-winged Hawk preys on Saw-whet Owl. *Passenger Pigeon* 41:60. ROSS, A. 1969. Ecological aspects of the food habits of insectivorous screech-owls. *Proc. West. Found. Vertebr. Zool.* 1:301–344. RUDOLPH, S. G. 1978. Predation ecology of coexisting Great Horned and Barn owls. *Wilson Bull.* 90:134–137. RUNTE, P. 1951. Zur "kuwitt Frage" (Stein- oder Waldkauz?) *Orn. Mitt.* 3:133–136. RUSSELL, S. M. 1964. A distributional study of the birds of British Honduras. *Amer. Orn. Union Orn. Monogr.* 1. RYDER, R. A. & PALMER, D. A. & RAWINSKI, J. J. 1987. Distribution and status of the Boreal Owl in Colorado. In Nero et al., 1987:169–174. SAEMANN, D. 1974. Der Rauhfusskauz im Erzgebirge. *Falke* 21:412–414. SALOMONSEN, F. 1931. Diluviale Isolation und Artenbildung. *Proc. VII Congr. Int. Ornith.* (Amsterdam, 1930):413–438. SALOMONSEN, F. 1951. *The Birds of Greenland*. Copenhagen. SALT, W. R. & SALT, J. R. 1976. *The Birds of Alberta*. Edmonton. SARUDNY, N. 1905. Zwei ornithologische Neuheiten aus West-Persien. *Orn. Jahrb.* 16:141–142. SAUROLA, P. 1987. Mate and nest-site fidelity in Ural and Tawny Owls. In Nero et al., 1987:81–86. SAUTER, U. 1956. Beiträge zur Ökologie der Schleiereule (*Tyto alba*) nach den Ringfunden. *Vogelwarte* 18:109–151. SAVIGNY, J. C. 1809. Description de l'Egypte. *Hist. Nat.* 1, *Syst. Oiseaux*. SAYERS, B. 1976. Blakiston's Fish Owl. *Avicult. Mag.* 82:61–63. SCHÄFER, E. 1938. Ornithologische Ergebnisse zweier Forschungsreisen nach Tibet. *J. f. Ornith.* 86 (Special No.):1–349. SCHALDACH, W. J. 1963. The avifauna of Colima and adjacent Jalisco, Mexico. *Proc. West. Found. Vert. Zool.* 1:1–100. SCHAUENSEE, R. MEYER DE & PHELPS, W. H. 1978. *A Guide to the Birds of Venezuela*. Princeton, NJ. SCHELPER, W. 1972. Ein Beitrag zur Biologie des Rauhfusskauzes *Aegolius funereus*. *Natur, Kultur u. Jagd, Beitr. Naturk. Niedersachs.* 25:77–83. SCHENKER, A. 1978. Höchstalter europäischer Vögel im Zoologischen Garten Basel. *Orn. Beob.* 75:96–97. SCHERZINGER, W. 1969. Eulen – Grimassenschneider unter den Vögeln. *Vogel-Kosmos*:226–229. SCHERZINGER, W. 1970. Zum Aktionssystem des Sperlingskauzes (*Glaucidium passerinum*). *Zoologica* 41:1–120. SCHERZINGER, W. 1971. Zum Feindverhalten einiger Eulen. *Z. Tierpsychol.* 29:165–174. SCHERZINGER, W. 1974. Die Jugendentwicklung des Uhus (*Bubo bubo*) mit Vergleichen zu der von Schneeule (*Nyctea scandiaca*) und Sumpfohreule (*Asio flammeus*). *Bonn. Zool. Beitr.* 25:123–147. SCHERZINGER, W. 1979. Brutverlust beim Sperlingskauz *Glaucidium passerinum* durch Rossameisen *Camponotus herculeaneus*. *Ökol. Vögel* 1:95–97. SCHERZINGER, W. 1980. Zur Ethologie der Fortpflanzung und Jugendentwicklung des Habichtskauzes (*Strix uralensis*) mit Vergleichen zum Waldkauz (*Strix aluco*). *Bonn. Zool. Monogr.* 15:1–66. SCHERZINGER, W. 1981. Die Situation der Eulen im Alpenraum. *Forschungsber. Nationalpark Berchtesgaden* 3:14–16. SCHERZINGER, W. 1981. Zum Nestbau der Kanincheneule *Speotyto cunicularia*. *Ökol. Vögel* 3:213–222. SCHERZINGER, W. 1981. Vorkommen und Gefährdung der vier kleinen Eulenarten im Mitteleuropa. *Ökol. Vögel* 3:283–292. SCHERZINGER, W. 1983. Beobachtungen an Waldkauz-Habichtskauz-Hybriden (*Strix aluco* × *Strix uralensis*). *Zool. Garten NF* 53:133–148. SCHERZINGER, W. 1986. Kontrastzeichnungen im Kopfgefieder der Eulen – als visuelle Kom-

munikationsmittel. *Ann. Naturalist. Mus. Wien* 88/89B:37–56. SCHEUREN, F. 1968. Nouveaux cas de nidification de la Chouette de Tengmalm dans l'est de la Belgique en 1968. *Aves* 5:124–136. SCHIFFERLI, A. 1957. Alter und Sterblichkeit bei Waldkauz (*Strix aluco*) und Schleiereule (*Tyto alba*) in der Schweiz. *Orn. Beob.* 54:50–56. SCHLATTER, R. P. & YÁÑEZ, J. L. & NÚÑEZ, H. & JAKSIĆ, F. M. 1980. The diet of the Burrowing Owl in central Chile and its relation to prey size. *Auk* 97:616–619. SCHMIDT, E. 1971. Hamsterfunde in Eulengewöllen. *Zool. Abhandl. Staatl. Mus. Tierk. Dresden* 30(16:219–222. SCHMIDT, E. 1972. Über die Vogelnahrung der Schleiereule *Tyto alba* und der Waldohreule *Asio otus* in Ungarn. *Ornis Fenn.* 49:98–102. SCHMIDT, E. 1973. Die Nahrung der Schleiereule (*Tyto alba*) in Europa. *Zeitschr. Angew. Zool.* 60:43–70. SCHMIDT, G. 1965. Winterfütterung der Greifvögel, Eulen und Spechte. *Orn. Mitt.* 17:225–228. SCHNEIDER, A. 1953. Schleiereulen (*Tyto alba guttata*) greifen Menschen zu. *Orn. Mitt.* 5:96–97. SCHNURRE, O. 1941. Der Uhu als Mitbewohner einer Kormorankolonie, nebst brutbiologischen Beobachtungen an anderen Vogelarten. *Beitr. Fortpfl. Biol. Vögel* 17:121–131. SCHNURRE, O. 1942. Ein Beitrag zur Biologie des Sperlingskauzes. *Beitr. Fortpfl. Biol. Vögel* 18:45–51. SCHODDE, R. & MASON, I. J. 1980. *Nocturnal Birds of Australia*. Melbourne. SCHÖNFELD, M. & GIRBIG, G. 1975. Beiträge zur Brutbiologie der Schleiereule, *Tyto alba*, besonders unter Berücksichtigung der Feldmausdichte. *Hercynia* 12:257–319. SCHÖNN, S. 1978. *Der Sperlingskauz*. Neue Brehm–Büch. 513. Wittenberg–Lutherstadt. SCHÖNN, S. 1980. Käuze als Feinde anderer Kauzarten und Nisthilfer für höhlenbrütende Eulen. *Falke* 27:294–299. SCHÖNN, S. 1986. Zu Status, Biologie, Ökologie und Schutz des Steinkauzes (*Athene noctua*) in der DDR. *Acta Ornithoecol.* 1:103–133. SCHOUTEDEN, H. 1954. Faune du Congo Belge et du Ruanda–Urundi. III. Oiseaux non passereaux. *Ann. Koninkl. Mus. Belgisch–Kongo. Reeks* 8°. *Zool. Wet.* 29:1–437. SCHOUTEDEN, H. 1961. La faune ornithologique des districts de la Tshuapa et de l'Equateur. *Doc. Zool. Mus. Roy. Afr. Centr.* 1:1–179. SCHÜZ, E. 1957. Das "Occipital-Gesicht" bei Sperlingskäuzen (*Glaucidium*). *Vogelwarte* 19:138–140. SCHWAB, E. 1972. Massnahmen zur Erhaltung des Steinkauzes im Beobachtungsgebiet Rodgau und Dreieich. *Luscinia* 41:272–276. SCHWARTZKOPFF, J. 1962. Zur Frage des Richtungshörens von Eulen. *Zeitschr. Vergl. Physiol.* 45:570–580. SCHWARTZKOPFF, J. 1963. Morphological and physiological properties of the auditory system in birds. *Proc. XIII Congr. Int. Ornith.* (Ithaca, 1962):1,059–1,068. SCHWARTZKOPFF, J. 1973. Mechanoreception. In Farner, D. S. et al., *Avian Biology* (New York–London) 3:417–477. SCHWARZENBERG, L. 1970. Hilfe unserem Steinkauz. *Jahresh. Deutsch. Bund Vogelschutz*:20–23. SCHWARZENBERG, L. 1984. Kritisches zur Steinkauzröhre: Model 1983 – ein Ausweg! *Eulen-Arbeitsgemeinschaft Saar*: 1–8. SEMENOV-TAISHANSKI, O. N. & GILJASOV, A. S. 1985. The ecology of the Hawk Owl in the Lapland nature reserve. In *Birds of prey and owls in the nature reserves of the RSFSR* (Central Scient. Res. Lab. Agric. and Nature Res., Moscow):130–138. SERLE, W. 1949. New races of a warbler, a flycatcher and a weaver, all from British Cameroons. *Bull. Brit. Orn. Cl.* 69:74–76. SERLE, W. 1950. A contribution to the ornithology of the British Cameroons. *Ibis* 92:343–376. SHARROCK, J. T. R. 1976. *The Atlas of Breeding Birds in Britain and Ireland*. Brit. Trust Ornith., Tring. SHARROCK, J. T. R. & SHARROCK, E. M. 1976. *Rare Birds in Britain and Ireland*. Berkhamsted. SHELLEY, B. A. G. 1895. The nesting of the Long-eared Owl (*Asio otus*) in India. *J. Bombay Nat. Hist. Soc.* 10:149. SHERMAN, A. R. 1912. Diurnal activities of the Great Horned Owl (*Bubo virginianus virginianus*). *Auk* 29:240–241. SHORT, L. L. 1975. A zoogeographic analysis of the South American Chaco avifauna. *Bull. Amer. Mus. Nat. Hist.* 154:163–352. SHORT, L. L. 1982. Woodpeckers of the world. *Delaware Mus. Nat. Hist. Monogr. Ser.* 4. SIBNEV, B. K. 1963. Observations of the Brown Fish Owl (*Ketupa zeylonensis*) in Ussuri Krai. *Ornithologyia* 6:486. SIDDLE, C. 1984. Raptor mortality on northeastern British Columbia trapline. *Blue Jay* 42:184. SIEGFRIED, W. R. 1965. On the food habits of the Spotted Eagle Owl. *Ostrich* 36:146. SILSBY, J. D. 1980. *Inland Birds of Saudi Arabia*. London. SIMON, P. 1965. Synthèse de l'avifaune du massif montagneux du Tibesti. *Gerfaut* 55:26–29. SIMONETTA, A. 1967. Cinesi e morfologia del cranio negli uccelli non passeriformi. II. *Arch. Zool. Ital.* 52:1–35. SLADEK, J. 1961–62. Knowledge on the food ecology of the owl *Strix uralensis macroura* Wolf. *Sborník Východoslov. Múzea Košiaciach Ser.* AII–IIIA:221–236. SLUD, P. 1964. The birds of Costa Rica. *Bull. Amer. Mus. Nat. Hist.* 129:1–430. SLUD, P. 1980. The birds of Hacienda Palo Verde, Guanacaste, Costa Rica. *Smithson. Contr. Zool.* 292:1–92. SMEENK, C. 1969. Legselgrootte bij de Bosuil (*Strix aluco* L.). *Limosa* 42:79–81. SMEENK, C. 1972. Ökologische Vergleiche zwischen Waldkauz *Strix aluco* und Waldohreule *Asio otus*. *Ardea* 60:1–71. SMITH, C. C. 1963. First breeding record of the Spotted Owl in British Columbia. *Condor* 65:440. SMITH, D. G. 1970. Close nesting and aggression contacts between Great Horned Owls and Red-tailed Hawks. *Auk* 87:170–171. SMITH, D. G. & DEVINE, A. 1982. Winter food of the Saw-whet Owl. *Connecticut Warbler* 2:43–55. SMITH, D. G. & GILBERT, R. 1981. Backpack radio transmitter attachment success in Screech Owls (*Otus asio*). *North Amer. Bird Bander* 6:142–143. SMITH, D. G. & MARTI, C. D. 1976. Distributional status and ecology of Barn Owls in Utah. *Raptor Res.* 10:33–44. SMITH, D. G. & MURPHY, J. R. 1979. Breeding responses of raptors to Jackrabbit density in the eastern Great Basin desert of Utah. *Raptor Res.* 13:1–14. SMITH, D. G. & MURPHY, J. R. 1982. Nest site selection in raptor communities of the eastern Great Basin desert. *Great Basin Nat.* 42:395–404. SMITH, D. G. & WILSON, C. R. & FROST, H. H. 1972. Seasonal food habits of Barn Owls in Utah. *Great Basin Nat.* 32:229–234. SMITH, D. G. & WILSON, C. R. & FROST, H. H. 1974. History and ecology of a colony of Barn Owls in Utah. *Condor* 76:131–136. SMITH, D. G., DEVINE, A. & DEVINE, D. 1983. Observations of fishing by a Barred Owl. *J. Field Ornith.* 54:88. SMITH, V. W. 1962. Some birds which breed near Vom, northern Nigeria. *Nigerian Field* 27(1):4–34. SMITH, V. W. & KILLICK-KENDRICK, R. 1964. Notes on the breeding of the Marsh Owl *Asio capensis* in northern Nigeria. *Ibis* 106:119–123. SMYTHIES, B. E. 1953. *The Birds of Burma*. 2nd edn. Edinburgh–London. SMYTHIES, B. E. 1960. *The Birds of Borneo*. Edinburgh–London. SNIJDER, L. L. 1961. On an unnamed population of the Great Horned Owl. *Roy. Ontario Mus. Life Sci. Contr.* 54:1–7. SNOW, D. W. (ED.). 1978. *An Atlas of Speciation in African Non-Passerine Birds*. London. SNYDER, N. F. R. & WILEY, J. M. 1976. Sexual size dimorphism in hawks and owls of North America. *Orn. Monogr.* 20:1–96. SOIKKELI, M. 1964. Über das Überwintern und die Nahrung der Waldohreule (*Asio otus*) in Südwestfinnland 1962/63. *Ornis. Fenn.* 41:37–40. SOKOLOV, E. P. 1986. New data on birds of south-eastern Transbaikalia. *Proc. Zool. Inst. USSR Acad. Sc.* 150:74–76. SOLHEIM, R. 1983. Breeding frequency of Tengmalm's Owl *Aegolius funereus* in three localities in 1974–78. *Proc. 3rd Nordic Congr. Ornith.* (1981):79–84. SOLHEIM, R. 1984. Breeding biology of the Pygmy Owl *Glaucidium passerinum* in southeastern Norway. *Proc. 4th Nordic Congr. Ornith.* (1983). SOLHEIM, R. 1984. Breeding biology of the Pygmy Owl *Glaucidium passerinum* in two biogeographical zones in southeastern Norway. *Ann. Zool. Fennici* 21:295–300. SOLHEIM, R. 1984. Caching behaviour, prey choice and surplus killing by Pygmy Owls *Glaucidium passerinum* during winter, a functional response of a generalist predator. *Proc. 4th Nordic Congr. Ornith.* (1983). *Ann. Zool. Fennici* 21:301–308. SONERUD, G. A. & MELDE, A. & PRESTRUD, K. 1972. Spurveuglehekking i Fuglehok. *Sterna* 11:1–12. SOUCY, L. J. 1982. Saw-whet Owls at sea. *N. J. Audubon*:20. SOUTHERN, H. N. 1954. Tawny Owls and their prey. *Ibis* 96:384–410. SOUTHERN, H. N. 1970. The natural control of a population of Tawny Owls (*Strix aluco*). *J. Zool.* 162:197–285. SOUTHERN, H. N. & LOWE, V. P. W. 1968. The pattern of distribution of prey and predation in Tawny Owl territories. *J. Anim. Ecol.* 37:75–97. SPARKS, J. & SOPER, T. 1970. *Owls, their Natural and Unnatural History*. Newton Abbot. SPEIRS, J. M. 1985. *Birds of Ontario*. Toronto. STEADMAN, D. W. 1986. Holocene vertebrate fossils from Isla Floreana, Galápagos. *Smithson. Contr. Zool.* 413:1–99. STEADMAN, D. W. & PREGILL, G. K. & OLSON, S. L. 1984. Fossil vertebrates from Antigua, Lesser Antilles: evidence for late Holocene human-caused extinctions in the West Indies. *Proc. Nat. Acad. Sci. USA* 81:4,448–4,451. STEINBACH, G. 1980. *Die Welt der Eulen*. Hamburg. STEINBACHER, J. 1962. Beiträge zur Kenntnis der Vögel von Paraguay. *Abhandl. Senckenb. Naturf. Ges.* 502:1–106. STEPANYAN, L. S. 1975. *Status and Distribution of the Avifauna of the USSR. Non-Passeriformes*. Moscow. STEWART, P. A. 1952. Dispersal, breeding behavior, and longevity of banded Barn Owls in North America. *Auk* 69:227–245. STEWART, P. A. 1969. Prey in two Screech Owl nests. *Auk* 86:141. STEWART, P. A. 1980. Population trends of Barn Owls in North America. *Amer. Birds* 34:698–700. STEYN, P. 1982. *Birds of Prey in Southern Africa*. Cape Town–Johannesburg (and Beckenham, 1983). STEYN, P. 1984. *A Delight of Owls*. Cape Town–Johannesburg. STOLLMANN, A. 1958. Die Zwergohreule (*Otus scops*) in der Slowakei und als Nistkastenbewohner. *Orn. Mitt.* 10:25–26. STORER, R. 1966. Sexual dimorphism and food habits in three North American accipiters. *Auk* 83:423–436. STRAUTMAN, F. I. 1963. *The Birds of the Western Provinces of the Ukrainian S.S.R.* Lwow Univ. STRAZDS, M. & STRAZDS, A. 1985. Birds wintering in the town of Riga. *Commun. Baltic Comm. Study Bird Migr.* 17:123–136. STREETS, T. H. 1870. Asymmetry in the skull of a species of owl. *Proc. Acad. Nat. Sci. Philadelphia* 20:173. STRESEMANN, E. 1923. Zoologische Ergebnisse der Walter Stötznerschen Expeditionen nach Szetschwan, Osttibet und Tschili. 2(12). Striges bis Ralli. *Abhandl. Ber. Mus. Tierk. Völkerk. Dresden* 16:58–70. STRESEMANN, E. 1925. Beiträge zur Ornithologie der indo-australischen Region. II. *Mitt. Zool. Mus. Berlin* 12:177–196. STRESEMANN, E. 1938. Aves Beickianae. Schluss. *J. f. Ornith.* 86:171–221. STRESEMANN, E. 1939. Die Vögel von Celebes. I, II. *J. f. Ornith.* 87:299–425. STRESEMANN, E. 1941. Die Vögel von Celebes. III. Systematik und Biologie. *J. f. Ornith.* 89:1–102. STRESEMANN, E. & HEINRICH, G. 1940. Die Vögel des Mount Victoria. *Mitt. Zool. Mus. Berlin* 24(2):151–264. STRONG, W. D. 1922. Burrowing Owl off the Virginia coast. *Condor* 24:29. STUPKA, A. 1963. *Notes on the Birds of the Great Smoky Mountains National Park*. Knoxville, Tennessee. SUBAH, A. 1983. Nesting by Hume's Tawny Owl in Nakhal Sekher. *Torgos* 3:21–32, 105. SUTTON, G. M. 1932. The birds of Southampton Island. *Mem. Carnegie Mus.* 12. SUTTON, G. M. 1971. *High Arctic*. New York. SUTTON, G. M. 1981. Do Screech Owls prey on Bobwhites? *Bull. Oklahoma Orn. Soc.* 14:32–33. SVENSSON, L. (ED.). 1978. *Sveriges Fåglar*. Stockholm. SWARTH, H. S. 1910. New owls from Arizona. *Univ. California Publ. Zool.* 7:1–8. SZOMJAS, L. 1955. Tawny-Owl attacking Marten. *Aquila* 59–62 (1952–55):450. TATE, J. 1981. The Blue List for 1981. *Amer. Birds* 35:3–10. TAVERNER, P. A. 1942. Canadian races of the Great Horned Owls. *Auk* 59:234–245. TAVERNER, P. A. & SWALES, B. H. 1911. Notes on the migration of the Saw-whet Owl. *Auk* 28:329–334. TAYLOR, A. L. & FORSMAN, E. D. 1976. Recent

BIBLIOGRAPHY

range extensions of the Barred Owl in western North America, including the first records for Oregon. *Condor* 78:560–561. TAYLOR, P. S. 1973. Breeding behavior of the Snowy Owl. *The Living Bird* 12:137–154. TCHERNOV, E. 1980. *The Pleistocene Birds of 'Ubeidiya, Jordan Valley*. Israel Acad. Sci. & Human. THIOLLAY, J. M. 1968. Le régime alimentaire de nos rapaces: quelques analyses françaises. *Nos Oiseaux* 29:249–269. THOMPSON, H. N. & CRADDOCK, W. H. 1902. Notes on the occurrence of certain birds in the southern Shan States of Burma. *J. Bombay Nat. Hist. Soc.* 14:600. THOMSEN, L. 1971. Behavior and ecology of Burrowing Owls on the Oakland Municipal Airport. *Condor* 73:177–192. THÖNEN, W. 1965. Tannenhäher plündern Beutevorräte des Sperlingskauzes. *Orn. Beob.* 62:196–197. THÖNEN, W. 1968. Die Ähnlichkeit der Rufe von Zwergohreule, Sperlingskauz und Geburtshelferkröte. *Orn. Beob.* 65:17–22. THORPE, W. H. & GRIFFIN, D. R. 1962. The lack of ultrasonic components in the flight noise of owls compared with other birds. *Ibis* 104:256–257. TINBERGEN, N. 1933. Die ernährungsökologischen Beziehungen zwischen *Asio otus otus* und ihren Beutetieren, insbesondere den *Microtus*-Arten. *Ecol. Monogr.* 3:443–492. TODD, W. E. C. 1963. *Birds of the Labrador Peninsula and Adjacent Islands*. Toronto. TRAUTMANN, M. B. 1940. The birds of Buckeye Lake, Ohio. *Misc. Publ. Mus. Zool. Univ. Michigan* 44:1–466. TRAYLOR, M. A. 1958. Variation in South American Great Horned Owls. *Auk* 75:143–149. TRÉCUL, M. A. 1876. On the capture of rattlesnakes, and on the association of these serpents with a small owl and a little marmot. *Ann. Nat. Hist.* 4th Ser. 18:439–440. TREE, A. J. 1963. The Marsh Owl (*Asio capensis*). *Nat. Soc. Centre. Afr. J.* 4:11–13. TRICOT, J. 1968. A propos de la capture des lombrics par la Chouette chevêche (*Athene noctua*). *Aves* 5:11. TRISTRAM, H. B. 1864. Report on the birds of Palestine. *Proc. Zool. Soc. London*:426–456. TUCKER, J. J. 1974. Letters to the Editor: Grass Owls and Marsh Owls. *Honeyguide, Rhod. Orn. Soc.* 79:46–47. TURNER, D. A. 1974. Cape Grass Owl in Ethiopia. *Bull. Brit. Orn. Cl.* 94:38–39. TUZENKO, A. U. 1955. *Birds of the Sakhalin Oblast*. Akad. NAUK SSSR, Moscow. ULFSTRAND, S. & HÖGSTEDT, G. 1976. Hur många fåglar häckar i Sverige. *Anser* 15:1–32. ULLRICH, B. 1973. Beobachtungen zur Biologie des Steinkauzes (*Athene noctua*). *Anz. Orn. Ges. Bayern* 12:163–175. ULLRICH, B. 1980. Zur Populationsdynamik des Steinkauzes (*Athene noctua*). *Vogelwarte* 30:179–198. URBAN, E. K. & BROWN, L. H. 1971. *A Checklist of the Birds of Ethiopia*. Addis Ababa. UTTENDÖRFER, O. 1939. *Die Ernährung der deutschen Raubvögel und Eulen*. Neudamm. UTTENDÖRFER, O. 1952. *Neue Ergebnisse über die Ernährung der Greifvögel und Eulen*. Stuttgart-Ludwigsburg. VACHON, R. 1954. Remarques sur les ennemis des scorpions à propos de la présence de restes de scorpions dans l'estomac de la Chouette. *Ois. Rev. Fr. Orn.* 24:171–174. VALENTIJN, J. 1984. *Braakbalanalyse*. Tegelen. VANCAMP, L. F. & HENNY, C. J. 1975. The Screech Owl: its life history and population ecology in northern Ohio. *North Amer. Fauna* 71. Fish and Wildlife Service, Washington, DC. VANDERPLANK, F. L. 1934. The effect of infra-red waves on Tawny Owls (*Strix aluco*). *Proc. Zool. Soc. London*:505–507. VAUGHAN, T. A. 1954. Diurnal foraging by the Great Horned Owl. *Wilson Bull.* 66:148. VAUK, G. & BINDIG, W. 1959. Rauhfusskauz (*Aegolius funereus*) auf Helgoland. *Orn. Mitt.* 11:5. VAURIE, C. 1960. Systematic notes on Palaearctic birds. 42. Strigidae; the genus *Athene*. *Amer. Mus. Nov.* 2,015:1–21. VAURIE, C. 1960. Systematic notes on Palaearctic birds. 43. Strigidae: the genera *Otus, Aegolius, Ninox* and *Tyto*. *Amer. Mus. Nov.* 2,021:1–19. VAURIE, C. 1965. *The Birds of the Palaearctic Fauna. Non-Passeriformes*. London. VERNON, C. J. 1971. Owls' food and other notes from a trip to South West Africa. *Ostrich* 42:153–154. VICKERY, P. D. & YUNICK, R. P. 1979. The 1978–1979 Great Gray Owl incursion across northeastern North America. *Amer. Birds* 33:242–244. VOOUS, K. H. 1951. Ein geval van kannibalisme bij de Kerkuil, *Tyto alba* (Scop.). *Ardea* 39:371. VOOUS, K. H. 1960. *Atlas of European Birds*. Edinburgh–London. VOOUS, K. H. 1964. Wood owls of the genera *Strix* and *Ciccaba*. *Zool. Meded. Rijksmus. Nat. Hist. Leiden* 39:471–478. VOOUS, K. H. 1966. The distribution of owls in Africa in relation to general zoogeographical problems. *Ostrich* (Suppl.) 6:499–506. VOOUS, K. H. 1973. List of recent Holarctic bird species. 1. *Ibis* 115:612–638. VOOUS, K. H. 1977. List of recent Holarctic bird species. Brit. Orn. Union, London (and *Ibis* 115 (1973):612–638), Non-Passerines). VOOUS, K. H. 1983. *Birds of the Netherlands Antilles*. Zutphen. WAGNER, P. W. 1981. Great Gray Owls in Utah – is weather a factor? *Southw. Nat.* 26:207. WAHLSTEDT, J. 1959. Ugglornas spelvanor. *Fauna och Flora* 54:81–112. WAHLSTEDT, J. 1976. Lappugglan *Strix nebulosa* i Sverige 1974. *Vår Fågelv.* 35:122–125. WALKER, F. J. 1981. Notes on the birds of Dhofar, Oman. *Sandgrouse* 2:56–85. WALKER, L. W. 1943. Nocturnal observations of Elf Owls. *Condor* 45:165–167. WALKER, L. W. 1978. *The Book of Owls*. New York. WARDHAUGH, A. A. 1983. *Owls of Britain and Europe*. Dorset. WATSON, A. 1957. The behaviour, breeding, and food-ecology of the Snowy Owl *Nyctea scandiaca*. *Ibis* 99:419–462. WATSON, A. 1972. *Birds of Moor and Mountain*. Edinburgh. WEAVING, A. J. S. 1970. Observations on the breeding behaviour of the Scops Owl. *Bokmakierie* 22:58–61. WEBSTER, J. D. & ORR, R. T. 1958. Variation in Great Horned Owls of Middle America. *Auk* 75:134–142. WEESIE, P. D. M. 1982. A Pleistocene endemic island form within the genus *Athene: Athene cretensis* n. sp. from Crete. *Proc. Kon. Ned. Akad. Wet.* Ser. B85:323–336. WEESIE, P. D. M. 1987. The quaternary avifauna of Crete, Greece. Doct. Thesis, Univ. Utrecht:1–90. WEIR, R. D. & COOKE, F., EDWARDS, M. H. & STEWART, R. B. 1980. Fall migration of Saw-whet Owls at Prince Edward Point, Ontario. *Wilson Bull.* 92:475–488. WELLS, D. R. 1966. Migrant Scops Owls *Otus scops* at Ibadan. *Bull. Nigerian Orn. Soc.* 3:10–11. WELLS, D. R. 1986. Further parallels between the Asian Bay Owl *Phodilus badius* and *Tyto* species. *Bull. Brit. Orn. Cl.* 106:12–15. WENDLAND, V. 1972. Zur Biologie des Waldkauzes (*Strix aluco*). *Vogelwelt* 93:81–91. WESKE, J. S. & TERBORGH, J. W. *Otus marshalli*, a new species of screech-owl from Peru. *Auk* 98:1–7. WETMORE, A. 1926. Observations on the birds of Argentina, Paraguay, Uruguay, and Chile. *Bull. US Nat. Mus.* 133:1–448. WETMORE, A. 1935. Shadowy birds of the night. *Nat. Geogr. Mag.* 67:217–240. WETMORE, A. 1943. The birds of southern Veracruz, Mexico. *Proc. US Nat. Mus.* 93:215–340. WETMORE, A. 1956. A check-list of the fossil and prehistoric birds of North America and the West Indies. *Smithson. Misc. Coll.* 131(5):1–105. WETMORE, A. 1968. The birds of the Republic of Panamá. 2. *Smithson. Misc. Coll.* 150(2):1–603. WETMORE, A. & SWALES, B. H. 1931. The birds of Haiti and the Dominican Republic. *Bull. US Nat. Mus.* 155:1–483. WETMORE, A. et al. 1965. *Water, Prey, and Game Birds of North America*. Washington, DC. WEYDEN, W. J. VAN DER. 1972. La Hulotte africaine *Strix woodfordii* au Sénégal. *Os. Rev. Fr. Orn.* 42:193–194. WEYDEN, W. J. VAN DER. 1973. Vocal affinities of the African and European Scops Owls. *Bull. IFAN* 35, Ser. A:716–722. WEYDEN, W. J. VAN DER. 1974. Vocal affinities of the Puerto Rican and Vermiculated Screech Owls (*Otus nudipes* and *Otus guatemalae*). *Ibis* 116:369–372. WEYDEN, W. J. VAN DER. 1975. Scops and Screech Owls: vocal evidence for a basic subdivision in the genus *Otus*. *Ardea* 63:65–77. WHISTLER, H. 1949. *Popular Handbook of Indian Birds*. 4th edn. Edinburgh–London. WHITE, C. M. N. 1965. *A Revised Check List of African Non-Passerine Birds*. Lusaka. WHITE, C. M. N. & BRUCE, M. D. 1986. The birds of Wallacea. *BOU Check-List* 7:1–524. WIJNANDTS, H. 1984. Ecological energetics of the Long-eared Owl (*Asio otus*). *Ardea* 72:1–92. WILLE, H-G. 1972. Ergebnisse einer mehrjährigen Studie an einer Population des Waldkauzes (*Strix aluco*) in West-Berlin. *Orn. Mitt.* 24:3–7. WILLET, G. 1921. Ornithological notes from southeastern Alaska. *Auk* 38:127–129. WILLIAMS, P. L. & FRANK, L. G. 1979. Diet of the Snowy Owl in the absence of small mammals. *Condor* 81:213–214. WILSON, D. S. 1975. The adequacy of body size as a niche difference. *Amer. Nat.* 109:769–784. WILSON, E. S. 1931. Tameness of a Saw-whet Owl (*Cryptoglaux acadica acadica*). *Auk* 48:266–267. WILSON, K. A. 1938. Owl studies at Ann Arbor, Michigan. *Auk* 55:187–197. WILSON, R. T. & WILSON, M. P. & DURKIN, J. W. 1986. Breeding biology of the Barn Owl *Tyto alba* in central Mali. *Ibis* 128:81–90. WILSON, V. J. 1970. Notes on the breeding and feeding habits of a pair of Barn Owls, *Tyto alba* (Scopoli), in Rhodesia. *Arnoldia*, Nat. Mus. Rhodesia 4(34):1–8. WINDE, H. 1970. Osteologische Untersuchungen an einigen deutschen Eulenarten. *Zool. Abhandl Staatl. Mus. Tierk. Dresden* 30:149–157. WINDE, H. 1977. Vergleichende Untersuchungen über Proportionalität und Sexualdimorphismus im Skelett von *Asio otus otus*. *Zool. Abhandl. Staatl. Mus. Tierk. Dresden* 34:143–146. WINKLER, R. 1975. Recapitulation des captures annuelles d'oiseaux au Col de Bretolet (Champéry, VS) de 1953 à 1974. *Bull. Murithienne* 92:41–49. WINTER, J. 1971. Some critical notes on finding and seeing the Flammulated Owl. *Birding* 3:205–209. WINTER, J. 1974. The distribution of the Flammulated Owl in California. *Western Birds* 5:25–44. WINTER, J. 1982. Further investigations on the ecology of the Great Gray Owl in the central Sierra Nevada. *Rep. US Forest Service*, Stanislaus National Forest. WITHERBY, H. F. (ED.). 1938. *The Handbook of British Birds*. 2. London. WOOD, N. A. 1951. The birds of Michigan. *Misc. Publ. Mus. Zool. Univ. Michigan* 75:1–559. WOODS, R. W. 1975. *The Birds of the Falkland Islands*. Oswestry. WYATT, C. W. 1870. Notes on the birds of the Peninsula of Sinai. *Ibis* New Ser. 21. YALDEN, D. W. 1973. Prey of the Abyssinian Long-eared Owl *Asio abyssinicus*. *Ibis* 115:605–606. YAMAMOTO, H. 1967. Mimetic threatening display of a Screech Owl, *Otus asio*, and a suggestion as to its roosting place in winter. *Tori* 18:193. YAMAMOTO, H. 1967. Winter records of Scops Owl, *Otus scopus*, in Iwate Prefecture. *Tori* 18:189. YEATMAN, L. 1976. *Atlas des oiseaux nicheurs de France*. Soc. Orn. France, Paris. ZANG, H. 1981. Zum Status des Rauhfusskauzes (*Aegolius funereus*) im Harz. *Ber. Nat. Ges. Hannover* 124:279–289. ZARN, M. 1974. Habitat management series for unique or endangered species. Rep. 10. Spotted Owl *Strix occidentalis*. *Techn. Note Bureau Land Management*, Denver Service Center 242:1–22. ZERUNIAN, G. F. & FRANZINI, G. & SCISCIONE, L. 1982. Little Owls and their prey in a Mediterranean habitat. *Boll. Zool.* 49:195–206. ZHENG, Z. et al. 1980. New records of Chinese birds from Xizang, Tibet. *Acta Zool. Sinica* 26:286–287. ZIMMERLI, E. 1964. Zur "Winterfütterung von Waldohreulen (*Asio otus*)". *Orn. Mitt.* 16:17.

INDEX

This list includes English and scientific names of all owl species mentioned in the text; other animals and plants are included under their vernacular name followed by their scientific name. Main species accounts are indicated by **bold** type; *italics* denote illustrations. Some subjects are also included, but most of the more obvious ones will be found by turning to the appropriate section in the species accounts.

Abert squirrel 58
Acid rain 145, 250
Acorn woodpecker *Melanerpes formicivorus* 150, 173, 174, 232
Aegolius acadicus 57, 61, 67, 68, 70, 82, 126, 146, 149, 150, 151, 158, 198, 232, 235, *256*, 260, 284, 286, 288, 291, 292, **293–8**, *295–6*
funereus 13, 45, 52, 91, 133, 137, 138, 141, 143, 144, 145, 146, 150, 151, 180, 185, 186, 213, 224, 237, 238, 241, 245, 246, 254, *256*, 257, **284–92**, *285*, *287*, 293, 294, 298
harrisii 224, 286, 298
ridgwayi 286, 293, 294, 298
African cedar *Podocarpus*, Podocarpaceae 253
African Grass Owl *see* Grass Owl
African hawk eagle *Hieraaetus spilogaster* 15
African marsh harrier *Circus ranivorus* 279, 280
African Marsh Owl 23, 25, 220, 272, 278, **279–83**, *281–2*
African mountain buzzard *Buteo oreophilus* 88
African/Afrotropical Scops Owl 33, 35, 37, 38, 40, 41, 42, 46
African Wood Owl 200, 203, 205, 209, 210
Age of first breeding 17
Agriculture, effects of 21, 278
Aircraft, owls as hazard to 278
Akinesis 141, 173
Akun Eagle Owl 87, 105
Alder *Alnus*, Betulaceae 231, 238, 252, 286, 293, 298
Alder flycatcher *Empidonax alnorum* 298
Alligator lizard *Gerrhonotus* 150
Almond tree 38
Alpine chough *Pyrrhocorax pyrrhocorax* 94, 130
Alpine swift *Apus melba* 94
Amur pike *Esox reicherti* 110
Ancient murrelet *Synthliboramphus antiquus* 128
Andaman Brown Hawk Owl 178
Andean Pygmy Owl 157, 158, 160
Arabian woodpecker *Dendrocopos dorae* 222
Arctic fox *Alopex lagopus* 128, 129, 130
Arctic tern *Sterna paradisaea* 104, 126
Arizona woodpecker *Dendrocopos arizonae* 173
Armadillo *Dasypus* 196
Arolla pine *Pinus cembra* Pinaceae 143
Ash *Fraxinus*, Oleaceae 45, 185
Ashy drongo *Dicrurus leucophaeus* 164
Ash-throated flycatcher *Myiarchus cineraceus* 173
Asian Barred Owlet *see* Cuckoo Owlet
Asio brevipes 261
capensis 23, 25, 220, 272, 278, **279–83**, *281–2*
clamator 9, 253, *266*, **267–8**, *269*, 272, 278
flammeus 9, *14*, 17, 18, 20, 21, 23, 42, 82, 91, 123, 126, 127, 130, 132, 133, *140*, 187, 196, 198, 210, 219, 246, *256*, 260, 261, 267, 268, 270, **271–8**, *273*, 279, 283, 297
madagascariensis 253
otus 9, 13, 15, 17, 20, 21, 41, 45, 57, 64, 67, 68, 79, 80, 82, 84, 85, 87, 91, 93, 143, 144, 181, 182, 185, 186, 187, 190, 195, 209, 210, 213, 214, 216, 218, 219, 226, 232, 235, 241, 244, 245, 246, **252–61**, *255*, *256*, *259*, 265, 267, 268, 271, 272, 274, 275, 276, 277, 278, 279, 288, 289, 290, 291, 292, 297
priscus 261
stygius 253, **262–5**, *263–4*, 267
Aspen *Populus*, Salicaceae 53, 57, 79, 150, 242, 252, 286
Association with man 21, 137, 160, 169, 192

Asvattha or Sacred fig tree (India) *Ficus indica*, Moraceae 52
Athene blewitti 165, 198–90, 192
brama 165, 181, *188*, **189–92**, *191*
cretensis 187
cunicularia 15, 16, 82, 173, 174, 181, 186, 187, 189, **193–9**, *194*, *197*
noctua 13, 15, 38, 41, 45, 64, 91, 143, 165, **181–7**, *183–4*, 189, 190, 192, 195, 198, 199, 209, 213, 214, 216, 222, 257
Attacking man 15, 57, 67, 86, 133, 141, 192, 195, 213, 232, 241, 246, 254, 274
Audubon's warbler *Dendroica auduboni*
Austral Pygmy Owl 157, 158, 160
Axolotl *Ambystoma mexicana* 294

Badger (American) *Taxidea taxus* 196, 199
Badger (European and Asian) *Meles meles* 185
Bald eagle *Haliaeetus leucocephalus* 82, 84, 110, 246
Balsam fir *Abies balsamea* 286
Balsas Screech Owl 60, 62
Baltimore oriole *Icterus galbula* 226
Bamboo rat *Rhizomys* 121
Banded Eagle Owl 87, 105, 108
Bank vole *Clethrionomys glareolus* 135, 138, 141, 144, 242, 246, 249, 290
Banyan or Sacred fig tree (Indonesia) *Ficus indica*, Moraceae 52
Baobab *Adansonia digitata* Bombacaceae 10, 16
Bare-shanked Screech Owl 74
Barking deer *Muntiacus muntjak* 108
Barn Owl **9–22**, *11*, *14*, 19, 25, 26, 28, 38, 45, 50, 67, 82, 84, 85, 91, 104, 150, 173, 181, 182, 185, 186, 187, 192, 196, 209, 213, 214, 216, 218, 219, 222, 230, 238, 245, 252, *256*, 257, 258, 260, 261, 267, 274, 275, 277, 280, 297
Barn swallow *Hirundo rustica* 144, 185
Barred Eagle Owl 105, 108
Barred forest falcon *Micrastur ruficollis* 77
Barred Owl 15, 59, 67, 68, 82, 84, 203, 208, 210, 213, **225–30**, *227–8*, 231, 232, 235, 236, 237, 238, 243, 245, 246, 252, 254, *256*, 257, 291, 294
Barred Owlet 161
Basswood *Tilia americana*, Tileaceae
Bay owls 9
Bergman's Rule 80
Bigamy 290
Binaural hearing 13
Biocide contamination 68, 86, 97, 175, 219, 260, 283
Birch *Betula* Betulaceae 42, 45, 132, 143, 238, 286, 288, 289, 290
Bittern *Botaurus stellaris* 94
Black-and-White Owl 200, 203, 204, 251
Black-backed woodpecker *Picoides arcticus* 284
Black-banded Owl 200, 203, 204, 251
Black-bellied plover *Pluvialis squatarola* 276
Blackbird (European and Asian) *Turdus merula* 185, 218
Black bulbul *Hypsipetes madagascariensis* 180
Black crake *Limnocorax flavirostra* 26
Black-footed ferret *Mustela nigripes* 196, 199
Black grouse *Tetrao tetrax* 94, 242
Black-headed gull *Larus ridibundus* 213, 276
Black kite *Milvus migrans* 28, 93, 214, 257, 274
Black rat *Rattus rattus* 84, 85
Black-shouldered kite *Elanus caeruleus* 28, 103, 283
Black stork *Ciconia nigra* 93, 241
Black-tailed prairie dog 193, 196, 199
Blacktail jackrabbit *Lepus californicus* 18
Black woodpecker *Drycopus martius* 45, 135, 143, 289
Blakiston's Fish Owl 87, 94, 98, **109–13**, *111–12*, 114, 116, 118, 119
Blindness 65
Blueberry *Vaccinium* Ericaceae 290
Bluebird *see* Eastern bluebird
Blue jay *Cyanocitta cristata* 18, 67, 226, 258
Bobcat *Lynx rufus* 196
Bobwhite *Colinus virginianus* 85
Body temperature 68, 86, 129, 174, 298
Bog lemming *Synaptomys* 135, 258
Bohemian waxwing *Bombycilla garrulus* 284, 298

Bonelli's eagle *Hieraaetus fasciatus* 187
Boobook Owl 42, 178
Booted eagle *Hieraaetus pennatus* 93, 182
Boreal Owl *see* Tengmalm's Owl
Box turtle *Terrapene carolina* 18
Brambling *Fringilla montifringilla* 290
Breeding density 26, 40, 45, 54, 110, 126, 137, 186, 196, 229, 241, 257
Brewer's blackbird *Euphagus cyanocephalus* 151
Bridled titmouse *Parus wollweberi* 149, 173
Bristle-cone pine *Pinus aristata* Pinaceae 53
Broad-winged hawk *Buteo platypterus* 229, 249, 294
Brooke's Scops Owl 32, 52
Brown creeper *see* Tree creeper
Brown Fish Owl 105, 109, **114–18**, *115*, *117*, 119
Brown Hawk Owl 50, 52, *176*, **177–80**, *179*
Brown-headed nuthatch *Sitta pusilla* 226
Brown lemming *Lemmus trimucronatus* 127, 128, 129, 276
Brown rat *Rattus norvegicus* 18, 67, 85, 128, 135, 144, 218, 249, 258, 275, 276, 283
Brown Wood Owl 108, 178, 203, **205–8**, *206–7*
Brush rabbit *Sylvilagus bachmani* 235
Bubo africanus 80, 86, 87, 88, 91, **100–4**, *101–2*, 219
ascalaphus see B. bubo
bengalensis 88, 98, 108
binagadensis 87
bubo 12, 15, 16, 45, 50, 79, 80, 82, 83, 85, 86, **87–98**, *89–90*, 92, *95–6*, 99, 100, 103, 104, 108, 109, 110, 113, 123, 124, 126, 127, 130, *140*, 143, 181, 182, 192, 213, 214, 218, 222, 226, 241, 244, 246, 253, 257, 274, 288, 291
capensis 15, 87, 88, 100, 103, 104
coromandus 98, 108, 114, 116
incertus 97
insularis 97
lacteus 15, 26, 87, 98, 100, 103, 104
leucostictus 87, 105
nipalensis **105–8**, *106–7*, 219
philippensis 114
poensis 87, 100, 105, 108
shelleyi 87, 105, 108
sinclairi 86
sumatranus 105, 108
virginianus 15, 16, 42, 57, 67, 68, **79–86**, *81*, *83*, 87, 88, 91, 93, 98, 100, 103, 104, 123, 124, 126, 127, 150, 170, 173, 195, 196, 203, 218, 225, 226, 230, 232, 244, 246, 253, *256*, 257, 274, 288, 291, 294
Buff-fronted Owl 224, 286, 298
Buffy Fish Owl *see* Malaysian Fish Owl
Bullock's oriole *Icterus bullockii* 226
Bulwer's petrel 20
Burbot *Lotta* 110
Burrowing Owl 15, 16, 82, 173, 174, 181, 186, 187, 189, **193–9**, *194*, *197*
Bush baby *Galago senegalensis* 104
Button quail *Turnix* 26
Buzzard *Buteo buteo* 93, 214, 218, 241, 246, 249, 257, 274, 277

Cabbage palm *Sabal palmetto*, Palmae 225
Cactus wren *Salpinctes obsoletus* 173
Camouflage 28, *43–4*, 53, 57, 133, 208, 249, 252, 288
Canada goose *Branta canadensis* 84
Cannibalism 16, 17, 246, 290
Canvasback *Aythya valisineria* 85
Cape Eagle Owl 15, 87, 88, 100, 103, 104
Cape polecat *see* Striped polecat
Capercaillie *Tetrao tetrax* 94
Captive breeding 97, 145, 210, 268
Captivity, owls in 196, 250, 268
Caracara 84
Carrion crow *Corvus corone*
Carrion-eating 85, 116, 128, 218
Casarca *see* Ruddy shelduck
Cassin's purple finch *Carpodacus cassinii* 151
Catfish *Clarias* 110
Cat Owl *see* Long-eared Owl
Cattle egret *Bulbulcus ibis* 28
Causes of death 21, 35, 58, 68, 86, 97, 104, 129, 145, 186, 219, 224, 250, 251, 260, 278, 283

Cedar waxwing *Bombycilla cedrorum* 284
Celebes Scops Owl 33, 36, 42
Century plant *Agave americana*, Agavaceae 174
Chaffinch *Fringilla coelebs* 45, 135, 138, 141, 144, 218, 290
Chestnut-backed chickadee *Parus rufescens* 231
Chestnut-collared longspur *Calcarius ornatus* 198
Chipmunk *Eutamias* 85, 229, 258, 297
Cholla prickly pear *Opuntia*, Cadaceae 174
Chough *see* Alpine and Red-billed chough
Chromosomes 13, 41, 124, 272
Chuckar *Alectoris graeca* 94
Ciccaba albitarsus 203, 226
huhula 200, 203, 204, 251
nigrolineata 200, 203, 204, 251
see also Strix
Cinereous harrier *Circus cinereus* 271, 274, 278
Civet cat *Viverra* 108
Clapper rail *Rallus longirostris* 18
Clark's nutcracker *Nucifraga columbiana* 231
Clines 10, 48, 80, 88, 116, 181, 189, 238, 286
Cloud-forest Screech Owl 69
Coal tit *Parus ater* 141, 144
Coast redwood *see* Redwood
Cockchafer *Melolontha* 218
Collared lemming *Dicrostonyx* 128, 130
Collared Owlet 32, 52, **161–4**, *162–3*, 165, 166, 169
Collared Pygmy Owl *see* Collared Owlet
Collared Scops Owl 29, 32, 33, 35, 42, **48–52**, *49*, *51*, 59, 60, 62, 78, 177, 178, 192
Collared turtle dove *Streptopelia decaocto* 18
Colonial nesting 16, 185, 257, 275, 280
Colonizing ability 10, 48
Colour morphs 42, 64, 65, 69, 77, 138, 149, 154, 157, 160, 161, 165, 210
Common dormouse *Muscardinus avellenarius* 218
Common eider *Somateria mollissima* 128
Common grackle *Quiscalus quiscula* 67
Common jay *Garrulus glandarius* 249
Common partridge *Perdix perdix* 94, 218, 242
Common shrew *Sorex araneus* 242, 246, 249, 290
Common snipe *Gallinago gallinago* 26, 258
Common tern *Sterna hirundo* 104, 185, 276
Common vole *Microtus arvalis* 144, 145, 218, 242, 257, 258, 275, 276, 290
Common wren *Troglodytes troglodytes* 151
Communal roosting 260, 274, 277, 278
Conservation 186, 199, 251
Continental drift 200
Convergent evolution 59, 283
Convolvulus hawk moth *Herse convolvuli* 29
Cooper's hawk *Accipiter cooperii* 67, 82, 150, 229, 235, 257, 294
Cooper's Screech Owl 60, 62, 158
Coot (American) *Fulica americana* 18
Coot (European and Asian) *Fulica atra* 94
Coppery-tailed trogon *Trogon elegans* 173
Cork oak *Quercus suber*, Fagaceae 45
Corncrake *Crex crex* 18
Cotton wood *Populus deltoides*, Salicaceae 59, 64, 170, 173, 231
Cottontail rabbit *Sylvilagus* 85, 198, 229
Courtship 16, 84, 124, 127, 143, 182, 213, 216, 245, 249, 254, 274, 275, 280
Coyote *Canis latrans* 196
Crane (European and Asian) *Grus grus* 94
Crested tit *Parus cristatus* 138, 141, 143, 144
Cricetine mouse *Zygodontomys* 268
Crossbill *Loxia* 135, 144, 235
Crow (American) *Corvus brachyrhynchos* 84, 85, 214, 249
Crow (European and Asian) *Corvus corone* 94, 241, 275, 276, 289
Cryptic plumage 41, 274, *see also* Camouflage
Cryptic posture 45, 57, 61, 67, 133, 141, 173, 208, 241, 254, 288, 294
Cuban Pygmy Owl 149, 158
Cuckoo *Cuculus canorus* 185
Cuckoo Owlet 161, 164, **165–9**, *167–8*, 180
Cypress (North American) *Cypressus*, Pinaceae 225

INDEX

Darwin's groundfinch *Geospiza* 20, 276
Date palm *Phoenix dactylifera*, Palmae 37, 38, 252
Daurian jackdaw *Corvus dauuricus* 242
Deer mouse *Peromyscus maniculatus* 18, 61, 67, 128, 135, 235, 276, 297
Deforestation 46, 68, 97, 199, 230, 265
Deodar *Cedrus deodara*, Pinaceae 161
Desert jerboa *Jaculus* and *Dipus* 94, 98, 218
Desert kestrel *Falco sparverius phalaena* 173
Desert Scops Owl *see* Striated Scops Owl
Dialects 35, 36, 42, 60, 149
Dipper *Cinclus cinclus* 144
Directional hearing 13, 190, 209, 213, 245, 250, 254, 286
Diseases, viral 9, 219
 immunity to 9
Dispersal 28, 94, 198
 of young 20, 128, 186, 219, 235
Distraction display, broken wing 91, 126, 127, 216, 254, 274, 280
Dive-bombing 126
Diving petrel *Pelecanoides* 276
DNA 13
Domestic pigeon *Columba (livia) domestica* 61, 67, 235, 242, 297
Dor beetle *Geotrupes stercorarius* 40
Dormouse *Muscardinus avellanarius* 258, 290
Douglas Fir *Pseudotsuga menziesii*, Pinaceae 53, 149, 150, 231, 235
Douglas squirrels 58
Dowitcher *Limnodromus* 276
Downy woodpecker *Dendrocopos pubescens* 67, 151
Dunlin *Calidris alpina* 276
Dunnock *Prunella modularis* 290
Dusky Eagle Owl 98, 108, 114, 116
Dusky field rat *Rattus sordidus* 28

Ear
 inner 286
 middle 286
 outer 13, 42, 80, 91, 103, 124, 133, 141, 170, 178, 181, 190, 195, 200, 203, 205, 210–13, 222, 226, 232, 238, 244, 245, 251, 252, *253*, 253–4, 268, 272, 279, 284, 286, 292, 294
Ear tufts 29, 54, 64, 70, 77, 109, 116, 124, 133, 137, 141, 252, 253, 268, 271, 272, 274, 278, 279
Eastern bluebird *Sialia sialis* 151
Eastern Screech Owl 48, 50, 52, 59, 60, 62, *63*, **64–8**, *66*, 69, 77, 78, 82, 230, 252, 294, 297
Edible dormouse *Glis glis* 18, 218, 258
Egg-collecting 97
Egg-laying dates 84, 216, 257
Eggshell thinning 21, 68, 145
Egyptian nightjar *Caprimulgus aegyptius* 222
Eleonora's falcon *Falco eleonorae* 45
Elephant shrew *Elephantulus* 19, 26
Elf Owl 42, 53, 57, 61, 70, 132, 150, 151, 153, 157, 158, **170–5**, *171–2*, 195, 198
Endangered species 68, 113, 199, 231
Engganan Scops Owl 33, 50
Environmental changes 118, 145, 196, 199, 271
 climatic 46, 199
Epithelium 13
Ermine *see* stoat
Etruscan shrew *Suncus etruscus* 18, 218
Evening grosbeak *Hesperiphona vespertina* 235, 298
Eurasian Eagle Owl 12, 15, 16, 45, 50, 79, 80, 82, 83, 85, 86, **87–98**, *89–90*, *92*, *95–6*, *99*, 100, 103, 104, 108, 109, 110, 113, 123, 124, 126, 127, 130, *140*, 143, 181, 182, 192, 213, 214, 218, 222, 226, 241, 244, 246, 253, 257, 274, 288, 291
Eurasian Pygmy Owl 41, 42, 45, 132, 137, **138–45**, *139*, *140*, *142*, 146, 149, 150, 151, 154, 160, 161, 164, 165, 166, 169, 181, 185, 214, 249, *256*, 257, 288, 289
European Scops Owl 33, 35, 36, 37, 38, 40, **41–6**, *43–4*, 47, 53, 54, 64, 91, 138, 141, 181, 185, 209

Facial disc 13, 42, 54, 78, 124, 133, 141, 173, 178, 203, 205, 210, 238, 244, 245, 250, 251, 252, 253, 274, 286, 294
Fan-tailed warbler *Cisticola juncidis* 28
Fasting 128
Feather lice *Strigiphilus* 9, 61
Fence lizard *Sceloporus* 150, 158
Fennec fox *Fennecus zerda* 94
Ferruginous hawk *Buteo regalis* 82, 84
Ferruginous Pygmy Owl 138, 149, 151, 153, 154, *156*, **157–60**, *159*, 173, 294
Fiddler crab *Uca* 229
Field mouse *Apodemus* 218, 276
Field sparrow 18
Fieldfare *Turdus pilaris* 249
Fir *Abies*, Pinaceae 109, 150, 161, 210, 238, 245
Fisher (Marten) *Martes pennanti* 246
Flammulated Owl 41, 42, **53–8**, *54–6*, 61, 67, 69, 70, 72, 149, 150, 173, 231, 232, 293, 294
Fledging success 94, 276
Flicker *Colaptes* 18, 61, 68, 289, 297
Flight 17, 26, 41, 116, 119, 126–7, 135, 141, 164, 166, 170, 173, 182, 190, 238, 244, 252, 254, 257, 271, 274, 275, 280, 283
 hovering 94, 135, 174, 186, 190, 198, 249, 258, 276, 283
Flocking 260, 275, 276, 277, 283
Florican bustard *Eupodotis bengalensis* 23
Flying squirrel (American) *Glaucomys volans* 57, 85, 235, 297
Flying squirrel (European and Asian) *Pteromys volans* 108, 290
Folklore 36, 193
Food-caching 67, 127, 138, 143, 144, 145, 151, 275, 290
Food intake 68, 129, 133
Food provision by man 21, 186, 260
 in captivity 58, 268
Forest Eagle Owl **105–8**, *106–7*, 219
Forest falcon *Micrastur*
Forest Owlet 165, 189–90, 192
Fossils 12, 46, 62, 97, 110, 132, 147, 199, 238, 284, 298
Fox (European and Asian) *Vulpes vulpes* 185, 275, 276
Fox (North American) *Vulpes fulva* 85
Fraser's Eagle Owl 87, 100, 105, 108
Fulvous Owl 203, 204, 225, 226, 238

Gambel's quail *Callipepla gambelli* 151
Garden dormouse *Eliomys quercinus* 218
Garganey *Anas querquedula* 94
Gerbil *Tatera leucogaster* 17, 20, 103
 Gerbillus 94, 103, 222
Giant Eagle Owl 15, 26, 87, 98, 100, 103, 104
Giant mole rat *Tachyorectes splendens* 258
Gila woodpecker *Melanerpes (Centurus) uropygialis* 61, 158, 173
Gilded flicker *Colaptes chrysoides* 61, 173
"Glacial speciation" 237, 238
Glaucidium brasilianum 138, 149, 151, 153, 154, *156*, **157–60**, *159*, 173, 294
 brodiei 32, 52, **161–4**, *162–3*, 165, 166, 169
 capense 161
 castanopterum (=cuculoides) 161, 164, **165–9**, *167–8*, 180
 gnoma 54, 57, 61, 70, 91, 133, 137, 138, **146–51**, *147–8*, 153, 154, 157, 158, 160, 165, 173, 231, 232, 294, 297
 jardini 157, 158, 160
 minutissimum 138, 146, 149, *152*, **153–4**, *155*, 157, 158, 160, 170
 nanum 157, 158, 160
 passerinum 41, 42, 45, 132, 137, **138–45**, *139*, *140*, *142*, 146, 149, 150, 151, 154, 160, 161, 164, 165, 166, 169, 181, 185, 214, 249, *256*, 257, 288, 289
 perlatum 138
 radiatum 161, 164, 165, 166, 169, 189, 192
 siju 149, 158
Glaucous gull *Larus hyperboreus* 126
Glider *see* Sugar opossum
Gloger's Rule 80
Glossy starling (Asian) *Aplonis panayensis* 20
Goldcrest *Regulus regulus* 141, 144, 276, 290
Golden eagle *Aquila chrysaetos* 82, 93, 97, 133, 235, 246, 274
Golden pheasant *Chrysolophus pictus* 61
Goldeneye *Bucephala clangula* 135, 137, 289
Golden-crowned kinglet *Regulus satrapa* 298
Golden-fronted woodpecker *Melanerpes (Centurus) aurifrons* 173
Goldfinch (European) *Carduelis carduelis* 45
Goosander *Mergus merganser* 135, 137
Goshawk *Accipiter gentilis* 15, 82, 84, 110, 126, 133, 135, 143, 146, 150, 182, 214, 229, 235, 241, 243, 246, 249, 257, 274, 288
Grass mouse *Arvicanthis* 61, 103
Grass Owl 12, 18, **23–8**, *24*, 27, 195, 279, 280
Great anteater *Myrmecophaga tridactylus* 196
Great blue heron *Ardea herodias* 84
Great grey owl *14*, 79, 80, 87, 91, 93, 97, 133, *140*, 225, 226, 232, 237, 238, 241, 242, 243, **244–51**, *247–8*, *256*, 288, 291
Great grey shrike *Lanius excubitor* 135, 137
Great Horned Owl 15, 16, 42, 57, 67, 68, **79–86**, *81*, *83*, 87, 88, 91, 93, 98, 100, 103, 104, 123, 124, 126, 127, 150, 170, 173, 195, 196, 203, 218, 225, 226, 230, 232, 244, 246, 253, *256*, 257, 274, 288, 291, 294
Great spotted woodpecker *Dendrocopus major* 45, 141, 143, 144, 185, 242, 289
Great tit *Parus major* 144, 249
Greater frigate bird *Fregata minor* 276
Greater snow goose *Anser hyperboreus* 126
Green heron *Butorides (virescens) striatus* 18
Green woodpecker *Picus viridis* 18, 38, 45, 143, 185, 237, 289
Greenfinch *Carduelis chloris* 218, 258
Green-winged teal *Anas crecca* 128
Grey heron *Ardea cinerea* 94
Grey jay *Perisoreus canadensis* 61, 132, 150, 298
Grey starling *Sturnus cineraceus* 52
Grey wagtail *Motacilla cinerea* 121
Grey-backed storm petrel *Garrodia nereis* 276
Grey-headed woodpecker *Picus canus* 45, 143, 237, 289
Grey-sided vole *Clethrionomys rufocanus* 242
Ground dove *Columbigallina* or *Columbina* 265
Ground squirrel *Citellus* 18, 82, 85, 94, 128, 196, 198, 218
Ground vole *Arvicola terrestris* 214, 241, 276, 290
Grunion *Leuresthes tenius* 18
Guatemala Barred Owl *see* Fulvous Owl
Guanaco *Lama guanacoe* 199
Gyrfalcon *Falco rusticolus* 93, 126, 135, 143, 274

Habitat destruction 28, 72, 78, 86, 145, 229, 231, 236, 241
Hairy woodpecker *Dendrocopos villosus* 150
Hamerkop stork *Scopus umbretta* 16, 103
Hamster *Cricetus cricetus* 18, 144, 218, 276
Hare *Lepus* 82, 85, 104, 108, 128, 218, 229, 242, 258
Harlequin duck *Histrionicus histrionicus* 128
Harris' hawk *Parabuteo unicinctus* 82, 84
Harvest mouse (American) *Reithrodontomys* 198
Harvest mouse (European) *Micromys minutus* 18, 61, 258, 290
Hawaiian petrel *Pterodroma phaeopygia* 275
Hawfinch *Coccothraustes coccothraustes* 144
Hazel grouse *Bonasa bonasia* 94, 135, 242
Hearing 80, 182, 190, 195, 203, 209, 219, 238, 250, 253–4, 272, 284, 286
Heat resistance behaviour 232
Hepatosplenitis infectiosa 9
Hermit thrush *Catharus guttatus* 298
Hibernation (torpor) 58
Himalayan Barred Owlet *see* Cuckoo Owlet
Hobby *Falco subbuteo* 93
Honey buzzard *Pernis apivorus* 93
Houbara bustard *Chlamydotis undulata* 94
House bunting *Emberiza striolata* 222
House martin *Delichon urbica* 144
House mouse *Mus musculus* 20, 28, 61, 67, 68, 128, 185, 216, 258, 290, 297
House sparrow *Passer domesticus* 15, 16, 18, 40, 61, 68, 144, 145, 151, 158, 185, 218, 222, 258, 290
House wren *Troglodytes aedon* 150
Hume's (Tawny) Owl 118, 182, 210, **220–4**, *221*, *223*
Hunger resistance 260
Hybridization 238, 267
Hybrids 79, 80, 88, 91, 210, 238

Imperial eagle *Aquila heliaca* 274
Incense cedar *Calocedrus (Libocedrus) decurens*, Pinaceae 53, 235
Indian Barred Jungle Owlet 161, 164, 165, 166, 169, 189, 192
Indian Eagle Owl 88, 98, 108
Indian pond heron *Ardeola grayii* 116
Indian roller *Coracias benghalensis* 178
Interbreeding 60, 80, 189
Interrelations 28, 32, 33, 36, 48, 52, 54, 59, 60, 70, 74–7, 98, 104, 105, 113, 114, 118, 119, 121, 132, 133, 137, 145, 146, 149, 151, 177, 181, 187, 199, 200, 208, 219, 225, 230, 241, 246, 252, 271, 275, 292, 293
Interspecific competition 15, 26, 33, 45, 52, 57, 61, 67, 72, 82, 87, 93, 103, 137, 173, 178, 222, 225, 231, 232, 235, 237, 243,
246, 275, 298
Introductions 12, 21, 181, 186
Irruptions 85, 94, 123, 128–9, 135–7, 144, 151, 250, 260, 277, 290–1, 292, 297
Island populations 10, 20, 21, 36, 48, 50, 164, 271

Jackal *Canis aureus* 108
Jackdaw *Corvus monedula* 18, 94, 214, 258, 289
Jardine's Pygmy Owl *see* Andean Pygmy Owl
Javan Spotted Scops Owl 30–1, *see also* Mountain Scops Owl
Jay 94, 182, 185, 214, 242
Jerusalem cricket *Stenopelmatus* 18, 58, 61, 297
Joshua tree *Yucca brevifolia*, Agavaceae 57
Jumping mouse *Zapus* 67, 235
Junco *Junco hyemalis* 151, 298
Jungle fowl *Gallus gallus* 108, 119, 121
Juniper *Juniperus* Cupressaceae 42, 59, 69, 222, 252

Kaleej pheasant *Lophura leucomelana* 108
Kangaroo rat *Dipodomys* 61, 85
Kestrel (American) *Falco sparverius* 15, 58, 61, 67, 68, 82
Kestrel (European and Asian) *Falco tinnunculus* 15, 16, 93, 135, 182, 185, 195, 214, 258, 260, 275
Ketupa blakistoni 87, 94, 98, **109–13**, *111–12*, 114, 116, 118, 119
 flavipes 14, 110, 114, 116, **119–21**, *121–2*
 ketupa 16, 105, 114, 116, 119
 zeylonensis 105, 109, **114–18**, *115*, *117*, 119
Killdeer *Charadrius vociferus* 276
King eider *Somateria spectabilis* 128
Kingfisher *Alcedo atthis* 93
Kleptoparasitism, mutual 126

Ladder-backed woodpecker *Dendrocopos scalaris* 173
Lamb's Screech Owl 60, 65
Lanner falcon *Falco biarmicus* 15, 103, 182
Lapland bunting or longspur *Calcarius lapponicus* 128
Lapwing *Vanellus vanellus* 18, 185, 258, 276
Larch *Larix*, Pinaceae 132, 143, 150
Larger gerboa *Allactaga* and *Alactagulus* 94
Lark *Alauda* 222
Lark bunting *Chondestes grammacus* 198
Laurelwood *Arbutus*, Ericaceae 174
Leach's storm petrel *Oceanodroma leucorhoa* 18
Learning 80, 141
Least Pygmy Owl 138, 146, 149, *152*, **153–4**, *155*, 157, 158, 160, 170
Least shrew *Cryptotis parva* 18
Least weasel (American) *Mustela rixosa* 126, 128
Least weasel (European) *see* Weasel
Legends and myths 32, 182
'Lemming display' 127
Lesser coucal *Centropus bengalensis* 23
Lesser cuckoo *Cuculus poliocephalus* 180
Lesser Horned Owl *see* Long-eared Owl
Lesser kestrel *Falco naumanni* 182, 187
Lesser snow goose *Anser caerulescens* 126
Lesser spotted eagle *Aquila pomarina* 241
Lesser spotted woodpecker *Dendrocopos minor* 144
Lesser whistling duck *Dendrocygna javanica* 116
Lesser yellowlegs *Tringa flavipes* 18
Letter-winged kite *Elanus scriptus* 28
Levant sparrowhawk *Accipiter brevipes* 46
Lewis' woodpecker *Asyndesmus lewis* 61, 231
Life span/longevity 20, 85, 97, 129, 186, 219, 250, 260, 277, 291
Lime 177
Linnet *Carduelis cannabina* 45
Little auk *Alle Alle* 128
Little brown bat *Myotis lucifugus* 67
Little bustard *Tetrax tetrax* 94
Little Owl 13, 15, 38, 41, 45, 64, 91, 143, 165, **181–7**, *183–4*, 189, 190, 192, 195, 198, 199, 209, 213, 214, 216, 222, 257
Live-oak *Quercus virginiana*, Fagaceae 225, 231, 235
Lodgepole pine *Pinus contorta*, Pinaceae 53, 57
Long-eared Owl 9, 13, 15, 17, 20, 21, 41, 45, 57, 64, 67, 68, 79, 80, 82, 84, 85, 87, 91, 93, 143, 144, 181, 182, 186, 187, 190, 195, 209, 210, 213, 214, 216, 218, 219, 226, 232, 235, 241, 244, 245, 246, **252–61**, *255*, *256*, *259*, 265, 267, 268, 271, 272, 274, 275, 276, 277, 279, 288, 289, 290, 291, 292, 297

318

INDEX

Long-haired rat *Rattus villosissimus* 26, 28
Long-legged buzzard *Buteo rufinus* 274
Long-tailed duck 128
Long-tailed field mouse *Apodemus sylvaticus* 135, 185, 258, 290
Long-tailed skua *Stercorarius longicaudus* 126
Luzon Scops Owl 32
Lynx (American) *Lynx canadensis* 246

Madagascar Hawk Owl 180
Madagascar Long-eared Owl 253
Madeiran storm petrel *Oceanodroma castro* 20
Magpie *Pica pica* 38, 45, 52, 65, 84, 85, 94, 214, 242, 249, 258, 289
Magpie robin *Copsychus* 164, 180
Mahogany *Berberis* (Mahonia), Berberidaceae 53
Malay Eagle Owl *see* Barred Eagle Owl
Malaysian Fish Owl 16, 105, 114, 116, 119
Mallard *Anas platyrhynchos* 85, 94
Mandarin duck 52
Mantanani Scops Owl 50
Mara *Dolichotis patagonum* 199
Marsh wren *Cistothorus palustris* 151
Marsupial mouse *Antechinus* 26
Masked Owl 12
Meadow vole *Microtus pennsylvanicus* 18, 67, 82, 128, 129, 257, 258, 290, 297
Meadowlark *Sturnella* 198, 276
Medicine, owls used in 52
Memory 13
Mentawai Scops Owl 33, 50
Merlin *Falco columbarius* 93
Mesquite *Prosopis*, Fabaceae 59, 60, 174
Metabolism 61, 65, 68, 129, 137, 169, 229, 260, 277, 279, 294
Micrathene whitneyi 42, 53, 57, 61, 70, 132, 150, 151, 153, 157, 158, **170–5**, *171–2*, 195, 198
Midwife toad *Alytes obstetricans* 164
Milky Eagle Owl *see* Giant Eagle Owl
Minahasa Barn Owl 9, 12
Minivet *Pericrocotus* 164
Mink (American) *Mustela vison* 275
Mink (European and Asian) *Mustela lutreola* 229, 242, 276
Mistle thrush *Turdus viscivorus* 144
Mixed clutches 38, 61
Mobbing 45, 65, 91, 126, 138, 141, 149, 154, 166, 213, 232, 252
Mole lemming *Alloblus* 94
Mole (European and Asian) *Talpa europaea* 18, 128, 218, 276
Montagu's harrier *Circus pygargus* 93
Moorhen *Gallinula chloropus* 18, 185, 258, 276
Mortality 20, 61, 65, 97, 186, 198, 219, 250, 260, 277
Mottled (Wood) Owl 158, **200–4**, *201–2*, 208, 219
Mountain Scops Owl **29–32**, *30–1*, 35, 52, *see also* Javan Spotted Owl
Mourning dove *Zenaida macroura* 67
Mulberry 38
Multimammate mouse *Microtus (Praomys) natalensis* 17, 20, 283
Musk rat *Ondatra zibethica* 18, 85, 128, 218

Negros Scops Owl 32, 50
Nest boxes 16, 21, 38, 40, 45, 46, 52, 57, 58, 65, 67, 68, 113, 135, 137, 144, 145, 180, 185, 186, 210, 214, 216, 219, 229, 230, 236, 242, 251, 257, 260, 289, 291, 292, 297, 298
Nest-robbing by man 97
Nest spacing 16, 26, 45, 84, 93, 127, 174, 186, 216, 280
Nesting close to other owls 16, 133, 150, 185, 246, 280, 294, 297
Nesting close to raptors 16, 82, 133, 185, 226, 246
Night heron *Nycticorax nyticorax* 84
Night snake *Hypsiglena* 61
Nightjar *Caprimulgus europaeus* 258
Ninox affinis 178
 novaeseelandiae 42, 178
 philippensis 178
 punctulata 180
 scutulata 50, 52, *176*, **177–80**, *179*
 strenua 87
 superciliaris 180
Nomadism 123, 127, 135, 250, 258, 261, 271, 272, 276, 277, 278, 280, 290, 292
Northern flicker *Colaptes auratus* 57, 150
Northern harrier *Circus cyaneus* 82, 93, 126, 257, 258, 271, 274, 275, 276, 277, 278, 280
Northern Hawk Owl *14*, *43*, 91, **132–7**, *134*, 136, 144, 169, 177, 178, 180, 246, *256*, 274, 288, 289, 291
Northern Pygmy Owl 54, 57, 61, 70, 91, 133, 137, 138, **146–51**, *147–8*, 153, 154, 157, 158, 160, 165, 173, 231, 232, 294, 297
Northern Saw-whet Owl 57, 61, 67, 68, 70, 82, 126, 146, 149, 150, 151, 158, 198, 232, 235, *256*, 260, 284, 286, 288, 291, 292, **293–8**, *295–6*
Norway lemming *Lemmus lemmus* 135
Norway spruce *Picea abies*, Pinaceae 145
Nutcracker *Nucifraga caryocatactes* 94, 242
Nuthatch *Sitta europaea* 141, 143, 144
Nuttall's woodpecker *Dendrocopos nuttalli* 226
Nyctea scandiaca 41, 44, 80, 85, 86, 87, 88, 91, 97, **123–30**, *125*, *131*, 132, 133, *140*, 250, *256*, 274, 275, 276, 277

Oak *Quercus*, Fagaceae 42, 53, 59, 64, 69, 72, 74, 149, 150, 161, 165, 173, 177, 185, 210, 235, 257, 289, 297
Observations at sea 277
Oleander hawk moth *Daphnis nerii* 45
Olivaceous flycatcher *Myiarchus tuberculifer* 173
Olive-sided flycatcher *Contopus borealis* 298
Opossum *Didelphis virginiana* 85, 196, 229
Opportunistic feeding/hunting 84, 94, 104, 242
Oriental Scops Owl **33–6**, *34*, 37, 38, *39*, 40, 42, 46, 50, 52, 54, 177, 178
Origins
 of genera 12, 41, 79, 87, 114, 192, 203, 284, 294
 of species 23, 46, 62, 69, 74, 78, 79, 87, 109, 113, 123, 132, 146, 154, 160, 161, 170, 177, 199, 232, 237, 241, 261, 267, 268, 278, 279, 284, 286, 293
Ornimegalonyx oteroi 12, 86
Osprey *Pandion haliaetus* 84, 93, 128, 249
Otus albogularis 69
 angelinae see Mountain Scops Owl
 asio 48, 50, 52, 59, 60, 62, *63*, **64–8**, *66*, 69, 77, 78, 82, 230, 252, 294, 297
 bakkamoena 29, 32, 33, 35, 42, **48–52**, *49*, *51*, 59, 60, 62, 78, 177, 178, 192
 barbarus 69
 brookii 32, 52
 brucei 33, *34*, **37–40**, *39*, 41, 42
 choliba 59, 60, 62, 74, 77, 78
 clarkii 74
 cooperi 60, 62, 158
 elegans 50
 enganensis 33, 50
 flammeolus 41, 42, **53–8**, *54–6*, 61, 67, 69, 70, 72, 149, 150, 173, 231, 232, 293, 294
 guatemalae 69, **74–8**, *75–6*
 ingens 69
 kennicottii 36, 48, 50, 52, 53, 54, 57, 58, *59–62*, 65, 66, 67, 68, 69, 70, 72, 77, 78, 82, 146, 150, 170, 173, 198, 232, 252, 288, 298
 lambi 60, 62
 longicornis 32
 manadensis 33, 36, 42
 mantanensis 50
 marshalli 69
 mentawi 33, 50
 nigrorum 32, 50
 nudipes 74, 77
 scops 33, 35, 36, 37, 38, 40, **41–6**, *43–4*, 47, 53, 54, 64, 91, 138, 141, 181, 185, 209
 seductus 60, 62
 senegalensis 33, 35, 37, 38, 40, 41, 42, 46
 silvicola 48
 spilocephalus **29–32**, *30–1*, 35, 52
 stresemanni 29, 32
 sunia **33–6**, *34*, 37, 38, *39*, 40, 42, 46, 50, 52, 54, 177, 178
 trichopsis 54, 57, 58, 60, 61, 67, **69–72**, *71*, *73*, 77, 146, 150, 151, 173, 198
Overheating 61, 129, 151, 158
Oxygen consumption 70, 129, 199

Pale rock sparrow *Petronia brachydactyla* 222
Pallas' fish eagle *Haliaeetus leucoryphus* 119
Pallas' sandgrouse *Syrrhaptes paradoxus* 94
Pallid harrier *Circus macrourus* 274
Pallid Scops Owl *see* Striated Scops Owl
Pampas deer *Odocoileus bezoarticus* 199
Paradise flycatcher 36
Peacock *Pavo cristatus* 108
Pearl-spotted Owlet 138
Peepal (pipal) or Sacred fig tree (India) *Ficus religiosa*, Moraceae 52
Penduline tit *Remiz pendulinus* 258
Peregrine falcon *Falco peregrinus* 15, 84, 85, 93, 126, 132, 135, 182, 257, 274
Persecution by man 79, 86, 97, 129, 186, 250, 260
Pesticides 46, 58, 97, 118, 145, 219
Pets, owls as 68, 154, 253
Pharaoh Owl *see* Eurasian Eagle Owl
Pheasant *see* Ring-necked pheasant
Philippine Eagle Owl 114
Philippine Hawk Owl 178
Phodilus 9
Pied flycatcher *Ficedula hypoleuca* 144, 170, 292
Pika *Ochotona princips* 235
Pileated woodpecker *Dryocopus pileatus* 135, 289, 297
Pine grosbeak *Pinicola enucleator* 132, 144, 284, 298
Pine marten *Martes martes* 144, 145, 214, 289
Pine siskin *Carduelis pinus* 151, 298
Pinon pine *Pinus cembroides*, Pinaceae 59, 149
Pintail *Anas acuta* 85
Pipistrelle bat *Pipistrellus pipistrellus* 276
Plain titmouse *Parus inornatus* 149
Plains wolf *Canis lupus* 196
Plumage insulation 61, 123, 124, 129, 298
Pocket gopher *Thomomys* 18, 61, 82, 85, 151, 196, 198, 258, 276
Poisoning 21
Pollution 46, 118, 186
Polygamy 16, 297
Pomarine skua *Stercorarius pomarinus* 126, 274, 275, 294
Ponderosa pine *Pinus ponderosa*, Pinaceae 53, 58, 59, 149, 150
Poplar *Populus*, Salicaceae 37, 38, 45, 132, 238, 252, 286, 289, 293
Population
 decline 46, 85, 199, 227–8
 fluctuations 20, 52, 58, 82, 85, 97, 110, 128, 135, 137, 144, 151, 219
 increase 292
 numbers 41, 137
Powerful owl 87
Prairie dog "towns" 196
Prairie falcon *Falco mexicanus* 15, 84, 196
Prairie vole *Microtus ochrogaster* 18
Pratincole *Glareola pratincola*
Predation
 on/by other owls 15, 45, 57, 61, 67, 82, 84, 85, 87, 91, 94, 126, 128, 133, 143, 149, 182, 196, 214, 222, 226, 232, 235, 241, 246, 247, 258, 274, 288–9, 294
 by raptors 173, 185, 196, 214, 222, 229, 241, 246, 257, 274, 288–9, 294
 on raptors 15, 82, 85, 87, 91, 93, 94, 103, 126, 128, 185, 214, 229, 258
Predator-mimicry 77
Ptarmigan *Lagopus mutus* 85, 94, 128, 130
Puerto Rican Screech Owl 74, 77
Pulsatrix perspicillata 113, 203
Pygmy nuthatch *Sitta pygmaea* 149, 226, 231
Pygmy shrew *Sorex minutus* 144, 218, 249

Quail (European and Asian) *Coturnix coturnix* 166

Rabbit *Oryctolagus cuniculus* 82, 84, 85, 86, 185, 198, 214, 218, 258, 276
Raccoon *Procyon lotor* 67, 196
Radio telemetry 229, 290, 294, 298
Rajah's Scops Owl *see* Brooke's Scops Owl
Rattlesnake *Crotalus* 193, 195, 196
Rat-tailed opossum *Metachirus* 268
Raven *Corvus corax* 16, 84, 87, 93, 94, 126, 130, 214, 235, 241, 249, 275
Red-backed vole (European and Asian) *Clethrionomys rufocanus*
Red-backed vole (North America) *Clethrionomys gapperi* 290
Red-billed chough *Pyrrhocorax pyrrhocorax* 94
Red-breasted nuthatch *Sitta canadensis* 149, 235, 298
Red cardinal *Cardinalis cardinalis* 258
Red-cockaded woodpecker *Dendrocopos borealis* 226
Red kite *Milvus milvus* 15, 93, 257
Redpoll *Carduelis flammea* 144, 151, 249
Red-shafted flicker *Colaptes cafer* 61
Red-shouldered hawk *Buteo lineatus* 67, 82, 84, 226, 229
Red squirrel *Sciurus hudsonicus* 18, 67, 218, 297
Red-tailed hawk *Buteo jamaicensis* 67, 82, 84, 85, 86, 229, 235, 246, 249, 274
Redwing *Turdus iliacus* 144, 249
Red-winged blackbird *Agelaius phoeniceus* 67, 85, 276
Redwood *Sequoia sempervirens*, Pinaceae 149, 150, 231, 235
Reed bunting *Emberiza schoeniclus* 276
Reintroductions 93, 97, 199, 237
Rhea *Rhea americana* 199
Rice rat *Oryzomys* 268
Richardson's ground squirrel *Citellus richardsoni* 82
Richardson's Owl *see* Tengmalm's Owl
Ringing recoveries 68, 85, 86, 94, 129, 260, 277, 291
Ring-necked pheasant *Phasianus colchicus* 61, 94
Ring ouzel *Turdus torquatus* 141
Roadside hawk *Buteo magnirostris* 265
Robin (American) *Turdus migratorius* 61, 151
Robin (European and Asian) *Erithacus rubecula* 290
Rock dove *Columba livia* 16
Rock partridge *Alectoris graeca* 187
Rock pigeon *Columba livia* 94
Rock ptarmigan *Lagopus mutus* 130
Rock squirrel *Citellus variegatus* 196
Rodents and owls 18, 26, 123, 124, 126–9, 130, 135, 276, 277
Roller flycatcher 36
Rough-legged buzzard *Buteo lagopus* 93, 126, 130, 133, 249, 274, 277
Ruby-crowned kinglet *Regulus calendula* 298
Ruddy shelduck *Tadorna ferruginea* 94
Ruffed grouse *Bonasa umbellus* 84, 85, 135, 298
Rufescent Screech Owl 69
Rufous-banded Owl 203, 226
Rufous-legged Owl 204
Ryu Kyu Scops Owl 50

Saguaro cactus *Cereus giganteus*, Cactaceae 59, 84, 170, 173, 174
Saker falcon *Falco cherrug* 93
Sand mouse *Meriones* 94, 224
Santa Barbara Screech Owl 69
Sapsucker *Sphyrapicus* 150
Savannah Screech Owl *see* Tropical Screech Owl
Saxaoul *Haloxylon ammodendron*, Chenopodiaceae 38
Scotopelia 114
Serpent eagle *Spilornis cheela*
Sexual dimorphism 12, 16, 26, 38, 45, 52, 57, 61, 67, 70, 84, 93, 108, 116, 126, 130, 133, 137, 150, 158, 173, 182, 195, 203, 214, 235, 246, 265, 268, 275, 280, 288
Shelley's Eagle Owl *see* Banded Eagle Owl
Sharp-shinned hawk *Accipiter striatus* 82, 246, 257, 298
Shikra *Accipiter badius* 46
Short-eared Owl 9, *14*, 17, 18, 20, 21, 23, 42, 82, 91, 123, 126, 127, 130, 132, 133, 140, 187, 196, 198, 210, 219, 246, *256*, 260, 261, 267, 268, 270, **271–8**, *273*, 279, 283, 297
Short-tailed vole *Microtus agrestis* 135, 141, 218, 241, 242, 246, 249, 257, 258, 276, 290
Short-tailed weasel (American) *see* Stoat
Siberian jay *Perisoreus infaustus* 93, 135, 242
Siberian pine *Pinus cembra sibirica*, Pinaceae 177
Silver fir *Abies alba*, Pinaceae 177
Siskin *Carduelis spinus* 135, 144
Skeleton 54, 110, 124, 178, 182, 268, 272
Skull 13, 91, 110, 170, 178, 238, 245, 253, 272, 284, 286, 294
Skylark 185
Snowcock *Tetraogallus* 94
Snow partridge *Lerwa* 94
Snow pigeon *Columba leuconota* 94
Snowshoe hare *Lepus americanus* 82, 85, 246
Snowy Owl 41, 44, 80, 85, 86, 87, 88, 91, 97, **123–30**, *125*, *131*, 132, 133, *140*, 250, *256*, 274, 275, 276, 277
Sociable weaver *Philetairus socius* 103
Solitary vireo *Vireo solitarius* 298
Song imitation by man 70, 141, 149, 164, 236
Song resemblance to amphibian voice 42, 77, 141, 164
Song thrush *Turdus philomelos* 144, 185, 290
Sooty Owl 9, 12
Sora *Porzana carolina* 18, 276
Southern beech *Nothofagus*, Fagaceae 265
Southern black-backed gull *Larus dominicanus* 85

319

INDEX

Sparrowhawk *Accipiter nisus* 93, 135, 143, 145, 182, 185, 214, 241, 257
Speciation 79
Speckled Hawk Owl 178
Spectacled Owl 113, 203
Speotyto megaloptera 199
Spiny pocket mouse *Liomys* 268
Spot-bellied Eagle Owl *see* Forest Eagle Owl
Spotted eagle *Aquila clanga* 93
Spotted Eagle Owl 80, 86, 87, 88, 91, **100–4**, *101–2*, 219
Spotted Owl 57, 59, 61, 150, 200, 203, 204, 205, 208, 225, 226, 229, **231–6**, *233–4*, 237, 243
Spotted Owlet 165, 181, *188*, **189–92**, *191*
Spotted Wood Owl 16, 205
Spotted skunk *Spilogale* 18
Spring pocket mouse *Heteromys anomalus* 204
Starling *Sturnus vulgaris* 16, 18, 38, 40, 85, 94, 135, 144, 185, 218, 258, 276, 289
Starvation 186, 198, 219, 250
Steller's jay *Cyanocitta stelleri* 61, 150, 226, 232
Steller's sea eagle *Haliaeetus pelagicus* 110
Steppe eagle *Aquila nipalensis* 182
Steppe marmot *Arctomys himalayensis* 186
Steppe polecat *Putorius eversmannii* 94, 185
Stoat *Mustela erminea* 18, 214, 218, 249, 276
Stock dove *Columba oenas* 185, 289
Storm petrel *Hydrobates pelagicus* 186, 276
Stresemann's Scops Owl 29, 32
Striated Scops Owl 33, *34*, **37–40**, *39*, 41, 42
Striped mouse *Rhabdomys* 283
Striped Owl 9, 253, *266*, **267–8**, *269*, 272, 278
Striped polecat *Ictonyx striatus* 94
Striped skunk *Mephitis mephitis* 85
Striped swallow *Hirundo abyssinica* 20
Strix aluco 13, 15, 17, 18, 20, 21, 45, 87, 88, 91, 93, 133, 141, 143, 145, 182, 185, 186, 187, 190, 205, 208, **209–19**, *211–12*, *215*, *217*, 220, 222, 224, 225, 226, 229, 230, 231, 232, 235, 237, 238, 241, 242, 244, 246, 249, 252, 253, 254, 257, 258, 260, 261, 288, 289, 291
 brevis 238
 butleri 118, 182, 210, **220–4**, *221*, *223*
 fulvescens 203, 204, 225, 226, 238
 intermedia 238
 leptogrammica 108, 178, 203, **205–8** *206–7*
 nebulosa 14, 79, 80, 87, 91, 93, 97, 133, *140*, 225, 226, 232, 237, 238, 241, 242, 243, **244–1**, *247–8*, *256*, 288, 291
 occidentalis 57, 59, 61, 150, 200, 203, 204, 205, 208, 225, 226, 229, **231–6**, *233–4*, 237, 243
 rufipes 204
 seloputa 16, 205
 uralensis 87, 91, 97, 133, 141, 143, 145, 210, 213, 214, 219, 225, 226, 230, 232, 235, 236, **237–43**, *239–40*, 244, 245, 246, 249, 251, *256*, 288, 291
 varia 15, 59, 67, 68, 82, 84, 203, 208, 210, 213, **225–30**, *227–8*, 231, 232, 235, 236, 237, 238, 243, 245, 246, 252, 254, *256*, 257, 291, 294
 virgata 158, **200–4**, *201–2*, 208, 219
 woodfordii 200, 203, 205, 209, 210
 see also *Ciccaba*
Stygian Owl 253, **262–5**, *263–4*, 267
Subcutaneous fat 128
Sugar opossum *Petaurus breviceps* 26
Sugar pine *Pinus lambertiana*, Pinaceae 53
Sulawesi Barn Owl 12
Sulphur-bellied flycatcher *Myiodynastes luteiventris* 173
Sunbathing 91, 182, 190, 193
Superstition 97, 104, 182, 186, 220
Surnia ulula 14, *43*, 91, **132–7**, *134*, *136*, 144, 169, 177, 178, 180, 246, *256*, 274, 288, 289, 291
Survival rate 17, 232, 242, 246
Swainson's hawk *Buteo swainsoni* 84
Swainson's thrush *Catharus ustulatus* 298
Swamp deer *Cervus duvauceli* 23
Swamp rat *Rattus littoralis* 28
Swift fox *Vulpes velox* 196
Sycamore *Planatus*, Platanaceae 59, 69, 150, 170, 173, 231, 235
Syrian woodpecker *Dendrocopos syriacus* 45

Tamarisk *Tamarix*, Tamaricaceae 37
Tameness 145, 151, 154, 250
Tawny Fish Owl *14*, 110, 114, 116, **119–21**, *121–2*
Tawny Owl 13, 15, 17, 18, 20, 21, 45, 87, 88, 91, 93, 133, 141, 143, 145, 182, 185, 186, 187, 190, 205, 208, **209–19**, *211–12*, *215*, *217*, 220, 222, 224, 225, 226, 229, 230, 231, 232, 235, 237, 238, 241, 242, 244, 246, 249, 252, 253, 254, 257, 258, 260, 261, 288, 289, 291
Tengmalm's Owl 13, 45, 52, 91, 133, 137, 138, 141, 143, 144, 145, 146, 150, 151, 180, 185, 186, 213, 214, 224, 237, 238, 241, 245, 246, 254, *256*, 257, **284–92**, *285*, *287*, 293, 294, 298
Territory size 16, 84, 93, 103, 127, 143, 149, 174, 185, 216, 249, 275, 280
Thermal adaptiveness 65
Thermoregulation during incubation 246
Three-toed woodpecker *Picoides tridactylus* 143, 144, 284
Tiger *Panthera tigris* 108
Towhee *Pipilo erythrophthalmus* 151
Townsend's solitaire *Myadestes townsendii* 231
Tree creeper *Certhia familiaris* 141, 144
Tree lizard *Urosaurus* 150
Tree mouse *Steatomys* 26
Tree sparrow (American) *Spizella arborea* 52, 151
Tree sparrow (European and Asian) *Passer montanus* 144, 218
Trembling aspen *Populus tremulides*, Salicaceae 293
Tropical Screech Owl 59, 60, 62, 74, 77, 78

Tufted duck *Aythya fuligula* 94
Turkey vulture *Cathartes aura* 82
Tyto alba **9–22**, *11*, *14*, *19*, 25, 26, 28, 38, 45, 50, 67, 82, 84, 85, 91, 104, 150, 173, 181, 182, 185, 186, 187, 192, 196, 209, 213, 214, 216, 218, 219, 222, 230, 238, 245, 252, *256*, 257, 258, 260, 261, 267, 274, 275, 277, 280, 297
 aurantia 12
 balearica 12
 capensis 12, 18, **23–8**, *24*, *27*, 195, 279, 280
 cavatica 12
 gigantea 12
 inexpectata 9, 12
 melitensis 12
 noeli 12
 novaehollandiae 12
 ostologo 12
 pollens 12
 riveroi 12
 robusta 12
 rosenbergii 12
 sauzieri 12
 soumagnei 9, 12
 tenebricosa 9, 12

Unspotted Saw-whet Owl 286, 293, 294, 298
Ural Owl 87, 91, 97, 133, 141, 143, 145, 210, 213, 214, 219, 225, 226, 230, 232, 235, 236, **237–43**, *239–40*, 244, 245, 246, 249, 251, *256*, 288, 291

Veery *Catharus fuscescens* 298
Ventriloquial calls 54, 124, 164, 283, 294
Vermiculated Screech Owl 69, **74–8**, *75–6*
Verreaux's Eagle Owl *see* Giant Eagle Owl
Vesper sparrow *Pooecetes gramineus* 198
Virginia rail *Rallus limocola* 276
Viscacha *Lagostomus maximus* 193, 196, 199
Vision 13, 65, 80, 91, 124, 141, 180, 182, 195, 209, 213, 220, 226, 244, 250, 254, 272
Vocal anatomy 54–7, 70, 173
"Vocal mimicry" 196–8
Vlei rat *Otomys irroratus* and *Otomys angonensis* 26

Wahlberg's eagle *Aquila wahlbergi* 15
Wallace's Scops Owl 48
Walnut 170, 173
Wandering shrew *Sorex vagrans* 297
"Wanderjahre" 20
Water rail *Rallus aquaticus* 276
Water vole *Arvicola terrestris* 18, 242
Weasel (European and Asian) *Mustela nivalis* 214, 218, 276
Weather tolerance 21, 28, 61, 68, 70, 86, 129, 169, 186, 199, 232
Weight comparisons 15, 23, 25, 38, 45, 53, 87, 91, 100, 123, 153, 170, 181, 203, 209, 214, 230, 241, 244, 257, 267, 274, 279, 280, 294

Western cedar *Juniperus occidentalis*, Pinaceae 149
Western Screech Owl 36, 48, 50, 52, 53, 54, 57, 58, **59–62**, *63*, 64, 65, *66*, 67, 68, 69, 70, 72, 77, 78, 82, 146, 150, 170, 173, 198, 232, 252, 288, 298
Wetland drainage 28, 271, 277, 283
Whiptail or whiptail lizard *Cnemidophorus* 150
Whiskered (Screech) Owl 54, 57, 58, 60, 61, 67, **69–72**, 71, *73*, 77, 146, 150, 151, 173, 198
White-backed woodpecker *Dendrocopos leucotos* 45
White-breasted nuthatch *Sitta carolinensis* 173
White-faced storm petrel *Pelagodroma marina* 20
White fir *Abies concolor* and *Abies grandis*, Pinaceae 53
White fish *Coregonus* 61
White-footed mouse *Peromyscus leucopus* 18, 67, 85, 258, 290, 297
White-headed woodpecker *Dendrocopos albolarvatus* 231
White-necked raven *Corvus albicollis* 280
White stork *Ciconia ciconia* 275
White-tailed booby *Sula sula* 276
White-tailed eagle *Haliaeetus albicilla* 93, 110, 143, 246, 274
White-tailed jackrabbit *Lepus townsendi* 128
White-tailed rat *Uromys caudimaculatus* 28
White-throated Screech Owl 69
Wied's crested flycatcher *Myiarchus tyrannulus* 173
Wigeon (European and Asian) *Anas penelope* 276
Willow flycatcher 298
Willow grouse *Lagopus lagopus* 128, 135, 242, 249
Willow *Salix*, Salicaceae 37, 38, 42, 45, 59, 60, 132, 170, 173, 185, 231, 252, 257, 286, 289, 293, 298
Willow warbler *Phylloscopus trochilus* 144
Wing-loading 17, 244, 257, 274, 275, 297
Wood lemming *Myopus schisticolor* 135, 218, 290
Wood mouse *Apodomus* 214, 218, 242
Wood pigeon *Columba palmubus* 185, 214, 257
Woodchuck *Marmota monax* 85, 196
Woodcock *Scolopax rusticola* 18, 67, 84, 132, 242
Woodrat *Neotoma* 85, 235
Wrentit *Chamaea fasciata* 149

Yellow pine *Pinus echinata*, Pinaceae 53
Yellowhammer *Emberiza citrinella* 144, 145
Yellow-billed hornbill *Tockus flavirostris* 104
Yellow Scops Owl *see* Striated Scops Owl
Young
 development of 17, 26, 84, 94, 103, 127, 143, 185, 280, 283
 size difference of 127
 feeding smaller siblings 17
Yucca *see* Joshua tree